HISTORY OF INDIAN AND INDONESIAN ART

HISTORY OF
INDIAN AND INDONESIAN ART

BY

ANANDA K. COOMARASWAMY

LATE KEEPER OF INDIAN AND MUHAMMADAN ART
IN THE MUSEUM OF FINE ARTS, BOSTON

WITH 400 ILLUSTRATIONS
ON 128 PLATES AND 9 MAPS

DOVER PUBLICATIONS, INC., NEW YORK

This Dover edition, first published in 1985, is an unabridged and unaltered
republication of the work originally published by Karl W. Hiersemann,
Leipzig, in 1927.

International Standard Book Number: 0-486-25005-9

Manufactured in the United States of America
Dover Publications, Inc.
31 East 2nd Street, Mineola, N.Y. 11501

DEDICATED TO
S. B.

CONTENTS

LIST OF MUSEUMS IN WHICH INDIAN
ART IS REPRESENTED

AMERICA: Boston, Museum of Fine Arts; New York, Metropolitan Museum of Art, and
Brooklyn Art Institute; Cleveland; Philadelphia, Pennsylvania Museum and University
Museum; Chicago, Art Institute and Field Museum; Detroit, Art Institute; Washington,
Freer Gallery; Newark; Cambridge, Fogg Art Museum; Montreal.

Berlin, Museum für Völkerkunde; Preußische Staatsbibliothek; Lipperheidesche Bibliothek.

Birmingham, Museum and Art Gallery.

Ceylon, Colombo Museum and Kandy Museum.

Copenhagen, Glyptothek.

FARTHER INDIA: Burma, Rangoon, Pagān; Siam, Bangkok; Cambodia, &c., Saigon, Phnoṁ
Peñ (Musée Sarrault), Tourane.

Hamburg, Museum für Kunst und Gewerbe.

INDIA: Calcutta, Indian Museum, and Baṅgīya Sāhitya Pariṣad; Madras, Government Museum;
Bombay, Prince of Wales Museum; Lahore, Pañjāb Museum; Mathurā, Archaeological
Museum; Patna; Ajmere, Rājputāna Museum; Jaipur; Rājshāhi, Varendra Research
Society; Nāgpur; Dacca; Sārnāth; Bhopāl; Lucknow; Śrīnagar, Śrī Pratāp Siṅgh Museum;
Cambā, Bhūri Siṅgh Museum; Jhalrapatan; Haidarābād; Karāchi; Taxila; Nālandā.

Java, Batavia.

Leiden, Ethnographisches Reichsmuseum.

London, British Museum; Victoria and Albert Museum; India Office; Horniman Museum.

Manchester, Museum.

München, Museum für Völkerkunde.

Paris, Musée Guimet.

PREFACE

Like all students of Indian art, I am deeply indebted to the Archaeological Survey of India. The work of this organisation in the time of Cunnigham, and in more recent years under the guidance of Sir John Marshall, provides in the Memoirs and Reports an indispensible source of information, of which the recent sensational discoveries in Sind are only the latest example.

In the present work the following illustrations are reproduced by permission from photographs taken by the Survey: Nos. 1—6, 12—19, 22, 28, 40, 58—60, 65—67, 69, 69a, 72, 73, 81—84, 89, 90, 102—105, 137, 138, 155—158, 163—168, 171, 176, 186, 199, 203—205, 218, 226, 233, 235, 248, 251, 257, 311—314. To the Archaeological Survey of Gwāliar I am indebted for Nos. 178, 183; the Archaeological Survey of Kashmir, Nos. 232; the Archaeological Survey of Ceylon, No. 184; the Direction des Arts Cambodgiens, Phnoṁ Peñ, Nos. 324, 325, 333, 364; the Oudheidkundige Dienst in Java for Nos. 345—48, 352, 355, 359—362, 366, 380; and to the Publicity Department of the Great Indian Peninsular Railway for Nos. 35, 254. The following are from photographs by the Lucknow Museum, Nos. 71, 74—79, 86, 222, 223; Rājshāhi Museum, No. 227; Indian Museum, Calcutta, No. 47; Colombo Museum, Nos. 289, 290, 296; Victoria and Albert Museum, London, Nr. 382; Birmingham Museum and Art Gallery, No. 160; Manchester Museum, No. 133; British Museum, No. 88; Field Museum, Chicago, No. 95; Detroit Institute of Arts, No. 91; Metropolitan Museum of Art, New York, No. 259; Fogg Art Museum, No. 335; University Museum, Philadelphia, Nos. 80, 224, 225, 272; Cleveland Museum of Art, No. 338; Museum of Fine Arts, Boston, Nos. 23, 57, 70, 85, 93, 94, 96—98, 109, 114, 121, 122, 125, 126, 131, 159, 228, 230, 242, 244, 246, 255a and b, 258, 260, 261, 264, 266, 270, 271, 276—278, 280, 281, 297—299, 322, 336, 337, 365, 368—370, 392—395, 397—400. I have to thank Mr. W. F. Barden for No. 328; Mrs. W. E. Briggs for No. 326; M. G. Coedès for No. 323; Mr. Davis Ewing, Nos. 288, 327, 331; M. Victor Goloubew for Nos. 181, 182, 195, 198; Mr. H. Gravely for Nos. 197, 256; Mr. S. Hadaway for No. 234; the Hon. G. Kemp for Nos. 305—307; Mr. H. Kevorkian for No. 229; Mr. Thornton Oakley for No. 262; M. H. Parmentier for Nos. 341, 342; Paṇḍit Rai Bahadur Radha Krishna for Nos. 20, 21, 92; Dr Denman Ross for Nos. 200, 201, 208, 240, 316, 317; Herrn R. Samson for Nos. 319, 321; Mr. H. L. H. Shuttleworth, for No. 273; Mr. D. V. Thompson, Jr. for No. 196; and Messrs. Yamanaka. for No. 87. Messrs. Johnston and Hoffmann have kindly permitted the use of their photos reproduced in figures 9, 11, 24—27, 32—34, 36, 53, 61, 148, 152, 153, 179, 180, 185, 188, 194, 202, 214—216, 219—221, 237, 253, 279, 282, 302—304; and the Lux Photo Studio, Garoet, Java,

I

of No. 357. The following are from the India Office and old India Museum nega-
tives (the latter now stored by the Archaeological Survey in India): Nos. 8, 10,
30, 37—39, 41—46, 48, 49, 135—136, 139, 140—147, 154, 172, 174, 177, 187,
191—193, 208, 209, 211, 213, 247, 249, 250. No. 203 is by Messrs. Platê, Colombo;
No. 286 by Messrs. Skeen and Co, Kandy. The following are from my own nega-
tives: Nos. 29, 50—52, 54—56, 63, 64, 76, 149, 151, 161, 169, 173, 175, 206,
207, 238, 239, 241, 243, 252, 263, 267, 268, 269, 291, 292—294, 300, 309, 315,
329, 330, 334, 339, 340, 354, 363, 367, 371, 373—376, 378, 379, 381, 383—391,
396. The sources of a few others, taken from published works, are mentioned in
the descriptions of the Plates.

I am very grateful to Miss Mary Fairbank for her assistance in reading the
first proof, to Dr. Hermann Goetz in Berlin both for his translation and a
final revision, to Dr. Wilhelm Olbrich in Leipzig for reading all intermediate
proofs and revising the index.

Attention may be called to some special features of the present volume.
The latest available information regarding Indo-Sumerian finds is embodied; the
early architecture as represented in reliefs and on coins has been rather fully
illustrated; the origin of the Buddha image is discussed in some detail; a synthetic
survey of Farther Indian and Indonesian arts is for the first time attempted.
Space did not permit a treatment of Musalmān art in India, and works dealing
exclusively with this phase of Indian art are omitted from the Bibliography. The
Bibliography and references in the footnotes, though not exhaustive, will provide
a sufficient guide to the student. It may be remarked that the author has personally
visited, often on several occasions, most of the sites and museums referred to.

The usually accepted International scheme of transliteration has been followed;
but the quantity of the vowels o and e, always long in Sanskrit, has not been
specifically indicated in Sanskrit words and names. In the case of a few Indian
place names, such as "Lucknow", properly Lakhnau, the accepted rather than
the scientific transliteration is retained. Some words, e. g. yaksa, yakkha will be met
with both in Sanskrit and in Pāli forms. In the case of Farther Indian and Indonesian
place names I have not always been able to secure an adequate transliteration.

As regards pronunciation, it may be remarked that the vowels should be pro-
nounced as in Italian; it is important to remember that a (short) should be pro-
nounced like a in America, never like a in man. C should be pronounced like ch
in church, ś and ṣ like sh in ship. In the case of kh, gh &c., the aspirate should
be distinctly heard. Ḥ is like ch in loch; the sound of kh and gh in Persian words
such as Mughal is somewhat similar. Most of the other consonants may be
pronounced approximately as in English.

Museum of Fine Arts, Boston, May 15, 1926 *Ananda K. Coomaraswamy*

2

PART I: PRE-MAURYA

INDO-SUMERIAN

It has long been known that seals of a type unique in India have been found in the Indus valley[1]. Quite recently excavations at two sites, Harappā in the Pañjāb, and Mohenjo-Daro in Sind, have revealed the existence of extensive city sites with remains of brick buildings by no means of a primitive character, and an abundance of minor antiquities indicating a period of transition from the stone to the copper age. These remains underly those of the Kuṣāna period, but are not far from the surface; the existence of still lower strata suggests that the Indus valley culture must have had a long previous history in the same area and that it may be regarded as indigenous[2].

"The more we learn of the copper age", says Rostovtzeff, "the more important it is seen to be. This epoch created brilliant centres of cultured life all over the world, especially in the Orient. To the centres already known, Elam, Mesopotamia and Egypt, we can now add Turkestan and Northern Caucasus"[3]. And finally the Indus valley. It may be remarked too that the further we go back in history, the nearer we come to a common cultural type, the further we advance, the greater the differentiation. The chalcolithic culture was everywhere characterised by matriarchy and a cult of the productive powers of nature, and of a mother goddess; and by a great development of the arts of design. We must now realise that an early culture of this kind once extended from the Mediterranean to the Ganges valley, and that the whole of the Ancient East has behind it this common inheritance.

The antiquities found in the Indus valley, other than brick buildings and a limited amount of masonry, include limestone figures of bearded men (fig. 1), and terracottas representing female figures and animals, the latter including the rhinoceros, now extinct in the Indus valley. No anthropomorphic images, other than the terracottas, have been found; but a blue faience tablet with pictographic

[1] Cunningham, 4, vol., p. 108 and pl. XXXIII; Fleet.

[2] For the Indus valley discoveries, still in progress, see Marshall, 9, 12, and in A. S. I., A. R., 1921—22, pl. XIII and 1923—24, pp. 47—54; Chanda, 2; Mackay.

[3] *The Iranians and Greeks in South Russia*, Oxford, 1922.

3

characters at the back has in front the representations of a cross-legged figure, with kneeling worshippers right and left, and a Nāga behind, a remarkable anticipation of familiar types in later Buddhist art of the historical period. Painted pottery analogous to the prehistoric pottery of Baluchistān is abundant; it may be remarked that in Baluchistān there survives an isolated Dravidian language, Brahui, which had long been regarded as a possible island, connecting Dravidian India with the West. Other remains include beads and other ornaments of chank, carnelian, etc; ring stones or maces; faience bangles; hematite pestles; polished gold jewellery; coins; abundant neolithic implements; and above all, seals. Iron is lacking, and the horse was unknown.

The seals (figs. 2—6) are of ivory, or blue or white faience, square in form, and with a perforated boss at the back for suspension. They bear a great variety of designs, including bulls both with and without humps, elephants, tigers, and a representation of a *pippala* tree *(Ficus religiosa)* with two horned monsters affronted attached to the stem. Further, the seals bear numerous characters of a pictographic script which it has not yet been possible to decipher[1]. The representation of these various animals, especially that of the bull and elephant, is masterly in the extreme; that of the limestone sculpture is aesthetically decadent, rather than primitive.

It has been shown that these antiquities bear a general resemblance to those found on Sumerian sites in Mesopotamia, especially Kish and Susa, dating from the fifth to third millenniums B. C. The resemblance amounts to identity in the case of an early Sumerian glazed steatite seal from Kish, alike in respect of the script and of the bull. The miniature funeral potteries of both areas are almost indistinguishable; it may be noted, too, that the oblong, short-legged terracotta sarcophagi of prehistoric South Indian sites are of a Mesopotamian type. Carnelian beads found at Kish are decorated with white lines on a red ground, obtained by local calcination of the surface; this technique, unknown west of Mesopotamia, is so common in India, though at a later date, as to suggest a probable Indian origin[2]. Some Indian boat designs are of a Mesopotamian character, the coracle in particular, while the presence of conch at Susa and of teak and Indian cedar in Babylon are evidences of a seaborne trade, as early as the eighth century B. C., nor is there much reason to doubt that it had begun still earlier[3].

While the remains alluded to above as found in the Sind valley certainly go back to the third or fourth millennium B. C., it must not be supposed that a

[1] Attempted by Waddell, 4, and Note in J. R. A. S., Jan. 1926. Waddell identifies Sumerians with Āryans; the equation Sumerian = Dravidian is much more plausible. For another attempt to read the seals see Bishan Svarup in J. B. O. R. S., IX, 1923, and criticisms by Chanda in the same volume. Some scholars connect Assyrians with Asuras.

[2] Mackay. Bloch, 1.

[3] Kennedy; Hornell, 2, p. 208.

complete hiatus divides this early period from later times. A part of the remains at Mohenjo-Daro probably dates between 1000 and 400 B. C., and on the other hand the minor antiquities from various Indian sites, as at Basāṛh, Taxila (Bhiṛ mound), Pāṭaliputra, and South Indian prehistoric sites go back at least to the fifth century B. C.

The study of Indo-Sumerian antiquities is still in its infancy, and it is too early to draw far-reaching conclusions. But it is at least probable "that the civilisation of which we have now obtained this first glimpse was developed in the Indus valley itself and was as distinctive of that region, as the civilisation of the Pharoahs was distinctive of the Nile"; and if the Sumerians, as is generally supposed, represent an intrusive element in Mesopotamia, "then the possibility is clearly suggested of India proving ultimately to be the cradle of their civilisation, which in its turn lay at the root of Babylonian, Assyrian and Western Asiatic culture generally"[1].

DRAVIDIANS AND ĀRYANS

Certainly before the second millennium B. C. the Dravidians, whether of western origin, or as seems quite probable, of direct neolithic descent on Indian soil, had come to form the bulk of a population thinly scattered throughout India. These Dravidians should be the Dāsas or Dasyus with whom the conquering Āryans waged their wars; their *purs* or towns, are mentioned in the Vedas, and they are described as *anāsaḥ*, noseless, a clear indication of their racial type.

Amongst the elements of Dravidian origin are probably the cults of the phallus[2] and of mother-goddesses, Nāgas, Yakṣas and other nature spirits; and many of the arts. Indeed, if we recognize in the Dravidians a southern race, and in the Āryans a northern, it may well be argued that the victory of kingly over tribal organisations, the gradual reception into orthodox religion of the phallus cult and mother-goddesses, and the shift from abstract symbolism to anthropomorphic iconography in the period of theistic and *bhakti* development, mark a final victory of the conquered over the conquerors. In particular, the popular, Dravidian element, must have played the major part in all that concerns the development and office of image-worship, that is, of *pūjā* as distinct from *yajña*[3].

[1] Marshall, A. S. I., A. R., 1923—24. For the theory of the eastern origin of Western Asiatic and even Egyptian culture, with special reference to the origin of copper and of early religious systems, see de Morgan.

[2] Worshippers of the *śiśna* are mentioned with disapproval in the Vedas. A prehistoric *liṅgam* is illustrated by Foote, 2, pl. XV. An object resembling a *liṅgam* has been found at Mohenjo-Daro.

[3] For the theory of northern and southern races see Strzygowski, *Altai-Iran*, etc. In India, Marshall, 11; and Kramrisch, pp. 79—87.

To the Dravidians are probably due the forms of architecture based on bamboo construction; the architecture of the Toda hut has been cited as a prototype, or at any rate a near analogue, of the early barrel-vaulted *caitya*-hall and the horseshoe arch[1]. Curved roofs, common in India, are rare in the rest of the world. The stone slab construction of many early temples is likewise of Dravidian (dolmen) origin. Early maritime trade and all that has to do with fishing must be Dravidian. The chank or conch industry is a case in point; the use of chank bangles, and of the conch as a trumpet in ritual and war must have been borrowed from Dravidian sources before the epic period[2].

The early history of the Dravidians in the Dekkhan and Southern India is obscure. It is fairly evident that in these areas Dravidian culture had already attained a high level, economic, martial, and literary, in centuries preceding the Christian era. Already in the third century B. C. the great Āndhra empire stretched across the Dekkhan from east to west[3]. In the far south a powerful and prosperous Pāṇḍyan kingdom flourished before the beginning of the Christian era, with a capital at Korkai. The first three centuries of the Christian era represent an Augustan period in the history of Tamil culture, and there is sufficient literary evidence for a high state of development of poetry, music drama, sculpture and painting. At the same time there had grown up a flourishing trade with Rome on the one hand, and with Farther India and Indonesia on the other, the principal articles of export being pepper, cinnamon, pearls and beryl[4].

A brief reference must be made to the prehistoric Indian antiquities which cannot be exactly placed or dated. Eoliths have been found in India and Ceylon, and paleoliths are widely distributed. Remains of the Neolithic cultures, some of incalculable age, others later than the beginning of the Christian era, include the usual types of stone weapons, pottery, and dolmens. In northern India a copper age succeeded and in part overlapped (Mohenjo-Daro, etc.) the neolithic. Finds of copper weapons have been made in many places, the most important being that at Gungeria, C. P., where silver ornaments were also found. The weapons include bare and shouldered celts, plain and barbed spearheads, swords and harpoons, often in handsome shapes and finely wrought; some are of great weight and may have been used for cult purposes. There is no bronze age, nor does bronze begin to appear much before the first century A. D. Iron may have come into use in the earlier part of the first millennium B.C., or may have been known

[1] Simpson, 3. But I cannot regard the "Indo-Āryan" *śikhara* as directly derived from a primitive type of bamboo construction: it is a later development, produced by the reduplication of vertically compressed storeys. See discussion on page 83.

[2] Hornell, 1.

[3] Smith, 4, p. 217; Jouveau-Dubreuil, 6; Bhandarkar, Sir R. G., *Early history of the Dekkhan*.

[4] Smith, 4, ch. XVI; Aiyangar, M. D., *Tamil studies*, Madras, 1914; Kanakasabhai.

6

to the Āryans still earlier; the facts that there is no copper age in the south, that then is a continuity of stone and iron using cultures, that the technique of chank working requires a thin iron saw, and that iron weapons (of uncertain age) are characteristic of prehistoric sites in the south, that iron ore is abundant and readily worked, and that steel was known already in Indian and Ceylon in the second century B. C.[1], all suggest that iron and steel may have come into use at an early date and may have been discovered in India. Against this view are the facts that iron is not mentioned in the early Vedic literature, and that the Hittites were using iron already about 1500 B.C. According to Sayce the Khalybes, who were neighbours of the Hittites, and perhaps of the same race, had the reputation of being the discoverers of steel; in any case, they were its transmitters to the Greeks[2]. The existence in India of Muṇḍā languages, of Mon-Khmer affinity, seems to show that the southward migration of Sino-Tibetan races which peopled the Irawadi, Menam and Mekong valleys and the Indonesian islands had also entered India at some very early period. A pre-Dravidian element in Southern India is probably Negrito or proto-Malay, and Hornell finds a trace of this first connection of India with the east in the single outrigger boat. Sylvain Levi recognizes survivals of a pre-Dravidian language in the occurrence of doublet place-names[3].

The Āryans, whose origin is uncertain, appear in India and Western Asia about the same time. The Indo-Īrānian separation may date about 2500 B. C. Āryan names are recognizable in the case of the Kassites, who ruled in Babylonia about 1746—1180 B. C., and those of Āryan deities were in use amongst the Mitani people at Boghaz-Koi in Cappadocia about 1400 B. C.[4] The Āryans appear to have entered India between 2000 and 1500 B. C. through Afghānistān and the Hindu Kush, settling at first in the upper Indus valley, later in the upper Ganges valley, later still reaching the sea, the Vindhyās and the Narbadā, and still later penetrating to the Dekkhan and the far south[5].

[1] Hornell, 1.

[2] For the prehistoric remains see Foote, 1, 2; Bloomfield; Smith, V. A. in *Imperial Gazetteer*. vol II; and references in C. H. I., pp. 692, 693. Most of the literature on the stone age in Ceylon will be found in Spolia Zeylanica (Colombo). For the literature on iron see p. 34, note 4. The making of steel in small ingots by a true "Bessemer" process has survived in Southern India and Ceylon into the present century. If the early Vedic *ayas* refers to iron we might suppose that the use of iron weapons enabled the invaders to overcome the indigenous copper-using Dasyus.

[3] Hornell, 2 (the introduction of the coconut, of Pacific origin, and of the double-outrigger boat, due probably to the seafaring Malays who colonised Madagascar, are referable to the later period of maritime expansion, about the beginning of the Christian era); Lévi, 3, pp. 55—57.

[4] The Hittite language has Indo-European affinities. A treatise by a Mitanian author on horse-breeding found at Boghaz-koi contains numerous Sanskrit words; the first breeders and trainers of horses seem to have been a Sanskrit speaking race.

[5] For recent general discussions of the Āryan question in India see C. H. I., Chs. III and IV; and Jarl Charpentier in B. S. O. S., IV. 1. 1926

The Vedic Āryans were proficient in carpentry, building houses and racing chariots of wood; and in metal work, making vessels of *ayas*, presumably copper, for domestic and ritual use, and using gold jewellery. They wove, knew sewing and tanning, and made pottery. The early books afford no certain evidence for the making of images of any kind; on the other hand it is impossible to suppose that the manufactures alluded to above were devoid of significant decoration. In all probability, the early Āryan art was "decorative", or more accurately, abstract and symbolical; in other words, a Northern art in Strzygowski's sense[1].

The probable character of early Āryan art at the time of the Indo-Īrānian separation has been brilliantly visualised by the same writer; he applies to this ancient art of Altai-Īrān, whose cognates we should naturally expect to find in India, the name Mazdean. The dominating conception is that of Hvarena (the Indian Varuṇa), the power of Ahura-Mazda "that makes the running waters gush from springs, plants sprout from the soil, winds blow the clouds, and men come to birth" and "governs the courses of the sun, moon, and stars". The characteristic expression of such ideas is to be sought in a kind of landscape "originating in a philosophy of the universe, and based upon significance and form... not upon natural objects exactly reproduced". This Mazdean art should include landscapes showing the sun and clouds, the earth with its plants and herds, and the waters; river landscapes with formal trees; hunting scenes; and symbolic geometrical arrangements of birds, animals and plants. The use of ornamented textiles and decorative hangings, characteristic for nomad races, is also indicated; and these are the forerunners of mural decoration consisting of formal floral ornament enclosed in framed spaces, where the essential element is pattern rather than representation[2]. Landscape of this type, indeed, can be recognized on punch-marked coins, in early Buddhist reliefs, Ajaṇṭā and Rājput paintings, and in types of folk-art used in ritual decoration[3] and in many textiles. Indian art and culture, in any case, are a joint creation of the Dravidian and Āryan genius, a welding together of symbolic and representative, abstract and explicit language and thought. Already at Bhārhut and Sāñcī the Āryan symbol is yielding to its environment and passing into decoration; Kuṣāna art, with the fact of imagery and its roots in *bhakti*, is essentially Dravidian. Already, however, the Indra-Sānti figure at Bodhgayā shows Āryan affecting Dravidian modes of expression, anticipating the essential qualities of all later *sāttvik* images. The Gupta Buddhas, Elephanta Maheśvara, Pallava *liṅgams*, and later Naṭarājas, are all products of the crossing of two spiritual natures; there is an originally realistic intention, but accommodated to the terms of

[1] Strzygowski, 1, 2, 3, 4.
[2] Strzygowski, 4.
[3] Tagore, 1; Annandale.

pure design. Every icon is thus at once a symbol and a representation; the worshipper, though he knows that the deity takes the forms that are imagined by his worshippers, is nevertheless persuaded that the form is like the deity. Just in the same way the ascetic and sensual, opposed in primitive thought, and all other pairs of opposites, are theoretically and emotionally reconciled in mediaeval philosophy and faith. This in a very real sense was a "marriage of the East and West", or North and South, consummated, as the donors of an image would say "for the good of all sentient beings': a result, not of a superficial blending of Hellenistic and Indian technique, but of the crossing of spiritual tendencies, racial *saṁskāras* (preoccupations), that may well have been determined before the use of metals was known.

THE ŚAIŚUNĀGA-NANDA PERIOD
642—320 B. C.

A definitely historical period may be said to begin with the first half of the sixth century B. C. The kings of two dynasties ruling in Magadha include the Śaiśunāgas (ca. 642—413 B. C.) and the Nandas (ca. 413—322); of the former, Bimbisāra (Śreṇika), the builder of New Rājagṛha, and Ajātaśatru (Kuṇika), the founder of Pāṭaliputra, were contemporaries of Mahāvīra and Buddha. The period is that of the later Vedic literature (*Brāhmaṇas, Upaniṣads,* and earlier *Sūtras,* and for the latter part of it the Buddhist *Jātakas* afford evidence. Vedic literature shows little or no knowledge of the West; but Darius in the sixth century B. C. had annexed a part of the Indus valley, and in the time of Alexander's invasion (327) the Indus was still the boundary between India and Persia. Vast areas of the Pañjāb and in Sind, now arid, were then still rich and prosperous.

The later Vedic books show that a knowledge of the metals has advanced; tin, lead, and silver are mentioned as well as two varieties of *ayas,* usually regarded as copper and iron. Cotton, linen, silk and woolen garments were worn; a linen robe used in the Rājasuya ceremony was embroidered with representations of ritual vessels. Storeyed buildings are mentioned (Ṛgveda Saṁhitā, 6, 46, 9)[1]. Round and square huts, bricks, plates, cups and spoons of gold and silver, iron knives, needles, mirrors, elevated bedsteads, thrones and seats, musical instruments, millstones, cushions, turbans (worn by the king in the Rājasuya ceremony and by students after graduation), crowns, jewellery, earthen-ware and a ship are mentioned in connection with the rituals. Writing, no doubt an early form of the Brāhmī character, must have been known in the eighth cen-

[1] For Vedic references to architecture, see Ganguly, 3.

tury B. C. or earlier, but mnemonic methods were preferred for handing down the sacred texts.

The *Jātakas* etc. describe the organisation of craftsmen in gilds, eighteen in number, including "the woodworkers, the smiths, the leather-dressers, the painters and the rest, expert in various crafts". The smiths, workers in any metal, were already called *kammāra*, a name by which the higher craftsmen are still known in the south and in Ceylon. As in Ceylon, too, a characteristic localisation of industries in craft-villages in indicated; in towns, a further localisation in streets or quarters. Ivory workers amongst others are mentioned[1].

Actual remains of pre-Maurya date, apart from the prehistoric antiquities above referred to, are comparatively few. The cyclopean walls of Old Rājagṛha are undoubtedly very ancient. Excavation of what are apparently Vedic burial-mounds of the seventh or eighth century B. C. at Lauṛiyā-Nandangaṛh have yielded amongst other objets a small repoussée gold plaque (fig. 105) bearing the figure of a nude female, probably the Earth goddess of the burial hymn[2]. M. Jouveau-Dubreuil believes that he has discovered in Keraḷa (Malabar) rock-cut tombs of Vedic age. The most remarkable type is the "hollow stupa with central column", a circular chamber, hemispherical in section, and with a very slender central pillar, apparently representing the centre pole of a tent or thatched hut, extending from floor to roof. A similar tomb is described by Longhurst; other caves by Logan, including another circular type with an opening or luffer in the roof[3].

Minor antiquities of undoubted pre-Maurya date have been found at various sites, of which the Bhiṛ mound at Taxila is the most important. The remains excavated here include beads and lathe-turned polished hard stones, terra-cotta reliefs (some resembling the Earth goddess from Lauṛiyā referred to above), and two polished sandstone discs. The antiquities found here and elsewhere prove that glass making had attained a high level before the Maurya period, and that the cutting and polishing of hard stones in the fourth and fifth centuries B. C. hat reached a level of technical accomplishment which was sustained in the Maurya period, but never afterwards surpassed. Other terra-cottas of probably pre-Maurya date have been found at Nagarī, Bhītā, Basāṛh, and Pāṭaliputra[4].

[1] Rhys Davids in C.H.I., Ch. VIII, p. 206.

[2] Bloch, 4.

[3] Jouveau-Dubreuil, 4; Longhurst, 5; Logan, 1 and 2. The Vedic age of these interesting antiquities is doubtful: see Finot in B. É. F. E. O., 1922, p. 247, and Shastri in A. S. I., A. R., 1922—23, p. 133.

[4] For the antiquities of the Bhiṛ mound see A. S. I., A. R., 1919—20 and 1920—21. The carved stone discs and some other probably pre-Mauryan objects are described on p. 20.

EARLY ASIATIC

The Indo-Sumerian and Indo-Īrānian background outlined in the preceding chapters naturally prepares us for the recognition of many common elements in Early Indian and Western Asiatic art. And in fact a great variety of motifs found in Maurya, Śuṅga and early Āndhra art, and thus antedating the age of Hellenistic influence, present a Western Asiatic appearance, suggesting parallels in Sumerian, Hittite, Assyrian, Mykenean, Cretan, Trojan, Lykian, Phoenician, Achaemenid and Scythian cultures. A partial list of such motifs would include such mythical monsters as winged lions, centaurs, griffons, tritons; animals formally posed in profile with head forward, facing, or turned back, animals addorsed and affronted, animal combats and friezes; the sun car with four horses; the bay wreath and mural crown; altar or battlement friezes of Bhārhut and Oṛissā; the tree of life; mountain and water formulae; palmette and honeysuckle (blue lotus), rosette and petal-moulding (rose lotus), acanthus, reel and bead; lotus or "bell" (so-called "Persepolitan") capital; Troy mark and other symbols on punch-marked coins. These and others, such as the fret, spiral, volute, labyrinth and *svastika* have survived in folk art up to modern times and are widely distributed in India and Ceylon[1].

A striking example is afforded by the group of designs representing two or more animals having but one head, so placed as to be equally appropriate to each of the several bodies. Designs of lions of this type occur on an Etruscan vase of the sixth century B. C., on a Śuṅga railing pillar from Gaṛhwā, and in eighteenth century Siṁhalese folk art[2]. A design of four deer is even more remarkable; it occurs on a Chalcidian vase of the sixth century B. C. (derived, no doubt, as Morin-Jean suggests, from an oriental textile), then on a capital of Cave I at Ajaṇṭā (fig. 7), in a Rājput drawing of the nineteenth century, and finally

[1] The material is too abundant to be cited in detail; see amongst other sources Birdwood, p. 325 ff.; Coomaraswamy, 5; Cunningham, 2, 3; Fergusson, 1, 2; Foucher, 1; Grünwedel; Marshall, 5, 6, 7; Maisey; Perera; Spooner, 7, 8, 10; Strzygowski, 3; Tagore, 1; Walsh. The Hittites, ca. 1700—1200 B. C. played a considerable part in developing Babylonian designs and transmitting them to the Eastern Mediterranean; most likely it is more for this reason than because of direct connections that Indo-Hittite and Indo-Lydian parallels can be recognized, the forms being cognate in West and East. The *svastika* appears in the lowest strata at Susa, the double-headed eagle is Hittite and probably earlier. For the early motifs see Pottier, Délégation en Perse, vol. 13. Animals with interlacing necks are Sumerian (Weber, O., p. 59, fig. 14). Indian numerals are used in ancient Hittite texts (Jensen, P., in Sitz. k. bai. Ak. Wiss., 1919, pp. 367 ff.).

[2] Morin-Jean, fig. 175; Cunningham, 4, vol. X, pl. V; Coomaraswamy, 5; cf. Martin, F. R., *Miniature painters and painting of Persia, India and Turkey*, 1912, pl. 164; Sarre and Mittwoch, *Zeichnungen von Riza Abbasi*, 1914, pl. 11; British Museum Ms. Or. 2529, f. 141; Museum of Fine Arts, Boston, Rajput drawing no. 25, 531.

in Southern India in the eighteenth and twentieth centuries[1]. An reverse type is illustrated by the two-headed bird which first appears in Hittite art at Boghaz-Koi, then on a Jaina *stūpa* base at Taxila, later as a common Saracenic and European armorial device, and finally in Simhalese folk art[2].

The cylindrical *stūpa* with drum in two stages, as seen at Beḍsā and in the Kuṣāna period is identical in form with a Phoenician tomb at Amrith (Marath) in North Syria[3]. The Bhārhut altar or battlement-frieze occurs as a string course on the same tomb and on a Babylonian *kudurru*[4]. Lydian excavated and monolithic tombs at Pinara and Xanthos on the south coast of Asia Minor present some analogy with the early Indian rock-cut *caitya*-halls; but the Lydian door jambs are erect[5]. The true arch, which is widely if sparsely distributed in India long before the Muḥammadan period, occurs in Sumerian and other Mesopotamian sites[6].

Another parallel is afforded by the occurrence of shoulder wings (figs. 16, 103) on certain terra-cottas and figures of deities found in India[7]. An early Indian terra-cotta type of female divinity closely resembles a form found at Ur[8].

Other analogies are technical: thus, the art of granulating gold, which may have originated in Egypt in the sixth dynasty, and is highly characteristic of Trojan, Mykenean and later pre-Christian Mediterranean cultures, is typical of the gold jewellery found at many early Buddhist sites in India, e. g. Toṛdher in the Yūsufzai district and Piprāhwā in Nepāl, and equally of modern Tamil and Simhalese jewellery in Ceylon[9]. On the other hand the art of encrusting gems seems to be of Indian origin, not appearing in the Mediterranean until after the time of Alexander[10]. The beaten pottery technique of the early eastern Mediterranean has been recognized at Chārsada, and is represented by ancient and modern

[1] Morin-Jean, fig. 154; Coomaraswamy, 5; Rajput drawing, M. F. A. Boston, no. 26, 50.

[2] Springer, *Kunstgeschichte*, 1923, fig. 177; Marshall, 6, p. 74; Bell, 2; Coomaraswamy, 1.

[3] Springer, loc. cit. fig. 193; Perrot and Chipiez, *Phénice-Chypre*, fig. 95; against this analogy is the fact that the *early* stūpas are always hemispherical (cf. fig. 292).

[4] Springer, loc. cit.; Delaporte, fig. 11. The form occurs in India not only in the frieze, but as an altar and as a battlement.

[5] Springer, loc. cit. figs. 188, 191.

[6] Sumerian examples, see Perrot and Chipiez, Phénice-Chypre, fig. 55; Woolley, C. L., *Excavations at Ur*, Antiquaries Journal, V, London, 1925, p. 387, and pls. XXXVII, XLV. For Indian examples see note on p. 73.

[7] Spooner, 8, p. 116 and pl. XLIV (Basāṛh); Vogel, 6, 1909—10, pl. XXVIII, c, and 13, p. 104 (Sūrya, D 46 in the Mathurā Museum); A. S. I., A. R., 1922—23, pl. X, b (bronze goddess from Akhun Ḍherī). Sir John Evans in Journ. Hellenic Soc. XLIV, 1925, pt. 1, states that the sacral knots on the shoulders of the Minoan goddess became the shoulder wings of Greek art.

[8] C. B. S. 15634 in the Philadelphia University Museum, from the cemetery of Diqdiqqeh near Ur, assigned to 2400—2000 B. C.

[9] Marshall, 11; Coomaraswamy, 1, pls. XLVIII—L. See also pp. 135, 136 and fig. 375.

[10] Marshall, 11; Coomaraswamy in Spolia Zeylanica, (technique), Vol. VI and I, pls. XLVIII, L, and p. 108, fig. 63, 1. This does not refer to "orfèvrerie cloisonnée".

practise in Ceylon[1]. Early Indian and Assyrian glass are of similar composition[2].

Thus, so far as its constituent elements are concerned, and apart from any question of style, there is comparatively little in Indian decorative art that is peculiar to India, and much that India shares with Western Asia.

In view of the fact that the forms referred to appear in Indian art for the first time in the Maurya and Śuṅga periods and that there is good evidence of Achaemenid influence at this time, it has been not unusual to assume that the whole group of Western Asiatic and Persian motifs came into India in the Maurya period[3]. It must, however, be constantly borne in mind that a motif was not necessarily invented or borrowed at the date of its first appearance in permanent material; indeed, a first appearance in stone is almost tantamount to proof of an earlier currency in wood. No one, in fact, doubts the existence of a pre-Maurya Indian art of sculpture and architecture in wood, clay modelling, ivory carving, cutting of hard stone, glass, textiles and metal work, and this art must have embraced an extensive ensemble of decorative motifs, ranging from lines and dots incised or painted on earthen pots and chank bangles to representations of the human figure. To suppose that the whole group of motifs of Western Asiatic aspect was introduced by Aśoka's Persian craftsmen *en bloc*, would thus necessarily imply a belief in the existence of a lost pre-Maurya art of some strange and unknown kind. As a matter of fact, it would be fantastic to postulate the existence of any such art, and, in view of our knowledge of the continous preservation of motifs, and the conservative character of Indian decorative art, it would be impossible to believe that it could have vanished without trace.

All this amounts to proof that the themes and motifs of pre-Maurya art cannot have differed very greatly from those of Maurya and Śuṅga; fantastic animals, palmettes, rosettes, and bell capitals must have been common elements of the craftsman's repertory under the Nandas as in the time of Aśoka. India, in centuries and perhaps millenniums B. C., was an integral part of an "Ancient East" that extended from the Mediterranean to the Ganges valley. In this ancient world there prevailed a common type of culture, which may well have had a continuous history extending upwards from the stone age. Some of its most widely distributed decorative, or more accurately speaking, symbolic motifs, such as the spiral and *svastika*, with certain phases of its mythology, such as the cults of Sun and Fire, may go back to that remote past; more sophisticated motifs

[1] Marshall and Vogel, p. 181; Coomaraswamy, I, p. 220.
[2] A. S. I., A. R., 1923—24, p. 115.
[3] According to Jouveau-Dubreuil, I, vol. I, p. 25, in the time of Darius. Cf. Kennedy, p. 283.

and technical discoveries may have originated in any part of the area; a majority, perhaps in southern Mesopotamia[1], others in India or in Egypt.

The effect of these considerations is to withdraw India from its isolation; as a background to the existing art there is a "common early Asiatic art, which has left its uttermost ripple marks alike on the shores of Hellas, the extreme west of Ireland, Etruria, Phoenicia, Egypt, India, and China"[2]. All that belongs to this phase of art is equally the common inheritance of Europe and Asia, and its various forms as they occur in India or elsewhere at various periods up to the present day are to be regarded as cognates rather than as borrowings.

[1] Pottier, E., *Les Sumeriens et la Chaldée*, Rev. de l'art ancient et moderne, XXVII, 1910: "La Chaldée nous apparaît comme le reservoir d'ou les formules d'art les plus connues se sont deversées sur le mond entier"; and Rostovtzeff, pp. 192, 193, 237: "All these types spread far and wide, eastward, westward, and northward".

[2] Okakura, introduction. Cf. Marshall in A. S. I., A. R., 1923—24, p. 49, and de Morgan.

PART II:

MAURYA, ŚUṄGA, EARLY ĀNDHRA
AND SCYTHO-PARTHIAN (KṢATRAPA)

MAURYA PERIOD, 320—185 B. C.

Candragupta Maurya, of whose origins little is known, displaced the last king
of the Nanda dynasty about 320 B. C. and made himself master of Pāṭaliputra,
the capital of Magadha. His more famous grandson Aśoka (272—232) B. C.,
whose early faith may have been Brāhmaṇical, Jaina, or possibly Magian, early in life
became an ardent Buddhist; Aśoka first made Buddhism a kind of state religion,
and sent Buddhist missionaries to other parts of India and to Ceylon, and west-
wards as far as Syria and Egypt. His monolithic pillar and rock edicts inculcating
the practice of the Dhamma, or (Buddhist) Law of Piety are well known; he is
credited with the erection of 80000 *stūpas*, and countless monasteries; excavations
have shown that his famous palace at Pāṭaliputra formed a large and magnificent
group of buildings. The empire included the whole of northern India from east
to west, Afghānistān and Kaśmīr, and the Dekkhan, only the far south remaining
independent. The later Mauryas ruled till about 184 B. C., when the Śuṅga
dynasty succeeded; but the kingdom had already begun to break up soon after
the death of Aśoka, when the power of the Āndhras in the Dekkhan was already
developing.

For this age we have abundant literary sources of all kinds. A general picture
of Indian civilisation can be drawn from the *Jātakas* and *Sūtras*, with some re-
serves from the Epics, in greater detail from the *Arthaśāstra* of Kauṭilya, and
from western sources, particularly Megasthenes. A few capital cities were now
acquiring increasing importance, amongst which Taxila, Ayodhyā, Ujjain,
Vidiśā, and Pāṭaliputra are most prominent; but the village is still the typical
centre of Āryan life. All the crafts were practised, eighteen of the most important,
amongst which that of the painters is mentioned, being organised in gilds (*seni*);
the term *kammāra* was already in use as a designation of the higher craftsmen.
Carpenters, iron-smiths and potters occupy their own villages, the former tra-

velling up and down the Ganges with timber ready out for building. The more pretentious houses were built of wood with squared beams, sometimes of several storeys supported by pillars and well provided with balconies. City walls were of burnt or unburnt bricks. The arts of glass-making and cutting of hard stones had in previous centuries attained great perfection, unequalled at any later period. Fine materials of cotton, wool, linen and silk were woven, and the art of printing on cotton was practised. Stone begins to come into use both in architecture and for sculpture in relief and in the round, the special characteristic of the Aśokan work being the fine finish and polish of the surface, conspicuous even in the case of the excavated monastic halls[1].

In religion, the Vedic rituals persist, and there must have existed Persian and Hindū modes of fire-worship; but the deities are now beginning to be conceived as worshipful persons (*Bhagavata*), rather than as elemental powers. Āryan philosophies, Aupaniṣadic and Bauddha, are undergoing great modifications in the process of adjustment to popular necessity, with a resulting development of devotional theism and the fusion of Dravidian with Āryan conceptions.

To some extent a distinction can be drawn in the art of this period between an official or court art, and a purely indigenous art. Probably the most important examples of the latter are the famous free-standing stone figures from Besnagar and Pārkham, etc. of colossal size (figs. 8, 9). Although of archaic aspect, and designed from a frontal viewpoint, with flattened sides, they represent a relatively advanced art and imply a long anterior development and practise, if only in the handling of wood. Magnificently conceived, they express an immense material force in terms of sheer volume; they are informed by an astounding physical energy, which their archaic "stiffness" by no means obscures. There is no suggestion here, indeed, of introspection or devotion; this is an art of mortal essence, almost brutal in its affirmation, not yet spiritualised. But this is the material that must later on be used to serve the ends of passionate devotion (*bhakti*) to spiritual and unseen powers, and for the exposition of cosmic theory in terms of an elaborate theology; this same energy finds expression in the early Kuṣāna Buddhas and survives even in the more refined creations of the Gupta age.

Mr. Jayaswal has attempted to prove that the Pārkham statue inscription identifies it as representing Kuṇika Ajātaśatru of the Śaiśunāga dynasty, who died about 459 (Pargiter) or 618 (Jayaswal) B.C.; and to show that two other massive figures discovered at Patna about a hundred years ago represent Udayin Nanda

[1] The official art of Aśoka seems to have somewhat the same relation to the older Indian tradition that Mughal painting and architecture have to Rājput at a later period. The distinction is not so much between a native and a foreign art as between a folk art and a court art. The same kind of distinction can be traced in Persia (Sarre, p. 29).

(fig. 67) and Varta Nandin, later kings of the Nanda dynasty reigning about 400 B.C. The archaic aspect of the statues themselves lends plausibility to these views, which have been tentatively accepted by several scholars, and by myself in previous works. But in view of more recent criticisms it is impossible to adhere to Jayaswal's views, and it is necessary to revert to the opinion that the statue represents a Yakṣa and must date from the third century B.C.[1] A seated figure in the same early style, with an inscription designating it, or rather her, as a Yakṣī, is in *pūjā* at Mathurā under the name of Manasā Devī[2]. The colossal standing female figure from Besnagar, sometimes called the Earth goddess, may be either a Yakṣī or a human figure. Another and more perfect example of the same school of art is represented by the large female *caurī*-bearer (fig. 17) recently found at Patna[3]. The upper part of a colossal male figure from Barodā near Pārkham is even more massive and archaic than any of the other figures; the complete statue must have been over twelve feet in height[4]. Whatever the actual age of this group of four large sculptures in the round, they illustrate and adequately establish the character of the indigenous school in and before the Maurya period. With this group must be associated the Besnagar *kalpa vṛkṣa* (fig. 10).

The official art of Aśoka's reign is mainly represented by the monolithic pillars (*stambha, lāṭ*) on which the edicts are engraved[5]. Of the numerous extant examples the finest is that of Sārnāth erected on the traditional site of the First Turning of the Wheel of the Law (fig. 12). The shaft is of plain polished sandstone, circular in section and slightly tapering; the capital consists of four addorsed lions, which originally supported a *Dhamma-cakka* or Wheel of the Law, resting on an abacus bearing in relief an elephant, horse, bull and lion separated by four small *dhamma-cakkas*, below which is the inverted lotus forming the "bell"[6]. As in other typical examples of Aśokan art the cutting and polishing of the sur-

[1] Jayaswal, 1 and 2; discussion in J. R. A. S., 1920, pp. 154—56. Criticism by Chanda, 1. The two Patna figures are probably the tutelary Yakṣas of the city of Nandivardhana, as suggested by Gangoly, O. C., in the Modern Review, Oct. 1919, and are to be dated in the second century.

[2] A. S. I., A. R., 1920—21, pl. XVIII; and Chanda, 5, p. 165.

[3] Spooner, 11.

[4] Vogel, 6, 1909—10, p. 76 and pl. XXVIII, a.

[5] For Aśoka pillars see Smith, 5; Oertel; Marshall, 8, pp. 619—622 and figs. 27, 28; Sahni and Vogel, p. 28 and pl. IV.

[6] It is impossible to regard the Aśokan lotus or "bell" capital as a copy of a Persian form; the resemblances are by no means sufficient to justify the designation "Persepolitan" (cf. Diez, p. 11). The two types are to be regarded as parallel derivatives from older forms current in Western Asia. Northern India as we now realise had long formed a part of the Western Asiatic cultural complex; inheritance of common artistic traditions, rather than late borrowing, affords the key to Indo-Persian affinities. Octagonal columns are essentially Indian (Ganguly, 3).

face are executed with extraordinary precision and accuracy; not only is great technical skill displayed in this respect, but the art itself is of an advanced and even late type with quite realistic modelling and movement. In other extant or now lost examples the crowning member consisted of similar lions, or of a single bull (fig. 14), horse, elephant or wheel, with the abacus variously ornamented, in one case with flying *haṁsas* in low relief, in another with lotus and palmette motifs. All the inscriptions are finely cut, and with the exception of two in Kharoṣṭhī are in Brāhmī characters. It may be inferred from the existence of these edicts, and from the inscribed bricks of the Morā and Gaṇeśra sites at Mathurā, and those of Tissamahārāma in Ceylon, that writing and reading had by this time become a fairly general accomplishment[1].

Architectural remains of Aśoka's reign in polished sandstone include a monolithic rail and fragments of inscribed capitals at Sārnāth; the altar (Bodhi-maṇḍa) at Bodhgayā, with four pilasters, exactly as represented in the Bhārhut relief (fig. 41), and similar to the altar in the verandah at Bhājā; the capital from Pāṭaliputra[2]; a railing (?) pillar with inscription from the Arjunpura site, Mathurā, now lost; the oldest parts, subsequently enclosed, of various *stūpas*; foundations of *caitya*-halls at Sāñcī and Sonārī; and the excavated *caitya*-halls in the Barābar hills, Bihār, dedicated to the use, not of Buddhists, but of the Ājīvikas. Of the latter, the Sudāma cave, dated in the twelfth year of Aśoka's reign consists of a circular chamber and an antechamber with side entrance; the two chambers are separated by a wall which, except for the narrow doorway, completes the circle of the inner shrine, and the upper part of this wall has overhanging eaves representing thatch. The remarkable plan of this cave is repeated in the somewhat later Buddhist cave at Kondivte, Salsette, in Western India, where, however the circular shrine or *garbha-gṛha* is occupied by a solid *stūpa* which leaves only a narrow passage for circumambulation within the screen; other examples at Junnār and Guṇṭupalle. The Lomas Ṛṣi cave, undated, and apparently unfinished, but certainly Maurya, has a similar plan, but the shrine chamber is oval, and the entrance façade is carved, in imitation of wooden forms, in the shape of an ogee arch above heavy sloping jambs, and the pediment is decorated with a frieze of well designed elephants (fig. 28). At least four other Maurya cave shrines or monasteries are found in the same district. All are excavated in the hardest rock, but are exquisitely finished and polished like glass inside. The forms are evidently those of contemporary structural buildings in indigenous style[3].

[1] Inscribed bricks at Mathurā, Vogel, 15; in Ceylon, Parker, 1.

[2] Waddell, 5, pl. II.

[3] For the Barābar caves and related later types mentioned see Fergusson, 2, pp. 130, 158, 167, 175; Jackson, 2; Banerji-Sastri.

It may be remarked that the ground plan of a church exhibited by a cave of the Sudāma type corresponds to that of a circular shrine preceded by a hall of assembly or approach (such as in later times would be called a *maṇḍapa* or porch) and that in fact it exactly reproduces that of the Sudhamma-sabhā of the Bhārhut relief (fig. 43). It is natural to suppose that simplest form of such a shrine consisted of the circular cella alone, and that the porch was later added to accommodate worshippers, the very narrow passage surrounding the *stūpa* at Kondivte being explained by the fact that circumambulation would be made in single file. By elimination of that part of the shrine wall which separates the cella from the porch the apsidal form of the familiar *caitya*-halls is immediately obtained[1].

Aśoka's palace at Pāṭaliputra (modern Bankipore, near Patna) was described by Megasthenes as no less magnificent than the palaces of Susa and Ecbatana; it was still standing at the beginning of the fifth century A. D., when Fa Hsien tells us that it was attributed to the work of genii, but when Hsüan Tsang visited the city in the seventh century the palace had been burnt to the ground and the place was almost deserted. Recent excavations have revealed the remains of a great hall with stone pillars, which seems to have been planned on the model related to that of the pillared halls of the Achaemenid kings of Persepolis. Sandstone capitals with acanthus ornament have also been found. There exist also massive pier-like foundation of timber, the purpose of which has not been explained. Minor antiquities included some fragments of polished sandstone sculpture, and a few very fine terracottas, now in the Museum at Patna[2] (fig. 22).

A number of interesting sculptures (Fig. 18, 19) of late Maurya or early Suṅga date, known only by fragments, most of which have been found at Sārnāth establish a well-marked stylistic group. These sculptures consist for the most part of broken heads, usually of moderate dimensions, but of quite extraordinary actuality, and not quite like anything else in Indian art. They can hardly be anything but parts of portrait figures, and presumably portraits of donors. They are characterised not only by their marked individuality, but by the type of headdress, which consists in most cases of a fillet, with a bay wreath or mural crown in other cases; the material, except in the case of the Mathurā examples, is polished buff

[1] It is quite possible and even probable that the circular and apsidal plans of early Christian church architecture were of eastern origin, and perhaps even of Indian origin so far as the apsidal form is concerned. Where practically a whole monastic system was copied, as happened in the case of Coptic Christianity, the adoption of an architectural formula may well have taken place. See also page 149. The question is briefly discussed by Stein, 7, p. 536, note 16. In Gandhāra there is a circular domed temple near Chakdana. For Indian influences in western architekture see also Beylié; Dalton, pp. 77 ff.; Pullé (pp. 111, 112); Rivoira pp. 114 ff. and 347).

[2] For Aśoka's palace see Waddell, 5, 6; Spooner, 7, 11; Fergusson, 2, fig. 117; and A.S.I., A. R., 1917—18, pt. 1. For the terracottas see pp. 20, 21.

sandstone[1]. Similar to the Sārnāth examples are a life-sized head from Bhīṭā[2] and two fragmentary heads from Mathurā, reproduced in figures 20 and 21.

Some other fragments of similar date are reliefs with lyrical themes. A fragment from Sārnāth representing a grieving woman appears to be a spandril filler belonging to a larger composition[3]. Another from Bhīṭā (fig. 13), decidedly advanced in its knowledge of pose and movement, represents a woman reclining, with a man fanning, and apparently massaging her limbs[4]. Fragments of a Maurya ribbed polished stone umbrella (chatta) have been found at Sāñcī.

In this connection reference may be made to two carved perforated circular stone plaques found at the Bhiṛ mound site, Taxila, and of very early Maurya or pre-Maurya date; of these Sir John Marshall remarks that "For jewel-like workmanship and exquisite finish these two objects are unsurpassed by any other specimens of stonework from ancient India". These plaques, which I believe to be large earrings — they are not larger or heavier than many of those represented in the early reliefs — are elaborately decorated in concentric circles, one zone consisting of a spirited series of elephants recalling those of the Sudāma cave pediment, another with a kind of palmette ornament alternating with mountains (?) and figures perhaps representing the Earth goddess; these zones being separated by narrow bands of cable and cross and bead ornament. The material is polished Chunār sandstone, the diameter of the plaques four inches in one case, two and three eighths in the other[5]. A similar disc in hard fine-grained soapstone, two and three quarter inches in diameter was obtained by Cunningham at Saṅkīsa (fig. 134): here the outermost decorated circle is composed of radiating bud-forms like those of a modern campākālī necklace, the next zone repeats the same form on a smaller scale, while the inner zone has alternating representations of fan-palms, the nude Earth goddess (?), and taurine symbols. The centre is sunk, but not perforated, a fact apparently fatal to the earring interpretation suggested above[6].

No less important is a considerable group of Maurya and Suṅga terracottas of which examples have been found in the lowest, or nearly the lowest, levels at several widely separated sites, extending from Pāṭaliputra to Taxila (figs. 16, 23, 57, 60). These moulded plaques and modelled heads and busts represent in most

[1] Hargreaves 2, p. III, and pls. LXV—LXVIII, and A. S. I., A. R., 1914—15, pt. 1, pl. XVIII; Sahni and Vogel, p. 32 (B 1 in the Sārnāth Museum).

[2] Marshall, 3, pl. XXXI, 7.

[3] Sahni and Vogel, p. 204 (C (b) 28 in the Sārnāth Museum); Gangoly, O. C., *Ein neues Blatt früher indischer Kunst*, Jahrb. d. as. Kunst, 1924.

[4] Marshall, 3, pl. XXXI, 8.

[5] A. S. I., A. R., 1920—21, pl. XVII, 29, 30. Similar object from Basāṛh, Bloch, ,1, p. 100, fig. 16 (7).

[6] Cunningham, 4, vol. XI, pl. IX, 3.

cases a standing female divinity, with very elaborate coiffure, dressed in a tunic or nude to the waist, and with a *dhotī* or skirt of diaphanous muslin. Despite the garment, especial care is taken to reveal the mount of Venus in apparent nudity, a tendency almost equally characteristic of the stone sculpture in the Śuṅga, Āndhra and Kuṣāna periods. In some cases the figure stands on a lotus pedestal and in two examples from Basāṛh (fig. 16) there are shoulder wings; the arms are generally akimbo, and there are often symbols represented in the space at the sides of the plaque. These types may have behind them a long history; they may have been votive tablets or auspicious representations of mother-goddesses and bestowers of fertility and prototypes of Māyā-devī and Lakṣmī. Other plaques, often in high relief, represent male and female couples like the *mithuna* and Umā-Maheśvara groups of later art[1].

The technique of these terracottas is stylistic and almost always accomplished; although made from moulds, few or no duplicates are met with, and there is great variety of detail. In some cases the figure is endowed with real grace, foreshadowing, as Sir John Marshall remarks, the free and naturalistic developement of the succeeding century. A much more refined type of terracotta found at Pāṭaliputra, and in particular the smiling child from that site, seems at first sight to belong to another and far more advanced school (fig. 22); but not only are similar types of headdress recognizable, a careful comparison with the less individualised types reveals an ethnic relation, and the refinement and sensitiveness that at first might suggest the working of some external influence may be only the result of local conditions.

We have already referred to the foundations of probably Aśokan *caitya*-halls traceable at Sāñcī, Sārnāth, Sonārī, and probably also in the Kistna-Godāverī delta. Besides these, remains of Brāhmaṇical temples have been excavated at at least two sites. At Nagarī near Chitor, the ancient Madhyamikā, an inscription of from 350—250 B. C. refers to a temple of Saṁkarṣaṇa and Vāsudeva at a place called Nārāyaṇa-vāṭa; this is the earliest known inscription indicating the existence of a Vaiṣṇava cult, and also the earliest known Sanskrit inscription. Aśvamedha and Vājapeya sacrifices are also mentioned. The original shrine was no doubt

[1] These terracottas have been found at Basāṛh, Spooner, 8: Taxila, Cunningham, 4, vol. XIV, pl. IX; A. S. I., A. R., 1919—20, pl. XI, 9, 10, and 1920—21, pl. XVI, 9, 15, 17; Bhītā, Marshall, 3, pl. XXII, 8; Nagarī, Bhandarkar, D. R., 6, pl. XXIV, 17, 21; Mathurā, a series in the Museum of Fine Arts, Boston; Pāṭaliputra A. S. I., A. R., 1915—16, pt. 1, p. 14, and 1917—18, pt. 1, pl. XVI; Kosām, Banerji, 4; and Saṅkīsa, Cunningham, 4, vol. XI, p. 29, and pl. IX, 4. These terracottas may range in date from the fifth century B. C. to the first A. D. The more primitive types from Pāṭaliputra and Mathurā, especially in respect of the two lateral masses or horns of the headdress, closely approximate to some very ancient examples from Mohenjo-Daro: cf. A. S. I., A. R., 1917—18, pt. 1, pl. XVI, I, 4, with *ibid.* 1923—24, pl. XXXI e. For *mithuna* see Gangoly.

of wood, but continuous Vaiṣṇava worship seems to have been conducted here from the third century B.C. to the seventh A.D.; the excavations revealed remains of a rectangular enclosure with walls nearly ten feet in height at the site now known as Hāthī-Bāda, evidently the *pūjā-śilā prakāra* of the inscription[1]. What would appear to be the earliest known depiction of a specifically Brāhmaṇical shrine is the pavilion with an ornamented basement, and enshrining figures of Skanda, Viśākha and Mahasena, found on a coin of Huviṣka[2].

It is only after about 800 B.C. that we can trace or infer any contemporary contact of Āryan India with Persia. From the evidence of Indian art, Maurya to Gupta — Aśoka's capitals and palace, certain terracottas, fire-altars on seals and coins, pointed caps, and so forth — a "Zoroastrian period of Indian history" has been inferred, and a "semi-Mithraic Buddhism" spoken of[3]. Elements of sun- and fire-worship are certainly indicated in early Buddhist art; we find the worship of a flaming pillar, and later, Buddhas, Śivas and kings (coins of Kaniṣka) with flames rising from their shoulders, while the nimbus is of solar origin and must have originated either in India or Persia. Magian ideas may have played a part in the development of the Buddhist holy legend, and of the Bodhisattva iconography; and were still current in the Pañjāb and Rājputāna in the sixth century A.D. It is interesting too to remark that the doctrine of the passing on from king to king of a divine royal glory, which is the essential element of the later Javanese-Cambodian-Cam Devarāja cult, is also Avestan. Kadphises II used the style "Maheśvara"; does this signify that he claimed to be a descent of Śiva? A Semitic origin of the Kharoṣṭhī script about the fifth century B.C. can hardly be doubted; an Aramaic inscription, too, of about the fourth century B.C. has been found at Taxila[4]. During a great part of the centuries immediately preceding the Christian era the Indus formed the eastern boundary of Persian dominion. It has been argued too that the Nandas, Mauryas and Licchavis were all of Īrānian extraction. It is certain that during this period contacts with Persia were easy.

Many of the parallels referred to, however, seem to indicate a common Aryan *Weltanschauung*, such as Hertel has adumbrated[5], rather than contemporary borrowing. It may be taken for granted that Persian influences were actually felt in India in and after the Maurya period; but there is no reason to infer that any of these parallels or borrowings connote a religious, social or political dependence of Northern India on Persia[6].

[1] Bhandarkar, D. R., 6.
[2] Gardner, p. 151 and pl. XXVIII, no. 24.
[3] Spooner, 11; Maisey, pp. 124, 216, etc. Cf. C. H. I., p. 87.
[4] Marshall, 6, p. 75; Barnett and Cowley, in J. R. A. S., 1915.
[5] Hertel, J., *Die arische Feuerlehre*.
[6] Marshall, in A. S. I., A. R., 1915—16, pt. I, p. 15.

ŚUṄGA, ĀNDHRA AND INDO-PARTHIAN OR KṢATRAPA
PERIOD, CA. 200 B. C. TO A. D. 20

(Śuṅgas, Āndhras, Kānvas, Satraps of the Western Ghāṭs,
Mathurā, and Ujjain; Indo-Greek and Indo-Parthian
rulers in the Pañjāb, Afghānistān and Bactria.)

The history is too complicated to be noticed here in any detail. Puṣyamitra
Śuṅga, the immediate successor of the last Maurya king ca. 185 B. C. was a zealous
Hindū, perhaps with Magian tendencies, and may have gone so far as to persecute
Buddhists and destroy monasteries; his dominions included Magadha and ex-
tended southwards to the Narmadā, northwards to Jālandhar in the Pañjāb.
Puṣyamitra repelled the Greek invader Mcnander, the Milinda of Buddhist tra-
dition, about 175 B. C.; but was defeated by Khāravela about 161 B. C. The
Kānvas (73—28 B. C.) succeeded the Śuṅgas. The dominant power in the Pañjāb
and Mathurā, ca. 70 B. C. — 20 A. D. was Scythian (Śakas of Seistān)[1]. Mean-
while the Āndhras, who already in Maurya times were a powerful Dravidian
people possessing thirty walled towns in the Kistna-Godāverī delta (later Veṅgī),
and had extended their domains across India as far as Nāsik and Ujjain, ruled
the Dekkhan; the dynasty lasted for four and a half centuries and was only suc-
ceeded by the Pallavas in the East in the third century A. D. A relief figure of
Sātakarṇī, third king of the dynasty, accompanies the important Āndhra inscrip-
tion at Nānāghāṭ, near Pūna[2]. Most of the Āndhra kings seem, by their names,
to have been Brāhmaṇical Hindūs, but they are best known by their benefactions
to Buddhist communities; to them are due most of the cave temples and monaster-
ies of the Western Ghāts, the Ghaṇṭaśāla, Bhaṭṭiprolu, Guṇṭupalle and Amarā-
vatī *stūpas* and other structures in the east, and probably the Sāñcī gateways.

In eastern India the Kaliṅgas recovered the independence they had lost under
Aśoka. The Jaina king Khāravela, about 161 B. C. took Pāṭaliputra, the Śuṅga
capital (see pp. 37, 43). Other events were taking place in the North-west. About
250 B. C. Parthia and Bactria broke away from the Seleukid Empire and set up
as independent Greek principalities. Yavana ("Greek") princes of the two houses
of Euthydemus and Eucratides reigned in Bactria, Kābul, and the Pañjāb west

[1] The Śaka invasion of the Indus delta, ca. 75 B. C. may represent the historical foundation
of the Jaina story of Kālakācārya; cf. C. H. I., p. 532.

[2] C. H. I., p. 530; Bühler, Arch. Surv. Western India, IV. The inscriptions refer in part
to Brāhmaṇical ceremonies performed for Āndhra rulers at an enormous cost in priestly fees
"which testify eloquently to the wealth of the realm and the power of the Brāhman hierarchy at
this date". The royal statues represent Simuka, founder of the line, Sātakarṇi and his queen, and
three princes. So far as I know the statues have never been published.

of the Indus, the leading names being those of Demetrios of Bactria (ca. 175 B. C.); Menander (Milinda) of Kābul (160—140 B. C.) who invaded India, reaching Mathurā, Saket, Madhyamikā (= Nagarī, Chitor) and perhaps Pāṭaliputra, then the Śuṅga capital, and is claimed as a convert by Buddhist tradition; and Antialkidas of Taxila, (ca. 140—130 B. C.) whose ambassador Heliodora professed himself a Bhāgavata and dedicated a monolithic column at Besnagar in honour of Vāsudeva (= Kṛṣṇa). Meanwhile the nomad Śakas or Scythians had attacked both Bactria and Parthia and the Hellenistic Bactrian kingdom came to an end about 130 B. C. but numerous princes with Greek names continued to rule as Parthian Satraps in Afghānistān and the western Pañjāb; amongst these, the best known are Maues (ca. 95—58), Azes I and Azes II (ca. 58—18 B. C.) and Gondophares (ca. 20—48 A. D.). At the same time Śaka princes ruled in Taxila and Mathurā (e. g. Śoḍāsa) and established a dynasty in Western India, known as that of the Western Satraps, which lasted until the time of Candragupta, ca. 390. The Indo-Greek kings of the Pañjāb are known almost exclusively by their coins, which are at first in a purely classical style, and subsequently Indianised, and by small objects, none of which are of a Buddhist or Hindū character. A temple with Ionic pillars, but not otherwise Greek, excavated at Taxila, may date from about 80 B. C.[1] Many authors are inclined to believe that the development of Graeco-Buddhist (Gandhāran) sculpture had begun towards the end of the first century B. C., but at present no positive evidence for or against this view can be adduced[2]. Others attach considerable importance to the indirect influence of Hellenistic art in Bactria, of which however we have no knowledge, and find evidence of it in the evolution which is certainly traceable at Sāñcī[3]. The subject of the Western Asiatic motifs in Maurya and later Indian art, and of Īrānian (Magian) elements in Indian culture and art from the Maurya to the Gupta period have been referred to above. Objects in the Scythian animal style have been found at Taxila[4].

Only the more important monuments of the period can be discussed. The old *vihāra* (monastery) at Bhājā[5] near Pūna in the Western Ghāṭs is the oldest, or if not the oldest in point of time, at any rate the oldest in respect of its sculptures. The plan, though irregular, is similar to that of most excavated *vihāras*; there is an outer verandah separated by a wall with two doorways and a barred window, from an inner hall, surrounded, in this case on two sides only, by excavated cells. The verandah roof is hollowed out to form half of a barrel vault, the two

[1] Cunningham, 4, vol. II, p. 129; vol. V, pp. 69—72 and pls. XVII, XVIII.
[2] See next Chapter; and references in Coomarasnamy, 16.
[3] Marshall, 5 and 8, p. 644.
[4] A. S. I., A. R., 1920—21, pt. I, pl. XXIV, b and c.
[5] Fergusson, 2; Burgess, 5, 8; Jouveau-Dubreuil, 1; Marshall 8.

gable ends and flat inner wall with cornices supported by alternate *stūpas* and caryatides. At the west end, a group of three cells is divided from the verandah by a pilaster and pillar, with a frieze below. The pillar has a lotus capital surmounted by addorsed sphinx-like creatures, with bovine bodies and female busts. The slender outer pillars of the verandah are all broken. The cave is most remarkable, however, in respect of its unique reliefs; these include the aforesaid frieze, five armed figures in niches on the east side of the hall and on the verandah wall, and the two reliefs at the east end of the verandah, separated by the cell doorway. On the left side is represented a royal personage driving in a four-horsed chariot (fig. 24); he is accompanied by two women, one a *chatra*-, the other a *cauri*-bearer. Figures on horseback form an escort, and of these the female rider in the inner angle of the verandah is clearly provided with some kind of stirrups, of which this appears to be the earliest known instance in the world[1]. The chariot is being driven across the backs of very grossly proportioned nude female demons, who seem to be floating face downwards in the air. I see no reason to question the original identifications of this scene as representing Sūrya with his two wives driving through the sky and dispelling the powers of darkness.

The relief on the right side is even more elaborate (fig. 27). A royal personage, with one attendant seated behind him bearing a standard, is riding on an enormous elephant which is striding over a broad landscape, and holds aloft in its trunk an uprooted tree. The elephant and its two riders are designed on a scale enormously greater than that of the landscape, and blotting out the greater part of it: an elephant forming part of the normal landscape is not much larger than the foot of the great elephant. Almost certainly, as former writers have suggested, this is Indra, riding upon his elephant Airāvata[2]. In his character of god of rain, and bearer of the *vajra* (= lightning) Indra is a hostile and dangerous power, especially in the Kṛṣṇa-Vāsudeva legends, which were already well known at this time. Moreover, nothing is more characteristic of the Vedic descriptions of Indra than the insistence upon his great size: "he surpasses in greatness heaven, and earth, and air", "were the earth ten times as large, he would be equal to it", and he is a warrior of irresistible power. And if it is only in the Epics that he

[1] Also at Sāñcī (Marshall, 5, p. 138) and at Pathaora near Bhārhut (Cunningham, 2, pl. XX). But a majority of riders in the early periods, and even in Kuṣāna and Gupta sculptures, are represented without stirrups. For bits and bridles see Hopkins in J. A. O. S., XIX, pp. 29—36.

[2] Similar figures appear on a medallion at Bhārhut, where too the elephant holds a tree in its trunk (fig. 48), on the Sāñcī *toraṇas*, and on the Kuḷū *loṭā* (Marshall, 8, fig. 22), but moving in calm and orderly progression. As regards these and other examples, it should be observed that not every rider in a four-horsed car necessarily represents the Sun, nor every rider on an elephant, Indra. The *triśūla* standard with floating banner seems to be used as royal insignia without specific religious significance.

is said to ride upon Airāvata in battle, it is easy to see how this connection arose: Indra is the power of the storm, he rides upon the clouds, the Maruts are his allies; in the *Mahābhārata*, *"airāvatas"* = lightning clouds; and in later poetry clouds and elephants are so constantly associated as to be practically synonymous[1].

Whatever the iconographic significance, the relief deserves close study from every point of view. The princely rider is his own driver; the attendant behind him, wearing an enormous collar and crenellated drawers, carries a scythe-shaped standard the shaft of which terminates in a trident, and what appear to be two spears. Both are seated on a richly embroidered cloth which covers the whole back of the elephant. Below the uprooted tree are falling figures.

The remainder of the landscape is unaffected by the storm. Below the falling figures is a sacred tree enclosed by a *vedikā*, and hanging on this *caitya-vṛkṣa* are three human figures, suspended in each case from a sort of inverted funnel, similar to those by which the garlands are attached to another sacred tree shown below; both trees are crowned by parasols, probably indicative of an indwelling spirit. It can hardly be doubted that this is a representation of human sacrifice[2]. Below, on the left, is a court scene, occupying the remaining space down to the foreground. The king, designated by a royal umbrella (*chatra*), is seated on a wicker throne (*moṛhā* or *bhadrāsana*), a *caurī*-bearer at his side; before him are dancers and musicians. On his right is the second, railed, parasol-crowned, and garlanded, *caitya-vṛkṣa*; and further to the right a more confused jungle scene, in which appear an armed man and a horseheaded fairy[3]. On the whole the costume and accessories are not unlike those of the Bhārhut reliefs, but the turbans and jewelry are much larger and heavier.

The composition rises immediately from the wall surface, without a frame, and it is carried a little way over the angle of the jamb of the doorway. This

[1] Cf. *Kathāsarit Sāgara, l.c., taraṅga, LV*: "Then the mast elephant of the wind began to rush, showering drops of rain like drops of ichor, and rooting up trees". The elephants in Māyā-Devī and Gaja-Lakṣmī compositions must likewise be regarded as rain-clouds. Cf. Hopkins, p. 126.

[2] "dryads are vegetal divinities that eat human flesh and have to be appeased with offerings" (Hopkins, p. 7). Cf. *Sutasoma Jātaka* (illustration at Degaldoruwa, Ceylon, Coomaraswamy, 1, fig. 152.)

[3] This horse-headed fairy recalls the Yakkhiṇī Assa-mukhī of the *Padakusalamāṇava Jātaka* (Nr. 432), "who dwelt in a rock cave in a vast forest at the foot of a mountain, and used to catch and devour the men that frequented the road". The same or a similar fairy appears at Sāñcī on a medallion of the railing of Stūpa 2, and at Bodhgayā on a railing relief (Foucher, 5, pl. 1, figs. 8 and 9). At Bhājā it hardly seems that so small a detail on so large a composition can refer directly to the *Jātaka*; more likely the Yakkhiṇī is represented simply as a forest goblin, as a type, and not as an individual; just as she appears amongst the peaks of Mt. Govardhana on the later Maṇḍor stele (fig. 166). Another "Assamukhī" appears on the ancient railing found at Pāṭaliputra (Waddell, 5, pl. 1). Cf. the Yakkhiṇī mare of *Mahāvaṃsa*, Ch. X.

earliest Indian landscape is a mental picture without any attempt at the representation of visual appearances as a whole, though realistic in detail; it shows great knowledge, but not a *study* of nature. The question of perspective in a modern sense does not arise, because, as in Indian and Eastern landscape at all times, the various elements are successively presented in half-bird's-eye view, with the horizon practically out of the picture; the "atmosphere" is not supposed to be seen in lateral section, but forms an ambient including the spectator and the whole picture[1]. To one accustomed to the convention, a three-dimensional effect is more obvious than in a modern painting; there is no crowding, or overlapping of planes, and the mutual relations of the parts are unmistakable.

The whole approach, like that of early Indian art generally, is realistic, i. e. without *arrière pensée* or idealisation. The main interest is neither spiritual nor ethical, but altogether directed to human life; luxury and pleasure are represented, interrupted only by death, and these are nothing but practical facts, endorsed by the inherently sensual quality of the plastic language. The art of these reliefs expresses a philosophy older than the Great Enlightenment.

These are not personal deities conceived in the manner of Hindū theism, but powers personified only in the way that they are personified in the Vedic hymns. Both reliefs are the creation of a wild and fertile, not to say an uncanny imagination. The forces of Nature are regarded only in the light of their relation to human welfare, and over all there hangs the dread of the tiger-haunted forest, the power of the storm, and the marvel of the sun that journeys through the air. None of this mystery appears in the orderly reliefs of Bhārhut and Sāñcī, and only some trace of it in the far less accomplished art of the Oṛissan caves. What the true meaning of these reliefs in a Buddhist *vihāra* may be, is hard to determine; the *vihāra* must be Buddhist, but the sculptures are not Buddhist. This is rather, a sample of the kind of non-Buddhist art which the Buddhists had to adapt to their own edifying ends; and it reminds us that much must have been going on outside the limited range of Buddhist art properly so called.

From the fact that the relief is high and the forms rounded, Sir John Marshall has assigned a late date to the cave (first century B. C. in place of the third or second century of former authors)[2]. The developed relief at Sāñcī does, indeed, represent an emancipation from an earlier compression, and tends to visual realism and conscious artistic grace; but the relief at Bhājā is a quality of volume and expansion, quite distinct from plastic modelling, and due, like the volume

[1] For a discussion of "vertical projection", which appears in western art only at a much later date, see Dalton, pp. 163, 229, 230.

[2] Marshall, 8: the earlier dating adopted above was originally proposed by Fergusson (2) and is endorsed by Jouveau-Dubreuil (1).

of the Pārkham statue, to pressure from within; at the same time both style and detail are related to those of the Maurya-Śuṅga terracottas.

Very near to the old *vihāra* at Bhājā there is a group of rock cut *stūpas*, and a large excavated *caitya*-hall (fig. 29), which, together with *caitya*-halls at Beḍsā (figs. 32, 33), Kondāñe, Pitalkhorā, and Ajaṇṭā (cave X) may be dated about 175 B. C. These *caitya*-halls are excavated copies of wooden structural buildings as clearly appears in the literal imitation of timbered construction; occasionally wood was combined with the stone, forming a screen of concentric ribs within the arch of the entrance, or applied to the stone ceiling to represent rafters, and in one or two cases part of the original woodwork has survived. Another feature derived from wooden construction is the inward slope of the entrance jambs, which is most marked in the earliest examples (fig. 29), and becomes much less conspicuous as the style develops.

The *caitya*-hall is really a Buddhist church, and like a Christian church, consits of a nave, apse and aisle, the latter separated from the nave by pillars, the apse containing in place of the altar, a solid *stūpa*, the whole excavated in the living rock or built of wood and brick. The aisle is continued round the apse, thus providing for circumambulation (*pradakṣiṇā*) and corresponding to the outer hall or verandah of structural temples. Except at Bhājā there is very little sculpture associated with the earliest *vihāras* and *caitya*-halls.

The *caitya*-hall at Nāsik (fig. 31), and the Nahapāna *vihāra*, Cave VIII, may be dated near the middle of the first century B. C. The façade of the *caitya*-hall is divided horizontally into two storeys, the lower with an arched door, the upper with a great "*caitya*"-window; beside the door is a Yakṣa guardian. The inscription states that the villagers of Dhambika gave, i. e. paid for[1], the carving over the doorway, which is more than usually elaborate. By this time the "batter" of the doorway jambs, so conspicuous in the earlier caves, is greatly reduced, and is hardly noticeable; but the internal rafters are still supplied in wood. The Nahapāna cave (*vihāra*) pillars, supported by pots above pyramidal pedestals, are crowned by large bell capitals, which support another member, consisting of an inverted pyramid and addorsed bulls, a form to which the later pillars at Kārlī (fig. 34) closely approximate; the railing of the architrave is quite plain, affording a contrast to that of Cave III, which is covered with lotus rosettes, and is supported by a narrow frieze of animals[2].

The *caitya*-hall, No. 9, at Ajaṇṭā, must be of about the same age.

[1] Many of the old Buddhist monuments were erected by public subscription.

[2] For Nāsik see Fergusson, 8, vol. 1, pp. 140, 183; Jouveau-Dubreuil, 1, vol. 1, Chs. 1 and 2; Marshall, 8, p. 637. In dating the early caves I follow Marshall, except as regards Bhājā. For the dating of the excavations in Cave III see Nilakantha Sastri in J. R. A. S., 1926, p. 665.

The largest of all the early Buddhist churches, and indeed, one of the most magnificent monuments in all India, is the great *caitya*-hall at Kārlī (figs. 34, 35), which may be dated near to the beginning of the Christian era. The general dimensions are in excess of a hundred and twenty four by forty-five feet in area, and forty-five in height, comparable in size with those of an average Gothic cathedral. The *stūpa* is of the high cylindrical type with two rail courses; the original wooden umbrella is still preserved. As at Nāsik the façade consists of two stages; there is a lower wall pierced by three doorways, and an upper gallery, over which is the usual enormous horse-shoe window, in which remains of structural woodwork, consisting of concentric arches forming a pediment, are still preserved. The great pillars separating the nave from the aisles have "Persepolitan" capitals, more elaborate than those which already appear at Pitalkhorā and Beḍsā, and having the effect, as Fergusson remarks, of a frieze and cornice; from these rise the wooden ribs attached to the domed stone of the roof, one of the last instances of this peculiar vestigial use of woodwork in combination with the solid stone. The lower storey of the screen or façade, in the spaces between the doorways, is decorated with sculptures of two periods. Those evidently representing donors, are pairs of human figures, of enormously massive type, and very grandly conceived; those representing Buddhas, which have been cut into the screen and side walls of the porch at a later date (Gupta) are far less vivid. The setting back of the entrance into the face of the rock forms an outer porch, the sides of which are sculptured in architectural façades of several storeys, the lowest supported by huge elephants, the second decorated with sculptured figures like those of the screen. Numerous mortice holes in the rock show that as usual the entrance was preceded by some kind of wooden antechamber or porch, and further outside stands one of the two original monolithic *dhvaja-stambhas* with a capital of four lions which once supported a wheel (*dhamma-cakka*)[1].

The five groups of caves near Junnār (48 miles north of Pūna) include a very interesting circular *caitya*-hall, in which a plain *stūpa* is surrounded by a ring of twelve pillars, the central area being domed, the circular "aisle" half domed, almost literally realizing the form of the double-roofed circular temple (the Sudhamma Sabhā) of the well-known Bhārhut relief (fig. 43). Later, and probably coeval with the Kārlī church is the *caitya*-cave at Mānmoda hill (fig. 30); two Nāgas are represented above the finial of the *caitya*-window, and the semicircular pediment is occupied by a standing figure of Māyā Devī with the two elephants and four worshippers, standing in niches consisting of seven petals of an expanded lotus[2].

[1] For Kārlī see Fergusson, 1, vol. 1, pp. 140 ff.; Jouveau-Dubreuil, 1; Marshall, 8, p. 637.
[2] For all the Western caves see Fergusson, 2; Burgess, 1, 2, 5, 8; Marshall, 8.

At Nānāghāṭ, 50 miles N. W. of Pūna, there are important inscriptions, proofs of the westward extension of the Āndhra power early in the second century B. C., and reliefs, including one of Sātakarṇi, probably the third king of the Āndhra dynasty and contemporary of Khāravela of Kaliṅga, affording an early example of the common Indian practise of placing figures of donors in the shrines due to them[1].

The most famous monuments of the post-Mauryan and pre-Kuṣāna period are the Bhārhut (Nāgodh State) and Sāñcī (Bhopāl State) *stūpas* and their railings and gateways. Before describing these specific examples of typical Buddhist architecture (the Jains also erected *stūpas*, but no Hindū examples are known, though the technical term *stūpī* is applied to the finial of a structural Hindū temple), we must briefly describe their nature.

The *stūpa* ("tope", or *dāgaba*), originally (pre-Buddhist) a funeral mound, becomes a symbol of the last great event of the Buddha's life, viz. the Parinirvāṇa, and usually enshrines relics of the Buddha (authentic relics have been discovered at Taxila), sometimes of other teachers, contained in reliquaries, which may be of crystal, gold, or other material. The early *stūpas* are of brick or brick and rubble, the later usually enclosed in a masonry casing; others are monolithic, e. g. those in excavated *caitya*-halls, where their character is purely symbolic. A *stūpa* usually rests on a basement of one or more square terraces (*medhi*) or is at least surrounded by a paved square or circle for circumambulation, the terraces being approached by stairs (*sopāna*); it consists of a solid dome (*aṇḍa* or *garbha*) with a triple circular base, and above the dome a cubical "mansion" or "god's house" (*harmikā*, Siṁ. *deva-kotuwa*), from which rises a metal mast (*yaṣṭi*) the base of which penetrates far into the *aṇḍa*; and this mast bears a range of symbolical parasols (*chatra*) and at the top a rain-vase (*varṣa-sthala*, corresponding to the *kalaśa* of a Hindū shrine)[2]. The form undergoes stylistic development; at first there is no drum, but later on the circular base becomes a cylinder, and the dome is elevated and elongated, and the base terraces are multiplied. The Chinese pilgrims speak of certain *stūpas* as towers; but a high wooden structure like Kaniṣka's at Peshāwar (see p. 53) must have been something more like a Chinese pagoda, and called a *stūpa* only because it enshrined relics.

The railing (*vedikā*) is identical in nature with the wooden fence that pro-tected any *caitya*, for example the *caitya-vṛkṣas* so often represented in old Indian art; it consists of a plinth (*ālambana*), uprights (*thabā*) with lateral sockets for the reception of the horizontal "needles" (*sūci*), and a coping (*uṣṇīṣa*). The railed

[1] Burgess, 5, p. 65; C. H. I., pp. 530, 600, etc.

[2] As described in the *Divyāvadāna*, quoted Foucher, 1, vol. 1, p. 96. The *harmikā* is not, and never was, a "relic box".

enclosure has four angled entrances; and above these are often erected high and elaborate single, double or triple arches (*toraṇa*), both railing and arches alike closely imitating wooden prototypes.

The Bhārhut brick *stūpa*[1], stone railing and entrance archways, of which all that now survives is to be found in the Indian Museum, Calcutta, most likely dates from about 150 B. C., in the Śuṅga period. The Bhārhut reliefs are usually accompanied by contemporary descriptive inscriptions. Inscribed figures of guardian Yakṣas and Yakṣīs, Nāgarājas, Devatās, etc., constituting an extensive iconography, are found on the *toraṇa* posts (figs. 37—39); *Jātakas (Vessantara*, fig. 47), and scenes from the life of Buddha; a group of floral, animal and monster motifs; and lotus rosettes often enclosing heads of men or women, are represented on the railing medallions and coping. It is very important to remark that in the scenes from the life of Buddha (Incarnation, Nativity, Enlightenment, etc) the Master is never represented in human forms[2], but only by symbols, of which the *caitya*-tree (Bodhi-druma = *aśvattha*, *pippala*, Ficus religiosa), umbrella (*chatta*), and feet (*pāduka*) (cf. Rāma's sandals, by which he is represented as ruler at Ayodhyā during the period of exile) and wheel (*Dhamma-cakka*) are the most usual. Beneath the Bodhi-tree is an altar or throne (Bodhi-maṇḍa, *vajrāsana*). The inscriptions make it certain that these symbols represent the actual presence of Buddha; Elāpatra kneeling before the tree and altar, Ajātaśatru kneeling before the *pāduka* altar, are both "worshipping Buddha". In later art the empty throne will be occupied by a visible image. On the other hand, in all *Jātaka* scenes, the future Buddha (Bodhisattva) is visibly represented (fig. 47).

The three-pointed Triratna symbol represents the "Three Jewels", the Buddha, the Law, and the Order. The Nativity is represented by a figure of Māyā Devī seated or standing on a lotus with or without elephants pouring water from inverted jars; this composition occurs also in Jaina usage, but after the third century A. D. disappears from Buddhist and Jaina art and invariably represents the Hindū goddess Śrī or Lakṣmī[3].

Both at Bhārhut and Sāñcī the elements of floral design are treated with an impeccable sense of decorative values. For Bhārhut, I am tempted to quote Fergusson's remarks, as an example of appreciation at a time when Indian art was but ill understood: "Some animals", he says, "such as elephants, deer, and monkeys, are better represented there than in any sculpture known in any part of the world; so too are some trees, and the architectural details are cut with an elegance and

[1] Cunningham 2: for theories relating to the iconography see Waddell, 2, 3.

[2] For apparent exceptions to this rule, at Bodhgayā and Sāñcī, see p. 33.

[3] It is highly probable that some older image of Abundance underlies both forms, cf. figures 16, 74 and pp. 21, 64. Cf. Foucher, 3.

precision that are very admirable. The human figures, too, though very different from our standard of beauty and grace, are truthful to nature, and, where grouped together, combine to express the action intended with singular felicity. For an honest purpose-like pre-Raphaelite kind of art, there is probably nothing much better to be found elsewhere"[1].

Some of the pillar figures reveal combined with their wonderful decorative fitness, an astonishing and poignant sense of the beauty of the human body.

Other fragments of Śuṅga date, and indicating the former existence of *stūpas* and *toraṇas* have been found at Besnagar, Kosām (Kośāmbī), Bhīṭā, Gaṛhwā[2], and at Amin, Karnal District, where there are two finely sculptured pillars near the Ṭhākurjī temple, Surajkund[3]. A monolithic column with a female figure in relief at its base is preserved at Rājasan (fig. 58)[4]. Remains of a railing from Pāṭaliputra are preserved in the Calcutta Museum[5]. There are fine pillars from Mathurā in the Victoria and Albert Museum, London[6].

A Śiva-liṅgam found at Bhīṭā, and now in the Lucknow Museum, is of interest; it is of the *pañca-mukha* type, the upper part consisting of a head and bust, the right hand in *abhaya mudrā*, the left, as in the case of the Guḍimallam example described below, holding a water-vessel. The four remaining heads are represented in low relief in a position corresponding to the waist line of the terminal bust, and below these heads the suture of the *liṅgam* is clearly indicated. The Brāhmī inscription, mentioning the donors, and concluding "May the Devatā be pleased!" has been assigned on palaeographic grounds to the first century B. C.[7]

The famous railing at Bodhgayā, referred to in the older descriptions as the "Aśoka railing", is, on the whole in Bhārhut style, but more evolved, and may be dated not far from 100 B. C.[8] It enclosed, not a *stūpa*, but a *caṅkrama* or promenade, where the Buddha was thought to have walked after the attainment of the Great Enlightenment beneath the Bodhi tree at the same site[7]. Amongst the pillars of more especial interest are one with a fine figure in relief representing Indra in the form of the Brāhman Śānti (fig. 40)[9]; one completely covered with architectu-

[1] Fergusson, 2. p. 36 (originally published in 1867).

[2] Cunningham, 4, vol. X.

[3] Near Thānesar. See A. S. I., A. R., 1922—23, p. 89 and Pl. V, e.

[4] A. S. I., A. R., 1918—19, pt. 1, pp. 32—33, and pl. IX b.

[5] Waddell, 5.

[6] Codrington, K. de B., Pl. XIV.

[7] Banerji, 1; Rao, 1, vol. II, p. 63.

[8] Marshall, 8, p. 626, and J. R. A. S., 1908, p. 1096; Cunningham, 3, and 4, vols. I and III; Bloch, 2; Mitra; Burgess, 8, pls. 171—175.

[9] Bachhofer, 2; Kramrisch, p. 83. This pillar was dedicated by a king Nāgadeva or queen Nāgadevā between 100 and 50 B. C. The figure of Śānti affords the earliest known example of the *uṣṇīṣa* in sculpture.

ral reliefs, and some subject panels, including a symmetrically and decoratively designed representation of the Sun in a chariot drawn by four horses (fig. 61); and one with the familiar "woman and tree" motif, in this case a *vṛkṣakā* embracing her tree[1] like the Devatā at Bhārhut (fig. 39). Amongst the smaller reliefs in medallions or half medallions may be remarked an illustration of the story of Assamukhī, referred to above (p. 26); a replica of the Bhārhut Jetavana-purchase scene; and two representing the approach to the Bodhi-tree. One of the latter is indeed of particular interest as it represents, in the figure approaching the tree, a personage who can be no other than the Bodhisattva, Siddhārtha[2]; the same subject is later on illustrated in a very interesting manner in more than one Gandhāran relief[3].

A special form of temple is connected with the Bodhi-tree[4], and consisted of a gallery, supported by pillars, encircling the tree. A large number of reliefs (figs. 41, 46, 55, 70), ranging from the second century B. C. to the second A. D., illustrate such temples, and some of these may be intended for representations of the one asserted by tradition, very probably correctly, to have been erected by Aśoka at Bodhgayā[5], where Cunningham's excavations revealed traces of an ancient structure underlying the mediaeval temple. The best known example is the relief at Bhārhut inscribed *Bhagavato Saka Munino Bodho*, i. e. "the attainment of enlightenment by the worshipful Śākya Muni" (fig. 41); there are others at Sāñcī, from Mathurā, and at Amarāvatī. All are of one type, representing a gallery with barrel-vaulted roof and *caitya*-windows of the usual type, supported by pillars, and with a ground plan like a Maltese cross; with the single exception of the Mathurā example in Boston (fig. 70), which represents a square structure supported by only four pillars, and with an entablature of the form of the *harmikā* shown above the *stūpa* in the Bhārhut relief (fig. 42). The only Bodhi temple now surviving is that of Anurādhapura in Ceylon, where the tree rises from a terraced pyramid, approached by arched gates. But Bodhi-trees must once have existed on all Buddhist sites; three,

[1] For this motif see page 64; and Berstl.

[2] See note 3 on p. 47.

[3] Spooner, 5, pp. 15, 16, 66, 67, referring to sculptures nos. 787, 792, then in Peshāwar, now in the Lahore Museum; and A. S. I., A. R., 1921—23, p. 59 and pls. XXIV c and XXV b.

[4] For general discussion see Cunningham, 3; Bloch, 2; Coomaraswamy 17; Spooner 12. Reliefs representing Bodhi-maṇḍa temples at Bhārhut, Cunningham, 2, pls. XIII and XXI; at Sāñcī, Fergusson, 1, pls. XV, XVI, XXV, XXX, Maisey, pl. XVIII, Marshall, 5, pl. VII, Kramrisch, 2, pl. XXXIV; at Mathurā, Vogel, 6, 1909—10, p. 63 and pl. XXVII and Coomaraswamy, 17; at Amarāvatī, Rea, 4, pl. XXX, and Burgess, 7, pl. XXI, 2.

[5] One of the railing inscriptions refers to the *rājapāsāda cetika*, which shows that it was erected round a temple originally built by a king, who in this case may well have been Aśoka. For this inscription see A. S. I., A. R., 1923—24, p. 99. *Rājapāsāda*, however, may only signify "regal", "splendid". The *Aśokāvadāna* mentions an "enclosure surrounding the tree on all four sides", upon which Aśoka mounted to perform his offering of 4000 vessels of perfumed water. See Przyluski, and Coomaraswamy, 17.

of special fame, were planted respectively by Ānanda at Śrāvastī, by Kaniṣka at Peshāwar, and by Devānampiyatissa at Anurādhapura in Ceylon.

Two statues of Yakṣas (fig. 67) inscribed with the names Nandi and Vardhana, found at Patna, have generally been regarded as dating in the second century B. C.[1]. Very much in the same style is the figure of the Yakṣa Māṇibhadra from Pawāyā, Gwāliar (fig. 63), now in the Gwāliar Museum, together with two fan-palm capitals from the same site; these were regarded by Garde as Kuṣāna, but have since been placed by Chanda in the second half of the first century B. C. on palaeographic grounds, and this dating better accords with the stylistic evidence, since the type is very like that of the Yakṣa statuettes at the top of the Sāñcī *toraṇas* (fig. 53)[2]. At Vidiśā (= Besnagar) there still stands the Garuḍa pillar, lacking only its capital, which was erected in ca. 140 B. C. by Heliodora, the ambassador of Antialkidas, in honour of Vāsudeva. At the same site have been found two fan palm capitals and a *makara* capital apparently derived from other pillars[3], indicating that at least one important Vaiṣṇava temple must have been in existence here in the second century B.C., and excavations have revealed the existence of a dove-tailed solid stone panelled railing surrounding the sacred enclosure. Two pieces of steel found below the Heliodora pillar confirm the conclusions based on the early steel found in Ceylon[4].

The Bhīlsā topes, of which the Sāñcī group afford the most complete and magnificent examples of structural Buddhist architecture in India, were erected near and about the old Malwā capital of Vidiśā (Besnagar)[5]. The main structures at Sāñcī, other than the Aśokan pillar, and the later temples referred to on p. 78, are the Great Stūpa, No. 1 (fig. 50) and two others, Nos. 2 and 3. These may be dated as follows:

Maurya, third century B. C., the small brick *stūpa* which forms the core of No. 1.

[1] Marshall, 8, figs. 29, 30; Chanda, 1, p. 26; Foucher in J.B.O.R.S., 1919, p. 519.

[2] Garde; Chanda, 1.

[3] Chanda, 4, p. 163 supposes that the *makaradhvaja* implies a cult of Pradyumna. The capitals are now in the Museum at Gwāliar.

[4] Bhandarkar, D. R., 5. For steel manufacture in early and mediaeval India, see Hadfield, Sir R., *Sinhalese iron and steel of ancient origin*, in Journ. Iron and Steel Institute, 1, London,1912, and in Proc. Roy. Soc., A., vol. 86, 1912; Lester, I. E., *Indian Iron*, Presidential Address, Staffordshire Iron and Steel Institute, Stourbridge, 1912; Belck, W., *Die Erfinder der Eisentechnik*, Zt. für Ethnologie, XLII, Berlin, 1910 (Englished in Ann. Rep. Smithsonian Institution, Washington, 1911); Coomaraswamy, 1, and Neogi. Steel may have been exported from India westwards well before the beginning of the Christian era. Quintus Curtius mentions that the chiefs of the Pañjāb presented Alexander with 100 talents of steel *(ferrum candidum)*. But see p. 7.

[5] Cunningham, 1; Maisey; Marshall, 4, 5, 8, 12. A fully illustrated monograph on Sāñcī has been announced to appear within a few years.

Śuṅga, 184—72 B. C., Nos. 2 and 3 with their railings; enlargement of No. 1 and addition of the plain railing on ground level and terrace.

Āndhra, 72—25 B. C., the gateways (toraṇa) of Nos. 1 and 3.

The sculptured reliefs are found on the railing of No. 2 and the toraṇas of Nos. 1 and 3. As at Bhārhut, the Buddha is invariably designated by symbols, and never represented in human form. The reliefs of the rail of No. 2 are not far removed in style from those of Bhārhut; this however only applies to a part of the work, evidently the earlier part, in which, despite the extraordinary sense of decorative design, the treatment of the human figure is still primitive (fig. 51). These earlier reliefs are in silhouette without any differentiation of planes, the only approach to modelling appearing in the occasional rounding of the contour; the feet are always in side view, regardless of the position of the figure. In some respects this art seems to start from a point less advanced than that of the preceding century. Other reliefs on the same railing (fig. 52) exhibit a much greater knowledge of the figure, of spatial relations, and represent pose and movement not merely with animation, but with conscious grace. Some authors attribute this rapid development to the influence of hypothetical Bactrian Hellenistic art, or to that of the Greek colonies in the Pañjāb[1]. Political relations would indeed have made this possible. But it must be remembered that development at one stage of any artistic cycle is as natural and inevitable as degeneration at another stage, and Indian art viewed as a whole offers no exception to the ordinary rules; so that external influences can never be taken for granted on the sole ground of a stylistic advance. Nor do Sir John Marshall's phrases "direct observation of nature" and "free from the trammels of the memory image" quite meet the case; since rarely if ever have Indian artists drawn with a model before them, and the image proper is at all times, from first to last, obtained by a process of mental visualisation. The process, at first no doubt, unconscious, is later on prescribed by śāstraic injunction[2]. Thus the form is always reached by a process of synthesis and abstraction, rather than by observation, and is always in the last analysis a memory image. When we perceive increased reality or truth, we must ascribe this, not to a change of habit, but to heightened consciousness, a more complete identification of consciousness with the theme itself, — in other words, to a more profound empathy.

The reliefs of the great gateways are marvels of decorative story-telling composition, and at the same time an encyclopedia of contemporary civilisation. The principal themes are drawn from the life of Buddha, and from the Jātakas. The more extended compositions are found on the toraṇa architraves, and here a whole succession of scenes belonging to a given event is represented within a

[1] Marshall, 5, 8.
[2] Śukrācārya, IV, lc. IV, 147—151. Cf. Masson-Oursel, discussing pramāṇa.

35

single frame, the presence of the Buddha at each stage of the story being indicated by an appropriate symbol. Figures of Yakṣas are placed as guardians on the upright posts, while at the ends of the architraves there are represented beautiful nude dryads leaning from their trees (figs. 53, 54).

The art of Sāñcī as a whole, is of course, Buddhist in theme; the story-telling reliefs successfully fulfil an edifying purpose. It is equally clear that their content is not religious, in the sense that Indian art at a later period becomes religious; the intrinsic quality of the early art is realistic and sensuous, and this is only more evident in the case of the dryads, because there the theme is anything but Buddhist. Or if we recognize in this very sensuousness with which the art is saturated, a true religious feeling, then it is religious on a plane very far removed from that of the aristocratic philosophy of the Upaniṣads and Buddhism. It is religious in the very real sense of the ancient cults of mother-goddesses and fertility spirits, not in the sense of the Great Enlightenment.

We cannot therefore be surprised at the "Puritanical" objections to art which were voiced at this time or a little earlier by Brāhmaṇical and Buddhist philosophers; art had not yet been conceived as an embodiment of spiritual ideas in terms of form; a theory of beauty as Perfect Experience (*rasāsvādana = Brahmāsvādana*) had not yet been imagined[1]. When the Church began to make use of art, it was only, as Sir John Marshall puts it, "as a valuable medium in which to narrate the legends and history of its faith". The art of Sāñcī is not, as art, created or inspired by Buddhism, but is early Indian art adapted to edifying ends, and therewith retaining its own intrinsic qualities. A pure Buddhist content is far more apparent in the early architecture, and especially in the undecorated hemispherical *stūpa*, with its "unheimlichem, ja grauenhaftem Ernst", and in the excavated *caitya*-halls, forming, so to speak „eine Art negativer Plastik"[2].

Art of the Sāñcī school has been found also at Sārnāth, where it is represented by twelve finely sculptured rail uprights[3]. A circular terracotta sealing from Bhīṭā, of minute and exquisite workmanship, in the style of the finest reliefs at Sāñcī, was probably made from an ivory die, and recalls the inscription at Sāñcī which describes one of the reliefs as the work of the "Ivory-workers of Bhīlsā"[4].

[1] For the mediaeval theory of beauty see Viśvanātha, *Sāhitya Darpaṇa* (v. 44 of Roer's edition, v. 33 in Ballantyne's translation in the Bibliotheca India); Regnaud, *La rhétorique sanskrite*; Coomaraswamy, 14, 1918, pp. 30ff; Masson-Oursel.

[2] Hoenig, p. 6.

[3] Sahni and Vogel, pl. VI.

[4] Marshall, 3, pp. 35, 36, 71 and pls. XXIII, XXIV; 8, p. 632 and pl. XXIX. For an early silver signet, with the name "of Nandivardha" in Brāhmī characters, and lion, fish and railed banner symbols, of fine workmanship, and dateable about 200 B. C., see Rapson in J. R. A. S., 1900, plate, facing page 97.

The school of Mathurā is more nearly related to Bhārhut than to Sāñcī, and is represented by some fragmentary sculptures which must go back to the middle of the second century B. C. Better known are those of the Kṣatrapa period immediately preceding the Kuṣānas. The famous lion-capital, indeed, which has a Kharoṣṭhī inscription and a somewhat Īrānian aspect, was dedicated by the queen of the satrap Rañjubula or Rājūla, the last Yavana king of the eastern Pañjāb, probably about 30 B. C.[1]. The same lady seems to have founded the Buddhist Guhāvihāra, now represented by mounds beside the Jamnā, south of Mathurā city. A Jaina votive plaque dedicated by the lady Āmohinī in the reign of Soḍāsa, son of the aforesaid Rañjubula, is dated in the year 42 or 72 of an unknown era: Soḍāsa probably flourished ca. 10—15 A. D. Another, dedicated by the courtesan Loṇaśobhikā, Q 2 in the Mathurā Museum (fig. 72), without date, represents a Jaina *stūpa* of the high cylindrical type standing on a terrace (*medhi*) approached by a single stair (*sopāna*): two female figures similar to those of the railing pillars lean against the *stūpa* drum, and there are two *stambhas* respectively with a *dhammacakka* and lion at the sides. The basement shows two arched niches like those of the Jaina *stūpa* base at Taxila, but containing figures[2].

The main Jaina establishment represented by the Kaṅkālī Ṭīlā site already existed in the second century B. C. Amongst the most interesting sculptures are the *āyāgapaṭas* or votive tablets, such as those above referred to, but usually square; they bear inscriptions in Brāhmī characters which can scarcely be later than the beginning of the Kuṣāna period. Some (fig. 71) bear in the centre the representation of a seated Jina with shaven head of the type of the larger cult image of Pārśvanātha from the same site (fig. 86), and of the early Buddhas. Other reliefs include representations of Hariṇegameśa, a minor divinity connected with the nativity of Mahāvīra[3].

We must now refer to the Jaina and Buddhist caves of Eastern India, especially those in Oṛissā, all of which are Jaina monasteries (*vihāras*). There is a large group of these excavations in the Udayagiri and Khaṇḍagiri hills. The Hāthī Gumphā, already mentioned in connection with the important inscription of Khāravela, ca. 161 B. C., is little more than a natural hollow. The Mañcapurī (Vaikuṇṭha or Pātālapurī of earlier authors) contains another inscription of Khāravela's reign, and a crudely executed frieze, somewhat reminiscent of Bhājā and Bhārhut: one female figure wears a mural crown. The most important of the remaining caves, viz. the Ananta, Rānī and Gaṇeśa Gumphas must range

[1] Ep. Ind. IX, p. 139; C. H. I., pp. 575, 576, 633.

[2] Vogel, 13, p. 184 and pl. V.

[3] For the Kaṅkālī Ṭīlā *āyāgapaṭas*, etc. see Smith 1. The majority are now in the Lucknow Museum. One example has been found at Kosām.

between 150 and 50 B.C. The pediment sculptures of the Ananta include a standing Māyā Devī with elephants. In Buddhist art this would represent the Nativity of Buddha, in Hindū art Gaja-Lakṣmī, but what it represents, unless perhaps the Nativity of Mahāvīra, we do not know; it is one of many motifs, such as the *triratna* and the *caitya*-tree, which are elsewhere Buddhist, but here employed in Jaina art. Each doorway is adorned with a pair of three-headed Nāgas, like those which appear at Nāsik and elsewhere in Western India.

The Rānī and Gaṇeśa caves are both two-storied, with friezes interrupted by the cell doorways, in both the upper and lower galleries; the former the largest and best decorated of all (fig. 36). The scenes, which include the hunting of a winged deer, fighting scenes, the carrying off of a woman, etc., have not been identified, but may be presumed to be taken from Jaina legends and to have an edifying value equivalent to that of the Buddhist *Jātakas*. The style is original and vigorous. "Shield" and *svastika* symbols are found in the same cave. The same themes are repeated in the Gaṇeśa Gumphā, in a somewhat inferior style, and degeneration proceeds further in the later Jayavijaya and Alakāpurī caves. The style appears to have had no descendants in Oṛissā but may have had some connection with the earlier work in Farther India and Indonesia, the *makara* lintel arch appearing here for the first time.[1]

Farther south, in the Āndhra homeland of the Kistna-Godāverī delta there certainly existed a *stūpa* at Amarāvatī in the first or second century B. C., and fragments of sculpture derived from it are extant (figs. 144—146), distinguishable by their low relief from that of the later work[2]. What appears to have been a more important early *stūpa* existed at Jaggayapeṭa, some thirty miles from Amarāvatī, and from this site a number of early reliefs of high interest have been recovered; amongst these may be especially mentioned a number of pilasters (fig. 143) with bell capitals and addorsed winged animals in Bhārhut style, one representing an elegant *puṇya-śāla* with worshippers (fig. 142), and another representing a king surrounded by emblems of royalty[3]. Near Guṇṭupalle there is an important group of Buddhist caves, including *vihāras* and monolithic *stūpas*, and a small circular *caitya*-hall similar to the curious early types at Junnār and Kondivte in the west, but with a façade recalling that of the Lomas Ṛṣi in the Barābar hills[4]. Here also are remains of the largest known structural *caitya*-hall, and there is another at Vidyādurrapuram near Bezwāḍa[5]. A large Buddhist

[1] For the Oṛissan caves see Fergusson, 2; description of reliefs in A. S. I., A. R., 1922—23.
[2] Burgess, 7, Chs. VII and IX. But the distinction of inner and outer rails is mistaken.
[3] Burgess, 7, pls. LII—LV.
[4] Fergusson, 2, vol. II, p. 167.
[5] Madras A. S. Progress Report, Dec. 1888 and Jan. 1899.

monastery existed in the Saṅkarām Hills, Vizagapatam District, the monolithic *stūpas*, some of the cells, and perhaps the three structural apsidal *caitya*-halls, dating from the first or second century B. C., though the site continued in occupation up to the Pallava period[1]. There was another large monastery at Rāmatīrtham, with the brick foundations of no less than six structural *caitya*-halls, some of which at least must be of quite early date[2].

In the same area, at Guḍimallam, near Reṇiguṇṭa, North Arcot District, exists one of the most interesting and important monuments of pre-Kuṣāna Brāhmaṇical art extant, the Śiva-liṅgam known as Paraśurāmeśvara, still in *pūjā*. This is a realistic phallic emblem, five feet in height, with a figure of Śiva carved on its lower side (fig. 66). The deity is two-armed, holds as attributes a ram, battle-axe (*paraśu*), and water-vessel, and stands firmly on a crouching Yakṣa of the Bhārhut pedestal type. This Yakṣa is evidently the *apasmāra puruṣa*, the symbol of *mala*, which supports the figure of Naṭarāja in the later iconography; can it too have been by this route, and by sea, that the formula reached Japan? The stone is finely wrought and highly polished. Both in style and costume the figure is closely related to the standing Yakṣa types of Bhārhut and Sāñcī, but the workmanship is more accomplished and more forcible. This sculpture is a document of great significance in the history of Indian art, and reminds us of what we are too apt to forget, that innumerable works and types of work must have existed, that are now lost. Rao is undoubtedly right in assigning the *liṅgam* on stylistic grounds to the first or perhaps the second century B. C.[3]

Remains of painting of pre-Kuṣāna date have survived in two localities. The early painting in Caves IX and X at Ajaṇṭā represents indigenous types of noble quality[4], more vigorous and less highly refined than those of the Gupta period, the costume, especially the large turbans twisted round the hair to form a top-knot, recalling that represented at Bhārhut and Sāñcī. This form is very suggestive of an *uṣṇīṣa*. A powerful standing figure, stylistically related to the early Yakṣa-Bodhisattva types, has been reproduced in colour by Taki (Cave IX = Griffith, pl. XXXVII); the *Chaddanta Jātaka* composition, with greater reserve, and less emotional than the later picture in Cave XVII, is reproduced in outline by Griffiths; and a beautiful royal group by Dey. In both caves there are later, probably early Gupta, paintings of seated and standing Buddhas, in part at least painted over the work of the early period. Burgess remarks that the pillars

[1] Rea, 1.
[2] Rea, 6.
[3] Rao, 1, vol. 11, pp. 65—69, with detailed illustration of the ornaments and attributes.
[4] Burgess, 4, pls. VIII—X.

of the *caitya*-hall at Beḍsā were originally painted, but were whitewashed late in the nineteenth century[1].

In the Jogīmāra cave, Sirguja State, Oṛissā, there is painting of two periods, the mediaeval work, of poor quality, almost obscuring that of the first century B. C., which, so far as decipherable, reveals figures, *makaras*, etc., drawn with vigour and decision[2].

The most detailed early literary reference to painting is found in the Pali *Ummaga Jātaka*. This is one of the younger *Jātakas*, but certainly pre-Kuṣāna. Painted halls and palaces are referred to, and in more detail the painted tunnel, as follows: "clever painters (*cittakara*) made all kinds of paintings, the splendour of Sakka, the zones of Mt. Sumeru, the sea and mighty ocean, the Four Continents, Himālaya, Lake Anotatta, the Sun and Moon, the Four Great Kings, the six sensational Heavens ... as though it had been the Sudhamma Hall of the gods". There are incidental references to painting in the *Vinaya Piṭaka*, *Therā-Therī-Gāthā*, *Mahāvaṁsa*, etc.; in the Brāhmaṇical Epics; and in Patañjali[3].

[1] For the Ajaṇṭā paintings see Griffiths (*Chaddanta* outline, pl. 41); Burgess, 4; Fergusson and Burgess, pp. 284 ff.; Dey, plate facing p. 106; Taki (= Griffiths, pl. 37); Foucher, 5.

[2] A. S. I., A. R., 1914—15, pt. 1, p. 12.

[3] Patañjali, *Mahābhāṣya*, describing the exhibition of Kṛṣṇa-Līlā paintings, see Keith, A. B., *The Sanskrit drama*, pp. 32, 34. This seems to have been an exhibit of the *Wayang Beber* type.

PART III:
KUṢĀṆA, LATER ĀNDHRA, AND GUPTA

THE BEGINNINGS OF HINDŪ AND BUDDHIST
THEISTIC ART

There is evidence in the early Vedic texts, revealing a connection of the elemental deities with certain animals, by which they might be represented in the ritual. Thus the horse was associated with Sūrya and Agni, the bull with Indra and Rudra (= Śiva). The animal Avatārs of Prajāpati, later appropriated by Viṣṇu, may also be cited. Material objects, too, were used as symbols. The wheel (*cakra*), which later on becomes the mark of a Cakravārtin, the discus of Viṣṇu, and the Buddhist Wheel of the Law, originally represented the Sun. The disk of gold placed behind the fire altar to represent the Sun may well be the origin of the later *prabhā-maṇḍala* or *śiraś-cakra* (nimbus[1]). Radiance is predicated of almost all the Devas, is indeed one of the root meanings of the word, and most of them are connected in their origins with Sun and Fire. Just as the tree behind the empty altar or throne, representing Buddha in the early art, remains in the later art when the throne is occupied, so the sun-disk behind the fire-altar may well have remained there when the deity was first made visible. The altar itself, usually wide above and below and narrow in the middle "like a woman's waist", is evidently the prototype of the *āsana* and *pīṭha* of later images.

The *vajra* (bolt) is constantly mentioned as wielded by Indra. A deprecatory reference to those who have the *śiśna* for their deity (Rv. 7, 24[5]) seems to employ the early use of a phallic symbol by non-Āryan. *Caitya-vṛkṣas* (cf. figs. 10, 27) are mentioned in the *Atharva Veda, pariśiṣṭa* LXXI; large trees are sometimes addressed as deities, they are connected with human fertility, and nymphs inhabiting them are asked to be propitious to passing wedding processions.

An elemental conception of the powers of nature does not necessitate an iconography, and there are no unmistakeable references to images in the early books. The most definite suggestion is that of Rv. 4. 24[10], "Who will buy my

[1] We do not know when the nimbus was first used in Indian iconography, as no early images, for which we have adequate literary evidence at least in the second century B. C., are extant. In western art it first appears in Alexandrian times. Cf. p. 57.

Indra?"; but just as the Bodhi- tree and *pāduka* at Bhārhut are called "Buddha" (Bhagavato), so here a symbol may have been referred to as "Indra". The "golden Puruṣa" of the Agniśayana, however, must have been a plaque in human form, probably something like the little plaque supposed to represent Pṛthvī found in a burial, regarded as Vedic, at Lauṛiyā-Nandangaṛh[1]. The ultimate tendency is to conceive the gods more and more in definitely anthropomorphic terms; and clear references to images occur not infrequently in the later Brāhmaṇas and Sūtras[2]. To a very considerable extent the development of theistic, devotional cults must represent an emergence of popular, non-Āryan tendencies, now recognized, absorbed, and systematised in relation to Āryan philosophies. It must never be overlooked that in the Vedas, and before the second century B. C. we possess only a one-sided view of "Indian" religion, and representing, quantitatively at least, the smaller part of Indian religion. The mass of the people worshipped, not the abstract deities of priestly theology, but local genii (Yakṣas and Nāgas) and feminine divinities of increase, and mother goddesses.

A description of a temple of post and thatch, with mat walls, is given in the *Śatapatha Brāhmaṇa*, but this was a building for the performance of sacrifices, not a temple in the later sense[3]. Many precise and elaborate details are given regarding the building of altars, generally fire-altars; and it is noteworthy that the rules for the construction of these sacrificial altars, given in the *Sulva Sūtras*, make use of dynamic symmetry, of which no trace can be recognized at a later period[4].

In the Epics, Manu, the *Gṛhya Sūtras*, etc., collectively good evidence for the second century B. C. or earlier, the transition from elemental to personal conceptions of the deities is completed, and at the same time images and temples are referred to fairly frequently and as a matter of course[5]. The words used for image are *daivata, pratimā, pratikṛti, mūrti, devatā-pratimā*, and those who make or carry about images are called *devalaka*. The *Harivaṁsa*, somewhat later, refers to stone images, but no stone image of a Deva is certainly older than the first century B. C., the Maurya or possibly earlier figures representing either human beings or Yakṣas[6].

[1] Bloch, Th., *Excavations at Lauriya*, A. S. I., A. R., 1906—07; Marshall, 8, pl. XI.

[2] Macdonell, 1, pp. 150, 155; Bhattacharya, 1, introduction. Bollensen's interpretation of Rv. I, 145, in Z. D. M. G., XLVII, 1890, p. 586, as implying a picture of Agni painted on cowhide, is very doubtful.

[3] Discussed by Simpson, 6.

[4] Mazumdar, N., *Manava Sulba Sutram*, Calcutta University, 1922.

[5] Hopkins, pp. 70—73. Quintus Curtius, Vit. Alex., VII, 14, 11, states that an image of "Hercules" was carried in front of the army of Porus as he advanced against Alexander. This may have been an image of Śiva or of a Yakṣa.

[6] Supra, p. 16 ff.

Images are mentioned about the same time in several other connections: thus Patañjali, commenting on Pāṇini, refers to the exhibition and sale of images of "Śiva, Skanda, Viśākha, &c."[1]. The moving about of images of bucolic deities is referred to in Āpastambha, *Gṛhya Sūtra*, 19. 13, a work perhaps composed in the Āndhra country. A *Nāga-bali* is described in Aśvalāyana, *Ghṛya Pariśiṣṭa*, 3. 16; a five-headed snake of wood or clay is to be made and worshipped for a year. This is interesting evidence of the making of images in impermanent materials; stone images of Nāgas, of the Mathurā school, are common in the Kuṣāna and Gupta periods.

Late Buddhist legends describe in the same way the making of images of Buddha at an early period, and even in the lifetime of Buddha; but these stories cannot be held to do more than emphasize the likelihood of wooden images having been made at some time anterior to the earliest known stone figures[2]. Khāravela's Hāthī-gumphā inscription mentions a wooden image of Ketu, a human hero; this inscription, dateable about 161 B. C. is good evidence for human images, and were it necessary the figure of Śātakarṇi at Nānāghāṭ, and the various epic references to human figures, generally of gold, might be cited as analogues[3].

The manner in which deities are or may be distinguished or represented by their symbols is well illustrated in a passage of the pseudo-epic, which claims all beings as creatures of Śiva, on the ground that they are marked by distinctions of sex, and not by the *cakra*, *padma*, or *vajra* (discus, lotus, or thunderbolt), by which they might have been claimed as Viṣṇu's, Brahmā's or Indra's. At a relatively early period the lotus may have represented Brahmā, for he is the successor of Prajāpati, who is born of the waters. The lotus pedestal appears already in Maurya or Śuṅga terracottas, and at Sāñcī and Bhārhut as the seat of Māyādevī-Lakṣmī, and is very soon employed in the case of all divine beings to denote miraculous birth and apparitional character; standing alone, in early Buddhist art, it seems to represent the Nativity.

Such symbols (*rūpa*) as are above referred to are found in great variety on the punch-marked coins (*kāhāpaṇa*, *kārṣāpaṇa*, *purāṇa*) (figs. 106—108) which were in

[1] Konow. Figures of Skanda and Viśākha appear on the coins of Huviṣka (fig. 126A, and Gardner, pl. XXVIII no. 24, &c.).

[2] Kern, p. 94; Hackin, J., in Ann. Musée Guimet, Bib. Vulg., 40; Bachhofer, 1, p. 15.

[3] For the Hāthī-gumphā inscription see Jayaswal, K., *Hāthī-gumphā inscription of the Emperor Khāravela*, J. B. O. R. S., vol. III; Banerji, *ibid*; and A. S. I., A. R., 1922—23, pp. 130 ff. The inscription further states that Khāravela recovered at the Magadhan capital (Pāṭaliputra) some objects connected with the first Jina (Ṛṣabhadeva) which had originally been taken away from Kaliṅga by King Nanda three centuries earlier. Smith, 4, p. 209, speaks of "it" as a statue, and were this justified, our ideas of the development of Indian art would have to be radically modified; in fact, however, the critical word is obliterated, and the correlative pronoun referring to it is in the plural. We may suppose that relics, or possibly symbols, may have been referred to.

general use from about 600 B. C. up to the beginning of the Kuṣāna period or somewhat later, on the closely related native cast and die-struck coins (figs. 110-115) of the latter part of the same period, and also on some of the Indianised coins of the Indo-Greek and Indo-Parthian kings of the Pañjāb e. g. Agathokles[1]. Some of the same symbols appear in Maurya, Śuṅga and Kuṣāna art at Pāṭaliputra, Bhārhut, Sāñcī, Mathurā and in Oṛissā, and together with some new forms on Kuṣāna and Gupta sealings from Bhīṭā, Basāṛh, and many other sites, and on *pādukas* (Buddha-pada, Viṣṇu-pada) and *aṣṭamaṅgala* of various periods[2]. With them can be associated, as belonging to the same kind of hieroglyphic art, the banner cognizances of gods and heroes mentioned in the Epics, those still used by Paṇḍās at *tīrthas* to facilitate recognition by visiting pilgrims, tattoo marks ancient and modern, cattle-brands, and folk art generally[3]. A few of the types appear in Western Asia, and the *svastika* is of world-wide distribution.

In determining the nature of the objects represented, all these, together with the formulae commonly employed in Indian art of less abstract types, must be considered; had this been done at first, the now universally recognized "mountain" would never have been mistaken for a *stūpa*[4]. The special religious meanings possible for each symbol must be considered in the light of Vedic and Epic references to avatārs and attributes, and to later and modern iconography, remembering always that the vocabulary was equally available to all sects, Brāhmaṇs, Buddhists and Jains each employing them in senses of their own. Finally, the heraldic significance, the secular usage by a particular king, city, or community, must be considered in the light of a comparative study of find places, and incidental references to *rāja-aṅka* of particular rulers, such as the bull mark of the Bṛhataratha dynasty of Magadha mentioned in the *Mahābhārata*, the tiger mark of the kings of Kāverī-pum-paṭṭinam mentioned in the *Paṭṭinappālai*; the later royal emblems used as seals on copperplate grants, and the heraldic usage of symbols on banners and standards. A passage of the *Visuddhimagga*, referring to *kāhāpaṇas* states that an experienced banker would be in a position to distinguish at what village, borough, town, mountain or river bank they were issued, and by

[1] On punch-marked coins and their symbols see Bhandarkar, 5; Rapson, 1; Spooner, 9; Theobald; Walsh; Smith, 6; and Whitehead, W. H.

[2] For symbols on *pādukas* see Fournereau, 2; Coomaraswamy, 1, fig. 69, and cf. *ibid.* pl. XLVIII, 15. 17. For the Jaina *aṣṭamaṅgala*, Coomaraswamy 9 (4) pl. XXXVII; Smith, 1; and fig. 72.

[3] For tattoo marks see Cunningham, 2 and Luard, 1.

[4] The mountain represented by 'arches' (peaks) is found in Mesopotamia and throughout the ancient world, as well as in later Indian and Central Asian and Chinese art, cf. Glotz, G., *The Aegean civilisation*, 1925, fig. 40, and Petrucci, R., in Burlington Mag., vol. v. 29, pp. 74—79, and Coomaraswamy, 8, pl. II. cf. Burgess, 7, pl. LV, 5.

what mint-master[1]. In general, the obverse marks seem to be those of the issuing authority, the reverse signs those of private bankers and merchants.

The commonest coin symbols (see figs. 106—114) in general use before the Kuṣāna period include human figures (singly or in threes), elephant, horse, bull, bull's head, dog, cobra, fish, peacock; caitya-vṛkṣa (railed tree), branch, flower, lotus; sun (circle with rays), moon (crescent); mountain (many varieties with one or more peaks, and with or without the dog, peacock, tree or crescent), river (often with fish), tank; taurine, nandipada, triratna or triśūla, svastika, double triangle (like a Tāntrik yantra), steel-yard, so-called cotton-bale or caduceus, shield (= triratna or fire-altar?), Taxila mark (equal-armed cross, tipped with four circles enclosing dots), "Troy" mark (three chatras or arrow heads interspaced with ovals about a central circle, generally regarded as another solar symbol), bow and arrow, pile of balls (= heap of gems?), and many others. Rarer marks include the lion, rhinoceros, camel and makara. Marks which we might expect, but which are not found, include the liṅgam, vajra, pāduka, and Garuḍa. Nor is there any sign clearly representing a stūpa of any kind; when this symbol finally appears on seals in the Gupta period it is quite unmistakeable[2].

For our purpose, the importance of these symbols, many of which have remained in use to the present day, lies in the fact that they represent a definite early Indian style, amounting to an explicit iconography. In Buddhist art, for example, we find at Bhārhut and Sāñcī the tree, wheel, &c., on or behind an altar, clearly designated in the inscriptions as "Buddha" (Bhagavato) and worshipped as such; even in elaborate scenes from the Life, the Master is represented only by the symbols (tree, wheel, chatta, pāduka), repeated as often as the technique of continuous narration may require. Later on the figure of a human teacher takes its place upon the throne, the old symbols being retained as specific designations, and in the scenes from the life too, he appears in human form. In the same way with Hindū types; thus we find at first the humped bull alone (fig. 109), then a two-armed (fig. 122), and finally a four-armed figure (figs. 125, 126) accompanying the bull, once the representative of the deity, now his "vehicle" (vāhanam), while other symbols are held in the hands as attributes. Finally the forms of such images are codified in descriptive mnemonic texts (dhyāna mantrams, sādhanā, included in the Śilpa-śāstras), and these texts, which are a development and definition of the older Vedic and Epic lauds, must be visualised before the work is begun.

[1] Text quoted, Bhandarkar, 5, appendix.

[2] For the stūpa on Gupta seals see Spooner, 8, pl. XLVI, no. 159. The so-called square stūpa of Amoghabhūti's coins (Smith, 6, p. 167, and pl. XXII; and fig. 115) seems to be simply a railed parasol caitya like those represented on the Bodhgayā railing, Cunningham, 3, pl. IX, no. 14. Structural shrines or pavilions appear on the Audumbara coins (figs. 116, 117) about the beginning of the Christian era, also on coins of Kaniṣka in the second century A. D.

Thus there is a natural development from indications, appropriate to elemental conceptions of the deities, to representations appropriate to the new conception of them as worshipful persons. As is always the case in India, styles of art are not developed arbitrarily, but as the result of changes in racial psychology. In this case the change may have been due in the last analysis to a fusion of Northern with Southern racial types, of Āryans with Dravidians.

It must always be remembered that the Vedas exhibit only a certain aspect of early Indian religion. Behind the pale of Āryan orthodoxy and its tendency to abstract symbolism there lay an extensive and deep-rooted system of popular beliefs and cults and a decided tendency to anthropomorphic presentation. These popular beliefs implied an iconography, such we actually find at Bhārhut, of Yakṣas and Nāgas, Devatās and Vṛkṣakās, the Earth and Mother-goddesses and divinities of fertility, fairies and goblins and human heroes[1]. Gradually all of these found their place in a theistic Hinduism and Buddhism which were not purely Āryan, but Indian; partly *in propriâ personâ* as minor divinities acting on behalf of the higher gods as guardians or servants, but also, by a fusion of concepts, representing them. India offered no exception to the general rule that a higher or developing religion absorbs, embodies and preserves the types and rituals of older cults without destroying them and establishes its churches in places already sacred[2]. If popular belief thus contributed a large element to the personalities of the gods as they came to be imagined, it can hardly be doubtful that popular religious art, of which the early terracottas and the Mathurā railing pillars may be cited as examples, made large contributions to the iconography of the ultimate pantheon. With this in view, for example, it is easy to see how it happened that the early figures of Śiva and the early Bodhisattvas should have so much resembled the current types of Yakṣas. The attendant *caurī*-bearers of early Buddha images (fig. 84), for example, predecessors of the Bodhisattvas of later trinities, are evidently Yakṣas: there is a good example in Amarāvatī style in the Field Museum, Chicago. What we see taking place in Indian art towards the beginning of the Christian era is not so much the creation of a brand-new icono-

[1] In addition, cf. the popular deities still worshipped (Whitehead, H.; Parker, 2, pp. 133—206, etc.).

[2] Thus, according to Hsüan Tsang, Nālandā was originally the name of a Nāga, "and the monastery built by the side of the pool is therefore called after his name" (Beal, 2, p. 110). It is highly probable that the Tibetan *Dulva* preserves a true tradition when it says that the Śākyas were accustomed to present all new-born children before the image of the Yakṣa Śākya-vardhana, (Rockhill, W. W., *Life of the Buddha*, popular ed., p. 17). For Yakṣas as tutelary deities see also p. 17, note 1, 47, 68; and Schiefner, 1, p. 81. For Yakkha (Yakṣa) worship in Ceylon, *Mahāvaṁsa*, Ch. X, vv. 84—90. The designation Bhagavata is applicable to Yakṣas and Nāgas (Chanda, 1, and Hopkins, p. 145), as well as to Viṣṇu, Śiva and Buddha.

graphy as the adaptation of an older iconography to new requirements, and the giving of a new and deeper content to time-honoured forms.

Temples or shrines are referred to in the Epics as *devatā-āyatana, deva-gṛha, devagāra*[1], *caitya*. Inscriptions mention *deva-kula, arahat-āyatana*, &c. The general meaning of the word *caitya* (from √*ci*) is something built or piled up, the related derivative *citya* referring to the altar or fire-altar. Hence the usual application to funeral mounds, built in honour of heroes, teachers or prophets, of which the Buddhist and Jaina *stūpa* is a familiar example. But the word applies to many other kinds of sacred objects coming under the head of sanctuary or holystead. Sacred trees (*caitya-vṛkṣa*) are perhaps the most commonly mentioned in the Epics, where it is remarked that "not even the leaf of a *caitya* may be destroyed, for *caityas* are the resort of Devas, Yakṣas, Nāgas, Apsarasas, Bhūtas, &c.". The Bodhidruma (*nyagrodha* of most Buddhist texts, the *akṣaya vaṭa* of the Epic, but *pippala* or *aśvattha* of the reliefs) was certainly a sacred tree[2], haunted by a Devatā, before the Bodhisattva took his seat beneath it on the eve of the Great Enlightenment[3]. Most of the *Yakkhacetiya* so frequently referred to in Buddhist and Jaina literature as having been the haunt (*bhavana*) of such and such Yakṣas, may have been sacred trees; the commentators however seem to understand sanctuaries in the sense of buildings, and this may be correct in some cases[4]. The existence of early images of well-known

[1] The term "gods' houses" is popularly applied even at the present day in Southern India to slab-built dolmen-like hero-shrines (Longhurst, 4). It can hardly be doubted that there exists some connection between temples and tombs. For discussion see Simpson; Hocart.

[2] Represented already on an Indo-Sumerian seal, fig. 6.

[3] In the Sujātā story the Bodhisattva is mistaken for the tree-spirit. Bloch, 2, interpreted the railing relief of Cunningham, 3, pl. VIII, fig. 4, as representing an earlier form of the story in which the tree-spirit makes the offering of food and drink. In this case the figure standing before the tree and receiving the gifts would be *the* Bodhisattva, who "stretching out his right hand to find the bowl, grasped the vase of water" (*Jātaka, I*, 685 = *Nidānakathā*, Warren, *Buddhism in Translations*, p. 73 = Rhys Davids, *Buddhist Birth Stories*, p. 93). In Gandhāran art the "Approach to the Bodhi tree" occurs in several reliefs (A. S. I., A. R. 1921—22, p. 59, and pls. XXIV, c., and XXV, b; also nos. 787, 792 in the Peshāwar Museum, referred to by Spooner, 5, pp. 15, 16, 66, 67). But the railing relief of Cunningham, 3, VIII, 4, alluded to above does not stand alone; exactly the same composition occurs at Bhārhut (Cunningham, 2, pl. XLVIII, II) with an inscription (*Ja(m)bu naḍode pavate*, "when the Jambutree-expedient is ready to hand"), which does not refer to the Bodhisattva or the Bodhi tree. It is possible that the two reliefs do not illustrate any form of the Sujātā story, but some other and different story. The only other supposed early representation of *the* Bodhisattva is on the inner face of the right hand pillar of the east gate at Sāñcī (Fergusson, 1, pl. XXXIII = Maisey, pl. XVI). The Bodhisattva is, of course, constantly represented in human form when a former incarnation is illustrated.

[4] In one case, explaining the *Sūciloma Sutta* of *Saṃyutta Nikāya*, 11, 5, a stone dais, throne or platform (*taṅkite mañco*) is stated to have been the Yakkha's haunt (*bhavanam*). I am indebted to Dr. W. Stede for this reference; I believe that an altar like a *Bodhi-maṇḍa* or *vajrāsana*, such as is represented in innumerable reliefs, is intended. If Yakkha temples existed, they may have served as prototypes of Buddhist Bodhi-shrines like those of figs. 41 and 55. Cf. page 46, note 2.

Yakṣas (Dadhikarṇa, Maṇibhadra, &c.) must indeed imply some kind of shrine, and such a *deva-kula* is thought to have been traced in the Jamālpur mound at Mathurā.

Where, in *Rāmāyaṇa* 5. 15. 15 a *caitya* is described as having railings (*vedikā*), terraces, coral stairs and a high roof, it is clear that a temple is meant; and a *caitya* or *āyatana* must always be a shrine or temple when it is "erected" and generally when images are mentioned[1]. The "horn of the trident-bearer, high as heaven and spotless", on seeing which the mortal knows that he has reached the city of Śiva must refer to the tower of a temple[2]; the words recall the later "Golden Horn" of Aṅkor Thom, which was the tower of the Baphuon temple, visible from afar (see p. 189).

Thus it is clear from the literature that both temples and images must already have existed certainly in the second century B. C. and perhaps earlier. Remains of two or three Brāhmaṇical and several Buddhist temples have been traced: an inscription at Nagarī (= Madhyamikā) near Chitor, in script of 350—250 B. C. refers to a temple of Saṁkarṣaṇa and Vāsudeva, which was doubtless a wooden building, and part of the stone enclosing wall, over nine feet in height, has been unearthed[3]; another inscription of the same period refers to a Vaiṣṇava temple at Besnagar, where in the second century Heliodora dedicated his *Garuḍa-dhvaja-stambha*, and two railings, one a solid morticed slab wall, have been traced[4]. The temple at Māt, near Mathurā, mentioned in two inscriptions as a *devakula*, seems, from the occurrence of the portrait statue of Kaniṣka, and other royal figures, to have been the royal chapel of the Kuṣāna kings; excavations have revealed a large rectangular plinth and some traces of a circular structure[5]. The foundations of an Aśokan *caitya*-hall have been recognized at Sāñcī; the earliest excavated *caitya*-halls and *vihāras* afford reliable indications of corresponding structural buildings. The reliefs at Bhārhut, Sāñcī, Gayā and Mathurā provide other valuable data (cf. figs, 41, 43, 45, 46, 55, 62, and 69). The only buildings represented on early coins are the domed pavilions of the Audumbara coins of Pathānkoṭ and Kāṅgrā (figs. 116, 117) dating about the beginning of the Christian era, and the pavilion with a double ornamented plinth, and enshrining figures of Skanda, Viśākha and Mahāsena, represented on a coin of Huviṣka (fig. 126A). Similar pavilions are represented on early Pāṇḍyan coins[6]. The last mentioned pavilion resembles one on a terracotta of early Gupta date from Bodhgayā[7].

[1] Hopkins, pp. 70—73; Chanda, 1. A list of pre-Buddhist *caityas* is given in the P. T. S. Pali Dictionary, s. v. *cetiya*, but the meanings of the word other than *stūpa* are ignored.

[2] *Mahābhārata*, 3, 88, 8.

[3] Bhandarkar, D. R., 6.

[4] Bhandarkar, D. R., 5.

[5] Vogel, 15.

[6] Pieris, pl. XIII, 7, 8, 11, 12.

[7] Cunningham, 3, pl. XXIV, B.

Theoretically, the Hindū shrine is the imitation of a building existing in another world (generally Indraloka) the form of which has been revealed or otherwise ascertained (see p. 125). Practically, it can hardly be doubted that, as in other countries, the form of the god's house is derived from that of human dwellings and tombs, the main sources leading back to the domed thatched hut, and the barrel vaulted types of the Todas, and to the slab-built dolmens.

KUṢĀNA AND LATER ĀNDHRA, CA. 50—320 A. D.

The Yue-chi tribe originally occupied a part of N. W. China. Driven thence about 165 B. C. they first occupied the territories of the Scythian (Śaka) nomads, and later took possession of Bactria, about 10 B. C. By about 50 A. D. under Kadphises I, the first Kuṣāna king of N. W. India, they had occupied Gandhāra, i. e. most of Afghānistān, and the Pañjāb as far as Taxila. Kadphises II (A. D. 90—110) and Kaniṣka (ca. 120—160) extended the Kuṣāna dominion certainly as far as Mathurā and probably as far as Benāres; the eastern territories were governed by viceroys (satraps), Kaniṣka's winter capital being at Puruṣapura (Peshāwar), and his summer capital at Kapiśa in Afghānistān. The ancient University city of Taxila, on the Indian side of the Indus, lay within easy reach of Peshāwar. The Kuṣāna dominions included also Kaśmīr, and in India proper, Mathurā and the Ganges Valley as far as Bihār.

It should be noted that the date of Kaniṣka has been the subject of a great controversy; the dates given above are those now accepted by a majority of Indianists, including the late Vincent Smith (4) and Marshall (6) and in accordance with the results of the excavations at Taxila. Rapson, however, adheres to A. D. 78, the initial year of the Śaka era.

In centuries preceding the Christian era the Indo-Greek and Indo-Scythian kings of Gandhāra and the Pañjāb had already come under the influence of Indian religions; we have a remarkable instance of this in the pillar erected by Heliodora, ambassador of Antialkidas of Taxila at the court of Vidiśā (Besnagar), about 126 B. C. in honour of Vāsudeva (Kṛṣṇa); Heliodora calls himself a Bhāgavata (Vaiṣṇava). Indian religious symbols appear not only as before on native punch-marked coins, but on various coins of Greek and Indo-Scythian kings from Agathocles (ca. 200 B. C.) onwards. In many cases these symbols had, no doubt, a Buddhist significance, but all are common to Buddhist and Brāhmaṇical usage, and many represent the deities of the cities in which they were struck (e. g. the elephant deity of Kapiśa, and the bull deity, probably Śiva, of Puṣkalāvatī). Religious benefactions by Śaka satraps or their queens are recorded in the Taxila copper plate (ca. 72 B. C.), the Mathurā lion capital inscription (ca. 30 B. C.

or near the beginning of the Christian era), and a Jaina votive tablet of about 16—17 B. C., likewise from Mathurā. In the first century of the Christian era figures of Indian deities appear on the coins of Gondophares and Kadphises II, followed in the second century by representations of Buddha, and of Śiva with four arms, on coins of Kaniṣka[1]. *Stūpa* bases of the Śaka period, associated with coins of Azes, appear at Taxila.

The Graeco-Buddhist art of Gandhāra must now be discussed in greater detail. The whole subject is highly controversial, and even the most important points at issue depend upon a balance of evidence rather than upon positive data. It will be helpful to distinguish, as M. Foucher has done, the Indian from the Hellenistic elements of the iconography. The former, which predominate, include a part evidently of Indian origin, and another part that belongs to the common Indo-Īrānian inheritance of "Early Asiatic"; for present purposes these can be considered together. The following motifs exemplify those current in pre-Gandhāran Indian art (cf. figs. 85—95):

Types and compositions: *Jātakas* (cf. figs. 47 and 93); the Sun god; Atlantes; Indra, Brahmā, and Yakṣas as probable prototypes of Avalokiteśvara, Maitreya, and Vajrapāṇi[2]; "woman and tree" (*Yakṣī* or *Vṛkṣakā*) motif[3]; figures of donors; lotus-seat, &c.

Architectural forms: *stūpas*[4]; the double-roofed *vihāra*; the *caitya*-window arch; Buddhist railing; "Persepolitan capital"; battlements.

Animals: Lion, elephant, bull, horse; winged lion, centaur, and othe *haṁsa, garuḍa, makara*, &c.

Floral: rose-lotus forms; blue-lotus derivatives (palmette and honeysuckle); vine (already at Sāñcī); various trees.

Patterns: diaper, dog's tooth, reel and bead, checker, &c.

Symbols: lion, elephant, bull, horse; wheel, *triratna*, &c.

[1] Kaniṣka is represented in Buddhist literature as a Buddhist emperor like Aśoka. His eclecticism is evident, however, from the fact that the deities represented on his coins include Hindū, Buddhist, Zoroastrian, Elamite and other types.

[2] Spooner, 1, remarks that the evolution of Indra and Brahmā "was an accomplished fact prior to any form of the Gandhāra school with which we are acquainted". One aspect of Vajrapāṇi too, seems to derive from old Indian *yakṣa* forms. See also Bachhofer, 2 and Grünwedel, *Athene-Vajrapāṇi*, Jahrb. k. Preuß. Kunstsamml., 1915.

[3] This most important characteristic of Gandhāra art will be discussed after the Kuṣāna art of the Mathurā school has been described.

[4] At least three types are now current, (1) the early hemispherical, which is becoming rare, except in Ceylon where it persists at least to the thirteenth century, (2) the type with high cylindrical drum and two *vedikā* courses (e. g. Vogel, 13, pl. V) which occurs already at Beḍsā and has been compared above with Phoenician forms, and (3) the type with a bulbous dome (Vogel, 13, pl. IV). A fourth type which must have differed considerably from these, was that of the pagoda-like wooden relic towers (see p. 53). Cf. Finot and Goloubew.

Costume: Indian *dhotī*, &c., and jewelry, turbans, &c.,

while the leading Gandhāran forms which do *not* occur at Sāñcī, Bhārhut, and Bodhgayā, &c., include:

Types and compositions: the Buddha figure; many *Jātaka* scenes and scenes from the life of Buddha which now appear for the first time[1] (but in many cases the composition — e. g. the "Visit of Indra" — is practically that of old Indian art, with the Buddha figure inserted); Hāritī (?); garland-bearing Erotes (fig. 89); the nimbus (see pp. 41, 57 ff.).

Architectural: the three Greek orders, especially the Corinthian.

Floral: acanthus.

Costume: various classical, Īrānian, and Central Asian garments and jewelry.

The dating of Gandhāra sculptures is a matter of great uncertainty. As remarked by Marshall, "Not one of the thousands of known images bears a date in any known era, nor do considerations of style permit us to determine their chronological sequence with any approach to accuracy"[2]. Foucher and others have attempted to prove that the school developed in the first century B. C., relying partly on the supposition that the best examples must have been the earliest, partly on the Bīmarān reliquary and the few sculptures which are dated in undetermined eras. The Bīmarān reliquary (fig. 88), if we can rely upon Wilson's (Masson's) account published in 1841, was associated with coins of Azes[3]; it is a golden casket, with standing figures of Buddha and worshippers in relief in niches of Indian form, the base engraved with an Indian lotus. This is generally cited as the earliest example of Graeco-Buddhist art[4]; but coins merely provide a *terminus post quem*, and Wilson himself concluded that the *stūpas* of Afghānistān "are undoubtedly all subsequent to the Christian era" (loc. cit. p. 322). A headless

[1] It is rarely safe to assume on negative evidence that a composition first met with in Gandhāran art must be of Gandhāran origin. Compare Figures 47 and 93; if we did not possess the first, we might easily have been misled to suppose that no Indian prototype existed for the second. What we know is only a part of what was produced in stone, and what was executed in stone was only a part, probably a very small part, of the total production.

[2] Marshall, 6, p. 31. For the whole problem consult Adam, Bachhofer, Burgess (8, 9), Codrington, K. de B., Foucher (1, 3, 4), Grünwedel, Marshall (5, 6, &c.), Rapson (2), Rawlinson, Smith (1, 2, 4), Spooner (1—5), Vogel (3, 7, 13), Wilson; also Goloubew, reviewing Foucher, 1, in B. É. F. E. O., 1923, pp. 438 ff., and Coomaraswamy, do. in O. Z., N. F. 1, 1924, and *Indian origin of the Buddha figure*, J. A. O. S., 1926. Goloubew, loc. cit. remarks: "Rien n'empêche en effet, dans l'état présent de nos connaissances, de supposer que le buddha indo-grec du Gandhāra soit une création plastique postérieur de quelques années au buddha indien de Mathurā." Smith (4, p. 255) calls the Lahore Pallas Athene type (Smith, 2, fig. 66) "the earliest known Indo-Greek sculpture", but elsewhere points out that the type is Indianised, and may be late (Smith, 2, p. 116).

[3] Wilson, H., *Ariana Antiqua*, 1841.

[4] Bachhofer; Marshall places it about the beginning of the Christian era, and this is possible.

standing Buddha figure from Loriyān Tāṅgai in the Calcutta Museum is dated 318, which, *if* the Seleukid era is to be understood, gives 6 A. D.; another figure, from Hashtnagar, is dated 384, equivalent by the same reckoning, to 72 A. D.[1]. Unsculptured reliquaries and parts of buildings undoubtedly date from the latter part of the first century B. C., e. g. part of the Dharmarājika *stūpa*[2], and the Jaina *stūpa* base at Sirkap[3]. Thus, all that can be safely said is that the Gandhāra school of Graeco-Buddhist sculpture may date from the first century B. C., probably antedates Kaniṣka, and certainly attains its greatest expansion in his reign[4], and that it continues an abundant production in the third and fourth centuries, with increasing Indianisation both there and in Kaśmīr. Gandhāra art is iconographically in part, plastically almost altogether, a local phase of Hellenistic (not Roman — Roman art is cousin, not parent), descended from the art of the Greek period in Afghānistān and the Pañjāb, but applied to themes of Indian origin. It may be described from one point of view as representing an eastward extension of Hellenistic civilization, mixed with Irānian elements, from another as a westward extension of Indian culture in a western garb.

It should be observed that while the Gandhāran Buddha (figs. 89, 90, 94) is stylistically Hellenistic, it follows Indian tradition, verbal or plastic, in every essential of its iconography. The whole conception of the seated *yogī* and teacher is Indian, and foreign to western psychology, while the Indian Yakṣas afford a prototype for the standing figures. The *uṣṇīṣa* is found already at Bodhgayā, the lotus seat at Sāñcī; indeed, the Gandhāran type of lotus, resembling a prickly artichoke, is far from realising the Indian idea of a firm and comfortable (*sthira-sukha*) seat, and this is really due to the misunderstanding of a purely Indian idea. Nor can the *mudrās, abhaya* and *dhyāna* for example, be anything but Indian. All that is really Hellenistic is the plasticity; the Gandhāran sculptor, even supposing his priority in time, did not so much make an Apollo into a Buddha, as a Buddha into an Apollo. He may not have copied any Indian sculpture, but his Buddha type and that of Mathurā are equally based on a common literary and oral tradition[5].

[1] Vogel, 3; Bachhofer, pp. 24, 25.

[2] Marshall, 6, 7.

[3] Marshall, 6, p. 73, and pl. XII.

[4] "It is a point on which most authorities agree, that the palmy days of Buddhism and Buddhist art in Gandhāra coincide with the reign of the great Kuṣāna kings, and more especially with that of Kaniṣka. This is somewhat more than a hypothesis" (Vogel, 3, p. 258).

[5] For the Indian conception of the *yogī* seated in meditation see *Bhagavad Gītā*, VI, vv. 10—21, and the *Samaññaphala Sutta* of the *Dīgha Nikāya*. A seated teacher is represented at Bhārhut, "Digha instructing his disciples", Cunningham, 2, pl. XLVIII, 4; a seated cross-legged figure occurs already on an Indo-Sumerian seal. The westward migration of the Yogī motif is traced by Berstl, who, unacqainted with the examples at Bhārhut, nevertheless inferred its representation in Indian art of the second or third century B. C.

The most important remains of Gandhāran art have been found or still exist at Jalālābād, Hadda, and Bāmiyān in Afghānistān, in the Svāt Valley (Udyāna), and at or near Taxila and Peshāwar. At Jelālābād (= Nagarahara, scene of the Dīpaṅkara legend) is the Khaesta *stūpa*, with a magnificent basement; the lower part of the *stūpa* drum is adorned with niches and statues. At Hadda the Tappa Kalan monastery proved to be a veritable museum of Gandhāra sculpture, but nothing that has been excavated has escaped the iconoclasm of the local Musalmāns. At Bāmiyān are many monasteries, innumerable "caves" and some colossal Buddha images; nothing seems to antedate Kaniṣka. One of the colossal images, 53 metres in height, is well proportioned, and slightly "swayed". The trefoil niche in which it stands preserves remains of painting, more or less Indian in aspect. The painting at Bāmiyān, however, exhibits a great variety of styles, and inclines more to the later Central Asian, than to Indian types, as a rule. The Kaniṣka monasteries were built in the open; later in date are the innumerable excavated monastic dwellings[1]. Sculptures from the Svāt valley (Udyāna) and many unknown sources are scattered in various collections all over the world, the most important series being that of the Lahore Museum, which includes the sculptures formerly at Peshāwar[2]. The gray slate in which Gandhāra sculptures are executed is supposed to come from an unknown site in the Svāt valley.

Excavations at Takht-i-Bāhi, in the heart of the Yūsufzai country and centre of Gandhāra have yielded abundant Gandhāra sculptures; the only actual date available is an inscription of Gondophares, A. D. 46, but most of the remains date from the third to fourth century[3]. The most remarkable monument of Kaniṣka's reign was probably his great *stūpa* near Peshāwar. To sum up the various descriptions of the Chinese pilgrims, it consisted of a basement in five stages (150 feet), a superstructure ("*stūpa*") of carved wood in thirteen stories (400 feet), surmounted by an iron column with from thirteen to twenty-five gilt copper umbrellas (88 feet) making a total height of 638 feet[4]. The monument was probably a transitional form between the simple *stūpa* and the Far Eastern pagoda; a storeyed tower represented on a *toraṇa* architrave in the Mathurā Museum (fig. 69) may perhaps give some idea of its appearance[5]. The site (at Shāh-jī-kī-Dherī) has been

[1] Godard; Fergusson, 2, vol. 1, pp. 84ff. Good illustrations of remains in Afghānistān are given by Hayden.

[2] Spooner, 5; and Foucher, 1.

[3] Spooner, 1; A. S. I., A. R., 1912—13, pt. 1, p. 17.

[4] Chavannes, 1 p. 424.

[5] Vogel, 6, 1909—10, pl. XXVII. Some further suggestion of what such a high wooden tower may have been like may be gleaned from the Go-jū-no-tō, Hōryuji, Japan; or from the Sembutsu Ha-no-tō (Hokke *mandara*) of the Hasedara monastery, Japan (*Japanese temples and their treasures*, 11, pl. 209). The *Bukyō Daijiten* (Japanese Buddhist Encyclopedia) explains *tō* as etymologically = *stūpa*. For Indian characteristics in Chinese architecture see also Boerschmann, *passim*.

identified and excavated[1]. The total base diameter proved to be some 286 feet, and the monument was thus by far the largest of its kind in India (the base diameter of the contemporary Maṇikyāla *stūpa* is less than 160 feet). In the relic chamber was found the famous Kaniṣka reliquary (fig. 89)[2]. This reliquary consists of a gilt copper alloy cylinder and lid, of total height 7¾ inches. On the lid are a seated nimbate Buddha and two Bodhisattvas, around the rim a series of *haṁsas* with extended wings; and on the cylinder are seated Buddhas, a representation of Kaniṣka, and the sun and moon deities, with garland-bearing Erotes. The inscription mentions the names of Kaniṣka and of Agiśala, the Greek or Eurasian craftsman by whom it was made. The inferior workmanship has provided an argument for regarding the Gandhāran art of Kaniṣka's reign as late in the development of the school, but it is doubtful how far this can be pressed.

The name Taxila (Takṣaśīla)[3] covers a number of neighbouring sites. The Bhīr mound has already been referred to; the city of Sirkap is Indo-Greek, Scytho-Parthian and early Kuṣāna; Sirsukh is the city of Kaniṣka's reign. The area has yielded remains dating from the Mauryan period onwards; Hellenistic art of the Scytho-Parthian period; and Buddhist art mainly of the Kaniṣka period and later. Of true Gandhāran (Graeco-Buddhist) sculpture not a single fragment occurs in Scytho-Parthian or early Kuṣāna strata. The remains of fifty or sixty *stūpas* and many monasteries have been traced. The following are the chief monuments:

Dharmarājikā *stūpa* (= Chir tope): originally Scytho-Parthian, repaired and enlarged in the Kuṣāna period, and partly refaced in the fourth century. In connection with the building of various periods here a succession of masonry types has been established as follows: rubble and *kañjur* work of the Scytho-Parthian (Kṣatrapa) period, small diaper of the latter part of the first century, massive diaper of the second century, and semi-ashlar of the third and later. The sculptures from this site are all of the later period and include many fine specimens of the stucco Buddha heads of the Indianised Gandhāran type.

Chapel G 5 at the Dharmarājikā site is of interest only because of the discovery beneath its floor of the relics of Buddha, accompanied by an inscribed silver scroll dated equivalent to A. D. 78. The Kuṣāna apsidal *caitya*-hall 13 has the end octagonal instead of round. Chapel F 1 had a floor of thick transparent glass tiles, mostly bright blue.

In the city of Sirkap, the plan of the great palace has been made out; partly of Scytho-Parthian (Kṣatrapa), partly of Kuṣāna date, it shows a remarkable resemblance to the planning of Assyrian palaces in Mesopotamia, a feature already

[1] Spooner, 2.

[2] Spooner, 2, 4; Foucher, 1; Smith, 2.

[3] See Marshall, 6 (the great mass of information contained in this invaluable handbook cannot be adequately condensed in the space here available), and 7.

remarked at Pāṭaliputra. The Jaina *stūpa* base in block F, probably of the Kṣatrapa period, has a façade with niches of three types, Greek pediment, Indian *caitya*-arch, and *toraṇa*: birds are represented as perched on the arches[1], amongst others the double-headed eagle, the oldest known example of this type in India. Temple D is a large structural *caitya*-hall. An elegant female statue in the round, dateable by the evidence of coins about 50 A. D. is of interest in view of the rarity of early dateable examples of Gandhāra sculpture, and of types in the round generally[2]. Amongst the small copper ornaments found are some comma-shaped forms exactly like the well-known prehistoric Japanese *makatama*[3].

A remarkable temple at Jaṇḍiāl had a lofty central tower and an otherwise flat roof; certainly not Jaina, Buddhist or Brāhmaṇical, it may have been a Zoroastrian fire temple with a *zigurrat* like those of Mesopotamia.

The ancient city of Puṣkalāvatī[4] is probably to be identified with the site known as Mīr Ziyārat or Balā Hiṣār at the junction of the Svāt and Kābul rivers, in the Peshāwar valley. Various sites in the immediate neighbourhood, such as Chārsada (= Haṣṭnagar), Pālāṭū Ḍherī, G̱ẖaz Ḍherī, &c. have yielded remains of Gandhāran art rather above the average quality, and it is noteworthy that at least five of the very few inscribed sculptures of this school, including two with dates in unknown eras, one however supposed to be equivalent to 6 A. D., have come from this area[5]. That Indian influence in Gandhāra was not exclusively Buddhist is illustrated by the occurrence of a Śiva image (Maheśa, a so-called Trimūrti) from Chārsada; the deity is three-headed, three-eyed, and six-armed, and stands before the bull Nandi, holding the *ḍamaru*, *triśūla* and *kamaṇḍalu*. This type is very close to that of Vāsudeva's coin, fig. 126. The style is that of the Indianised Gandhāran art of the third century[6]. The same is true of a four-armed female figure from the Momand frontier[7].

[1] A fact of interest in connection with the resemblance and like usage of the Indian *toraṇa* and Japanese *torii*, and the meaning of "bird roosting-place" assigned to the latter term.

[2] A. S. I., A. R., 1919—20, pl. IX.

[3] A. S. I., A. R., 1919—20, pl. X. So far as I know, the related *tomo-e* form appears first on a Gupta seal (Marshall, 3, pl. XXI, 120); it is not uncommon as an architectural ornament in later south Indian art.

[4] The site of Foucher's classic picture of the Indian Buddhist visiting the Eurasian craftsman and asking him to make a Buddha.

[5] Bachhofer, 1; Marshall and Vogel; Stratton; Vogel, 3. In the last mentioned the plate references on the first page need correction.

[6] Natesa Aiyar, 1; and A. S. I., A. R., 1914—15, p. 1, pl. XVI d. The type (seated), whether representing Śiva, or as has been suggested, Lokeśvara, reached Kaśmīr and Khotān (Kak, 1, and Stein, 4, pl. 230). Cf. pp. 67, note 1, 99, note 2, and 149. What appears to be part of a three-headed Viṣṇu of the later Kulū type is illustrated by Burgess, 8, pl. 22, no. 5. Cf. p. 143, note 4.

[7] Smith, 2, fig. 78.

Another important group of *stūpas*, at least fifteen in number, is found at Maṇikyālā, some twenty miles south east of Rāwalpiṇḍi, and several have yielded valuable relics. The largest, and best preserved of all the Pañjāb *stūpas*, is a hemi-spherical dome of the ancient type, but probably dating from the second or third century and repaired, perhaps in the eighth, when the pillared basement must have been added. Other *stūpas* are met with further down the valley, at Mohenjo-Daro, where fragments of frescoes have been recovered, and at Thūl Mīr Rukhan near Daulatpur[1], Saīdpur[2] and Mīrpur Khas[3], the latter here regarded as of early Gupta date.

Few sites in India are of greater interest than Mathurā. If all that has been excavated had been adequately surveyed at the time, or if all that remains could be made accessible, it is probable that many of the most doubtful problems of Indian political and artistic history might be solved, and much light would be thrown on the early development of the iconography. Even the rich finds, ranging from the Śuṅga to the Gupta period, which are now preserved in the Mathurā, Lucknow and Calcutta Museums, have not been adequately studied[4].

The pre-Kuṣāna sculptures of the Scytho-Parthian Kṣatrapa period have already been alluded to. Here we are chiefly concerned with those assignable to the reign of Kaniṣka which was the time of greatest production, and those of his immediate successors.

The most obvious characteristic of the Kuṣāna school in Mathurā is the fact, by no means astonishing, that it represents in the main a direct development of the older Indian art of Bhārhut and still older art of Besnagar. The position is nevertheless complicated by the development of a new iconography in which the Buddha figure is one of the most important elements, and by the evidence in a few of the sculptures, especially in certain reliefs, of the influence of the contemporary school in Gandhāra.

The early Kuṣāna Buddha and Bodhisattva type of Mathurā (figs. 79, 83—85)[5]

[1] Cousens, 8, pl. 10.

[2] Bhandarkar, D. R., 7.

[3] Cousens, 5; 8, pl. 11.

[4] These finds have been secured very largely through the indefatigable efforts of Pandit Radha Krishna, Honorary Curator of the Mathurā Museum. The inadequate space available for the exhibition is by no means compensated for by the publication of Vogel's Catalogue in 1910. No catalogue of any kind is available at Lucknow, and no recent or illustrated catalogue in Calcutta. Publications fully illustrating all that has been found in Mathurā are one of the first necessities.

[5] The early inscriptions distinguish by the designations "Buddha" and "Bodhisattva" types which are to all appearances the same; in these cases "Bodhisattva" must refer to Gautama, Śākya Muni, and may be freely equated with "Buddha". In the early Kuṣāna period the iconography is not yet fixed, and there is considerable variety of costume, and it would appear that prototypes of the later crowned Buddhas can already be recognized (fig. 87). It will be noticed that in some cases the right hand raised in *abhaya mudrā* is held sideways (*vyāvṛtta*) in others with the palm forward (*parivṛtta*) as in all later types. The clenched fist should be a symbol of stability, as it is in dance gesture.

is characterised by the following peculiarities: the sculpture is in the round, or very high relief, and always in the mottled red sandstone of Sikrī or Rūp Bās; the head is shaven, never covered with curls; the *uṣṇīṣa*, wherever preserved, is spiral; there is no *ūrṇa* and no moustache; the right hand is raised in *abhaya mudrā*, the left is often clenched, and rests on the thigh in seated figures, or in standing figures supports the folds of the robe, the elbow being always at some distance from the body; the breasts are curiously prominent, though the type is absolutely masculine, and the shoulders very broad; the robe leaves the right shoulder bare; the drapery moulds the flesh very closely, and is arranged in schematic folds; the seat is never a lotus, but always a lion throne (*siṁhāsana*) without miniature figures, while in the case of standing figures there is often a seated lion between the feet; the gesture and features are expressive of enormous energy, rather than of repose or sweetness, nor is there any suggestion of intended grace. The nimbus is plain or scalloped at the edge in low relief. All of these characteristations apply with equal force to the early Kuṣāna images of Jinas (fig. 86), and the great majority represent the contrary of what is to be found in Gandhāra.

This is in fact the type of which Vogel remarks that it "cannot be derived from any known class of images in Gandhāra[1]". It is obviously a product of the Indian school, and related by continuous tradition with the type of the pre-Kuṣāna Yakṣas. This is especially evident in the case of the great standing images.

The following list includes the more important examples of the Buddha, Bodhisattva and Jina type above described, all either dated in, or dateable in or before, the reign of Kaniṣka:

Mathurā (1—6 seated, 7—9, standing): (1) Bodhisattva from the Katrā mound, A 1 of the Mathurā Museum[2] (fig. 84), with inscription in characters like those of no. 10; (2) Buddha from Anyor, A 2 in the Mathurā Museum, headless, with similar inscription[3]; (3) Buddha in the Museum of Fine Arts, Boston (fig. 85), without inscription; (4) Buddhas in relief, of small size, not cult images, N 1

[1] Vogel, 6, 1909—10, p. 66. Only for the nimbus and robe has a western origin been suggested (Sahni and Vogel, p. 19). It is hard to believe that the nimbus can have originated outside the classic area of sun worship. It may be of Irānian origin, or of Indian origin as suggested on p. 41. The earliest examples in India are found on coins of Hermaios and Maues, thus about 100 B. C. As regards the robe, it is true that the Gandhāran craftsman makes it look like a toga, but the actual shape and use accord with the prescriptions in the Pali canon, and must have been fixed long before the first century A. D. The stylistic handling of the drapery in Indian and Gandhāran types could hardly be more unlike; in India the fleshy form is clearly revealed, ("wet drapery") and the folds of the material are formally arranged, in Gandhāra the body is concealed and the folds of material are loosely and naturalistically treated.

[2] Vogel, 13, p. 46, and pl. VII.

[3] Vogel, 13, p. 48, and pl. VIII.

and J 24 in the Mathurā Museum[1]; (5) Jina from the Kaṅkālī Ṭīlā site, J 39 in the Lucknow Museum (fig. 86); (6) Jinas represented in relief on several *āyāgapaṭas* from the same site, now in the Lucknow Museum[2]; (7) standing Buddha relief, J 18 in the Mathurā Museum[3]; (8) A 41 in the Mathurā Museum, like nos. 9—12; (9) headless figure from the Gaṇeśra mound, like nos. 10—12, but with ornaments, now in the Lucknow Museum[4].

Sārnāth: (10) colossal standing Bodhisattva, B (a) 1 in the Sārnāth Museum (fig. 83) dedicated by Friar Bala in the third year of Kaniṣka (123 A. D.), with a richly carved umbrella, lion between the feet, and traces of original colouring, a magnificent and powerful figure, perhaps the finest of the group, and with no. 1, the most important[5]; (11) headless Bodhisattva of similar type now in the Indian Museum, Calcutta[6]. The two last similar to no. 7.

Śrāvastī: (Saheṭh-Maheṭh): (12) standing Bodhisattva from the Jetavana site, dedicated by Friar Bala, similar to no. 10, now in the Calcutta Museum[7]; (13) seated figure, all above the waist now missing, but evidently like nos. 1—3, made by "Śivamitra, a sculptor of Mathurā" and set up "in the Jetavana at Śrāvastī" by two brothers "with special regard to the welfare of their parents", the inscription in Kuṣāna Brāhmī script[8]. Pāṭaliputra: (14) Bodhisattva fragment "which can only have been produced by the famous school of sculpture which flourished at Mathurā", also referred to as "at least one large and inferentially elaborate Bodhisattva statue from Mathurā, which is to be assigned probably to about the dawn of the Christian era or a little later"[9]. No reason is given for this early

[1] Vogel, 13, pp. 148, 166, and pls. III a and IV.

[2] Smith, 1, pls. VII, XVII, CI.

[3] Vogel, 13, p. 146, and pl. III c. Other very important railing pillars with Bodhisattva or similar figures are numbered B 82, B 83, B 88 in the Lucknow Museum; similar reliefs in the Pennsylvania University Museum (fig. 80). Cf. fig. 87.

[4] Smith, 1, pl. LXXXVII.

[5] Sahni and Vogel, pp. 18, 33—37 and pls. VII, VIII; Oertel, pl. XXVI a, b. Cf. fig. 96 (head in the Museum of Fine Arts, Boston). The similar figure B (a) 2, Sārnāth Museum, in Chunār sandstone, is regarded by Sahni and Vogel, p. 37, as a copy of the Mathurā type by a local sculptor. Friar Bala's name occurs also at Śrāvastī and in Mathurā (Sahni and Vogel, p. 36). As regards the tendency to colossal size, it may be noted that a detached left hand found at Mathurā (Cunningham, 4, vol. 1, p. 239) measured a foot across the palm, indicating a figure twenty four feet high. Cf. also the older statues from Pārkham and Baroda.

[6] Smith, 2, fig. 94.

[7] Oertel, pl. XXVI d; Ep. Ind., VIII, pp. 180ff.; J. A. S. B., XLVII, 1, 1898, p. 278.

[8] Sahni, 4. Dedications, not necessarily of images, "for the welfare of departed relatives" are mentioned in the *Milinda Panha*. The Sāñcī Buddha A 83 was dedicated "for the happiness of the donor's parents and of all creatures". Dedications were generally made *ātmāparahitam*, "for the benefit of oneself and others".

[9] Spooner, 7; and in A. S. I., A. R., 1912—13, Pt. 1, p. 26.

dating. Rājagṛha: (15) fragment of a Kuṣāna Buddha pedestal of Mathurā origin[1]. Sāñcī: (16) Buddhas, A 82 and A 83 from Mathurā, assigned to the second century, and a Bodhisattva fragment[2].

In addition to these sculptures the supposed figure of Buddha, but perhaps a king, of the early Kuṣāna type, seated cross-legged, broad shouldered, the left hand on the thigh, the elbow extended, but with some undetermined object held in the raised right hand, appears on certain coins (fig. 119) of a king Kadapha, who is probably to be identified with Kadphises I, and must have reigned near to the middle of the first century A. D.[3]. Certain of Kaniṣka's coins bear the standing figure of Buddha in loose diaphanous robes, with nimbus and body-halo, and the legend "Boddo" (fig. 123)[4]; others a seated Buddha, apparently with curly hair and in any case of a later type than Kadapha's, with the legend "Goboydo" (Go[tamo] Budo)[5]. Mr. Longworth Dames believed that the much earlier seated broad-shouldered cross-legged figure on the reverse of a coin of Maues (Smith, 6, p. 12, and pl. VIII, 4) was a figure of Buddha[6]. The type is at least as close to a Buddha figure as that of the Kadapha coin, and would be the earliest Buddha figure known; but the identity cannot be regarded as established beyond all doubt in either case.

None of these examples, other than the doubtful coins of Kadapha and Maues, can be proved to be older than the reign of Kaniṣka. It would nevertheless by very rash to assume that none of the sculptures can be older, or that any one of them is necessarily the oldest of its kind ever made. In any case Mathurā must have acquired a high reputation as the source of Buddha images before so many colossal figures would have been exported to comparatively distant sites, and this consideration certainly involves the existence of Mathurā Buddhas in the first century A. D.

It is evident from what has been said, and from the illustrations, that a type of Buddha image had been created at Mathurā independently of any Hellenistic prototype; and that this Mathurā type was transported to many other sacred sites, for at the very beginning of Kaniṣka's reign we find Mathurā "sending down

[1] Vogel, 6, 1906—07, p. 143, note.

[2] Marshall, 12, pp. 29, 30, and pls. II, XII. A 82 Sāñcī closely resembles A 45 at Mathurā (Vogel, 13, pl. X). See also A. S. I., A. R., 1912—13, Pt. 1, pl. VIII b.

[3] For this coin see Whitehead, R. B., pl. XVII, 29; and Smith, V. A., in J. A. S. B., LXVII, pt. 1, 1898; also Marshall, 13, pag. 34 and pl. XXV, 18, 19.

[4] Gardner, pl. XXVI, 8; Whitehead, R. B., pl. XX, 7; enlarged reproduction, Adam, p. 21.

[5] Zeit. für Num., 1879, pl. IX, 1; Marshall, 13 pag. 34 and pl. XXV, 20 and Cunningham, Coins of the Kushans, pl. XVII, 12.

[6] In J. R. A. S., 1914, p. 793.

images to the sacred sites of the Gangetic plains, thus setting examples to the sculptors of Benares and Gayā"[1].

These facts, taken into consideration with the subsequent continuity of the tradition, and the obvious and natural relationship of Gupta to Kuṣāna types, exclude the possibility of a "Greek origin of the Buddha image" in India. That in certain directions a Hellenistic element, plastic and iconographic, was absorbed into Indian art, and that the presence of this factor is sometimes unmistakeable, is all that can properly be asserted in this connection.

All the Mathurā sculptures showing traces of Hellenistic influence, taken together, constitute a very small fraction of the whole production of the school. Given the identity of theme, a greater divergence of the early Mathurā Buddha, Bodhisattva and Jina type from that of the Buddha and Bodhisattva of Gandhāra could hardly be imagined (cf. figs. 94, 96). The wide distribution of the Mathurā type and the fact that it was locally copied show that it was regarded as the orthodox model. Incidentally, this has a bearing on the question of the date of the Gandhāra school; for if the Gandhāran type had been evolved and acquired prestige long before Buddhas were made at Mathurā, the Indian sculptors, who had no prejudice against a foreign style, would surely have made use of it[2]. The only possible conclusion is that the Buddha figure must have been produced simultaneously, probably in the middle of or near the beginning of the first century A. D., in Gandhāra and in Mathurā, in response to a demand created by the internal development of the Buddhism which was common ground in both areas[3]; in each case by local craftsmen, working in the local tradition.

Only after the local types had been established did each affect the other. Here, indeed, there is a legitimate field for discussion with a view to definition of the influence, and of the extent to which its trace can still be recognized in *the* Buddha type which is definitely established early in the Gupta period (figs. 98, 154, 158—161, 164). The possibility of any further Hellenistic influence having been exercised at that time is of course excluded, as it is well known that the Gandhāra

[1] Vogel, 13, pp. 28, 34: "There is plenty of evidence that the Mathurā school greatly influenced Buddhist art throughout the period of its existence". I fail to understand why Vogel regards this circumstance as "not a little curious". A study of the literature also shows "que l'église de Mathurā eût parmi les communautés bouddhiques une situation priviligiée et qu'elle eût contribué pour une large part au rayonnement du foi" (Przyluski, p. 9). Mathurā fragments have also been found at Taxila (Marshall, 7, p. 39). The later Kusāna type has been recognized in Central Asia (Foucher, 1, figs. 562, 563 = Grünwedel, 3, pl. IV, 1, and Stein, 4, II, pl. LXXXII); and in China (Sirén, 1, pp. 37, 38, 43, 66, 144). See also p. 17, and Coomaraswamy, 16.

[2] It should not, however, be forgotten that as Le Coq (3, p. 28) remarks "Allen Asiaten erscheinen Europäergesichter (also auch die der Hellenen) sehr unschön". Cf. Masson-Oursel.

[3] The development of devotional theism, cf. Jacobi, S. B. E., vol. XXII, p. XXI.

type in Gandhāra and in Kaśmīr was then subject to Indian influence and had already been greatly Indianised.

Somewhat later than the type above described is another closely related to it, characterised by the following peculiarities: the general treatment is rather more refined; the robe is often thrown over both shoulders, and in seated figures, both feet are hidden, and more voluminously rendered; figures, probably of donors, appear on the pedestals; and above all, the head is covered with short curly hair, examples of the shaven head gradually disappearing. Amongst examples of these later Kuṣāna figures from Mathurā may be cited:

Mathurā: (1) the Sītalā Ghāṭī image, A 21 in the Mathurā Museum[1]; (2) standing image A 4 in the Mathurā Museum[2]; (3) small standing image with shoulder flames 25. 439, in the Museum of Fine Arts, Boston[3]; (4) Mathurā relief, fig. 104.

Śrāvastī: seated image exactly like no. 1[4].

Sāñcī: no. 19, Sāñcī Museum, possibly early Gupta[5].

It is this type, though it still closely adheres to the vigorous Kaniṣka formula, with prominent breasts and full features, that shows the first signs of a rapprochement with Gandhāran art, as indeed, specifically remarked by Goloubew with reference to no. 2[6]. On the other hand, a rapid Indianisation of the Hellenistic type begins in Gandhāra, in general, though not invariably accompanying a degeneration of the style, and a substitution of stucco for stone. Thus, about the end of the second or beginning of the third century some mutual influence of the two styles upon each other is traceable, and it is at this stage if at all that a Hellenistic element can be said to have entered into the constitution of *the* Buddha type[7].

The exact date at which the type with curly hair appears is uncertain; Sahni[8], restricts it to the Gupta and subsequent periods, but it certainly appears, both in Gandhāra and Mathurā before the end of the third and probably before the end of the second century. The source of the type is probably to be found in the tradition which first appears in the *Nidānakathā* to the effect that when the Bod-

[1] Vogel, 13, pl. XVI.

[2] Vogel, 13, pl. XV a.

[3] One of very few known examples, the others all Gandhāran: see A. S. I., A. R., 1921—22, p. 65; 1922—23, pl. XXV; and J. A. S. B., III, pl. XXVI, i. Figures of Śiwa and of kings on Kuṣāna coins also exhibit shoulder flames. Cf. the "essence of fire and hereditary royalty" of the Devarāja cult (see page 197).

[4] Marshall, in T. R. A. S., 1909, p. 1065, and pl. III b .

[5] Marshall, 12, pl. 11.

[6] B. É. F. E. O., 1923, p. 452.

[7] A conclusion quite in accordance with the fact that Gandhāran characters are rather more clearly traceable at Amarāvatī than at Mathurā.

[8] Sahni and Vogel, p. 33, note 8, but contradicted, *ibid.* p. 75.

hisattva shore his locks, becoming a hermit, his hair "was reduced to two inches in length, and curling from the right, lay close to his head, and so remained as long as he lived"[1]. The spiral form of the early Kuṣāna *uṣṇīṣa* must have a like meaning, the later type merely covering the whole head with short curls in place of the original single lock. This later type becomes the universal rule, alike in India and the Far East, only one figure with shaven head (the Māṅkuwār image fig. 62) being known of early Gupta date.

If none of the Buddha images in the round found at Mathurā can be said to be copies of Gandhāra types, and only the later Kuṣāna type exhibits a few Gandhāran characteristics, the same cannot be said in the case of the rarer reliefs illustrating scenes from the Life, particulary the Eight Great Miracles. Good examples of such reliefs include H. 1 (fig. 104), H 7 and H 11 of the Mathurā Museum; here, as remarked by Vogel, the copying of Gandhāran compositions is evident[2]. The same applies to the life-scenes of the Dhruv Ṭīlā *stūpa*-drum, N 2 of the Mathurā Museum, described by Foucher as a "caricature lamentablement indianisée" of the *stūpa*-drum of the Lahore Museum from Sikri in the Peshāwar district[3]. The decorative motif of garland-bearing Erotes, already indianised at Mathurā (fig. 76), and much more so by the time it reaches Amarāvatī, is likewise of Gandhāran origin. The only example of actual Gandhāran sculpture in the well-known blue slate of the Swāt valley certainly found in Mathurā is a late image of Hāritī, the "Buddhist Madonna" and consort of Kubera as Pāñcika, F 42 in the Mathurā Museum[4]. Another group of sculptures, stylistically Indian, is nevertheless strongly suggestive of the West in respect of its themes; well-known examples include the so-called Herakles and the Nemean lion, and the various Bacchanalian compositions, which are really representations of the aforesaid Pāñcika and are of Buddhist significance[5].

No complete railings have been traced in Mathurā, but parts of many different Buddhist and Jaina railings have been discovered at several sites. Of these the most important are the pillars and pillar-bases from the Jamālpur ("Jail") mound, also the source of the water-nymph (fig. 74), most of the pillars and the nymph being now in the Lucknow Museum, the bases divided between Calcutta and

[1] Rhys Davids, *Buddhist Birth Stories*, p. 93.

[2] Vogel, 13, pl. VI; Vogel 6, 1909—10, pls. XXV, etc.

[3] Smith, 1, pls. CV—CVII; Foucher, in J. A., serie X, vol. 11, 1903, p. 323; Vogel, 13, pp. 166—168. Sikri near Peshāwar should not be confused with Sikrī, one source of the red sandstone used at Mathurā.

[4] Vogel, 13, p. 118; Burgess, 8, pls. 56, 57. For the "Buddhist Madonna" and "Tutelary pair" (Hāritī and Pāñcika) see Foucher, 4, and for examples from Mathurā, Vogel, 6, 1909—10.

[5] For the Bacchanalian scenes see Smith, 4, pp. 134—139 and references there cited; Vogel, 6, 10, 13, 16; Coomaraswamy, 9, 2, pl. III; Foucher, 1, vol. II, p. 151.

Lucknow: pillar bases from the Court-house mound; pillars and cross-bars from the Kaṅkālī Ṭīlā site of the Jaina Yaśa-vihāra and *stūpa* of Vāsiṣka: pillars from the Bhūteśar site, divided between the Calcutta, Lucknow and Mathurā Museums: those from Jaisiṅghpura, and some others.

The pillars and bases from the Jamālpur mound are of three sizes; some bear dedicatory inscriptions of the reigns of Kaniṣka and Huviṣka. Those from the Kaṅkālī Ṭīlā are associated with inscriptions ranging from the Kuṣāna years five to ninety eight. Older fragments are not unknown, one from the Arjunpura site bearing a Mauryan inscription; but those here considered appear to belong for the most part to the latter half of the first, and to the first half of the second centuries A. D., with some perhaps as late as the end of the second century. It is unfortunate that so many of the Mathurā pillars, and *āyāgapaṭas* cannot individually be more exactly dated. The Mathurā excavations were conducted solely with a view to collecting sculptures and without regard to scientific observation of the sites; and the difficulties of study have been increased by a distribution of sculptures from the same site amongst at least three different museums[1].

The sculptures represented in high relief on the front sides of the pillars include Buddhas, Bodhisattvas, Yakṣīs (or Vṛkṣakās), toilet scenes and other genre subjects, and a few male figures; the backs of the pillars bear lotus medallions, or in a few examples, *Jātaka* panels. Of the Bodhisattvas or Buddhas, the standing figure from the Jamālpur site, B 83 in the Lucknow Museum (fig. 79) is identical in type with the Sārnāth Bodhisattva from Mathurā, dated in the third year of Kaniṣka. J 18 in the Mathurā Museum is of the same kind. B 82 in the Lucknow Museum (fig. 78) is a crowned Bodhisattva in secular costume, holding the *amṛta* vase in the left hand, and having the representation of a Dhyāni Buddha in the crown. This is one of the earliest examples of an Avalokiteśvara thus unmistakeably designated: for a Gandhāran example see fig. 95. B 88 in the Lucknow

[1] Fa Hsien describes about twenty Buddhist monasteries with three thousand monks as existing in Mathurā at the beginning of the fifth century. Some of these are represented by the mounds from which sculptures have been extracted. Amongst the buildings for which rather more precise evidence exists may be mentioned the Jaina Guha-vihāra founded by the chief queen of the Satrap Rañjubula towards the end of the first century B. C.; the main Jaina establishment with the Vodva stūpa at the Kaṅkālī Ṭīlā site, which had existed in the second century B. C. and survived into the twelfth A. D.; the Buddhist Yaśā-vihāra and stūpa at the Katrā site, restored by Vāsiṣka, later replaced by a Brāhmaṇical temple and finally by Aurangzeb's mosque; the Buddhist monasteries and stūpas at the Jamālpur and Court-House sites, with a monastery named for Huviṣka and a shrine of the Nāgarāja Dadhikarṇa; the Brāhmaṇical temple at Māt, mentioned in two inscriptions as a *deva-kula*, source of the royal statues, and perhaps the particular church of the Kuṣāna kings. For a general account of these sites, see Vogel, 13; for other details, Smith, 1, Cunningham, 4, vol. III, and Vogel, 6, 10, 15, 16. An inscription indicating the existence of a Vaiṣṇava shrine with a *toraṇa* and *vedikā* at or near Mathurā in the reign of Śoḍāsa has been edited by Chanda, 4, pp. 169—173.

Museum is another figure in secular costume, holding a bunch of lotuses in the raised right hand, and probably represents a donor (fig. 77), or may be connected with the Dīpaṅkara legend.

The great majority of the remaining figures are female (figs. 73—75). The commonest and most characteristic type, indeed, is that of the nude or semi-nude female figures associated with trees, unmistakeable descendants of the Yakṣīs and Vṛkṣakās of Bhārhut, Bodhgayā and Sāñcī, and ancestors of the Rāmeśvaram verandah brackets at Elūrā, those of the Vaiṣṇava cave at Bādāmī, and many later derivatives. What is the meaning of these sensuous figures, whose connotation and implications are by anything but Buddhist or Jaina? They are certainly not, as they used to be called, dancing girls[1]; they are Yakṣīs, Devatās or Vṛkṣakās, nymphs and dryads, and to be regarded as auspicious emblems of vegetative fertility, derived from popular beliefs[2]. Trees, as we have already seen, are closely connected with fertility, and tree-marriages have survived to the present day; the twining of the limbs of the dryads, as in the Bodhgayā pillar, deliberately or unconsciously expresses the same idea[3]. It will, indeed, have been observed that there is scarcely a single female figure represented in early Indian art without erotic suggestion of some kind, implied, or explicitly expressed and emphasized; nowhere, indeed, has the vegetative sexual motif been presented with greater frankness or transparency, though in certain later phases of Indian art, as at Khajurāho and Koṇārak, more specifically. The railing types are to be connected with and perhaps derived from the early terracottas, which in their

[1] Even Le Coq, 3, p. 82, makes the mistake of describing Māyādevī's stance in the Nativity scene as "in der Tänzerinnenstellung"; No Indian representation of a dancer in this position can be cited. It may be remarked further, that no sufficient reason exists for the usual description of the female figure on the coins of Pantaleion and Agathokles as an "Indian dancing girl". For the Bhārhut figures, however, cf. Mitra, K., *Music and dance in the Vimānavatthu-atthakathā*, J. B. O. R. S., XII, 1926.

[2] The later Saṁhitās speak of trees as the homes of Gandharvas and Apsarases. Vogel, 13, p. 44, quotes appositely from the *Mahābhārata*, "Who art thou, bending down the branch of the Kadamba tree? A Devatā, a Yakṣī, a Dānavī, an Apsaras, a Daityā, a Nāginī, or a Rakṣasī?". The *Mbh.* also speaks of dryads (Vṛkṣakā, Vārkṣī) as "goddesses born in trees, to be worshipped by those desiring children". The female figures associated with trees in Bhārhut reliefs are labelled as Yakṣīs and as Devatās. On the other hand some of the figures standing under trees are evidently human. The special adaptations of the dryad motif (1) in the case of the Buddha Nativity in the Lumbinī garden, where Māyādevī supports herself by the Śāl tree, and (2) in the poetical fancy of the Aśoka tree, which blooms only when touched by the foot of a beautiful woman, are evidently secondary, though still closely connected with the idea of fertility. For the general significance of feminine divinities worshipped through the ancient world see Glotz, J., *The Aegean civilisation*, 1925, pp. 243—245.

[3] Cf. the tree-girl married by the ten Pracetas in *Mahābhārata*, I, 196, 15; and Hsüan Tsang's story of the origin of the name Pāṭaliputra, from the marriage of a student to the maiden of a Pāṭali tree, resulting in human offspring.

turn remind us of the nude goddess once worshipped throughout Western Asia, and of the gold plaque of the Earth goddess from Lauṛiyā-Nandangaṛh. In the presence of these emblems of abundance we must not be misled by modern ideas; their meaning, if not Buddhist or Jaina, is nevertheless religious, and reveals an essential purity of spirit that has at all times preserved the East from many psychological disasters that have overtaken the West. The two polar themes of Indian, indeed, of all experience, are there presented, side by side, though not in opposition; in much later, mediaeval, Vaiṣṇava art we find them unified[1].

Reference must also be made to an isolated column (fig. 74) from the Jamālpur site representing the almost nude figure of a woman or water-nymph, an *apsaras* in the etymological sense of the word, represented as standing on lotus flower springing from a globular jar[2]. The conception in related to that of the Maya-devī and Lakṣmī types, and might be described as the completest possible treatment of the auspicious motif of the "full jar" (*puṇṇa-ghaṭa*) an auspicious symbol of abundance common in early Indian art[3]. If we combine this Mathurā water-nymph with the woman and child type of J 16 (fig. 73) in the Mathurā Museum, we have the exact components of the water-sprite of the well-known eighth century fresco (fig. 283) at Dandān Uiliq, Khotān, where the erotic, or rather, fertility motif is even more evident[4].

The Yakṣīs and dryads are not the only figures found on the railing pillars. Some figures are evidently those of mortal women, and the themes in favour are generally toilet scenes. Amongst others there occurs the well-known motif of a woman wringing the water from her long tresses, which is common in Rājput painting, and has received an edifying interpretation in the Buddhist art of the Farther India[5]. In a Mathurā relief a crane is drinking the drops of water that fall from the hair, as though they were raindrops falling from a dark cloud. *Jātaka* scenes are found in some cases occupying square panels on the reverse sides of the pillars each panel complete in itself; amongst those represented being the universal

[1] The subject has been ably discussed by Berstl, who traces the westward migration of both motifs, Vṛkṣakā and Yogī, *via* Alexandria and Syria. See also an admirable article on *Art and Love*, by Eric Gill, in Rūpam, no. 21; and remarks by Keyserling, *Travel Diary of a Philosopher*, vol. 1, p. 97.

[2] Cunningham, 4, vol. 1, p. 240, and pl. XI. Now in the Lucknow Museum.

[3] Cf. the Māyādevī-Lakṣmī series at Sāñcī, illustrated in Foucher, 3.

[4] For the Dandān Uiliq fresco, see p. 150 and fig. 283. For J 16, Mathurā, see Vogel, 13, p. 146; the "dwarf, crouching at her feet" is really a child trying to grasp a rattle held in the woman's hand.

[5] For the story of the Water of Merit wrung from her hair by the Earth Goddess Vasundharā (Burm. Wathundaya), see Duroiselle, in A. S. I., A. R., 1921—22; Salmony; Coedès in M. C. A. O., II, p. 117—22. The motif is also found at Amarāvatī, Burgess, 7, pl. XI, 4.

favorite, the *Vessantara Jātaka*[1]. A pillar of Mathurā stone with a Vṛkṣakā in typical Mathurā style has been found at Ṭandwā, near Saheṭh-Maheṭh[2].

The Buddhist and Jaina sculptures above described by no means exhaust the productions of the Mathurā workshops. The portrait statues of Kuṣāna kings are of very special interest; they include the well-known inscribed, but unfortunately headless statue of Kaniṣka found at Māt (fig. 65), several others more fragmentary from the same site, and the complete figure now worshipped in Mathurā as Gokarṇeśvara[3]. Similar types on coins are illustrated in figure 120, 122, 123, 124. All the figures, standing or seated, are in a purely Indian style of art, but the costume, consisting of a pointed cap, tunic, open coat, trousers and high heavy boots, is Central Asian[4]. The latter point is of interest in connection with the early Mathurā images of the Sun (Sūrya), which are represented in a similar costume, especially as regards the boots; it is by no means impossible that the Kuṣāna kings, whose attachment to the cults of Fire (whether Magian or Indian) is well known, and who paid special honour to the Sun, may have set up and popularised a form of Sūrya image dressed in their own fashion[5].

The early Brāhmaṇical fragments found at Mathurā have not been adequately studied; they include representations of Śiva, various forms of Devī, a slab, D 47 in the Mathurā Museum, representing Kṛṣṇa as Govardhanadhara[6] (fig. 102), and a three-headed image, E 12 in the Mathurā Museum, not identified; and many

[1] The method of continuous narration is highly characteristic at Bhārhut and Sāñcī, and it is curious that it is not found at Mathurā, and is very rare in Gandhāra, though it reappears in Khotān and is common in later Indian art, including Rājput painting. The method is familiar in late classical western art, and is supposed by Stryzgowski (I, p. 39) to have originated in the Hellenistic Near East. Della Setta regards both the method of continuous narration and the use of the three-quarter profile in early Indian art as evidences of western influence.

[2] "From which it would appear that Mathurā must have been the great manufactory for the supply of Buddhist sculpture in northern India" (Cunningham, 4, vol. XI, pp. 70 ff). The Ṭandwā figure is now worshipped as Sītā-maī. Another Mathurā sculpture, found at Tusāranbihār, Partabgaṛh District, is a group of seven or eight figures, mostly nude females, perhaps a Bacchanalian scene (Cunningham, loc. cit. p. 65). Cf. *supra*, pp. 57 ff., on the export of Buddha images from Mathurā.

[3] For the images of Kuṣāna kings see Vogel 15; and A. S. I., A. R., 1920—21, p. 23 and pl. XVIII. One of the Māt figures bears the name of the Āndhra king Caṣṭana, who reigned ca. 80—110 A.D. (J. B. O. R. S., VI, 1920, pp. 51—53). Vogel, *loc. cit.* (15) quotes an inscription from the Mora site speaking of "images of the Five Heroes" (Pāṇḍavas) and reproduces torsos which may have belonged to the figures in question.

[4] Another common form of the Kuṣāna coat fastens at the side and is hardly distinguishable from the Mughal *jāma*.

[5] Vogel, 15, p. 127.

[6] Vaiṣṇava sculptures from the mediaeval Keśava Deva temple at the Katrā site, destroyed by Aurangzeb, must not be confused with those of Kuṣāna date. Cf. D 26 in the Mathurā Museum, Vogel, 13, p. 100.

small images of Kuṣāna and early Gupta date. Śiva is represented with or without the bull, two-armed and nimbate on all the coins of Wima Kadphises, Kaniṣka's predecessor; this Kadphises was a worshipper of Śiva and himself used the style "Maheśvara" which may indicate that he claimed to be a descent of the god. A great variety of deities appears on Kaniṣka's coins, amongst them being Śiva in two- and four-armed types (fig. 122, 125, 126), the Buddha above referred to (fig. 123), the Sun and Moon, Skanda and Viśākha, a Fire-god and a Wind-god, running[1] (fig. 128). The latter, if not to be identified with Hanuman, is certainly a prototype of many later representations of the "Son of the Wind" [2]. An early Kuṣāna seal of fine quality also bears the figure of a two-armed Śiva[3].

A Śiva-liṅgam with a figure of Śiva, analogous to the older Guḍimallam figure described above, but four-armed, is certainly a Mathurā work of the second or third century A. D.; its present position is unknown (fig. 68). The fact is so curious as to be worth mentioning that an image of Ardhanārīśvara (the combination of Śiva and Devī in one half-male, half-female figure) is unmistakeably described by a Greek author, Stobaeus (fl. ca. 500 A. D.), quoting Bardasanes, who reports the account of an Indian who visited Syria in the time of Antoninus of Emesa, i. e., Elagabalus, who reigned 218—222 A. D.[4].

The seated Sun images from Mathurā are of great interest. The type occurs at Bhājā in an uncanonical form, then on a railing pillar at Bodhgayā (fig. 61) where it is strictly symmetrical, and evidently follows a literary source. Probably the earliest Mathurā figure is that from the Śaptasamudrī well, D 46 in the Mathurā Museum (fig. 103)[5]. Here the Sun is represented as squatting in a car drawn by four horses and holding some object in each hand; especially to be remarked is the sun-disk or nimbus behind him, quite plain except for the indication of rays around its edge; there are also small shoulder wings, peculiar to this example. In two other images, one in Boston[6], and one in the Mathurā Museum the car and

[1] For the development of the iconography on the coins see Macdonell, 2, 3, 4; Stein, 1; and the coin catalogues of the Calcutta, Lahore, and British Museums. A three-headed figure occurring on Ujjain coins assigned to the second century B. C. has been regarded as representing Śiva, "whose temple stood in the Mahākāla forest to the north of the city" (C. H. I., p. 532, and pl. V, 119). Strong evidence would be needed to prove the existence of a polycephalous type at that time; Cunningham (5, pl. X, fig. 6), however, also dates this coin in the second century B. C., assigning it to Śātakarṇi, third Āndhra king.

[2] Cf. Coomaraswamy, 4, fig. 59.

[3] A. S. I., A. R., 1914—15, pl. XXIV, 51.

[4] The full reference, for which I am indebted to my colleague Mr. A. Sanborn, is Stobaeus, *Eclogarum Physicarum et Ethicarum*, ed. L. Herren, Göttingen, 1792, Bk. 1, Ch. IV, Sec. 56. Fergusson quotes the "Gainsford edition", p. 54.

[5] Vogel, 13, p. 104. For the Bodhgayā Sūrya, see Marshall in J. R. A. S., 1908, p. 1096.

[6] Coomaraswamy, 9 (2), pl. 1.

horses, though the latter are still four in number, are still further reduced, and it can be seen that the costume consists of a cuirass and boots, while the attributes are a kind of club or mace and a staff or more probably a sword; in the Mathurā example the nimbus is preserved, and is marked by curved radiating rays. The two last mentioned are in a cream-coloured sandstone. These images may be compared with two others, one in the Mathurā Museum (fig. 64) representing a royal personage, apparently a Kuṣāna king in tunic and boots, with the same attributes, but without horses, and seated on a throne flanked by lions and marked in front by a fire altar; the other in purely Indian costume, torso nude, and holding in the left hand a cup, and flanked by two small figures of women, is apparently a Bacchanalian Yakṣa. Standing Sun images apparently of Kuṣāna age and the same type (with cuirass and boots) are numbered D 1 and D 3 in the Mathurā Museum but have not been published[1].

It is evident that a cult of Yakṣas and Nāgas continued to flourish in the Kuṣāna period, each of these classes of beings evidently partaking in some measure of the character of a *genius loci* or land-wight, and receiving honour as the presiding genius of a city, district, or lake or well[2]. The Yakṣa is a massive, and often pot-bellied *(kalodara)* type, whose ancestors we have noticed above; the type is likewise adapted to many other purposes in this period of undeveloped and unstable iconography, and gives rise not only to the Buddhist Pāñcika-Jambhala and very probably to Bodhisattva types like Friar Bala's at Sārnāth, but also to the later Hindū Gaṇeśa[3]. The Nāga is represented in human form, but with snake hoods attached to the shoulders and rising above the head; the finest Kuṣāna example is perhaps the life-size figure, C 13 in the Mathurā Museum, dated in the fortieth year of Huviṣka. Others in Mathurā and in local stone to be seen at Sāñcī are of Gupta date and over life-size[4]. There is also a Bacchanalian type (C 15 in the Mathurā Museum). The nature and importance of the old Indian cult of Nāgas can be best realised from a study of its survivals in the Pañjāb Himālayas, where snake-gods are still by far the most common objects of worship; the Nāgas are genii of lakes and springs, and worshipped as powers of the waters, alike in their beneficent and their destructive aspects[5].

[1] Vogel, 13, p. 94.

[2] Chanda, 1; Gangoly, O. C., in Modern Review, Oct. 1919.

[3] Cf. Scherman. The pot-bellied type has something to do with the iconographic origins of Agastya (e. g. from Caṇḍi Banon, Java fig. 359), Durvasa Mahārṣi (Dhenupureśvara temple, Palleśvaram, Tanjore District), and of Gaṇeśa.

[4] Marshall, 5, pp. 108, 141.

[5] Emerson, *Historical aspects of some Himalayan customs*, J. P. H. S., VIII, 2, 1921, p. 195; Hutchinson, J., and Vogel, J. Ph., *History of Bhadrawāh State*, ibid, IV, 2, 1916, p. 123; Kangra Gazetteer, pt. 11, 1917, p. 62. The accounts of Sung Yün and Hsüan Tsang show that the Nāga cult was still flourishing in the Pañjāb and Ganges valley in the fifth and seventh centuries.

It is noteworthy that an identical form surviving in modern art is worshipped as Baldeo, i. e. Balarāma. Now in the *Mahābhārata*, 13, 147, 54ff., Baladeva is described as having a head wreathed with snakes, as carrying a club, and as being addicted to drink, and he is identified with Śeṣa-Nāga from which it would appear not unlikely that some of the old Mathurā Nāgas may really have been regarded as images of Balarāma[1].

Sacrificial posts (*yūpa*) in stone with one of the earliest inscriptions in pure Sanskrit were set up at Īsāpur near Mathurā by Vāsiṣka, a son, viceroy and successor of Kaniṣka, in the Kuṣāna year 24 (144 A. D.?); and wooden sacrifical posts of like date also have been preserved[2].

For the Mathurā railing pillars, many and perhaps most of which may be of Kuṣāna date, see above, p. 63.

Mathurā, if the most prolific, was not of course an isolated or unique centre of production in the Kuṣāna period. Every excavated site which was continuously occupied during the Kuṣāna period has yielded corresponding antiquites, and of these Pawāyā (= Padmāvatī), Bhīṭā, Basāṛh (= Vaiśālī), Besnagar, Sārnāth and Pāṭaliputra may be mentioned. The site of the old Suratgaṛh fort in Bikanīr has yielded late Kuṣāna or early Gupta moulded bricks and terra-cottas showing Gandhāran characteristics, and others representing Brāhmaṇical subjects, including an Umā-Maheśvara group, a Kṛṣṇa-Govardhanadhara and a Dān-Līlā scene[3]. Kaśmīr was a part of Kaniṣka's dominions and is discussed in another chapter: Kaniṣka's influence extended to Khotān, "where India and China meet".

South of the Vindhyās, the powerful kingdom of the Āndhras had embraced the whole of the Dekkhan from east to west long before the beginning of the Christian era: the earlier caves (*caitya*-halls and *vihāras*) have already been referred to. Of those of the later Āndhra period the most important are the excavated *caitya*-hall at Kaṇheri, and Cave III at Nāsik. The Kaṇheri hall is a large one, in the style of the older *caitya*-hall at Kārlī, and like that has figures of royal donors carved on the outer screen (fig. 135). The roof inside was ornamented with wooden rafters of which the pegs are still in place; in front, as in the Nāsik, there is an elaborately decorated railing in relief, quite suggestive of the great structural railing at Amarāvatī. Some of the capitals bear representations of the worship of *pāduka*; the Buddha figures carved above those of the donors on the screen are

[1] Vogel, 10; 13, pp. 45, 48; 15, p. 122. Some of the Bacchanalian Nāgas hold instead of a cup, a flask like Maitreya's; suggesting that the amṛtaflask may once have been a bottle of wine.

[2] Vogel, 16, and A. S. I., A. R., 1922—23, p. 138.

[3] A. S. I., A. R., 1917—18, Pt. I, p. 22, and pl. XIII.

doubltess of later date. The hall itself and figures of donors may date about the
end of the second century[1].

The *vihāra* at Nāsik (Gautamīputra cave, Cave III) is just like the older Nāha-
pana *vihāra*, Cave VIII in plan, both square halls with cells on the three inner sides,
and a verandah in front; the one is evidently a later copy of the other, and may
be dated about 130 A. D. A little later is the Śrī Yajña cave, No. 15, dateable
about 180 A. D. and chiefly remarkable for the small shrine excavated at the farther
end, probably in the Gupta period, and containing figures of Buddha, and in
front, two richly carved pillars with horizontally ribbed brackets like the early
Pallava forms[2].

The monuments of the Āndhras in the east, in Veṅgī, are more magnificent. By
far the most important is the great *stūpa* at Amarāvatī (figs. 136—141 and 144—146)[3].
A *stūpa* certainly existed here in the second century B. C., and some sculpture
fragments from this period survive. But the sculptured casing slabs of the
monument and the great railing, the most elaborate ever made: are additions of
the late second century A. D., and the Buddha figures in the round of the same
date or a little later. All the stone is marble, and must have been covered originally
with thin plaster, coloured and gilt.

More than one of the casing slabs affords a picture of the *stūpa* as it must have
appeared in the height of its glory (fig. 136); others are carved with scenes of
worship and from the life of Buddha. The slabs were apparently arranged, in
two tiers, forming a kind of wainscot on the *stūpa*-drum, which was about a
hundred and sixty feet in diameter. The single railing was about six hundred feet
in circumference and thirteen or fourteen in height. Each upright (*thaba*) was
decorated with one full lotus disk in the centre and a half disk above and below,
often with crowded figure sculpture between; or the disks themselves, in place
of the full lotus, may be elaborately carved. The coping bore a long wavy floral
scroll, carried by men who are really Indianised analogues of the garland-bearing
Erotes of Gandhāra, which found their way into India *via* Mathurā. The inner
face of the railing was even more elaborately treated. It has been estimated that
the railing alone provided a superficial area of nearly 17000 square feet covered
with delicate reliefs, while the *stūpa* itself, all the lower part of which was cased
in carved stone, had a diameter of 162 feet. The various stories illustrated in-
volve the representation of abundant architectural detail; there are walled and
moated cities, palace buildings, *toraṇas*, *stūpas*, and at least one elaborate temple
of the Bodhi tree. It would hardly be possible to exaggerate the luxurious beauty

[1] Fergusson, 2, vol. 1; Jouveau-Dubreuil, 1, vol. 1.; Burgess, 8, pls. 24, 212.

[2] Fergusson, 2, vol. 1, pp. 183 ff.; Jouveau-Dubreuil, 1.; Fergusson, 1, 2.

[3] Burgess, 7, 8 (pls. 209, 210); Rea, 4.

or the technical proficiency of the Amarāvatī reliefs; this is the most voluptuous and the most delicate flower of Indian sculpture. Compared with such a liveliness and chic as this, even the lovely traceries of Mt Ābū seem to be mechanical.

In the casing reliefs we find side by side the old method of representing the Buddha by symbols, and the human figure of more recent introduction. The statues of Buddha in the round (figs. 97 and 137—139), which may date from the beginning of the third century are magnificent and powerful creations, much more nearly of the Anurādhapura (Ceylon) than of the Mathurā type. The type is severe, but the features are full, the body often anything but slender, and the expression is at once aristocratic and benign. All have short curly hair.

GUPTA PERIOD 320—600 A. D.

A rājā of Pāṭaliputra, who assumed the name of Candragupta I and extended his dominions as far as Allahābād (Prayāg), established the Gupta era, 319—20, to commemorate his coronation. Samudragupta extended the kingdom to the Satlaj, and made conquests in Southern India. Candragupta II, the legendary Vikramāditya, annexed Mālwā and Ujjain, and dispossessed the Saka rulers of Surāṣṭra, known as the Western Satraps; he removed the capital to Ayodhyā. The White Hūns invaded northern India in the reign of Kumāragupta I, and in the time of Skandagupta, about 480, broke up the empire. In about 528 the Hūns, under Mihiragula, were defeated by Balāditya, a later Gupta, allied to a rājā of Mālwā, and those of the Hūns who were not permanently settled in Rājputāna retired to Kaśmīr. As a culture period, and for the purposes of this book, the Gupta period is taken as covering the years 320—600 A. D.

The outstanding characteristic of the art of India at this time is its classical quality. In the Kuṣāna period the cult image is still a new and important conception, and there we find, quite naturally, magnificent primitives, or "clumsy and unwieldy figures", according to our choice of terms. In the Gupta period the image has taken its place in architecture; becoming necessary, it loses its importance, and enters into the general decorative scheme, and in this integration acquires delicacy and repose. At the same time technique is perfected, and used as a language without conscious effort, it becomes the medium of conscious and explicit statement of spiritual conceptions; this is equally true of sculpture, painting, and the dance. With a new beauty of definition it establishes the classical phase of Indian art, at once serene and energetic, spiritual and voluptuous. The formulae of Indian taste are now definitely crystallised and universally accepted; iconographic types, and compositions, still variable in the Kuṣāna period, are now standardised in forms whose influence extended far beyond the Ganges valley,

and of which the influence was felt, not only throughout India and Ceylon, but far beyond the confines of India proper, surviving to the present day.

The period is often described as one of the revival of Brāhmaṇism and of Sanskrit learning and literature. But actually there is no evidence of any preceding lack of continuity in the development of Brāhmaṇical culture. The *kāvya* style is already foreshadowed in the *Rāmāyaṇa* and fairly well developed in the second century A. D. Certainly there had never existed a "Buddhist India" that was not as much and at the same time and in the same areas a Hindū India. In any case, an age of heightened aesthetic consciousness, of final redactions of the Epics and *purāṇas*, and of codifications and systematisation in the arts[1] must have been preceded by centuries, not of inactivity, but of intense and creative activity. The period is thus one of culmination, of florescence, rather than of renaissance. No more than a passing allusion can be made here to the close parallels that exist at this time between the development of art and literature: the same abundance pervades the Sanskrit *kāvya* literature, the Ajaṇṭā paintings and the decoration of the Gupta reliefs.

The rich decorative resources of Gupta art are to be understood in terms of its inheritance, indigenous, Early Asiatic, Persian and Hellenistic. The Gupta style is unified and national. Plastically, the style is derived from that of Mathurā in the Kuṣāna period, by refinement and definition, tendencies destined still later, in the natural course of events, to imply attenuation. Meanwhile Gupta sculpture, though less ponderous than the ancient types, is still distinguished by its volume; its energy proceeds from within the form, and is static rather than kinetic, a condition that is reversed only in the mediaeval period. In all these respects Gupta art marks the zenith in a perfectly normal cycle of artistic evolution. In India, as elsewhere, we find a succession of primitive, classical, romantic, rococo, and finally mechanical forms; the evolution is continuous, and often, especially in the earlier periods, rapid; and wherever our knowledge is adequate, Indian works, like those of other countries, can be closely dated on stylistic evidence alone.

The school of Gandhāra, in the earlier part of the Gupta period, continues to flourish in the North West, though in more or less Indianised forms. The remains at Jauliāñ and Mohṛā Morādu (Taxila) afford a good illustration of its character. The former consist of a main and smaller *stūpas*, chapels, and a monastery; the latter with an assembly hall, refectory, kitchen, store-room, bathroom and latrine, indicating a comparatively luxurious development, and that the monks no longer depended upon the begging bowl for all their food. The sculp-

[1] An important piece of evidence given by Hsüen Tsang proves what might in any case have been inferred, the existence of *Śilpa-śāstras* in the late Gupta period: he mentions five *Vidyās* or *Śāstras*, of which the second is the *Śilpasthānavidyā* (Beal, I, p. 78).

tures date from a little before or after 400 A. D. There is no evidence that any appreciable production in stone took place after the third century; almost all the Jauliañ sculpture is executed in clay or stucco, once coloured and gilt. The style is still fairly vigorous, freer, indeed, and more animated than that of the earlier work in stone; it is at once less refined, less well-considered, and less academic. It is profoundly Indianised; but it cannot be equated in any aesthetic sense with the central productions of Gupta art, and in comparison with these is essentially provincial[1].

The Bhallaṭ *stūpa*, of third or fourth century date, at Taxila, with an unusually high drum, stands on a rectangular basement approached by one flight of steps, illustrating the simple form from which the many-terraced types of Kaśmīr and Java and Burma were later evolved[2].

Farther to the North West, at Chārsada and other old sites near Puṣkalāvatī, Gandhāran stucco and clay figures have been found, similar to those of Jauliañ, but of finer and more pleasing quality, though likewise dating about 400[3].

Other stūpas of early Gupta date are found in the Sind valley, and of these the Mīrpur Khās example is the most important; it is a brick structure standing on a square basement, and chiefly remarkable for the existence of three small chapels or cellas within the mass of the basement on the western side, affording the only Indian instance of a type of structure combining *stūpa* and chapels in a way later on to be greatly elaborated in Burma. In the central chapel there is a true brick arch[4]. The decoration consists of carved bricks, like those of Jamāl-gaṛhī, Bikanīr, and other early Gupta sites, both Buddhist and Hindū. There are also terracotta Buddhas, with Gandhāran affinities, and the figure of a donor, still preserving its original colours, the flesh wheat-coloured, the hair or wig black, the waist-cloth red[5]. Most of the Gandhāra sites seem to have been wrecked

[1] Marshall, 6, 7.

[2] Marshall, 5, pl. XXVIII.

[3] Marshall and Vogel.

[4] It may be remarked here that many isolated occurrences of a true vaulted arch are found in Indian architecture of pre-Muḥammadan date. E. g., Piprāwā, Peppé and Smith; Pāṭaliputra, Maurya arch stone, A. S. I., A. R., 1921—22, pl. XXXVI; Bhītārgāon, Cunningham, 4, vol. XI; Nālandā, A. S. I., E. Circle, 1916—17, p. 45; Bodhgayā, Cunningham, 3, pp. 85, 86, and 4, vol. XI, pp. 42, 43, and Mitra, pp. 104ff.; Konch, Peppé, J. A. S. B., XXXV, pt. 1, p. 54; Kāfir Koṭ, A. S. I., A. R., 1920—21, pt. 1, p. 7; Kaśmīr, Sahni, 3, p. 73; Kiyul, Cunningham, 4, vol. III, p. 157; Burma, Fergusson, 2, p. 352; and at Poḷonnāruva, in Ceylon. All these represent true voussoirs, not merely the pointed arch form, which also occurs in monolithic and corbelled construction. As a rule in the Indian arches the bricks are placed sideways so that the thin edges are in contact. For pre-Muḥammadan buttresses see A. S. I., A. R., 1922—23, p. 118; for domes, Fergusson, 2, vol. 1, pp. 312—319. See also page 12 and fig. 146.

[5] Cousens, 5, pl. XXXVIII; 8, pl. 14.

by the White Huns under Mihiragula in the latter part of the fifth century, and this practically ended the activity of the school. The original influence, nevertheless continues to be apparent in the architecture and sculpture of Kaśmīr, and that of a few related monuments, such as that at Malot (fig. 274)[1], dating from the time of Kāśmīrī domination in the Pañjāb.

The Buddha figure in the early Gupta period is fully evolved, and this classical type is the main source of all later forms both in and beyond the Indian boundaries. The only example of the old Kuṣāna type with shaven head is the Māṅkuwār image, dated 448/9 A. D. (fig. 162). This figure at the same time exhibits a peculiarity rather common in the Gupta period, that of webbed fingers[2]. Apart from this exceptional figure, the Gupta type is characterised by its refinement, by a clear delineation and definition of the features, by curly hair, absence of ūrṇā, greater variety of mudrās, elaborately decorated nimbus, the robe covering one or both shoulders and extremely diaphanous, clearly revealing the figure; and by a lotus or lion pedestal, usually with figures of donors. Scarcely any trace of Hellenistic plasticity is apparent.

The leading variations are exemplified in the fine fifth century image by the colossal standing image from Mathurā (fig. 158), the beautiful but less vigorous seated figure B (b) 181 at Sārnāth (fig. 161) and others at the same site, the Sultāngañj copper image of over life-size in Birmingham (fig. 160), and the figures in relief at Ajanṭā, Cave XIX (fig. 154), and those of Kārlī, Kaṇheri (fig. 164) and other western caves.

All of these are executed in local material, at Sārnāth, for example, in Chunār sandstone; it is obvious that by this time local ateliers existed at every sacred site. But that Mathurā still maintained a high reputation is illustrated by the existence of Buddha images in Sikrī sandstone, e. g. at Kasiā (colossal Parinirvāṇa image made by Dinna of Mathurā and seen by Hsüan Tsang)[3], at Bodhgayā[4], Prayāg (Māṅkuwār, mentioned above) and Sāñcī.

In view of the wide distribution of Mathurā images in the second, third, fourth and fifth centuries, it is easy to understand the evident derivation of the Gupta from the Mathurā type, and the fact that, as Smith remarks apropos of the Sārnāth figure B (b) 181, the Gupta Buddha is "absolutely independent of the Gandhāra school"[5]. As Marshall too observes, "Hellenistic art never took a real and lasting

[1] Burgess, 8, pls. 237—241; A. S. I., A. R., 1918—19, p. 5, and 1920—21, pl. 11.

[2] Other examples, B (b) 103 and 181 at Sārnāth, B 10 Lucknow Museum (from Mathurā), and reliefs at Cave XIX, Ajanṭā.

[3] For Kasiā (= Kuśinagara, site of the Parinirvāṇa) see Sastri, H., 1; Vogel, 5, and 13, and in A. S. I., A. R., 1906—07, pp. 49 ff.; and Sahni, 4.

[4] Cunningham, 3.

[5] Smith, 2, p. 170.

hold upon India"[1]. In fact "le buddha de Mathura, ce prototype d'inspiration et de facture indiennes et peut-être même l'authentique ancêtre de toutes les images du Bienheureux, ne s'est pas éclipsé au contat de l'art Gandharien et . . . a survécu à la vogue classique sans avoir subi d'altération essentielle"[2].

Thus the famous theory of the Greek origin of the Buddha image, propounded by Foucher, and since adopted by many scholars, proves to lack all solid foundation, and falls to the ground, and with it the implied Greek inspiration of other Indian images, Brāhmaṇical and Jaina. The fact that a Hellenistic element, plastic and iconographic, of some kind, enters into and is absorbed by Indian art, remains. Opinions may differ as to its extent and significance; its importance is slight, and perhaps rather historical than aesthetic.

Gupta architecture may be discussed under heads as follows: (1) *stūpas*; (2) excavated *caitya*-halls and *vihāras*; (3) structural *caitya*-halls and apsidal Hindū temples; (4) flat-roofed temples; (5) *śikhara* shrines, and exceptional types such as those at Gop, Bodhgayā, and the Maṇiyār Maṭha; (6) palace and domestic architecture and the theatre.

Only two structural *stūpas* of Gupta date survive outside the Gandhāra area in anything like a fair state of preservation, both of the cylindrical type, the globular dome of the monolithic *caityas* being, no doubt, difficult to realise constructively. The first is the well-known Dhamekh *stūpa* at Sārnāth, probably of sixth century date. The structure consists of a circular stone drum, resting on the ground level without the usual rectangular basement; above this drum rises a cylindrical mass of brickwork to a total height of 128 feet. Halfway up the base are four niches which must have held Buddha images; immediately below these niches is a broad course of exquisitely carved elaborate ornament, geometrical and floral, in the manner of the painted ceilings at Ajaṇṭā. The other *stupa* is the later of the two Jarāsandha-kā-Baiṭhak at Rājagṛha, a tower-like erection, rising from a substantial basement, and dateable about 500.

The caves afford numerous examples of monolithic forms; here, e. g., at Cave XIX, Ajaṇṭā, there is usually a high cylindrical drum, decorated with standing or seated Buddha figures between pilasters crowned by a *makara*-arch, richly ornamented, and supporting a globular dome (*aṇḍa*) with the usual pavilion (*harmikā*) and range of umbrellas (*chatravali*). This form is directly derived from that of votive *stūpas* of the Kuṣāna period such as N 1 in the Mathurā Museum[3]. Outside Cave XIX, at Ajaṇṭā, on the right hand side, there is a relief apparently representing a pavilion with a globular dome and umbrellas; this is not

[1] Marshall, 8, p. 649.
[2] Goloubew, in B. É. F. E. O., 1923, p. 451.
[3] Vogel, 13, pl. IV.

really a domed pavilion but the elevation of a solid *stūpa* like that within the hall[1].

There exist many "caves" of the Gupta period. At Ajaṇṭā Caves, XVI and XVII are *vihāras* dating about 500 A. D., Cave XIX a *caitya*-hall dateable about 550; all of these contain paintings, referred to below.

The two *vihāras*, XVI and XVII are pillared halls with the usual cells and the addition of shrines in the back wall containing seated Buddhas in *pralambapāda āsana*, "European fashion", which now appears for the first time. The beauty and variety of the pillars in these *vihāras* is remarkable, the types in the two caves differing, and no two of any type being exactly alike. In Cave XVI, vertically or spirally fluted pillars are characteristic, with rounded bracket capitals, sometimes with horizontal ribs like the early Pallava brackets of the South. In Cave XVII the pillars are square above and below, the centre is fluted, and the brackets are provided with squatting figures of *gaṇas* supporting the horizontal cross-beams, and this placed back to the roof and face downwards; this type of *gaṇa* capital becomes almost universal in mediaeval architecture.

The *caitya*-hall, XIX, retains the plan of the early types, but with extensive changes in the façade and a great development of (Mahāyāna) sculpture. The façade (fig. 154) is a further development of the Nāsik type, but in place of the railing, which at Nāsik extends across the whole width of the wall from side to side, separating the doorway from the window above it, there is a double roll cornice decorated with *caitya*-windows framing heads, a form most likely of Āndhra origin, but already common in early Gupta work. Above these cornices, the frame of the great window stands out in relief against a many storied screen of architectural reliefs; below it is the flat-roofed entrance porch supported by four pillars, and very shallow. The aisle pillars within are richly ornamented fluted columns with pot and foliage capitals, and massive, decorated, rounded brackets, supporting an elaborate frieze of niches with Buddha figures. The *stūpa* is of the type already described, with a range of three heavy umbrellas, far removed from wooden forms. Outside, right and left of the façade and on the walls of the excavated court in front of the cave are many more Buddha figures in relief; the type is full-fleshed, but gracefully *hanché*, and the drapery is treated with the greatest possible simplicity, closely moulding the body. It is these types, or those of Sārnāth, which are as nearly as can be indicated, analogues of the pre-Khmer Indianesque Buddhas of Romlok, while, as remarked elsewhere, the Kaṇheri sculptured reliefs are no less closely related to the Stoclet Avalokiteśvara. In this connection it may be remarked that the Vākāṭaka kings to whom Caves XVI and XVII are due, to some extent successors of the Āndhras in the Dekkhan,

[1] A structural stone domed pavilion is unmistakeably represented at Amarāvatī, see fig. 146.

76

controlled the Telugu country almost to the mouths of the Godāverī, and by this route the Gupta tradition found easy access to the East[1].

Closely related to those of Ajaṇṭā are the *vihāra* and *caitya* caves at Bāgh, which are likewise painted, and date about 500[2].

At Elūrā, the Viśvakarmā *caitya*-hall is internally like Cave XIX at Ajaṇṭā; externally, it is remarkable for its unique façade, of which the lower storey is a verandah with pot and foliage capitals and the upper (fig. 155) contains a divided window flanked by two niches in which are standing figures of Buddha. The superstructure of these niches is two-storied, with angle *āmalakas*, and is topped by a *kīrttimukha*. The excavation is Gupta or early Cālukyan, dating about 600[3].

Of caves in Kāṭhiāwāḍ, the most interesting and beautiful is the two storeyed pillared hall in the Uparkoṭ at Junāgaṛh. The varied fluted columns, capitals with elaborate figure groups like Ajaṇṭā paintings, cornices with *caitya*-window niches like those at Gop, the acanthus ornament of the pillar bases like the Bhumara lintel, all point to a late Gupta date. The excavation includes a bath and lacks the ordinary cells of a monastery; it would almost seem that it may have been the underground summer chamber of a palace. It is in any case one of the most elegant of all works of the Gupta period, and fully the equal of the little temple, no. 17 at Sāñcī[4]. The important group of cave and structural temples at Udayagiri, Bhopāl, mostly Brāhmaṇical, is nearly related to the same Sāñcī type and that of the Tigowā series[5].

Several structural apsidal temples, planned like the *caitya*-caves, have survived, including one Brāhmaṇical example. At Ter (= Tagara), Sholāpur District, the structural brick *caitya*-hall, of fourth century or perhaps earlier date, seems once to have enshrined a *stūpa*, and only subsequently to have been converted to Vaiṣṇava usage. Characteristic external features are the barrel-roof, rounded at the rear end, and terminating above the entrance in a gable-end of *caitya*-window form, enclosing an architectural relief; roll mouldings; and walls decorated with simple pilasters. The *maṇḍapam* is perhaps a little later in date[6]. At Chezārla, in the Kistna District, the Kapoteśvara temple (fig. 147) is similarly a structural *caitya*-hall, originally Buddhist and later converted to Hindū usage. Here the gable end is decorated with reliefs including both architectural forms and figures; the roll mouldings are more developed, but the wall is plain. Near this temple is a curious little rectangular cella recalling Indianesque types of Hanchei; and a number of

[1] For Ajaṇṭā see Fergusson, 2, vol. 1; Fergusson and Burgess; and Burgess, 4.
[2] For Bagh see Haldar; Luard; Dey. A full publication by the India Society is announced.
[3] Fergusson, 2, vol. 1, p. 159; Burgess, 8, pl. 275.
[4] Burgess, 1.
[5] Cunningham, 4, vol. IX.
[6] Cousens, 1.

small monolithic votive shrines, with domed roofs decorated with single *caitya*-arches, like the rock-cut Pallava shrines at Bhairavakoṇḍa in the Guntūr District, and the Arjuna Ratha at Māmallapuram[1].

The Brāhmaṇical Durgā temple at Aiholé (fig. 152) is probably of sixth century date, and rather early Cāḷukya than Gupta, but is connected with the types now described. Entirely of stone, it follows the plan of the apsidal *caitya*-halls, but the roof is flat and constructed of stone slabs, a northern *śikhara* rises above the *garbha-gṛha*, and there is a verandah, roofed with sloping slabs, supported by massive square columns with heavy brackets. The whole stands on a high basement of several horizontal courses, of which one is fluted, another decorated with *caitya*-arches, and another with reliefs[2].

Small, flat-roofed shrines consisting of a cella with almost plain walls, generally with a shallow verandah, and often surrounded by a pillared hall, and without any kind of *śikhara* are typical of the early Gupta period. The beautiful little shrine at Sāñcī, temple 17 (fig. 151), is a good example. Here the verandah pillars exhibit a typical development; the capitals are square and very massive, with addorsed animals now separated by a tree; this form is found also at Tigowā, Erān, Gaṛhwā, and Udayagiri. It is characteristic, too, that the line of the verandah architrave is carried round the wall of the otherwise plain cella as a string course[3].

At Tigowā, C. P., there is a flat-roofed Hindū shrine of identical design; the roof slabs are fitted together by overlapping grooves, as in the case of many of the flat-roofed temples at Aiholé. In the case of the Patainī Devī temple near Uchahara the roof consists of a single slab[4]. Other and simpler flat-roofed shrines are illustrated in the Goṇḍ temples of the Lalitpur District[5].

Two extremely interesting flat-roofed temples have been found at Bhumara[6] in Nagoḍh State and at Nāchnā-Kuṭharā[7] in Ajaigaṛh, Bundelkhaṇḍ. A description of the former will suffice for both. The Bhumara Śiva temple consists of a masonry cella (*garbha-gṛha*) with a flat slab-roof and a carved doorway having representations of river-goddesses on the jambs and a fine bust of Śiva, with flying figures, on the lintel. The cella contained a Śiva-liṅgam of the type of the still finer example existing at Khoh in the same State. Around the *garbha-gṛha* are the scattered remains of a larger chamber which surrounded it, providing a roofed *pradakṣiṇā patha*,

[1] Burgess, 2, vol. I, p. 126; Longhurst, 3, pl. XIII; A. S. I., Southern Circle, A. R., 1917—18; Diez, p. 29.

[2] Cousens, 4.

[3] Cunningham, 4, vol. X; Marshall, 5.

[4] Cunningham, 4, vol. IX.

[5] Mukerji.

[6] Baneryi, 3.

[7] A. S. I., Western Circle, 1919, pl. XV—XVII and pp. 53, 60.

and of a *maṇḍapam* attached to and preceding this enclosure. These remains consist of a great variety of columns which are not monolithic, of richly carved lintels that supported the roofing slabs, of *caitya*-window niches from the cornice, of parts of the doorway, and of carved slabs which decorated the lower part of the outer wall like a deep wainscot. Some of the *gaṇa* figures have *rākṣasa* faces on their bellies. There is a tendency to unrestrained development of arabesque[1].

The most interesting flat-roofed temple in the Dekkhan is the Lāḍ Khān at Aihoḷe (fig. 148). This temple, dating about 450 A. D. is very low and flat, its walls consisting of stone slabs set between heavy square pilasters with bracket capitals; roll-mouldings decorated with small well-spaced *caitya*-arches are characteristic of the roof. On the pillars of the porch are figures of the river-goddesses, which are most characteristic of Gupta work and persists into the mediaeval period, extending also to Java. On the roof is a small square cella of slab construction, with a porch, forming an independent shrine of the Sun. The walls have central projecting niches with reliefs. The windows are stone slabs, perforated in a variety of beautiful designs. Three other temples at Aihoḷe have either never possessed, or did not originally possess a *śikhara*, that of Kont Guḍi having been added as late as the tenth or eleventh century[2].

There are other low, massive, flat-roofed, cave-like temples, not unlike the Lāḍ Khān, but provided with simple Nāgara *śikharas* above the cella; these shrines, originally Vaiṣṇava, have been later converted to Śaiva usage, and it is just possible that their *śikharas*, together with that of the Durgā temple, are later additions. The best examples of this group are the Hucchīmallīguḍi (fig. 153), which is not at all unlike the well-known Paraśurāmeśvara temple at Bhuvaneśvara (fig. 216), but much more severe, and with only two courses between successive angle-*āmalakas*; and the temple in Field 270[3].

Of these pre- and early Cālukyan temples at Aihoḷe, some (Durgā, Lāḍ Khān, Hucchīmallīguḍi, and Meguti) have shrines detached from the back wall, as at Bhumara and Gop, providing for *pradakṣiṇā* with the roofed area; others (Kont Guḍi, etc. follow the mediaeval plan, in which the cella is connected with the back wall, so that *pradakṣiṇā* is only possible outside, in the open air. Where this

[1] For Bhumara, see Banerji, 3. The *rākṣasa* faces are found also in the Durgā temple, Aihoḷe, in Cave III at Aurangābād, and at Prambanam in Java. The motif seems to have originated in Gandhāra (Spooner, I, fig. 3).

[2] For the Lāḍ Khān and other Aihoḷe temples see Cousens, 4. The resemblance of the slab cella at Hanchei to the roof shrine of the Lāḍ Khān will be remarked in respect of the construction, with Bhumara as a very possible analogy for the surrounding building, which may have been of wood at Hanchei.

[3] Cousens, 4; Fergusson, 2.

plan is followed in a cave, of course, circumambulation is altogether precluded. Both in caves and structural temples the two plans appear side by side during several centuries; the older arrangement, for example, persists at Elephanta, but it is doubtful if any later instance could be cited.

The northern *śikhara*, as we have already seen in the case of several temples where it is an accessory rather than an essential, begins to appear in the late Gupta period. In more characteristic examples in the Ganges valley the *śikhara* and cella together form a tower, which may be provided with a porch, but forms the main part of the temple. These early towers are built up of elements similar in design to the cella itself, and with straight or nearly straight edges, and are thus nearer to the type of the Dieng Caṇḍi Bhīma (fig. 346) than to the fully developed curvilinear form under which the northern *śikhara* is most familiar. What may be regarded as a prototype of the early towers in which the reduplication of the main structure is still quite apparent, may be studied in a Kuṣāna railing pillar, J 24 in the Mathurā Museum (fig. 69)[1], and still better in the "Bodhgayā plaque" (fig. 62).

The Bhītārgāon brick temple is a good example of the kind of tower referred to. The plan is square, with doubly recessed corners, double cornices, and a recessed frieze of carved brick. Above the double cornice rises the pyramidal roof with tiers of *caitya*-niches in horizontal courses. The walls are decorated with terracotta panels of Brāhmaṇical subjects. The general effect is not far removed from that of the early towers in Campā[2].

Other brick and stone towers of similar character but more developed are found at Sona Tapan and Chinpur near Bāṅkurā, and several others at Manbhum and Dalmi, all in Bengal. In the case of the brick Kevaleśī shrine at Pūjārī Pālī, Bilāspur District, the tower is provided with angle-*āmalakas* on each storey[3].

The well-known Gupta Daśāvatāra temple at Deogaṛh, near Lalitpur, dating about 600, is of stone, with plain walls, except that on three sides there are recessed sculptured panels, representing the Gajendramokṣa episode, Viṣṇu-anantaśayin, and a scene betwen two ascetics, and on the fourth a sculptured entrance with river-goddesses on the door jambs. The basement was decorated with fine panels representing *Rāmāyaṇa* scenes, an almost unique instance of an arrangement quite common in Java. The tower was of several stories, with *caitya*-arches and angle-*āmalakas*[4].

[1] Vogel, 13, pl. III.
[2] Burgess, 8, pls. 303, 304; Cunningham, 4, vol. XI, pls. XIV—XVII; Vogel, 8.
[3] Some of these illustrated in Burgess, 8, pls. 288—290, 298, 300.
[4] Burgess, 8, pls. 248, 252; Mukherji.

The great Buddhist temple (fig. 210), known to archaeologists as the Mahābodhi, was most likely originally designated "Gandhakuṭi of the Vajrāsan"[1]; as it now stands it is a restoration (1880—1881) of the Burmese restorations of 1105 and 1298, and still earlier mediaeval renovations and restorations. It consists of a high straight-edged pyramidal tower of nine storeys, with an angle *āmalaka* at each stage, surmounted by a *htī* with a fluted, bulbous, *āmalaka*-like lower member; this tower in its lower part, over the entrance, has tall narrow lancet opening, admitting light to the sanctum, and a part of the construction clearly shown in photographs taken before the last restoration consists of true arches. There is a porch on the east side, later than the main part of the shrine; and the whole stands on a single high *pradakṣiṇā* terrace. On the western edge of this terrace the *Bodhi*-tree was still growing until its decay and fall in 1876.

This temple was certainly standing when Hsüan Tsang visited Bodhgayā in the seventh century; he describes it rather minutely and gives its dimensions practically as they now are, quoting the height exactly and the width approximately[2]. Fa Hsien states that there existed a temple at each of the four sites at which the Four Great Events of the Buddha's life had taken place; proving that some temple existed here in the fifth century. Other considerations make it probable that the present temple, substantially in its present form, but of course without the later porch, was erected in the second century A. D., at any rate not later than the very beginning of the Gupta period. These reasons include (1) the presence of a coin of Huviṣka amongst the relics deposited at the foot of the interior Vajrāsan (2) a coping inscription in Kuṣāna or very early Gupta characters, referring to the "Great Gandhakuṭi temple (*pāsāda*) of the Vajrāsana" (3) a Kuṣāna inscription on the edge of the outer Vajrāsana placed against the back wall of the basement, on the ground level. Further, the "Bodhgayā plaque" (fig. 62) found at the Kumrāhār site, Patna (Pāṭaliputra), and the Kuṣāna relief reproduced in fig. 69 both show that temples of this kind might very well have been built as early as the second century A. D. In all probability then the new temple was built to enshrine a Buddha image, at the time when images were coming into general use; it was built, of course, as Hsüan Tsang expressly states that it was built, on the original site, following the usual rule in such cases. The building of a roofed temple, however, involved the removal of the Bodhi-druma to its modern position on the edge of the terrace at the back of the temple; there could have been no objection to this, so long as

[1] The words Vajrāsana "adamantine seat" and Bodhi-maṇda "place of enlightenment" are both used by Hsüan Tsang to designate the seat occupied by the Bodhisattva on the occasion of the Great Enlightenment (Mahāsambodhi). The term Gandhakuṭi used to designate a Buddhist temple is derived from the name of a cell occupied by the Buddha in his lifetime. For descriptions of the temple, see Cunningham, 3, and Bloch, 2; the former seems the better account.

[2] Beal, 1, vol. II, p. 118.

the Bodhi-maṇḍa was kept in its original place, where, indeed, Hsüan Tsang saw it. And in fact, Cunningham discovered behind the mediaeval grey sandstone Vajrāsana in the cella, another plastered throne, and behind this a polished sandstone slab resting on four pilasters exactly as represented in the Bhārhut relief (fig. 41) and undoubtedly of Aśokan age.

The one other Vajrāsana referred to above as the "outer Vajrāsana", found by Cunningham when the late mediaeval buttress of the back wall was removed, is large and beautifully decorated[1], on its upper surface with a simple geometrical design of circles and squares, on its sides with *haṁsas* and palmettes like those of some of the Aśokan capitals.

The famous centre of Buddhist learning at Nālandā, South Bihār, was founded by Narasiṁha Balāditya (467—473). Hsüan Tsang describes the great brick temple over three hundred feet in height, erected by this king, as resembling the tower at Bodhgayā, and says that it was exquisitely decorated and magnificently furnished. Nothing survives but the massive basement[2]; some of the niches on this basement representing fully developed curvilinear Nāgara *śikharas* may be later additions. Nothing at Nālandā, the most famous of mediaeval monasteries and centres of learning, antedates the fifth century, or postdates the twelfth.

The temple at Gop in Kāṭhiāwāḍ (fig. 191) is more or less unique, but evidently connected in some way with the Kāśmīrī school of architecture. The square tower which is now its conspicuous feature was once surrounded by a flat-roofed hall providing for *pradakṣiṇā* under cover, concealing half its height; it is surmounted by a double pent-roof of the Kāśmīrī type, and decorated with large *caitya*-niches containing figures of deities. The basement of the outer structure, decorated with a *gaṇa* frieze, still remains. The shrine is Brāhmaṇical, and dates about the end of the sixth century, and is thus early mediaeval rather than Gupta properly so-called[3].

The hollow circular building at Rājagṛha, known as the Maṇiyār Maṭha is quite unique; traditionally known as a treasury, it is just possible that it represents a colossal *liṅgam* like those at Faṭehpur, near Bārāmūla, Kaśmīr, and Tiruparakuṇram near Madras. All that remains is the circular basement, with a small portion of the superstructure. All round the base are niches, separated by pilasters, and containing stucco images of fine and sensitive workmanship representing a *liṅgam*, Bāṇāsura, a six-armed dancing Śiva, and many Nāgas and Nāginīs (fig. 176). A date between 250 and 500 A. D. has been suggested, the fifth century seeming most likely[4].

[1] Cunningham, 3, pl. XIII. It must be of early Śuṅga, if not Maurya date.
[2] Burgess, 8, pls. 227, 228.
[3] Burgess, 2, and 8, pl. 266.
[4] Marshall, 1.

We have already had occasion to refer to Nāgara and Drāviḍa *śikharas*. Both are towers rising above the *garbha-grha* of a temple, the chief difference being that the Nāgara type comes to have a curvilinear form and forms a real spire, while the Drāviḍa type retains its original terraced formation, with ranges of cells at each level. Much discussion has been devoted to the question of the origin of the Nāgara curvilinear spire, which has variously been derived from the *stūpa*, the simple domed cell, and the bamboo processional car[1]. For the most part these theories represent deductions drawn from appearances presented by the fully developed form, not taking into account what may be called the primitives of the type. The original view propounded by Fergusson[2] I believe to be the correct one. This is that the Nāgara spire, however elaborately developed, really represents a piling up of many superimposed storeys or roofs, much compressed. The key to this origin is the *āmalaka*; properly the crowning element of a tower, its appearance at the angles of successive courses shows that each of these corresponds in nature to a roof. Thus the Nāgara and Drāviḍa towers both originate in the same way, but in the case of the former the storeys are so compressed and multiplied that at last the vertical effect completely dominates that of its horizontal components, while in the latter the storeyed principle and horizontal lines are never lost sight of. In the later northern towers, indeed, the suppression of the horizontal elements in many late examples is carried so far as to produce a smooth-surfaced pyramid with continuous outlines unbroken by any angle-*āmalaka*. It may be remarked that the northern tower developes convex curves, while in the southern *gopuras* the ultimate outlines are concave.

In both cases the aspiring aspect of the mediaeval towers contrasts most markedly with the static character of the early low flat-roofed temples. Just in the same way in Burma and Siam the *stūpa*, originally a hemispherical dome with one umbrella and clearly differentiated division of parts, develops into soaring types like those of the Shwe Dagon at Rangoon, with a continuous convex curve from base to pinnacle. The change from horizontal and domed to vertical and pointed forms is the most conspicuous tendency represented in Indian architecture, and must reflect an emotional qualification taking place in religious psychology not unlike that which distinguishes Gothic from Romanesque. A parallel tendency in India in narrative art has been traced by Foucher, contrasting the reserve of the earlier *Jātaka* scenes with the emotional emphasis already so marked at Ajaṇṭā[3]. The same development can be followed in the literature, and no doubt, if we knew enough about it, could be recognized in music and dancing.

[1] The theories are summarised in Chanda, 2, with references.
[2] Fergusson, 2, vol. II, p. 119. This view is shared by M. Parmentier (6).
[3] Foucher, 4.

Indian palace architecture, with rare exceptions, mainly in Rājputāna of late date, has always been one of wooden construction, and for this reason no very ancient examples have survived. But palace architecture is very well illustrated in the sculptures of Amarāvatī and in the paintings of Ajaṇṭā, and from these it is evident that a palace consisted essentially of connected groups of one or two-storeyed pillared halls with flat or pointed roofs, the wooden pillars and capitals, cornices, &c., being elaborately decorated with painting and carving. It is in fact just this kind of palace architecture that survives in Burma (Mandalay), Siam (Bangkok), Cambodia (Phnoṁ Peñ), Java (Yogyakarta and Surakarta) and in Japan (Kyoto); from these sources a very fair idea of the planning and appearance of much older Indian palaces can be gathered[1].

The classical palace was always provided with a picture gallery (*citra-śāla*) and a concert-hall or theatre (*saṁgītā-śāla*, or *nāṭya-maṇḍapa*)[2]. The former, of course, was a hall specially decorated with frescoes, such as we find it described in the *Uttara-Rāma Carita*. The latter was an open pillared hall, with a stage raised some-what above the level of the ground, and visible to the spectators from three sides, the "head of the stage" on the fourth side being a decorated partition shutting off the green-room. There was no curtain separating the stage from the audience, but two curtained doors led from the green-room to the stage, just as in a modern Chinese theatre, and it is with reference to these doors that we have the common stage direction "Enter with a toss of the curtain". Another constructional feature that survives in Far East is the low railing that runs round the edge of the stage platform. The outer walls were solidly built of brick, and "like a mountain cave" i. e. an excavated *vihāra*, without angles or projection, to the end that the voices of the performers and the low notes of the *kutapa* might be adequately heard.

The general characteristics of Gupta sculpture have already been referred to. In the following paragraphs some of the more important examples are listed.

(1) Buddhas at Mathurā or of Mathurā origin include a magnificent standing Buddha from the Jamālpur (Jail) mound (fig. 158), A 5 in the Mathurā Museum, and a similar figure in the Indian Museum, Calcutta, both of the fifth century[3]; another with webbed fingers, from the Katrā mound, B 10 in the Lucknow Museum, dated equivalent to 549/50 A. D.[4]; colossal reclining Buddha of the Pari-nirvāṇa shrine at Kasiā (Kuśinagara), with fifth century inscription mentioning the donor, the Abbot Haribala and the sculptor, Dinna of Mathurā[5]; seated Buddha

[1] For palaces in Burma, see Ko, 3; in Cambodia, Groslier, 3.
[2] Bharata, *Nāṭya-śāstra*, Ch. 2 (ed. Grosset, Paris, 1898). Cf. *Mahāvaṁsa*, Ch. LXXIII, v. 82.
[3] Vogel, 13, p. 49, and pl. IX; Smith, 2, fig. 117; A. S. I., A. R., 1922—23, pl. XXXIX.
[4] A. S. I., A. R., 1911—12, p. 132.
[5] Vogel, 5; Cunningham, 4, vol. XVIII, p. 55, and vol. XXII, p. 16.

with shaven head (the only Gupta example) and webbed fingers (fig. 162), from Māṅkuwār near Allahābād dated equivalent to 448/49 A. D.[1]; seated inscribed Buddha from Bodhgayā, dated equivalent to 383 A. D.[2]; seated Buddha at Sāñcī[3]. The two colossal Nāgas, in Mathurā stone, at Sāñcī may also be mentioned[4].

(2) Other Buddhist sculptures in stone include the wellknown seated Buddha from Sārnāth (fig. 161)[5]; other Sārnāth Buddhas and Bodhisattvas[6]; the Sārnāth lintel, with representations of Jambhala and *Jātaka* scenes[7]; Buddha figures in relief at Ajaṇṭā, cave XIX and Nāgarāja group at the same site[8]; Buddha figures of the façades at Kārlī, Kaṇheri, &c.[9]; Avalokiteśvara litany groups at Kaṇheri fig. 164), Ajaṇṭā Cave IV[10], and Auraṅgābād; Bodhisattva torso from Sāñcī in the Victoria and Albert Museum, London, early Gupta or perhaps late Kuṣāna[11].

(3) Buddhist sculpture in metal: the most remarkable figure is the colossal (copper) image (fig. 160) from Sulṭāngañj, Bhagalpur District, Bengal, now in the Museum and Art Gallery, Birmingham, date ca. 400 A. D.[12]. Other important examples include the richly decorated, copper and silver inlaid, brass figure (fig. 163) from Fatehpur, Kāṅgrā[13]; the Boston bronze Buddha, said to have been found in Burma (fig. 159)[14]; the rather clumsy statuettes from the Bāndā District, Bengal[15]; and the fragments from Bezwāḍā[16]; small gold Buddha in the British Museum[17].

(4) Brāhmaṇical, &c.: colossal Varāha Avatār relief at Udayagiri, Bhopāl, about 400 A. D. (fig. 174)[18]; Paurāṇik and epic panels of the Gupta temple, Deogaṛh,

[1] Smith, 2, p. 173 and fig. 119; Bloch in J. A. S. B., LXVI, p. I, p. 283.

[2] Cunningham, 3, pl. XXV; A. S. I., A. R., 1922—23, pl. XXXVIII a, and p. 169.

[3] Marshall, 4, 5 and 10 (pls. 1, 2).

[4] Marshall, 10.

[5] Sahni and Vogel, pl. X; Smith, 2, pl. XXXVIII; A. S. I., A. R., 1904—05, p. 81.

[6] Sahni and Vogel, pl. XIII b, XX, etc.; Marshall and Konow; Vogel, 2; Hargreaves, 2, pl. LXIII.

[7] Sahni and Vogel, pls. XXV—XXIX; Marshall and Konow.

[8] Burgess, 8, pl. 200; Coomaraswamy, 7, pl. 72.

[9] Burgess, 8, pls. 168, 212.

[10] Burgess, 8, pl. 185.

[11] Cunningham, 4, vol. X, pl. XXI; India Society, 1; Smith, 2, p.64 (misdated).

[12] Smith, 2, p. 171 and fig. 118; Rūpam, no. 21. A magnificent figure, seven and a half feet high and weighing over a ton.

[13] Vogel, 4. The *ajourée* pedestal is closely related to one found at Suvarṇapura in Siam, J. S. S., vol. XIX, pl. XV.

[14] Coomaraswamy, 9, 2, p. 61 and pl. XXI.

[15] Smith and Hoey.

[16] Sewell, R., 2. Some perhaps later: inscriptions of tenth (?) century.

[17] Smith, 2, pl. LXXIV.

[18] Cunningham, 4, vol. x, pl. XVIII; Coomaraswamy, 7, pl.99; Burgess, 8, pls. 216, 217.

early Gupta (fig. 167)[1]; Umā-Maheśvara group from Kosām (Kauśāmbī) near Allahābād, dated equivalent to 458/59 A. D., now in the Indian Museum, Calcutta[2]; Nativity of Mahāvīra or Kṛṣṇa from Paṭhārī, in the Museum at Gwāliar (fig. 178)[3]; slab with flying Gandharvas and Apsaras from Sondani, in the Gwāliar Museum (fig. 173); pillars from Chandimau with scenes from the Kīratārjuniya of the *Mahābhārata*, in the Lucknow Museum[4]; river goddess from Besnagar, in the Boston Museum (fig. 177)[5]; *toraṇa* pillars at Maṇḍor, Jodhpur State, with Kṛṣṇa Līlā scenes (fig. 166)[6]; pillars and architrave from Gaṛhwā, in the Lucknow Museum[7]; Narasiṁha from Besnagar, in the Gwāliar Museum (fig. 170); stucco reliefs of the Maṇiyār Maṭha, Rājagṛha (fig. 176)[8]; Kārttikeya belonging to the Bhārata Kalā Pariṣad, Benares (fig. 175)[9]; the Bhumara and Khoh *liṅgams* and Gaṇeśa[10]; sculptures of the Bādāmī caves and early temples at Aihoḷe[11]; sculptures of the Rāmeśvara cave, Elūrā, especially the verandah pillars (fig. 190); small bronze of Brahmā (fig. 168) from Mīrpur K͟hās, in the Karāchi Museum; upper part of a bronze Śiva in the Victoria and Albert Museum, London; bronze-coated iron plummet from the River Surma, Bengal, in the British Museum (fig. 169)[12]: sacrificial pillars (*yūpa*) of Viṣṇuvardhana at Bijayagaṛh, 371 A. D.[13]

A colossal Hanuman from Pārkham, D 27 in the Mathurā Museum appears from the style and fine modelling of the torso to be of Gupta age[14]. Four colossal images and groups at Rūp Bās, Bharatpur State include an image of Baladeva with cobra hoods, over twenty seven feet in height, his wife Ṭhākur Rānī, a

[1] Burgess, 8, pls. 250—252; Smith, 2, pls. XXIV, XXV.

[2] Fleet, *Gupta inscriptions*, p. 256; Banerji, 4, pl. LXX b.

[3] Smith, 2, pl. XXVI. Probably rather later in date.

[4] Banerji, 2.

[5] Smith, 2, fig. 112; Vogel, 18.

[6] Bhandarkar, 2; Marshall and Sahni.

[7] Smith, 2, figs. 114, 115; Burgess, 8, pls. 242, 243; Cunningham, 4, vol. X, pls. VI, VII. For another lintel with *Mahābhārata* scenes see Banerji, 1, pl. LIV. For *toraṇa* pillars like those of Gaṛhwā, found at Bilsaṛ, Cunningham, 4, vol. XI, pl. 13 and pls. VI, VII.

[8] Smith, 2, fig. 113; Marshall, 1.

[9] Rūpam, no. 21, 1925, p. 41.

[10] Banerji, 3. Another fine *mukha-liṅgam* at Ataria Khera, Nagoḍh State.

[11] Burgess, 8, pls. 267—274; Cousens, 4 (the four massive roof slabs, of which three are from the temple in Field 270, Aihoḷe, reproduced in Cousens, 4, pl. LXXVI, and dating about 600 are in the Prince of Wales Museum, Bombay; the fine roof slab (fig. 165) of Cousens, 4, fig. 6, may be still *in situ*.

[12] Coomaraswamy, 4, fig. 100. In the same volume, p. 77, there is reproduced a rubbing of a handsome Gupta seal in copper; the text should be understood as "Seal of the Warden of the Frontier of Śrīvadra".

[13] A. S. I., A. R., 1902—03, p. 207.

[14] Vogel, 13, p. 100. An earlier example is illustrated in A. S. I., A. R., 1923—24, pl. XXXV, K.

Nārāyaṇa with Lakṣmī over nine feet in height, and a group supposed to represent Nārāyaṇa standing on the head of Yudhṣthira, who is surrounded by the Five Pāṇḍavas. No information is available as to the style or date of these evidently important sculptures[1].

(5) Terracottas, mostly Brāhmaṇical: panels of Brāhmaṇical subjects, decorating the brick temple at Bhītārgāon[2]; *Rāmāyaṇa* subjects, Saheṭh-Maheṭh (Srāvastī[3]); large image of Hāritī, and Buddha figures, at Kasiā (Kuśinagara)[4]; Mīrpur Khās, Buddhas and donor[5]; seals and small terracottas from Basāṛh (Vaiśālī)[6]; seals and small terracottas from Bhīṭā[7]; figures from Kurukṣetra, Delhi[8]; Bikanīr (more likely late Kuṣāna)[9]; carved and moulded bricks at Bilsaṛ[10].

Indian literature of all kinds and at all periods, at any rate after the Maurya, makes incidental references to painting. It may be taken for granted that from a very early period, not only were sculptures and architectural details covered with thin plaster and coloured, but that the flat walls of temples and palaces were decorated within and without with pictures or with painted "wreaths and creepers". In the Epics we often hear of painted halls or chambers (*citra-śāla*) in palaces. A whole scene of Bhavabhūti's *Uttara-Rāma-Carita*, dating from the close of the Gupta period, is laid in such a gallery, where Rāma and Sītā are represented as viewing newly executed paintings of scenes from their own life, which awaken in Sītā a longing to revisit the forests, creating in her a "latent impression" (*bhāvana*)[11]. The *Viṣṇudharmottaram* distinguishes the kinds of painting appropriate to temples, palaces and private houses; and applies the theory of *rasa* to painting. Paintings are there classified as *satya*, *vainika*, *nāgara* and *miśra*, which I am inclined to render as true, lyrical, secular and mixed, mainly with reference to their themes[12]. The same text devotes considerable space to the question of foreshortening as applied to the features and limbs; and lays great stress on adherence to canonical proportions. The necessity of giving expression to the move-

[1] Cunningham, 4, vol. VI, p. 21, gives only a list of the images and their dimensions.

[2] Vogel, 8; Cunningham, 4, vol. XI, pls. XIV—XVII.

[3] Vogel, 7.

[4] Sastri, 1; Vogel, 5. In the Lucknow Museum.

[5] Cousens, 5.

[6] Bloch, 1.

[7] Marshall, 3.

[8] Cunningham, 4, vol. XIV, pl. XXVII.

[9] A. S. I., A. R., 1917—18, pt. 1, pl. XIII; and see page 69.

[10] Cunningham, 4, vol. XI.

[11] Belvalkar, p. 26 (= Act 1, v. 39). For painting representing events in the life of a still living king, cf. *Mahāvaṁsa*, Ch. LXXIII, v. 83.

[12] *Satya* seems to mean here "true to life, realistic", perhaps with reference to portraiture. *Vainika* suggests pictures of musical modes (cf. p. 129, note 1). *Nāgara* perhaps = erotic; *nāgarika* (see p. 88) might be translated "man about town".

ment of life (*cetanā*) is emphasized; he understands painting who can represent the dead without life movement, the sleeping possessed of it. Finally it is said, with good reason inasmuch as both are occupied with the exact expression of emotion, that without a knowledge of dancing (*nrtya-śāstra*) it is hardly possible to understand the true skill of painting[1].

Painting appears in all lists of the sixty-four *kalās*, the fine arts or accomplishments[2]. Portrait painting, usually from memory, and on wooden panels, is a device constantly employed in classical Sanskrit plays[3]. The *Kāmasūtra* of Vātsyāyana, a work essentially of the Gupta period, mentions the drawing panel, paints and brushes as parts of the ordinary furniture of a gentleman's (*nāgarika*) chamber and taken in its context this throws some light on the meaning of the term *nāgara* as used to define a kind of painting. It is quite evident that, in the Gupta period at least, painting was not exclusively an ecclesiastical, but also a secular art, practised by amateurs as well as by professional members of gilds; it was a social acomplishment, at least among princes and ladies of the court, and in the "fast set"[4].

Yaśodhara's commentary on the *Kāmasūtra* refers to the *Sadaṅga*, the Six Limbs or Canons of Painting, viz. *Rūpa-bheda, Pramāṇam, Bhāva, Lāvaṇya-yojanam, Sādṛsya, and Varṇika-bhaṅga.* It is impossible to accept Tagore's subjective interpretation of these terms[5]; they can be far better understood in a purely practical sense as Distinction of Types, Ideal Proportion, Expression of Mood (with reference to the theory of *rasa*), Embodiment of Charm, Points of View (with reference to stance, *sthānam*) and Preparation of Colours (grinding, levigation, &c.). Thus understood, moreover, these subdivisions of the art are just those which the technical treatises, *Viṣṇudharmottaram* and *Śilparatnam* treat of at greater length, and they might be inserted in such works as paragraph headings. There cannot be traced here any parallel to the Chinese Six Canons of Hsieh Ho; a likeness to Chinese ideas can be much more probably recognized in connection with what is said about *cetanā*, the movement of life, in the *Viṣṇudharmottaram*[6].

[1] *Vinatu nrtyaśāstreṇa citrasūtram sudurvidam, Viṣṇudharmottaram,* III, II, 3. The *Viṣṇudharmottaram* (see translation, Kramrisch) is a mediaeval composition apparently embodying older, and probably Gupta materials. A later mediaeval text by Śrī Kumāra, the *Śilparatna,* Ch. 64, deals in a similar fashion with painting; translated by Coomaraswamy, 13. Keyserling has remarked of Indian dancing and religious images the "identity of the spirit in both appearances".

[2] Venkatasubbhiah; Schmidt, 2, p. 45.

[3] Saunders.

[4] Schmidt, 2, p. 61.

[5] Tagore, 2.

[6] For a valuable discussion of *pramāna*, see Masson-Oursel.

A special kind of painting depicted the reward of good and evil deeds in the other world, and was executed on scrolls called *Yamāpaṭa* which were exhibited with accompanying explanatory monologue. This format and presentation survive in the Javanese *Wayang Beber*.[1]

Painting of the Gupta period is preserved in two of the Ajaṇṭā *vihāras* and in one *caitya*-hall as follows:[2]

Cave XVI, ca. 500 A. D.: A Buddha triad, the Sleeping Women, the Dying Princess. The Boston Museum fragment is also from this *vihāra*.

Cave XVII, ca. 500 A. D.: Wheel of Causation, Seven Buddhas, "Ceylon Battle", Return to Kapilavstu, Abhiṣekha scenes, love scene (fig. 179), Gandharvas and Apsarases (fig. 180), and the Mahāhaṃsa, Mātṛposaka, Ruru, Saddanta, Śibi (gift of eyes with inscription), Viśvantara (fig. 182), and Nālagiri *Jātakas*.

Cave XIX, *caitya*-hall, ca. 550 A. D.: numerous Buddhas, and another Return to Kapilavastu.

Another group of Buddhist wall-paintings, fewer in number and on the whole less well preserved is found in the excavated *vihāras* at Bāgh, about 375 kilometres north of Ajaṇṭā, and especially in Cave IV. (fig. 183)[3].

Jaina paintings of similar character, and of great interest, have lately been discovered by M. Jouveau-Dubreuil at Sittanavāsal, Pudukoṭṭai State, near Tanjore, and assigned by him to the seventh century[4].

The technique of the painting at Ajaṇṭā, and of Indian wall-painting generally is as follows: the surface of the hard porous rock was spread over with a layer of clay, cowdung and powdered rock, sometimes mixed with rice-husks, to a thickness of from three to twenty millimetres. Over this was laid a thin coat of fine white lime-plaster which was kept moist while the colours were applied, and afterwards lightly burnished. It should be observed that practically all sculptures and sculptured surfaces were covered in the same way with a thin plaster slip and coloured. The underdrawing is in red on the white plaster surface, then comes a thinnish terraverde monochrome showing some of the red through it, then the local colour, followed by a renewed outline in brown or black, with some shading, the latter employed rather to give some impression of roundness or relief, than to indicate any effect of light and shade. The bold freedom of the brush strokes seems to show that all the work was freehand, or if any use was made of stencils,

[1] *Mudrā-rākṣasa* of Viśākhadatta, act. 1; Groenevelt. See also page 211.

[2] Most of the Ajaṇṭā paintings have been published from photographs or copies: see Burgess, 4; Griffiths; India Society, 1; Goloubew, 1; Coomaraswamy, 10, pl. 15; Dey (the frontispiece, representing the Return to Kapilavastu a monumental composition, should be specially noted); Kokka Magazine Nos. 342, 345, 374. For the earlier and later paintings see pages 39, 98.

[3] Dey; Haldar; Luard; Burgess, 4.

[4] Jouveau-Dubreuil, 3.

freely redrawn. It is difficult to understand how the work can have been done in such dimly lighted halls[1].

The best general description of the paintings has been given by Lady Herringham[2]: "The outline is in its final state firm, but modulated and realistic, and not often like the calligraphic sweeping curves of the Chinese and Japanese. The drawing is, on the whole, like mediaeval Italian drawing... The artists had a complete command of posture. Their knowledge of the types and positions, gestures and beauties of hands is amazing. Many racial types are rendered; the features are often elaborately studied and of high breeding, and one might call it stylistic breeding. In some pictures considerable impetus of movement of different kinds is well suggested. Some of the schemes of colour composition are most remarkable and interesting, and there is great variety. There is no other really fine portrayal of a dark race by themselves... The quality of the painting varies from sublime to grotesque, from tender and graceful to quite rough and coarse. But most of it has a kind of emphatic, passionate force, a marked technical skill very difficult to suggest in copies done in a slighter medium"[3]. Mr. Dey writes: "It is impossible for anyone who has not seen them with his own eyes to realise how great and *solid* the paintings in the caves are; how wonderful in their simplicity and religious fervor"[4].

It would be an error, however, to regard this appearance of "simplicity and religious fervor" as in any sense primitive or naive; a more conscious, or, indeed, more sophisticated art could scarcely be imagined. Despite its invariably religious subject matter, this is an art "of great courts charming the mind by their noble routine"[5]; adorned with *alaṁkāras* and well acquainted with *bhāva-bheda*. The familiarity with gesture is a matter of scholarship, rather than of happy inspiration; and this illustrates what the author of the *Viṣṇudharmottaram* has to say on the relationship of dancing (acting) and painting.

The specifically religious element is no longer insistent, no longer antisocial; it is manifested in life, and in an art that reveals life not in a mode opposition to spirituality, but as an intricate ritual fitted to the consummation of every perfect experience. The Bodhisattva is born by divine right as a prince in a world luxu-

[1] For the technique generally see A. S. I., A. R., 1916—17, pt. I; India Society, 2; Dey, p. 237; and cf. Coomaraswamy, 12, 13.

[2] India Society, 2.

[3] India Society, 2, p. 18.

[4] Dey, p. 51.

[5] Bāṇa, *Harṣa-carita*, transl. Cowell and Thomas, 1897, p. 33. The *Harṣa-carita, Kādambarī,* and the works of Kālidāsa and other classic Sanskrit dramatists, and the later Ajaṇṭā paintings all reflect the same phase of luxurious aristocratic culture. In many matters of detail the painting and literature supply a mutual commentary.

riously refined. The sorrow of transience no longer poisons life itself; life has become an art, in which mortality inheres only as *karuṇā-rasa* in a poem whose *sthayi-bhāva* is *śṛṇgāra*. The ultimate meaning of life is not forgotten, witness the great Bodhisattva[1], and the Return to Kapilavastu[2]; but a culmination and a perfection have been attained in which the inner and outer life are indivisible; it is this psycho-physical identity that determines the universal quality of Gupta painting. All this is apparent, not in the themes of the pictures, which are no other than they had been for at least five centuries preceding Ajaṇṭā, and no other than they have remained to this day wherever specifically Buddhist art has survived, but intrinsically in the painting itself. Nor is there any stronger evidence of the profundity of recognition characteristic of this golden age, than that afforded by its extensions in south-eastern Asia and the Far East; the Stoclet Bodhisattva from Funan is fully the equal of any painting at Ajaṇṭā. Far-Eastern races have developed independently elements of culture no less important than those of India; but almost all that belongs to the common spiritual consciousness of Asia, the ambient in which its diversities are reconcilable, is of Indian origin in the Gupta period.

[1] Figure 181.
[2] Dey, Frontispiece.

PART IV:

EARLY MEDIAEVAL, MEDIAEVAL, RĀJPUT PAINTING AND LATER ARTS AND CRAFTS

EARLY MEDIAEVAL:

HARṢA OF KANAUJ; EARLY CĀLUKYAS; RĀṢṬRAKŪṬAS; AND PALLAVAS

Largely as a result of the Hun invasions of the fifth century the empire of the Guptas become reduced; the Huns, however, were definitely repulsed in 528 and a Later Gupta dynasty survived in Magadha, 535—720. Meanwhile in the first half of the seventh century, Harṣavardhana of Thānesar (= Sthānviśvara) and Kanauj (606—647), revived the glories of the Gupta empire, ruling over the greater part of northern India down to the Narmadā, the boundary of the Cālukya dominion of his great contemporary and enemy, Pulakeśin II (608—642). From the standpoint of art history these two reigns have generally been included in the Gupta period, a position justified by the fact of the actual persistence of Gupta culture. The three deities of Harṣa's family were Śiva, the Sun, and Buddha; he erected costly temples for the service of each. In later years he more particularly followed Mahāyāna Buddhism.

The famous monasteries and Buddhist university of Nālandā were at the zenith of their glory in the seventh century. Hsüan Tsang describes their magnificence:

"The whole establishment is surrounded by a brick wall. One gate opens into the great college, from which are separated eight other halls standing in the middle. The richly adorned towers, and the fairy-like turrets, like pointed hilltops, are congregated together. The observatories seem to be lost in the vapours of the morning, and the upper rooms tower above the clouds. From the windows one may see how the winds and the clouds produce new forms, and above the soaring eaves the conjunctions of the sun and moon may be observed. And then we may add how the deep, translucent ponds bear on their surface the blue lotus, intermingled with the Kie-ni (*kanaka*) flower, of deep red colour, and at intervals the Mangroves spread over all their shade.

All the outside courts, in which are the priests' chambers are of four stages. The stages have dragon- (*makara*) projections and coloured eaves, the pearl-red pillars, carved and ornamented, the richly adorned balustrades, and the roofs covered with tiles that reflect the light in a thousand shades, these things add to the beauty of the scene"[1].

Iching gives another, less picturesque, but hardly more explicit description. Most of the monasteries thus described may have been of late Gupta date. Hsüan Tsang, however, also describes a magnificent copper image of Buddha, eighty feet in height, enshrined in a temple of six storeys, as having been set up by Pūrṇavarman, early in the seventh century, and a great and much revered image of Tārā close by. The super-colossal bronzes of Nara must have been made in imitation of some such figures as Pūrṇavarman's Buddha.

Very probably the two elegantly decorated reliefs, with *kinnaras* and lotuses, which form the facing slabs of a low *cābutra* at the lowest level of Site I at Nālandā date from the early seventh century[2]. Site II is represented only by another plinth, but this is decorated with 211 sculptured panels of sixth or seventh century date; these panels represent gods, animals, mythical creatures, and geometric ornament[3].

Kings of the Valabhī dynasty had long been reigning in Surāṣṭra (Kāṭhiāwāḍ), Sind and Gujarāt. Harṣa made himself master of Valabhī in 635, and in Hsüan Tsang's time it was ruled by his son-in-law. Hsüan Tsang describes Valabhī and Western Mālwā as centres of Buddhist learning comparable in importance with Nālandā. The city was overthrown by the Arabs in 770, and from that time Anhilavāḍ-Pāṭan (Gujarāt) became the leading city of Western India until in the fifteenth century, it was succeeded by Aḥmadābād.

No sharp line of division can be drawn between late Gupta art and that of the early seventh century. The brick temple of Lakṣmaṇa at Sīrpur (fig. 186), Rāipur District[4], however, one of the most beautiful in all India, may perhaps be assigned to the reign of Harṣa; the temple is unsurpassed in the richness and refinement of its ornament, and it is fairly well preserved. The cella is decorated with false windows (very like those of the Bayang tower in Cambodia) and *caitya*-

[1] Beal, 2, p. III. The Śaiva king Śaśāṅka of Central Bengal had destroyed the Bodhi tree at Bodhgayā and persecuted the Buddhists and broken up monasteries throughout Bihār (an example of intolerance almost unique in India), about 600. The condition of Nālandā as described by Hsüan Tsang must have been due in the main to the benefactions of Pūrṇavarman and other local rājas of Magadha, and perhaps in part to Harṣa himself.

[2] A. S. I., A. R., 1921—22, pl. VII.

[3] A. S. I., A. R., 1915—16, p. 12, and A. S. I., A. R., 1915—16, Eastern Circle, p. 36ff.

[4] Longhurst, 1. This temple has more recently been assigned to the ninth century in A. S. I., A. R., 1923,—24 p. 28.

window niches enclosing architectural reliefs. The roof, of which the summit is lost, consisted of several stories, of which the lowest very exactly repeats the lines of the cella below, without curvature, while those above carry large centrally placed *caitya*-window arches in addition to smaller niches of the same type. There seems to have been an angle *āmalaka* above each story, and no doubt a larger *āmalaka* crowned the summit. The general effect is not unlike that of Caṇḍi Bīma, but much richer. The whole was originally covered with stucco, which may have been coloured. The triangular window above the entrance is characteristic of many other late Gupta or early Mediaeval temples, including that of Bodhgayā. The lintel of the stone doorway bears a representation of the Birth of Brahmā.

Certainly falling in the reign of Harṣavardhana is the octagonal Muṇḍeśvarī temple, near Bhabua in the Shāhābād District[1].

The existing remains of an apsidal *caitya*-hall (fig. 149), temple 18 at Sāñcī, date from the seventh century, and may well fall within the reign of Harṣa. Most of the monolithic columns of the nave, seventeen feet in height, with their architraves, are still standing. The roof was originally of wood, and covered with tiles. The apse itself was enclosed by a solid wall, broken only by windows. These remains stand on the site of three older floors and foundations, of which the lowest dates back to the Maurya period, while the uppermost is Gupta — illustrating the very common case in which an existing stone temple occupies the site of earlier wooden structures of the same type. Sixth and seventh century sculpture is represented at Sāñcī by detached images "infused with the same spirit of calm contemplation, of almost divine peace, as the images of the fourth and fifth centuries, but they have lost the beauty of definition which the earlier artists strove to preserve, and, though still graceful and elegant, tend to become stereotyped and artificial"[2].

EARLY CĀLUKYA

It would be less logical to include the early Cālukyan and Pallava temples in a "Late Gupta" classification, inasmuch as these represent a relatively independent development mainly of southern traditions. Of pre-Cālukyan times, in which were built the fifth-sixth century temples of Aihoḷe, already referred to, very little is known. The following are the leading events of Early Cālukyan history:

Pulakeśin I (550—566), of Rājput origin, founded the dynasty, with a capital at Bādāmī, within a few miles of Aihoḷe and Paṭṭakadal. Pulakeśin II (608—642) had another capital at Nāsik. In 611 he conquered the old Āndhra and now Pal-

[1] A. S. I., A. R., 1902—03, p. 42; 1923—24, p. 25.
[2] Marshall, 4 and 5, p. 22.

lava country of Vengī between the Godāvarī and Kistna, and here his brother founded the Eastern Cāḷukya dynasty in 615. In 620 he repulsed Harṣa. In 642 he was defeated and presumably slain by the Pallava king Narasiṁhavarman I at Bādāmī. Vikramāditya I (655—680) captured the Pallava capital Kāñcīpuram, an exploit repeated by Vikramāditya II (733—746) in 740. In 753 the dynasty was overwhelmed by the Rāṣṭrakūṭas.

Early Cāḷukyan structural architecture is represented by the old brick temples of Uttareśvara and Kāleśvara at Ter[1], and more fully by the many shrines of Aiholẹ, Paṭṭakadal and Bādāmī. Of the temples at Aiholẹ, those which can be dated before 600 have already been referred to; of others, the unfinished Jaina Meguti temple with the shrine isolated from the outer wall, dated 634, seems to be the earliest. Of nearly the same date (ca. 625) is the small, exquisitely proportioned and magnificently situated Mālegitti Śivālaya at Bādāmī (fig. 187)[2].

The most important of the temples at Paṭṭakadal date from the first half of the eighth century and show the strongest possible evidences of Pallava influence. The great Virūpākṣa temple (fig. 188)[3], dedicated to Śiva as Lokeśvara by the queen of Vikramāditya II, and to be dated about 740, was most likely built by workmen brought from Kāñcīpuram, and in direct imitation of the Kailāsanātha at Kāñcīpuram, where an inscription of Vikramāditya engraved at the time of his conquest, ca. 740, is to be found. The main shrine is distinct from the *maṇḍapam*, but has a *pradakṣiṇā* passage; the pillared *maṇḍapam* has solid walls, with pierced stone windows. The square *śikhara* consists of clearly defined storeys, each of considerable elevation. *Caitya*-window motifs are much used and there are many sculptured lintels, slabs and monolithic pillars; the sculptures include representations of Śiva, Nāgas and Nāginīs, and *Rāmāyaṇa* scenes. Like other early Dravidian temples, it is built of very large, closely-jointed blocks of stone without mortar. The architect, Guṇḍa, received the title of Tribhuvanācārya. One of the noblest structures in India, this is the only ancient temple at Paṭṭakadal still in use. Very much in the same style, but with an open *maṇḍapam*, is the neighbouring Saṁgameśvara temple, perhaps forty years earlier in date[4].

[1] Cousens, 1, and for the architecture of Western India generally, Cousens, 6.

[2] Fergusson, vol. 1, p. 356, and pl. VIII: Jouveau-Dubreuil, 1, vol. 1, p. 179, note, and pl. LXII (sculptures). This masterpiece of Dravidian architecture is the only structural temple in the style of the Māmallapuram *rathas* now surviving; it is of pure early Pallava type, which may have first affected the Cāḷukya as a result of Pulakeśin II's conquest of Vengī in 611.

[3] Fergusson, 2, vol. I, p. 353; Jouveau-Dubreuil, 1, vol. 1, p. 179, and pl. LXIII — the latter regards this temple as the type of the Paṭṭakadal (early Cāḷukyan) style combining the Dravidian (Pallava) exterior with northern details (particularly as regards the pillars).

[4] For plans and illustrations of the seventh and eighth century temples of Bādāmī, Aiholẹ and Paṭṭakadal above described, see Fergusson, 2; and Burgess, 1. The pre-Cāḷukyan shrines are illustrated and described by Cousens, 4 and 8.

The Pāpanātha temple, about 735, almost contemporary with the Virūpākṣa is in a different style, with a true Āryavārta *sikhara* (of early type with angle *āmalakas* on every third course), and with wall niches of corresponding form; this temple may fairly be described as a cross between the Dravidian and Āryavārta styles, a feature which is really the most obvious characteristic of the Cāḷukya style.

Four cave temples at Bādāmī date from the early Cāḷukyan period. Of these, Nr. 3 (Vaiṣṇava) is of special importance, as it is exactly dated (578 A. D.), and contains some admirable reliefs (Viṣṇu seated on Ananta, and a Narasiṃha, both in the verandah); the pillars of the verandah are decorated with triple brackets ornamented with magnificent human figures in the full bloom of Gupta abundance. This is probably the earliest of the four caves; the Jaina cave, like another at Aihoḷe, contains figures of Tīrthaṃkaras, and is probably the latest[1].

Most of the Buddhist caves at Aurangābād are not apsidal *caitya*-halls but excavated pillared *maṇḍapams* with a shrine either isolated or placed in the back wall, and containing a Buddha seated in *pralambapāda āsana*, "European fashion". Caves I, II and VII may date from the end of the sixth century or the early seventh. In Cave III there are very unusual groups of male and female worshipping figures in full round sculpture, kneeling towards the image; these layfolk doubtless represent the donors. The figure sculptures in this group of caves are remarkable for the heavy and elaborate headdresses, in which curled and bulky wigs play an important part. The physical type is a little unusual, too, but in respect of the full drooping lower lip recalls the Maheśa of Elephanta. In Cave III there is a remarkable relief representing the "Litany of Avalokiteśvara" the deity being surrounded by representations of suppliants suffering from various misfortunes; the most literal visual translation of a prayer imaginable. In general the pillars, capitals and brackets, which are of great variety and beauty, resemble those of the latest caves at Ajaṇṭā (I—V and XXI—XXVI). Fergusson considers that these caves, which both in date and place are certainly Early Cāḷukyan rather than Gupta, may be as late as the seventh or eighth century; but the fact that in Caves III and VII we find pillar brackets with small struts adorned with human figures, like those of the Rameśvara cave at Elūrā and Cave III at Bādāmī seems to indicate a nearly contemporary date for all these excavations[2].

The following Brāhmaṇical caves at Elūrā date from the early Cāḷukyan period, ranging between 650 and 750, if not, perhaps, a century earlier: Das

[1] The Bādāmī caves are illustrated in Burgess, 1 and 8, vol. 11, pls. 269—272.

[2] The Aurangābād caves are illustrated in Burgess, 3. The type represents a survival of that of the Sāñcī *toraṇa* Vṛkṣakā brackets.

Avatāra, Rāvaṇa kā Khai, Dhumar Leṇā, and Rāmeśvara. The Rāmeśvaram verandah (fig. 190) is adorned with massive pillars with pot and foliage capitals, and magnificently decorated with bracket figures of Devatās or Vṛkṣakās, accompanied by dwarfs, under mango-trees in full fruit; at each end of the verandah are river-goddesses. One of the finest sculptures within represents a four-armed dancing Śiva. The Das Avatāra, in which Śaiva and Vaiṣṇava sculptures appear impartially, consists of two storeys, each consisting of a large pillared hall, of which the walls are lined with niches containing the sculptures, amongst others, one of the finest of this period, the well known "Death of Hiraṇyakaśipu"[1]; in this relief, Viṣṇu appears in the Narasiṁha Avatāra and lays his hand upon the shrinking figure of the impious king. In front of the cave a mass of the living rock has been left, in the shape of a structural *mandapam*.

In this connection it may be remarked that the Brāhmaṇs did not begin to make excavated shrines, whether underground or monolithic, much before the sixth century nor continue to do so much after the eighth, and that of over twelve hundred "cave" temples in India not many more than a hundred are Brāhmaṇical, while nine hundred are Buddhist and the remainder Jaina. All cave temples are more or less direct imitations of structural buildings. But while in the course of seven or eight centuries something like a Buddhist "cave style" had been evolved, at least so far as the pillars are concerned, the Brāhmaṇical caves, temples and monoliths are imitations of structural shrines of the fully evolved types existing in the sixth century. The inference seems to be that the evolution of structural temple architecture before the late Gupta period took place mainly in connection with the necessities of Brāhmaṇical cults. The square-roofed cella with flat roof, with or without a porch, and with or without a surrounding chamber *may* have been a specifically Hindū type, the apsidal *caitya may* have been a specifically Buddhist type; but it would be very rash to assert that this must have been the case, or that the Hindūs borrowed extensively from the Buddhists, in view of the fact that in all periods for which adequate evidence is available we find that architectural style is a function of time and place, not of sectarian differentiation.

The square flat-roofed cella may perhaps be derived from the "prehistoric" dolmens which are so abundant in many parts of India; in these in any case we find the most primitive form of the slab construction — sometimes a single slab covering the roof — which is so characteristic of Hindū architecture. To judge from its wide distribution in the Gupta period this may at one time have been the nearly universal form of the Hindū temple[2].

[1] Coomaraswamy, 7, pl. XLIII.

[2] For a discussion of dolmen origins see Longhurst, 4.

The next stage (e. g. Bhumara) surrounded the cella (*garbha-gṛha*) with a pillared hall, permitting circumambulation under cover; and it is this stage which we find generally reproduced in caves such as the Dumar Lenā at Elūrā and the great Śaiva shrine at Elephanta. The next step (but all these stages overlap) is to place the shrine in the back wall of the temple, with the result that in a structural temple circumambulation can only take place in an external verandah or on a terrace plaform, and in a cave becomes impossible. In the meanwhile a tendency was developing to emphasize the importance of the cella by a duplication of the roof above it (as at Gop, Aihoḷe, &c.), and this led to the development of the two *śikharas*, Āryavārta and Dravidian. (*Nāgara* and *Drāviḍa*) Prototypes of the various roof forms which were thus, by reduplication, developed into towers, occur abundantly in the early reliefs.

At this point it will also be convenient to refer to the pillars of caves and structural temples. In the north, in the Gupta and Early Mediaeval period we find two forms fully developed; both square-based, but one having a ribbed cushion capital, the ribs divided by a plain horizontal fillet, the other characterised by the "pot- and-foliage" capital (fig. 190). The former bears some relation on the one hand to the bulbous lotus capital of Aśokan pillars, and on the other to the *āmalaka* finials of Āryavārta *śikharas*, the latter is undoubtedly developed from the lotus-decorated partially chamfered square pillars familiar in early Buddhist railings and caves[1]. In Early Cāḷukyan the tendency is to employ these forms in combination with a construction in other respects Dravidian (Pallava); even the Rāṣṭrakūṭa Kailāsa at Elūrā is northern in this sense. These Northern capitals, as is naturally the result of their cave development, are at first extremely massive; in mediaeval architecture the pot-and-foliage type becomes almost universal, becoming more and more slender, until we find such forms as those of the Arhāī Din kā Jhomprā at Ajmīr (a mosque constructed from the remains of Hindū shrines), or the Sūrya Temple at Osiā.

At Ajaṇṭā, caves I—V and XXI—XXVI (all *vihāras* with the exception of one *caitya*) date from the early seventh century. The paintings in I and II are referred to below. Caves IV and XXIV are incomplete, but would have been the most richly decorated of the whole Ajaṇṭā series (figs. 156, 157); the details of XXIV are so like those of Cave III at Auraṅgābād that they must be of similar date, and much the same applies to the others. There is a large Parinirvāṇa image in Cave XXVI. At Nāsik, Cave XVII, containing many figures of Buddha, including one colossal Parinirvāṇa image, and with pillars similar to those of Elephanta and the Brāhmaṇical caves at Elūrā, dates from about 600 or a little later.

[1] It should be noted that the Āryavārta *śikhara* is a late—certainly not earlier than late Kuṣāna — development, and cannot be derived from Assyrian forms.

The paintings in *vihāras* I and II, at Ajaṇṭā[1], hardly to be distinguished in style from those of the Gupta period strictly defined as such, include the following subjects:

Cave I, ca. 600—650 A. D., Great Bodhisattva (fig. 181), Māra-dharsaṇa, Bacchanalian scene (Pāñcika, *not* a "Persian embassy") on ceiling, love scenes, Śibi (weighing scene) and Nāga *Jātakas*, and ceiling decoration (fig. 185).

Cave II, ca. 600—650 A. D., Great miracle at Śrāvastī, Indra-loka scenes, palace scenes, Kṣāntivādin and Maitribala *Jātakas*, and decorative panels on ceiling.

Of all these, the Great Bodhisattva (to judge from the blue lotus held in the hand, Avalokiteśvara) is perhaps the most impressive, perfectly realizing the conception of one born by right of virtue to the enjoyment of all that the world can offer — and in this age the world could offer great things to an Indian prince — and yet preoccupied with the one ruling passion of compassion. Of the ceiling paintings in Cave I, representing drinking scenes, and so often described as pictures of the Persian embassy received by Pulakeśin in 625 or 626, it may be remarked that as with the other paintings, the subject is Buddhist. These are really Bacchanalian scenes of the type that recurs in Buddhist art from the early Kuṣāna period onwards, the personage carousing being Pāñcika[2].

RĀṢṬRAKŪṬAS

The Rāṣṭrakūṭas succeeded the Cāḷukyas in the western Dekkhan in 753 and made their capital at Mālkhed. The Kailāsanātha at Elūrā (fig. 192) is due to Kṛṣṇa II (ca. 757—783). This famous rock-cut shrine is a model of a complete structural temple, and may be a copy of the Pāpanātha at Paṭṭakadal. The whole consists of a *liṅga* shrine with Dravidian *śikhara*, a flat-roofed *maṇḍapam* supported by sixteen pillars, and a separate porch for the Nandi, surrounded by a court, entered through a low *gopuram*; five detached shrines are found on the edge of the perambulation terrace of the *vimāna* proper, and in one corner of the court there is a chapel dedicated to the three river goddesses, with their images in relief. There are two *dhvaja-stambhas* or pillars bearing emblems; these, and all the columns are northern, everything else is Dravidian, thus exhibiting the combination of styles characteristic of Early Cāḷukyan architecture, and perpetuated by the Rāṣṭrakūṭas. The same applies to the later Jaina Indra-Sabhā, likewise a monolithic temple, and of even more Dravidian aspect (ca. 850).

[1] For reproductions see references on p. 89.

[2] Coloured reproduction in Kokka No. 342. Fergusson goes so far as to speak of a "portrait" of Khusrū Parvīz (J. R. A. S., vol. XI, N. S., pp. 155—170). The error is repeated in Smith 2, p. 279 and 4, p. 328. The correct interpretation is given by Foucher, 1, vol. II, p. 151. But cf. Le Coq, 3, p. 51.

The Kailāsanātha is decorated with some of the boldest and finest sculpture compositions to be found in India. The representation of Rāvaṇa's attempt to throw down Mt. Kailāsa, the mountain throne of Śiva, is especially noteworthy. Only a part of this grandiose design is shown in figure 193. Here the quivering of the mountain has been felt, and Pārvatī turns to Śiva and grasps his arm in fear, while her maid takes to flight: but the Great God is unmoved, and holds all fast by pressing down his foot. The lower half of the composition exhibits Rāvaṇa exerting all the force of his twenty arms against the side of his subterranean prison. In no other art have geotectonic conceptions been visually realised with any such power as here, and in the Elevation of the Earth at Udayagiri (fig. 174). Other fine relief panels at Kailāsa include a Gaṅgāvataraṇa composition, Śiva as Tripurāntaka, and a Viṣṇu on Garuḍa.

The Śaiva shrine at Elephanta, dating probably from the second half of the eighth century, is on the other hand, an underground excavation; the two *liṅga* shrines are detached within the halls, permitting circumambulation, the various back and side-wall panels being occupied with magnificent sculptures, of which the so-called Trimūrti, really a representation of Śiva as Maheśa[1] (figs. 194, 195) is deservedly famous, as one of the finest reliefs in all India. Other sculptures include compositions similar to many of those found at the Kailāsa, Elūrā. Outside the cave there was formerly preserved a five-headed Sadāśiva (not Brahmā)[2]. In this cave, too, the northern pillars with ribbed cushion capitals attain their greatest perfection[3].

It has long been known that remains of frescoes are preserved at Elūrā[4]. The most important of these are found on the ceiling of the porch on the second storey of the upper temple, which is known locally as the Raṅg Mahall, probably from the coloured decoration which once covered the interior and perhaps the whole exterior of the structure. The painting is of two periods, the first contemporary with the excavation, thus of late eighth century date, the second several centuries later; in what is now preserved, the later layer overlaps and partly conceals the earlier. The earlier painting is reminiscent of Ajaṇṭā, but rather less sensitive; the later is decidedly inferior. The most important composition represents Viṣṇu and Lakṣmī (fig. 196) riding through the clouds, borne by Garuḍas, which are of the human type, though with very long sharp noses, bird-like lower

[1] For detailed illustrations see Rodin, Coomaraswamy and Goloubew. For the iconography of three-headed forms of Śiva see Rao, I, vol. II, p. 379ff.; Aiyar, 1; Cousens, 1 (Uttareśvara lintel); Coomaraswamy in Rūpam, 18, p. 66, and Ganguly, M., 2, p. 68 (Sadāśiva); and cf. p. 55, note 6, 67, note 1, 149, and figs. 126, 285, in this work.

[2] Coomaraswamy, 7, pl. XLIII; Diez, fig. 152 (not *catur-* but *pañca-mukha*).

[3] Burgess, 8, vol. II, pl. 256—259.

[4] For recent accounts of the Elūrā frescoes, see Thompson; Coomaraswamy, 12.

limbs, and small wings. It is of special interest to observe that, quite apart from the special characteristics of the Garuḍa faces, the features are sharply defined, and the long sharp nose and bulging eyes of the later Gujarātī style are unmistakeable; in other words this is already a definitely mediaeval style, and considerable removed from that of Ajaṇṭā. Another composition includes a rider upon a horned lion (*śārdula*) and many pairs of Gandharvas or Vidyādharas floating amongst clouds. The clouds have sharply defined crenellated margins, like those of the contemporary reliefs, and those of Borobuḍur. They are practically the same in the painting of both periods, and survive in the Gujarātī miniatures, but not later. The spandrils about the lotus rosettes in the centre of the ceiling are occupied by representations of lotus pools, with elephants, fish, etc., of both periods; while the main composition of the later layer consists of a procession of Śaiva deities.

A much later painting of a battle scene, with contemporary inscriptions giving the names of the combatants (one is "Pramāra Rāū") may date from a period not before 1200 and perhaps as late as 1500.

PALLAVA

Whatever their antecedents, the Pallavas seem to have been vassals of the Āndhras in the Godāvarī-Kistna deltas (Veṅgī) in the second century, and to have succeeded them as rulers in the third and fourth. Several legends trace their origin to the union of a Coḷa prince with a Nāga princess at Kāverīpumpaṭṭanam[1]. Originally Buddhists, they became for the most part Śaivas by the end of the sixth century, when Buddhism was declining in the south. From about 400 to 750 they were the dominant power on the east coast, and constantly at war with the Cāḷukyas on the other side of the Dekkhan. The following are the main events of Pallava history:

Siṁhavarman about 437 dedicated a Buddhist image at Amarāvatī. Siṁhaviṣṇu (575—600) lost Veṅgī to the Cāḷukyas, after which the Pallavas extended their dominions southward to Tanjore, with the capital at Kāñcīpuram. Mahendravarman I (600—625) seems to have been converted to Śaivism by the Śaiva Saint Apparsvāmi. In the reign of Narasiṁhavarman I (625—645) surnamed Māmalla, Hsüan Tsang visited Kāñcī and found there many Mahāyāna shrines; Bādāmī was captured in 642. Parameśvaravarman (655—690) won a victory at Peruvalanallūr, but lost Kāñcī temporarily in 674. Rājasiṁhavarman (Narasiṁhavarman II) built the Kailāsanātha at Kāñcī. Nandivarman Pallava again lost Kāñcī about 740 but ruled during the greater part of the last half of the century.

[1] For the great sea-port of Kāverīpumpaṭṭanam and early Tamil culture see Kanakasabhai. For the Nāga story in Cambodia see p. 180. Similar stories were current in Kaśmīr and Khotān.

Aparājita, early ninth century, was the last of the ruling Pallavas and was apparently a vassal of the Rāṣṭrakūṭas, who had inherited the Cāḷukyan enmity, and won victories in 775 and 803.

The Pallava styles may be classified as follows: Mahendra style 600—625, Māmalla style, 625—674, Rājasiṁha and Nandivarman style 674—800, Aparājita style, early ninth century[1].

Mahendra style: the very interesting cave temple inscription of Mahendravarman I at Maṇḍagapattu, South Arcot District, together with the inscription containing his *birudas* found on an ancient pillar embodied in the later Ekāmbaranāthasvāmin temple at Kāñcī, proves what might in any case be taken for granted, that structural temples of "bricks, timber, metals (stone) and mortar" were the rule, rather than the exception in the Pallava country, and indicates that Mahendravarman (whose *biruda*, Vicitracitta, refers to his many accomplishments) was personally responsible for introducing the cave style, probably from the Kistna district. Mahendravarman was "one of the greatest figures in the history of Tamilian civilisation"[2]. In addition to the cave just mentioned, those of Daḷavānūr, Trichinopoly and many others date from Mahendra's reign. Characteristic features are the square pillars, the central portion being octagonal; the brackets generally plain, sometimes with horizontal fluting. There are *dvārapālas* leaning on heavy clubs. There is a convex roll cornice, decorated with *caitya*-window niches (*kuḍu*) enclosing heads, the crest of the arch quite plain. The Buddhist railing (rare in Hindū art) is sometimes seen.

Reference may be made here to the Jaina Pallava painting recently discovered in a cave shrine at Sittanāvasal, Pudukoṭṭai state, assigned to the reign of Mahendravarman I[3].

Māmalla style: the greater part of the work on the cave temples, the Descent of the Ganges, and the five "*rathas*" at Māmallapuram seems to have been executed early in the seventh century. Of the cave temples, the Trimūrti, Varāha, Durgā, and "Five Pāṇḍava" are the most important. The Varāha, like the Five Pāṇḍavas, has a verandah with the slender octagonal pillars supported by a sitting lion, characteristic of Pallava architecture after Mahendra (cf. figs. 197, 199, 202); this is the prototype of the later *yāli* pillars of mediaeval Dravidian art. The capital is bulbous, often surmounted by a flat abacus (*palagai*); the brackets as before, usually with the horizontal fluting.

[1] The best account of all the Pallava monuments is given by Jouveau-Dubreuil, 1 and 2. See also Rea, 4; Longhurst, 3; Vogel, 14; and Rodin, Coomaraswamy and Goloubew.

[2] Jouveau-Dubreuil, 2, and *Conjeevaram inscription of Mahendravarman I*, Pondicherry, 1919; also Longhurst, 3.

[3] Jouveau-Dubreuil, 3.

In the Varāha cave is a series of well-known and magnificent reliefs representing the Varāha-avatāra, Vāmana-avatāra, Sūrya, Durgā (in Pallava art always with the attributes of Viṣṇu), Gaja-Lakṣmī (fig. 205) and two fine groups of royal figures representing Siṁhaviṣṇu and Mahendravarman with their queens (fig. 204)[1]. In the Durgā shrine (Yamapuri or Mahiṣa maṇḍapam) are two still better known reliefs representing Viṣṇu-Anantaśayin (fig. 209) and Durgā-Mahiṣamardinī (fig.208); the Five Pāṇḍava shrine contains reliefs representing Kṛṣṇa-dudhādhārī and Govardhanadhara.

With these sculptures must be mentioned the open-air rock-cut *tīrtham*[2] commonly known as "Arjuna's Penance" (figs. 198, 206, 207). Here a great rock wall with a median fissure, has been covered on both sides with sculptured figures of deities, human beings, Nāgas, and animals of all kinds, approaching or facing towards the fissure, and for the most part with hands joined in adoration. Immediately to the left of the fissure is a small sculptured shrine (the Dravidian temple in its simplest form) containing the standing figure of a four-armed deity, probably Śiva; before this temple is bowed an emaciated *yogī* (Bhagiratha, fig. 198), who is also represented above with raised arms (*urdhva-bāhu*), practising *tapas*. The fissure is occupied by the Nāgas, who are beings associated with the waters; above, on either side are flying figures of gods, and below are the wild creatures of the forests, amongst which the monumental elephants may be specially mentioned. If any further evidence were needed to support the suggestion of Goloubew that the whole scene represents the Descent of the Ganges (Gaṅgāvataraṇa)[3] it could be found in the figure of the ascetic cat standing erect as a *tapasvī* in *urdhvabāhu* pose, while trustful mice play at his feet (fig. 207); stories of false ascetic cats deluding innocent mice on the banks of the Ganges are to be found in the *Hitopadeśa, Mahābhārata*, and elsewhere. A detached group in the round, representing a monkey family, is a masterpiece of animal sculpture[4]. In the same style and probably of the same period are the Kapila and unfinished elephants of the Isurumuniya Vihāra at Anurādhapura in Ceylon (see page 162).

The five *rathas* at Māmallapuram[5] are all monoliths, cut from a series of boulder-like granulitic outcrops on the sandy shore. All are of the same period,

[1] A. S. I., A. R., 1922—23, p. 137; Sastri, H. K., 2.

[2] Fully illustrated in Rodin, Coomaraswamy and Goloubew; some details, including the monkey family, in Coomaraswamy, 7; others in Vogel, 14.

[3] Goloubew, 2. Another, somewhat different treatment of the same subject appears in the Varāha-avatāra cave (ca. 400 A. D.) at Udayagiri, Bhopāl (Cunningham 4, vol. X, p. 48).

[4] Coomaraswamy, 7, pl. 83.

[5] Fergusson, 2, I, ch. 3, and Jouveau-Dubreuil, 1, the latter showing that the *rathas* are considerably earlier than the structural temples at Kāñcī, with which Fergusson would make them contemporary.

the first half of the seventh century, and in the same style, though of varied form, evidently reproducing contemporary types of structural buildings; named after the Five Pāṇḍavas, they all appear to be Śaiva shrines. The Sahadeva, Dharmarāja and Bhīma *rathas* have characteristic pyramidal roofs of three distinct storeys, ornamented with the little pavilions called *pañcarams* and with *caitya*-window niches; the uppermost member of the first having the form of the older structural and excavated apsidal *caitya*-halls, that of the second being a hexagonal dome, that of the third an elongated barrel vault of the type so often represented on the Bhārhut (fig. 45), Sāñcī and Amarāvatī reliefs. The Arjuna *ratha* illustrates the simplest form of the Dravidian temple, like the small rock-cut shrines at Uṇḍavalli[1] and the shrine represented in the Gaṅgāvataraṇa relief (fig. 198). The Draupadī *ratha* (fig. 200) is a small square shrine with a square curvilinear roof like that of modern Bengālī thatched cottages and brick temples; the form is without doubt derived from bamboo construction, and occurs already in the small shrine represented at the left end (obverse) of the Katrā Mound *toraṇa* architrave, M 1, in the Mathurā Museum[2]. Characteristic details in these temples include capitals without *palagaï*, brackets plain or horizontally fluted, roll cornices with *caitya*-window niches enclosing heads or figures without a crowning *kīrttimukha* (Tam. *siṁhamugam*), and *makara toraṇa* lintels. Seventh century Pallava sculpture, represented in and on the shrines above described, is of a very high order; it differs chiefly from that of the Gupta period and area in the greater slenderness and freer movement of the forms, the more oval face and higher cheek bones. The divine and human figures are infinitely gracious (figs. 204), and in the representation of animals this school excels all others. Deities have four arms, Dvārapālas two only. *Liṅgams* are cylindrical, never fluted.

Rājasiṁha style: the structural temples at Kāñcīpuram[3], with the "Shore temple" at Māmallapuram, date from the beginning of the eighth century and are due to Rājasiṁha, the most important of them being the famous Rājasiṁheśvara temple, or Kailāsanātha, of Kāñcī. The shrine (fig. 197) with its pyramidal tower and flat-roofed pillared *maṇḍapam* is surrounded by a peristyle composed of a continuous series of cells resembling *rathas*. But here the Pallava style is further evolved and more elaborate; in matters of detail may be mentioned the vertical median band on the horizontally fluted brackets, the constant presence of the *palagaï* as uppermost element of the capital, the fact that many of the lions supporting pillars are now rampant and are sometimes provided with riders, and the appear-

[1] Longhurst, 3, pl. XIII.
[2] Vogel, 13, pl. XXV.
[3] The fullest descriptions and illustrations in Rea, 4; see also Fergusson, 2, and Jouveau-Dubreuil, 1.

ance of *kīrttimukhas*, as yet in very low relief, surmounting the *caitya*-window niches. The *liṅgam* is now prismatic[1]. Other Rājasiṁha temples dateable near to 700—720 include the structural Shore temple at Māmallapuram (fig. 201), the great temple at Panamalai (fig. 203) and the Tiger (or rather "Lion") cave at Sāluvankuppam. The Vaikuṇṭha Perumāl at Kāñcī may date nearer to 750, the Mātaṅgeśvara at Kāñcī from the time of Nandivarman, the apsidal temple at Kūram from the end of the century; but all these are still in the Rājasiṁha style, as developed in the time of Nandivarman.

Aparājita style: at the beginning of the ninth century we find the Pallava style further evolved, and approaching the Coḷa. The *liṅgams* are again cylindrical, the abacus (*palagaī*) above the capital more conspicuous, the *kīrttimukha* head now in full relief. There is a shrine of this type at Bahur, near Pondicherry. Much more important is the remarkable temple of Tiruttaṇeśvara[2] built by Nambi-Appa in the reign of Aparājita, at Tiruttaṇi. The temple is a small square *vimāna*, with one door, and with a *maṇḍapam*, facing east; the upper portion is apsidal like the Sahadeva *ratha* at Māmallapuram.

Characteristics of the developed style, beside those already mentioned include the representation of *dvārapālas* with four arms. It is worthy of note that the pillar brackets are still curved; in the early Coḷa style they become angular.

MEDIAEVAL

FROM 900 A.D.: PĀLA, CĀḶUKYA, COḶA, RĀJPUT, &c.

The history of this period is again too complex to be treated in detail here. The outstanding feature in the North is the rise of the Rājputs, many of whom were descended from earlier foreign invaders, but were now completely hinduised, while others could trace their descent with plausibility to far earlier times. The most important kingdoms in this period included that of Kanauj or Pañcāla ruled by the earlier Rājā Bhoja (Parihāra) in the ninth century, and extending from Magadha to the Satlaj, and including Kāṭhiāwāḍ. The later Rājā Bhoja (Paramāra or Pawār) of Dhārā, r. 1018—1060 A. D., was a liberal patron of literature and art, himself the author of works on architecture[3]; in Indian tradition his name marks the culminating age af Hindū civilisation. The Candels of Bundelkhaṇḍ, with a capital at Mahobā, were at the height of their power about 1000 A. D. In the lower Ganges valley the kings of the Pāla dynasty ruled for four and a half

[1] A feature repeated in Java, cf the Cupuvatu *liṅgam*, Krom, 2, pl. VIII.

[2] Jouveau-Dubreuil, 2, vol. II, 1918, pls. I—VIII.

[3] Bhoja, 1, 2.

centuries, from about 730 to 1197 A. D. fostering the later Buddhist art of Bihār. From about 1070 onwards the kings of the Sena dynasty, Brāhmaṇical Hindūs, dispossessed the Pālas of a large part of their dominions, including Dacca and Gauṛ. Both were swept away by the Muhammadans at the close of the twelfth century, when monasteries and temples were destroyed, and Buddhism practically extinguished. Oṛissā was governed for the most part by independent princes of the Eastern Gaṅgā dynasty.

In the Dekkhan the last of the Rāṣṭrakūṭa kings was overthrown by the first representative of the Later Cāḷukya dynasty of Kalyān, descendants of the early Cāḷukyas of Bādāmī; the kingdom was extended to include almost all the former possessions of his ancestors, and the dynasty lasted until about 1190. The Hoyśala dynasty ruled in Mysore (Maisūr), attaining the zenith of their power in the twelfth and thirteenth centuries; in 1310 the kingdom was overrun by the Muhammadans. In the south, the Coḷas came into prominence about the middle of the ninth century, in succession to the Pallavas. Rājarāja-deva, the Great, r. 985—1018 A.D., made himself paramount lord of the south, ruling over almost the whole of the present Madras Presidency including on the north the Kistna-Godāverī delta and part of Oṛissā, part of the Cāḷukya domain on the west, the Pāṇḍya kingdom of Madura in the south, and a great part of Ceylon. Rājarāja was a great builder, constructing in particular the great temple at Tanjore. Both he and his son Rājendra maintained relations with the kings of Sumatra, and though ardent Śaivas, made endowments to the Sumatran Buddhist shrine at Negapatam (see p. 199). The last Coḷa king died in 1287. For a short time the Pāṇḍyans of Madura reasserted themselves but in 1310 the Muhammadans under Malik Kāfūr broke the power of all the southern States with the exception of Malabar. Had it not been for the rapid rise of the Vijayanagar kingdom about 1370, ruled by the Rāyas, of whom the most famous was Kṛṣṇa Deva, r. 1509—29, the southern Hindū kingdoms would have been completely subverted. Vijayanagar broke up about 1565; its chief Hindū successors in the South were the Nāyyakas of Madura, of whom Tirumala reigned 1623—1659.

The nomenclature of the mediaeval architecture presents considerable difficulty. In any case, a sectarian classification, such as that which forms the main defect of Fergusson's work, is quite misleading. For just as in the case of sculpture, there are no Buddhist, Jaina or Brāhmaṇical *styles* of architecture, but only Buddhist, Jaina and Brāhmaṇical buildings in the Indian style of their period. Nor can a clear distinction of Viṣṇu and Śiva temples made in the *Mānasāra* and followed by Havell and Diez, be recognized in mediaeval practise. The Indian temple (*vimāna*) is one; but there are provincial variations in its formal development, existing side by side with the secular variation in pure

style. In respect of these, the only adequate classification is geographical. The three most clearly differentiated types are the Northern, marked by the curvilinear *śikhara*, the Southern, with a terraced pyramidal tower, of which only the dome is called the *śikhara*, and the Central, combining both types with peculiarities of its own. These three types have been designated as follows in the *Śilpa-Śāstras* (A) and by Fergusson (B):

	A	B
Northern (mainly North of the Vindhyas).	Nāgara	Indo-Āryan or Āryavārta
Central (Western India, Dekkhan and Maisūr)	Vesara	Cāḷukyan
Southern (Madras Presidency and northern Ceylon)	Drāviḍa	Dravidian

The classification (A) of Śrī Kumāra and the *Mānāsara* is only unsatisfactory insofar as it partly involves a definition by ground plan which does not altogether fit the facts[1]; that of Fergusson, on account of its ethnic implications. In the present work both sets of terms are used, but strictly with a geographical connotation and without reference to plans or races.

The great abundance of mediaeval Nāgara shrines in the Pañjāb, Rājputāna, Western India, the Ganges valley, Central Provinces, and Oṛissā makes a consecutive historical treatment almost impossible in a work of the present dimensions. All that can be done is to describe the more important buildings, dating for the most part after 900 and before 1300 A. D. under the headings of the various sites at which they are found, and with some account of the sculpture.

A considerable series of Nāgara temples is found in the Pañjāb Himālayas. The most important of these is the eight or ninth century monolithic group at Masrūr, Kāṅgṛā[2]. Structural temples apparently of the ninth century are found at Baijnāth, where the *maṇḍapam* has an interesting balcony window, and the porch is provided with elegant columns having cylindrical shafts and pot and foliage capitals. Baijnāth is equivalent to Vaidyanātha, a name of Śiva as Lord of Physicians, and may be possibly connected with an early cult of Lokeśvara[3]. The Viśveśvara temple at Hāṭ, Bājaurā, Kuḷū has three projecting side chapels containing fine relief sculptures of Gaṇeśa, Viṣṇu and Durgā; there are river-goddesses at

[1] But see Acharya, p. 19, and Thesis V. "The technical names of the three styles of Indian architecture are geographical, in the same sense as those of the four Graeco-Roman orders."

[2] Hargreaves, 3; also A. S. I., A. R., 1912—13, pt. 1, pl. XIII, and 1914—15, pt. 1, pl. III. Amongst the sculptures is a representation of Varuṇa on a *makara*.

[3] Vogel, 22.

the sides of the porch; the decorative motifs include *caitya*-arches enclosing heads and *makaras* almost dissolved in arabesque. Thus the ensemble presents an appearance analogous to that of later Javanese architecture. The shrine is undated, but may be assigned to the tenth century[1].

In Cambā there are extant in temples at Brahmaur and Chatrāṛhi large brass images of Lakṣaṇā Devī (Mahiṣāsura-mardinī), Śakti-devī, Gaṇeśa, and Nandi with inscriptions showing that they were to the order of a king Meruvarman by a craftsman (*kammīṇa*) of the name of Gugga; assigned on palaeographic grounds to the eighth century, the images themselves are mechanically conceived, and apart from the inscriptions would be assigned to a later date[2]. More interesting is the Nirmaṇḍ mask of Mujunī-devī (fig. 273), queen or goddess of a Rājā Hemaprakāśa of Kuḷū, of ninth or tenth century date[3]. Many temples of great interest are preserved in the Kumāon and Almora tracts of the Himālayas[4].

The only monolithic Nāgara temple, other than that of Masrūr, Kāṅgṛā, is the excavated Vaiṣṇava Dharmanātha temple at Dhamnār in Rājputāna, dating about 800 A. D. This shrine stands in the pit in the side of the hill in which it was excavated. The chief peculiarity is the arrangement of six or seven smaller cells round the main shrine, which consists of a *garbha-gṛha* and *maṇḍapam*[5]. At the same site there is an extensive series of older Buddhist excavations.

Of numerous brick towers in the Pañjāb and Ganges valley, the following are amongst the most important: the temple at Kālar, near the junction of the Sawān and Indus in the Jhelam District[6]; smaller shrines at Āmb in the Shāhpur District: temples at Kāfir Koṭ[7]; Malot (see p. 143 and fig. 274); Dalmi, Manbhum, Bengal[8]; Sona Tapan and Bahulara (fig. 213) in the Bāṅkurā District, Bengal[9]; Paraulī (with a circular cella) and Sinbhua in the Cawnpore District, and Tindūlī, Bahua, Ṭhiṭhaurā, Kurārī, &c., in the Faṭehpur District[10]. Most of these date between the eighth and twelfth centuries, and continue the series represented by the earlier Gupta and early mediaeval temples of Bhītargāoṅ, Sīrpur and Nālandā.

[1] Vogel, 11.

[2] Vogel, 1.

[3] Shuttleworth; Vogel, 19. Tho the former I am indebted for the photograph reproduced in fig. 273 and for a manuscript copy of a note on the inscriptions by Vogel.

[4] A. S. I., A. R., 1913—14, pl. 1; 1921—22, pp. 50ff.

[5] Cousens, 7; Burgess, 8, pl. 286.

[6] Talbot.

[7] Cunningham, 4, vol. XIV; A. S. I., A. R., 1914—15; pt. 1, pl. III; Codrington, K. de B., pl. XLIII, c, d.

[8] Burgess, 8, pl. 290; Cunningham, 4, vol. VIII.

[9] Burgess, 8, pl. 298, 299; A. S. I., A. R., 1922—23, pp. 58, 59, 112, and pl. XII.

[10] Vogel 8.

Amongst the more important stone temples in Nāgara style not elsewhere referred to may be mentioned the circular tower at Candrehe, Rewā State, where there is also a well preserved Brāhmaṇical monastery; the shrine at Sohāgpur, recalling Khajurāho, but with even finer sculptures; columns of an eleventh century Buddhist temple at Bihār, Narsiṅghpur State; and the Siddheśvara or Siddhanātha temple at Nemawāṛ, Indore State, the finest in Mālwā[1].

The groups of Hindū and Jaina temples at the old Candela capital of Khajurāho in Bundelkhaṇḍ are second in importance and magnificence only to the mediaeval temples at Oṛissā[2]. All appear to have been erected between 950 and 1050. Of the Hindū temples the finest is the Kaṇḍārya Mahādeva (fig. 214); the effect of height, actually 116 feet over all, is greatly increased by the deep basement and by the vertical lines of the reduplications of the tower upon itself. The *pradakṣiṇā* path is included in the whole mass of the structure, and is provided with shaded balcony windows. All parts except the tower are covered with elaborate figure and floral sculptures, and amongst this are some remarkable erotic friezes, a feature by no means usual in Śaiva shrines. The Vaiṣṇava Caturbhuja and the Jaina Adinātha temples are in exactly the same style, to be distinguished only by the details of their sculpture[3].

At Gwāliar, within the area of the fort there is preserved the porch of an important Vaiṣṇava temple erected in 1093 and known as the Sās-Bahu. Of more unusual form is the Vaiṣṇava Teli-kā-Mandir (fig. 212) which although in northern style, seems to have been crowned by a barrel-vaulted roof like that of the Vaitāl Deul at Purī in Oṛissā. The finest and best preserved temple in Gwāliar State is the Nīlakaṇṭha or Udayeśvara at Udayapur, built by Udayāditya Paramāra between 1059 and 1080. The *śikhara* is ornamented with four narrow flat bands running from base to summit, the intervening spaces being occupied with repeated ornament consisting of reduplications in miniature of the main tower; the whole is carved with particular precision and delicacy, and both tower and *maṇḍapa* are in perfect preservation[4].

Remains of once magnificent Vaiṣṇava temples survive in the Lalitpur District at Candpur, Dudhahi, and Madanpur. Frescoes which seem to illustrate fables are preserved on the ceiling of the Vaiṣṇava temple known as the Chotī Kācāri at the latter place, and have been assigned by Mukerji to the twelfth century or earlier, but need reëxamination[5].

[1] For all these see A. S. I., A. R., 1920—21.
[2] A. S. I., A. R., 1922—23, pls. XXIV—XXVI. See also p. 110.
[3] Fergusson, 2, vol. II, pp. 49, 140.
[4] Fergusson, 2, pp. 137, 147.
[5] Mukerji, 1, pls. 29, 30, 35—38, 45—48, and Diagram 11.

As may have been gathered from the foregoing descriptions, the culture of the Candels in Central India was predominantly Brāhmaṇical, and most of the temples and sculptures are of a corresponding character (cf. fig. 222). But a number of fine Buddhist sculptures found at Mahobā, and now for the most part in the Lucknow Museum show that Buddhism was still followed. These sculptures, which are executed with faultless mechanical perfection and considerable grace, are in the local buff sandstone, and several inscribed with dedicatory inscriptions by various relatives of an accomplished artist (*citrakāra*) of the name of Sātana, were probably made in his workshops. The figures may be dated approximately in the latter part of the eleventh century, in the reign, perhaps, of Kīrttivarman, the greatest of the Candela rājas. An image of Lokanātha (Avalokiteśvara) is illustrated in fig. 223; the other images included a Buddha, a Tārā, and a Siṁhanāda Avalokiteśvara[1].

An unusual temple type, perhaps in essentials of great antiquity, is that of the circular colonnaded enclosures dedicated to the Cauṅsat Joginīs, or sixty-four goddesses associated with Durgā. The ninth or tenth century or possibly much older example at Bherāghāṭ, near Jabalpur, a hundred and sixteen feet in internal diameter, with eighty-one peripheral chapels, was probably provided with a main central shrine containing an Umā-Maheśvara group[2]. The temple at Mitauli, near Padhauli, of eleventh century date, was a hundred and twenty feet in diameter, with sixty-five peripheral chapels, and a central round shrine provided with a *maṇḍapa*[3]. Other circular Joginī temples are found in Coimbatore, at Rāṇīpur-Jhariā near Sambhalpur, at Dudhahi in the Lalitpur District[4], and in the Kālāhandi District[5]. The Joginī temple at Khajurāho, is by exception rectangular, measuring a hundred and two by fifty-nine and a half feet, with sixty four small peripheral cells and one larger one, all surmounted by spires; like all the others, the court is open to the sky, only the cells having roofs[6]. It may be remarked that early examples of similar plans, based no doubt on still earlier Indian prototypes, can be recognized in the case of more than one Gāndhāran monastery shrine, e. g. at Jamālgaṛhi and Takht-i-Bāhi[7], and so far as the rectangular type is concerned can be paralleled in the cloistered courts of the Kāśmīrī shrines, and those of some Jaina temples at Girnār and Śravaṇa Belgola (*beṭṭa* type, see p. 118), and of the Cālukya Keśava temple at Somnāthpur in Maisūr (see p. 117).

[1] A. S. I., A. R., 1915—16, pt. 1, p. 17, and pl. III; Dikshit.
[2] Cunningham, 4, vol. IX, pp. 60—74, and pls. 12—15.
[3] A. S. I., A. R., 1915—16, pt. 1, p. 18.
[4] Mukerji, 1, pl. 39.
[5] Cunningham, 4, vol. XIII, pp. 132ff., and pls. 13, 14; Indian Antiquary, vol. VII, p. 20.
[6] Fergusson, 2, vol. 11, p. 51, and fig. 291.
[7] Fergusson, 2, vol. 1, figs. 119, 120.

Another important group of mediaeval temples is found at Osiā[1].

The old Hindū and Jaina temples of Gujarāt have been almost entirely destroyed by the Muḥammadans, who nevertheless in their turn employed the Indian architects to construct the beautiful mosques of Aḥmadābād, which are in a purely Hindū style, only adapted to the requirements of Musalmān worshippers. Probably the greatest of the older temples is the Rudramālā, at Siddhapur, a city named from the great royal builder Siddha Rāj (1093—1143), one of the kings of Anhillavāḍa-Pāṭan, and connected by marriage with the Cālukyas. Another great shrine stood at Vāḍnagar; still another imposing ruin is that of the temple of the Sun at Mudhera. Little remains at Anhillavāḍa-Pāṭan, but at Somanātha-Pāṭan in Kāṭhiāwāḍ are the ruins of the famous Somanātha temple, destroyed by Maḥmūd of Ghazna in 1025, rebuilt by Kumārapāla (1143—1174), and later again sacked and converted into a mosque[2]. All these temples connected with the Solanki (Cālukya) rulers of Gujarāt are in a local variety of the Cālukyan (Vesara) style; they are further specially characterised by the presence of *kīrttistambhas* or decorative storied "Towers of Fame". The finest example of such a tower, however is that of the Chitor Fort, the capital of Mewāṛ before Udaipur. This tower (fig. 251) was constructed in the eight years following 1440, and restored in 1906, to commemorate the building of the Kumbhasvāmi Vaiṣṇava temple, consecrated in 1440. In the fifth storey are effigies of the architect Jaita and his two sons[3]. The similar, but smaller Jaina tower at Chitor dates probably from the twelfth century[4].

The Jaina temples at Mount Ābū are deservedly famous[5]. These take their name of Dilvāṛa from the adjoining village, situated at a height of 4000 feet on an isolated hill in Southern Rājputāna; the group consists of four temples, of which the most important are those of Vimala Shā and Tejahpāla, respectively ca. 1032 and 1232. They are constructed entirely of white marble, quarried in the plains below, and carried up the steep hill by infinite labour. These are domed shrines with pillared halls. As Cousens remarks "the amount of beautiful ornamental detail spread over these temples in the minutely carved decoration of ceilings, pillars, doorways, panels, and niches is simply marvellous; the crisp, thin, translucent, shell-like treatment of the marble surpasses anything seen elsewhere, and some of the designs are veritable dreams of beauty. The work is so delicate that ordinary chiselling would have been disastrous. It is said that much of it

[1] Bhandarkar, D. R., 4; Burgess, 8, pls. 307—310. The Sūrya temple is the finest.
[2] Cousens, 8, pp. 35ff.; Fergusson, 2.
[3] A. S. I., A. R., 1920—21, p. 34; Cunningham, 4, vol. XXIII.
[4] Fergusson, 2, fig. 295.
[5] Bhandarkar, D. R., 8; Cousens, 8.

was produced by scraping the marble away, and that the masons were paid by the amount of marble dust so removed". The two great domical ceilings are the most remarkable feature (fig. 221); all the fretted marble is deeply undercut, and in the centre there hangs a great carved pendant. It must not be supposed that all this work is overwrought; this is rather one of those cases where exuberance is beauty. It will be understood, of course, that all the figure sculpture is necessarily in the same key, each individual figure being but a note in the whole scheme, not a profound invention to be separately studied. The same applies even to the images of the Jinas in this period; each is severely simple, but all are alike in representing nothing more than the skilled realisation of a fixed formula. Just a millennium had passed since the setting up of Friar Bala's Bodhisattva at Sārnāth: not one of the mediaeval craftsmen could have created a work of like intensity, but had such a thing been possible, such a figure would have completely destroyed the unity of any mediaeval shrine. Under these circumstances it is not a fault, but a virtue in the craftsman that he could not, if he would, have achieved what have been utterly inappropriate to his design.

There is another and even more picturesque Jaina *tīrtha* or place of pilgrimage at Tāraṅga, not far from Siddhapur, with a temple of Ajitnātha, built by Kumārapāla. The most remarkable of such *tīrthas* however, are the great temple cities — cities not built for human habitation, but consisting of temples alone — picturesquely situated on the hills of Girnār in Kāthiāwāḍ and Śatruñjaya or Pālitāna in Gujarāt[1]. At Girnār the great temple of Nemīnātha is certainly older than 1278 when it was repaired; another, built by the brothers Tejaḥpāla and Vastupāla, founders of the second temple at Mt. Ābū above referred to, dates about 1230. The former stands in a colonnaded court of some seventy cells, the latter is a triple shrine arranged in Cāḷukyan fashion about a central hall. At Śatruñjaya the total number of shrines, in eleven separate enclosures, exceeds five hundred. Some date back to the eleventh century, the majority range from 1500 to the present day. One of the largest is the temple of Ādinātha in the Kharataravasī Tuk, built by a banker of Aḥmadābād in 1618; this is a shrine of two storeys, with a well proportioned *śikhara*, and with a verandah of which the pillars bear capitals richly carved with figures of musicians and dancers. A small shrine built by the Nagar Seṭh, or Head of the Gilds of Aḥmadābād in 1840, is a pillared hall of unique design, with external verandahs; the floor is divided by twelve piers into nine smaller squares, those of the angles having domed roofs, those of the centre and sides being crowned by towers; the five principal icons represent sacred mountains. Other picturesquely situated Jaina temple groups

[1] For Girnār and Śatruñjaya, &c., see Fergusson, 2; Cousens, 8, p. 44.

are found at Rāṇpur (expecially the Gaumukha temple, A. D. 1438) in Jodhpur State, and Parasnāth in Bengal.

Probably the best preserved remains of any mediaeval Indian city are those of Dabhoi, twenty miles south east of Baroda, and Jhinjuvāḍ in the northern angle of Kāṭhiāwāḍ. Both of these cities were provided with powerful defensive walls in the time of the Solanki kings of Gujarāt, probably about 1100. They were partically destroyed by the Muḥammadans in the thirteenth century, but at least two of the great gates and parts of the massive walls are still preserved. The Jhinjuvāḍ wall is decorated with three string courses, interrupted at intervals by sculptured panels with figures of gods. The gates of Dabhoi (fig. 250) are more elaborate; like all Hindū gates, the arch is formed of overlapping (corbelled) horizontal brackets, covered by a massive lintel. These gates, and those of Gwāliar are the finest now standing in India[1].

The development of the Pāla school of architecture and sculpture, the "Eastern school" of Tāranātha, is typically illustrated at Nālandā, of which the importance as a centre of Buddhist learning continued undiminished by the political decadence of Magadha, until the destruction of the monasteries by the Muḥammadans about 1197. Nālandā has been the richest source of the well-known smooth black slate images of the Pāla school, and has also yielded a very extensive series of Buddhist bronzes (fig. 232). It may well have been here that the famous artists Dhīmān and Bitpālo, painters and sculptors mentioned by Tāranātha, worked in the latter part of the ninth century[2]. The importance of Nālandā as a centre of Buddhist culture and a source of iconographic and stylistic influences throughout the Buddhist cast is well illustrated by the close relations existing between it and Sumatra-Java in the ninth century, as revealed by the copper plate of Devapāladeva, in which reference is made to the important monastery built by Bālaputra of Suvarṇadvīpa, ca. 860[3]. Traces have been found of what may have been a statue of the founder[4]. Nepāl and Burma, too, had close connections with Nālandā.

A general analysis of all the finds at Nālandā tends to show three stages in the later development of Magadhan art, first early Mahāyāna types, with Buddha and Bodhisattva images and votive *stūpas*; then, marking the development of the Tantrayāna on the basis of the older Yogācāra doctrines, the appearance of Śaiva influences and images; and finally the introduction of the Kālacakra system with Vaiṣṇava figures. Moreover, throughout the period of this development, the

[1] Cousens, 8.

[2] Schiefner 2. For a good discussion of Tāranātha's remarks on the history of Buddhist art see Smith, 2, pp. 304—07, Goetz, 8.

[3] Hirananda Sastri, in Epigraphica Indica, XVII, pt. VII; Bosch, 4 (with a valuable summary of the history of Nālandā). See also p. 199.

[4] A. S. I., A. R., Eastern Circle, 1917—18, p. 41.

later Magadhan schools exerted a powerful iconographic and to some extent a stylistic influence upon the arts of Nepāl in the north, and of Burma, Sumatra and Java beyond the seas. Even in Ceylon, certain identities of design with Nālandā types can be recognized.

Stone sculptures of the Pāla school are found not only at Nālandā, but elsewhere in Magadha, as for example at Rājagṛha, Bodhgayā, Kurkihār, Dinājpur, Bhagalpur, Rājshāhi (fig. 227), Candimau, Kichang in Mayurabhañja, &c., and are represented in almost all large Museums, in India more especially at Lucknow, Calcutta and Rājshāhi; in Europe, London, Paris and Berlin, in America, Boston (fig. 228) and New York (fig. 229)[1].

Another large series of Pāla "bronzes", perhaps of Nālandā origin, has been found at Chittagong (Catisgāoṅ), and appears to date from the ninth to the thirteenth century[2]. Some others now in Kaśmīr are evidently of the same type (fig. 232)[3].

Vaiṣṇava images in the same style, and of beautiful workmanship have been found at Rangpur[4], and others are represented in the collection of the Baṅgīya Sāhitya Pariṣad in Calcutta (fig. 231)[5]. Other Buddhist, Vaiṣṇava and Śaiva (fig. 230) images are in the Museum of Fine Arts, Boston[6].

Stylistically, the art of the Pāla school is of high technical accomplishment, elegant and even modish in design. But even the stone sculpture approximates to metal work; everything is conceived in clear cut outlines, and there is no true modelling to be compared with that of earlier schools.

Almost the only surviving documents of Indian painting of the Pāla school are the illustrations in the two palm leaf Mss. Add. 1464 (*Aṣṭasāhasrika-prajñāpāramitā*) and 1688 (*Pañcarakṣa*) in the Cambridge University Library, the former dating from the beginning, the latter from the middle of the eleventh century, and containing between them fifty-one miniatures, forming square panels of the height of the page[7]. All the illustrations represent Buddhist divinities or scenes from the life of Buddha; their general character is Tāntrik, but not to any exaggerrated extent. They are very closely related to the contemporary painting of

[1] Burgess, 8, pls. 224—235; Ganguly, M., 2; Coomaraswamy, 9 (2). For related but somewhat earlier sculpture in the Manbhum and Singhbhum Districts, Bengal, see Burgess, 8, pls. 291—295. For other dated Pāla sculptures from the Bodhgayā district in Bengal see A. S. I., A. R., 1923—24, pp. 102, 103.

[2] A. S. I., A. R., 1921—22, p. 81.

[3] Kak, 1, p. 72.

[4] Spooner, 6.

[5] Ganguly, M., 2, pp. 137ff.

[6] Coomaraswamy, 9 (2).

[7] Bendall, 2; Foucher, 2, vol. 1, pls. IX, X, and pp. 30 ff.

Nepāl (see p. 146) on the one hand, and that of Burma (see p. 172) on the other. Like the paintings in Jaina manuscripts from Gujarāt these illustrations are evidently replicas of traditional compositions; as justly remarked by Foucher, "nous devons supposer derrière ces miniatures une période de transmission vraisemblement assez longue ... productions d'un art dès longtemps stéréotypé". On the other hand, their intrinsic quality is essentially late mediaeval; all the features are defined by delicate, somewhat tormented outlines, with an expression at once nervous and sensual. The eyes and eyebrows are almost always doubly curved, and the nose very sharp; but there is a distinction from the Gujarātī types in that a large part of the farther cheek is always seen in the three-quarter profile, and the nose never projects beyond its outline, though in some cases the further eye is noticeably bulging. The work is that of accomplished craftsmen, and is marked by considerable facility of execution, though it has scarcely the lightness of touch of the Gujarātī paintings.

The most complete series illustrating the development of the Nāgara temple from the eighth to the thirteenth centuries is found in Oṛissā, at Bhuvaneśvara, Purī, and Koṇārak. The following are the approximate dates of the more important of the vast series of temples found in this Kaṭak District of Oṛissā (at Bhuvaneśvara except where specified): Paraśurāmeśvara, ca. 750; Mukteśvara, 950; Liṅgarāja, 1000; Rājrānī, and the Jagannātha at Purī, ca. 1150; Megheśvara, ca. 1200; Koṇārak Sun temple (Sūrya Deul), and Liṅgarāja *nāṭya maṇḍapa*, thirteenth century.

The first (fig. 216) is a small, exquisitely and richly decorated Śaiva shrine, the low double-roofed *maṇḍapa*, with solid walls lighted by openings between the roofs forming a kind of clerestory. The Mukteśvara temple has a *maṇḍapa* already in the typical Oṛissan style, that is, with a pyramidal roof of many closely approximated cornices. The Liṅgarāja is perhaps the most majestic Indian temple now standing, giving an impression of great height, despite the many buildings clustered round it. The illustration (fig. 215) shows it from the side, with the original *maṇḍapa* on the left; in the latter the superimposed cornices are divided into two storeys. The effect of height of the *śikhara* is greatly enhanced by the vertical lines of the strongly emphasized ribs, of which two on each side bear reduced replicas of the whole. As usual, the *śikhara* is crowned by an immense ribbed *āmaluka*, above which there is a pot-shaped finial (*kalasa*). The temple of Jagannātha, which dominates the cathedral town of Purī and has become famous as "Juggernaut"[1] throughout the world, is somewhat inferior in design and detail.

[1] The Jagannātha car festival is in no way different in principle from that of most other Hindū temples, and in any case human sacrifice would be unthinkable in connection with a Vaiṣṇava shrine. It is possible that the site was once Buddhist; the crude Vaiṣṇava trinity which forms the principal icon bears a strong resemblance to a modified *triratna* symbol.

Almost as famous is the much more beautiful, though sadly ruined Sūrya Deul (Sun temple, or "Black Pagoda") at Koṇārak, built between 1238 and 1264. This temple of the Sun differs in no structural essential from those already described, the most remarkable feature of what now survives being the roof of the *maṇḍapa*, or *jagamohana* as it is called in Oṛissā; this roof (fig. 217) is divided into three stages, instead of the two of the Liṅgarāja, and this arrangement, combined with the reduction of the number of cornices in the upper stage, at once lightens and ennobles the design. The *śikhara* is no longer standing; the base is represented as resting upon immense richly carved wheels and as drawn by galloping horses.

Most of the Oṛissan temples are adorned with decorative sculptures, the finest probably those of the Mukteśvara where the figures of Nāgas and Nāginīs are (particulary charming (fig. 219). Larger and more magnificent Nāgas and Nāginīs embrace the pillars of the Rājrānī porch. The great horse and the elephants that stand near the Koṇārak shrine are monumental and so too are the colossal human figures that stand on the upper stages of the *jagamohana*; the *śikhara*, or what remains of it, is covered with erotic sculptures of the most explicit character, illustrating all the *bandhas* known to the *Kāma Śāstra*. Some of the last mentioned sculpture is very beautiful, but the figure work here, and even that of the older Rājrānī has passed its zenith, and is often overstrained. That of the Vaitāl Deul at Purī has a decided elegance (fig. 218).

A group of brick temples at Viṣṇupur, Bāṅkurā District, Bengal, due to the Vaiṣṇava rājas of Mallabhūm, and dating between 1622 — 1758 is characterised by the use of a simple curved roof reproducing the form of the bamboo and thatch roofs of Bengālī and Oṛissan cottages, and recalling that of the Draupadī Ratha at Māmallapuram; and further, by an abundance of fine moulded brickwork[1].

As good examples of quite modern temples in the Nāgara style may be cited that built by the rāja of Benares at Rāmnagar about 1800; the Viśveśvara temple in Benares, rebuilt from the foundations in the eighteenth century; the temple of Scindia's Mother, and others associated with the cenotaphs at Gwāliar, built in the nineteenth century; the seventeenth century Jugal Kiśor and Madan Mohan temples at Bṛndāban; the nineteenth century Dharmanātha (Jaina) temple at Ahmadābād; the groups of sixteenth and seventeenth century Jaina temples at Sonāgaṛh in Bundelkhaṇḍ and Muktagiri in Berār; and amongst the many temples, *dharmśālās*, *ghāṭs*, and wells built by Ahalyā Bāī (1765—95), the Gristaneśvara temple at Elūrā. In all of these there is a tendency for the form of the *śikhara* to

[1] A. S. I., A. R., 1921—22, p. 25. Moulded bricks from this and many other localities such as Hūghli, Dinājpur, Paṇḍuā, &c., are well represented in the Baṅgīya Sāhitya Pariṣad, Calcutta, see Ganguly, M., 2. For a temple of this kind at Kāntanagar, see Fergusson, 2, vol. II, p. 160.

become smooth and straight-sided, with abundant reduplication of the main form on a smaller scale.

The Golden Temple begun by the Sikhs at Amritsar in the reign of Akbar, and rebuilt in 1766 is a square two-storied building in an eclectic style, decorated largely with marbles taken from the tomb of Jahāṅgīr. Much of the interior woodwork is admirably ornamented with ivory inlay, in a manner still extensively practised at Amritsar and Hoshiārpur[1].

The temples of the Vesara or later Cāḷukyan style[2] are widely distributed in Dhārwār, Maisūr (Mysore) and the Dekkhan, and as their geographical position might lead us to expect, are to a large extent intermediate in character, combining Nāgara and Drāviḍa elements, and with peculiarities of their own. In the fully developed type the conspicuous features are the relatively low elevation and wide extension, star-shaped plan, the grouping of three shrines about a central hall, pyramidal towers not distinctively storeyed as in typical Drāviḍa temples but carrying upward the indentations of the shrine below, elaborate pierced windows, cylindrical polished pillars, elevated basements in several richly decorated tiers, and very great elaboration of the sculptured decoration.

The Vesara style developed in the Dhārwār District and is there exemplified in the fine Śaiva shrines at or near Ittagi and Gadag dating in the tenth and eleventh centuries. One of the latest twelfth century examples is that of Doḍḍa Basavanna, consisting of a shrine and *maṇḍapa*, both star-shaped in plan, the rectangular projections in the one case representing the corners of six, in the other of eight intersecting squares; the architectural design is of exceptional beauty, and the carving the richest and most elaborate of any building in Western India[3].

The style attained its fullest development in Maisūr under the Hoyśalas. The most famous temples are those at Doḍḍa Gaḍavaḷḷi, Somnāthpur, Belūr, and Halebīd[4].

The Keśava temple at Somnāthpur is a triple shrine attached to a central pillared hall, the whole enclosed in a square cloistered court. At Belūr there is a complex of five or six temples and subordinate buildings surrounded by a high wall with two fine *gopurams* on the east. The decoration of the pierced windows of the main *maṇḍapa* is especially rich and varied. The Kedareśvara shrines at Balagāmi and Halebīd are equally richly ornamented. The extreme limit of abundant and

[1] Cole, H. H., *Golden Temple at Amritsar*, J. I. A., vol. 2, 1888; Ellis, T. P., *Ivory carving in the Panjab*, J. I. A., vol. 9, 1902.

[2] For Cāḷukyan temples see especially Fergusson, 2, vol I; Cousens, 6, 8, 9; Havell, 4; Yazdani; Kramrisch, 2, pls. 35—37; Workman, in J. R. A. S., 1904; Burgess, 8, pls. 311 to 314; A. S. I., A. R., pt. 1, 1914—15, p. 9.

[3] A. S. I., A. R., 1914—15, pt. 1, p. 9, and pl. VIII.

[4] Narasimachar, 1, 2, 3; Cousens, 8, &c.

elaborate ornament is reached in the unfinished Hoyśaleśvara temple at Halebīd where the unstinted labour expended in carving a stone that is soft when quarried but hardens on exposure has clothed the entire building in an almost incredibly abundant *parure*. The basement exhibits a succession of animal friezes following all its indentations, representing elephants, horsemen, *sārdulas* or *vyālas*, and scenes from the *Rāmāyaṇa*, above this a deep frieze of gods and *āpsarases* in niches in high relief, interrupted by pierced windows and turned pillars. Yet in spite of all this richness of detail, the decoration does not obscure the main structural lines (fig. 211).

Cālukyan sculpture exhibits the same characteristics; most of it is in very high relief, deeply undercut, and most elaborately decorated (fig. 224, 225). The bracket figures of many temples afford typical examples; they reproduce the ancient motif of the woman and tree; they are unmistakeable descendants of the oldest Kuṣāna and pre-Kuṣāna forms, with the dwarf bearer now detached to form an abacus support below the main figure[1]. The intention is sensuous, but the treatment is wiry, and lacks the true *volupté* of the Sāñcī dryads. An example at Nārāyaṇpur is nude. At Palampet the tree-women are replaced by danseuses or *āpsarases*, in technical dance poses, in one case nude.

The chief seat of the Jainas in Southern India, Śravaṇa Belgoḷa, Hāsan District, Maisūr, contains innumerable shrines, some being situated in the village itself, others on the two hills, the Cikka and Doṭṭa Beṭṭas. The term *beṭṭa* is applied to a special form of shrine consisting of a courtyard open to the sky, with cloisters round about and in the centre a colossal image, not of a Tirthaṁkara, but of a saint. By far the most remarkable of these is the great image of Gommaṭeś-vara on the Doḍḍa-beṭṭa hill, fifty-seven feet in height, thus one of the largest freestanding images in the world. It was set up, or rather, carved *in situ*, for Cāmuṇḍa Rāja about 983 A. D. The saint, who was the son of the first Tīr-thaṁkara, and resigned his kingdom to become an ascetic, is represented in the immoveable serenity of one practising the *kāyotsarga* austerity, undisturbed by the serpents about his feet, the ant-hills rising to his thighs, or the growing creeper that has already reached his shoulders. Another figure at Ilivālā is over twenty feet in height. There exist also statues to Bharateśvara, the saint's brother. The treatment is very formal.

Ordinary temples known as *bastis* and containing images of Jinas are like-wise abundant at Śravaṇa Belgoḷa, most of them being in Coḷa-Drāviḍa style and dating from the eleventh or twelfth century. At least two metal images of about the same date are still in private possession in the village; an example from the

[1] Cousens, 8, pl. 29; Yazdani; Smith, 2, fig. 156; Kramrisch, in Jahrb. as. Kunst, 1, 1924, pl. 52.

same district is illustrated in fig. 234. The Jaina *matha* or monastery in the village is decorated with paintings of scenes from the life of certain Tīrthaṁkaras and Jaina kings[1].

A more peculiar type of Jaina temple is represented in the Kannaḍa (Kanara) country below the *ghāṭs*, especially at Mūdabidri near Mangalore. The style belongs to the time of the kings of Vijayanagar, and is characterised by its sloping roofs of flat overlapping slabs, and a peculiar kind of stone screen enclosing the sides, recalling a Buddhist railing. The nearest analogy for the sloping roofs is found in the Himālayan forms, and some authors have assumed a connection of style between Kannaḍa and Nepāl; more likely similar conditions have produced similar forms, the Kannaḍa roofs being well adapted to the excessive rainfall below the *ghāṭs*[2].

Figures of Gommaṭeśvara are not found in northern India. But there is a series of rock cut temples, and colossal images at Gwāliar. Most of the excavated shrines are mere niches containing the statues, all of which represent Tīrthaṁkaras, the largest being fifty-seven feet in height[3].

Strictly analogous to the mediaeval painting of Bengal and Nepāl is that of the illustrated manuscripts of the Gujarātī school. Here too we have a series of constantly repeated compositions, varying only in unimportant details, and clearly indicating a long precedent tradition. As before, the pictures form square panels of the height of the page, occupying spaces left for them in advance by the scribe, and in many cases the subjects are identified by brief legends. In accomplishment, and in detachment from all preoccupation with effect or with emotion, they rank indeed, although represented by examples of later date, above the works of the Eastern school. With one exception, to be referred to below, all the Gujarātī works are illustrations of Jaina texts, and in almost all cases of the *Kalpa Sūtra*, a work dealing with the life of Mahāvīra and certain other Tīrthaṁkaras, and another poem, the *Kālikācārya Kathā*, which is an edifying tale describing the faithful dealings of the holy monk Kālika with the wicked king Gardabhilla[4].

[1] For Śravaṇa Beḷgoḷa see Narasimachar, 4. The Jaina image, fig. 234 has been published by Hadaway in Rūpam, 17, 1924. Other early Jaina bronzes include one published by Nahar and Ghose, *Epitome of Jainism*, and one in the Barton Museum, Bhavnagar, examples of later date are common, cf. Coomaraswamy, 9 (2), pp. 142—5; Hadaway, 4; Luard, in J. I. A., vol. XXI; Rivett-Carnac, in J. I. A., vol. IX; Hendley, T. H., in J. I. A., vol. XVII, 1916; Narasimachar, *loc. cit.*, &c. The painting in the Jaina *matha* at Śravaṇa Beḷgoḷa is illustrated by Narasimachar, pl. XLVIII. Another example of a southern Jaina painting, of uncertain date is preserved on the ceiling of a Jaina temple at Kāñcīpuram (fig. 256); another, ascribed to the eleventh century at Tirumalai, N. Arcot District (Epigraphia Indica, IX, 229).

[2] Cousens, 8 (p. 34) and 9; Fergusson, 2, vol. II, pp. 75ff.; A. S. I., A. R., 1914—15, pt. 1, d. 9.

[3] Fergusson, 2, vol. II, p. 48.

[4] For full descriptions and illustration of paintings in Jaina manuscripts see Hüttemann; Coomaraswamy, 9 (4); and Glasenapp.

Only one example of an illustrated *Kalpa Sūtra* on palm leaf is known, dated equivalent to 1237 A.D. and now preserved in a *bhaṇḍār* at Pāṭan[1]. Several examples on paper, dated in the fifteenth century are known, others undated, and others of later date[2]. The paper manuscripts reproduce the form of the old palm leaves, the illustrations being arranged in the same way (fig. 255). It is indeed characteristic of the illustrated manuscript in India, that the picture bears no organic relation to the page, and merely occupies a space (*ālekhya sthāna*) left un-filled by the scribe for the purpose; in all probability scribe and painter were always different persons. The style is one of pure draughtsmanship; the colour is indeed brilliant, but it is the outline that establishes the facts, and this outline, though exceedingly facile and almost careless, is very accomplished, and very legible. In many cases the execution might well be called brilliant, and this applies as much to the tiny thumb-nail indicatory sketches in the margins as to the finished miniatures. The variety of scenes and circumstances represented is very considerable, and the pictures afford valuable information on contemporary, or more probably, considering the conservatism of the style, earlier than fifteenth century manners, customs and costumes.

Another document of the same school is a manuscript of the Gujarātī poem, *Vasanta Vilāsa* (fig. 257), now in the possession of Mr. N.C. Mehta. Quite exceptionally, this manuscript is in the form of a scroll, verses of the text alternating with the painted panels, seventy-nine in number, by which it is fully illustrated. The poem describes the pomps and glories of the Spring, and the paintings, in consequence are all of a lyrical character, and as such unique in the Gujarātī school. In point of style, they are absolutely identical with those of the religious manuscripts, and may have been executed by some of the very same artists. The *Vasanta Vilāsa* was written, according to the colophon, at Ahmadābād in the year 1415 A.D.[3].

It may be remarked that all the Gujarātī painting exhibits marked peculiarities in the delineation of the human form, the most conspicuous being those of the three-quarter profile position, in which the further eye protrudes unnaturally, and the long pointed nose projects beyond the outline of the cheek. The expansion of the chest, moreover, is so much exaggerated, that it is often difficult to distinguish a man from a woman. Of these peculiarities the bulging eye and projecting pointed nose are met with already in the eighth century frescoes of

[1] Nahar and Ghose, pp. 696, 706.

[2] Beside those in Boston, there are good examples in the India Office Library and in the British Museum, London, in the Museum für Völkerkunde and the State Library, Berlin, in the Freer Gallery, Washington, U. S. A., and in the collections of P. C. Nahar, and A. Ghose, Calcutta, and of P. C. Manuk, Patna, as well as others in the Pāṭan *bhaṇḍārs*.

[3] Mehta, 1; Gangoly, 3.

Elūrā (fig. 196); Gujarātī painting is no doubt a continuation of the early western style, referred to by Tāranātha as that of the "Ancient West", the Rāṣṭrakūṭa and perhaps Paramāra frescoes of Elūrā representing an intermediate stage in the development. The wall paintings of Śravaṇa Belgola and Kāñcīpuram referred to above, are of course, in another and southern (Drāviḍa) style.

In the later mediaeval period, from the fifteenth century onwards, but more especially in the seventeenth and eighteenth centuries, the use of stone for palace and domestic architecture became general in Rājputānā and Bundelkhaṇḍ; twenty or thirty royal residences in Central India, and numerous cities are remarkable for their interest or beauty, nor are the traditions of civil architecture of this kind by any means yet altogether lost[1].

The immense palace at Gwāliar (fig. 252), which extends along a great part of the edge of the vertical cliff of the ancient fort is due in part to Mān Siṅgh (1486—1518), his successor Vikrama Śāhi, and in part to Jahāṅgīr and Shāh Jahān in the time of Mughal occupation. Along the outer walls tall towers alternate with flat surfaces, the domes of the towers formerly covered with gilt copper, the walls still preserving much of their inlay of enamelled tiles representing conventional trees, men, elephants, tigers, and ducks. The two great gates, the Hiṇḍola and Hāthī Paur guarding the steep road leading to the summit, the latter an integral part of the façade, date from the fifteenth century, and are in the same grand style as the palace itself; the same applies to the Gujarī Mahal at the foot of the hill, now used as the Museum.

The magnificent palaces at Datiā (fig. 254) and Orchā built by Bīr Siṅgh Deva in the seventeenth century, the former a large architectural block over a hundred yards square; the garden and water palace at Dīg (fig. 253) with its great double cornices, built by Sūraj Mall in the second quarter of the eighteenth century; the palace at Amber, the former capital of Jaipur State, built by another Mān Siṅgh and by Jaisiṅgh I in the seventeenth century; the imposing palace at Udaipur, the capital of Mewāṛ since 1568, of various dates (Baṛī Pol, 1600; Tripulia Gate, 1725; Rāī Aṅgan, 1571; Chīnī kī Citra Mahal, 1725—34; Baṛī Mahal or Amar Vilās, 1699—1711; Karan Vilās, 1620—1628, exhibiting nevertheless a real unity of style, and the Gul Mahal, 1640, on the Jagmandir island, and Jagnivās, 1740, on another island in the lake, composing an ensemble of the most romantic beauty); and the Jodhpur fort with its tremendous bastions, and the fairylike Old Palace on its summit, dating from the seventeenth century, are the most important examples of Rājput civil architecture. Many of the Rājput princes built or still possess palaces along the river edge (*ghāṭs*) at Benares, and some

[1] Cf. Sanderson and Begg; Growse. The best work of the present century is the Mahārāja's private railway station at Jaipur. For modern religious building see p. 125.

of these, built as late as the nineteenth century are very noble structures; the best is perhaps that of the Rāja of Nāgpur, at the Ghōslā Ghāṭ. Other fine *ghāṭs* are those of Ahalyā Bāī at Māheśvar on the Narmadā, and those at Ujjain.

During the last three centuries Rājput princes have erected near most of the great capitals beautiful pillared cenotaphs (*chatrī*) marking the cremation sites of successive rulers. The most picturesque group of such buildings, with types ranging from little domed canopies with four pillars to large octagonal domes with as many as fifty six pillars. At first sight tombs of this kind have a Muḥammadan air, but in fact all their details are Hindū, and in principal the construction does not differ from that of the earliest pavilion of the same type represented at Amarā-vatī (fig. 146). The best examples are those at Udaipur, of seventeenth and eigh-teenth century date, and those of Jodhpur, Chaṇḍor, and Jaipur.

The later development of Dravidian art must be considered more briefly. We can distinguish the following styles: 1. Pallava, already discussed, the only one in which cave temples appear, 2. Coḷa (850—1100), 3. Pāṇḍya (1100—1350), 4. Vijayanagar (1350—1600) 5. Madura (1600 to present day).

Coḷa: the classic examples are the great *vimānas* at Tanjore built by Rājarā-jadeva Coḷa about 1000 A. D., and at Gaṅgaikoṇḍapuram, built by his son Rā-jendra Coḷa about 1025. The former (fig. 235) consists of the temple proper, two *gopurams* and another small shrine; everything else, and particularly the Subrah-maṇiya shrine, is later. The *vimāna*, is actually as well as relatively to the temple adjuncts, of enormous size; grandeur is achieved with very little loss of simplicity. The straightsided square pyramid of the tower rises in fourteen storeys, each decorated with *pañcarams*, and the whole is surmounted by a dome; the lowest storey and the body of the temple are of almost equal elevation. All the deco-ration is subordinate to the outline of the main form. Another very important *vimāna* of the Coḷa period is the Koraṅganātha temple at Śrīnivāsanalūr, nearly a century older than the two last mentioned.

Peculiarities characteristic of this stage in the Dravidian evolution include the very large abacus of the capital, the simple angular form of the bracket (no hint as yet of the pendent lotus), the decorative pilaster between the niches, the deve-lopment of the old niche- reliefs into full-round statues, and the development of the *makara toraṇa* (the *makaras* still with pendent floriated tails) towards the later circular glory (*tiruvāsi*).

Pāṇḍya: examples of the great *gopuras* of this period are to be found at Śrīraṅgam, Cidambaram, Kumbakonam, Tiruvannāmalai (fig. 237); these gate towers are themselves as large as the Coḷa *vimānas*, and from this period onwards we find the actual shrines dwarfed by the enclosing walls and gates. The vertical band of the old Pallava bracket has now developed into a small pendent, without

as yet approaching the lotus in form; in the fourteenth century, however, the vertical face of the bracket bears a lotus in low relief.

Vijayanagar: examples of the great pillared *maṇḍapams* of this period are to be found at Kāñcīpuram (Ekāmranātha temple), Vijayanagar (Viṭṭhalasvāmin temple), Auvaḍaiyar Kovil (fig. 239), and Vellūr ("*Kalyāṇa maṇḍapam*"). The great city of Vijayanagar, which contains so many magnificent deserted shrines was founded about 1379 by Hari-hara II, who repulsed the Musalmāns, who had invaded the south between 1311 and 1319, and controlled the Dekkhan. In this way the south was for a long time protected from further inroads. The Vijayanagar power reached its zenith under Kṛṣṇa Deva Rāya (1509—1529) and Acyuta Rāya (1529—1542). Kṛṣṇa Deva was not only a great warrior, but a man of the highest cultivation, an impartial and lavish patron of all sects alike, a great builder and patron of literature. The magnificence of Vijayanagar has been described by contemporary Arab and Portuguese writers[1]. Abdu'r-Razzak remarks that "all the inhabitants of the country, whether high or low, even down to the artificers of the bazaar, wear jewels and gilt ornaments in their ears and around their necks, arms, wrists and fingers": he describes, too, an avenue with figures of lions, tigers, panthers and other animals on each side "so well painted as to seem alive". Paes describes a room in the palace (ca. 1522) "all of ivory, as well the chamber as the walls from top to bottom, and the pillars of the cross-timbers at the top had roses and flowers of lotuses all of ivory and all well- executed, so that there could not be better". Only a few of the many Vijayanagar temples, Śaiva, Vaiṣṇava and Jaina, can be referred to here. The finest of all is the Viṭṭhala or Viṭhoba begun by Kṛṣṇa Deva in 1513 and still unfinished when the Vijayanagar empire was destroyed and the city sacked by the forces of the allied Dakhanī Sultāns in 1565. The pillared *maṇḍapas* of the shrine, the Kalyāṇa Maṇḍapam, and the stone car are especially noteworthy; the latter is composed of stone blocks so finely wrought that it has often been regarded as a monolithic. The Kadalaikallu Gaṇeśa temple is one of the most elegant in southern India; the plain walls and flat roof line of the cella, and the unusually tall pillars of the *maṇḍapam* produce an effect of simplicity and restraint rare at this time. The same plain cella walls, however appear in the curious oblong Anantaśayin temple at Hospet, of which the archaic-looking vaulted roof is apsidal at both ends. The Hazāra Rāma temple, probably Kṛṣṇa Deva's private chapel, is contemporary with and similar to the Viṭṭhalasvāmin, and equally typical of the period. The outer enclosure walls in both cases are covered with reliefs; the inner walls of the Hazāra Rāma with relief scenes from the *Rāmāyaṇa*. The remains of palaces and connected buildings consist partly of Indo-Saracenic structures, of which the Lotus Mahal is the best

[1] Sewell, A.; Longhurst, 2; Smith, 3 (quotations from Abdu'r-Razzak and Paes).

example, combining Hindū roof and cornices with Muḥammadan arches; and the massive stone platforms or basements which once supported elaborate wooden superstructures covered with gilt copper plates. Of these basements, Kṛṣṇa Deva's "Dasara Dibba", decorated with friezes representing Daśahrā and Holī festival scenes, is the best example. Much of the stone architecture evidently reproduces contemporary wooden and metal forms. The great temples of the Vijayanagar period at Tāḍpatri are remarkable for most elaborate but unfinished *gopuras* (detail, fig. 247).

The chief peculiarities of the style are as follows: the full evolution of the pendent lotus bracket takes place; the monolithic columns unite to the main straight-sided shaft a number of slender cylindrical "columnettes" with bulbous capitals (fig. 239); the roll cornice is doubly curved, the corners having upward pointing projections, the under side repeating the details of wooden construction.

The pillar caryatides, whether rearing lions or *yālis* (*gaja-siṁhas*) are products of a wild phantasy; at the end of the sixteenth century rearing horses are also found, provided with fighting riders and groups of soldiers below (fig. 240), but these are more especially a feature of the Madura style. Enclosing walls and basements are decorated with continuous reliefs representing epic and festival themes.

Madura: after the fall of Vijayanagar the Nāyyaks of Madura established an independent kingdom, the most important king and builder being Tirumala Nāyyak (1623—1659). As before, and as at the present day, the temples are in the purely Dravidian tradition, unaffected by any outside influences, while the palaces are half Hindū, half Muḥammadan in style. The well known Vasanta or Puḍu Maṇḍapam in front of the great Mīnākṣī temple is strictly speaking neither a *maṇḍapam* nor a "choultry" (travellers resting place), but a flat-roofed corridor with three aisles; it illustrates extremely well the most obvious feature of the style, appearing also in the 1000-pillared *maṇḍapam* of the great temple, viz. the pillar caryatides in full-round sculpture, representing deities, and in the case of one of the Puḍu Maṇḍapam pillars, Tirumala Nāyyak himself with his wives[1]. For the rest, the peculiar character of the style, so evident in the great temple at Madura, which for most tourists establishes the type of Drāviḍian architecture, is rather due to an exaggeration of already developed shapes than to any new development; it may be remarked however that the decorative pilaster has now become a *kumbha-pañcaram* i. e. it rises from a pot, and bears aloft a little pavilion, and that the pendent lotus bracket is so elongated as to touch the abacus of the capital.

The Subrahmaṇiya shrine at Tanjore, close to the great Coḷa *vimāna* is a simple

[1] This temple is evidently a later development of the Gupta type of temple 17 at Sāñcī; note especially the continuation of the porch roof as a moulding round the cella wall. The same applies to the little Dravidian shrine at Riḍī Vihāra in Ceylon.

example of the style, so far as the general form is concerned, but with characteristic and very elaborate decoration (fig. 238); it has been aptly compared to the work of the goldsmith executed in stone. The Drāviḍian tradition of temple building is very far from being extinct at the present day; the hereditary *śilpins* or *sthapatis* of the Kammālar caste, who, in their own estimation, rank with Brāhmans and are indeed the descendants of men who received great honour and high-sounding titles from builder kings, can still be seen at work (fig. 241), still making use of the *śilpa-śāstras*, either in Sanskrit versions or vernacular abstracts. The craftsman's methods and psychology survive unchanged and unmodified; for this reason a detailed study of the building of a modern temple, which no one has yet undertaken, is a very great desideratum; and indeed, it is only from the living craftsman that Jouveau-Dubreuil[1] who illustrates and briefly describes the twentieth century temple buildings at Tiruppāppuliyūr, was able to obtain the technical information which enabled him to prepare his masterly account of the development of Drāviḍian architecture. Here we can only refer briefly to the Ponambalavāneśvaran Kovil, still in process of construction near Colombo in Ceylon. The following data, for which I am indebted to my cousin, Sir Ponambalam Ramanāthan, are of interest: "The name of the temple I am rebuilding is Ponambala-vāna-Īśvaram, spoken of as "Ponambalavāneśvaran Kovil". Pon-ambalam in Tamil stands for the Sanskrit Kanakasabai. Since the beginning of the rebuilding, two śilpis or architects have come and gone. The third one's name is Sornakkāḷai Āsāri, which means "golden field artisan" (in building works). He is a Tamil man from South India, whose ancestors have followed the same profession. There are about 100 men working at the temple side and at the quarry side, all of them Tamil men from South India. The *śilpa śāstras* he uses are Kāśipam, Manusāram, Viśvakarmayam and Mayamatam, but, of course, the traditions which every workman is bound to remember and reproduce, according to the directions of the artist *(śilpi)*, are the very life of the written books[2]. "It is commonly supposed that our ancient architecture is a laboured creation of men according to their respective fancies and abilities, but our Śaiva Āgamas teach that the architecture of our Temples is all Kailāsa-bhāvana, that is, of forms (*bhāvanas*) prevailing in Kailāsa, which is on the summit of Mahāmeru far beyond the stratas of existence known as Bhuvar-loka and Svar-loka" (letter dated August 6, 1925).

The conception last indicated recurs many times in Indian literature whenever the work of the architect is mentioned; either he is inspired by Viśvakarmā, or

[1] Jouveau-Dubreuil, 1, vol. II, pp. 154ff. *L'architecture contemporaine.*

[2] For these and related books see Acharya; Coomaraswamy, 1, 13; Kramrisch, 1; Ram Raz; Rao, 1, 3. For printed texts, Bhoja; Kumāra; Mayamuni; *Viṣṇudharmottaram.*

he visits the heaven of Indra to bring back with him the design of some palace or temple there existing. In the same way the other arts, such as dancing, are practised on earth after a divine model[1].

The importation of craftsmen and labourers, including quarrymen, who have their own methods of obtaining the large stone beams required, is of interest in connection with the vexed question of the construction of Hindū temples in Farther India and Indonesia[2]. In my own view, it is far from unlikely that in some cases the whole of the work may have been done by workmen of Indian birth under the guidance of a *śilpin* using Indian *śilpa-śāstras*. Such workmen have moved from India to Ceylon in large numbers at various periods; the *Mahāvaṁsa* mentioned "craftsmen and a thousand families of the eighteen gilds" sent by a Pāṇḍyan king from Madura to Ceylon in the time of Vijaya. Twenty-three hundred centuries later the same process was going on in the reign of Kīrti Srī; and these eighteenth century Tamil *kammālars* are already indistinguishable in language and appearance from true Simhalese[3].

Fuller reference must be made to the later mediaeval southern school of bronze, more usually copper, rarely brass, founding. This art[4] was already practised under the Āndhras in the Kistna-Godāverī District (Veṅgī) and the Śaiva and Vaiṣṇava development must have been a continuation of the same tradition. We know from inscriptions that (presumably metal) images of Śaiva saints were set up in temples by Rājarājadeva Coḷa in 1014, and Vaiṣṇava images at least as early as the thirteenth century[5]. The great series of metal images in South-Indian style found at Poḷonnāruva in Ceylon cannot be later than the thirteenth century[6]. A Naṭarāja from Belūr is dated, but the reading is uncertain, either 910 or 1511[7]. The two great collections are those of the Colombo and Madras Museums, and there are important examples in Boston[8]. The main types represented are the various forms of Śiva, especially the Naṭarāja (fig. 242); Pārvatī (fig. 244); the Śaiva

[1] *Mahāvaṁsa*, XVII, 24, XXVII, 18, and XXXIII, 10, 18; Coomaraswamy, 2, Ch. V, and 14, p. 79. As remarked in the *Bṛhat Saṁhitā* "the science of house-building has come down to us from the *ṛṣis*, who had it from Brahmā".

[2] Bosch; Schoemaker; Groslier, 3, Ch. XIX.

[3] Coomaraswamy, 1, Ch. III. Cf. page 164, note 2.

[4] Sewell, R.; Rea, 4, 1908—09.

[5] Aiyangar, Essay XI.

[6] Coomaraswamy, 6; Arunachalam, 2.

[7] Hadaway, 2, the latter date more probable. The Naṭarāja type appears in stone sculpture, at Tanjore and Gaṅgaikoṇḍapuram, only in the eleventh century; cf. Jouveau-Dubreuil, 1, vol. II, pp. 28—30. The still older representations of Śiva dancing are of other, and usually six-armed types.

[8] Coomaraswamy, 6 and 9 (2); Rodin, Coomaraswamy and Goloubew. For others in English collections, India Society, 1. There is a fine stone fragment in the Victoria and Albert Museum, London.

saints, Māṇikka-Vāsagar, Tirujñānasambandha-Svāmi, Appar-Svāmi, and Sundaramūrti-Svāmi (fig. 243), all of whom lived before the tenth century; Viṣṇu (fig. 246) and Lakṣmī; Kṛṣṇa; Rāma; the Vaiṣṇava saints called Āḷvārs; and figures of royal donors (fig. 245). The art is still practised by Kammālar *sthapatis* in the Madras Presidency, and some modern productions are very nearly as good as those of the seventeenth or eighteenth century. But the earlier work has full and rounded forms, the later is relatively attenuated and sharply outlined.

The Naṭarāja type is one of the great creations of Indian art, a perfect visual image of Becoming adequate complement and contrast to the Buddha type of pure Being. As remarked by Kramrisch, its finest realisations exhibit a "sinnlich reifste Körperlichkeit voll plastischer Bewegung mit geometrischer Allgemeingültigkeit verschmolzen". The movement of the dancing figure is so admirably balanced that while it fills all space, it seems nevertheless to be at rest, in the sense that a spinning top or a gyrostat is at rest; thus realising the unity and simultaneity of the Five Activities (*Pañcakṛtya*, viz. Production, Maintenance, Destruction, Embodiment and Release) which the symbolism specifically designates[1]. Apparently the type appeared in the Cōḷa period; it is now very widely distributed in the South, in innumerable examples still in *pūjā*.

RAJPUT PAINTING

Rājput painting is the painting of Rājputāna and Bundelkhaṇḍ, and the Pañjāb Himālayas. The known examples ranging from the latter part of the sixteenth into the nineteenth century fall into two main groups, a Rājasthānī (Rājputāna and Bundelkhaṇḍ), and a Pahāṛī. The latter group is again divisible into a school of Jammū, with reference to all the Hill States west of the Satlaj, and a school of Kāṅgṛā, with reference to all the Hill States of the Jālandhar group, east of the same river. With Kāṅgṛā is included Gaṛhwāl, a Hill State east of Simla, which derived its style diretly from Kāṅgṛā at the end of the eighteenth century. Sikh painting, mainly done in Lahore and Amritsar in the time of Ranjīt Siṅgh and Sher Siṅgh (together about 1790 to 1843), is also an immediate derivative of the Kāṅgṛā school.[2]

It is important to understand the relation of Rājput to Mughal painting. Pure types of either can be distinguished at a glance, usually by their themes, always by their style. Thus Mughal painting, like the contemporary Memoirs of

[1] For the symbolism, &c., see Coomaraswamy, 9 (2), pp. 87 ff., and 14; Rodin, Coomaraswamy and Goloubew; Kramrisch, 2, pp. 71, 83, 87; Jouveau-Dubreuil, 1, vol. II, p. 28. The *śāstraic* prescription is given in full by Rao, 1. Further details in A. S. I., A. R., 1922—23, p. 143. The linear composition has been discussed by Hadaway, 5.

[2] Coomaraswamy, 8, and 9 (5), the latter with full Bibliography; Diez; Goetz, 1, 2, 3, 4, 8; Mehta, 2; Gangoly, 2; a large work on Rājput painting is announced by Gangoly.

the Great Mughals, reflects an interest that is exclusively in persons and events; is essentially an art of portraiture and chronicle. The attitude even of the painters to their work is personal; the names of at least a hundred Mughal painters are known from their signatures, while of Rājput painters it would be hard to mention the names of half a dozen, and I know of only two signed and dated examples. Mughal painting is academic, dramatic, objective, and eclectic; Rājput painting is essentially an aristocratic folk art, appealing to all classes alike, static, lyrical, and inconceivable apart from the life it reflects. After Akbar, Mughal painting is almost devoid of any poetical background; in the words of Jahāngīr (when still Prince Daniyāl) "The old songs weary my heart ... the love-story of Farhād and Shirīn has grown old and lost its savour ... if we read at all, let it be what we have seen and beheld ourselves"[1]; Rājput painting, on the other hand, illustrates every phase of mediaeval Hindī literature, and indeed, its themes cannot be understood without a thorough knowledge of the Indian epics, the Kṛṣṇa Līlā literature, music, and erotics.

Technically and stylistically the differences are equally clear, most of all perhaps when Mughal painting deals with Hindū themes, as in the *Razm Nāmah* and *Rasikapriyā*. Apart from the illustration of manuscripts, in direct continuation of Persian tradition, Mughal painting is essentially an art of miniature painting, and when enlarged, becomes an easel picture; Indian manuscript illustrations are very rare, and in a totally different tradition (see p. 120), and Rājput painting enlarged, becomes a mural fresco, historically, indeed, is a reduced wall painting. Mughal painting uses soft tonalities and atmospheric effects; Rājput colour suggests enamel or stained glass, and while it may be used to establish the planes, is never blended to produce effects. Mughal outline is precise and patient, Rājput interrupted and allusive or fluent and definitive, but always swift and facile. Relief effect is sought and obtained in Mughal painting by means of shading, and Rembrandt-like chiaroscuro is often introduced; Rājput colour is always flat, and a night scene is lighted as evenly as one in full sunlight, the conditions being indicated by accessories (such as candles or torches), rather than represented. Thus, in spirit, Mughal painting is modern, Rājput still mediaeval[2].

[1] *Burning and Melting, being the Sūz u Gudāz of Nau'i, translated into English* by Dāwud and Coomaraswamy, London, 1912, pp. 24, 25.

[2] It is unnecessary here to discuss in detail the Rājput elements present in true Mughal painting. These Indian elements are apparent in several directions, (1) the illustration of Hindū themes in the first quarter of the seventeenth century, (2) the adoption of Hindū costume at the courts of Akbar and Jahāngīr in the "Rajput period", (3) the fusion of themes and styles in the eighteenth century, especially in Oudh, producing mixed types, and (4) the fact that more than half of the Mughal painters were native Hindūs. All these conditions create resemblances between Mughal and Rājput painting, quite superficial in the case of 1 and 2, more fundamental in the case of 3 and 4.

One of the oldest Rājput paintings is probably the Kṛṣṇa Līlā theme illustrated in fig. 258, which, in style, lyrical theme and the representation of bees, and in the language of the superscription shows a relation to the Gujarātī painting of the fifteenth century.

More typical are the several series of Rāgmālā pictures (figs. 259, 260), known as S. 1., S. 2, etc.[1]. S. 1 and S. 2 may be dated in the latter part of the sixteenth century, certainly not later than 1600; these with four in the Ghose collection Calcutta, represent the purest Rājput style in its most vigorous form. Their most obvious features are the great vitality of the drawing and colour; the former analytic, or abstract, not so much representing forms as designating them with a maximum economy of means, the latter glowing like enamel, and used with organised skill to establish the planes. The painter is not concerned to create picturesque effects, but to state all the facts clearly, leaving these to evoke their appropriate and inevitable emotional reactions; he knows his audience and does not need to cross his *t*'s and dot his *i*'s and so proceeds in the boldest and broadest manner. The style itself is passionate rather than sentimental.

A little later, in another group, S. 3 (fig. 261) we can trace apparently a Mughal influence in the softer tonality. More often the colour retains much of its strength, but loses in coordination. The old compositions are copied again and again in the eighteenth century; the colour is brilliant, but not so deep as before, nor is it used with any plastic sense of space which is partially rendered by a semi-European perspective derived from Mughal art. Many popular works illustrating all kinds of subjects, and for the most part in a pure Rājput idiom have been produced in Jaipur throughout the nineteenth century, and in spite of the best efforts made by the local "School of Art", the old traditions still survive; even in the nineteenth or twentieth century a work like the "Pig-sticking" of fig. 263 could be produced, in which there are recognizable at once a force and a sense of beauty — note especially the horses' heads — worthy of a classic age.

On a much larger scale, in the eighteenth or at the beginning of the nineteenth century there still flourished a school of design on a larger scale to which are due the fine Rās Līlā paintings in the Jaipur Palace Library, and the cartoons from which they were prepared, now scattered amongst various museums (fig. 265)[2]. Actual mural decorations survive in a number of Rājput palaces (Datiā, Oṛchā, Udaipur, Bikanīr, and as external decoration in the case of even quite modern buildings (fig. 262).

[1] Rāgmālā pictures illustrate the thirty-six Rāgas and Rāginīs, musical modes, that is to say they depict the situations appropriate to the various moods expressed and evoked by the different modes. They are usually inscribed with the Hindī poems which describe the same situations, often in highly poetical and graphic fashion. For the different series and fuller details see Coomaraswamy, 8 and 9 (5) and references there listed.

[2] Mehta, 2, assigns these to the reign of Sawāi Jai Siṅgh II (1693—1743).

Portraiture is not the typical expression of Rājput art, nor on the other hand can its practise be ascribed wholly to Mughal influence. Such relatively early examples as exist (fig. 264) are of a rather more monumental character than is the case in even the best Mughal portraits; the Rājput manner is more abstract and flatter, more "ideal" and less intensely personal. These features are well seen to in some of the large portrait heads from Jaipur, seen at the Lucknow Exhibition in 1921; and this quality is transmitted to Mughal art when Rājput types are copied, of which the beautiful Head of a Girl in the Bodleian[1] affords a good instance.

The Rājasthānī physical type and even the manner of representation are indeed sometimes carried over into works that must have been done under Mughal auspices, such as the very lovely group of girls on a terrace also in the Bodleian[2]. On the other hand, in the eighteenth century there developed at the court of Oudh a mixed style ("Late Mughal") in which Rājput composition and elements of design are frequent, but where the treatment is generally inferior. In any case, when Rājput themes are taken over into Mughal art, it is for their picturesque and romantic character, rather than in their true significance; this is especially the case with the humorous Mughal treatments of Rāgmālā subjects.

A group of paintings in a somewhat different style emanating from the Pañjāb Himālayas, and especially from the Ḍogrā Hill States, of which Jammū was the wealthiest and most powerful, dates mainly from the earlier part of the seventeenth century. Apart from their style, many of these paintings (which are generally known to Amritsar dealers as "Tibati" pictures) are recognizable by their inscriptions in Ṭākrī[3] characters, the peculiar illegibility of which often baffles the most ardent student. Characteristic examples of the Jammū school are illustrated in figs. 266, 267. The former belongs to a well-known series of unusually large *Rāmāyaṇa* pictures, dealing with the Siege of Laṅkā; here the drawing is not especially sensitive, but the whole design, the sense of space, and the glowing colour are all to be admired. An even more mural character is apparent in the Kṛṣṇa welcoming Sudāma (fig. 267). Other subjects commonly found in works of this school include *Rāgmālā* pictures with classifications and compositions different from those of Rājasthān, and series illustrating *Nāyaka-nāyakā-bheda*, or classification of heroines in accordance with their temperament, age and circumstances, following the works of the rhetoricians. Miscellaneous mythological subjects, other themes from the Kṛṣṇa cycle, and finally a series of portraits make up a

[1] Coomaraswamy, 3, 1910, pl. XV.

[2] Coomaraswamy, 8, pl. XX.

[3] See Grierson, *On the modern Indo-Aryan alphabets of north-western India*, J. R. A. S., 1904; Linguistic Survey of India, Vol. IX, pt. 1; and Coomaraswamy, 8, p. 19.

considerable total. The portraits are mostly of the late seventeenth and eighteenth century; rather splendidly composed, they present a strongly marked local physical type with a retreating forehead; almost always we find fresh flowers worn in the turbans, which is a practise confined to the hills.

The other Pahārī school, that of Kāṅgṛā, with its offshoot in Garhwāl, and another derivative in the Sikh school of the Pañjāb, belongs essentially to the last quarter of the eighteenth century and earliest years of the nineteenth. A few of the pictures in which the colour is soft and powdery in effect may date from the earlier part of the eighteenth century, but the main development is due to the patronage of Rāja Saṁsār Cand, the last great Katoch ruler of Kāṅgṛā (1774 to 1823). Most of the work seems to reflect the periods of his residence at Sujān-pur near Nādaun on the Biās where he constructed lovely palaces and gardens, and spent his days in the intervals between his many wars in listening to the recitations of poets and the songs of musicians. Moorcroft records that he had in his posses-sion many paintings of "the feats of Krishna and Balaram, the adventures of Arjuna, and subjects from the Mahabharata".

This Kāṅgṛā, or Katoch school as it might well be called, is the third and latest of the three clearly defined groups of Rājput painting, and one of the most productive, despite its rapid development and comparatively short duration. Its favorite themes are the *Kṛṣṇa Līlā*, *Nāyaka-nāyakā-bheda*, especially sets of the *Aṣṭa-nāyakā*, *Śākta* subjects, romances taken from the epics, such as *Nala and Damayantī*, and others of later origin such as the *Hamīr-haṭh*, genre and portraiture; *Rāgmālā* series are altogether absent. The inscriptions are always in Nāgarī characters and for the most part represent texts of well-known Hindī poets, especially Keśava Dās. The scenes are laid for the most part in the fairy palaces and gardens of Nādaun, with the river Biās flowing amongst low hills in the back-ground, more rarely amongst the snow-clad peaks of the Himālayas, and in one or two examples we find representations of the deodār. The narrative and erotic themes provide, incidentally, a precious picture of intimate daily life at a Rājput court; this is especially the case with the *Nala and Damayantī* series, where marriage ceremonies, official duties, athletic exercises, daily prayers, meals, and love scenes are all represented. In addition to the costumes found elsewhere, there appears as a highly characteristic feature the *jagulī*, worn by women, a sort of empire gown fastening at neck and waist, opening between the fastenings and permitting a glimpse of the breasts, and with long tight wrinkled sleeves and a long flowing skirt. Examples of the Kāṅgṛā school are illustrated in figs. 268—271.

The style has completely changed. The intention is more realistic; Mughal and even European influences are not wholly absent, and to these must be ascribed the occasional rendering of dramatic night effects, in which deep shadows are

cast by torches, or the golden rain of fireworks stands out against a dark ground. But the great work of the school was to create a feminine type peculiar to itself, and of infinite charm; not robust, like the Rājasthānī types, but slender, and moving with an irresistible grace, intentionally accentuated by the long flowing lines of the drapery (fig. 271). Nothing, indeed, is more characteristic of the style than its use of flowing, unbroken lines, not ingeniously calligraphic like late Persian, nor boldly allusive like those of the early Rājasthānī school, but creating a pure melody. The painter uses this flowing outline unwearyingly to define and repeat the forms to which he is attached; thus the aesthetic purity of the work is less than that of earlier schools, much less than that of the Gujarātī manuscript illustrations, but the charm of the result is all-compelling and almost personal, like the grace of an individual woman. The Kāṅgṛā *qalm* is indeed a feminine art, contrasted with the masculine force of the early *Rāgmālās*; intrinsically an art of sentiment, rather than of passion. The same quality appears in the colour, which is pure and cool; it is used in a quite different way, not to establish the planes but to fill in the areas defined by outline, so that we have to do now with coloured drawings rather than with paintings. And in fact many of the most charming works of the school are those unfinished pictures and sketches in which the figures are still represented in outline, only the colouring of the background being partly completed (fig. 271).

A minor provincial school of painting appears in the Hill State of Gaṛhwāl about the close of the eighteenth century. Here already there lived the descendants of a family of Hindū painters, who had originally worked at the Mughal court, but had followed Prince Salīm, Aurangzīb's nephew, in his flight to the hills. Of these, Mola Rām, fifth in descent, b. 1760 and d. 1833, is the best known; and some signed and other attributed works, some in a late Mughal, but for the most part in the current style are undoubtedly from his hand[1]. On the whole, the work of the Gaṛhwāl school bears the closest possible relation to that of Kāṅgṛā; we may safely assume in this connection that as conditions in Kāṅgṛā became more and more unsettled, Kāṅgṛā painters sought elsewhere a patronage that could no longer be extended to them at home, and it is highly probable that some accompanied the two sisters of Anirudh (son of Saṁsār Cand, d. 1828) who were married to the Rāja of Gaṛhwāl.

In the Pañjāb the Sikh style covers the period approximately 1775—1850. As the Sikh culture was based on personal achievement, and lacked an aristocratic tradition, and as the Sikh religion has no mythology and no images, it was natural that the Sikh paintings should be mainly portraits, representations of the

[1] Coomaraswamy, 8, p. 23; Mukandi Lal, *Notes on Mola Ram*, Rūpam, 8, 1921; Guleri. The work of two other Gaṛhwālī painters, Mānaku and Caitu, has been described by Mehta (2).

Gurus, and of chiefs and courtiers singly or in *darbār*. In this respect the Sikh school was determined by conditions analogous to those which find expression in Mughal painting; but unlike Mughal art, it is derived directly from the formal, fluent style of the hills[1]. It was not an original art, but one created by selection, that is to say by the omission of religious and emphasis on personal motifs; it owes its special aspect more to the fact of its representation of Sikh types and costumes than to any new design. The best of the Sikh portraits are sensitively drawn and finely composed.

INDIAN ARTS AND CRAFTS

To give any adequate account of Indian arts and crafts, even as practised during the last three centuries, would require a volume scarcely smaller than the whole of the present work[2]. Under these circumstances it seems desirable merely to indicate in tabular form, with occasional comment, the leading types of technique. For this purpose a scheme is adopted similar to that used in Sir George Watt's *Indian Art at Delhi*, which embodies the very valuable and too little known results of Mr. Percy Brown's researches undertaken in connection with the great exhibition of Indian art held at Delhi in 1903. The best detailed account of the crafts practised in a single area will be found in my *Mediaeval Sinhalese Art*.

Metal work. (1) Iron and steel. The early knowledge of iron and steel has been referred to above, p. 34. The finest work in engraved steel is found in the weapons of Southern India[3]. Good work, but more like Persian is found in Rājputāna[4]. There exist many elegant types of iron writing styles[5].

(2) Brass. Brass and to a less extent copper are widely used amongst Hindūs for domestic utensils and ceremonial implements[6]. The commonest form is the small water vessel known as the *loṭā*, spouted forms of the same type likewise

[1] Gupta, S. N., *The Sikh school of painting*, Rūpam, 12, 1922; Coomaraswamy, 9 (5).

[2] See Watt; Birdwood; Mukharji, T. N., *Art manufactures of India*, Calcutta, 1888; Coomaraswamy, 1, 2, 4; Baden-Powell, *Panjab Manufactures*, Lahore, 1868—1872; Victoria and Albert Museum, London, *Portfolios of Industrial Art*; numerous articles in the Journal of Indian Art; and titles listed in Coomaraswamy, *Bibliographies of Indian Art*, Boston 1925, pp. 34-41.

[3] Watt, pls. 4, 66; Clarke, S. C., *Dravidian (Śivaganga) swords*, Burlington Mag. 29, 1916.

[4] For Indian weapons generally see Egerton, W., *Ill. handbook of Indian arms...*, London, 1880; Baden-Powell, B. H., *Indian arms and armour*, J. I. A., 6, 1896.

[5] Burkhill, J. H., *Fashion in iron styles*, J. A. S. B., N. S., VI, I (10).

[6] Hadaway, S., *Illustrations of metal work in brass and copper, mostly south Indian*, Madras, 1913; Coomaraswamy, 4; Ujfalvy, *Les cuivres anciens au Cachemire et au Petit-Thibet*, Paris, 1883, and *L'art des cuivres ancient dans l'Himalaya occidental*, Paris, 1884; Mukharji, *Brass and copper manufactures of Bengal*, Calcutta, 1894; and articles by Gait, Griffiths, Havell, Kipling, Rivett-Carnac, in J. I. A., vols. 7, 3, 1, 9.

dating from the remotest antiquity; the large South Indian type used for fetching water, and carried on the hip is especially handsome, and often decorated with engraved designs. The *surāhi* is an elegant vessel with a very long neck used for carrying Ganges water. The introduction of smoking at the beginning of the seventeenth century led to the development of handsome *huqqa* furniture, of which the main forms are the globular (seventeenth century, fig. 383) and inverted bell-shaped (eighteenth century) bowls, and the fine copper fire-bowl covers, often *ajourée* and silver inlaid, formerly made at Purnea near Murshidābād, Bengāl. The ceremonial vessels (*pañcpatr, acmani, dhūpdān* &c.) and lamps (*dīpdān, artī,* &c.) used in temple and personal ritual are found in an endless variety of fine and sometimes elaborately decorated forms[1].

(3) Gold and silver. Vessels and dishes of gold are naturally found only in royal use or as votive offerings; those of silver being more usual. The finest examples of gold known to me are the votive *dalamura taṭuwa* and *ran-vaṭaha-pata* in the Daḷadā Māligāwa, Kandy, Ceylon (figs. 381, 385), both decorated in exquisite taste with encrusted cabochon sapphires.

(4) Other alloys. The most important of these is *bidrī*, so called from Bidār in Haidarābād State. The colour is black, the basis of the alloy zinc, with the additional metals lead, tin, and copper. Boxes, *huqqa* bowls, and trays and basins are made of it, and almost invariably decorated with silver encrustation (fig. 382). The chief places of manufacture in the eighteenth century were in Lucknow, under late Mughal patronage, and in Haidarābād; and as remarked by Brown, it would require the production of a special treatise to give anything like a satisfactory conception of the many beautiful designs met with; the poppy, which occurs in design throughout India, may be specially mentioned.

(5) Applied decoration of metal. The principal forms are inlay and overlay of one metal upon another. In inlay and incrustation (damascening, *koftgarī*) a groove is made, and silver or gold wire inserted, and then hammered down; or an area is excavated, and undercut at the edges, a thin plate of silver or gold in the required shape applied, and the edges hammered down, holding it fast (figs. 384, 386). The best work was done in the Pañjāb in connection with the decoration of weapons in the Sikh period. A cheaper form of *koftgarī* known as *devālī* the surface of the metal is not engraved, but merely roughened, and then silver or gold wire is beaten on in the required designs. Both forms are practised all over India and in Ceylon.

Similar decoration is applied to brass, as in the mounting of the Siṁhalese *hak-geḍiya* of fig. 390. Niello is rarely applied to brass (fig. 384) more often to

[1] For temple lamps see especially Gangoly, O. C., *South Indian lamps*, J. I. A., 17, and Burlington Mag., July 1916; Watt, pl. 12. For Nepalese incense burners, Gangoly, 5.

silver. Enamel is applied to gold and silver objects of some size, such as scent sprinklers and *huqqa* bowls (fig. 379), and to the handles of weapons, of which there are superb examples in the collection of the Mahārāja of Cambā[1]. In imitation enamel, good effects are still obtained by the craftsmen of Morādābād; the surface of the metal is excavated in champlevé style, and filled in with hot wax and when the whole surface is rubbed down and polished, the design stands out in metal on a coloured surface. Copper, brass, gold and silver are also commonly decorated by repoussing or chasing. Thin objects such as trays are of course beaten, heavier ones are cast by the *cire perdue* process, and turned on the lathe.

Jewellery[2]. Jewellery is made and worn in quantity and great variety by all classes throughout India and Ceylon; the materials range from real flowers, to base metal, silver, and gold. Many, perhaps most, of the metal forms bear the names of, and approximate in form to floral prototypes. Space will not permit of a description of the forms, and only the leading technical process can be referred to. No finer effects are produced than in gold enamelling[3]; a cream ground, with designs in bright red and green are usual (figs. 370, 371, 372), the metal being excavated (*champlevé*) and the colour filled in and fired. The art is typically North Indian; it is especially associated with Jaipur, where the best work has been done, but seems to have originated in Lahore, still the source of the raw material. Cheaper work is applied to silver, in this case the colours being usually blue and green. The use of enamel in Siam is presumably of Indian origin; the art is unknown in southern India and Ceylon, and in the Indonesian islands. Typically Indian is the incrustation of gold and silver with gems (fig. 376), by the process of gold-embedding[4]; each stone rests in a separate cell, and is held in place by a bezel of soft gold shaped and pressed into shape by a steel tool. It should be observed that all gems used in this way are cabochon cut, the object of the Indian jeweller being to produce, not a flashing, but a fully coloured effect; this use of gems as colour, rather than as light, is one of the chief virtues of Indian jewellery, modern facetted European jewellery always seeming vulgar by contrast. Another typical and very ancient technique is that of filigree or wire and pip, the wire and tiny balls of gold being applied to the surface of the object to be decorated (figs. 368, 375). Other objects are made in a similar way, many small shaped pieces of gold being first prepared, and then joined together to make an elaborate design (fig. 369).

[1] Watt, pl. 68.

[2] Birdwood; Havell, in J. I. A., vols. 3, 5 and 6; Hendley, T. H., *Indian jewellery*, J. I. A., vol. 12, also in vol. 4; Marshall, 11; Vinson, *Les bijoux du pays Tamoul*, Pondicherry, n. d.; Coomaraswamy, 1, 4; Fischer, L. H., *Indischer Volksschmuck* . . . Ann. K. K. Naturhist. Hofmuseum, Wien, 1890; Haberlandt, M., *Völkerschmuck* . . . Leipzig, 1906.

[3] Hendley, in J. I. A., vol. 1 (staff of Mahārāja Mān Siṅgh); *Jeypore enamels*; Birdwood.

[4] Method described, Coomaraswamy, in Spolia Zeylanica, 6, 1909.

Other jewels are made in finely chased or repoussé metal. A very fine example of a gold bead worn by a South Indian Brāhman is illustrated in fig. 374; here the whole bead is covered with figures of deities, in minutest detail.

The *cire-perdue* process is well illustrated in the Būndī (Rājputāna) method of casting flexible anklets (*sānt*) of base metal in a single mould. A composition of wax, resin, and oil is prepared in a long string, and twisted spirally round a stick of the diameter of the proposed links. One cut along the stick separates the links, which are then interlaced every one into two others, and each joined up by the application of a hot knife edge. When sixty or seventy rings are thus united, the ends of the chain are joined, and the whole gently manipulated and flattened until it forms a perfectly flexible model of the future anklet. It is then dipped into a paste of clay and cowdung, and finally enclosed in an outer layer of clay; when dry, the mould is scraped until a small piece of each link is just visible, then a wax leading line is attached all round, and the whole again covered. Two such moulds are cast at once side by side, the two leading lines being brought up into a hollow at the top of the mould; this hollow is filled with metal and borax, and then covered with clay, leaving only a small blow-hole. When this mould is placed in a furnace and fired, the wax melts and the metal takes its place; and when the mould is afterwards opened, it is only necessary to remove the leading lines and file down irregularities, to have a flexible anklet ready for use.

Ivory[1]. The use of ivory, which dates from the earliest times, must necessarily belong to the large group of crafts of non-Āryan origin in India. It has been used for an enormous range of purposes, from sacred images to dice, but never more successfully than in the form of carved or pierced plaques applied to architectural and other woodwork. Good examples of inlaid doors are found in Rājputānā (Bikanīr); at the Ridī Vihāra, in Ceylon, the combination of pierced carved ivory with the ebony of the door frame is especially admirable (cf. fig. 388). Engraved and carved plaques applied to small two-wheeled carriages are illustrated in figs, 387, 389; musical instruments, especially in Rājputānā and Southern India are often beautifully decorated in a similar way. The turning of ivory has also been developed in great perfection, especially in Ceylon, where large scent sprays are made, so thin that the ivory container can be as easily compressed as a metal oil-can.

The very early use of conch or chank (*śankha*) of which bracelets are made has been alluded to above[2]. It need only be remarked that the whole shell, used

[1] Watt, pl. 76—79; Coomaraswamy, 1, 4; Kunz, G. P., *Ivory and the elephant in art*, New York, 1916; Burns, Donald, Ellis, Pratt, and Stubbs in J. I. A., 9, 1902; Cole, H. H., *Golden temple at Amritsar, ibid.*, 2, 1888.

[2] Watt, pp. 101, 172; Hornell. *Supra*, pp. 4, 6.

as a trumpet, is often elaborately decorated with metal mountings, and may be decorated with engraved designs, filled with wax (fig. 390).

Textiles. Indian textiles are deservedly famous, and have been articles of export to Europe since the Roman period, and probably earlier[1]. The following classification based entirely on the technical means employed in producing the design will give an idea of their range and interest:

The only process by which the design is, so to speak, created before the weaving is begun[2], is the very interesting one employed in the *paṭola* silk of Gujarāt. Here each of the warp, and usually also of the weft threads, is separately dyed in various colours along its length according to precalculated measurements, and arranged on the loom, so that as the weaving progresses, the design appears, and is the same on both sides of the material. The process is most laborious, but no other can produce the same effect. The same technique (but the warp threads only are tie-dyed) is employed in the preparation of striped *mashrus* used mainly for *paijāmas* by Hindū and Sikh women; some of the finest of these are made in Cambā (gold and cotton thread, the former tie-dyed); others at Ayyampeṭ in the Tanjore District. Not only is the technique thus widely distributed in India, but it occurs sporadically over the entire area extending from Turkestān and Persia (*daryāī* silks and velvets of Bokhāra, &c.) on the one hand and on the other to Burma (Kāchin skirts), Cambodia, Malaya (Tringannu), Sumatra (Palembang), Java, Bali, Sumba (fig. 400) and other islands, and in a simple form (*kasuri*) to Japan. It is unknown in Ceylon. In the islands, the double dyeing (warp and weft) is practised only in the case of the cotton cloths made in Tengānan (Bali); in all other cases only the warp threads are dyed; but Indian *paṭola* silk has also reached Bali by way of trade. In the islands the technique is known as *ikat*, as mentioned on p. 212. In the case of the most elaborate work (Gujarāt) designs with flowers, elephants or birds enclosed in a geometrical trellis are produced

[1] For Indian textiles, see South Kensington Museum, *Illustrations of the textile manufactures of India*, London, 1881; Baker, G. P., *Calico painting and printing in the east Indies . . .*, London, 1921; Coomaraswamy, 1; Hadaway, S., *Cotton painting and printing in the Madras Presidency*, Madras, 1917; Hunter, S. L., *Decorative textiles*, Philadelphia, 1918; Jasper en Pirngadie; Lewis, A. B., *Block prints from India*, Chicago, 1924; Perera; Ray, J. C., *Textile industry in ancient India*, J. B. O. R. S., III, 1917; Riefstahl, R. M., *Persian and Indian textiles*, New York, 1923; Rouffaer en Juynboll; Scherman, E., *Brettchen-Webereien . . .*, Münch. Jahrb. der bild. Kunst, 1913; Watson, J. F., and Kaye, J. W., *Textile manufactures and costumes of the people of India*, London, 1886; Watt (the best account); also Banerji, Brandon, Das, Edwards, Enthoven, Gupta, Hailey, Hardiman, Havell, Kipling, Ravenshaw, Samman, Silberrad, Steel, Thurston, and Wardle, in different vols. of J. I. A. For Indian rugs, the usual books on rugs, and Andrews, F. H., in J. I. A., 11, 1912; Hendley, T. H., *Asian carpets . . . from the Jaipur palaces*, London, 1905; Watt.

[2] Ali, A. Yusuf, *Silk fabrics of the United Provinces*; Watt, pp. 255—259. Cf. Jasper en Pirngadie, vol. II.

(fig. 393); extremely complex designs are found also in Cambodia and Sumatra; but the technique in its simplest form produces a characteristic multiple zigzag pattern (*khañjarī*) or if in narrow bands, a succession of v-shaped points, the colour being always the same on both sides of the material, which is not the case in the imitation *khañjarī mashrus* made at Azamgaṛh. The wide distribution of the technique indicates for it a high antiquity; and it may be remarked that the characteristic v-forms can be unmistakeably recognized in some of the Ajaṇṭā paintings.

In the second and largest group of textiles, the design is produced by the use of warp and weft threads of different colours and materials, suitably woven; the design here presenting a different appearance on the front and back of the material. A vast series of brocades made in Murshidābād, Benares, Gujarāt, Auraṅgābād, Ḥaidarābād, Madras and Tanjore, &c., range from the types in which gold thread is lavishly employed(*kimkhwāb*, fig.394) to the *himrus* made of mixed silk and cotton, and the all-figured muslins (*jamdāni*) of Bengal, and heavy cotton *ẹtirili* of Ceylon. For a detailed account of the Indian types the descriptions by Percy Brown in Watt's book should be consulted. There is, of course, also an immense variety of goods with patterns in stripes or checks, produced by direct weaving, and not of brocade character. Kaśmīr shawls of the woven type are made of fine wool, woven in small strips by a kind of tapestry method on small looms, and afterwards so skilfully joined together as to appear to consist of a single fabric.

A third type of designed goods is produced by processes applied to the material after the weaving is completed. The simplest of these are dyed in one plain colour. Of more elaborate processes, the most important are those of tie-dyeing and of printing or dye-painting, or a combination of the two; and block printing.

Tie-dyeing (*cunarī*) extensively practised in Rājputāna and at Mathurā, but rarely elsewhere, results in patterns made up of small dots, or in designs of zigzag lines and larger patches of colour. In the first case, the cloth is laid over a wooden block having blunt nails projecting from it in the required pattern; the operator presses the material, usually cotton, sometimes silk, unto this, and rapidly taking hold of each portion of the material pressed upwards by a nail, ties it tightly; or may dispense with the guide altogether, having the design, so to speak, at his or her fingers' ends. When all the required points have been tied, the cloth is immersed in dye, the tied points remaining unaffected. In case several colours are required, the whole process must be repeated without removing the first ties. Zigzag patterns are produced by first folding the cloth in four, and then tieing. This, too is a very ancient technique, and though rare in the south and unknown in Ceylon, is commonly found in the Indonesian area, especially in Bali. Woven goods may also be decorated by means of printing and dye-painting, with or

without the use of a wax resist[1]. In ordinary cotton printing wood blocks are employed; almost every part of India has local types, but Sanganir near Jaipur in Rājputāna may be mentioned as the source of some of the best work. The most exquisite effects are obtained in the tinsel printing of floral designs on delicate muslins at Nāsik and in Rājputāna. Very fine results in the block printing of gold leaf are obtained in Bali (fig. 399).

The great centres of dye-painting, or more correctly, wax-resist drawing known as *qalmdar*, and equivalent to the Javanese batik technique, are Masuli-patam, Coconada, North Arcot, Kalahastri and Madura in Southern India. The designs are drawn with a thick pencil, dipped in hot wax, and not, as in Java, with a *chanting*. Block printings may be used in combination with the drawn designs. The curtains known as *palampores*, in which the typical design is a "tree of life" growing on a mountain, are the best known types. Masulipatam worked not only for the local market, but in special designs for export, mainly to Persia, and also to Siam; many of the so-called Persian prints on the market, with prayermat designs and Arabic texts are really of Indian origin, and perhaps none of them are really Persian.

Block printing is of high antiquity in India, and may have originated there. No early Indian textiles have survived, but indications can be found in some sculptures and paintings, and Egyptian printed cottons and textiles dating from the Roman period seem to show Indian influence. It is rather surprising that the use of blocks for textile printing never led to the production of woodcut illustrations or block printed books, though the latter are known in Tibet, doubtless as a result of Chinese influence there. The Indian word *chap*, used also in Java, designating a wood or metal block used for textile printing, seems to be of Chinese origin.

Embroidery[2]. Only the leading types of the many fine styles of embroidery practised in India can be referred to. The term *phulkārī* is applied to the heavy *cādars* or veils worn by the Jāt women of the Pañjāb. The work is done in darn stitch in silk on a coarse red cotton ground. In one type the motifs are floral, scattered over the whole field; in another, geometrical, covering almost the whole field, leaving only small areas of ground colour between the embroidered parts. In the latter case, to produce a perfect result, the threads of the field are used as guides, and must be minutely counted.

Another fine type (*sīsadār*) of embroidery used for large *cādars*, and also for skirts and *colīs*, especially in Kāṭhiāwāḍ, uses the same red cotton material, but is carried out in floral motifs with birds, in wide chain stitch, with small circular pieces of dull mirror glass bound down in suitable places, such as flower centres,

[1] For these techniques see Watt, pp. 259 ff.; Hadaway, and Baker, loc. cit.
[2] The only satisfactory works on this subject are Mrs. F. A. Steel's *Phulkārī work in the Pañjāb*, J. I. A., 2, 1888; Watt; and Coomaraswamy, 1.

by means of a chain stitch frame. *Cādars* embroidered in cross stitch in white on a similar ground are characteristic of central Rājputāna and Central India.

Kaśmīr shawl embroidery, mainly applied to *cādars*, is a darn stitch, carried out in the same designs as the woven goods, and superficially similar in effect, though the distinction is always evident when the back of the material is examined, the embroidered threads running irregularly, the woven ones in straight lines like those of a brocade. Cambā (and Kāṅgṛā) *rumāls* (kerchiefs) are embroidered in double satin-stitch alike on both sides with brightly coloured flowers and animals and mythological groups like those of Rājput paintings, scenes from the Rās Līlā being a favorite theme.

The finest types of all Indian embroidery are perhaps those of Kāṭhiāwād, and of Bhūj in Kach, especially those carried out in chain stitch. The work is chiefly applied to skirts, *colīs* and the caps (*nāṭīs*) with a long back flap worn by children. In a well known type, the skirt is covered with peacocks and flowers in alternating diagonals, and there is an elaborate floral border of lotus rosettes alternating with brilliant parrots; the ground is often a black or dark blue satin. Other types (fig. 397) are striped. Small pieces of mirror glass are often worked into the design. In Rājputāna, very exquisite embroideries in silk and gold on muslin are done on fine muslins intended for use as turbans (fig. 395). Admirable chain stitch is done on cotton in Jaipur, especially in connection with tent hangings, floor coverings, *gaddis* for shields, and *gaumukhs*. At Dacca, in eastern Bengāl, centre of a weaving industry already alluded to, fine darn and satin stitch work (*kasida*) is done in old gold and wheat coloured silk on muslin. The embroidered satin stitch *kamarbands* of Azamgañj are so minutely worked as to look more like paintings than needlework. *Cikān* is a type of embroidery done on white washing material, usually calico or muslin in many centres, and often for European use, but above all in Lucknow, where it is applied to the coats and caps worn by the people of the country, and may be described as the most refined form of purely indigenous needle-craft. A good account of it is given by Brown in Watt. Embroidery is less widely practised in Southern India, but reappears in Ceylon, usually in the form of chain stitch in white and red on a blue cotton ground.

Theatre[1]. The classical Sanskrit theatre scarcely survives, unless in Malabar. But acting and dancing are alike in principle and practise, both consisting in the rhythmic presentation of formal gestures, accompanied by instrumental music and singing. Much of this technique survives in the religious folk plays, such as the *yātras* of Mathurā and Bengal; still more in the dramatic dances presented by *devadāsīs* in temples and on occasions of festivity.

[1] Coomaraswamy and Duggirala; Lévi, S., *Le théâtre indien*; Keith, A. B., *The Sanskrit drama*.

PART V:
KAŚMĪR, NEPĀL, TIBET, CHINESE TURKISTĀN, AND THE FAR EAST

KAŚMĪR

Kaśmīr formed a part of the dominions of Aśoka and of Kaniṣka and Huviṣka, was for a time tributary to the Guptas, but by the time of Harṣa was an independent power controlling Taxila, much of the Sind valley, and the Pañjāb Himālayas. The eighth and ninth centuries are the classic period of Kāśmīrī culture. In about 431 Guṇavarman, a prince of Kaśmīr, travelled as a Buddhist missionary to Sumatra and China. Lalitāditya (733) and another king in the eighth century received investiture from the Emperor of China. Avantivarman (855—883), was a patron of literature and the builder of many shrines. A local Muḥammadan dynasty came to the throne in 1339, and during the fourteenth century Islām spread throughout the valley, though never to the exclusion of Hinduism, before which the early Buddhism had long since declined. In 1587 Akbar included Kaśmīr in the Mughal empire.

At Uṣkur (Huviṣkapura) near Bārāmūla have been found remains of a *stūpa* and terracottas and stucco fragments in the Indianised late Gandhāra style, and on the whole superior to those of Jauliāñ[1]. Very interesting remains at Harvan (Sadarhadvāna) dating ca. 400—500 A.D. include a unique tiled cock-pit of considerable size[2]. The devices on the moulded tiles represent men seated, and in balconies; horseman archers in chain armour, Tātar caps and Turkī cloaks; deer; fighting cocks, lotuses, and a fleur-de-lys motif corresponding to the later Kāśmīrī iris. The technique of these tiles resembles that of the so called Han but probably later grave-tiles of China. Not far from the same site have been found remains of a *stūpa* and of an apsidal *caitya*-hall.

The old town of Vijabror has yielded a number of early sculptures amongst which the most interesting are those representing the goddess Lakṣmī. A series

[1] Kak, 1.

[2] Kak, 1 and 3. In India proper, a representation of fighting cocks is found at Ajaṇṭā, Cave XVII (Griffiths, pl. 142).

of types, indeed, can be traced in Kaśmīr, ranging from characteristically late Gandhāran forms, to thoroughly Indianised types of the ninth or tenth century. Even in the latest examples the Gandhāran cornucopias and suggestions of Hellenistic drapery are preserved[1].

The old capital of Pāṇḍreṇṭhān (Purāṇādhiṣṭhāna) near Śrīnagar has yielded Buddhist remains, chiefly sculptures, amongst which may be mentioned standing and seated Buddhas, Avalokiteśvara, and a Lumbinī garden Nativity in Sārnāth style[2]. In the first half of the eighth century Lalitāditya founded a new capital at Parihāsapura, nearly halfway between Śrīnagar and Bārāmūla and raised a series of magnificent Buddhist and Brāhmaṇical temples. The former include a large *stūpa* with double platform, a stairway on each side, and probably indented corners as at Borobuḍur, a monastery, temple, seated Buddha figures, and two crowned Buddhas, or Bodhisattvas in monastic robes; the latter a Śiva-lingam in temple E.[3]. Extraordinarily massive stones are employed; the floor of the Buddhist temple consists of a single block approximately 14 by 12 by 6 feet.

A number of interesting Buddhist bronzes have been found in Kaśmīr, and like many of the sculptures above described are now in the Śrī Pratāp Museum in Kaśmīr. A standing Buddha, which cannot be later than the sixth century is a clumsy figure like that from Bāndā in Bengal. Much more elegant is a fine group representing Padmapāṇi accompanied by two Śaktis, with an inscription of the reign of Queen Diddā (983—1003), showing that Buddhism survived at least until the eleventh century. Another in typical Pāla style (C 3 in the Śrī Pratāp Museum) must be of Magadhan origin (fig. 233)[4]. For an inlaid brass Buddha from Kāṅgṛā see p. 85 and fig. 163.

When Avantivarman in the latter half of the ninth century founded a new capital at Avantipur, the modern Vāntipor, Buddhism had already lost its predominant position, giving place to Hinduism; the character of the art, too, has changed, becoming definitely mediaeval, though still showing both Gandhāran and Gupta reminiscences. Avantivarman's temples are not equal in size to those of Lalitāditya, but yet "rank amongst the most imposing monuments of the ancient Kaśmīr architecture, and sufficiently attest the resources of their builder"[5].

[1] Examples from an unknown source and from Vijabror illustrated in Foucher, 3; another from Vijabror of about the sixth century in Kak, I, p. 59; a later example, Kak, I, p. 64. Another evidently Kāśmīrī, of about the ninth century is in the Museum of Fine Arts, Boston (M. F. A., 25. 470 [unpublished]).

[2] Kak, 1; Sahni, 2, 3.

[3] Sahni, 3.

[4] Kak, 1.

[5] Stein, 2, vol. I, p. 97.

The typical Brāhmaṇical temple of Kaśmīr from about 750—1250 A. D. has a special character of its own, and in some cases a curiously European aspect, due in part to a Gandhāran inheritance of certain elements, though all the details are Indian. The special forms include a double pyramidal roof; triangular pediment enclosing a trefoil niche; fluted columns with Doric or Ionic capitals; a wood or stone "lantern" ceiling of superimposed intersecting squares; and cloistered courts or colonnaded peristyles surrounding the main shrine. Temples of this type, in limestone with two exceptions, are found at Laduv (the earliest, perhaps fifth or sixth century), Mārtāṇḍa and Vāngath (both due to Lalitāditya, the latter in granite), Paṭan, Pāyar, Buniār (in granite, the best preserved), Pāṇḍrenṭhān (fig. 275), and at Pañjnāra in Jammū. The temple of Pāṇḍu-kuṇḍ at the last mentioned site was once a magnificent structure, with a central shrine with a double basement, and a peristyle of fifty-three cells, the whole court measuring 191 by 121 feet. But of all those mentioned, the Mārtāṇḍa, in size and situation, is by far the most imposing, even in its now ruined state[1]. Wooden architecture of the same character is found in Camba and Kuḷū[2]. In India proper, the typical Kāśmīrī roof is found only at Gop in Kāṭhiāwāḍ; the trefoil arch as an integral architectural form only in parts of the Pañjāb which were subject to Kaśmīr in the eighth and ninth centuries, particularly at Malot (fig. 274) and Kāfir Koṭ[3].

Amongst the numerous small sculptures from the Avantipur sites are a number of very interesting Viṣṇu groups in a style peculiar to Kaśmīr and its then tributary States of Cambā and Kuḷū. The workmanship is very accomplished, while the modelling preserves reminiscences both of western and of Gupta tradition. The general type (fig. 272) is that of a four-armed Viṣṇu, with elaborate jewellery, crown and dagger, the latter an unique feature, standing between attendants, and with the Earth goddess rising from the pedestal, between his feet. In some the deity is three-headed, the additional heads being those of a lion and a boar[4]. Śaiva sculptures of the same type include an Ardhanārīśvara and more than one example of the three-headed Maheśamūrti form commonly but erroneously called Trimūrti[5]. An example of the Viṣṇu image in Avantipur style but in brass inlaid with silver has been found in Kāṅgṛā[6].

[1] For the Kāśmīrī temples generally see Sahni, 3; Kak, 4, 5; Cole. Fergusson, 2, is quite inadequate. For lantern ceilings cf. Le Coq, 3, p. 31.

[2] For Cambā, see Vogel, 1, pl. XXXIV; for Kuḷū, Longhurst, 6.

[3] For Malot see Burgess, 8, pls. 237—214; A. S. I., A. R., 1918—19, p. 5, and 1920—21, pl. III. For Kāfir Koṭ, ibid., 1914—15, pt. 1, pl. III; Codrington, K. de B., pl. XLIII.

[4] Sahni, 2; Kak, 1. Cf. three-headed Viṣṇu from Cambā, Vogel, 20, p. 248, and pl. XXXIX a. For a late Gupta example in Mathurā stone see Coomaraswamy, 9 (2), pl. XIX. For Viṣṇu statuettes probably from Avantipur, now in the Pennsylvania University Museum, see Coomaraswamy, 18. Also p. 55, note 6; and A. S. I., A. R., 1903—04, p. 218.

[5] For literature on this subject see pages 55, 100.

[6] Vogel, 4.

NEPĀL

The isolated and rather inaccessible Himālayan valley of Nepāl was occupied in prehistoric times by a people of Tibetan origin, relatives of the Sino-Tibetan races who were at the same time finding their way into Indo-China. In the second century A. D. the Indian Licchavis founded a dynasty in Nepāl, taking with them from Vaiśālī all the elements of Indian civilization. Mānadeva in the sixth century erected a Garuḍa — crowned *dhvajastambha* in the Vaiṣṇava temple of Changu Nārāyaṇ. A sculpture of the same reign is a bas-relief representing Viṣṇu as Trivikrama dedicated to the queen-mother Rājyavatī. This work, which has now been lost, is described by Lévi as follows "one of the oldest pieces of Indian sculpture (but this is an exaggeration by nearly a thousand years!), properly Indian; it brings us into the presence of a definitely formed art, master of its means, of free and sure inspiration; the sculptor utilizes the traditional methods of Indian art by grouping in one frame the stages of the story ... It is a great work, almost a masterpiece"[1]. An Umā-Maheśvara group, dated in the reign of Guṇakāmadeva, the founder of Kāṭhmaṇḍū in the tenth century; an image of Sūrya of the eleventh century[2]; images of Sūrya and Candra, dated in the thirteenth century are still extant. Chinese authors in the seventh century describe admiringly the splendours of Nepalese architecture: for example, "in the middle of the palace there is a tower of seven storeys, covered with copper tiles. Railings, grilles, columns, beams — everything is ornamented with precious stones and jewels ... On the top of the tower, water plays into basins; from the mouth of the dragons the water spurts out as from a fountain ..., the houses are built of wood; the walls are sculptured and painted"[3]. The features of this account, as Lévi adds, are always true in Nepāl; the taste for wooden houses sculptured and painted has lasted under all the Nevārī dynasties. Some idea of the style can be gathered, by the student who cannot visit Nepāl, from the Nepalese temple in Benares. These wooden edifices preserve the elements of much older styles, of which the monuments are no longer preserved in India; they illustrate too a half-way stage between Indian prototypes and Chinese derivatives.

Great antiquity is ascribed to the Nepalese *stūpas*, four at Pāṭan having been founded, according to tradition, by Aśoka; these four are still intact, and in any case are of the old Indian hemispherical type. The chief characteristics of the later types is the exaggeration of the *chatravali* or range of umbrellas; the same feature is characteristic of the modern Tibetan form (known as *mchod-rten*); and this development certainly had a share in that of the Far Eastern pagoda. The Nepalese

[1] Lévi, 4. For Nepāl generally, see Lévi, 2, 4; and Hackin.
[2] Bendall, pl. II.
[3] Lévi, 1, 4.

temple is typically provided with a succession of sloping roofs. One of the most elegant is that of Bhavānī at Bhatgāoṅ, built in 1703; it stands on a pyramidal basement of five stages, recalling the basements of Burmese *stūpas* and Cambodian temples. The most venerated Śaiva shrine in Nepāl is that of Paśupatinātha, near Kāthmaṇḍu, but here too most of the buildings date from the seventeenth century.

It may be remarked that during the middle ages Buddhism and Brāhmaṇism, or rather a Tāntrik combination of the two, are equally prevalent, and images of Hindū deities and those of the Buddhist Tāntrik pantheon occur in equal numbers and side by side. For a time, in the eleventh century, Indian princes from Tirhūt controlled the valley, and at this time very much the same religious conditions must have prevailed in a large area extending from Nepāl through the Ganges valley on to Burma and Indo-China.

Nepalese art is best known by the metal images, usually copper or brass, and of fine workmanship, which have found their way into India and thence into European and Indian museums. Many of these are often wrongly described as Tibetan; but there is, notwithstanding the close relation of the schools, and in spite of the Nepalese origin of most of the Tibetan craftsmen[1], a real difference of style that can be easily recognized in the best examples, though it disappears in the inferior specimens. On the whole the Nepalese "bronzes" are more Indian in character, and better executed, and somewhat milder in the prevailing types, than those of Tibet.

Some of the best and earliest examples, which can hardly be dated later than the tenth century, are now in the Museum of Fine Arts, Boston (figs. 276—278)[1]. The standing Avalokiteśvara (fig. 276), of copper gilt, is perhaps the best of all known bronzes that can be definitely classed as Nepalese; it illustrates a Nepalese peculiarity rarely seen in Indian works, that of inlay with precious stones, garnet and turquoise, but in style it is very near to Indian types, and is more suggestive of a late Gupta than of the contemporary Pāla styles of the Ganges valley. On the whole the art of Nepāl may be described as having *retardataire* tendencies, and thus at any given moment, likely to be superior to that of the plains. Metal figures of considerably later date are often of high merit, and even up to quite recent times good work has been done[2].

Side by side with the later and specifically Lamaistic development which Nepal shares with Tibet, Nepāl possesses an important school of painting, which in the

[1] "Lhasa is, to a great extent, a Nepalese colony. And it was chiefly Newaris who built temples there, cast statues, painted images; their reputation spread all over Central Asia, and they were called from far away, at great expense, even in more recent times, for decorating religious buildings" (Lévi, 4, p. 63. Cf. the mention of A-ni-ko, ibid., pp. 63—65, and in the present work, p. 147).

[2] For later examples cf. Havell, 2; and Rūpam, nos. 7, 1921, and 19—20, 1924.

same way as the bronzes reflects Indian forms, and has preserved even up to modern times a hieratic style, comparable to that of the Pāla and Gujarātī schools. In the eleventh century indeed, the distinction of style as between the Bengālī and the Naipālī illustrated manuscripts, is so slight as to be scarcely definable in few words. Amongst the more important Nepalese manuscripts of this date may be cited the palm leaf Mss. Add. 1643 and A 15, Royal Asiatic Society, Calcutta, both of the *Aṣṭasāhasrikāprajñāpāramitā*, both of the eleventh century and containing respectively eighty-five and thirty-one miniatures[1]; a manuscript of the same text in the Museum of Fine Arts, Boston, no. 20. 589, dated apparently equivalent to 1136 A. D. with eighteen miniatures and contemporary painted wooden panel covers[2] (figs. 280, 281); a manuscript of the same text dated 1019, formerly in the collection of E. Vredenberg and probably the finest known example[3]; a manuscript of the same text, probably of twelfth or thirteenth century date, belonging to Professor A. N. Tagore, Calcutta, with contemporary painted covers, one of which bears extremely interesting representations of four episodes of the *Vessantara Jātaka* (fig. 279); a manuscript of the same text and age, with eighteen miniatures in the possession of Mr. Jackson Higgs, New York, with later painted covers; and one in the possession of Professor S. Sawamura of Kyoto.

Nepāl has also been at all times productive of temple banners (*taṅka*). Very early examples have been found at Tun Huang[4]. Even in the eighteenth century the paintings of this type preserve high qualities in colour and design. A good example is afforded by a banner illustrating the *Kapīśa* and *Piṇḍapātra Avadānas*, dated in Nevārī script equivalent to 1716 A. D.[5] An example of a Vaiṣṇava painting of Naipālī origin is afforded by the Gajendra-mokṣa picture in the library of the Royal Asiatic Society, London, which I formerly regarded as Rājput[6].

TIBET

A type of animistic religion known as Bon-po originally prevailed in Tibet, and has left its traces on the later Buddhist developments[7]. The first king of Tibet "who was the maker of the Tibetan nation ... married a Nepalese princess about

[1] Fully illustrated and described in Foucher, 2.

[2] Coomaraswamy, 10, pls. XXXII—XXXV.

[3] Vredenberg, E., *Continuity of pictorial tradition in the art of India*, Rūpam, 1 and 2, 1920.

[4] Stein, 7, pp. 1428, 1429, and pl. LXXXVII.

[5] Coomaraswamy, 10, pl. XXXVI. For Nepalese and Tibetan paintings the following may also be consulted: Foucher, 8; Smith, 2, pp. 314—325; Francke; M. F. A. Bull., nos. 106, 144; and Hackin (Bibliography, p. 125).

[6] Coomaraswamy, 8, pl. XVI.

[7] Das, S. C., *A brief sketch of the Bon religion ...* Journ. Buddhist Text Soc. India, 1, 1893; Hackin, pp. 116, 117.

the year 630; the young bride brought with her, her Gods and priests; she converted her husband, and after her death she was given a place in the Tibetan pantheon as an incarnation of the Goddess Tārā"[1]. The same king married a daughter of the T'ang emperor T'ai Tsong, and she, likewise a Buddhist, was deified in the same way. Lying on one of the highways from India to China, through Nepāl, Tibet was thus naturally and from the beginning open to Indian and to Chinese influences, and these are always recognizable in Tibetan art. In the eighth century the magician Padmasambhava was summoned to Tibet from Udyāna (Kāfiristān)[2]. In the eleventh century the paṇḍit Atīśa, after his ten years of study in Sumatra, introduced reforms in what must have been an strange admixture of Buddhism magic and animism[3]. Atīśa died in 1058. In the meanwhile, in the ninth century Tibet attained the zenith of its military and political power, extending its rule even to Tun Huang, on the western Chinese border, where the oldest known remains of Tibetan painting have been found. By the thirteenth century, political power had declined, but Buddhism was at the height of its power, the Mongols receiving the religion and a new script from the Tibetans. A-ni-ko worked for Tibetan kings on his way to the court of Kublai Khān, who bestowed various honours on Lamaistic priests from Tibet. With the fall of the Mongols Buddhism fell into disfavour in China; in the sixteenth century under the Mings, it again flourished, and to this period must be attributed a majority of the Sino-Tibetan brass images so common in various collections. In the sixteenth century the Dalai-Lama took up residence in the palace of the Tibetan kings on the Mar-po-ri (Lhasa); to this residence of the head of the Tibetan church, regarded as the incarnation of Avalokiteśvara was given the name of Potala, the mountain on which this Bodhisattva has his seat. The Manchu emperors gradually assumed control of Tibetan affairs, and the country is still partially subject to Chinese suzerainty.

Tibetan art consists chiefly in the palace and monastery architecture and in the Buddhist paintings and bronzes. The palace-monastery at Lhasa is a noble pile of successive stages, dominating the whole city. The paintings are for the most part votive temple banners. Of two groups, the first, dealing with scenes from the life of Buddha, is devoid of Tāntrik elements; this group is directly based on Indian tradition, derived from Bengal and Nepāl, and to be connected with the ministry of Atīśa, who exercised a direct influence on Tibetan art up to the end of the twelfth century. In a second group of later origin, dealing in a different way with the life of Buddha, the Master occupies the centre of the picture,

[1] Levi, 4, p. 63.

[2] Ribbach, S. H., *Vier Bilder des Padmasambhava und seiner Gefolgschaft*, Jahrb. Hamb. wiss. Anst., XXXIV, 1916, Hamburg, 1917; Grünwedel, 8; other references in Hackin, pp 125—127.

[3] Das, S. C., *Indian pandits in Tibet*, Journ. Buddhist Text Soc. India, 1, 1893.

while grouped around him are other scenes, separated from each other by winding rivers, clouds or trees, these subsidiary compositions being often in a quite Chinese manner. Another series represents the Dhyāni Buddhas, the Bodhisattvas and Tārās, and the fierce World Guardians. Another group represents, so to say, a vast series of local saints and spiritual heroes, amongst whom will be found such as Padmasambhava, Mi-la-ras-pa the wandering poet, monk and magician, and sainted Lamas. Another series deals with Bon-po themes. In these works, the iconographic conceptions range from the most peaceful Buddhas to the most violent and terrifying Tāntrik forms of the Lokapālas; as art they maintain a satisfactory tradition of colour, while the drawing is generally accomplished, though scarcely ever sensitive[1].

CHINESE TURKISTĀN

There exists some foundation in historical fact for the tradition recorded by Hsüan Tsang, asserting a partial occupation of Khotān by Indian immigrants from the region of ancient Taxila[2]. A Prākrit language was spoken in the oasis, Kharoṣṭhī and Brāhmī scripts were in use, a cult of Vaiśravaṇa (Kubera) was widespread, and coins of Kadphises and Kaniṣka are met with in some quantity. The ruling class in Khotān was of Indian origin and remained predominant up to the time of the Uigur Turkish invasions of the eighth and ninth centuries; thus, during the first seven centuries of the Christian era the name "Turkistān" is really an anachronism. Beyond Khotān, the principal remains of *stūpas* and monasteries, constructional or excavated, have been met with at Mirān and Endere, further north at Kuca and Turfān, and in the east at Tun Huang on the western border of Chinese territory, these various settlements representing stations on the old silk trade route from China to the west, and revealing a mixed culture and art in which Hellenistic, Indian, Īranian and Chinese elements are all more or less clearly to be distinguished[3]. A few of the more striking examples of the Indian forms will be noticed in the following paragraphs.

[1] Hackin, pp. 70ff. For Tibetan painting and bronzes generally see also Hackin, J., *Illustrations tibétaines d'une légende du Divyāvadāna*, Musée Guimet, Bib. Vulg., Paris, 1914. *Notes on Tibetan paintings*, Rūpam, 7, 1921. Getty, A., *The gods of Northern Buddhism*, Oxford, 1914. Schlagintweit, E., *Buddhism in Tibet*, London, 1863. Francke, A. H., *Antiquities of Indian Tibet*, A. S. I., Calcutta, 1914. Roerich, *Tibetan paintings*. Pander, E., *Das Pantheon des Tschangtscha Hutuktu*, Berlin, 1890. Grünwedel, A., *Mythologie du Bouddhisme au Tibet et en Mongolie*, Paris, 1900, and *Padmasambhava und Verwandtes*, Baessler Archiv, III, I, 1912. Waddell, L. A., *Buddhism of Tibet, or Lamaism*, London, 1895. Stein, 7, pp. 719, 816ff., 838ff., 865, 1052, 1068.

[2] Stein, 4, Ch. VII, sec. 2.

[3] The literature of Central Asian art is conveniently listed by Le Coq, 3, pp. 34, 35, and by Hackin, pp. 122—123; The most important works include Grünwedel, 3, 4, 5; Le Coq, 1, 2, 3; Stein, 3, 4, 6, 7 (see "India", "Indian", in index); Stein and Binyon.

The two ruined temples at Mīrān are of special interest, both on account of their form, and for the frescoes there preserved. Temple M V is a hollow domed circular shrine containing a solid *stūpa*, thus a constructional example of a form known in India only in rock-cut halls (see pp. 18, 38). This form, as Stein (7, p. 532, note 16) suggests, may have played a part in connection with the origins of Christian rotundas; the dissemination of Buddhism in eastern Īrān about the beginning of the Christian era may well have carried with it Indian architectural forms, with circular or apsidal plans. Equally interesting, the inner wall of the same shrine is decorated with a fresco frieze and dado, the former illustrating the familiar *Vessantara Jātaka* (fig. 284) in exact accordance with the formula already established at Bhārhut and followed in Gandhāra (cf. figs. 47, 93 and 279). The dado consists of garland-bearing figures, and like the winged cherubs of another part of the decoration, presents a much more western aspect than the frieze. A short inscription in Kharoṣṭhī characters states "This fresco is the work of Tita, who has received 3000 bhāmakas for it". As pointed out by Stein, Tita may represent Titus, who may have been of Western Asiatic origin, adhering to the Indian formulae in the definitely religious representation, and working in a more definitely western manner in the secular decorations. The work may be dated about the fourth century[1].

Of somewhat later date are the various wooden panels and a fresco found at Dandān Uiliq, and other panels and part of a birch bark manuscript, doubtless of Kāśmīrī origin, found at Khādaliq. These works appear to date from the seventh or eighth century, and afford illustrations of Indian painting of that period, subject to Persian and Chinese influences, the Indian element predominating. One of the panels bears on one side a representation of the three-headed Maheśa or Sadāśiva, seated on a pair of bulls (fig. 285), a form which in this environment may have had a Buddhist significance (Lokeśvara?). The type, which already occurs in Gandhāra and on coins of Vāsudeva, could easily have reached Khotān through Kaśmīr in the second century; it extended later even to China (Yun Kang[2]) and appears in Japan as Dai Itoku, usually rendered as Yamantāka. The reverse of the same panel shows a seated four-armed figure (Bodhisattva or Bacchanalian Pāñcika?) bearded, and wearing a tight-fitting coat and boots[3]. Another panel represents two mounted saintly or princely personages, nimbate, holding cups; another, a four-armed Gaṇeśa. Of even greater interest is the well-known fresco representing a nymph, nude but for girdle and transparent "fig-leaf", standing in a lotus tank, with a nude boy beside her, stretching out his

[1] Stein, 7, pp. 516—532 and figs. 134—138.
[2] Chavannes, 2, pl. 224.
[3] Stein, 4, pls. LX, LXI.

arms (fig. 283). This group of erotic, that is to say, auspicious significance, is strongly reminiscent of various Indian Yakṣiṇīs or Devatās, in particular of the lotus lady of the Kuṣāna pillar, B. 89 in the Lucknow Museum (see p. 65 and fig. 74).

As Foucher has pointed out with unusual perception, certain Buddha figures from these areas are more nearly related to Mathurā Kuṣāna types than to Gandhāran; examples are afforded by a stucco figure from the Rawak *stūpa* court (Stein 4, pl. LXXXII) and by a seated Buddha with shaven head from Idikucari, now in the Museum für Völkerkunde, Berlin[1].

In the Kuca area, and for the most part at Ming Öi various Indian elements are easily recognizable amongst the vast series of paintings in the caves[2]. We find, for example, figures of Brahmā, Indra, and Śiva, the latter four-armed, accompanied by Pārvatī and Nandi. An interesting and unmistakeably Indian motif is found in a ceiling painting in the Hippokampenhöhle[3], a decoration representing *cātakas* drinking drops of water falling from the clouds, in which flashes of lightning are represented in the form of snakes: the elements of this representation are commonplaces of Indian rhetoric, and are well preserved in various Rājput paintings, particulary those of the old palace at Bikanīr[4]. At Tun Huang, even more than in Kuca, we are in the domain of Chinese art properly so-called, and while Indian peculiarities are still traceable, and some few works of Nepalese and Tibetan origin are actually met with, the foreign elements are in the main confined to the iconography. That Chinese Buddhist works of art could not have existed without their Indo-Gandhāran prototypes does not make them anything but Chinese; as Binyon justly remarks "all that derives from Gandhara in subject matter and form is subdued to the creative instinct of design by which the Chinese genius makes them its own."

THE FAR EAST

Indian influence extended to China, Korea and Japan, with Indian ideas generally and Buddhist forms of art specifically, by direct and indirect routes; overland through Khotān, and by the southern sea route and through Cambodia and Campā. In China, however, where an ancient civilisation had long previously attained to a high stage of consciousness, and had found expression in a solemn and cultivated art dating back to the second millennium B. C., and where,

[1] Grünwedel, *Idikutschari*, IV, I (= Foucher, 1, fig. 563).
[2] Grünwedel, 5; and 4, figs. 106, 208, 210, 241, 373, 410, 538, 543.
[3] Grünwedel, 4, fig. 241. Cf. Andrae, Farbige Keramik aus Assur, Pl. 8.
[4] Coomaraswamy, 8, pl. VIII, and 9 (5), p. 201.

despite the settlement of Indian traders and priests, especially at Loyang, there was never any question of Indian social or political domination, the situation was far other than that of Farther India and Indonesia. The Indian element in the art of the Far East is nevertheless a considerable one; for here there was not merely the acceptance of an iconography and of formulae, but the assimilation of a mode of thought; so that we have to take into account effects both of the outer form of Indian art and of an inner emotional working of Indian thought[1].

A Chinese contact with Indian Buddhism was made in the first century, 67 A. D. and probably earlier. Our knowledge of Chinese painting and sculpture in the third, fourth, and early fifth centuries is, however, so slight that we cannot seriously discuss the Indian, Irānian, and Hellenistic influences that may have been exerted at this time, except to point out that all are apparent in Central Asia[2]. Between 357 and 571, however, we read of no less than ten embassies sent from India to China; and amongst Indians settled in China may be mentioned the priest Kumārajīva (383), and Prince Guṇavarman of Kaśmīr, who is credited with Buddhist converts in Sumatra, is said to have painted a *Jātaka* scene in Canton, and to have died in Nankin in 431. In the contrary direction Fa Hsien, travelling in 399—413 across Central Asia and entering India through the Pañjāb, spent six years in Magadha and Bengal, and returned home *via* Ceylon and Sumatra. It is certain that from at least the middle of the fourth century A. D., probably a good deal earlier, there was constant intercourse between India and China by the sea route; perhaps also by a southern land route through Burma, whereby the Indian water-buffalo was introduced to Chinese agriculture. Taking these facts into consideration with the difficulty of the northern land route, we might expect to find unmistakeable evidences of Indian influences in Southern China, as we do in Campā. Unfortunately we know very little about Chinese art in the third, fourth, and early fifth centuries. Some of the so-called Han tiles may date from this period, and it is interesting to find that while their decoration is not in general suggestive of India, some bear numerous representations of what would be called in India *caitya-vṛkṣas*, not indeed railed, but rising from pedestals marked with diagonal lines; and still more curious, other representations of trees enclosed by and rising above the double roof of a surrounding building, just as in the numerous examples of Indian reliefs depicting temples of the Bodhi-druma[2]. But if these forms are of Indian origin, it seems probable that they can only have been borrowed as decoration, and not as Buddhist symbols. There are really no tangible evidences of Buddhist influences in Chinese art before the fifth century.

[1] Okakura; Visser; Warner, Introduction, p. 13; Waley. Full references in Visser.
[2] Coomaraswamy, 17.

From the period of the Six Dynasties, Southern China has yielded a few Buddhist bronzes, of which the earliest, dated equivalent to 435 A. D. has been described as quite in an Indian style[1]. The oldest known Chinese Buddhist stone sculpture, of 457 A. D., and unknown proveniance, is regarded by Sirén as derived from the early Kuṣāna type, Mathurā Museum Nos. A 1 and A 2 (see p. 59)[2].

According to some, too, the Chinese pagoda is nothing but a transformed Indian *stūpa*. More likely the pagoda has been developed from indigenous forms, though under the strong influence of Indian models of the type of Kaniṣka's "stūpa" at Peshāwar, which made so great an impression on all the Chinese pilgrims[3].

In the meanwhile had developed the art of the Northern Wei dynasty, best exemplified by the well-known sculptured caves of Yun Kang near Ta-Tung-fu. This is a highly original art, Chinese more than Indian or Gandhāran in feeling, and no more Indian in detail than must inevitably be the case with an art representing an Indian religion. This art and its more immediate offshoots represent the flower of Buddhist sculpture in the Far East. Its formal sources cannot be directly traced, but must be in the main Gandhāran, Irānian and Indian; it is most nearly related to the earlier mural painting of Tun Huang[4].

In the transition period, sculptures at T'ien Lung Shan are compared by Sirén with Mathurā types of the fifth and sixth centuries, and he suggests that some may have been the work of an Indian artist "well acquainted with the products of the great Mathurā school"[5]. In the Sui period there is clear evidence of Indian, or perhaps rather, Indonesian design in the pedestals of Buddhist figures at Mien-Cheu, Sze-Chwan[6].

With the establishment of Chinese unity under the short-lived Sui dynasty, and their immediate successors the T'angs (618—906), with the development of a cosmopolitan capital at Loyang, where resided a considerable colony of Indian merchants and priests, and with the active development, from the sixth century onwards, of the trade route across Central Asia, there was established a closer connection with India and the West by land. Fa Hsien, the first Chinese pilgrim,

[1] Ashton, introduction, p. 79.

[2] Sirén, I, pp. XXXVII—XXXVIII, and pls. 116—117.

[3] See p. 54. Also Longhurst, 6; Simpson, 3; Visser. For the Chinese forms, Boerschmann, 1, 2; Sirén, pls. 422, 423a, 425; Finot and Goloubew, *Le Fan-Tseu T'a de Yunnanfou*, B. É. F. E. O., 1925.

[4] Mission Pelliot, Paris, 1920, 1921. Sirén, 1, p. XLI, describes the Yun Kang figures as related to Mathurā types but considers the Indian element came through Tun Huang. The two polycephalous figures are „of purely Indian origin"; but the five-headed image cannot be, as suggested, a "Garuḍa-rāja", and must be derived from some form of Viṣṇu.

[5] Sirén, 1, p. LXVI; 2, pl. XLIX.

[6] Visser, fig. 4, after Segalen.

had reached India about 399; Sung Yün about 518; Hsüan Tsang travelled extensively in India between 630 and 644, and is recorded to have taken back with him to China not only books, but also images and relics; Iching travelled in India and returned to China *via* Indonesia ca. 671—695. In the contrary direction, Guṇavarman of Kaśmīr, ca. 431, Bodhidharma of Southern India, ca. 529—36, and Paramārtha of Magadha, ca. 545, reached China and there spread the doctrines of Buddhism in various Mahāyāna forms. In the eighth century China had direct political relations with Kaśmīr.

It is not surprising, then, that we find in the T'ang period a more mixed and less purely Chinese art developing, Indian (Gupta) and late Hellenistic elements crossing and intercrossing with the Chinese idioms of the Six Dynasties. There exist Chinese works of the T'ang period that could almost be thought to be Indian[1]; just as there exist Indian (fig. 171) and Cambodian (fig. 100) works of late Gupta or early mediaeval date that seem to foreshadow Far-Eastern types.

Still more eclectic is the mixed Central Asian art of Tun Huang in the far west of China; this Central-Asiatic-Indian art, though its actual examples are the work of artisans rather than of great artists, forms the foundation of Chinese Buddhist art in the T'ang period; and is almost our only source of knowledge for T'ang painting.

Towards the close of the T'ang period the vitality of Chinese Buddhist art is on the wane; specifically Buddhist art is becoming exquisite, over-refined, and finally lifeless. But there comes into being in the Yüan and Sung periods another kind of painting, philosophical and poetic, which is essentially a product of a fusion of Taoist and Ch'an ideas.

In the meantime Chinese influence was extending westwards (Mongol period of Persian art) and in the contrary direction Tibetan Lamaism was spreading through Mongolia and China carrying with it all its apparatus of elaborate iconography, and ritual mysteries. M. Pelliot, indeed, has remarked that "a monograph ought to be prepared, dealing with the religious art in Hindū style which was favoured in China from the thirteenth to the fifteenth century".

A specific instance of the migration of a Nepalese artist is afforded in the case of A-ni-ko, who became Controller of Imperial Manufactures at the court of Kublai Khān in 1279, and made large numbers of images and paintings for his Chinese patron. One Yi Yuan became his pupil, "studying under him the making of Hindū images", and this Yi Yuan or Lieu Yuan in turn became the author of innumerable Buddhist figures set up in all the celebrated sanctuaries of the two capitals,

[1] A definitely Indian character is present in the British Museum T'ang wooden stele, Binyon, L., *Asiatic art at the British Museum*, pl. IX, 4.

Shang-tu and Pekin[1]. Nepalese artists, too, settled in Tibet, and there produced the bronzes and temple banners which are familiar to collectors. There is in fact a common Lamaistic art which extends, from the thirteenth century onwards, from Nepal through Tibet into China, of which the creations are iconographically similar, and only to be distinguished by the gradual change of style which corresponds to the local ethnic conditions. As remarked by Hackin "La Chine reste, tout compte fait, nettement tributaire de l'art bouddhique népalo-tibetain. Le XIIIe et XIVe siècles marquent l'apogée de cette influence ... si proches de l'ancien tradition indienne"[2].

The North Wei types passed directly into Korea, and thence, through the energy of Shōtoku Taishi, to Japan, to form the models of the art of the Suiko period in the Yamato valley (ca. 645 A. D.). No great antecedent civilisation had preceded these developments in Japan; Japanese culture and unity were developed in the seventh century under Chinese influence; Buddhism and Buddhist art and learning, though coming for the most part indirectly through Korea and China, brought Japan for the first time into contact with the outer world and with India; and as Okakura points out it was not merely the doctrine of the Buddha as an individual, but a whole new mode of thought that affected Japanese life.

Chinese influence continued to predominate in the T'ang age, and is reflected in the art of the Hakuhō and Nara periods in Japan. Long before the Northern Wei art had been assimilated or an adequate understanding of Buddhist thought reached, Japanese pilgrims or ambassadors, successors of Shōtoku Taishi, came into contact not merely with the Chinese aspect of T'ang art, but with its remoter sources in India and the West (Khotān). The famous paintings on the Hōryūji walls, assignable to the eighth century, have been much discussed; I am inclined to agree, like Visser, with most of those who have seen both Hōryūji and Ajaṇṭā, that there exists no very close connection between the two, and that the sources of the Japanese work are to be sought rather in Khotān than in India. But it seems as though the Japanese must have depended in some degree diretly upon Indian sources; it would be impossible otherwise to explain such remarkable iconographic parallels as that of the Jikoku Ten (= Dhṛtarāṣṭra) of the Kondō, standing on a crouching demon, with the Kubera Yakṣa of Bhārhut[3]; and difficult to account for the great admixture of Brāhmaṇical, especially many-armed, forms

[1] Lévi, 1, 2, 4. The *Tsao hsiang liang tu Ching* is a Japanese edition of a Tibetan canon of proportions for images, with diagrams. There are illustrated Chinese and Mongol Lamaist iconographic texts in the Musée Guimet (Hackin, pp. 114, 115).

[2] Hackin, p. 68.

[3] Cf. Warner, fig. 35 or *Nara Horyūji Okagami*, vol. 38, pl. 7, with Cunningham, pl. XXII (Kuvera).

that is so characteristic of the mixed Shintō-Buddhist pantheon. The Japanese *torii* may be related to the Indian *toraṇa*.

Japanese Buddhism on the ritualistic side elaborated the cult of Amida and the Western Paradise[1], and on the mystical side the practise of the Ch'an Buddhists of China, which had been established, ca. 527—536, by the Indian monk Bodhidharma, and derived in the last analysis from the Indian Yoga[2]. Dhyāna (meditation) = Jhāna = Ch'an = Zen. The external influence of Indian thought created a theology and forms of art resembling those of India; the more fundamentally stimulating influence of a method, acting inwardly, enabled the Japanese genius to realise itself in an attitude of aesthetic appreciation of natural beauty and an art which bear no evident resemblance to anything Indian.

[1] Cf. Lodge, J. E., In Museum of Fine Arts Bulletin, 141, 1925.
[2] For an admirable short account of Zen Buddhism see Waley.

PART VI:
FARTHER INDIA, INDONESIA
AND CEYLON

FARTHER INDIA AND INDONESIA

The main element of the population of this area may be described as Malay-Polynesian. Probably a thousand years before the beginning of the Christian era northern races were moving southwards from Tibet and Yunnan and settling in the Irawadi, Menam and Mekong valleys and the Malay Peninsular; where they are afterwards known as Pyus, Mon-Khmers, and Malays. Most likely by 500 B. C. they were also reaching and occupying the islands of the Indonesian archipelago, driving out and replacing the aboriginal Negritos. Previous to their contact with India, these northern races probably possessed a knowledge of the terrace-cultivation of rice, metal-work and carpentry, weaving, ship-building, some forms of musical and dramatic art, and locally differentiated but related languages. Apart from certain dolmens and other so-called Polynesian antiquities, these races have left no monuments; but they are nevertheless of importance as representing the local psychological factor in each of the great national cultures, Indo-Khmer, Indo-Javanese, etc.

Indian contacts may have been made some centuries before the beginning of the Christian era; Suvarṇabhūmi (Sumatra) is mentioned in the *Jātakas*, Epics, and *Mahāvaṁsa* and the sea-route must have been familiar, before the commencement of the general eastward extension of Indian culture. What is probably the oldest positive evidence of this Indian movement eastwards occurs in the remotest area, in the Sanskrit inscription of Vocanh in Annam, dateable about 200 A. D. Before the fifth century the greater part of the area, so far as accessible by sea, had been more or less thoroughly Hinduised, and rulers with Indian names ending in the patronymic *varman*, and using an Indian alphabet, were established in Campā, Cambodia, Sumatra, and even Borneo. Traces of Indian culture have been found in the Philippines, and some scholars believe that the Maya culture of Central America has an Indo-Polynesian background.

According to Ptolemy, the principal Indian port of departure for the Land of Gold, *locus unde solvunt in Chrysen*, was Gūdūrū, undoubtedly the modern Kod-

156

dura at the mouth of the Godāverī, and thus on the Āndhra coast, and giving access to the west. This agrees well with the fact that it is really the art and culture of the Dekkhan, rather than those of Southern India, of which the traces are most apparent in the earlier art of Cambodia, Campā and Java. The early Cām Sanskrit inscription of Vocanh, for example, is in an alphabet closely resembling that of Rudradāman's inscription at Girnār, and facts such as these at one time led to the view that the colonists of the East had sailed from western India, which is not likely to have been the case, nor do the facts require this explanation. In the same way, the Indianesque of Funan is much nearer to the Gupta art of the western caves and of Bādāmī, than to anything further south, and parallels between the architecture of the Dieng Plateau and that of the early Cāḷukyas have been drawn by Dutch scholars. That Indian immigrants in the Malay Archipelago are still called *Orang Kling* is a survival of the name Kaliṅga, by which the inhabitants of Oṛissā were once known. It cannot be doubted that long before the time of the Pallavas at Kāñcī, the Kaliṅgas and Āndhras of Oṛissā and Veṅgī had laid the foundations of Indian or Indianised states "beyond the moving seas". Ceylon in the same way as the more distant islands, but probably at an earlier date, received its Buddhist culture by sea from northern India; the later development is similar in principal to that of the more distant islands of the Indian archipelago, subject to the condition of much greater proximity to the mainland.

Broadly speaking we can trace in each area, first of all, an Indianesque period, when the local art constitutes to all intents and purposes a province of Indian art, so that the art of Funan in the sixth and seventh century, may indeed be said to complete and fulfil our knowledge of Gupta and Pallava art; then a classical period (800—1200 A. D.), in which a local national formula is evolved and crystallised; and finally a local national phase no longer in direct contact with India and passing into an age of folk art which has generally survived up to the present day.

To apply the name of "Indian colonial" to the several national schools, after the end of the eighth century, is an injustice to the vigor and originality of the local cultures. There is scarcely any monument of Farther Indian or Indonesian art which, however nearly it may approach an Indian type, could be imagined as existing on Indian soil; equally in architecture, sculpture and in the drama and minor arts, each country develops its own formula, freely modifying, adding to, or rejecting older Indian forms. India ,indeed, provided the material of a higher culture, and perhaps a ruling aristocracy, to less developed and less conscious races; but the culture of these races, plastic, musical, dramatic and literary, as it flourished in the twelfth and thirteenth centuries and still survives in Java and Bali, may justly be called native. Japan, which owes more than is generally realised to direct Indian influences, is but a more obvious example of the same condition.

Thus the history of Indian and Indonesian art deserves in the general history of art a higher place than can be denoted by the term colonial. It is true that like much of Chinese and Japanese art it can only be understood in the light of Indian studies; but it derives its energy from indigenous sources.

It is only within the last twenty years that Farther Indian and Indonesian art have been seriously studied. Much has already been accomplished by the Archaeological Survey of Ceylon, the Archaeological Survey of Burma, the École française d'Extrême-Orient, at Hanoi, the Oudheidkundige Dienst in Java, and more recently by the Service archéologique du Siam. But only the broad outlines have been deciphered, and there remain to be investigated innumerable undescribed monuments, and unsolved problems of more than local interest.

CEYLON

The earliest inhabitants of Ceylon are spoken of as Yakkhas (Yakṣas) and Nāgas. Tradition[1] asserts the settlement at an early date of a prince from the Ganges Valley, by name Vijaya, who founded a city at Tambapaṇṇi in the southern part of the island near Hambantoṭa in the fifth century B. C. Vijaya allied himself with a native princess, Kuvēnī, and acquired power. About a hundred years later, with the foundation of Anurādhapura, the whole island was brought under one rule. In the reign of Devānam-piya Tissa (247—207 B. C.) Aśoka sent his son Mahinda, and later his daughter Saṅghamittā to Ceylon as apostles of Buddhism; a branch of the Bodhi-tree of Gayā was brought to Ceylon and planted at Anurādhapura[2]. A little later the South Indian Tamils made incursions, usurping the throne for several decades. Duṭṭha-Gāmaṇi (101—77 B. C.) recovered the sovereignty and reoccupied Anurādhapura; he holds a place in Siṁhalese history analogous to that of Aśoka in Indian. In succeeding centuries and during the whole of the mediaeval period the Tamils and Siṁhalese were constantly at war, with varying success, only the south of Ceylon and the mountains remaining continuously in Siṁhalese possession. In the fifth century A. D. Fa Hsien visited Ceylon; the *Mahāvaṁsa* chronicle was composed; and the parricide king Kassapa retired to Sīgiriya and made a fortress of that isolated rock. In the latter part of the eighth century Anurādhapura was abandoned to the Tamils, but later restorations were effected on various occasions up to 1290 by the kings of Poḷonnāruva,

[1] For Siṁhalese history see Arunachalam, 1 (early dates uncritical); Geiger; Turnour and Wijesinha; Parker, 2; Codrington; A. S. C. Reports, *passim;* Epigraphia Zeylanica; C. H. I., Ch. XXV, and Bibliography, pp. 663, 690.

[2] A pious Siṁhalese Buddhist visited Bodhgayā in the second century B. C. and recorded a donation in the following terms *"Bodhi rakhita Ta(ṁ)bapa(ṁ) nakasa dānam"*.

to which city the seat of government was now transferred. But before long this city too was taken by the Tamils, and Ceylon became a viceroyalty of the Coḷa kings of Southern India. Siṁhalese rule was reëstablished by degrees. In the twelfth century the greatest of Siṁhalese kings, Parākrama Bāhu I (1164—1197), the Great, recovered possession of the whole island, invaded Southern India, and maintained relations with the transmaritime kingdoms in Siam and Sumatra. Renewed Tamil invasions again wasted the country, and although in the thirteenth century under Vijaya Bāhu IV, Bhuvaneka Bāhu I, and Parākrama Bāhu III Poḷonnāruva was again occupied, and in 1361 Ceylon was still in a position to respond to a Siamese request for a Buddhist mission (see p. 177), the capital had to be shifted successively to Dambadeṇiya, Kuruṇēgala, Gampola, Koṭṭe, Sītāvaka, and finally in 1592 to Kandy, where the Siṁhalese maintained their independence until 1815. By this time the ancient seats of population in the north, at Anurādhapura and Polonnāruva had long been deserted, and that once most populous and best irrigated part of the island reverted to forest; and Siṁhalese culture and art had acquired a provincial and "folk" character. The last great Buddhist king, builder and patron of religion and the arts ruled in Kandy from 1747 to 1780, and to him the surviving beauty of the city is largely due.

The remains of earlier architecture in |their present aspect, though often of earlier foundation, date mainly from the late Kuṣāna, Gupta and early mediaeval periods. The extant remains of Siṁhalese art thus fall broadly into three groups, a classical period (before the eighth century), a mediaeval period (ninth to fourteenth century) and a late mediaeval period (fifteenth century to 1815)[1].

The earliest surviving structures are *stūpas*, or *dāgabas* as they are called in Ceylon. At Tissamahārāma in the Southern Province, near the probable landing place of the first settlers at the mouth of the Kirindi River, there are remains of several which must have been built in the third or second century B. C.; the Mahānāga Dāgaba was repaired in the first and third centuries A. D. and again about 1100, and has not been restored since the thirteenth century. The Yaṭṭhāla Dāgaba dating from the third or second century B. C. was repaired in 1883, and on this occasion many important finds were made, amongst which the inscribed bricks, silver square coins without marks, crystal and amethyst relic caskets, and a very fine carnelian seal, representing a seated king (fig. 133).[2]

[1] For Siṁhalese art generally see A. S. C. Reports and Bell, 2; Coomaraswamy, 1, 4, 6 and 15 and in J. I. A., vol. XVI; Arunachalam; Perera; Smith, 2 and 7; Smither; Parker, 2; Cave, H. W., *Ruined cities of Ceylon*, Colombo, 1897 (good illustrations); Burrows, *Buried cities of Ceylon*, various editions; an essay on *Kandyan Architecture* by Lewis, J. P., in Cave, H. W., *The book of Ceylon*; the Ceylon National Review; the Ceylon Antiquary and Literary Register; Spolia Zeylanica; Ceylon Journal of Science; Kramrisch, S., *Wandmalereien zu Kelaniya*, Jahrb. as. Kunst, 1, 1924.

[2] For the Yaṭṭhāla Dāgaba see Parker, 1, 2; and Mahāvaṁsa, Ch. XXII, v. 7.

Few of the early *dāgabas* at Anurādhapura exist exactly in the form in which they were first constructed, but most of them nevertheless preserve the early Indian hemispherical *stūpa* type. The typical Simhalese dagaba consists of a hemispherical dome rising from three low circular courses, which rest directly on the ground on a single square basement approached by four stairways; above the dome is a small square enclosure and a railed pavilion, the Indian *har-mikā*, here called *devatā koṭuwa* or "citadel of the gods", and above thus rises the tee, in all extant examples a pointed ringed spire representing an earlier *chatravali*; the relic chamber was often a relatively large cell contained in the mass of the dome. The first *dāgaba* to be founded was the Thūpārāma (244 B. C.)[1], which stood on a circular paved basement and was surrounded by a quadruple ring of tall slender pillars, of which the two inner rows bore tenons, and most of which are still standing. The main purpose of these pillars was to support festoons of lamps. This *dāgaba* was preserved and adorned throughout the classical period, the last restorations being made by Parākrama Bāhu II in the thirteenth century.

The third *dāgaba*, the much larger Maha Sēya, was likewise erected in the reign of Devānam-piya Tissa ca. 243 B. C., at Mihintale, about eight miles from Anurādhapura, a place deriving its name from the apostle Mahinda, whose stone couch, affording a magnificent view over wide stretches of forest, then populous and cultivated, can still be seen. It has probably been rebuilt by Parākrama Bāhu I after the Tamil invasion, in the twelfth century.

The famous king Duṭṭha-Gāmaṇi built two large *dāgabas* at Anurādhapura. One of these, the Ruanwẹli, was of very great importance, and we possess a much more complete history of it and of its construction than of any other early building either in Ceylon or India[2]. It is said to have been completed by his successor Sadhā-Tissa (77—59 B. C.); its long history ends with the restorations begun in 1873 and not yet completed. Undoubtedly the original *dāgaba* has been enclosed in a later addition; but the whole is of brick, as are all the Ceylon examples, and the enlargement was probably made before the beginning of the Christian era. According to the *Mahāvamsa*, the relic chamber was adorned with paintings ("rows of animals and haṁsas), and contained a Bodhi-tree with a silver stem and leaves of gold, relics of Buddha, jewellery, a gold image of Buddha and a representation (painting) of the *Vessantara jātaka*. As regards the image, some doubt may be entertained as to the existence of a Buddha figure in the first century B. C., but it is not impossible that images of precious metal were made long before any in stone. The dome is 254 feet in diameter, and this is but one of several

[1] See Hocart, A. M., in J. R. A. S., Ceylon Branch, 1920.
[2] *Mahāvamsa*, Chs. XXVIII—XXXI.

Siṁhalese *dāgabas* that are as large as all but the largest of the Egyptian pyramids; the paved platform measures 475 by 473 feet. Facing each of the four cardinal points and attached to the dome there is a kind of frontispiece (*wāhalkaḍa*) consisting of superimposed horizontal stone courses, flanked by pillars, decorated in a style recalling that of the Sāñcī *toraṇa* posts. On the platform of the Ruanwẹli Dāgaba there were formerly preserved colossal dolomite standing figures, two of Buddhas and one of a king (traditionally known as Duṭṭha-Gāmaṇi) or Bodhisattva, in a severe and very grand style (figs. 293, 294), related to that of the Amarāvatī images. The probable date of these images is the latter part of the second century A. D.; together with the well-known seated Buddha (fig. 295) in the forest near the circular Road, Anurādhapura, these images were until lately the noblest and at the same time historically by far the most important monuments of Siṁhalese sculpture extant; quite recently the misplaced zeal of pious but ignorant and insensitive Buddhists has resulted in their ruthless restoration, and a complete destruction of all their original qualities; it is devoutly to be hoped that the seated Buddha will escape a like fate. Two early heads (figs. 289, 290) and a standing image in the same style are preserved in the Colombo Museum; another standing image at Wāt Binchamopit, Bangkok, Siam.

The description of the Ruanwẹli Dāgaba applies in a general way to the second great *dāgaba* erected by Duṭṭha-Gāmaṇi, the Miriswẹtiya, Maricavatti, but here the decoration of the *wāhalkaḍ* with processions of animals — horses, bulls, lions, horned lions, and elephants — is more elaborate; the flanking pillars have lion capitals, and are ornamented with elaborate trees, with *pāduka* below and a *dhamma cakka* above. On the stylistic effect of these two buildings Parker remarks that "Duṭṭha-Gāmaṇi and his brother Sadhā-Tissa may claim the credit of being the first rulers to appreciate the grandeur of the effect of an enormous white dome, far greater than anything of the kind previously erected in Ceylon or India, and admirably adapted to be an expression of stability, and permanence, and inaccessibility, such as the purpose of its construction demanded"[1].

The Jetavana Vihāra and Dāgaba were built by Mahāsena (277—304 A.D.). The present *dāgaba*, so called, seems to be wrongly identified. Waṭṭha-Gāmaṇi Abhaya (ca. 100—76 B. C.) had meanwhile built the Abhaya-giri Dāgaba, and this structure has since been confused with the Jetavana. The latter, properly so called is the largest in Ceylon, the diameter of the dome at its base, that is to say above the three basal cylinders called "bracelets" (and corresponding to the Indian *stūpa* "drum") being 325 feet, that of the lowest "bracelet" 367 feet. Beside the

[1] Parker, 2, p. 296.

wāhalkaḍ of the Jetavana stand finely carved pillars (fig. 286) with figures of Nā-gas and Nāginīs and decorative motifs reminiscent of Sāñcī[1].

The Nikawę Kande Dāgaba, in the North Western Province, has yielded crystal and blue glass beads of very early types, ten relic cases of crystal, and two of green glass.

The Loha Mahāpeya, Loha-pāsāda or "Brazen Palace", constructed by Duṭṭha-Gāmaṇi, and so called from the gilt bronze dome with which it was once crowned, must have been a magnificent building[2]. It was a monastery, and originally consisted of nine storeys; destroyed by fire in the fourth century A.D. it was rebuilt with five. All that now remains is the foundation, consisting of 1600 granulite monoliths twelve feet in height covering an area 250 feet square; the superstructure was always of wood. The best idea of the general appearance of such a building may be gained from some of the *rathas* at Māmallapuram, and from Akbar's five-storeyed pavilion, which is in a thoroughly Hindū style, at Fathpur Sikrī.

At what is now the Isurumuniya Vihāra near Anurādhapura there is an outcrop of enormous granulite boulders, divided by a fissure and having before them a partly artificial pool. This site, no doubt in the seventh century, has been treated very much in the manner of the Gaṅgāvataraṇa *tīrtham* at Māmallapuram, though less elaborately. A niche cut in the face of the rock contains a seated figure in relief[3], accompanied by a horse; apparently representing the sage Kapila, it is in pure Pallava style, and one of the finest sculptures in Ceylon; the rock surface below, down to the water level, is carved on each side with beautiful but unfinished groups of elephants amongst lotuses. The effect is to increase the apparent dimensions of the pool, in the same way that the painted scenery at the back of a modern stage apparently extends its actually limited area.

Similar in style are the groups of elephants amongst lotus and fish, carved in low relief on the rock slopes bordering a *pokuna* (tank) near the Tissawęwa lake bund, not far from Isurumuniya. More remarkable on account of its extraordinary realism is the elephant carved in the full round from a boulder in the bed of a stream at Kaṭupilana in the North West Province; when partly covered by water, this could easily be mistaken for a real elephant[4].

The natural fortress of Sīgiriya ("Lion Rock") was occupied by Kassapa I

[1] For the Abhayagiriya, see A. S. C., A. R., 1894, p. 2: Jetavanārāma, 1910—11, p. 11, and both, Parker, 2, pp. 304ff.

[2] The Lohapāsāda is described at length in *Mahāvaṁsa*, Ch. XXVII (Geiger).

[3] Coomaraswamy, 7, pl. 52; Smith, 2, pl. XXIII. The figure is certainly not, as suggested by Parker, 2, p. 548, a soldier in helmet and plume.

[4] Smith, 7. The *pokuna* groups recall the spandril paintings at Elūrā.

(479—497 A. D.) during a great part of his reign[1]. On the summit of the rock he constructed a palace, of which the foundations survive, and as a means of access built a remarkable walled gallery, with a façade in the form of an enormous seated lion, which may have given its name to the rock. In the vertical wall of the cliff above the gallery are two sheltered rock pockets, not deep enough to be called caves, but in which are still preserved frescoes of the fifth century (fig. 184), in a style closely related to that of Ajaṇṭā, and representing celestial women, with their attendant maids, casting down a rain of flowers; the fact that the figures are all cut off by clouds a little below the waist proves that the persons represented cannot have been regarded as human beings. These paintings combine a great elegance of manner with a penetrating sensuality. The colours used are reds, yellow, green and black. The perfect preservation of these paintings is extraordinary, considering that they have been exposed to the open air for fourteen hundred years. It may be noted that many of the figures wear a *colī*, quite unmistakeably indicated.

Another painting, in the Pulligoḍa Galkande, Tamankaḍuwa, near Poḷonnāruva represents five seated male persons, all nimbate, and may date from the seventh century[2]. Many of the *dāgabas* at Anurādhapura, wherever plastered surfaces are preserved, show traces of decorative colouring[3]. Rock paintings at Hiṇḍagala, near Kandy, representing Buddha in the Trayastriṁśa Heavens, have been assigned to the seventh century, but are probably of later date[4]. Those at the Ridī Vihāra do not seem to be very old.

All of the buildings at Poḷonnāruva (Pulatthipura) must date between 781 and 1290, including the periods of Tamil (Coḷa) occupation from about 1049 to 1059 and one of a few days in 1198. What survives even to the present day constitutes a veritable museum of mediaeval styles, but only a few of the most important buildings can be referred to in detail. There is a large series of *dāgabas*, of the usual hemispherical type, amongst which the Rankot Vehera or Ruanweḷiseya, and the Kiri, and Laṅkātilaka *dāgabas*, all of the "bubble" type, are the largest. Of the many works ascribed to Parākrama Bāhu I (1164—1197) may be mentioned the Gal Vihāra, consisting of an apsidal cave shrine, containing a seated rock-cut Buddha and traces of ancient painting, and with a seated Buddha over fifteen feet in height to the right of the entrance; and a rock-cut Parinirvāṇa image over forty-six feet in length, with a standing figure of Ānanda, with arms

[1] General account in A. S. C., A. R., 1905. Further details, 1896, p. 10, and 1897, p. 14. There are good copies of the frescoes in the Colombo Museum.

[2] Smith, 2, fig. 213.

[3] Smither, pp. 21, 27, 31 and pl. XXXII.

[4] Joseph, G. A., *Buddhist fresco at Hiṇḍagala near Kandy*, Ceylon Administration Reports, 1918, Colombo, 1919. A poor copy is in the Indian Museum, Calcutta.

crossed, beside it, nearly twenty-three feet in height[1]. The Thūpārāma is a rectangular brick temple in Dravidian style[2], but with vaulted arches and narrow triangular windows like those of Bodhgayā and other brick temples in the Ganges valley. The roof is flat, with a low pyramidal tower of successively reduced storeys; the inner walls were plastered and painted, the outer decorated with architectural façades. The whole structure recalls the "cubic" architecture of Campā[3]. The Northern Temple, formerly but incorrectly designated Demaḷa Mahā-sęya, has plaster covered brick relief figures in the niches of the external decoration (fig. 302); when the interior was cleared much of the plastered surface covered with paintings (fig. 291) of Jātakas, the *Vessantara* and *Maitribala* amongst others, was found in a fair state of preservation, but as a result of some twenty years exposure and neglect, these paintings, which formed by far the most extensive remains of their kind anywhere in India or Ceylon, have almost disappeared. Both temples contained large standing Buddha figures of brick[4].

The Jetavana monastery at the other end of the city consists of a group of buildings, amongst which the Laṅkātilaka, containing a gigantic standing Buddha of brick, is the largest Buddhist temple in Ceylon. The roof was probably a storied structure like that of the Thūpārāma. Remains of frescoes include a *nārī latā* design on the ceiling[5].

Still another building due to Parākrama Bāhu I is the Potgul Vihāra, the "delightful circular house" where he was accustomed to sit and listen to the reading of the *Jātakas* by the learned priest who dwelt there[6]. The building consists of a circular cella, originally painted, now roofless, with a small *antarāla*, and a *maṇḍapa* added later by Candravatī, while at each angle of the outer platform are small *dāgabas*[7].

The colossal rock-cut statue (fig. 301), eleven and a half feet in height, carved in high relief from a granulite boulder to the east of the Tōpawęwa bund, is traditionally regarded as a representation of Parākrama Bāhu himself. One of the finest sculptures in Ceylon, it represents a dignified bearded sage reading from

[1] For the Gal Vihāra, and similar rock-cut images at Tantrimalai, see A. S. C., A. R., 1907, p. 34; for the painting, *ibid.*, 1909, p. 34. The image of Ānanda carried in procession in the reign of Sena II (886—901), *Mahāvaṁsa*, Ch. LI, v. 80, was probably of metal.

[2] The *Mahāvaṁsa* states casually that Parākrama Bāhu brought "Damiḷo" artificers from India to decorate Poḷonnāruva. Even at the present day the Siṁhalese masons (*galwaḍuwo*) and some of the higher craftsmen are of acknowledged Tamil descent. Cf. page 126.

[3] For the Thūpārāma, see fig. 303, and A. S. C., A. R., 1903, pp. 30ff.

[4] For the Northern Temple frescoes see A. S. C., A. R., 1909, pls. XXV—XXVII and A—P: and *ibid*, 1922—23, figs. 12, 13. There are poor copies in the Colombo Museum.

[5] A S. C., A. R., 1910—11, pp. 30ff.

[6] *Mahāvaṁsa*, ch. LXXIII.

[7] A. S. C., A. R., 1906, pp. 14ff.

a palm-leaf book; the identification has been doubted, but it does not seem at all impossible that the pious king should have wished to be represented in this fashion[1].

The Sat Mahal Pāsāda is a solid seven storied building, more like a traditional Mt. Meru than any other building in India or Ceylon. Bell has called attention to the Cambodian affinities of this and other buildings, calling this the "Cambodian quarter of the city"[2].

To Nissaṅka Malla (1198—1207) is attributed the beautiful Nissaṅka Latā Maṇḍapaya, a railed enclosure containing eight curvilinear lotus pillars which once supported a roof[3]. Credit is given to the same king for the Waṭa-dā-gē (fig. 304), a building quite unique, but for the similar circular shrine at Meḍagiriya twenty miles distant. Bell calls it the "most beautiful specimen of Buddhistic stone architecture in Ceylon". It consists of a circular terrace, 375 feet in circumference, stone faced and paved; upon this a circular pedestal, elaborately ornamented and supporting a low railing of stone slabs divided by octagonal pillars twice their height; a narrow circular passage separating this pillared railing from a high brick wall; and within this a small *dāgaba*, with two circles of pillars round it, and seated Buddhas facing each of the four entrance stairways, which are provided with Nāga *dvārapālas* of the usual Siṁhalese type. Quite possibly this was the shrine erected by Parākrama Bāhu I as a "round temple of the Tooth-relic", and Nissaṅka Malla merely restored it[4].

Also ascribed to the twelfth century are the colossal standing Buddha at Sęsēruwa, N. W. P., 16' 2" in height, that at Āwkana, 46' in height, and the seated Buddha protected by the Nāga Mucalinda at Kon Wewa, N. C. P.[5]

There is also at Poḷonnāruwa a series of Hindū temples (*devāles*) built in the time of Cola occupation and in Cola style[6]. The Śiva Devāle, No. I, miscalled the Daḷadā Māligāwa, is the finest Hindū shrine in Ceylon. The Śiva Devāle no. 2 is of granulite and limestone, and consists of *garbha-gṛha, antarāla, ardha-maṇḍapa* and *maṇḍapa*, with a four-storeyed *vimāna*; the exterior was originally plastered and painted, traces of a lattice pattern in red and white remaining on the façade of the second storey. Originally known as the Vaṇuvaṇmā-devī Īśvaramuḍaiyār, it has inscriptions of Adhirājendra Coḷadeva, ca. 1070 and Rā-

[1] A. S. C., A. R., 1904, p. 4; 1907, p. 21, note. Smith, 2, p. 241.

[2] A. S. C., A. R., 1906, p. 17; 1910—11, p. 39.

[3] A. S. C., A. R., 1910—11, p. 38.

[4] A. S. C., A. R., 1903, pp. 22—26; 1904, p. 5; *Mahāvaṁsa*, ch. LXXVII, translation, pp. 40, 41.

[5] Smith, 7.

[6] General description, A. S. C., A. R., 1908, pp. 4—20; also 1906, p. 17, 1907, p. 17.

jendracoḷa I (1020—1042), and like most of the *devāles* at Poḷonnāruva, seems to have been desecrated by Parākrama Bāhu II of Dambadeṇiya in the thirteenth century, a fact which affords a *terminus ante quem* for the date of the bronzes, found in the course of excavations. Five other *devāles* are found outside the old city walls, three of these being Vaiṣṇava; with the exception of No. 2, described above, all are of brick, or brick and stone, and have enclosing walls (*prakāra*) of brick.

Another fine temple of the Coḷa period, known as the Geḍige, is found at Nālandā. This temple which may be dated about 1040, has a barrel roof and *caitya*-window gable, and was of mixed Hindū and Buddhist dedication[1]. Later, probably of sixteenth century date, is the beautiful, but unfinished Berendi Kovil at Sītāwaka[2]. There is also an elegant early Hindū shrine at Ridī Vihāra, consisting of a stone *maṇḍapam* in front of a cella situated beneath an overhanging rock. Smaller Hindū shrines (*kōvils* and *devāles*) are numerous (e. g. Kataragama, Kandy and Ratnapura), and in many cases these are associated with or even form a part of Buddhist temples, as at the beautiful Buddhist temple of Laṅkātilaka, near Gaḍalādeṇiya, a fine building partly of stone, in a Dravidian style with Kandyan roofs[3].

A fair number of Siṁhalese bronzes, actually in most cases of copper, and ranging in date from about the fifth to the twelfth century A. D. have been recovered and published, mainly by myself[4]. A purely Gupta type is represented by the fine example from Badullā, in the Colombo Museum (fig. 296). Two of the finest small figures known from any site in India or Ceylon are the bronze Avalokiteśvara (fig. 297) and Kuvera (Jambhala) (fig. 298), now in the Museum of Fine Arts, Boston; the former a spiritual type in style and movement like the rock-cut Śiva of the Kailāsanātha at Elūrā (fig. 193), the latter wonderfully realising an ideal of material well-being, and very like the Siṁhala-dvīpa Jambhala of a Nepalese manuscript of the eleventh century[5]. Both of these may be assigned to the eighth century. Probably of the ninth century, and not quite equal in conception to these, is the Vajrapāṇi of fig. 299; the pedestal shows marked analogies with early Pala and Javanese forms. There are other good examples of Mahāyāna bronzes from Ceylon in the British Museum. In this connection it may be pointed out that while Siṁhalese Buddhism has remained predominantly Hīnayāna, there existed a Mahāyāna monastery of the eighth or ninth century at Anurādhapura, known as the Vijayarāma Saṁghārāma,

[1] A. S. C., A. R., 1910—11.

[2] Bell, 2, p. 63.

[3] Coomaraswamy, 1, pl. VII, 1.

[4] Coomaraswamy, 6, 7, 9 (2) and 15.

[5] Foucher, 1, pl. IX, 2 (Cambridge Ms. Add. 643). The manuscript illustrations, as pointed out by Foucher, evidently repeat older types.

and a scroll has been found, inscribed with a hymn to Tārā[1]. On the other hand, no characteristic example of Tāntrik Buddhist art has been found in Ceylon.

A standing Bodhisattva from Anurādhapura, of adequate workmanship, but scarcely a masterpiece, may also be assigned to the close of the classic period[2]. Much finer was the copper figure of a Bodhisattva, heavily gilt, but greatly corroded, purchased for the Boston Museum, but stolen in transit[3]. This figure was clearly related stylistically to the colossal statue known as Parākrama Bāhu I at Poḷonnāruva above referred to.

The British Museum has possessed since 1830 a very splendid brass or pale bronze image of nearly life size (fig. 300), from somewhere between Trincomalee and Batticaloa, and traditionally identified as a representation of Pattinī Devī[4]. The drapery, below the waist, is very sensitively realised, the material clinging closely to the limbs in Gupta style. It is difficult to date the figure exactly; the angularity of the elbows may perhaps relate it to the Poḷonnāruva Parākrama Bāhu and the copper figure above referred to; but it compares well in aesthetic value with the Indian Sulṭāngañj Buddha and is far superior to the twelfth century sculptures of the Gal Vihāra, with which the figure of Parākrama Bāhu is supposed to be contemporary.

Another bronze of great beauty is a panel, which once formed part of a door jamb, from Anurādhapura, now in the Colombo Museum; the floral scroll and pala-peti band have all the decorative abundance of the Gupta style at its best[5].

Very different from the bronzes described above are the Hindū bronzes excavated at the Śiva Devāles in Poḷonnāruva[6]. These include copper images of Śiva in various forms (Naṭarāja, etc.), Pārvatī, Kārttikeya, Gaṇeśa, the Śaiva saints Sundara-mūrti Svāmi, Māṇikka Vāsagar, Tirujñāna Sambandha Svāmi, Appar Svāmi; Viṣṇu, Lakṣmī, Bāla Kṛṣṇa, Hanuman; and Sūrya. Some of the Śaiva saints, especially the Sundara-mūrti Svāmi (fig. 243) and Māṇikka Vāsagar are superior to any South Indian examples, but all the figures are in Dravidian style, and though probably cast in Poḷonnāruva, must have been made by South Indian sthapatis. They are further of interest as being necessarily to be dated before 1300; it is certain that metal images were made at Tanjore in the eleventh century, but no positive evidence exists enabling us to date any of the known Indian examples so far back.

[1] A. S. C., A. R., 1891, pp. 4, 5.

[2] Coomaraswamy, 6, fig. 9.

[3] M. F. A. Bull., no. 120, fig. 13.

[4] For the legend of Pattinī Devī see Coomaraswamy, 15, p. 293; Parker, 2, p. 631 ff. The full story is related in the Tamil *Silappatikāram*.

[5] Coomaraswamy, 6, fig. 90.

[6] Coomaraswamy, 6; Arunachalam, 2.

By the eighteenth century, Siṁhalese art had become a provincial, and practically a folk art, and as such is extraordinarily rich and varied. We possess, too, a more detailed account and knowledge of it than is the case with any similar area in India. What survives of it is to be found mainly in the Colombo and Kandy Museums in Ceylon and in the Victoria and Albert Museum, London. It is more adequately represented in the architecture and painted decoration of the countless Buddhist temples and monasteries of Kandy (Maha Nuwara) and the Kandy district[1]. These, as they stand are mainly due to the patronage of the last great king of Ceylon, Kīrti Śrī Rāja Siṁha (1747—1780). The finest temples are the Daḷadā Māligāwa in Kandy, where the tooth-relic is preserved, and the Gadalādeṇiya, Laṅkātilaka and Ridī Vihāra temples; the best preserved monastery, the Malwatte Pansala in Kandy. Admirable paintings, in the formal style of the period, are preserved at Degaldoruwa[2], executed between 1771 and 1786 in part by Devaragampala Silvateṇna Unnānse, an "unordained" Buddhist priest who worked also at the Ridī Vihāra; at the Danagirigala, Laṅkātilaka, Doḍantale and Gaṇegoḍa temples; and at the Keḷaṇiya Vihāra[3] near Colombo, though in the latter case affected by European influences. The paintings at the Dambulla Gal Vihāra, and at Aluvihāra, while not ancient in their present state, to a large extent preserve ancient designs[4]. A few illustrated Buddhist manuscripts on paper, of late eighteenth and early nineteenth century date are known. The Kandyan craftsman of the superior class practised several arts, as painting, ivory- and wood-carving, metal work and jewellery; the blacksmiths, potters, ivory-turners, and potters belonging to lower groups. In jewellery, two techniques are of special interest, the one that of decoration of surfaces with rounded grains and wire (fig. 375), the other that of "gold-embedding" or incrustation, in which a surface is covered with thin rounded stones set in soft gold shaped with a hard tool; the variety and beauty of the beads (fig. 373) is remarkable. Probably the finest as well as the largest collection of jewellery and encrusted gold plate (figs. 381, 385) and silver ware is that of the Daḷadā Māligāwa in Kandy, the jewellery for the most part representing personal adornments dedicated by royal benefactors. Purely Kandyan weaving is always in cotton, the decoration being added while the work is in progress in tapestry technique; textiles of finer quality were imported from Southern India. In pattern almost all of the oldest Indian motifs are to be met with (fig. 396). Broadly speaking the Kandyan style is closely related to that of Southern India; many of the higher craftsmen, indeed, are of south Indian extraction,

[1] Bell, 2; Coomaraswamy, 1; Lewis, J. P., in Cave, H. W., *The book of Ceylon.*
[2] Coomaraswamy, 1.
[3] Coomaraswamy, in J. I. A., vol. 16, No. 128, 1914; Kramrisch, in Jahrb. as. Kunst, I, 1924.
[4] Cf. Beylié, L. de, *L'architecture hindoue en Extrême Orient*, Paris, 1907, pp. 373—378.

although so completely adapted to their environment that this would never be guessed from their appearance, language or workmanship. Descendants of the higher craftsmen are still able to carry out difficult tasks with conspicuous ability, and suffer more from lack of patronage than lack of skill. But the taste of "educated" Siṁhalese has degenerated beyond recovery, and some modern Buddhist constructions are not surpassed for incongruity and ugliness by any buildings in the world.

BURMA[1]

At an early period, probably by 500 B. C., the dominant races of Burma were the Pyus, of Central Asian origin, in the north (Arakan and as far south as Prome), and the Talaings in the south (Thaton, and after 573 A. D. also Pegu). The latter belong to the Mon-Khmer family, which embraces the Khmers in the east, and the Bhīls and Goṇḍs in India proper. Contact with India both by land and sea had been established perhaps already in the Maurya period. In all probability by the first century A. D., Tagaung in the north, Old Prome (Śrīkṣetra and Pisanu Myo or City of Viṣṇu) on the Irawadi, and Thaton on the sea coast possessed Indian colonies or at least were strongly subject to Indian influence. From the fifth century onwards Prome and Thaton were certainly important centres of Buddhist and Hindū culture; Vaiṣṇava and Śaiva sculptures, Buddhist *stūpas*, brick buildings and terracottas in or closely related to the Gupta tradition have been found at Tagaung, Prome, Thaton and other places[2]. The Buddhism of Prome, source of the oldest and indeed the only Burmese Sanskrit inscription, was Mahāyāna, that of Thaton, where the inscriptions are in Pali in a South Indian alphabet, Hīnayāna. The Śaka era was in use; a later Burmese era was established in 639. Buddhaghoṣa is said to have visited Thaton about 450 A. D. bringing with him the books of the Pāli canon, and from this time onwards Burma has been more exlusively a Buddhist country than was the case in any other part of Further India or Indonesia. Northern Burmese Buddhism on the other hand at an early date acquired a Tāntrik character and had close connections with Nepāl.

In the eighth century the Talaings of Pegu conquered Prome and a new northern capital was established at Old Pagān. The walled city, of which the southern gateway still survives, dates from 847. The eighth and ninth centuries were marked by Shān-Thai invasions from the north, bringing in a fresh influx of Tibeto-Burman blood, and introducing the Burmese proper who have gradually replaced the old Pyus and absorbed the Talaings.

[1] Duroiselle; Ko (also many shorter notes by the same authors in A. S. I., A. R.); Harvey.
[2] For an early mediaeval Sūrya from the Akyab District, see A. S. I., A. R., 1922—23, p. 123; bronze Tārā, *ibid.*, 1917—18, pl. I, p. 27 and pl.XVII, 1, 2.

Only a few of the Pagān temples and *stūpas* date from the tenth century. The Vaiṣṇava Nat Hlaung Gyaung (fig. 305), traditionally dated 931, is the only surviving Hindū building[1]. The Ngakywe Nadaung (fig. 306) is a cylindrical or more accurately bulbous *stūpa*, recalling the Dhāmekh at Sārnāth. The Pawdawmu too has evident Indian affinities; the Pebin Gyaung is of the Siṁhalese type.

The unification of Burma was first accomplished by Anawratā (Aniruddha) of Pagān (1040—1077). Anawratā invaded and conquered Thaton, and brought back with the Talaing king (Manuha) Hīnayāna books and priests to Pagān; he attempted to drive out the Tāntrik Arī; he established connections with foreign countries, obtained relics, and initiated a great era of building. Remains of more than 5000 "pagodas" can still be traced in and near Pagān. The following are the names and dates of some of the most important:

> eleventh century — Kyanzittha cave temple (1057—1059); Shwezigon (1059, enlarged 1084—1112), Ānanda, (1082—1090), Nanpaya, Seinnyet, the two Petleik pagodas, and the library (Bidagat Taik);
> twelfth century — Sapada, Thatbinnyu and Shwegugyi pagodas;
> thirteenth century — Mahābodhi, Kondawgyi, Mingalazedi (1274) and Tilominlo pagodas.

With the exception of the Kyanzittha and Nanpaya these are all brick structures, and were decorated with carved stucco. The Nanpaya is of stone. The Nat Hlaung Gyaung and Ānanda pagodas are remarkable for their contemporary sculpture (fig. 316, 317), the Kyanzittha, Kondawgyi and others for their mural paintings, the Shwezigon, Ānanda, Petleik and some others for their glazed terracotta bricks illustrating the *Jātakas*. The Tilominlo is unique in its decoration of green glazed sandstone.

The architectural forms are very varied and reflect a contact with many countries. The bulbous (fig. 306) and cylindrical forms recall Sārnāth and the votive *stūpas* of the Pāla period; the Pebin Gyaung and Sapada are of the old Siṁhalese hemispherical type; several others are crowned by a kind of Āryavārta *śikhara* shrine; the Mingalazedi (fig. 313) and Shwesandaw have truncated pyramidal terraced bases with angle towers, and a central stairway on each side, recalling Cambodian terraced *prāngs* and the older Boroboḍur; the Mahābodhi (fig. 309), with its high straight-edged *śikhara*, is modelled on the older shrine at Bodhgayā (fig. 210); the library (fig. 308) is surmounted by a five-fold roof with angle points suggesting the wooden forms of the Mandalay palace, and the prison-palace of King Manuha is in the same style; the decoration of the Seinnyet shows Chinese peculiarities.

[1] Assigned to 11th—13th century by Duroiselle, A. S. I., A. R., 1912—13, p. 137.

In the most distinctively Burmese types (Ānanda, Thatbinnyu, Shwegugyi, Gawdawpalin, etc., and the Hindū temple of 931) one of the lower terraces is independently developed to a great height, giving a cubic aspect to the main part of the building, and chapels and galleries are opened in the solid mass thus made available. An Indian parallel can be cited at Mīrpur Khās, Sind, where a brick *stūpa*, which cannot be later than 400 A. D. has a deep square base containing within its wall mass, though only on one side, three small shrines[1].

The modern Burmese pagodas of the Shwedagon type (fig. 310), like many in Siam, slope almost smoothly upwards from the broad base, thus without a marked distinction of the separate elements, and presenting a very different appearance from the old Indian and Siṁhalese bell and domed types, as well as from the mediaeval cylindrical forms of Sārnāth, Pagān and Hmawza; the later type is more picturesque, but architecturally over-refined, and aspiring, but unsubstantial. Many such pagodas are built over and conceal much older structures.

Materials for the study of Burmese sculpture are rather scanty. The older fragments of the seventh or eighth century reflect Gupta tradition; the typically Gupta bronze of figure 159 said to have been found in Burma, is probably of Indian origin. The Das Avatāra sculptures of the Nat Hlaung Gyaung are still markedly Indian, so too the Nanpaya reliefs (fig. 314), and most of the small bronzes and stone reliefs of the eleventh century; many of the latter may be importations from Bihār or Bengāl. Classical Burmese sculpture is best represented by the eighty-one reliefs of the Ānanda pagoda[2] (figs. 316, 317), which represent scenes from the life of Buddha according to the *Avidura-Nidāna*, with one panel perhaps referable to the *Lalita-Vistara*; a figure of Kyanzittha, warrior-king and founder of the Ānanda temple, is included in the scenes. These reliefs are remarkable for their clarity, animation and grace. Each is inserted in a niche of its own; thus there are no continuous relief surfaces like those of Borobuḍur or Aṅkor Wāt. Very much in the same style, but rather nearer to old Indian terracottas and to reliefs like those of the Chandimau pillars[3] are the glazed *Jātaka* bricks of the Petleik, Ānanda, Shwezigon, Mingalazedi and other pagodas; the earliest and best are those of the western Petleik[4].

Several of the Pagān pagodas contain contemporary frescoes. The *Jātaka* paintings of the Kubczatpaya (11th—12th century) and Kubyaukkyi consist of small square panels closely grouped and collectively covering a large area[5]. Separate figures of

[1] Cousens, 5.

[2] Duroiselle, 2; and Seidenstücker.

[3] Banerji, 2.

[4] Duroiselle, 1; Ko, 1. References listed, Coomaraswamy, *Burmese glazed tiles*, in M. F. A. Bulletin No. 98; and Duroiselle, 1.

[5] Thomann; Duroiselle, 1.

Buddhas and Bodhisattvas are on a larger scale. Other frescoes are found in the Nandamannya pagoda (fig. 311). Those of the Payathonzu triple temple at Minnanthu near Pagān (fig. 312) illustrate the Tāntrik Buddhism of the Burmese Arī sects, a mixture of Buddhism, Hinduism and local elements, often highly erotic[1]. Frescoes in the Kyanzitthu cave temple, dateable about 1287, represent unmistakeable Mongols[2]. Those of the small brick monastery near the Ānanda temple are quite modern, and show European influence. A pair of carved wooden door panels of the Pagān period is preserved in a temple near the Shwezigon.

The stylistic affinities of the frescoes are with Bengāl and Nepāl as illustrated in Cambridge Ms. Add. 1643 (Nepalese of 1015 A. D.), Ms. A. 15 Calcutta, (Nepalese of 1071 A. D.), Mss. Cambridge Add. 1464 and 1688, (Bengālī of the eleventh century[3]; the Boston manuscript 20. 589, Nepalese of 1136 A. D. (figs. 280, 281), and more remotely with Elūrā. The wiry nervous outline is characteristic. The hair line above the brow descends in a central point, the eyebrows and eyelids are doubly curved, the round chin clearly indicated, the whole pose has conscious aesthetic intention. The three-quarter face is often shown, and in this case the further eye is made to project; this peculiarity, in conjunction with the long very pointed nose presents a rather close parallel to the Gujarātī (Jaina, etc.) painting of the 12th—16th centuries. Thus from Elūrā, Nepāl-Bengāl, Gujarāt, Poḷonnāruva, and Pagān we can obtain a fairly clear idea of mediaeval Indian painting.

Another extensive series of remains is to be found at and around Prome (Yathemyo and Hmawza). Urns with Pyu legends may date from the fourth century. Inscriptions on gold scrolls in Eastern Cāḷukya characters date from the seventh century or slightly later. Of ancient cylindrical *stūpas* the best preserved is the Bawbawgyi, a hundred and fifty feet in height, and supported by five low receding terraces; dating perhaps from the eighth century. Sculptures representing the Buddha with *caurī*-bearers as attendants are of Kuṣāna-Gupta derivation. At Yathemyo there are very extensive remains of walled cities, burial grounds, sculptures and pagodas, mostly perhaps of the eleventh century.

At Tagaung, the earliest seat of Burmese rule, and receiving its Indian culture rather through Assam and Maṇipur than from the south, nothing has so far been found but terracotta plaques of the Gupta period.

Pegu, Talaing capital from 573 to 781 and again from the thirteenth to the sixteenth centuries, attained the zenith of its development in the latter period. The remains include a number of *stūpas*, of which the Shwemawdaw has grown by successive additions from an original height of 75 feet to one of 288, with a base

[1] Duroiselle, 3.

[2] Duroiselle, in Rep. Arch. Surv. Burma, for 1922, pl. 1.

[3] Foucher, 2.

circumference of 1350. On the west side of the town there is a Parinirvāṇa Buddha image 181 feet in length.

At Thaton in the south, the Shwezaya and Thagyapaya may date from the classical period; the latter contains terracotta panels like the glazed bricks of Pagān, but with Śaiva subjects.

After the twelfth century, when direct Indian influence is no longer strongly felt, the quality of Burmese sculpture rapidly declines; as the art grows more provincial the element of local colour becomes more evident. Some of the postclassical lacquered wooden figures of standing Buddhas are not lacking in nobility and grace, and much of the older architectural woodcarving, or that seen on the decorated sterns of the river boats is altogether delightful. After the eighteenth century taste becomes increasingly rococo. The characteristic seated and reclining alabaster Buddhas which have often been regarded as typical of Burmese art are quite modern, and usually sentimental and inefficiently realistic.

The great expenditure of resources during the Pagān period prepared the way for the northern invader — "the pagoda ready, the people destroyed". In 1287 Kublai Khān sacked Pagān; after this followed Shān-Thai incursions. The Shāns then built a capital at Ava and pushed down the Irawadi to Prome. Later history has mainly to do with the struggle between the northern Shān (Burmese) kingdom, and the Talaings of Pegu, who were finally dispersed by Alaungpaya in 1760. Bawdawpaya (1781—1819) planned the Mingun Pagoda, which was to have been the largest in Burma; still over a hundred and forty-three feet in height, this represents only a third of the originally intended dimension. The great bell mentioned below was intended for this shrine.

A series of painted alabaster plaques, illustrating *Jātakas*, in imitation of the old terracottas, was made for the Pathodawgyi, Amarapura, in 1820.

Mandalay was founded only in 1857 and occupied two years later by Mindon Min, the last great patron of Burmese art, to whom we owe the Mandalay palace, as well as innumerable beautifully illuminated Buddhist texts prepared for him and presented to the monasteries as an act of pious devotion. The palace buildings and several groups of monasteries, e. g. the Myadaung Kyaung of Queen Supalayat, and the Sangyaung monasteries at Amarapura, are magnificent examples of richly decorated wooden architecture, and in scale and plan, afford some idea of the magnificence of older Indian palaces in wood of which no trace remains. The main features of the style are the use of immense teak columns, finely lacquered and gilt, the multiple roofs and spires with flamboyant crockets, and the interior decoration with glass mosaic inlay[1].

[1] Ko, 3, 4, and Duroiselle, in A. S. I., A. R., 1912—13.

Of the minor arts, Burma is famous for its lacquer[1], which is applied both architecturally and to small objects designed for personal or monastic use; thus wooden columns, boxes of all sizes, and book covers are typically so decorated. The chief centres of modern work are Nyaung-u near Pagān, Prome, and Laihka. In the case of small objects the framework is made of very finely plaited bamboo or of plaited horse-hair; the interstices are filled, and the whole varnished black. Other colours, red, green, and yellow are then successively applied, engraving of the design and polishing of the surface being necessary after each coat of colour is applied. A good deal of the work is restricted to black and gold, in other and coloured examples the design may be extremely elaborate, including figures of Buddhist divinities and illustrations of *Jātakas*. Three or four months are required for all the stages of manufacture. The lacquered Buddhist texts alluded to above are written in black on a surface richly decorated in red and gold. The basis is palm leaf of the usual form. Here as elsewhere in Indo-China a decline in the quality of the minor arts is apparent only after the middle of the nineteenth century.

Repoussé silver-work, niello and cloisonnée, and gold and silver jewelry have all been made in fine designs and with admirable technical skill; but most of the modern production is designed for European buyers, and is often nothing but an imitation of the "swami-work" of Madras. The Burmese have always been expert founders, especially of images and bells, and makers of fine gongs. The great bell cast for Baw-dawpaya in 1790, the second largest in the world, weighs eighty tons; such works as this are undertaken, of course, with what would now be regarded as totally inadequate apparatus. Burmese shot silks, still made at Amarapura, are deservedly famous. *Ikat* technique is found only in narrow bands of v-shaped elements in lengthwise succession in the skirts woven by the Kāchin tribes. Embroidery, too, with the exception of the well-known Burmese appliqué curtains, is mainly the work of hill tribes.

The Burmese theatre (*pwe*) is well developed. Plays are performed at temple fairs, occasions of domestic celebration, dedications and as an honour paid to the dead. The stage is a temporary thatched or mat covered pavilion open at the sides; but the Mandalay palace has a regular dancing hall, where performances took place for the entertainment of the royal family. The favourite themes are drawn from the *Jātakas* (*Zāt*) and from romantic legends. There exists too an elaborate marionette (*zotthe*) theatre, the puppets being worked by strings from above. There appears to exist also a shadow play, in which large cut-leather scenes from the *Rāmāyaṇa* are employed, without any moveable parts[2].

[1] Lacquer dating from the 12th or 13th century has been found at Pagān (A. S. I., A. R., 1922—23, p. 193).

[2] Ferrars, M. and B., *Burma*, London, Ch. VIII. Cut leather examples in the Ethnographische Museum, München.

SIAM[1]

Siam was by no means a unified kingdom before the fourteenth century. The simplest possible statement of Siamese history would be to the effect that at the beginning of the Christian era the greater part of the Menam valley was in the hands of the Mon-Khmers, whose sway extended from Cambodia to Southern Burma, and that gradually the Sino-Tibetan Lao-Thais, ancestors of the modern Siamese, pressed downwards from the north until they obtained possession of the whole delta, Cambodia, and the greater part of the Malay peninsular.

An early Thai capital was established at Lamphun about 575. A little further south, from the combination of Lao-Thai-Khmer races developed the powerful kingdom of Sukhotai-Sawankalok (twin capitals also called Sukhodaya and Sajja-nālaya), and here Indian culture, Brahmanical and Buddhist, derived from the south through the Khmers, prevailed. This kingdom attained the zenith of its power in the eleventh century.

Meanwhile the southern kingdom of Lopburi (Lapapurī) formed a part of the Cambodian hegemony known to the Chinese as Fu Nan and Kan To Li, and embraced, at any rate nominally, a part of Southern Burma (Thaton-Pegu) and the northern part of the Malay Peninsular as far as Kedah and Ligor (Sithammarat = Śrī Nakon Thamarat = Śrī Dharmarāja Nagara) in Jaiyā. The chief city of this southern kingdom was Dvāravatī, afterwards Sano, later the site of Ayuthiā. Indian influences were here strongly felt; remains of the Gupta and Pallava periods have been found at Rājaburi, Prapathom, Chantaburi, Kedah, Takua-Pa and Ligor. From the sixth to the thirteenth century Lopburi was politically, and culturally a part of Cambodia. It is therefore not at all surprising that just as in Southern Cambodia (Funan) so in Southern Siam we find unmistakeable remains of an Indianesque art of Gupta character. Amongst the more important examples of this type may be mentioned the Viṣṇu from Vien Srah, and a Lokeśvara from Jaiyā, both in the National Library, Bangkok; a pre-Khmer Buddha of the Rom-lok kind in the Museum at Ayuthiā; Buddhas from Dvāravatī in the Museum at Lopburi; a bronze ajourée pedestal in the manner of the Kāṅgṛā brass (fig. 163) and a *Dhamma-cakka* at Prapathom (fig. 318).[2]

About 1100 the northern Lao Thais established another capital at Pitsanulok in what had hitherto been Khmer territory. Sukhotai-Sawankalok maintained a diminished power for several centuries, but its cities were certainly abandoned by

[1] Aymonier, 1; Coedès, 5, 6; Döhring, 1, 2; Fournereau, 2; Gerini, 1, 2; Graham 1, 2; Lajon-quière; Salmony 1, 2; Seidenfaden; Voretsch, 1, 2.

[2] Some of these types are illustrated in Salmony 1, 2; others in J. S. S., vol. XIX, pt. I, pls. IV, XIII, XV.

the end of the fifteenth. Pitsanulok became the main centre of power, under princes of mixed Thai-Khmer blood. Meanwhile Cambodia and Pegu attempted with varying success to assert or maintain their supremacy. About 1280 a new Khmer capital was founded at Sano.

At the beginning of the thirteenth century a new Thai invasion resulted from the Mongol pressure, exerted by Kublai Khān in Southern China. The Thais soon occupied the whole Menam valley, and in 1296 ravaged Cambodia. They gradually wrested the Peninsular provinces from Śrīvijaya, and about 1400, after a long struggle with Malacca (Malayu) reached the Straits. In the same century a Siamese army reached Aṅkor, and the Cambodians never recovered their independence. The building of Ayuthiā on the site of Sano, taken from the Khmers, is dated 1350 according to the Annals, but most likely a date nearer to 1460 would be more correct. Siam could now at last be regarded as one country, Ayuthiā remaining the capital for four centuries; even Chieṅmai in the north, which had replaced Lamphun as the Lao capital, owed allegiance to Ayuthiā. Wars with Burma met with varying success. About 1600 Siam was the dominant power in Southern Burma, the Malay Peninsula and Cambodia, and an active trade developed with India, China and Europe. In 1757, however, the Burmese captured and destroyed Ayuthiā, and the capital was transferred to Bangkok.

Little is known of the beginnings of Indo-Thai art at Lamphun and Sukhotai Sawankalok. Buried in the jungle and yet unstudied there may well exist some traces of an Indianesque period, dependent like that of the south[1] on Gupta tradition. Before the eleventh century all the northern building is in laterite, contrasting with the brick of the Indo-Khmer south. Bronzes have been found that may have come from Ceylon[2]. Later, and quite definitely by the tenth and eleventh centuries the classical Siamese (Thai) type emerges and asserts itself. In spite of occasional Khmerisms recognizable even at Sukhotai, and the use of the Khmer language in inscriptions up to the end of the thirteenth century the northern Thais remained artistically independent; even in the south we find occasional bronzes of Thai character, and the stucco modelling in Lopburi is by no means so purely Khmer as the stone sculpture. The Thai type evolved in the north is characterised by the curved elevated eyebrows, doubly curved upward sloping eyelids (almond eyes), acquiline and even hooked nose, and delicate sharply moulded lips and a general nervous refinement contrasting strongly with the straight brows and level eyes, large mouth and impassable serenity of the classic Khmer formula. The Buddha heads referable to the classic Thai period, as well as the earliest of those from Pitsanulok, dating from about 1000 A. D.

[1] Figs. 318, 319; Salmony, 1, pls. 1 to 6.
[2] Salmony, 1, Pl. 10, cf. Coomaraswamy, 6, pl. XXVII, fig. 180 etc.

are the supreme achievement of the Thai genius. Almost equally fine examples have been found even at Lopburi (fig. 321 and probably 322).

In the meantime, in the south, at Lopburi (fig. 323) and Prapathom, and in the east (Korat), there developed a stone architecture and sculpture in stone and bronze in a purely Khmer style; so much so that the early mediaeval art of the "Siamese provinces" belongs rather to the study of Cambodian than of Siamese archaeology[1].

In the twelfth and thirteenth centuries the classic type is already becoming a matter of routine; all the features are defined by outlines, and there is a general attenuation of the form and the modelling is less sensitive. Meanwhile the north, including Chienmai, remains superficially nearer to the Gupta tradition; but the curiously heavy rounded forms are not true volumes corresponding to an inner concentration, they are rather inflated than modelled.

Perhaps the most pleasing work of the later period at Sukhotai is the series of *Jātaka* (Pali canon) engravings of Wāt Si Jum (fig. 320)[2], dateable with some exactitude in the reign of Sūryavaṁsa Mahādharmarājādhirāja (1357—1388), the script being identical with that of the inscriptions of 1357 and 1361. These engravings are essentially outline drawings on stone, rather than sculpture. The draughtsmanship shows no Siamese peculiarities, on the other hand it exhibits a very close affinity with that of the *Jātaka* frescoes of the Northern temple at Poḷonnāruva in Ceylon, dateable in the twelfth or thirteenth century (fig. 291). Intimate relations had long been maintained between Ceylon and Ramañña; and Mahādharmarājādhirāja's long inscription of 1361 states that in that year a very learned Saṁgharāja (Buddhist priest of the highest rank) came by invitation from Ceylon to Sukhotai, that he was received with great honour, and that in connection with his arrival temples were built "in the mango garden west of Sukhodaya". So that there exists every possibility that the engravings, which in any case appear to have been executed after the completion of the building in which they are found, may be from the hand of a Siṁhalese artist, perhaps a priest who accompanied the Saṁgharāja.

Much less interesting from an artistic point of view are the large bronze statues of Śiva and Viṣṇu, cast, according to the inscription, in 1354 and 1361 and erected by a later king at Kampen Phet, when Sukhotai was already in ruins[3]. Only their large size, perfect preservation, and the romantic circumstances of their discovery have given to these figures, now in the Museum at Bangkok, a fictitious value. Here too may be mentioned a Buddha figure from Grahi, in

[1] Coedès, 4; Gerini; Lajonquière; and especially Seidenfaden.
[2] Fournereau, 2.
[3] Fournereau, 2, pls. XLIX, L.

Jaiyā, likewise now in Bangkok, of which the pedestal bears a Khmer insrciption in which it is stated that it was made by order of a Malayu king, through his Viceroy; this inscription is dateable about 1250[1]. The first inscription in Siamese, that of Rāma Khamheṅ, about 1292, records the Siamese advance as far as Sithammarat, or Ligor.

When the Khmers were finally expelled from Lopburi, or at least reduced to impotence, and a new capital at Ayuthiā inaugurated the later political development of the Thais, Siamese art was already decadent. Only occasional pieces, hardly to be dated after the fifteenth century reflect the former perfection. The general tendency is to a simplification of the formula; where art and craft were once indivisible, the craft now predominates. This kind of simplification, accompanying the transition from classic to folk art must be clearly distinguished from the abstraction of primitive art, whose tendency is always toward fuller expression. Here, the simplification is the effect of exhaustion, there of concentration; and the resemblance is altogether superficial. In late Ayuthiā art we find not merely the linear definition of the features accentuated, but that the area between the eye and eyebrow is modelled continuously with the side of the nose, and that the elongated fingers become first languid, then unbending, and finally of equal length. On the other hand the decorative emphasis is heightened; the jewellery is overwrought and the drapery is covered with restless excrescences representing heavy gold embroidery. Thus at the same time that the art declines it travels further and further from obedience to canonical prescription. Thus a formula is exhausted; there is nothing more to be said, because everything has been said, and only the phrase remains. The only possible "development" of an art in this stage is in the direction of a sentimental realism (Raphael), or an equally sentimental archaism (Pre-Raphaelites); both of these tendencies already exist in the East. Only a new experience can lead to another creation of living form.

Siamese painting exists mainly in illuminated manuscripts, also on temple walls, and banners with figures of Buddha and *Jātaka* scenes in late Ayuthiā style[2]. Lacquer painting on wood attained a high state of perfection; it is found chiefly on temple doors and windows, book covers, and book chests[3].

A Siamese manufacture of porcelain attained importance at two different periods. At Sawankalok, where the art was introduced from China in the eleventh or twelfth century, monochrome crackled wares and "celadon" were made in considerable quantity and even exported; the fine "Siamese jars" of the Borneo Dyaks may be instanced. The remains of ancient kilns are extensive; the manu-

[1] Coedès, 3, pp. 33—36; Ferrand, p. 125.
[2] Döhring, 2; Yamanaka, Exhibition catalogue, Feb. 1926.
[3] Döhring, 1; Coedès, 5 (describes also the making of books).

facture persisted for six or seven centuries but declined in quality. A later attempt to imitate Chinese porcelain was less successful.

Nearly all the later porcelain called Siamese was imported from China; the same is true of the fine blue, yellow, and red glazed tiles used for temple, monastery and palace roofs. That is to say, the porcelain was made in China, but in Siamese designs as regards form and decoration. The period covered by these wares ranges from the sixteenth century to about 1868. They consist of coarse white porcelain in shapes designed for practical use, such as rice-bowls, enamelled in five vivid colours, often with a black ground. The quality of the base continuously improved. Before the fall of Ayuthiā the favourite decoration included lotus ("flame") motifs, and very often the whole bowl represented a lotus flower; figures of praying *devatās* (*tayponam*) and mythical animals such as the man-lion (*nora-singh*) are also characteristic. Afterwards, the figure motifs are replaced by diapers, and bird and flower designs on a gold ground come in; finally the latter are still more general, and at the same time the old figure motifs reappear, but in a thinner enamel. Most of the porcelain now in use is of modern European or Chinese origin[1].

Weaving and embroidery have been highly developed. Beautiful shot silks are characteristic; *ikat* technique occurs only to a limited extent, and may be essentially Khmer. Cotton prints were especially printed in Masulipatam, and exported to Siam. The principal garment, worn by men and women alike is the *phā-nung*, a form of the Indian *dhotī*, but with both ends twisted together and passed between the legs. Country women still wear above this a breast cloth (*phā-hom*) corresponding to the Javanese *slendang* and old Indian *kuca-bandha*; but tight and loose bodices are coming into general use. Silver work and jewellery of a very fine quality have been made until about the end of the last century. The former (*tompat*) is decorated in niello in lotus and arabesque forms, and often with the mythical lion (*rachi si*). The art is supposed to have originated in Ligor, and may have come from India, where it was certainly practised at Lucknow in the eighteenth century. Excellent silver filigree is also made. All the silverwork, like the porcelain, appears in forms adapted to practical use. In Siam, as in India, the production of objects whose only use is ornament is a modern development.

Of the jewellery, the finger-rings are perhaps the best examples; some of those not older than the late nineteenth century are comparable with the best classical productions. A common type is enamelled in bright colours and set with cabochon rubies. The enamel resembles that of Jaipur, and here again the technique is probably of Indian origin, though the forms are characteristically Siamese. Good examples of damascening on steel are also met with. A highly developed

[1] For the porcelain of Siam see Graham, 1, 2; le May; and Silice and Groslier.

art peculiar to Siam is the making of fresh artificial flowers by recombining the separate parts of living blossoms[1].

The regular Siamese theatre is known as *lakhon*, which is the Siamese form of Malay Ligor (Sithammarat), and is held to indicate an indirect Indian origin of the drama. In form the Siamese theatre resembles the Cambodian, or rather, the Cambodian theatre in its modern form is essentially Siamese. The dresses are gorgeous; there is no scenery. The gesture is abstract. *Pas seul* dances of love, triumph, defiance, etc., are characteristic; *morceaux de ballet* represent the array of armies, flight of *āpsarases* or wanderings of princesses accompanied by their maids of honor. All parts except those of clowns, are take by women; masks are worn only by divinities, demons and monkeys. There exists also an ancient masked play, called *khon*, always representing *Rāmāyaṇa* themes, in which all the parts are taken by men. A special form of the theatre known as Lakhon Nora or Lakhon Chatri is again played entirely by men, and to it attaches a miraculous legend recalling the origins of drama related in the Indian *Bhāratīya Nāṭya-śāstra*. In the puppet-plays, the figures are manipulated from below by means of concealed strings. In the shadow plays, *Nang Talung* (from Patalung, the supposed place of origin) the leather figures are supported from below, and as in Java may be stuck in a banana stem if the scene is long and movement is not required. The themes are mythological, and the performances are sometimes used to exorcise evil spirits, and in this case the ritualistic character of the performance is strongly emphasized[2].

CAMBODIA[3]

The Khmers, Mon-Khmers, or Kāmbujas (= Cambodians) are of Sino-Tibetan origin, and at the beginning of the Christian era had already occupied the Mekong and Menam deltas as well as Southern Burma (Talaings). Most of our information about the early period is derived from Chinese sources. The kingdom or group of kingdoms including Cambodia, Cochin China and Southern Siam is spoken of as Funan. We hear of an Indian Brāhman, Kaundinya, who probably in the first century A. D. landed in Funan from a merchant vessel, married a princess who had or received the name of Somā, and so became master of the country. The story is again referred to in a Cām inscription of 659 where the

[1] For the minor arts of Siam see Gerini, 2; Graham, 2.

[2] Gerini, 2; Graham, 2; Damrong, Prince R., *Tamrā Fon Rām*, Bangkok, 1923; Nicolas, R., *Le Lakhon Nora ou Lakhon Chatri et les origines du théatre classique siamois*, J. S. S., XVIII, 2, 1924.

[3] Aymonier, 1, 2; Coedès, 1, 2, 4; Finot, 1, 2; Foucher, 6; Fournereau, 1; Goloubew, 3, 4; Groslier, 1—8; Parmentier, 4; Pelliot; Seidenfaden.

princess is called a Nāginī[1]. The name Nāga is applied in India both to certain actual races and to half-human, half-serpentine beings who inhabit the waters, are guardians of treasure, are renowned for their beauty, and are the first inhabitants of the country. These Nāgas were long the object of a cult, which is not yet extinct even in India; in general, however, they have become attached as guardians and worshippers to the higher beings of more developed cults, e. g., to Buddha and Viṣṇu. The Kauṇḍinya-Somā story is probably of Indian origin, where the Pallavas are derived from the union of a Cola king with a Nāginī.

Śrutavarman, under whom Cambodia (Funan) seems to have become for the first time fully organised on the lines of Hindū civilisation, ruled about 400 A.D. He was followed by other kings, direct descendants, having the same Pallava patronymic, -varman; this was a Lunar dynasty[2].

The Indianesque, pre-Khmer (Indo-Khmer of some authors) art of Funan in the fifth, sixth and seventh centuries differs radically from the classic Khmer of the ninth to twelfth, chiefly in its greater concentration and more definitely Indian character[3]. Bilingual inscriptions in the South Indian (Pallava) script, revealing a knowledge of the Vedas, Purāṇas and Epics, appear; the Sanskrit is very correct, the lettering magnificent, fully equal to anything of the sort to be found in India proper. Buddhist influences seem to have predominated in the fifth, Brāhmaṇical in the sixth and seventh centuries, but neither exclusively. That wooden architecture was well developed may be taken for granted.

At the old capital Vyādhapur there survive remains of laterite ramparts over a kilometre and a half along each side, and a monolithic column with a bull capital[4]. In other localities in the delta area there are found numerous shrines in brick, one in laterite and a few in stone, of sixth and seventh century date, in a style that may in a general way be spoken of as Gupta. Thus at Hanchei, near Sambuor[5] there is an elegant rectangular cell built of slabs of sandstone, the lintel of the porch bearing a four-armed Viṣṇu-Anantaśayin, the roof flat and likewise of slab construction; there is a close resemblance to the little shrine on the roof of the Lāḍ Khān temple at Aihoḷe (p. 79 and fig. 148). The Hanchei cella may

[1] The Nāgas, nevertheless, have all the appearance of being native on Cambodian soil. The kings of Ankor, we are told, slept with a Nāginī, the guardian of the land, in the first watch of every night. An ancient and impressive musical composition, to be heard even to-day, refers to Kauṇḍinya and Somā — "played as a part of the ritual office, and reverently heard, it provokes a profound emotion, which often finds expression in tears" (Aymonier, 1, vol. I, p. 45).

[2] It should not, however, be overlooked that the use of the patronymic -varman in India is by no means exclusive to the Pallavas. The word means "protector".

[3] For the whole period see Groslier 3 (Ch. 24), 6, 7; Finot, 2; Goloubew, 3, 4; Aymonier, 2.

[4] Aymonier, 2, p. 35.

[5] For the remains at Hanchei see Groslier, 3, ch. 24.

well have been the *garbha-grha* of a Brāhmaṇical shrine like that of Bhumara (p. 78), but with a surrounding wooden *maṇḍapam* now lost; it certainly cannot have been, as Groslier suggests, the relic chamber of a *stūpa*. At the same site are found two small shrines with pyramidal towers, one in brick, the other in laterite, both having stone doorways and *makara* lintels, and as decorative motifs, *haṁsas* with extended wings and *caitya*-arches enclosing heads. The tower of the brick temple consists of successive stages repeating the form of the cella, that of the laterite tower by diminishing repetitions of the roll cornice; an inscription of the first half of the seventh century dates the former.

Another and even more elegant rectangular sandstone cell (fig. 324), is found at Préi Kuk, Kompoṅ Thoṁ[1], but here there is no porch; there are delicately ornamented narrow corner pilasters, between which the wall is perfectly plain; the roll cornice and pedestal are decorated with the usual arches enclosing heads. Here too there is a group of fifty or more brick tower shrines, of which some are polygonal; the walls are decorated with architectural reliefs, the stone doorways with *makara*-lintels. The whole group is even more conspicuously Indian than Hanchei, and affords a substantial addition to our knowledge of late Gupta art.

Somewhat further south are the Bayang tower (fig. 325), of the same type, and the unique granite temple, Aśrām Mahā Rosēi[2]. The latter may have been dedicated to Harihara; the cella is square, the roof a blunt pyramidal tower with deep horizontal mouldings, in all three cornices with *caitya*-window ornaments, the lowest and projecting cornice bearing the largest of these; the whole effect is remarkably like that of the Pallava temple on the hill at Paṇamalai in Southern India (fig. 203). Other early brick temples, of Gupta character, are found on the summit of Mt. Kulen, together with monolithic elephants carved *in situ* in the round[3].

The contemporary stone sculptures of deities form a group of great importance, not merely for the history of local stylistic development, but for the general history of art; more than one is at least as fine as anything to be found in India proper at any period. A standing female figure from Phnoṁ Da, with some others, may date from the fourth century[4]. More surely of fifth or early sixth century date are the characteristic standing Buddha figures from Romlok, Ta Kèo[5]; in the simplicity of the form, the *hanché* (*ābhaṅga*) stance, and the complete transparency of the drapery they are very closely related to the rock-cut Buddhas in the precinct of Cave XIX at Ajaṇṭā, and to some Gupta types from Sārnāth. From

[1] Groslier, 6, 7.
[2] Groslier, 6.
[3] Goloubew, 3.
[4] Groslier, 7.
[5] Groslier, 6.

the same site is a very fine Buddha head (fig. 100), of Indian character with Chinese affinities; not that is shows Chinese influence, but that it may be taken as an indication of the kind of Buddhist art that reached Southern China in the time of the Six Dynasties[1].

A beautiful and well preserved standing figure of Lokeśvara (Avalokiteśvara) from Rach Gia, now in private possession in Saïgon, is probably of sixth or early seventh century date[2]. A superb Lokeśvara (fig. 332) now in the Stoclet collection, Brussels, exhibits the Indianesque school of Funan at its highest level of achievement. To judge from the costume and wig-like ringlets it cannot be a Buddha, as the absence of ornaments might otherwise suggest; the absence of ornaments, as in the case of the Harihara of Prasāt Andèt, must be regarded as a characteristic of the style and not iconographically significant. A close parallel to the treatment of the hair may be found at Kaṇheri, Cave LXVI, in the Tārā of the Avalokiteśvara litany group (fig. 164), on the right, from which it is evident that the projection on the head is not an *uṣṇīṣa*.

The Cambodian figure exhibits a miraculous concentration of energy combined with the subtlest and most voluptuous modelling. Works of this kind are individual creations — not, that is to say, creations of personal genius unrelated to the racial imagination, but creations of a unique moment. It is as though the whole of life had been focussed in one body. In classic Khmer art the situation is different; there the whole of life is represented in all its multiplicity, and in such abundance it is impossible that individual works should possess the same insistent and poignant intensity. The Bayon towers in terms of like concentration would be unthinkable. In other words, the classic art can only be compared in its cumulative effect with individual sculptures of the earlier school of Funan; and it is in this sense that Aṅkor Wāt, exhibiting a lesser profundity only in detail, should be regarded as an extension rather than as a decadence of Khmer art. Perfection is only possible where, as in the figure under discussion, the coexistence of infinite potentialities is realised; where these potentialities are severally manifested in detail and infinite variety, perfection is present in every part only in so far as each part presupposes every other part. Pre-Khmer sculpture is complete in itself, and needs no architectural background.

An almost equally impressive example of pre-Khmer Brāhmaṇical art is presented in the Harihara of Prasāt Andèt, Kompoṅ Thoṁ (fig. 333) now in the Musée Sarrault at Phoṁ Peñ[3]. Here the ornament is restricted to the narrow

[1] For another example of Indian art anticipating the plastic qualities of Far-Eastern art, see the Sārnāth head, fig. 171.

[2] Finot, 2; Parmentier, in B. É. F. E. O., 1923, p. 292 and pl. XVI.

[3] Groslier, 7.

jewelled girdle; but the ears are pierced for the reception of earrings, a feature characteristic of Pallava art of the same period in India (Kailāsanātha of Kāñcī-puram, ca. 700 A. D.). The cylindrical headdress occurs likewise in India, in works of late Āndhra, Gupta and Pallava date at Amarāvatī, Deogaṛh, and Māmallapuram. Another figure of Harihara, from Phnoṁ Da, now in the Musée Guimet, is of similar type[1]. Both figures may be dated early in the seventh century; the latter should perhaps be associated with the Aśrām Mahā Roséi temple above referred to.

After the seventh century the Chinese begin to speak of Chenla rather than Funan. The history of the seventh and eighth centuries is obscure. This much is clear, that it was a period of unrest and of continual warfare, and here lies the explanation of the absence of monuments and rarity of inscriptions. The name Khmer (Kihmieh, Kmir, Qimara, respectively in Chinese, Javanese and Arabic) likewise appears. At the same time Funan or Chenla was apparently subject in some degree to Java (Śrīvijaya).

The best explanation of these facts, and of the artistic revolution revealed in the ninth century, is to be found in the view that Chenla was originally a northern kingdom centering in or near the Dangrek range, and that here lived the Kām-bujas, "born of Kambu", the legendary founder (with the nymph Merā) of the Cambodian Solar dynasty; the wars of the eighth century resulting in the estab-lishment of a Khmer autonomy, the original Chenla becoming Chenla of the Land, and the former Funan becoming Chenla of the Sea[2].

Purely Indian art in Cambodia disappears just at the time when permanent building materials, which are quite exceptional before the classic period, are first found. Classic Khmer art is on the other hand, a unified style and fully de-veloped when it appears for the first time in the sandstone buildings of the Praḥ Khān and Bantéai Chhmar; and it preserves its essential character, though with internal development, for at least three centuries. Classic Khmer architecture seems to be derived mainly from northern indigenous wooden types; there is no direct continuity with the older Indianesque of the south, described above, but only a general parallel with the evolution of the Indian *śikhara* by the reduplication of similar elements. We must not forget too that other than Indian sources of culture, the Chinese above all, were always available to Cambodia as to Campā: the appearance of glazed tiles, and of imitations of tiles in stone construction are a case in point. Classic Khmer rejects the characteristic Pallava motifs the *makara toraṇa* lintel, the *caitya*-window, and the use of *haṁsas* with extended wings as abacus supports; its round and square columns are un-Indian; and new and quite

[1] Goloubew, 4.
[2] See Groslier, 7, Map, fig. 37.

un-Indian elements such as the towers with human faces, Garuḍa caryatides and Nāga balustrades are introduced[1]. In sculpture, too, a national formula is evolved (figs. 335, 337, 338); this type is characterised by the straight line of the hair, the level brows, the scarcely sloping eyes, full and wide lips and impassible serenity, often, especially in the case of the beautiful faces of the *apsarases*, by an exotic smile and a peculiar sweetness. This type, again, has practically nothing in common with the older Indianesque sculpture of the south above referred to; it persists throughout the classical period, only gradually acquiring a mechanical facility of execution and only after the thirteenth century modified by Siamese contacts (fig. 336). All that has been said applies of course equally to the classic art of Cambodia as now delimited and to the old Cambodian provinces of Southern Siam.

Mythology and cult on the other hand remained Indian in all essentials, though not without special local developments. Śaivism at first predominates, later on with an increasing mixture of Tāntrik Mahāyāna Buddhism; but specific dedications are to be found in all reigns, and almost all the deities of the Hindū and Mahāyāna pantheons are represented. Two cults must be specially referred to. The first, the deification of royal ancestors; identified after death with the deity of their allegiance, under corresponding posthumous names, their images, in the outward form of these same deities, were set up by their descendants in memorial temples. The same custom existed in Java, cf. the portrait of King Erlanga as Viṣṇu (fig. 360). In India, royal images were indeed often set up in temples, but so far as we know always in human form; that temples were sometimes specially erected for this purpose is indicated in Bhāsa's *Pratimānāṭika* where the scene is laid in a temple of royal images in Ayodhyā. In Cambodia it is mainly in connection with temples of this ancestor cult that the old type of brick tower survives in the classical period, e. g. the Ruluos group near Aṅkor. Still more abstract is the other cult, that of the Devarāja or King-god, founded by Jayavarman II at Mahendraparvata, and served by the great Brāhman Śivakaivalya, the king's chaplain, and his descendants for many generations. The King-god, always represented by a *lingam*, did not appertain to any particular king, but embodied the divine fiery essence incarnate in every king and essential to the welfare of the kingdom. The famous inscription of Sdok Kak Thom (1042) states that the Devarāja was first set up and the cult initiated by Jayavarman expressly to the end that Cambodian independence of Java (Śrīvijaya) should be secured.

[1] M. Groslier cites the characteristic Khmer half-vaulted galleries as un-Indian. In principle, however, they recall the half-vaulted aisles of Indian *caitya*-halls, and wooden examples of these may well have existed in Cambodia in the pre-Khmer period, providing a model for stone building. In India a stone half-vaulted verandah appears in what is perhaps the unique case of the Harihara temple, No. 3, at Osiā (Bhandarkar, 4 and Codrington, K. de B., XLIII, B). Cf. the Bhājā verandah (pp. 24, 25).

We must now discuss in greater detail the more important monuments of the classic period (802 to the end of the twelfth century). Jayavarman II (802—869) who, according to the last mentioned inscription came from "Java" and at first ruled at Indrapura, perhaps a preëxisting capital near Phnoṁ Peñ, appears to have founded three other capitals, Amarendrapura, Hariharālaya, and Mahendraparvata. These have been identified with Bantéai Chhmar in the Battambang district, the temple and city of Prāḥ Khān near Aṅkor Thoṁ, and Beng Méaléa at the foot of Mt. Kulen; but some scholars regard the two last as of later date. Bantéai Chhmar is a great temple and fortress city in the north-west, in the Khmer hills. Here the Khmers for the first time, and with extraordinary boldness, considering their lack of experience, undertook to create a permanent fortress city and temple in stone. That they did this without regard to the foreign style of the south involved the copying of the preëxisting national wooden architecture in the new material; and in fact, these imitations of wooden forms and tiled roofs, reproduced in stone, are characteristic of the classic style from first to last. The main features of the Khmer city and temple are already fully evolved — the moats crossed by causeways with Devas and Asuras supporting Nāga parapets, triple gateways, Garuḍa caryatides, vaulted and half-vaulted roofs, high towers, ogee tympanum framed by Nāgas, and long galleries covered with bas-reliefs[1]. Hariharālaya repeats the Bantéai Chhmar formula on a smaller scale. The city lies in the fertile plains; it was surrounded by a moat, 40 metres wide, crossed by superb causeways with parapets of giants supporting many-headed Nāgas. Next came the city wall of laterite, measuring 850 by 750 metres, in which were four triple gates crowned by towers with human masks representing Śiva or possibly Lokeśvara; the giant Garuḍa caryatides are a striking feature of this wall. An inner enclosure surrounded the temple proper, now a ruin, overgrown with rank vegetation, a complicated and almost indecipherable maze of buildings, minor chapels, and galleries, of which the four largest lead to the central sanctuary, a high sandstone tower. It cannot now be determined whether or not the sanctuary towers had masks. East of the city and forming part of the whole plan lay an artificial lake, 3000 by 1000 metres in area, now dry, in the centre of which is the beautiful shrine called Néak Péan, laid out on a square, partly artificial island. On this island, at the corners, are four basins, and within these, four others surrounding a central pool, in the centre of which is the actual shrine, facing east, circular in plan and girt by many-headed Nāgas. Some scholars find in this shrine and in the similar shrines of the great lakes at Bantéai Chhmar and Beng Méaléa, temples dedicated to the Nāginī Somā, the legendary ancestress; more recently Goloubew

[1] An analogous situation existed in India at the close of the Kuṣāna period: here too a fully developed stone architecture appears unannounced.

has plausibly suggested that these were shrines of Lokeśvara, the Buddhist divinity of healing powers, whose cult, in Cambodia, may have been combined with that of the *lingam*. Magnificently conceived, the Praḥ Khān must have been a royal residence of the first importance, and the centre of a large population. It is surrounded by fertile lands. Its eastern wall lies very close to the outer boundary of the future capital, Aṅkor Thoṁ; and here, at the close of his long reign the first of the great Khmer builders returned to spend his last days.

Aymonier identifies Beng Méaléa with Mahendraparvata. On the other hand, Goloubew, mainly because of the high sense of order in the planning and the fineness of the workmanship, and also Parmentier, regard the city as contemporary with Aṅkor Wāt or even later. Goloubew (3) is inclined to recognize the remains of Jayavarman's capital rather in some of the ruined temples on the summit of Mt. Kulcn, and in fact, as he suggests, the great laterite stairway on the western ascent is evidence of the importance of the site. The question is still unresolved.

Indravarman I (877—889), who married the famous Indradevī, claimed descent from an Indian Brāhman named Agastya, suggestive of South Indian origins. Indravarman must be credited with the planning and initial construction of Aṅkor Thoṁ; and with the building of the Baku temple, a shrine of six brick towers dedicated to his grandparents, and also of the important Śaiva foundation of Bakong, which together with the later Lolei towers constitute what is now called the Ruluos group, from the village of that name. The Bakong is a construction of the *prāng* type with a pyramidal base in five receding stages, doubtless originally crowned by a *lingam* shrine. Forty lions adorn the four median stairways, and huge stone elephants stand at the corner of the terraces. Around this structure and below it are eight brick towers (fig. 326); the whole is enclosed by a wall and moat, with bridges guarded by many-headed Nāgas on two sides. A whole treatise[1] has been devoted to the "Art of Indravarman", regarded as a distinct and well-defined style: Parmentier emphasizes the stylistic succession and development in classic Cambodian art, while Groslier maintains its essential unity.

The building of Aṅkor Thoṁ and its central temple the Bayon belongs to the last quarter of the ninth century, Yaśovarman removing from the Praḥ Khān and taking up his official residence in the new capital about 900. The city is walled and moated, measuring over three thousand metres along each side of its square plan. The moat is 100 metres in width, and crossed by five bridges with parapets of Devas and Asuras, fifty-four an each side of each bridge, supporting the bodies of many-headed Nāgas. The five bridges lead to as many triple gateways, surmounted by towers over twenty metres in height, with human masks, and flanked by three-headed elephants. The high wall encircling the city is of laterite, inter-

[1] Parmentier, 3; and B. É. F. E. O., 23, 1923, pp. 413 ff.

rupted only by the five gates. From the four symmetrically placed gates straight paved streets lead to the Bayon, whose central tower is precisely the centre of the city. The fifth street, parallel to one of the four, leads directly to the main square in front of the palace. This palace, with the royal temple, Phiméanakas, must have been the main feature of the city, after the Bayon.

The palace occupied a relatively restricted area behind the great terrace; it was protected on three sides by a double wall and moat, and on the fourth, the eastern side, next the terrace, by an elegant gateway of later date. The plan of the palace, which must have been of wood, is irrecoverable[1], but the Phiméanakas[2] (fig. 331), a Vaiṣṇava foundation occupying the court between the palace and the terrace is still in a fair state of preservation. As it now stands it consists of a three storied pyramid with central stairways on each side, and a fenestrated stone gallery above; here it was that the king slept each night with the legendary foundress of the race. The terrace itself, three or four metres in height, stretched before the palace for some three hundred and fifty metres, and was provided with five projecting stairways leading to the street level; along its edge ran a Nāga parapet. The long panels between the projecting stairways were treated as a continuous frieze representing lions, Garuḍas, elephants, horses, warriors mounted and on foot, hunting scenes, games and combats, and this long series of reliefs still presents a magnificent spectacle. A belvedere at the north end of the terrace projects beyond it and rises higher; the retaining wall is richly decorated with superimposed rows of high relief sculpture representing kings, queens and *apsarases*. This was perhaps a place of honour reserved for the King's own person on state occasions, such as the review of armies or public festivals. On this belvedere is still to be found a nude male statue, traditionally known as the Leper King, who may have been Yasóvarman himself. North east of the belvedere on the other side of the square are the remains of the Praḥ Pithu, an elegant and richly sculptured temple or monastery, perhaps of later date.

South of the palace, but further east, and as has already been remarked, in the exact centre of the city, is the Bayon temple (fig. 327, 330) originally approached by the eastern street, but now generally from the south. Within the main eastern entrance we find a paved platform with Nāga parapets; inner gateways led on to the first galleries, about a hundred and sixty metres long on two sides and a hundred and forty on the two other sides. These galleries had a vaulted roof, with a half-vaulted roof in addition on the outer side, supported by square pillars, an arrangement quite un-Indian but highly characteristic of classic Khmer design. Within, on the second level, is another series of galleries. The inner walls of both series are richly decorated with low-relief representations of divinities, epic

But cf. Groslier, 3, fig. 166. — [2] Sanscrit, Ākāśa-vimāna.

legends. Brāhmaṇs, ascetics, kings, princesses, palaces, processions of soldiers and elephants, horses, chariots, naval combats, fisheries, markets and other scenes of daily life (including the transport of heavy stones), and animals and trees; as though the royal founders of Aṅkor had desired to perpetuate for ever a picture of their glory[1]. These reliefs are naively executed, rather drawn than modelled, and lack the technical assurance of the Aṅkor Wāt series, though their vitality and interest are abundant. Not only the galleries, but the whole surface of the great structure is decorated; apart from the galleries, mainly with foliage and with standing or dancing *apsarases*. A bronze *apsaras* (fig. 365) dancing on a lotus flower, now in Boston, is almost certainly of Bayon origin.

The lateral porches of the great gallery entrances lead to the interior of the temple by narrow openings, only wide enough for the passage of men in single file. These narrow doors lead to a third system of smaller inner galleries surrounding the enormous base of the central tower. All the great gallery gateways and gallery transepts of the second stage are surmounted by towers with four human masks. The central tower rises from a terrace which forms the upper part of the base just mentioned, and on this terrace are other towers, all with masks; it is possible that a fifth head once crowned the central tower. In the lower part of the tower are a dozen small cells or chapels opening on the terrace, and beneath the tower itself a central chamber which probably held the Devarāja *liṅgam*, the smaller chapels holding the "portrait" statues of deified kings and queens. As regards the towers (figs. 327, 334), it is most probable that they represent four-faced *mukha-liṅgams*, emblems of Śiva. It is just possible, however, that Lokeśvara, whose cult is closely associated with that of the *liṅgam*, may have been intended.

The Bayon enshrined many other images, beside the Devarāja *liṅgam*. Thirty four are mentioned in inscriptions, and these fall into four classes as follows: (1.) Hindū deities (Śiva, Viṣṇu and Devī in various forms), (2.) Buddhas (including Bhaiṣajyaguru Vaidurya Prabhārāja, the Buddha of healing, whose cult was much favoured in the time of Jayavarman VI) having the character of (3.) patron deities of particular places, especially the chief cities of Cambodia, and (4.) the majority, representing deified human beings in two forms, one that of a "portrait", the other, that of the deity from whom their posthumous name derived. The Bayon was thus a veritable gallery of historical portraits and a national pantheon.

So far as we can tell, all the great buildings of the Aṅkor Thoṁ construction period were Brāhmaṇical; the Buddhist foundations within the city are all on a much smaller scale. But the two cults were closely assimilated, and no doubt every great temple contained chapels where the image of Buddha was enshrined and worshipped, just as the modern Buddhist *vihāras* of Ceylon all contain Brāhmaṇical images.

[1] Dufour at Carpeaux.

A little to the south of Aṅkor Thoṁ lies the three-storied pyramid known as Phnoṁ Bakeṅ, a typical *prāng*, with its pyramidal base consisting of three diminishing stages, with a stairway in the middle of each, and angle-towers at the corners. The shrine can no longer be made out, but a *liṅgam* has been found with an inscription speaking of "Yaśodheśvara" showing, perhaps that this was Yaśovarman's funeral shrine. The two large temples of Bantéai Kedéi and Ta Prohm, east of Aṅkor, belong to the same period. Further away, at Ruluos, not far from Indravarman's two foundations, Yaśovarman erected the Lolei temple, consisting of four brick towers with stone doorways; the inscriptions show that these towers were dedicated to Śiva and Pārvatī, by Yaśovarman "for the well-being of his parents and grand-parents", whose images, indistinguishable from those of the deities, doubtless once occupied the shrines[1].

By this time the old South Indian script had been considerably modified. Yaśovarman made use of one nearly identical with the Śrīvijayan script of Kalasan. The reign affords many magnificent examples of bilingual stelae.

A new capital, Liṅgapura, was built by Jayavarman V and occupied by himself and by his son Harṣavarman II, whose combined reigns extended from 928 to 944. The construction is referred to in an inscription of 948. The site is now known as Koh Ker (Kompoṅ Sway), and lies far from Aṅkor, beyond Mt. Kulen, in the midst of wild and inhospitable forests. The principal temple lies to the west of a group of *liṅgams*, which are monoliths hewn from masses of rock lying in situ along a line running twenty degrees south of east, and this alignment seems to have determined the unusual orientation of the town and all its buildings. The temple is moated, as usual with bridges guarded by Nāga balustrades. The park within contains a dozen brick shrines, and beyond this is another enclosed park within which is a pyramidal structure of the *prāng* type, faced with sandstone.

Rajendravarman (944—968) returned with the Devarāja to Aṅkor Thoṁ, and restored and beautified the city. Though himself a Śaiva, numerous Buddhist foundations were dedicated in his reign. Two important Brāhmaṇical constructions of the reign are those of Pré Rup, and the "Mebun" or island-temple in the middle of the great lake excavated by Yaśovarman fifty years earlier. The latter consisted of five brick towers dedicated to Brahmā, Śiva, Pārvatī, Viṣṇu, and a Śiva-liṅgam. This was perhaps the latest survival of the old brick tower type.

Jayavarman VI constructed the Baphuon, a temple of the *prāng* type, of enormous bulk, situated north west of the Bayon and south of the palace. The present remains consist of the usual pyramid of three receding terraces (the two

[1] Cf. the dedication of an early Kuṣāna image of Buddha set up at Śrāvastī by two brothers "with special regard to the welfare of their parents" (Sahni, 4): and *Milinda Panha*, IV, 8, 29 (S. B. E., XXXVI, p. 151). See also p. 58, note 8.

upper with *Mahābhārata* and *Rāmāyaṇa* reliefs) with steep median stairways, and above this a fenestrated stone gallery. The temple was approached from a triple gateway on the line of the great terrace, by a causeway two hundred metres in length, guarded by Nāga balustrades, and resting on circular pillars where it crosses the temple moat. It is no doubt this temple, which probably carried a tall *śikhara* shrine, that Chou Ta Kuan in the twelfth century refers to when he says "about one li north of the Tower of Gold (Bayon) is a copper tower still higher, and its appearance is indeed impressive"[1]. The shrine was called, in fact, the "Horn of Gold". Pyramidal shrines of this kind generally represented such mythical mountains as Mt. Meru, the habitation of gods; the older Phnom Bakeṅ had been called the "Resting Place of Indra". The name of the architect of the "Horn of Gold" and of the Jayendragiri palace has been preserved; he was a certain Vap Śivabrahma (presumably he would have been called a *śilpin* and *sthapati*), and he earned by his labour the price of seven slaves.

In this reign the Buddhist and Brāhmaṇical rites were assimilated so that the priests of the Devarāja could officiate in both rituals. All that we know of the next reign is that the king in the year 1001 dedicated to Viṣṇu a golden statue "which was his own future effigy", which proves that the deified portrait figures were not always posthumous.

Sūryavarman I (1002—1050) seems to have been especially devout, to judge by the long list of the foundations by himself and his ministers. Buddhist and Hindū deities were equally favoured, but the king's posthumous name Nirvāṇapada indicates that he died a Buddhist. One of the largest temples of the reign is the Ta Kèo (not to be confused with the province of the same name) lying east of Aṅkor and north of Ta Prohm; a rather severe pyramidal structure of the usual type, faced with sandstone and surmounted by stone towers, dedicated by the king's Guru, Paṇḍit Yogeśvara, to Śiva Kapāleśvara, it originally held images of Śiva and Durgā.

Thirty leagues east of Aṅkor, Sūryavarman constructed a temple and residence of some importance, known as Praḥ Khān (Kompoṅ Sway), not to be confused with Jayavarman's Harihārālaya of the ninth century. In the principal temple, which was provided with the usual moats, causeways, gateways, terraces and cells, Buddhist and Śaiva deities were associated, the inscriptions honouring both in their ascetic aspect. It will be recalled that even in India (Elephanta) the figure of Śiva as Mahāyogi is practically indistinguishable from that of a Buddha.

Praḥ Vihéar, built on a spur of the Dangrek mountains, is not only nobly designed and soberly but exquisitely decorated, but its situation is uniquely dramatic. From the north the approach is gradual, and it is quite suddenly that one

[1] Pelliot, 1.

reaches the edge of a dizzy cliff four or five hundred metres above the low country. The view is magnificent; on either hand extends the escarpment of the Laos hills, and to the south there is an endless undulating tropical forest. The temple is situated at the edge of the cliff, and was dedicated to Śiva Śikhareśvara, the "Lord of the Peak".

Phnoṁ Chisor, "Ancestral Sun", is the name of a hill near the old capital of Aṅkor Baurei. Near the summit is a temple, whose situation, though less remarkable, nevertheless recalls that of Praḥ Vihéar. A laterite stairway leads to the monumental gate of the narrow outer gallery; within is a brick sanctuary with a vaulted roof, which once held the figure of a seated king, perhaps Sūryavarman himself[1]. The temple was built by a courtier, the Brāhmaṇ Śivācārya, between 1015 and 1019.

Sūryavarman's successor is one of those who laid claim to having erected the Horn of Gold, more probably he added to or embellished it. In this reign a victorious general set up a golden *liṅgam* in which to worship the king's "invisible personality".

Sūryavarman II (1112 — ca. 1152) is in all likelihood the Paramaviṣṇuloka of Aṅkor Wāt (figs. 328, 329, 339, 340), and to him must be attributed its building, though the work may have been begun in a previous reign. The planning is spacious and generous to a degree; everything is on a huge scale, and all in proportion. The moat, a hundred and ninety metres in width and eight in depth requires a walk of nearly twenty kilometres to complete its perambulation. It is crossed on the west side by a paved bridge, guarded by Nāga parapets, leading to the central gate of the western enclosing wall, a gate in itself to be regarded as one of the great monuments of Khmer art. To right and left extends a double gallery; the gate has triple openings surmounted by towers, and is decorated both within and without with richly carved porticos and pediments. The porches at the remote ends of the gallery, east and west, large enough to admit both elephants and chariots, balance the whole design of the main western approach.

From within this main entrance a paved causeway, raised above the ground level and protected by a Nāga balustrade, leads between two small and elegant buildings which were probably libraries (*puṣṭakāśrāma*), to a cruciform platform immediately in front of the main entrance of the temple proper. This entrance is one of four, situated in the middle of each of the four sides of the great double gallery, vaulted and half-vaulted, which encloses the inner terraces. The inner wall of this gallery, to a height of some three metres and along a length of, in all,

[1] Formerly in the Moura collection (Foucher, 6, 1913, pl. IV, 2), now in the Chicago Art Institute. Aymonier, 2, pp. 134, 135.

about eight hundred metres, is covered with low reliefs illustrating Hindū epic mythology, as follows:

On the west side, left, battle scenes from the *Rāmāyaṇa*; north side, right, battles of Devas and Asuras; left, legend of Garuḍa and Banāsura; east side, right, apparently Viṣṇu's battle with the Dānavas, for the rescue of Nārada; left, the Churning of the Ocean, perhaps the most magnificent composition of all, the Devas and Asuras using Śeṣa Nāga as the churning rope and Mt. Meru as the churning post; south side, right, a double register, representing, above, the delights of Paradise, and below, the pains of Purgatory; left, promenade of queens and princesses, and a royal *darbār* (here the king is named in the accompanying inscription as Paramaviṣṇuloka), followed by the march past of an army (fig. 340), wonderfully realising Chou Ta Kuan's descriptions[1]; west side, right, *Mahābhārata* scenes. Other themes of Vaiṣṇava and Śaiva mythology are represented on the walls of the vestibules at the four corners, where the galleries intersect. In these gallery reliefs are combined a superb vitality and a complete preoccupation with the heroic themes, as correlated and inseparable conditions; technically superior to those of the Bayon, the Aṅkor Wāt reliefs are thus spiritually greater than those of Borobuḍur, where the craftsman has deliberately devoted a part of his energies to the successful pursuit of tangible graces.

Four entrances lead from these galleries to an inner court on a higher level, and this court, on the western side, encloses a smaller court of richly sculptured galleries (fig. 339) surrounding four shallow reservoirs; passing through this, we reach the outer wall of the innermost gallery, and again ascending, reach the innermost court, in the centre of which stands the enormous pyramidal basement supporting the five ultimate towers, reached by very steep stone stairways (fig. 328). The platform at the top is occupied by the five towers (*śikhara* shrines) and the rectangular and cruciform galleries connecting them together. The total height of the central tower above ground level is sixty-five metres.

Thus the last and greatest of Khmer temples adheres to the already well known scheme of moat, outer wall, paved causeways, inner concentric galleries forming a terraced pyramid, and central shrine surmounted by a high tower, with rich decoration of all the wall surfaces. During a period of some three centuries the fundamental elements of the design, like the methods of the workmen, have not changed. Nevertheless, a very distinct evolution has taken place: the towers with masks have altogether disappeared, the whole conception is clarified and ordered, the decoration more brilliant and more sophisticated, without any loss of vitality. Even though the plastic elements of twelfth century architecture are perhaps a little less monumental than those of the ninth, e. g. the great terrace

[1] Pelliot, 1.

of Aṅkor Thoṁ, and though the sculpture in the round has by this time acquired a rather mechanical perfection, it is still true that on the whole the movement has been a forward one, and the last great monument of Khmer architecture may well be considered the finest.

No inscription has been found that certainly dates or refers to Aṅkor Wāt. We do know, however, that a great temple of Śiva Bhadreśvara was in process of building between 1090 and 1108 and was still receiving dedications in 1146. This may have been Aṅkor Wāt; and it is not unlikely that its architect was the powerful and learned Divakara, Sūryavarman's Guru, and master of the coronation ceremonies for Sūryavarman and two predecessors. In any case the name Aṅkor (= Nagara) Wāt is of much later origin, and the temple can only have been adapted to Buddhist usages in the Siamese period; the Buddhist sculptures now found in the temple are all of post-fifteenth century date.

With Aṅkor Wāt the history of Cambodian art is almost at an end; the very succession of the later twelfth century kings is doubtful. To Jayavarman IX (1182—1201) may be attributed the main sanctuary at Phimai, Korat, now a part of Siam; this is a Buddhist foundation, with towers like those of Aṅkor Wāt. In 1195 the same king carried his conquests as far west as Pegu, and we find the Khmer language still in use at Jaiyā about 1250. The Siamese, however, were growing in strength; Chou Ta Kuan describes Cambodia in 1296 as having been laid waste.

To the thirteenth and fourteenth century however are to be attributed a good number of Buddhist sculptures which show the influence of the Thai formula in the now more elongated *uṣṇīṣa*, and almond eyes. Some scholars, as we have mentioned, regard Beng Méaléa as of later date than Aṅkor Wāt.

By the fifteenth century, however, Aṅkor Thoṁ was deserted. When another series of inscriptions begins at Aṅkor Wāt, ancient Cambodia is no more, and we are introduced to a comparatively modern world of Hīnayāna Buddhism, the only survivals of the ancient Brāhmaṇism being traceable in the sacerdotal functions of a group of descendants of Brāhmaṇs, still exercised at the court of Phnoṁ Peñ.

On the other hand, the theatre (dramatic dances), music and minor art (textiles, metal work, jewellery) have survived almost in their former perfection up to the present day. The theatre[1] is precariously protected by the patronage of the court at Phnoṁ Peñ, and a local troupe at Siem Réap presents the legends of Prince Préa Samuth and of Prince Chey Cheth for the benefit of visitors to Aṅkor. The remnant of the other arts is protected and fostered at Phnoṁ Peñ by the Direction

[1] Groslier, 1; Leclère, A., *Le théâtre cambodgien*, Rev. d'Ethnographie et de Sociologie, 1910, pp. 257—282; Laloy, L., *Les principes de la danse cambodgienne*, Rev. musicale, III, 9, 1922; Marchal, S., *Danses Cambodgiennes*, Saigon, 1926.

des Arts Cambodgiens. The silk weaving is mainly of *sampots*, the Cambodian garment corresponding to the Indian *dhotī* and Siamese *phā-nung*. Of *sampot* weaves, those of shot silk are called *sampot phā-muong*, those with designs produced by the dyeing of the warp threads before weaving, *sampot hol*[1]. The latter are probably the finest of all the textiles that are still actually produced anywhere in India, Further India and Indonesia.

CAMPĀ [2]

Campā, the land of the Cams and of Indo-Cam civilisation during a period of about a thousand years, corresponds with the modern Annam, the eastern coast of the Indo-Chinese peninsula. Before the beginning of the Christian era the country was under Chinese rule as far south as Binh-dinh; Chinese culture again predominated after the fourteenth century, by which time the Annamites, advancing southwards, had made themselves masters of almost the whole country.

The oldest Hindū monument is the Sanskrit inscription of Vo-canh, in an early South Indian script recording the name of a king of the Srī-Māra dynasty and dating from the third or second century A. D. At this time there existed in the Nhatrang region a Hindū kingdom known as Kauthāra, succeeded a little later by that of Pāṇḍuraṅga at Phanrang. Indo-Cam rulers of Cambodian, and ultimately of Pallava origin, gradually extended their power to the north and established a capital at Tra-kiệu (Siṁhapura or Indrapura) with a citadel at Kiu-su and temple cities at Mi-son and Dong-duong. In the tenth century the Tonkinese Annamites began their advance, and the Cams were slowly but surely forced to retrace their steps; a new capital was set up at Binh-dinh (Vijaya), guarded by the great fortresses of Chamban and Bin-lam, and under Jaya Harivarman the country enjoyed a brief respite. Forced to retire again, they erected citadels at Thanh Ho and Song Luy. In the thirteenth century they were able to repulse the forces of Kublai Khān, but very soon they were no longer able to build or to utilise fortresses; their few survivors, of whom some have been converted to Islām, live in isolated groups under Annamite domination, and have lost almost all of their ancient culture.

The ancient art of Campā is closely related to that of Cambodia, but almost all the temples are isolated *śikhara* shrines of brick, with stone doorways, or groups of such towers with their related structures. Wood remained in use as a building material throughout the classical period, so that many buildings are known only

[1] The usual sizes are 1×3 m for men, $0,95 \times 2,5$ m for women. *Sarongs* are also worn.
[2] For the art of Campā see Parmentier, 1, 3 and 5; Leuba; Bose, 2.

by their foundations. The existing remains fall into two main divisions, those of a Classic period (Mi-son and Dong-duong, seventh to tenth century) and those of the Decadence (from Binh-dinh, about 1100, to the seventeenth century)[1]. The earliest sculptures, of the seventh century are magnificent, but already formulated in a local sense, and there is no trace of a pre-Cam or Indianesque style comparable with that of Cambodia.

The sacred city of Mi-son was founded by Bhadravarman I about 400 A. D. when the Bhadreśvara *liṅgam* was set up. The great shrine now existing (fig. 341) was built by Bhadravarman's second successor on the site of the original wooden temple, soon after 600. As Leuba remarks, this great tower "par ses nobles lignes et son exquise ornementation, peut être considéré comme le chef d'oeuvre d'architecture chame". The main body of the temple is almost cubic, but higher than it is wide, and this effect of height is greatly enhanced by the narrow decorated pilasters that emphasize the perpendicular aspect of the construction, reminding us of the great shrine at Malot in the Pañjāb. Between the pilasters are false porches or niches, with figures carved in relief in the brick surface. The pyramidal roof consists of three diminishing stories, repeating the main design on a smaller scale, and the summit was crowned by a flame-like or lotus-bud finial. The decorative motifs included *makara toraṇa* niches, *haṁsas* with extended wings, and *pièces d'accent* such as *apsarases* whose outlines are silhouetted against the sky. These ornaments, like the door frame, are of grey sandstone, and stand out clearly against the ochre red of the brick surface, which, however, would originally have been covered with white plaster. The interior is plain, and was separated from the hollow pyramidal vault of the roof, if at all, only by an awning. Later kings added successive temples of brick or wood, pilgrim shelters, and royal pavilions. Of these later structures, those of group D, essentially horizontal, recall the Northern temple (fig. 302) and similar buildings at Poḷonnāruva in Ceylon. The latest Mi-son buildings, of the tenth century, have terracotta plaques in place of stone ornaments.

The sculpture of Mi-son, largely of the seventh century, is now collected in the Museum at Tourane[2]; it is almost all of Śaiva character, and includes representations of Śiva (fig. 344), Skanda and Gaṇeśa. The style cannot be called primitive, but is still creative; unequal in quality, the finest pieces are marvels of powerful modelling or grace of conception.

[1] Art Primaire and Art Secondaire of Parmentier, 3, who restricts the term "Classic" to the art of the eleventh century.

[2] Parmentier, 5; Leuba; Bosch, 3. The "doctrine of the passing on from ruler to ruler and from saint to saint of the divine, sacerdotal, and kingly glory" is also Avestan as remarked by Spooner, 11, p. 445. See also pp. 61, 200.

At Dong-duong, even nearer to Tra-kiệu, has been found the important in-
scription of Indravarman, dated 875, praising the virtues of the Sambhu-Bhadreś-
vara *lingam* "filled with the essence of fire and hereditary royalty", proving the
existence of the Devarāja cult. The inscription identifies this *lingam* with the
original (Haṭakeśvara) *lingam* which "fell from Śiva", as related in the Indian
Devadāru Mahātmaya, which may be the ultimate source of the cult of the King-
god[1]. We hear too of a Bhadrapatīśvara *lingam* in the south, desecrated by (Su-
matran) Malays in the eighth century. Incidentally we may remark that the *Sūrya
Siddhānta* speaks of Yavakoṭi (in Sumatra) as a famous city in the land of the
Bhadreśvas, again suggestive of a Sumatro-Javanese source.

The same king, who was an usurper and apparently a Buddhist, founded the
great Buddhist shrine at Dong-duong, in honour of Lokeśvara, about 900; this
is the only Buddhist site in Campā, but it is scarcely inferior to Mi-son in richness
and aesthetic importance. Moreover the buildings are related in accordance with
a dominating plan, and all of one period, not as at Mi-son, independantly erected
at various dates. A noteworthy discovery here was that of a bronze standing
Buddha (fig. 342) in style very near that of Amarāvatī and Anurādhapura; this
figure, indeed, is very probably of Indian or Siṁhalese origin, and may date from
the third or fourth century. This solitary trace of purely Indian art may perhaps
be referable to an early Hīnayāna period in Campā, more likely it was brought
thither long after the date of its manufacture[2].

The Dong-duong shrines were soon ravaged by the Annamites in search of
treasure and new sanctuaries were erected at Binh-dinh at the close of the tenth
and in the eleventh centuries. Conditions no longer permitted the erection of
great temple cities, and we find only separate *kolans*, hastily built and with inferior
decoration, though still in large numbers. The main groups are those of Hung-
thanh and Binh-lam, the colossal towers of Duong-long, and those known as the
Tower of Gold, the Tower of Silver, and the Tower of Copper.

Meanwhile, still further south, in the cradle of Cam power, the legendary
king Vicitrasāgara had erected the wooden temple of Po Nagar, the "Lady of the
Land", and in the eighth or ninth century followed the first brick building, near
which still later temples were added. The main sanctuary contains an image of
Bhagavatī = Pārvatī, which has replaced an original *lingam*. The *linga* temple of
Po Klaun Garai on the other hand, founded by Siṁhavarman III contains the ori-
ginal Siṁhavarmalingeśvara, still worshipped by a residue of Cams. It is not clear
whether this *mukha-lingam* is an icon of Śiva, a Devarāja, or a posthumous

[1] Amongst the sculptures of the Kailāsa temple at Kāñcī (see p. 104) is one representing
Śiva as mendicant in the Tāraka-daṇḍa (Jouveau-Dubreuil, 1, vol. I. pl. XXVI).

[2] Rougier; Leuba. Cf. the figure from E. Java reproduced in Cohn, pl. 29.

"portrait" of the king. The last remains of Cam architecture are found at Po Rome.

Important treasures have been found on ancient Cam sites. That of Po Nagar, dating probably from the eighth century, consists of silver ritual vessels, gold jewellery and pearls, while at Mi-son a sealed earthen vessel contained all the wrought gold ornaments (crown, collar, bracelets and girdle) belonging to an image of half human size. Other treasures, like that of Lovang, consisting of golden vessels and jewellery, ancient inlaid arms and ceremonial robes, are still in use.

SUMATRA[1]

Scarcely anything survives of the ancient art of Sumatra, unless we define the art of middle Java in the Śailendra period as such; and yet the great Sumatran kingdom of Śrīvijaya, with its capital at Palembang, can by no means be left out of consideration in any discussion of the art of Indonesia.

Sumatra appears to have received Indian colonists at a very early date, probably well before the beginning of the Christian era. The Land of Gold (and this name is really applicable to Sumatra, and not to Java) is referred to already in the *Jātakas* and the *Rāmāyaṇa* as Suvarṇadvīpa and Suvarṇabhūmi, and when the same text speaks of *Yavadvīpa suvarṇākaramaṇḍita*, it is Sumatra that is to be understood[2]. Sumatra is the Zabadion of Ptolemy, the Zabag and Zabej of later Arabic writers. Madagascar seems to have been colonised by Hinduised Sumatran Malays early in the Christian era[3]. Fa Hsien visited Sumatra about 414 A. D. and found there few or no Buddhists. A few years later Guṇavarman of the royal house of Kaśmīr landed in Yavadvīpa; he converted first the queen, and she in turn her son, to (Mahāyāna) Buddhism, which thus became the official cult. At this time the land was already known to the Chinese as Chō-po = Vijaya = Śrīvijaya (later Arab Sribuza), which was the name of the Palembang kingdom ruled by the kings of the Śailendra dynasty, who originated in Malayu = Malaka = Minaṅkabaw, and asserted their independence perhaps before the seventh century. The name Mo lo yeu, the aforesaid Malayu, also appears in Chinese texts. I-ching, who visited Sumatra about 690, states that Malayu had then become subject to Śrīvijaya; he studied Sanskrit grammar as well as the old Malay language, and Buddhist texts and commentaries. All this evidence of a high state of culture existing

[1] Coedès, 3; Ferrand (bibliography, pp. 1, 2); Krom, 3, Ch. III; Bosch, 4.
[2] Ferrand, p. 146; C. H. I., p. 213; Cowell, III, 188, and VI, 34 ff. According to the *Mahāvaṁsa*, Ch. XI, v. 44, Aśokan missionaries reached Suvaṇṇabhūmi.
[3] Ferrand, pp. 150, 151.

in Sumatra in the seventh century prepares us to appreciate its secular power and wealth; Palembang, the most important port between India and China, must have been truly a cosmopolitan city. The foundations of a great maritime empire had already been established.

We reach now the sure ground of inscriptions. That of Kota Kapur in Bañka records the despatch of a military force to Java, which did not at this time acknowledge Sumatran suzerainty. The inscription of Vien Srah in the Malay Peninsular, 778, speaks again of Śrīvijaya and records the erection by its king of two fair brick buildings in which were honoured Vajrapāṇi, Padmapāṇi and the Buddha and of the erection of *stūpas* by the king's chaplain Jayanta and his disciple. About this time must be placed the expedition to Cambodia, which resulted in the acknowledgement of Sumatran overlordship. The Śailendra power seems to have been established in Central Java by the middle of the eighth century. About the same time Sumatran Malays invaded Campā. The Kalasan inscription of 778 suggests that at this time Prambanam may have been the virtual capital of Śrīvijaya, and as we have seen, this state of affairs lasted until about 860. The great Buddhist monuments of this period are described in the chapter dealing with Java.

At the beginning of the ninth century Jayavarman II of Cambodia, "who came from Java", asserted his independence. From this time onwards the power of Śrīvijaya very slowly declined. Relations with India, however, sometimes friendly, sometimes hostile, were long maintained. The Nālandā copper plate of about 860 shows King Devapāla building a monastery and granting villages on behalf of King Bālaputradeva of Suvarṇadvīpa, grandson of a king of Javabhūmi[1]. The names of Śrīvijaya and Kaṭāha (? = Kedah in the Malay Peninsular, more likely an unknown city in Sumatra) are found in the Nepalese Ms. Camb. Add. 1643[2]. The Tanjore Coḷa inscriptions of Rājendracoḷa and Rājarāja Rājakeśari-varma, 1030 and 1044—46, refer to a king of Kaṭāha and Śrī Viṣaya (*sic*); this Śailendra king Cuḍāmaṇivarman endowed and supported a Buddhist temple at Negapatam (Nāgīpaṭṭanam). Rājendracoḷa on the other hand claims to have conquered Kaṭāha and Śrī Viṣaya "beyond the moving seas". At this time Kaṭāha was evidently a part of Śrīvijava. In 1084, Kullotuṅgacoḷa dedicated a village to the above mentioned Buddhist temple, which is spoken of in the inscription as the Śailendra-cuḍāmaṇi-varma-vihāra[3]. These evidences, confirmed by others in the *Mahāvaṁsa*, prove a comparatively late survival of Buddhism in Southern India; this is of interest in connection with the occurrence at Kāñcī-

[1] A. S. I., A. R., 1920—21, p. 27, and A. S. I., Central circle Rep. 1920—21; Hirananda Sastri, Epigraphia Indica, XVII, pl. VII; Bosch, 4.

[2] Foucher, 2.

[3] Ferrand, pp. 44—48. Ruins of this *vihāra* seem to have survived until 1867.

puram of Buddha images of a late type, showing the flame-like projection above the *uṣṇīṣa*, an iconographical peculiarity probably of Farther Indian origin.

In the eleventh century the famous Indian monk Atīśa (Dīpankaraśrījñāna of the Vikramaśīla monastery) spent ten years in Sumatra, completing his religious education in the study of the pure Sarvastivādin Buddhist doctrine[1].

In the thirteenth century the Sumatrans raided Ceylon on two occasions, being allied with the Tamils of Southern India in the second attack. On the other hand, about 1275 the East Javanese king Kertanagara sent an expedition against Malaya (= Sumatra, and to be distinguished from Malayu = Minankabaw = Malacca, the original home of the Malays on the Malay Peninsular) and brought back two princesses. A little later the kings of Majapahit established their suzerainty over Palembang and Pahang in Sumatra, and over Malayu from Singapore to Kedah and Tringānnu. After 1400 the Śailendra dynasty cannot be traced.

Islām was introduced into Sumatra by Indian missionaries and traders. The first converted ruler, Maliku-ṣ-Ṣāliḥ of Pasai in Sumatra, died in 1397. Muslim traders spread the faith throughout the eastern ports. Musalmān Sulṭāns in the Malay Peninsular threw off the Siamese or Javanese yoke and set up independent kingdoms. By the end of the fifteenth century Islām had spread all over Java, and the Hindūs and Buddhists were forced to retire to Bali. Of the ancient civilisation of Sumatra hardly any trace remains.

JAVA[2]

With the exception of certain dolmens and other so-called Polynesian antiquities, the Malay-Polynesian (Indonesian) races of Java, who form the bulk of the population, have left few monuments; nevertheless they are of great importance as representing the Javanese element in Indo-Javanese art, a factor of increasing importance after the classical period, and, in Bali, the dominating factor.

Early Indian settlements in Western Java probably date back to the beginning of the Christian era. Of the old Hindū kingdom of Tārumā, and a king named Purṇavarman we learn something from the Sanskrit inscriptions in Pallava script, of the fourth or fifth century A. D. Hindū rule in Western Java, however, did not persist much later than the sixth century, and has left few traces. Subsequently Western Java seems to have remained independent, under native rule, even in the time of the kings of Majapahit.

[1] Das, S. C., *Indian Pandits in Tibet*, Journ. Buddhist Text Soc. India, 1, 1893, p. 8.

[2] Fruin-Mees; Bosch, 1, 3; Foucher, 4, 9; Groeneveldt; Juynboll; Yzerman; Krom, 2, 3; Krom and Erp; Kern; Stutterheim; Kats; Vogel, 20; Oudheidkundige Dienst.

More extensive evidences of Indian culture are found in Middle Java in the seventh century. This development may have been the result of long-continued or of renewed immigration from Southern India. The oldest dated inscription, that of Caṅgala in Keḍu, 732 A. D., refers to the original home of the Hindū immigrants as Kuñjarakuñja-deśa, evidently the Kuñjara of Varāhamihira's *Bṛhat Saṁhitā* in the far south of India, and probably the source of the cult of the sage Agastya, which is well developed in Java[1]. The inscription further refers to a miraculous radiant *liṅgam* brought over from Kuñjarakuñja. The Dinaya inscription of 760 (Eastern Java) similarly speaks of a fiery "Pūtikeśvara" closely connected with the ruling house. From these data has been inferred a Javanese origin of the Devarāja cult of Cambodia and Campā[2].

Indo-Javanese civilisation was by this time a harmonised unity; but while the official cults were of Indian origin, the real basis of popular belief remained, as it still remains, animistic. The Brāhmaṇism of the Javanese courts was throughout predominantly though not exclusively Śaiva. No traces remain of any early Hīnayāna Buddhism in Java. The Mahāyāna as a separate and integral cult belongs mainly to the period of Sumatran rule in Central Java; even at this time it is of a Tāntrik character, later it becomes increasingly so, and as in Nepāl, in Cambodia, and in Bali at the present day, Buddhism and Śaiva Hinduism are inseparably combined: Kertanagara received the posthumous name of Śivabuddha!

The architectural remains and sculpture of the Diëng (Ḍihyang) plateau, where stone construction is for the first time employed in Java, date from the seventh or early eighth century. Whether developed from the older school of Western Java, of which nothing survives, or in connection with renewed immigration, the architectural forms show clear analogies with those of the Gupta, Pallava and early Cāḷukya of the Indian mainland. Architecture and ornament are reserved, and in perfect correlation; and though we could not imagine these monuments in India proper, nevertheless they are more Indian than Javanese, and the local factor is only apparent, if at all, in a certain free development of the ornament itself, not in its motifs or application.

The Diëng plateau represented, not a civil capital, but a place of pilgrimage comparable with the Jaina temple cities of Palitāna and Girnār in Western India; permanently inhabited only by priests and temple servants, and for the rest providing only temporary accommodation for pilgrims, amongst others for the king, who visited the plateau once a year. The temples are small and mutually independent. Out of a much larger number, only eight are now standing. The leading characteristic of the style is a generally box-like or cubic construction with ver-

[1] Gangoly, 4; Bosch, 3.
[2] Bosch, 3, and cf. p. 196.

tical and horizontal lines strongly emphasized. Each temple consists of a single cell, approached by a porch or vestibule projecting from one face of the outer wall, the three other wall surfaces being divided by pilasters into three parts occupied by projecting niches or sculptured panels. The roof repeats the form of the main cell; the interior is a plain hollow cube below the hollow pyramid of the roof, whose inner walls approach until the remaining space can be covered by a single stone. A grotesque *kīrttimukha* (*kāla makara* and *banaspati* of Dutch authors) crowns the doorways and niches; the *makara* itself is already developed into floriated ornament and scarcely recognizable.

This description applies to the four temples of the Arjuna group, Caṇḍis Arjuna, Śrīkaṇḍi, Puntadeva (fig. 345), and Sembhadra, and to Caṇḍi Ghaṭotkaca[1], but not of course, to Caṇḍi Semar, a small and elegant rectangular building, perhaps originally a treasury, which forms a part of the Arjuna group. The isolated and unique Caṇḍi Bīma (fig. 346) presents a very different appearance. The lower part of the building is similar to the buildings already described, but the roof is definitely pyramidal in effect; it consists of diminishing horizontal stages, of which the first repeats the form of the basement with pilasters, the others being decorated with *caitya*-window motifs enclosing heads or symbols in high relief, while the angles of the fourth and sixth stages are occupied by three-quarter ribbed *āmalakas*. In all probability a complete *āmalaka* crowned the summit. Thus the roof structure corresponds exactly with that of a typical Indo-Āryan *śikhara*[2], such as that of the Paraśurāmeśvara at Bhuvaneśvara, the more developed form of the latter differing only in that the stages are more numerous and more closely compressed.

The Diëng affords many examples of sculpture. Of that applied to architectural surfaces the best instance is afforded by the Brahmā, Śiva, and Viṣṇu panels of Caṇḍi Śrīkaṇḍi. The forms are in general slender, with the leading lines clearly developed. The separate heads from the *caitya*-window niches of Caṇḍi Bīma present a variety of interesting forms, which suggest a more or less personal effort on the part of the sculptor (fig. 355); exhibiting an individuality not yet completely attuned to purely symbolic and decorative ends, these heads are the nearest to primitives that Javanese art affords.

[1] It need hardly be remarked that the nomenclature of the Diëng temples, taken from the *Bharatayuddha*, is of later origin, and gives no indication of their original dedication, which was in all cases Śaiva. Stutterheim, in Djawa, V, 1925, p. 346, shows that the "wayang" names were probably applied to the Diëng temples by the Javanese from Kediri in the thirteenth century. Just in the same way the Śaiva rock-cut shrines of Māmallapuram have been popularly named after the heroes of the *Rāmāyaṇa* (see Jouveau-Dubreuil, 1, pp. 75—77), and so also those of Masrūr, all in India proper.

[2] Cf. Yzerman.

East and south of the Diëng plateau are to be found a number of small temples fundamentally in the same style, but rather more freely, and often exquisitely, decorated. Examples may be cited in the Śaiva Caṇḍi Pringapus dateable about 850, and Caṇḍi Selagriya near Mt. Sumbing. The most important series, however, is that of the temple complex of Mt. Ungaran, known as Geḍong Saṅga, which includes nine small groups of temples situated on hill-tops probably along a pilgrim route.

We must now consider the many important monuments of the Śailendra period, i. e. under Sumatran rule in Middle Java (ca. 732 to 860). Caṇḍi Kalasan, dated 778, is an invaluable landmark, in which, for the first time we meet with a Buddhist monument on Javanese soil, and erected, as the inscription informs us, by a Śailendra king, and dedicated to Tārā, whose image must once have occupied the central chamber. The temple is situated on the west side of the Prambanam[1] plain, a richly populated area and the site of an important capital or capitals throughout the Middle Javanese period, both before and after the restoration. Caṇḍi Kalasan is of the Diëng type, but having the lateral projecting niches developed into side-chapels with separate entrances. Enormous kīrttimukhas crown the main entrance and the niches, while the makara toraṇa arches below are completely transformed into arabesque; the walls are decorated with delicate strips of floriated tracery between plain vertical pilasters.

A little to the north is another and contemporary Śailendra building known as Caṇḍi Sāri, a large building of the storeyed vihāra type containing shrines and monastic apartments, and probably the monastery attached to Caṇḍi Kalasan.

Further east, beyond the later Caṇḍi Loro Joṅgrang lies the great Buddhist temple complex of Caṇḍi Sewu of early ninth century date. Here there is a large central temple, a further development of the Kalasan design, with side chapels open to the exterior and lavishly decorated with arches and niches originally containing images; most likely the main cell held a sedent bronze Buddha. Around this central temple and at some distance from it within the large area delimited by the enclosing wall are two double series of small independent chapels, some two hundred and fifty in number. The order and beauty of the whole design are no less apparent than the variety and beauty of the decoration.

Caṇḍi Borobuḍur (figs. 101, 347, 349, 353), with the related and contemporary Caṇḍis Mendut and Pawon in Keḍu, is the greatest and by far the most famous of Javanese monuments. Caṇḍi Mendut (fig. 350) follows the general plan of the temples already described, but there are no side chapels, and the inner walls of the large open vestibule are decorated with reliefs representing Hāritī (fig. 354) and Pāñcika.

[1] It should be observed that the term "Prambanam group" is of wide application covering more than thirty temples of differing periods and types, and both Buddhist and Śaiva.

The triple panels of the three other sides of the cella are richly decorated with reliefs representing Bodhisattvas and Tārās. The original stone images, a sedent Buddha (fig. 357) and two Bodhisattvas are still in place within; serenely beautiful, they represent the highest level of classic Indo-Javanese art.

Borobuḍur[1] is wonderfully situated in the Keḍu plain, on an eminence commanding an extensive view of green rice fields and more distant towering conical volcanoes, comparable in grandeur with Fujisān. Architecturally it is unlike any other monument of the period. A rounded hill has been terraced and clothed with stone; the result is a truncated terraced pyramid supporting a relatively small central *stūpa* surrounded by seventy two much smaller perforated *stūpas* arranged in three concentric circles; a stairway in the middle of each side of the pyramid leads directly to the upper platforms with the *stūpas*. The ground plan of the six lower terraces is square with reëntrant corners, that of the three upper terraces is circular; in vertical section the whole structure fills, not a semicircle, but the segment of a circle. Each of the lower terraces is a perambulation gallery whose walls are occupied by long series of reliefs (fig. 353) illustrating the life of Buddha according to the *Lalita Vistara*, and stories from the *Divyāvadāna*, *Jātakamālā* of Sūra, and the *Gaṇḍāvyūha* and other sources. The rich and gracious forms of these reliefs[2], which if placed end to end would extend for over five kilometers, bespeak an infinitely luxurious rather than a profoundly spiritual or energised experience. There is here no nervous tension, no concentration of force to be compared with that which so impresses the observer at Aṅkor Wāt. Borobuḍur is like a ripe fruit matured in breathless air; the fullness of its forms is an expression of static wealth, rather than the volume that denotes the outward radiation of power. The Sumatran empire was now in the very height of its glory, and in intimate contact with the whole of the then civilised world; in the last analysis Borobuḍur is a monument of Śailendra culture, rather than of Buddhist devotion. It is only curious, in the light of our limited knowledge of historical details, that we should find such a monument in Java, and not in Sumatra; probably at this time (7th to 8th century) Middle Java was the real centre of the Sumatran empire, and here the Śailendra kings resided.

We must, however, return to the specific architectural problem which Borobuḍur presents. The lowest terrace is concealed beneath a heavy outer plinth, not part of the original plan, but added while the work was in progress to overcome a dangerous weakness which was only revealed as the weight of heavy masonry accumulated above; it is not unlikely that the same causes provoked a radical

[1] Foucher, 4; Hoenig; Krom, 2, 3; Krom and Erp (with illustrations of all the sculptures).

[2] The nearest Indian parallels to the Borobuḍur and Prambanam reliefs are to be found in the Gupta reliefs of the basement (*Rāmāyaṇa* and dancing scenes) at Deogaṛh (fig. 167).

change in the design of the whole superstructure. For many years, in accordance with the suggestion of Foucher (4) the whole building as it stands has been regarded as a *stūpa*. Various considerations invalidate this theory: in the first place no example of a segment *stūpa* is anywhere known in India or Indo-China, and secondly, a structure supporting seventy complete *stūpas* can hardly with logic be called a *stūpa*. No other *stūpa* of any kind, except as an architectural ornament, or as represented in the Borobuḍur reliefs, has been found in Java, and practically none are known in Cambodia before the Siamese period. On the other hand, the terraced pyramid supporting a temple is highly characteristic in Java and in Cambodia during many centuries (Caṇḍis Loro Jongrang, Jāgo, Jābung, and Panataran, and Phnoṁ Bakeṅ and the Phiméanakas), and terraced pyramids are typically found in Burma, though at a later period (Mingalazedi, Shwesandaw, and others at Pagān). Moreover, contemporary Indian parallels can be cited from Kaśmīr, which was presumably the source, through Guṇavarman, of Sumatran Mahāyāna Buddhism. The large *stūpa* founded by Lalitāditya's minister Caṅkuṇa at Parihāsapura in the first half of the eighth century rises above a double platform with recessed corners, having stairways in the centre of each side, while in the same way the basements of the central shrines of the Hindū temples exhibit a double platform, providing two *pradakṣiṇā* paths, one above the other[1]. Many earlier Indian *stūpas* such as those of Bhallaṛ (Taxila), Shpola (Khyber) and Mīrpur Khās (Sind), and others in Afghānistān stand on a single square or rectangular platform with axial approaches on one or four sides. The many-terraced pyramids of Java, Cambodia and Burma are thus merely the elaboration of a simpler prototype.

The very plausible theory of Hoenig, based on such considerations, is that Caṇḍi Borobuḍur was at first intended to be a pyramid of nine stories, with a relatively small upper platform supporting, not a *stūpa*, but a temple, the existing design having been substituted for the original when in the course of building it became necessary to reduce the weight of the superincumbent masonry. And in the galleries as originally planned would have been continued the reliefs illustrating the life of Buddha, which now for some otherwise inexplicable reason end with the First Sermon.

The date of the monument can only be inferred from the stylistic and paleographic evidence. The latter indicates a date certainly between 760 and 878 A. D. probably between 760 and 847, and most likely in the latter part of the eighth century[2]. The style of the reliefs suggests rather the eighth century.

[1] Sahni, 3, 4. Cf. seals from Ladakh, Kak, 1, p. 103; and one of unknown origin, Coomaraswamy, 9 (2), pl. XXXIX.

[2] Krom, 2, p. 257.

A Śaiva temple of the Śailendra period may be instanced in Candi Banon; the fine images of Agastya, formerly known as Śiva-Guru (fig. 359), and of Viṣṇu, from this temple, are now in Batavia.

Central Java has proved a prolific source of small Buddhist and Tāntrik Buddhist metal images, some of gold (figs. 361, 362) others of copper (fig. 363); the best examples are of admirable workmanship, many others quite crude. Later Brāhmaṇical examples from Eastern Java are also known. The various types exhibit a relationship with those of Magadha and Ceylon[1].

The Sumatran governance seems to have ended about 860, the Javanese kings returning at this time from East Java to take up their residence at Prambanam. While Buddhism and Hinduism continued to exist side by side in friendly relation, the official religion of the court was now again Śaiva. Of numerous small temples of the restoration period (860—915) may be mentioned the Hindū Candi Asu and the Buddhist Candi Plaosan. The great Candi Loro Jongrang, the greatest Hindū monument in Java, and comparable in scale with Borobuḍur and Candi Sewu, must be described more fully. The complex consists of eight temples situated on a walled terrace surrounded by smaller chapels and two outer walls. The three largest of the inner temples are dedicated respectively to Brahmā, Śiva and Viṣṇu. The largest is the central temple of Śiva (fig. 348); in principle it resembles the *prāngs* of Cambodia and the supposed original design of Borobuḍur, i. e. it consists of a temple occupying the summit of a steep truncated terraced pyramid, square in plan, with stairways in the middle of each of its three sides, leading respectively to the main entrance and to those of the side chapels. The temple itself, raised above the upper terrace by a richly decorated plinth, contains a standing image of Śiva. The terrace below is surrounded by an even more richly sculptured balustrade, the continuous series of reliefs (fig. 356) on the inner side illustrating the earlier part of the *Rāmāyaṇa*, of which the continuation was probably to be found on the corresponding terrace of the now ruined Brahmā shrine on the right; the reliefs of the Viṣṇu temple illustrate the Kṛṣṇa cycle[2]. The Prambanam reliefs are if anything superior to those of Borobuḍur, and certainly more dramatically conceived, and the aspect of the shrines, despite their rich ornament, is more masculine. It is possible that the complex served as a royal mausoleum as well as a temple.

These temples were no sooner completed than abandoned. About the year 915 the whole of Middle Java was suddenly deserted, evidently as the result of some great natural catastrophe, whether pestilence or earthquake, and we have to trace the later development of Indo-Javanese art in the east. It is of great im-

[1] Coomaraswamy, 15; Juynboll, 2; Krom, 1, 4; Pleyte; With, 1, 3; Heine-Geldern.

[2] Stutterheim, 1; Krom, 4.

portance to recognize, however, that the breach in continuity is purely geographical, and not at all stylistic. The art of Prambanam, though it adheres to the principles established on the Diëng plateau, and still shows unity of plan and harmony of construction and ornament, is already advanced in its conception of the inner relations of the fundamental elements, and any further development could only lead to what we actually find in East Java. On the other hand the early eastern monuments Gunung Gansir (977 A. D.), the Belahan gateways, Caṇḍi Sumber Nanas and Caṇḍi Sangariti are distinctly of Middle Javanese character[1].

Caṇḍi Lalatunda, tomb and bathing place, are due to Udayana, father of the great Erlaṅga. Near to Belahan is another bathing place ascribed to Erlaṅga himself (1010—1042), and this site is the source of a portrait statue in which he is represented as Viṣṇu riding upon Garuḍa (fig. 360), "een prachtstuk als kunstwerk, tevens bepaaldelijk een portretbeeld"[2]; recalling, and yet very different from an Indian treatment of the same subject found near Nālandā[3].

Java was now becoming a great maritime power, destined soon to occupy the old position of Sumatra. The eastern Javanese kings had already made their power felt in Palembang; the Arab and Chinese trade were flourishing, and the island of Bali was dependent on Java. And what is more important, a national Javanese culture had developed, based indeed on the old Indian tradition, but Indonesian in essence, idiomatic in expression, and in the truest sense of the word, original. The Javanese language (Kawi) had become a fitting vehicle of classic epic literature. Javanese versions of the Indian epics, and the classic *Arjuna-vivāha* in which the shadow-play is mentioned for the first time, date from Erlaṅga's reign.

Unfortunately we know practically nothing of the monuments of Erlaṅga's reign, and very little of those of the next century. Nevertheless, the twelfth century in Java, like the thirteenth in Europe, was the "greatest of centuries" and more than any other moment stands for the living past in Javanese consciousness. This was an age of chivalry and romantic love. A twelfth century king, Kāmeśvara, may be, in part, the prototype of Rāden Pāñji, the hero of the Pāñji cycle and the most romantic figure in Javanese tradition. Much of the Pāñji literature may have been composed before the end of the century. And this development, which is reflected in the art of the succeeding centuries, naturally accompanied an immense extension of secular power; the Javanese kings now held Baṅka, over against Palembang, and their traders sailed to the eastern coast

[1] Remains of a temple, Caṇḍi Badut, near Malang in East Java, are apparently in the Dieng style, but have not yet been studied (Bosch, 3, p. 284).

[2] Krom, 3, p. 150. Cf. Krom, 1, p. 410 and pl. 42.

[3] Burgess, 8, pl. 235.

of Africa on the one hand and to China on the other. Only with the accession of a new dynasty, ruling in Siṅgasāri (1280—1292) and Majapahit (1294—1478) are we able to take up again the history of Javanese art. The whole period, however, forms from this point of view a unity, a kind of post-classical romantic style in which the purely Indian tradition is almost submerged, and the Indonesian factor comes increasingly to the fore. There is a loss of balance as between construction and ornament, and the ornament itself grows more exuberant. In all this embroidery, nevertheless, there is infinite charm.

The chief monuments of Siṅgasāri[1] include Caṇḍi Kidal (Śaiva), distinctively East Javanese in respect of its heavy pyramidal roof with conspicuous horizontal courses, overweighting the whole building. Even more definitely East Javanese is Caṇḍi Jāgo, with its *wayang*-like reliefs, illustrating the Javanese *Kṛṣṇāyaṇa*, which seems strange in a Buddhist temple; the separate images are still, however, of Middle Javanese character. Śaiva-Buddhist syncretism is well seen in Caṇḍi Jawi, where the main cell enshrines a Śiva image with a Buddha above it. Caṇḍi Siṅgasāri itself has yielded many large Śaiva images, especially the well known Durgā-Mahiṣamardinī and Gaṇeśa of Leiden. From another Siṅgasāri shrine come the even more famous Leiden Prajñāpāramitā, superficially lovely and exquisitely ornamented, but without vitality, and also the more vigorous Arapacana Mañjuśrī, dated 1343 (fig. 358).

The remarkable Śaiva temple of Caṇḍi Jābung (fig. 366)[2] is "relatively old"[3]. The shrine is circular (unique in Java) and must have been very high, and stands on the usual terraced base. This basement too is unusually high. The transition from the rectangular base to the circular tower is admirably managed, and the rich decoration is well subordinated to the main outlines. This temple may well be regarded as the finest example of East Javanese art.

The power and prosperity of East Java attained their zenith under the kings of Majapahit. Four great rulers, including Kertanagara and Hayam Wuruk, occupied the throne in succession from 1294 to 1389. Western Java remained independent, and little is known of Central Java, but Majapahit controlled all the eastern islands, the coastlands of Borneo, the coastlands of Sumatra including Palembang, and the Malay Peninsula. Trade with China in Indian and Javanese products, chiefly silk and cotton goods, continued to flourish. In the *Nāgarakertā-gama*, Prapañca[4] presents a vivid picture of the walled city of Majapahit with

[1] Melville, Knebel and Brandes.

[2] Fergusson, 2, pl. LII; but the temple is situated in the far east of Java, beyond Pasuruhan, not as Fergusson states, near Borobuḍur.

[3] Krom, 3, p. 154.

[4] Kern and Krom.

its streets and palaces, and of the manners and customs of its inhabitants. Entertainments are mentioned, amongst others the *Wayang Beber* (exhibition of scroll paintings with spoken text, and equivalent of the old Indian *Yamapaṭa* exhibition as described in the *Mudrārākṣasa*) and *Wayang Topeng*, or masked dance, in which the king himself took part on the occasion of a *śrāddha* for the queen mother[1].

Amongst the numerous monuments of this golden age of East Java the finest and most important is the Śaiva temple complex of Panataran near Blitar. Here we are far removed from the unity of conception and organic relation of parts characteristic of Middle Java; the temple complexes of East Java, like those of Bali, consist of groups of unrelated buildings of various dates, ranging in the case of Panataran (fig. 352) over the fourteenth and first half of the fifteenth century. Of the main temple only the basement remains; it is square with recessed corners; the lower of the terraces is decorated with alternate medallions and reliefs illustrating the *Rāmāyaṇa*, the upper with a continuous frieze illustrating the *Kṛṣṇāyaṇa*. All these reliefs are designed in a heroic and grotesque *wayang*-like style and form a sort of popular theatre. The reliefs of the shrine walls represented Brahmā, Viṣṇu and Śiva. The richness of all the ornament is overwhelming; even the backs of the *dvārapālas*, in a style we should now call Balinese, are decorated with reliefs.

Other Hindū monuments of the fifteenth century are mostly of laterite and built on terraced hill slopes. Here the worship of Śiva as a mountain god facilitated a combination of Hinduism with old Indonesian terrace cults; in the resulting mixture of Indo-Javanese and Indonesian elements and a new combination of both there appeared for a brief period a definite style not lacking in vitality. Selakelir (1434—1442), Penampikan, Sukul and Lewu are amongst the main sites. In completing the above account of Javanese architecture it may be remarked that no pier or column is found in any Javanese temple, and mortar is never employed.

Nothing is known of Javanese paintings, except in manuscript illustrations, but there exists a Central Javanese engraved copper plate, essentially a drawing on copper, representing the figure of a woman with a child, in a style reminiscent of Ajantā[2]. This beautiful figure gives at least a suggestion of the style of the mural paintings that must have once existed. In Bali, on the other hand, very interesting mural paintings and tablets, as well as book illustrations and scrolls of seventeenth or eighteenth century date are still extant. Even the scrolls that are still made are in a style absolutely unaffected by foreign influences, and possess considerable distinction; the subjects are generally epic, sometimes erotic[3].

[1] Kern and Krom, p. 200.
[2] Stutterheim, 2; Juynboll, 1, 2.
[3] Bastian; Nieuwenkamp, figs. 139, 140; Juynboll, 1, 2.

The architecture of Islām in Java is of comparatively little importance. Amongst the oldest monuments are the minaret of the mosque at Kadua, really a modified Caṇḍi without images, and the neighbouring gateway. The situation, in fact, is similar to that of Gujarāt at the same period: the local architectural tradition constituted a national style, of which Islām naturally made use with only such necessary modifications as the change of faith demanded. The same is true of the theatre, despite its fundamentally Hindū themes. The followers of Islām were conscious of no hostility to the national culture; the Javanese remained Javanese. The decline of Javanese art is to be ascribed only to natural and inherent causes. The will and the power to create great works, imaginatively or dimensionally great, had departed, and just as in Ceylon, there remained only the rich inheritance of tradition embodied in the folk arts. Only in the theatre and music and in the field of textiles, where aristocratic influences have been continuously at work, the spirit of classical art has survived.

A few words on Bali. In all probability Bali was originally directly Hinduised, and only came under Javanese influence and rule after the twelfth century, and this Javanese influence was never so overpowering as to prevent the development of a distinctive national civilisation. This unique culture, as it survives to the present day nevertheless presents us with a marvellous miniature picture of the conditions that prevailed in Eastern Java during the last centuries of Hindū rule — "ritual offerings, festivals, feudal relations, all appear in Bali still to correspond with the old descriptions" (of the *Nāgarakertāgama*)[1]. It is only in Bali that there survive that mixture of Hinduism and Buddhism which we have so constantly observed in classic and post-classic Further Indian and Indonesian art; and in costume, that nudity of the upper part of the body, which was characteristic both of India and Further India until the end of the classic ages.

The only really ancient remains are those of Tampaksiring, a royal burial place of eleventh or twelfth century date; here niches with temple façades have been cut in the wall of a deep ravine. These help to bridge the gaps in our knowledge of East Javanese art: the form of the roof is intermediate between the Middle Javanese type with turrets and the later East Javanese and Balinese type in which the roof is formed of closely compressed horizontal courses, of which the turrets are suppressed. The Pura ye Ganga temple of fourteenth or fifteenth century date resembles Panataran. Sculptures at Pejeng date from the same period. The more modern temples of Sangsit, Bangli, Batur (fig. 351), Kesiman, etc., consist of groups of small unrelated shrines enclosed in a ring-wall with high roofed gateways; the decoration is wild and free, quite

[1] Krom, 3, p. 206.

210

without relation to the structural forms. The material generally employed is limestone.

As we have remarked (p. 139), the ancient culture of Java and Bali has survived to the present day mainly in the theatre (*wayang*) and in textiles (*kain*). With the theatre are inseparably associated music and dancing, both developed to a high degree of perfection.

The theatre embraces a number of forms, of which the oldest may be the *Wayang Beber*[1] already mentioned. The *Wayang Purva*, *Wayang Gedog* and *Wayang Klitik*, together embracing Javanese history beginning with the Indian epics and ending with the last kings of Majapahit, constitute the shadow play; this cannot with certainty be traced further back than the *Arjunavivāha* and may by either of local or of Chinese origin; we have no positive proof of the early existence of shadow plays in India[2]. The Javanese shadow figures are cut in leather and have moveable arms, but they are not translucent like those of China. Those of Burma and Siam on the other hand are combined with landscape in whole scenes and are not moveable. The Javanese shadow figures are handled with reverence, and, indeed, the shadow play is much more than an amusement, it is a ritual performed in honour of the ancestors of the race, whose spirits are represented by the leather puppets. A true puppet play (*Wayang Golek*) is also known, in which the figures are in the same way manipulated from below, unlike those of Burma, which have moveable legs as well as arms[3].

Finally we have plays in which living actors take part: the masked play (*Wayang Topeng*)[4] of high antiquity, and the regular theatrical performances (*Wayang Wong*) in imitation of shadow plays. This human theatre is mainly an eighteenth century creation of aristocratic origin, but the themes are invariably drawn from the ancient sources, and the noble costumes, absence of scenery, and traditional dances and gestures lend to the whole performance an air of antiquity. And this antiquity if not historically true, is certainly psychologically true; the Javanese theatre presents a living and emotionally convincing picture of a heroic and romantic past. Permanent troupes of actors are supported at the Yogyakarta and Surakarta courts, and it is by no means unknown for some member of the royal family to play. On great occasions hundreds of actors are trained for months in advance and no expense is spared. The Javanese theatre embodies spiritual and cultural values of deep significance; only the *No-gaku* of

[1] An example illustrated in Krom, 4, pl. LIX.

[2] Jacob, G., *Geschichte des Schatten-Theaters*, 2. ed., Hannover, 1925; Laufer, B., . . . *Chinesische Schattenspiele* . . ., Abh. K. B. Akad. Wiss., Vol. 28, München, 1915.

[3] Kats, 1; Serrurier; Gröneman; Helsdingen, R. van B. van, *The Javanese theatre: Wayang Purwa and Wayang Gedog*, in Straits Branch R. A. S., 65, 1913.

[4] For Javanese masks, see Hidenosuke; and fig. 367.

Japan can be compared with it, and even so the Javanese has a wider range of theme and is far more than an exquisite survival[1].

Closely connected with the theatre are the dances, especially the character dances of the actors, given when they first appear upon the stage. Beside these there are the ritualistic dances of the Bedoyo and Serimpis, who are court ladies; and also many court dances of a purely decorative type. The gesture shows in a general way reminiscences of Indian tradition, but less specifically so than in the case of the dances represented in the ancient sculptures[2].

The typical Javanese textile is cotton *batik* (fig. 398), the material of all ordinary garments[3]. The technique of *batik*, of South Indian origin, consists in painting and repainting the cotton ground with wax in such a manner as to reserve all those parts of the cloth which are not to take up colour at the next dipping in the dye vat. Many of the designs in use date from the earlier part of the Muḥammadan period in Java, others, especially the medallion types, recall such decorated wall surfaces as those of the Caṇḍi Sewu. In Middle Java only two colours, brown and blue, are employed, elsewhere combined with red and green. The material as sold is ready to wear without tailoring: the ordinary pieces are *kain panjang* corresponding to the Indian *dhotī, kain slendang*, the long breast cloth worn by women, and *kain kapāla* the square head piece, folded like a turban. This turban is small and closely fitting in Java, but in Bali the ends are left loose in a more coquettish fashion. The *sārong*, a piece of material sewn up to form a skirt, is more usual in Western Java and the Malay Peninsular. In Bali very gorgeous materials (*kain prāda*) worn by princesses and dancers are prepared by stamping Javanese *batiks* with designs in gold (fig. 399); the technique is probably Indian, but some of the designs show Chinese influence. Silk is only very rarely employed as a material for *batik*.

Of extraordinary interest and beauty are the *ikat* silks and cottons, the former in some cases combined with gold and silver, and woven in Sumatra, Java, Bali, Sumbawa (fig. 400) and other islands. In this technique the warp or woof threads are individually coloured by the tie dye process, each thread exhibiting different colours along its length in such a way that only when the cloth is woven on the loom does the pattern appear. Double *ikat*, in which both warp and woof threads are thus treated occurs only in Bali where the very handsome *kain tengānan* are used

[1] For a good account of a court performance see Kats, 2. Also Coomaraswamy *Notes on the Javanese theatre*, in Rūpam, 7, 1921.

[2] Lelyveld; Hadiwidjojo, P. A., *De Bedojo Katawang*, Eerste Congress Taal, Land en Volkenkunde, Weltevreden, 1921; Helsdingen-Scoevers and de Kleen, *De Srimpi- en Bedajadansen*, Weltevreden, 1925.

[3] For *batik* see Rouffaer and Juynboll; Loebèr; for *batik* and all other Indonesian textiles, especially *ikat*, see Jasper and Pirngadie.

as covering for temple offerings. In Bali we also find a double silk *ikat* known as *paṭola*, but whether this is of local manufacture or an importation from Surat it would be hard to say. In any case the *ikat* technique, which is widely distributed both in Further India and Indonesia, is certainly of Indian origin and probably of high antiquity. Needless to remark that *ikat* weaving requires the most elaborate precalculation and measurement.

The beautiful cottons woven by the more primitive races in the Toba-batak lands of Sumatra, by the Dyaks of Borneo, and in other islands in brilliant geometrical designs, belong rather to the Malay-Polynesian than to the Indian tradition.

BIBLIOGRAPHY

References in the text are quoted by the author's name only, when only one work is listed, and by the author's name followed by a number, when more than one work by the same author is listed. For the abbreviations see page 227.

Acharya, P. K., *A summary of the Mānasāra*, Leiden, 1918.

Adam, L., *Buddha-Statuen*, Stuttgart, 1925.

Aiyangar, M. S., *Tamil studies*, Madras, 1914.

Aiyar, V. Natesa, 1. *Trimūrti image in the Peshawar Museum*, A. S. I., A. R., 1913—14.

 2. *Shpola stupa, Khyber*, A. S. I., A. R., 1915—16.

Allan, J., *Catalogue of the coins of the Gupta dynasties*, British Museum, London, 1914.

Annandale, N., *Plant and animal designs in the mural decoration of an Uriya village*, Mem. A.S.B., VIII, 4, 1924.

Anonymous, 1. *Le Musée indo-chinois* (Trocadéro), Paris, n. d.

 2. *Tsao hsiang liang tu ching*, Tokio, 1885.

Arunachalam, Sir P., 1. *Sketches of Ceylon History*, Colombo, 1906.

 2. *Polonnaruwa bronzes and Siva worship and symbolism*, J. R. A. S., Ceylon Br., XXIV, no. 68, 1917.

Ashton, L., *Introduction to Chinese sculpture*, London, 1924.

Aymonier, E., 1. *Le Cambodge*, Paris, 1900—1904.

 2. *Histoire de l'ancien Cambodge*, Strasbourg, n. d. (1924?).

Ayyar, P. V., *South Indian shrines*, Madras, 1920.

Bachhofer, L., 1. *Zur Datierung der Gandhara-Plastik*, Neubiberg, 1925.

 2. *Ein Pfeilerfigur aus Bodh-Gaya*, Jahrbuch as. Kunst, II, 1925.

Baker, G. P., *Calico painting and printing in the East Indies in the 17th and 18th centuries*, London, 1921.

Banerji, R. D., 1. *Three sculptures in the Lucknow Museum*, A. S. I., A. R., 1909—10.

 2. *Four sculptures from Chandimau*, A. S. I., A. R., 1911—12.

 3. *The temple of Siva at Bhumara*, Mem. A. S. I., 16, 1924.

 4. *Some sculptures from Kosām*, A. S. I., A. R., 1913—14.

Banerji-Sastri, A., *The Lomas R̥si cave facade*, J. B. O. R. S., XII, 1926.

Barnett, L. D., *Antiquities of India*, London, 1913.

Bastian, A., *Indonesien, Vol. V, Java*, Berlin, 1894.

Beal, S., 1. *Buddhist records of the western world (Si-yu-ki)*, London (Popular ed., n. d.).

 2. *Life of Hiuen Tsiang*, London (1914 ed.).

 3. *Travels of Fa Hian and Sung Yun . . . 400—518 A. D.*, London, 1869.

Bell, H. C. P., 1. *Archaeological Survey of Ceylon*, Annual Reports.

 2. *Report on the Kegalla District*, Colombo, 1904.

Belvalkar, S. P., *Rāma's later history, (Uttara-Rāma-Carita)*, H. O. S., Cambridge, 1915.

Bendall, M. C., 1. *A journey in Nepal and Northern India*, Cambridge, 1886.

 2. *Cat. Buddhist Sanskrit Mss. in the University Library*, Cambridge.

Berstl, H., *Indo-koptische Kunst*, Jahrb. d. as. Kunst, I, 1924.

Beylié, L. de, *L'architecture hindoue en Extrême-Orient*, Paris, 1907.

Bhandarkar, D. R., 1. *Jaina iconography*, A. S. I., A. R., 1905—06.

 2. *Two sculptures at Maṇḍor*, A. S. I., A. R., 1905—06.

 3. *Lakulīśa*, A. S. I., A. R., 1906—07.

 4. *The temples of Osiā*, A. S. I., A. R., 1908—09.

 5. *Excavations at Besnagar*, A. S. I., A. R., 1913—14 and 1914—15.

 6. *The architectural remains and excavations at Nagarī*, Mem. A. S. I., 4, 1920.

 7. *Buddhist stūpa at Saidpur, Sind*, A. S. I., A. R., 1914—15.

 8. *Some temples in Mt. Abu*, Rūpam, 3, 1920.

Bhandarkar, R. G., *Vaiṣṇavism, Śaivism and minor religious systems*, Gr. i.-a. Ph. A., Strassburg, 1913.

Bhattacharyya, B., 1. *Indian images*, I., Calcutta, 1921.

 2. *The Indian Buddhist Iconography*, London, 1924.

Bhavabhūti, *Uttara-Rāma-Carita*, trans. S. K. Belvalkar, Cambridge, 1915.

Bhoja, King of Dhārā, 1. *Samarāṅgana Sūtrādhāra*, Baroda, 1925.

 2. *Yuktikalpataru*, ed. N. N. Law, Calcutta, 1917.

Bidyabinod, B. B., *Varieties of the Vishnu image*, Mem. A. S. I., 2, Calcutta, 1920.

Binyon, L., 1. *Les peintures radjpoutes du British Museum*, Rev. des arts asiatiques, III, 2, 1926.

 2. *Examples of Indian sculpture at the British Museum*, London, 1910.

Birdwood, Sir G., *Industrial arts of India*, London, 1880.

Bloch, Th., 1. *Excavations at Basāṛh*, A. S. I., A. R., 1903—04.

 2. *Notes on Bodh-Gayā*, A. S. I., A. R., 1908—09.

 3. *Excavations at Lauriya*, A. S. I., A. R., 1906—07 (see also 1904—05).

 4. *Conservation in Assam*, A. S. I., A. R., 1906—07.

Bloomfield, A., *Silver and copper objects found near the village of Gungeria* (C. P), Proc. A. S. B., 1870.

Boerschmann, E., 1. *Die Baukunst und religiöse Kultur der Chinesen*, Berlin, 1914.

 2. *Chinesische Architektur*, Berlin, 1925.

Bosch, F. D. K., 1. *Epigraphische en iconographische Aantekeningen*, Oudh. Dienst, Weltevreden, 1920.

 2. *Een hypothese omtrent der oorsprung der Hindoe-Javaansche kunst*. Congress Taal, Land en Volkenkunde, I., Weltevreden, 1921. English translation in Rūpam, 17, 1924.

 3. *Het Linga-heiligdom van Dinaja*, Ind. T. L. en Volkenkunde, LIV, 1924.

 4. *Een Oorkonde van het Groote Klooster te Nālandā*, Ind. T. L. en Volkenkunde, LXV, 1925.

Bose, P. N., 1. *The Indian Teachers in China*, Madras, 1925.

 2. *The Indian colony of Champa*, Madras 1925.

Brown, J. C., *The coins of India*, London, 1922.

Brown, P., *Indian painting*, London and Calcutta, n. d.

Burgess, J., 1. *Report on the antiquities of Belgām and Kaladgi*, A. S. I., N. I. S., vol. I, London, 1874.

 2. *Report on the antiquities of Kāṭhiāwāḍ and Kachh*, A. S. I., N. I. S., vol. II, London, 1876.

 3. *Report on the antiquities of Bidar and Aurangābād*, A. S. I., N. I. S., vol. III, London, 1878.

 4. *Notes on the Bauddha rock temples of Ajaṇṭā . . . and . . . Bagh*, Bombay, 1879.

 5. *Report on the Buddhist cave temples*, A. S. I., N. I. S., vol. IV, London, 1883.

 6. *Report on the Elurā cave temples*, A. S. I., N. I. S., vol. V, London, 1883.

 7. *The Buddhist stupas of Amarāvatī and Juggayyapeta*, London, 1887.

 8. *The ancient monuments, temples and sculptures of India*, 2 vols., 1897.

 9. *Gandhāra sculptures*, Journ. Indian Art, VIII, 1898—1900.

Burgess, J., and Cousens, H., *Antiquities of the town of Dabhoi in Gujarat*, London, 1888.

Chanda, R. P., 1. *Four ancient Yakṣa statues*, University of Calcutta, Journ. Dep. Letters, IV, 1921.

 2. *Beginning of the sikhara of the nagara (Indo-Aryan) temple*, Rūpam, 17, 1924.

 3. *Note on prehistoric antiquities from Mohen-jo-Daro*, Calcutta, 1924.

 4. *Archaeology and Vaishnava tradition*, Mem. A. S. I., Calcutta, 1920.

Chanda, R. P., 5. *The Mathurā school of sculpture*, A. S. I., A. R., 1922—23, p. 164.

 6. *Mediaeval sculpture in East India*, Calcutta University, Journ. Dep. Letters, III, 1920.

Chavannes, E., 1. *Voyage de Song Yün dans l'Udyāna et le Gandhāra* 518—522 *A. D.*, B. É. F. E. O., 1903, pp. 379—441.

 2. *Mission archéologique dans la Chine septentrionale*, Paris, 1909.

Codrington, K. de B., *Ancient India, from the earliest times to the Guptas* . . ., London, 1926 (to be completed in three volumes).

Coedès, G., 1. *Catalogue . . . sculpture khmère . . . Trocadéro et au Musée Guimet*, B. C. A. I., 1900.

 2. *Les bas-reliefs d'Aṅgkor Wāt*, B. C. A. I., 1911.

 3. *Le royaume de Śrīvijaya*, B. É. F. E. O., 1918.

 4. *Bronzes khmèrs*, Ars Asiatica, V, Paris, 1923.

 5. *The Vajirañāṇa National Library*, Bangkok, 1924.

 6. *Tablettes votives bouddhiques du Siam*, Études asiatiques, Paris 1925. Trans. in J. S. S., XX, 1926.

Cohn, W., 1. *Buddha in der Kunst des Ostens*, Leipzig, 1925.

 2. *Indische Plastik*, Berlin, 1921.

Connor, J. E., *Forgotten ruins of Indo-China*, Geographical Magazine, XXIII, 3, Washington 1912.

Coomaraswamy, A. K., 1. *Mediaeval Sinhalese Art*, London and Broad Campden, 1908.

 2. *The Indian craftsman*, London, 1909.

 3. *Indian Drawings*, 2 vols, London, 1910—12.

 4. *Arts and crafts of India and Ceylon*, Edinburgh, 1913. (= *Les arts et métiers de l'Inde et de Ceylan*, Paris, 1924.)

 5. *Some ancient elements in Indian decorative art*, O. Z., II, 1913.

 6. *Bronzes from Ceylon*, Mem. Colombo Museum, I., Colombo, 1914.

 7. *Viśvakarmā*, London, 1914.

 8. *Rajput Painting*, Oxford, 1916.

 9. *Catalogue of the Indian collections in the Museum of Fine Arts, Boston*

 1. *Introduction*, 1923 (= *Pour comprendre l'art hindou*, Paris, 1926.)

 2. *Sculpture*, 1923.

 4. *Jaina paintings and Mss.*, 1924.

 5. *Rajput Paintings*, 1926.

 10. *Portfolio of Indian Art*, Boston, 1923.

 11. *Introduction to Indian art*, Adyar, 1923.

 12. *The frescoes of Elūrā*, O. Z., N. F., 3, 1926.

 13. *Citralakṣaṇa* (Śrī Kumāra, Śilparatna, Ch. 64), Sir Ashutosh Mukerjee Memorial Vol., Patna, 1927.

 14. *The Dance of Śiva*, 2 nd ed., London, 1925 (= *La Danse de Çiva*, Paris, 1922).

 15. *Mahayana Buddhist bronzes from Ceylon and Java*, J. R. A. S., 1909.

 16. *The Indian origin of the Buddha image*, J. A. O. S., vol. 46, 1926.

 17. *Six sculptures from Mathurā*, M. F. A. Bull., no. 144, 1926.

 18. *Statuette of Vishnu from Kashmir*, Museum Journal, Philadelphia, March, 1926.

Coomaraswamy, A. K., and Duggirala, G. K., *The Mirror of gesture*, Cambridge, U. S. A., 1917

Cousens, H., 1. *Ter-Tagara*, A. S. I., A. R., 1902—03.

 2. *The iron pillar at Dhar*, A. S. I., A. R., 1902—03.

 3. *Temple of Brahmā at Kheḍ-Brahmā*, A. S. I., A. R., 1906—07.

 4. *The ancient temples of Aihoḷe (and Paṭṭakadal)*, A. S. I., A. R., 1907—08.

 5. *Buddhist stūpa at Mīrpur Khās, Sind*, A. S. I., A. R., 1909—10.

 6. *Chālukyan temples*, J. I. A., vol. II, 1888.

 7. *Dhamnar caves and monolithic temple of Dharmanātha*, A. S. I., A. R., 1905—06.

 8. *The architectural antiquities of Western India*, London, 1926.

216

Cousens, H., 9. *The Chalukyan architecture of the Kanarese districts.*

 10. *The mediaeval temples of the Dakhan.* }announced.

 11. *Somanatha and other mediaeval temples in Kathiawad.*

Cowell, E. B., *Jātaka: or stories of the Buddha's former births*, Cambridge, 1895—1907.

Cunningham, A., 1. *The Bhilsa topes, or Buddhist monuments of Central India*, London, 1854.

 2. *The stupa of Bharhut*, London, 1879.

 3. *Mahābodhi, or the Great Buddhist Temple at Buddhagaya*, London, 1892.

 4. *Archaeological Survey Reports*, 1862—1887, vols. I—XXIII, Calcutta, 1871—1887.

 5. *Coins of Ancient India*, 1891.

 6. *Coins of Mediaeval India*, 1894.

Dalton, O. M., *East Christian art*, Oxford, 1925.

Delaporte, L., *La Mésopotamie*, Paris, 1923.

della Setta, Al., *Genesi dello Scorcio nell'arte greca*, Rome, 1907.

Dey, M. C., *My pilgrimage to Ajanta and Bagh*, London, 1925.

Diez, E., *Die Kunst Indiens*, Potsdam, n. d. (1925—26).

Dikshit, K. N., *Six sculptures from Mahobā*, Mem. A. S. I., 8, Calcutta, 1921.

Dimand, M., *Indische Stilelemente in der Ornamentik der syrischen und koptischen Kunst*, O. Z., IX,
 pp. 201—215.

Döhring, K., 1. *Kunst und Kunstgewerbe in Siam*, 1. *Lackarbeiten in Schwarz und Gold*, Berlin, 1925.

 2. *Buddhistische Tempelanlagen in Siam*, Berlin, 1920.

 3. *Siam, II, Die bildende Kunst (mit Ausnahme der Plastik)*, München, 1923.

Dokumente der indischen Kunst. 1: Malerei. Das Citralakṣaṇa. Hrsg. und übers. von B. Laufer,
 Leipzig, 1913.

Dufour, H., and Carpeaux, C., *Le Bayon d'Angkor Thom*, Paris, 1914.

Dupont, M., *Kunstgewerbe der Hindu*, Berlin, (1925).

Durier, A., *Dekorative Kunst in Annam*, Stuttgart, (1926).

Duroiselle, Ch., 1. *Pictorial representations of Jātakas in Burma*, A. S. I., A. R., 1912—13.

 2. *The stone sculptures of the Ānanda temple*, Pagān, A. S. I., A. R., 1913—14.

 3. *The Arī of Burma and Tāntric Buddhism*, A. S. I., A. R., 1915—16.

 4. (*Frescoes at Pagan*), in Rep. Arch. Surv. Burma, 1921—22.

Elliott, Sir H. M., *Hinduism and Buddhism*, 3 vols., London, 1922.

Fergusson, J., 1. *Tree and serpent worship*, 2nd ed., London, 1873.

 2. *A history of Indian and eastern architecture*, 2nd ed., London, 1910.

Fergusson, J., and Burgess, J., *Cave temples of India*, London, 1880.

Ferrand, G., *L'Empire sumatranais de Śrīvijaya*, Paris, 1922.

Finot, L., 1. *Les bas-reliefs de Bapuon*, B. C. A. I., Paris, 1910.

 2. *Lokeśvara en Indochine*, Études asiatiques, Paris, 1925.

Finot, L. and Goloubew, V., *Le Fan-Tseu T'a de Yunnanfou*, B. É. F. E. O., 1925.

Finot, L., Parmentier, H., and Goloubew, V., *Le temple d'Içvarapura (Banta Srei, Cambodge)*, Mem.
 Arch. É. F. E. O., I.

Fleet, J. F., *Seals from Harappa*, J. R. A. S., 1922.

Foote, R. B., 1. *The Foote collection of Indian prehistoric and protohistoric antiquities*, Madras, 1914.

 2. do., *Notes on their age and distribution*, Madras, 1916.

Foucher, A., 1. *L'Art gréco-bouddhique du Gandhāra*, Paris, 1900, 1918, 1923.

 2. *L'Iconographie bouddhique de l'Inde*, Paris, 1900, 1905.

 3. *Les images indiennes de la Fortune*, Mem. conc. l'Asie orientale, I., 1913.

 4. *The beginnings of Buddhist art*, London, 1918.

 5. *Les représentations de Jataka dans l'art bouddhique*, Mém. conc. l'Asie orientale, III, 1919.

 6. *Matériaux pour servir a l'étude de l'art khmère*, B. C. A. I., 1912, 1913.

217

Foucher, A., 7. *Preliminary report on the interpretation of the paintings and sculptures of Ajanta,* Journ. Hyderabad Arch. Soc. 5, 1919—20.

 8. *Cat. des peintures népalaises et tibétaines de la collection Brian-Hodgson,* Mem. Acad. Inscriptions, Ière sér., t. XI.

 9. *The influence of Indian art on Cambodia and Java,* Sir Ashutosh Mookerjee Memorial Volumes, III, 1, Calcutta, 1922.

 10. *On an old bas-relief in the Museum at Mathurā,* J. B. O. R. S., VI, 1920.

Fournereau, L., 1. *Les ruines khmères,* Paris, 1890.

 2. *Le Siam ancien,* Paris, 1908.

Fox-Strangways, A. H., *Music of Hindustan,* Oxford, 1914.

Francke, A. H., *Antiquities of Indian Tibet,* A. S. I., Calcutta, 1914.

Fruin-Mees, W., *Geschiedenis van Java, I. Hindoetijdperk,* 2nd. ed. Weltevreden, 1922.

Führer, A., *Indo-Skythic architecture and sculpture of the Mathura school,* Journ. Indian Art, V, 1894.

Gangoly, O. C., 1. *South Indian bronzes,* Calcutta, 1914.

 2. Editorial articles, Rūpam, *passim.*

 3. *Vasanta Vilāsa, a new document of Indian painting,* O. Z., N. F., 2, 1925.

 4. *The cult of Agastya: and the origin of Indian Colonial art,* Rūpam, 25, 1926.

 5. *Some Nepalese incense burners,* Rūpam, 7, 1921.

 6. *The Mithuna in Indian art,* Rūpam, 22—23, 1925.

Ganguly, M., 1. *Orissa and her remains, ancient and mediaeval,* Calcutta, 1912.

 2. *Handbook to the sculptures in the museum of the Bangiya Sahitya Parishad,* Calcutta, 1922.

 3. *Indian architecture from the Vedic period,* J. B. O. R. S., XII, 1926.

Garde, M. B., *The site of Padumāvatī,* A. S. I., A. R., 1914—15, pt. I.

Gardner, P., *Catalogue of the coins in the British Museum, Greek and Scythian kings of Bactria and India,* London, 1886.

Geiger, W., *The Mahāvaṁsa,* text, London 1908; translation, London, 1912.

Gerini, G. E., 1. *Siamese archaeology, a synoptic sketch,* J. R. A. S., 1904.

 2. *Siam and its productions, arts and manufactures,* 1912.

Getty, A., *The gods of northern Buddhism,* Oxford, 1914.

Ghose, A., *A comparative study of Indian painting,* Ind. Hist. Qtly., June, 1926.

Glasenapp, H. von, *Der Jainismus,* Berlin, 1925.

Goetz, H., 1. *Studien zur Rajputen-Malerei,* O. Z., X, 1922, and O. Z., N. F., I, 1924.

 2. *Der Zusammenbruch des Grossmogulreiches im Lichte der Kostümgeschichte,* Zeit. für Waffen- und Kostümkunde, 1924.

 3. *Kostüm und Mode an den indischen Fürstenhöfen des 16.—19. Jahrhunderts,* Jahrb. as. Kunst, 1924.

 4. *Die ind. Miniaturen der Sammlung W. Rothenstein, London,* Jahrb. as. Kunst, II, 1925.

 5. *Geschnitzte Elfenbein-Büchsen aus Süd-Indien,* Jahrb. as. Kunst, II, 1925.

 6. *The relations between Indian painting and culture,* Bull. School of Oriental Studies, III, 4, London, 1925 and Rūpam, 22—23, 1925.

 7. *Indische Buchmalereien,* see Kühnel, E., and Goetz, H.

 8. *Die Malschulen des Mittelalters und die Anfänge der Moghul-Malerei in Indien.* O. Z., N. F. 3, 1927.

Goloubew, V., 1. *Peintures bouddhiques aux Indes,* Ann. du Musée Guimet, Bib. de Vulgarisation 40, Paris, 1914.

 2. *La descente de la Ganga sur Terre,* Ars Asiatica, III, Paris, 1921.

 3. *Le Phnom Kulen,* Cahiers de la Soc. Geog., VIII, Hanoi, 1924.

 4. *Le Harihara de Maha-Rosei,* Études asiatiques, Paris, 1925.

 5. *Documents pour servir a l'étude d'Ajanta. Les peintures de la première grotte.* Ars Asiatica, X.

Graham, W. A., 1. *Pottery in Siam,* Journal Siam Society, XVI, Siam.

 2. *Siam,* London, 1924.

Griffiths, J., *The paintings in the Buddhist cave temples of Ajunta*, London, 1896—97.

Groenevelt, W. P., *Notes on the Malay Archipelago and Malaca compiled from Chinese sources*, Verh. Bat. Kunst en Wet., Batavia, 1876.

Gröneman, J., *Tjandi Parambanan na . . . de ontgraving*, Leiden, 1893.

Groslier, G., 1. *Danseuses cambodgiennes*, Paris, 1913.

 2. *Note sur la sculpture khmère ancienne*, Études asiatiques, 1925.

 3. *Recherches sur les Cambodgiens*, Paris, 1921.

 4. *Praḥ Khan: Objets rituels en bronze*, A. A. K., I, 1921, 1923.

 5. *Étude sur la psychologie de l'artisan cambodgien*, A. A. K., I, 1922—23.

 6. *L'Art hindou au Cambodge: Le Buddha Khmèr: Asram Maha Rosei*, A. A. K., II, 1925.

 7. *Introduction à l'étude des arts khmèrs*, A. A. K., II, 1925.

 8. *La sculpture khmère*, Paris, 1925.

 9. *La Femme dans la sculpture khmère ancienne*, Revue des Arts asiatiques, II, 1, 1925.

Grünwedel, A., 1. *Buddhist art in India*, English edition, London, 1901. (= *Buddhistische Kunst in Indien*, 2nd ed., Berlin, 1919.)

 2. *Mythologie des Buddhismus in Tibet und der Mongolei*, Leipzig, 1900.

 3. *Bericht über arch. Arbeiten in Idykutschari . . . 1902—03*. Abh. K. bair. Ak. Wiss., München, 1906.

 4. *Altbuddhistische Kultstätten in Chinesisch-Turkestan*, Berlin, 1912.

 5. *Alt-Kutscha . . .*, Berlin, 1920.

 6. *Padmasambhava und Verwandtes*, Baessler Archiv, III, 1, 1912.

 7. *Tāranātha's Edelsteinmine*, Petrograd 1914.

Guleri, C., *A signed Molārām*, Rūpam, 2, 1920.

Gupta, S. N., *Catalogue of paintings in the Central Museum Lahore*, Calcutta, 1922.

Hackin, J., *Guide Catalogue du Musée Guimet, Collections bouddhiques*, Paris, 1923.

Hadaway, S., 1. *Cotton painting and printing in the Madras Presidency*, Madras, 1911.

 2. *Some Hindu "Silpa" Shastras . . .*, O. Z., III, 1914.

 3. *Note on a dated Nataraja from Belur*, Rūpam, 10, 1922.

 4. *Notes on two Jaina metal images*, Rūpam, 17, 1924.

 5. *Notes on the composition of Nataraja images*, Rūpam, 9, 1922.

Haldar, A. K., 1. *The paintings of the Bagh caves*, Rūpam, No. 8, 1921.

 2. *The Buddhist caves of Bagh*, Burlington Magazine, 1910—11.

Hargreaves, H., 1. *Excavations at Takht-i-Bāhī*, A. S. I., A. R., 1910—11.

 2. *Excavations at Sārnāth*, A. S. I., A. R., 1914—15.

 3. *Monolithic temples of Masrur*, A. S. I., A. R., 1915—16.

Harvey, G. E., *History of Burma*, London, 1925.

Havell, E. B., 1. *Benares, the sacred city* (various editions).

 2. *Indian sculpture and painting*, London, 1908.

 3. *Indian architecture: its psychology, structure and history*, London, 1913.

 4. *Ancient and mediaeval architecture of India*, London, 1915.

 5. *Handbook of Indian art*, London, 1920.

 6. *The Himalayas in Indian art*, London, 1924.

 7. *The ideals of Indian art*, London, 1911.

Hayden, H. H., *Notes on some monuments in Afghanistan*, Mem. As. Soc. Bengal, XI, 1, pp. 841—6, Calcutta, 1910.

Heine-Geldern, R., *Altjavanische Bronzen . . .*, Wien, 1925.

Herringham, Lady, see India Society, 2.

Hoenig, H., *Das Formproblem des Borobudur*, Batavia, 1924.

Hopkins, E. W., *Epic mythology*, Gr. i-a. Ph. A., III, I, B, 1915.

Hornell, J., 1. *The sacred chank of India*, Madras, 1914.

 2. *The origins and ethnological significance of Indian boat designs*, Mem. A. S. B., VII, 1920.

Hoever, O., *Indische Kunst*, Breslau, 1923.

Hüttemann, W., *Miniaturen zum Jinacarita*, Bässler-Archiv, 1914, pp. 47—77.

Imperial Gazetteer of India.

I Tsing, see Takakusu.

India Society, 1. *Eleven plates . . . Indian sculpture*, London (1911).

 2. *Ajanta frescoes*, London, 1915.

 3. *Examples of Indian sculpture at the British Museum*, London (1923).

 4. *The influences of Indian art*, London, 1925.

 (other publications listed under author's names.)

Jackson, V. H., 1. *Notes on Old Rajagriha*, A. S. I., A. R., 1913—1914.

 2. *Notes on the Barabar hills*, J. B. O. R. S., XII, 1926.

Jasper, J. E., en Pirngadie, M., *De inlandsche Kunstnijverheid in nederlandsche Indie*, The Hague, 1912.

Jayaswal, K. P., 1. *Statues of two Saisunaka emperors*, J. B. O. R. S., V., 1919.

 2. *Another Saisunaka statue*, J. B. O. R. S., V, 1919.

 3. *A Hindu text on painting*, J. B. O. R. S., IX, 1923.

Joseph, G. A., *Buddhist fresco at Hindagala near Kandy*, Ceylon Administration Reports for 1918, Colombo Museum Report, Colombo, 1919.

Jouveau-Dubreuil, 1. *Archéologie du Sud de l'Inde*, 2 vols. Paris, 1914.

 2. *Pallava Antiquities*, Pondicherry, 1916—18.

 3. *The Pallava Painting*, Pudukoṭṭai, 1920.

 4. *Vedic Antiquities*, Pondicherry and London, 1922.

 5. *The Pallavas*, Pondicherry, 1917.

 6. *Ancient history of the Deccan*, Pondicherry, 1920.

 7. *La Tholos aryenne du Malabar*, J. R. A. S., 1926, p. 715.

Juynboll, H. H., 1. *Farbenzeichnungen aus altjavanischen Schriften*, Int. Archiv f. Ethnographie, XXX, 1, Leiden 1925.

 2. *Katalog des ethn. Reichsmuseums*, Leiden, 17 vols., 1910—24.

 3. See Rouffaer and Juynboll.

Kak, R. C., 1. *Handbook of the archaeological and numismatic sections of the Sri Partap Singh Museum*, Srinagar, London, 1923.

 2. *Antitiquies of Marev-Wadhwan*, Mem. A. S. Kaśmīr, 1924.

 3. *Cock-fighting in ancient India*, Illustrated London News, Dec. 12, 1925.

 4. *Ancient and mediaeval architecture of Kashmir*, Rūpam, No. 24, 1925.

 5. *Antiquities of Bhimbar and Rajauri*, Mem. A. S. I., No. 14, 1923.

Kanakasabhai, V., *The Tamils eighteen hundred years ago*, Madras, 1904.

Kats, J., 1. *Het Javaansche Tooneel, I. Waiang Poerwa*, Weltevreden, 1923.

 2. *Djaja Semadi and Sri Soewela*, Weltevreden, (1924).

 3. *Het Rāmāyana op Javaansche tempel-reliefs*, Weltevreden (1925).

Kavi, Lallū Lal, *Prema-sagara*, trans. P. Pincott, London, 1897.

Kern, H., 1. *Manual of Indian Buddhism*, Gr. i-a. Ph. A., Strassburg, 1896.

 2. *Verspreide Geschriften*, The Hague, 1917—1925 (includes the next item).

Kern, H., and Krom, N. J., *Het oud-Javaansche Lofdicht Nāgarakertāgama*, The Hague, 1919.

Kersjes, B., en Hamer, C., *De Tjandi Mendoet voor de Restauratie*, Batavia, 1923.

Kleen, T. de, *Mudras: the ritual hand poses . . . of Bali*, London and New York, 1924.

Ko, Taw Sein, 1. *Plaques found at the Petleik Pagoda, Pagan*, A. S. I., A. R., 1906—07.

 2. *Archaeological notes on Pagan*, Rangoon, 1917.

 3. *The Mandalay palace*, A. S. I., A. R., 1907—08.

Ko, Taw Sein, 4. *The Sang yaung monasteries of Amarapura*, A. S. I., A. R., 1914—15.

 5. *Archaeological notes on Mandalay*, Rangoon, 1924.

Konow, S., 1. *Notes on the use of images in ancient India*, I. A., XXXVIII, 1909.

 2. *Aryan gods of the Mitani people*, Kristiania, 1921.

 3. *The inscription on the so-called Bodh-Gayā plaque*, J. B. O. R. S., XII, 1926.

See also Marshall and Konow.

Kramrisch, S., 1. *The Vishnudharmottaram, pt. III, a treatise on Indian Painting*, Calcutta, 1924.

 2. *Grundzüge der indischen Kunst*, Hellerau, n. d. (1924).

Krom, N. J., 1. *De Buddhistische bronzen in het Museum te Batavia*, O. D. Rapp, 1912.

 2. *Inleiding tot de Hindoe-Javaansche Kunst*, The Hague, 1920.

 3. *Het oude Java en zijn Kunst*, Haarlem, 1923.

 4. *L'Art javanais dans les Musées de Hollande et de Java*, Ars Asiatica, VIII, 1926.

 5. *The life of Buddha, on the stūpa of Barabudur*, The Hague, 1926.

Krom, N. J., and Erp, T. van, *Beschrijving van Barabudur*, The Hague, 1920.

Kühnel, E., u. Goetz, H., *Indische Buchmalereien*, Berlin, (1924).

Kumāra, Śrī, *Śilparatna*, ed. Sastri, T. G., Trivandrum, 1922. (See Coomaraswamy, 13 and Jayaswal, 3).

Lajonquière, L. de, *Essai d'inventaire archéologique du Siam*, B. C. A. I., 1912.

La Roche, E., *Indische Baukunst*, 6 Bde., München, 1921—22.

Le Coq, A. von, 1. *Chotscho*, Berlin, 1913.

 2. *Die buddhistische Spätantike von Mittelasien; I—IV*, Berlin, 1922—24.

 3. *Bilderatlas zur Kunst- und Kulturgeschichte Mittelasiens*, Berlin, 1925.

Legge, J., *A record of Buddhistic kingdoms . . . Fā Hien . . . travels in India and Ceylon* (A. D. 339—414), Oxford, 1886.

Lelyveld, Th. B. van, *De javaansche Danskunst*, Weltevreden, 1922.

le May, R. S., *A visit to Sawankalok*, J. S. S., XIX, 2, 1925.

Leuba, J. (Madame H. Parmentier), *Les Chams et leur art*, Paris and Brussels, 1923.

Lévi, S., 1. *Le théâtre indien*, Paris, 1890.

 2. *Le Nepal*, Paris, 1905—08.

 3. *Pré-aryen et pré-dravidien dans l'Inde*, J. A., CCIII, I, 1923.

 4. *The art of Nepal*, Indian art and Letters 1, 2, London, 1925.

Loebèr, J. A., *Das Batiken. Eine Blüte indonesischen Kunstlebens*, Oldenburg, 1926.

Logan, W., 1. *Find of ancient pottery in Malabar*, I. A., VIII.

 2. *Malabar*, Madras, 1887.

Longhurst, A. H., 1. *Ancient brick temples in the Central Provinces*, A. S. I., A. R., 1909—10.

 2. *Hampi ruins*, Madras, 1917.

 3. *Pallava architecture*, I., Mem. A. S. I., 17, Calcutta, 1924.

 4. *The origin of the typical Hindu temple of Southern India*, A. S. I., Southern Circle, Annual Report 1915—16.

 5. *Rock-cut tomb near Calicut*, A. S. I., A. R., 1911—12.

 6. *Influence of the umbrella on Indian architecture*, J. I. A., vol. XVI, 1914.

Luard, C. E., 1. *Tattooing in Central India*, I. A., XXIII, 1904.

 2. *Buddhist caves of Central India: Bagh*, I. A., Aug. 1910.

Macdonell, A. A., 1. *Vedic mythology*, Gr. i-a. Ph. A., III, I, A, 1897.

 2. *Early Hindu iconography*, J. R. A. S., 1917, p. 602.

 3. *The development of early Hindu iconography*, in Festschrift Ernst Windisch.

 4. *The history of Hindu iconography*, Rūpam, no. 4, 1920.

Mackay, E., *Sumerian connections with ancient India*, J. R. A. S., 1925.

Maisey, F. C., *Sanchi and its remains*, London, 1892.

Marshall, Sir J. H., 1. *Rajagriha and its remains*, A. S. I., A. R., 1904—05.
 2. *Excavations at Saheth Maheth*, A. S. I., A. R., 1910—11.
 3. *Excavations at Bhītā*, A. S. I., A. R., 1911—12.
 4. *The monuments of Sānchī*, A. S. I., A. R., 1913—14.
 5. *Guide to Sānchī*, Calcutta, 1918.
 6. *Guide to Taxila*, Calcutta, 1918.
 7. *Excavations at Taxila, the Stūpa and Monastery at Jauliāñ*, Mem. A. S. I., 7, 1921.
 8. *The monuments of ancient India*, in Cambridge History of India, vol. 1, Cambridge, 1922.
 9. *First light on a long-forgotten civilization*, Ill. London News, Sept. 20, 1924.
 10. *The influence of race on early Indian art*, Rūpam, 18, 1924.
 11. *Buddhist gold jewellery*, A. S. I., A. R., 1902—03.
 12. *Unveiling the prehistoric civilization of India*, Illustrated London News, Feb. 27 and March 6, 1926.
 13. *Excavations at Taxila*, A. S. I., A. R., 1915—16.
Marshall, Sir J. H. (editor), *Catalogue of the Museum of Archaeology at Sanchi*, Calcutta, 1922.
Marshall, Sir J. H., and Konow, S., *Excavations at Sārnāth*, A. S. I., A. R., 1907—08.
Marshall, Sir J. H., and Sahni, D. R., *Excavations at Maṇḍor*, A. S. I., A. R., 1909—10.
Marshall, Sir J. H., and Vogel, J. Ph., *Excavations at Chārsada*, A. S. I., A. R., 1902—03.
Martin, H., *L'art indien et l'art chinois*, Paris, 1926.
Masson-Oursel, P., *Une connexion dans l'Esthetique et la Philosophie de l'Inde. La Notion de Pramāna*, Revue des Arts asiatiques, II, 1, 1925.
Mayamuni, *Mayamatam*, Trivandrum Sanskrit series, no. 65.
Mehta, N. C., 1. *Indian painting in the fifteenth century*, Rūpam, 22—23, 1925.
 2. *Two Pahari painters of Tehri-Garhwal: Mānaku and Chaitu*, Rūpam, 26, 1926.
 3. *Studies in Indian painting*, Bombay, 1926.
Melville, H. H. L., Knebel, J., and Brandes, J. L. A., 1. *Beschrijving van . . . Tjandi Djago*, Arch. Onderzoek op Java en Madoera, I. The Hague, 1904.
 2. *Beschrijving van Tjandi Singasari en . . Panataran*, Arch. Onderzoek op Java en Madoera, II, The Hague, 1909.
Mitra, P., 1. *Prehistoric cultures and races of India*, Calc. Univ. Journ. Dep. Letters, I, 1920, pp. 113—200.
 2. *Prehistoric arts and crafts of India*, ibid. III, 1920, pp. 159—224.
Mitra, Rajendralal, *Buddha Gayā*, Calcutta, 1878.
Mookerji, N. B., *A history of Indian shipping and maritime activity*, London, 1912.
de Morgan, J., 1. *L'Égypte et l'Asie aux temps antéhistoriques*, J. A., CCIII, 1923.
 2. *La préhistoire orientale*, Vols 1 and 2, Paris, 1925—26.
Morin-Jean, *Dessin des animaux en Grèce d'après les vases peints*, Paris, 1911.
Mukerji, P. C., 1. *Report on the antiquities of the District of Lalitpur*, N. W. P., Roorkee, 1899.
 2. *Report on the results of exploration in the Nepal Tarai*, Calcutta, 1901.
Mukharji, T. N., *Art manufactures of India*, Calcutta, 1888.
Narasimachar, R., 1. *The Keśava temple at Somanathapur*, M. A. S., I, Bangalore, 1917.
 2. *The Keśava temple at Belur*, M. A. S., II., Bangalore, 1919.
 3. *The Lakshmīdevī temple at Dodda Goddavalli*, M. A. S., III, Bangalore, 1919.
 4. *Inscriptions at Sravana Belgola*, Epigraphica Carnatica, II, 2nd ed., Bangalore, 1923.
Neogi, P., *Iron in ancient India*, Calcutta, 1914.
Niedermayer, O. von, *Afganistan*, Leipzig, 1925.
Nieuwenkamp, W. O. J., *Kunstwerke von Java . . . Bali* . etc., Berlin, 1924.
Oertel, F. O., *Excavations at Sārnāth*, A. S. I., A. R., 1904—05.
Okakura, K., *Ideals of the East*, 2nd ed., London, 1904.
Parker, H., 1. *Report on archaeological discoveries at Tissamahārāma*, J. R. A. S., Ceylon Branch, Vol. VIII, no. 27, 1884.

Parker, H., 2. *Ancient Ceylon*, London, 1909.

Parmentier, H., 1. *Les monuments du cirque de Mison*, B. É. F. E. O., 1904.

2. *Catalogue du Musée Khmère de Phnom Peñ*, B. É. F. E. O., 1912.

3. *Inventaire descriptif des monuments Čams de l'Annam*, Paris, 1909 and 1918.

4. *L'Art d'Indravarman*, B. É. F. E. O., 1919.

5. *Les sculptures chames au Musée de Tourane*, Ars Asiatica, IV, 1922.

6. *Architectures asiatiques*, Études asiatiques, vol. II, Paris, 1925.

7. *L'art khmēr primitif*, B. É. F. E. O., XI, XXII.

Pelliot, P., 1. *Mémoires sur les coutumes du Cambodge*, B. É. F. E. O., II, 1902.

2. *Indian influences in the early Chinese art in Tun-Huang*, Journ. Ind. Art and Letters, II, 1926.

Peppé, W. C., and Smith, V. A., *The Piprāhwā stūpa containing relics of Buddha*, J. R. A. S., 1898.

Perera, E. W., *Singhalese banners and standards*, Mem. Colombo Museum, 2, Colombo, 1915.

Pieris, P. E., *Nāgadīpa and Buddhist remains in Jaffna*, J. C. B. R. A. S., XXVII, No. 72, 1919.

Pleyte, C. M., *Indonesian art*, The Hague, 1901.

Przyluski, J., *La légende de l'Empereur Açoka*, Paris (Musée Guimet), 1923.

Pullé, *Riflessi indiani nell'arte romaica*, Atti del Congr. internat. di Scienze storiche, VII, Rome, 1903.

Ram Raz, *Essay on the architecture of the Hindus*, London, 1834.

Rao, T. A. G., 1. *Elements of Hindu Iconography*, Madras, 1914—15.

2. *Buddha vestiges in Kanchipura*, I. A., XLIV, 1915.

3. *Talamana, or iconometry*, Mem. A. S. I., 3, Calcutta, 1920.

Rapson, E. J., 1. *Indian coins*, Gr. i-a. Ph., A., Strassburg, 1898.

2. editor, *Cambridge History of India*, Cambridge, 1922.

Rawlinson, H., *Bactria; from the earliest times to the extinction of Bactrio-Greek rule in the Panjab*, Bombay, 1909.

Rea, A., 1. *A Buddhist monastery in the Sankaram hills*, Vizagapatam District, A. S. I., A. R., 1907—08.

2. *South Indian Buddhist Antiquities . . . Bhaṭṭiprolu, Guḍivada and Ghaṇṭasala . . .*, Madras, 1894.

3. *Chalukyan architecture*, A. S. I., Madras, 1896.

4. *Excavations at Amarāvatī*, A. S. I., A. R., 1905—06 and 1908—09.

5. *Pallava architecture*, A. S. I., Madras, 1909.

6. *Buddhist monasteries on the Gurubhaktakoṇḍa and Durgākoṇḍa hills at Rāmatirtham*, A. S. I., A. R., 1910—11.

Rivoira, R., *Architectura musulmana*, Milano, 1914.

Rodin, A., Coomaraswamy, A., and Goloubew, V., *Sculptures Çivaites*, Ars Asiatica, III, Paris and Brussels, 1921.

Rostovtzeff, M., *Iranians and Greeks in South Russia*, Oxford, 1922.

Rouffaer, G. P., and Juynboll, H. H., *Die indische Batikkunst und ihre Geschichte*, Haarlem, 1901—05.

Rougier, V., *Nouvelles découvertes čames au Quang Nam*, B. C. A. I., 1912.

Sachs, C., *Die Musikinstrumente Indiens und Indonesiens*, 2nd ed., Berlin, 1923.

Sahni, D. R., 1. *Excavations at Rāmpurvā*, A. S. I., A. R., 1907—08.

2. *Excavations at Avantipura*, A. S. I., A. R., 1913—14.

3. *Pre-Muhammadan monuments of Kashmir*, A. S. I., A. R., 1915—16.

4. *Buddhist image inscription from Śrāvastī*, A. S. I., A. R., 1908—09.

5. *Guide to the Buddhist ruins of Sārnāth*, Simla, 1923.

Sahni, D. R., and Vogel, J. Ph., *Catalogue of the Museum of Archaeology at Sārnāth*, Calcutta, 1914.

Salmony, A., 1. *Sculpture in Siam*, London, 1925.

2. *Die Plastik des hinterindischen Kunstkreises*, Jahrb. as. Kunst, I, 1924.

Sanderson, G., and Begg, T., *Types of modern Indian building*, Allahābād, 1913.

Sarkar, G., 1. *Notes on the history of Shikhara temples*, Rūpam, 10, 1922.

Sarkar, G., 2. *The Barnagar temples in Murshidabad*, Rūpam, 19—20, 1924.

Sarre, F., *Kunst des alten Persien*, Berlin, 1923.

Sastri, H., 1. *Excavations at Kasiā*, A. S. I., A. R., 1911—12.

 2. *The "Hamir Hath", or the Obstinacy of Hamir* . . ., Journ. Ind. Art., XVII, 1916.

 3. *. . . recently added sculptures in the Provincial Museum, Lucknow*, Mem. A. S. I., 11, 1926.

Sastri, H. K., 1. *South Indian images of gods and goddes*, Madras, 1916.

 2. *Two statues of Pallava Kings . . . at Mahabalipuram*, Mem. A. S. I., 26, Calcutta, 1926.

Saunders, V., *Portrait painting as a dramatic device in Sanskrit plays*, J. A. O. S., vol. 39

Sayce, A. H., *The Hittites*, London, 1925.

Scherman, L., *Dickbauchtypen in der indisch-ostasiatischen Götterwelt*, Jahrb. as. Kunst, 1, 1924.

Schiefner, F. A. von, 1. *Tibetan tales derived from Indian sources, from the Kahgyur*, trans. by Ralston, 2 nd. ed., London, 1882.

 2. *Tāranātha's Geschichte des Buddhismus in Indien . . .*, St. Petersburg, 1869.

Schmidt, R., 1. *Beiträge zur indischen Erotik*, 6. Aufl., Berlin, 1902.

 2. *Das Kāmasūtram des Vatsyāyana*, 6. Aufl., Berlin, 1920.

Schoemaker, C. P. W., *Aesthetik en Oorsprong der Hindoe-kunst op Java*, Soerabaia, 1924.

Seidenfaden, E., *Complément à l'inventaire des monuments du Cambodge pour les quatre provinces du Siam oriental*, B. É. F. E. O., 1923.

Seidenstücker, K., *Die Buddha-Legende in den Skulpturen des Ananda-Tempels zu Pagan*, Mitt. Mus. Völkerkunde, IV, Hamburg, 1916.

Sen, D. C., *History of Bengali language and literature*, Calcutta, 1911.

Serrurier, S., *De Wajang-Poerwa*, Leiden, 1896.

Sewell, A., *A forgotten Empire (Vijayanagar)*, London, 1900

Sewell, R., 1. *Buddhist remains at Guṇṭupalle*, J. R. A. S., 1887.

 2. *Some Buddhist bronzes and relics of Buddha*, J. R. A. S., 1895.

Shuttleworth, H. L. H., *An inscribed metal mask discovered on the occassion of the Bhunda Ceremony at Nirmand*. Acta orientalia: vol. I. P. IV. pp. 224—229, Leiden 1923.

Silice, A., et Groslier, G., *La céramique dans l'ancien Cambodge*, A. A. K., 2, I, 1924.

Simpson, W., 1. *Indian Architecture*, Trans. Roy. Inst. British Architects, 1861—62, pp. 165—78.

 2. *Buddhist Architecture: Jallalabad*, Ibid. 1879—80, pp. 37—64.

 3. *Origin and mutation in Indian and Eastern Architecture*, Ibid. 1891, pp. 225—76.

 4. *Classical influence in the Architecture of the Indus region and Afghanistan*, Jour. Roy. Inst. British Architects, I, 1894, pp. 93 ff., 191 ff.

 5. *The Buddhist Caves of Afghanistan*, J. R. A. S., 1882, pp. 319—331.

 6. *Some suggestions of origin in Indian Architecture*. Ibid. 1888, pp. 49—71.

Sirén, O., 1. *Chinese sculpture from the fifth to the fourteenth century*, London 1925.

 2. *Documents d'art chinois . . .*, Ars asiatica, VII.

Smith, G. E., *Elephants and ethnologists*, New York, 1925.

Smith, V. A., 1. *The Jain stūpa and other antiquities of Mathurā*, Allahābād, 1901.

 2. *History of Fine Art in India and Ceylon*, Oxford, 1911.

 3. *Oxford history of India*, Oxford, 1920.

 4. *Early history of India*, 4th ed., Oxford, 1924.

 5. *The monolithic pillars or columns of Asoka*, Z. D. M. G., LXV, 1911.

 6. *Catalogue of the coins in the Indian Museum, Calcutta*, vol. I, London, 1906.

 7. *Sculpture of Ceylon*, J. I. A., 1914.

Smith V. A., and Hoey, W., *Ancient Buddhist statuettes from the Bāndā District*, J. A. S. B., 64, 1895.

Smith, V. A., and Peppé, see Peppé.

Smither, J. G., *Architectural remains, Anuradhapura, Ceylon*, London 1894.

Sohrmann, H., *Die altindische Säule*, Dresden, 1906.

Spooner, D. B., 1. *Excavations at Takht-i-Bāhi*, A. S. I., A. R., 1907—08.

 2. *Excavations at Shāh-jī-kī-Dherī*, A. S. I., A. R., 1908—09.

 3. *Excavations at Sāhri Bahlol*, A. S. I., A. R., 1909—10.

 4. *Dīdarganj image now in Patna Museum*, Journ. Bihar and Orissa Research Soc. V, I, 1919.

 5. *Handbook to the Sculptures in the Peshawar Museum*, Bombay, 1910.

 6. *Vishnu images from Rangpur*, A. S. I., A. R., 1911—12.

 7. *Mr. Ratan Tata's excavations at Pāṭaliputra*, A. S. I., A. R., 1912—13.

 8. *Excavations at Basāṛh*, A. S. I., A. R., 1913—14.

 9. *A new find of punch-marked coins*, A. S. I., A. R., 1905—06.

 10. *(Terracottas from Pāṭaliputra and bronzes from Nālandā)*, A. S. I., A. R., 1917—18, pt. 1.

 11. *The Zoroastrian period of Indian history*, J. R. A. S., 1915.

 12. *The Bodh Gayā plaque*, J. B. O. R. S., I, 1916. (For further discussion and illustration by Smith, Spooner and Konow, see *ibid.* II, 1916 and XII, 1926.)

 13. *Temple types in Tirhut*, J. B. O. R. S., II, 1916.

Śrī Kumāra, *Śilparatna*, ed. H. Sastri, Trivandrum Sanskrit Series, 1922.

Stein, M. A., 1. *Zoroastrian deities on Indo-Scythian coins*, I. A., vol. XVII, 1888.

 2. *Rājataraṅgiṇī of Kalhaṇa*, London, 1900.

 3. *Sand-burned ruins of Khotan*, London, 1903.

 4. *Ancient Khotan*, London, 1907.

 5. *Excavations at Sahrī-Bahlol*, A. S. I., A. R., 1911—12.

 6. *Ruins of Desert Cathay*, London, 1912.

 7. *Serindia*, London, 1921.

Stein, M.A., and Binyon, L., *Ancient Buddhist paintings from the caves of the Thousand Buddhas* (Tun Huang) . , London, 1921.

Strzygowski, J., 1. *Orient oder Rom*, Leipzig, 1901.

 2. *Altai-Iran und Völkerwanderung*, Leipzig, 1917.

 3. *Origins of Christian church art*, Oxford, 1923.

 4. *Perso-Indian landscape in northern art* in "The influences of Indian art", India Soc., London, 1925.

 5. *Die asiatische Kunst*, Jahrb. as. Kunst, 1924.

 6. *The northern stream of art, from Ireland to China, and the southern stream*, Yearb. Or. Art, 1925.

Stutterheim, W., 1. *Rama-Legenden und Rama-Reliefs in Indonesien*, München, 1924—25.

 2. *Een belangrijke Hindoe-Javaansche Teekening op Koper*, Djawa, October, 1925.

Śukrācārya, *Śukra-nīti-sāra*, ed. Calcutta 1890; trans. S. B. H., vol. XIII (inadequate), Ch. IV, rec. IV.

Swarup, B., *Konarka, the Black Pagoda of Orissa*, Cuttack, 1910.

Tagore, A. N., 1. *L'Alpona, ou les Decorations rituelles au Bengale*, Paris, 1921.

 2. *Sadanga, ou les six canons de la Peinture hindoue*, Paris, 1922.

Takakusu, J., *A record of the Buddhist religion as practised in India, and the Malay Archipelago* (A.D. 671—695), by I-Tsing, Oxford, 1895.

Taki, S., *An example of the earliest Indian painting*, Kokka, No. 355, 1919.

Talbot, W. S., *An ancient Hindu temple in the Panjab*, J. R. A. S., 1903.

Tāranātha, see Schiefner, 2.

Theobald, W., *Notes on . . . symbols found on the punch-marked coins of Hindustan . . .*, J. A. S. B., LIX, pt. 1, 1890.

Thomann, Th. H., *Pagan, ein Jahrtausend buddhistischer Tempelkunst*, Heilbronn, 1923.

Thomson, D. V., *Preliminary notes on some early Hindu paintings*, Rūpam, 26, 1926.

Turnour, G., and Wijesinha, L. C., *The Mahavansa*, Colombo, 1889.

Vajhe (Vaze), K. V., *Pracīn Hindī Śilpa-śāstra-sāra*, Nāsik, 1924.

Venkatasubbiah, A., *The Kalās*, Madras, 1914.

Verneuil, M. P., *L'art à Java. Les temples de la période classique Indo-Javanaise.* (Announced.)

Viṣṇudharmottaram (text), Bombay, 1912.

Visser, H. F. E., *Indian influence on Far Eastern art*, in "The influences of Indian art", India Soc., London, 1925.

Vogel, J. Ph., 1. *Inscriptions of Chambā State*, A. S. I., A. R., 1902—03.
 2. *Buddhist sculptures from Benares*, A. S. I., A. R., 1903—04.
 3. *Inscribed Gandhāra sculpture*, A. S. I., A. R., 1903—04.
 4. *Inscribed brass statuette from Fatehpur (Kāṅgrā)*, A. S. I., A. R., 1904—05.
 5. *Notes on excavations at Kasiā*, A. S. I., A. R., 1904—05 and 1905—06.
 6. *The Mathurā school of sculpture*, A. S. I., A. R., 1906—07 and 1909—10.
 7. *Excavations at Saheṭh-Maheṭh*, A. S. I., A. R., 1907—08.
 8. *The temple of Bhitargaon*, A. S. I., A. R., 1908—09.
 9. *The Garuda pillar at Besnagar*, A. S. I., A. R., 1908—09.
 10. *Nāga worship in ancient Mathurā*, A. S. I., A. R., 1908—09.
 11. *The temple of Mahādeva at Baiaurā, Kuḷū*, A. S. I., A. R., 1909—10.
 12. *Catalogue of the Bhuri Singh Museum at Chambā*, Calcutta, 1909.
 13. *Catalogue of the Archaeological Museum at Mathurā*, Allahabad, 1910.
 14. *Iconographical notes on the "Seven Pagodas"*, A. S. I., A. R., 1910—11.
 15. *Explorations at Mathurā*, A. S. I., A. R., 1911—12.
 16. *The sacrificial posts of Īsāpur, Muttra*, A. S. I., A. R., 1910—11.
 17. *Facts and fancies about the Iron Pillar of Old Delhi*, Journ. Panjab Hist. Soc., IX, 1923.
 18. *Gaṅgā et Yamunā dans l'iconographie bouddhique*, Études asiatiques, Paris, 1925.
 19. *Note on the Nirmand mask inscriptions*, Acta orientalia, Vol. I.
 20. *The relation between the art of India and Java*, in "The influences of Indian art", India Soc., London, 1925.
 21. *Antiquities of Chambā*.
 22. *Ancient monuments of Kāṅgrā . . .*, A. S. I., A. R., 1905—06.

Vogel, J. Ph., and Sahni, D. R., *Catalogue of the Museum of Archaeology at Sārnāth*, Calcutta, 1914.

Voretsch, E. A., 1. *Über altbuddhistische Kunst in Siam*, O. Z., V and VI, 1916—17.
 2. *Indian art in Siam*, Rūpam, 1920.

Vredenberg, E., *The continuity of pictorial tradition in the art of India*, Rūpam, 1920.

Waddell, L. A., 1. *The Indian Buddhist cult of Avalokita . . . remains in Magadha*, J. R. A. S., 1894.
 2. *Evolution of the Buddhist cult, its gods, images and art*, Imp. and Asiatic Quart. Review, 1912.
 3. *Buddha's diadem, or "Usnisa" . . .*, O. Z. III., 1915.
 4. *Indo-Sumerian seals deciphered*, London, 1925.
 5. *Report on excavations at Pāṭaliputra*, Calcutta, 1903.

Waldschmidt, G., *Gandhara-Kutschā-Turfan*, Leipzig (1925).

Waley, A., *Zen Buddhism, and its relation to art*, London, 1922.

Walsh, E. H. C., *Indian punch-marked coins*, J. R. A. S., Centenary Volume, London, 1924.

Warner, Langdon, *Japanese sculpture of the Suiko period*, New Haven, 1923.

Watt, Sir G., *Indian art at Delhi, 1903*, Calcutta, 1904.

Weber, O., *Ein silberner Zeptergriff aus Syrien*, Jahrb. K. preuß. Kunsts., 1915, p. 59.

Weber, W., *Der Siegeszug des Griechentums im Orient*, Die Antike I, 1925.

Whitehead, R. B., 1. *The village gods of Southern India*, London and Calcutta, 1916.
 2. *Catalogue of the coins in the Panjab Museum, Lahore*, Oxford 1914.

With, K., 1. *Java: brahmanische, buddhistische und eigenlebige Architektur und Plastik auf Java*, Hagen, 1920.
 2. *Bildwerke Ost- und Südasiens aus der Sammlung Yi Yuan*, Basel, 1924.

With, K., 3. *Javanische Kleinbronzen*, in "Studien zur Kunst des Ostens" Josef Strzygowski
 gewidmet, Wien (1923).
Yazdani, G., *The temples of Palampet*, Mem. A. S. I., 6, 1922.
Yzerman, J. W., *De Chalukyasche bouwstijl op den Diëng*, Album Kern, Leiden, 1903, pp. 287ff.
Zimmer, H., *Kunstform und Yoga im indischen Kunstbild*, Berlin, 1926.

JOURNALS AND SERIES, WITH LIST OF ABBREVIATIONS.

Acta orientalia, Leiden
Archaeological Survey of Ceylon, Annual Reports, Colombo (A. S. C., A. R.).
— Memoirs, Colombo (Mem. A. S. C.).
Archaeological Survey of India (A. S. I.).
— Annual Reports (A. S. I., A. R.) Calcutta. Note that references are to Part 11 unless
 otherwise stated. After the year 1919 only one part was issued.
— Memoirs (Mem. A. S. I.).
Archaeological Survey of Kaśmīr (A. S. K.).
Ars Asiatica, Paris.
Artibus Asiae, Hellerau-Dresden.
Arts et Archéologie khmèrs, Paris (A. A. K.).
Asia Major, Leipzig.
Bibliotheca Indica, Calcutta.
Bulletin of the Museum of Fine Arts in Boston (M. F. A. Bull.).
Bulletin de l'École française d'Extrême-Orient, Hanoi (B. É. F. E. O.).
Bulletin de la Commission archéologique de l'Indo-Chine, Paris (B. C. A. I.).
Bulletin of the School of Oriental Studies, London (B. S. O. S.).
Calcutta University, Journal of the Department of Letters.
Cambridge History of India (C. H. I.).
Ceylon Journal of Science (C. J. S.).
Columbia University, Indo-Iranian Series.
Epigraphia Indica (Ep. Ind.).
Epigraphia Zeylanica (Ep. Zey.).
Grundriss der indo-arischen Philologie und Altertumskunde, Strassburg and Berlin (Gr. i-a.
 Ph. A.).
Harvard Oriental Series (H. O. S.).
Indian Antiquary (I. A.).
Indian Art and Letters, London (I. A. L.).
Indian Historical Quarterly (I. H. Q.).
Jahrbuch der asiatischen Kunst, Leipzig (Jahrb. as. Kunst).
Journal asiatique, Paris (J. A.).
Journal of Indian Art and Industry, London (J. I. A.).
Journal of the Bihar and Orissa Research Society, Patna (J. B. O. R. S.).
Journal of the Royal Asiatic Society, London (J. R. A. S.).
Journal of the Royal Asiatic Society, Ceylon Branch (J. C. B. R. A. S.).
Journal of the Asiatic Society, Bengal (J. A. S. B.); Memoirs, do. (Mem. A. S. B.).
Journal of the Panjab Historical Society Lahore (J. P. H. S.).
Journal of the Siam Society, Bangkok, (J. S. S.).
Mémoires archéologiques publiées par l'École Française d'Extrême-Orient (Mem. arch.
 É. F. E. O.).
Mémoires concernant l'Asie orientale, Paris (M. C. A. O.).

Memoirs of the Colombo Museum (Mem. C. M).
Mysore Archaeological Series (M. A. S.).
Ostasiatische Zeitschrift (O. Z.).
Oudheidkundige Dienst in Nederlandsch-Indië: Rapporten, Batavia (O. D. Rapp.).
Revue des Arts Asiatiques, Paris (R. A. A.).
Rūpam, Calcutta.
Tijdschrift voor Indische Taal-, Land- en Volkenkunde, K. Bataviaasch Genootschap van
 Kunsten en Wetenschapen, Weltevreden (Verh. Bat. Kunst en Wet.).
Yearbook of Oriental Art and Culture, London (Yearb. Or. Art).
Zeitschrift der Deutschen morgenländischen Gesellschaft, Leipzig (Z. D. M. G.).

INDICES AND BIBLIOGRAPHIES.

Archaeological Survey of India, Library of the Director General of Archaeology, author and
 subject indices, Calcutta, 1917.
Bulletin de l'École française d'Extrême-Orient, Index to Tomes I—XX, in Tome XXI, fas-
 cicule 2, 1921.
Cambridge History of India, vol. 1, 1922 (C. H. I.).
Coomaraswamy, A. K., *Bibliography of Indian art*, Boston, 1925.
— *Catalogue of the Indian Collections, Museum of Fine Arts, Boston*, pt. V, *Rajput Painting*, Boston
 1926, includes an almost exhaustive Bibliography of Indian painting, other than Mughal.
Ethnographische Museum, Leiden, *Katalog*, vol. 3, *Katalogus der Bibliothek*.
Guerinot, A., *Essai de Bibliographie Jaina*, Paris, 1906.
Hackin, J., *Guide Catalogue du Musée Guimet, Collections Bouddhiques*, Paris, 1923, pp. 119—127.
Indian Antiquary, Index, vols. I—L, Bombay, 1923.
Juynboll, H. H., *Katalog des ethn. Reichsmuseums, Leiden*, 17 vols., 1910—1924, esp. vol. V, Java.
Kaye, G. R., *Index to the Annual Reports, Archaeological Survey of India*, 1902—1916, Calcutta, 1924.
Museum of Fine Arts Bulletin, Boston, *General Index* 1916—1925, Boston 1926 (Indian Art,
 references on p. 7).
Royal Asiatic Society, London, Centenary Volume (author and subject indices), London, 1924.
Smith, V. A., *General Index to the Reports of the Archaeological Survey of India*, vols. I—XXIII,
 Calcutta, 1887.

DESCRIPTION OF THE PLATES[1]

PLATE I.
 1. Statue of a man, from Mohenjo-Daro. Limestone. Indo-Sumerian, third millennium B. C. See page 3.

PLATE II.
 2—6: Seals or plaques with various devices and pictographic script, from Mohenjo-Daro. Faience. Indo-Sumerian, third millennium B. C. See page 4.
 2. with humped Indian bull;
 3. with bull;
 4. with bull or "unicorn";
 5. with elephant;
 6. sacred tree (*pippala, Ficus religiosa*), with animal heads with long necks attached to the stem. See page 47 note 2.
 7. Four deer with one head, Ajaṇṭā, Cave 1, capital relief *in situ*. Early seventh century A. D. but a very ancient motif. See page 11.

PLATE III.
 8. Yakṣī, from Besnagar, now in the Indian Museum, Calcutta. Sandstone, 6' 7". Mauryan or older. See page 16.
 9. Yakṣa, from Pārkham, now C 1 in the Mathurā Museum. Polished sandstone, 8' 8". Maurya or older. See pages 5, 16.

PLATE IV.
 10. A banyan tree represented as a *kalpa-vṛkṣa* yielding abundance, enclosed by a plaited rail and rising from a square railed base, and probably the capital of a monolithic pillar. From Besnagar, now in the Indian Museum, Calcutta. Sandstone, 5' 8". Maurya or older. See pages 17, 41, 47.
 11. Elephant, monolithic, forming part of the rock at Dhauli, Kaṭak District, Oṛissa. The rock is engraved with one of Aśoka's Fourteen rock-edicts. Maurya, ca. 257 B. C.
 12. Lion-capital (originally surmounted by a Wheel of the Law [*Dhamma-cakka*], from the Aśoka column at Sārnāth, erected to commemorate the Preaching of the First Sermon, now A 1 in the Sārnāth Museum. Polished Chunār sandstone, 7' by 2' 10". Maurya, between 242 and 232 B. C. See page 17.
 13. Woman reclining, a man fanning her, relief from Bhīṭā. Sandstone. Maurya or Śuṅga. See page 20.
 14. Bull-capital of an Aśokan column, viz. one of the two erected at Rāmpurvā, Tirhūt, now in the Indian Musum, Calcutta. Polished Chunār sandstone. Maurya, ca. 242 B. C. See pages 18, 62.

PLATE V.
 15. Fragment of a colossal male figure, Yakṣa or king, from the back, from Barodā, near Pārkham, now C 23 in the Mathurā Museum. Sandstone, 4' 2" (the height of the complete figure would have been about twelve feet). Maurya or older. See page 17.

[1] Measurements are given in feet and inches. Where only one dimension is given, it represents the height of the object.

16. Winged goddess, standing on a lotus, from Basāṛh. Moulded terracotta. Mauryan or older. Compare the pearl-fringed bracelet and 27, the triple armlet with figures 25, 38. See pages 12, 20, 21, 31 note 3.
17. *Caurī*-bearer, from Dīdargañj, now in the Patna Museum. Polished Chunār sandstone. Maurya or Śuṅga. See page 17.

PLATE VI.
18. Male head from Sārnāth, now in the Sārnāth Museum. Polished Chunār sandstone, 8″. Maurya or Śuṅga. See page 19.
19. Male head from Sārnāth, now in the Sārnāth Museum. Polished Chunār sandstone, 5 ½″. Maurya or Śuṅga. See page 19.
20. Male head from Mathurā. Mottled red sandstone. Maurya or Śuṅga. Author's collection. See page 20.
21. Male head from Mathurā (fragment). Mottled red sandstone. Maurya or Śuṅga. See page 20.
22. Head of a child, from Pāṭaliputra, Bulandi Bāgh excavations. Now in the Patna Museum. Modelled terracotta. Mauryan. See pages 19, 21.
23. Head of a woman or goddess, from Mathurā, now 26. 34 in the Museum of Fine Arts, Boston. Modelled grey terracotta, 3 ¾″. Maurya or older. See page 20.

PLATE VII.
24. Sūrya, relief *in situ*, Bhājā, west end of verandah, left of cell door. Early Śuṅga. See page 25.
25. Guardian or royal figure, relief *in situ*, Bhājā, on screen wall of verandah; pilaster on the left. Early Śuṅga. See page 25.
26. Frieze with a winged horse, horse and female rider using stirrup, other figures, and bulls, relief *in situ*, Bhājā, east end of verandah, below the pilaster, continuous with lower left hand portion of figure 25. Early Śuṅga. See page 25.

PLATE VIII.
27. Indra, relief *in situ*, Bhājā, west end of verandah, right of cell door, facing figure 24. Early Śuṅga. See pages 23—28, 41.

PLATE IX.
28. Façade of the Lomas Ṛṣi cave, Barābar Hills, near Bodhgayā. Maurya. See page 18.
29. Façade of *caitya*-hall, Bhājā, showing the monolithic *stūpa* within. Śuṅga. See page 28.
30. Façade of *caitya*-hall, Mānmoda, Junnār. Late first century B. C. See page 29.
31. Façade of *caitya*-hall, Nāsik. Mid-first century B. C. See page 28.

PLATE X.
32—35. *Caitya*-halls, at Beḍsā and Kārlī:
32. Interior of *caitya*-hall, Beḍsā. Śuṅga, ca. 175 B. c. See page 28.
33. Façade and great pilaster at the south end of the verandah, Beḍsā. Compare the bull with figure 14. Śuṅga, ca. 175 B. C. See page 28.
34. Interior of *caitya*-hall, Kārlī, showing original wooden *chatta* above the monolithic *stūpa*. Late first century B. C. See pages 28, 29.
35. Part of screen, and façade in the verandah, Kārlī. Late first century B. C. See page 29.

PLATE XI.
36. Frieze in the upper storey of the Rānī Gumphā, Khaṇḍagiri, Oṛissā. Ca. 100 B. C. See page 38.
37—39. *Toraṇa* pillar reliefs, Bhārhut and Batanmārā, Nagoḍh State. Śuṅga, early second century B. C. See pages 31, 33.
37. Yakṣī, Batanmārā.

38. Kuvera Yakṣa, Bhārhut.

39. Culakoka Devatā, Bhārhut.

40. Indra in the form of the Brāhmaṇ Śānti, railing pillar dedicated by a king Nāgadeva or queen Nāgadevā, Bodhgayā. Ca. 100 B. C. See pages 8, 32.

PLATE XII.

41—44. Reliefs, Bhārhut. Now in the Indian Museum, Calcutta. Śuṅga, early second century B. C. See pages 18, 25 note 2, 29, 33, 47 note 4, 48, 82, 104.

41. Bodhi-shrine of Śākya Muni (Gautama Buddha), with inscription in Brāhmī characters "*Bhagavato Sakya Munino Bodho*".

42. A *stūpa* with a lion pillar, worshippers, *Puṣpāni Divyāni* raining flowers, and two fan palms.

43. The Turban-relic of the Buddha enshrined in the temple of the gods (inscription, "*Sudhamma Deva-Sabhā*") in the heaven of Indra, beside the palace of the gods (inscription "*Vijayanta Pasāde*"), with dancers in the foreground.

44. Donors or worshippers.

PLATE XIII.

45—49. Reliefs, Bhārhut. Now in the Indian Museum, Calcutta. Śuṅga, early second century B. C. See pages 18, 31, 33, 48, 50, 51 note 1, 149.

45. A two-storied *dhamma-cakka* shrine.

46. Bodhi-shrine, perhaps that of the previous Buddha, Krakucanda, with an elephant pillar, and worshippers.

47. Fragment of railcoping, with an episode of the *Vessantara Jātaka*, viz. the giving away of the sacred elephant Jettatura.

48. Pillar with king on an elephant, with attendants, like the Indra group of figure 27.

49. Lotus medallion enclosing a royal head, from a railing cross-bar.

PLATE XIV.

50. The great *Stūpa*, No. 1 at Sāñcī, as enlarged in the second and first centuries B. C., and now restored. See pages 34 ff.

51. Reliefs on one of the early railing pillars of *Stūpa* No. 2, second century B. C. See p. 35.

52. Reliefs on one of the later railing pillars of *Stūpa* No. 2, first century B. C. See page 35.

PLATE XV.

53. The north *toraṇa*, Sāñcī. Early first century B. C. See pages 34, 36.

PLATE XVI.

54—56. Sāñcī, details, early first century B. C. See pages 33, 36, 47 note 4, 48.

54. The east *toraṇa*, Sāñcī, detail showing woman-and-tree bracket.

55. Bodhi-shrine, detail from east *toraṇa*, Sāñcī. With dedicatory inscription in Brāhmī characters.

56. Worshippers at shrines, Sāñcī. Part of a two-storied pavilion seen below.

PLATE XVII.

57. Goddess, wearing tunic and *dhotī*, with emblem of two fish at the side. Stated to be from Mathurā; now 25.448 in the Museum of Fine Arts, Boston. Moulded red terracotta, 6″. Maurya or Śuṅga. See page 20.

58. Monolithic pillar, with the figure of a Yakṣī or woman wearing girdle and *dhotī*, at Rājasan, Muzaffarpur District. Śuṅga. See page 32. Cf. Marshall, 8, fig. 52.

59. Monolithic railing pillar, with a figure of a Yakṣī wearing girdle and *dhotī*, supported by a dwarf Yakṣa, from Mathurā, now J 2 in the Mathurā Museum. Red sandstone, 6′ 5″. First century B. C. (?) Cf. page 63.

60. Goddess, radiate (?), wearing tunic and *dhotī*. From Kosām. Terracotta, 2¾″. Maurya or Śuṅga. See page 20.

61. Detail from a railing pillar, showing the Sun in a four-horsed chariot, with female archers dispelling the powers of darkness; above, the lower part of a shrine, with *triratna* symbol on the altar, supported by three Yakṣas (so-called Atlantes). Bodhgayā. Sandstone. Ca. 100 B. C. See pages 33, 67.

62. So-called "Bodhgayā plaque", found at the Kumrāhār site, Patna (Pāṭaliputra), representing a straight-edged *śikhara* temple; with Kharoṣṭhī inscription. Patna Museum. Probably of Pañjāb origin, and first or second century A. D. date. See pages 48, 62, 80, 81; and Spooner, 12; and Konow, 2.

PLATE XVIII.

63. Maṇibhadra Yakṣa. From Pawāyā, Gwāliar State, now in the Museum at Gwāliar. Sandstone, life-size. First century B. C. See page 34.

64. Kuṣāna king, seated on a lion-throne, with a fire-altar engraved on the front of the pedestal. From Mathurā, now in the Mathurā Museum. Red sandstone. Second century A. D. See page 68.

65. Statue of Kaniṣka. From the Māt site, Mathurā, now in the Mathurā Museum. Red sandstone, 5′ 4″. Early second century A. D. See page 66.

66. Paraśurāmeśvara *lingam*, with two-armed representation of Śiva. In *pūjā* at Guḍimallam. Polished stone, 5′. First century B. C. See page 39.

67. Nandi Yakṣa, from Patna, now in the Patna Museum. Polished stone, *ca.* 5′. Second century B. C. See pages 17, 34.

68. *Lingam*, with four-armed figure of Śiva. Evidently from Mathurā. Formerly in possession of M. Léonce Rosenberg. Second century A. D. See page 67.

PLATE XIX.

69. Representation of a *śikhara*-temple, detail from a railing pillar. From Mathurā, now J 24 in the Mathurā Museum. Red sandstone, ca. 8″ by 9″. First or second century A. D. See pages 48, 53, 80, 81.

69 A. Representation of a wooden *śikhara*-temple, detail from a *toraṇa* architrave. From Mathurā, now M 3 in the Mathurā Museum. Red sandstone, 7½″. First or second century A. D. See pages 53, 205.

70. Medallion of a railing cross-bar, showing a Bodhi-temple of unique type, but like the *stūpa harmikā* from Bhārhut, figure 42. From Mathurā, now 26. 96 in the Museum of Fine Arts, Boston. Red sandstone, 9″. Second century B. C. See page 33.

71. Jaina *āyāgapaṭa*, a stone votive plaque. In the centre a seated Jina, surrounded by four triratna symbola; above and below the Eight Auspicious Symbols (*Aṣṭamaṅgala*); on the left a pillar with a *dhamma-cakka* capital, on the right a pillar with an elephant capital. Brāhmī inscription not dated. From the Kaṅkālī Ṭīlā, Mathurā, now in the Lucknow Museum. Mottled red sandstone, probably first century A. D. See pages 37, 70.

72. Jaina *āyāgapaṭa* dedicated by the courtesan (*gaṇikā*) Loṇāśobhikā at the "Nigathānāṁ Arahatāyatana", or shrine of the Nirgrantha Saints; with Brāhmī inscription not dated. The slab represents a *stūpa* with high cylindrical drum, standing on a high basement and approached by steps leading under a *toraṇa* to the circumambulation platform. On the side of the basement are represented two niches enclosing a male figure with a child, and a female. Leaning against the drum are Yakṣīs, like those of the Mathurā railing pillars. Above, two nude flying figures (*siddhas?*) bearing an alms-bowl and a cloth, and worshipping, and two *suparṇas*, winged, and with bird feet, offering flowers and a garland; *dhamma-caka* and lion pillars at the sides. From Mathurā, now Q 2 in the Mathurā Museum. Mottled red sandstone, 2′ 4″ by 1′ 9¾″. End of the first century B. C. See pages 37, 44 note 2.

PLATE XX.

73. Railing pillar, woman and child, another woman peering over a curtain behind; the child is reaching for the rattle which the woman holds. From Mathurā, now J 16 in the Mathurā Museum. Sandstone, 2′ 2″. First or second century A. D. or slightly earlier. See pages 64, 65.

74. Pillar, in the round, consisting of the figure of a female figure, probably representing Abundance standing on lotus flowers springing from a globular jar; at the back, sprays of lotus rise to the full height of the pillar. From the Jamālpur mound, Mathurā, now B 89 in the Lucknow Museum. Mottled red sandstone, 3′ 10¹/₂″ × 10″ × 10″. First or early second century A. D. See pages 31 note 3, 64, 65, 150.

75. *Toraṇa* bracket, Yakṣī, Devatā or Vṛkṣakā beneath a tree, and supported by an elephant. The figure wears a *dhotī*, the usual metal girdle, and sash. Compare with the figure inscribed with the name Culakoka Devatā at Bhārhut, figure 39. From the Kaṅkālī Ṭīlā, Mathurā, now J 595 in the Lucknow Museum. Red sandstone, 4′ 3″ × 8′ 5″ × 10″. First or second century B. C. See page 64.

76. Relief fragment. Above, male figures carrying a heavy ornamented roll, a motif of Gandhāran origin; below, two scenes, probably from a *Jātaka*, but not identified. From left to right, apparently a cobra, an bearded long-haired ascetic, a man with two baskets attached to a yoke, a fire altar, and a water-vessel (*kamaṇḍalu*), then a domed round ascetic's hut (*panna-sālā*) of post and thatch dividing the scenes, then a group of deer in a rocky landscape with two trees; then another hut, and the beginning of a third scene, with the same or another bearded man. Probably from the basement of a small *stūpa*. Now I 4 in the Mathurā Museum. Red sandstone, 11″ by 3′. First or second century A. D. See page 62.

PLATE XXI.

77. Railing pillar representing a lay worshipper or donor, with lotus flowers in the raised right hand. Mottled red sandstone. From Mathurā, now B 88 in the Lucknow Museum. First or early second century A. D. See pages 57, 64.

78. Railing pillar. Bodhisattva (Avalokiteśvara); the right hand in *abhaya mudrā*, the left holding the *amṛta* vase, the Dhyāni Buddha Amitābha in the headdress, probably the earliest known example of this iconographic feature. From Mathurā, now B 82 in the Lucknow Museum. Mottled red sandstone. First or early second century A. D. See pages 57, 63 and cf. fig. 87. 2′ 6″ × 10″ × 10″.

79. Railing pillar. Bodhisattva (Maitreya?), with shaven head and wearing a necklace and *dhotī*; scalloped halo and umbrella; the right hand in *abhaya mudrā*, the left holding the *amṛta* vase. From Mathurā, now B 83 in the Lucknow Museum. Mottled red sandstone. First or early second century A. D. See pages 56, 63.

80. Pillar. Bodhisattva (Maitreya?), wearing crown, jewels, scarf and *dhotī*, the right hand in *abhaya mudrā*, the left resting on the hip. Defaced Brāhmī inscription. From Mathurā, now in the Pennsylvania University Museum, Philadelphia. Mottled red sandstone. First or second century A. D.

81. Fragment of a railing pillar, woman under *aśoka* tree, a child at her breast, a rattle in her left hand. Mathurā, now F 16 in the Mathurā Museum. Mottled red sandstone, 1′ ½″.

82. Back of a part of a multiple image of a Nāginī or snake goddess, carved in low relief with an *aśoka* tree in flower, with a squirrel on the stem. From Mathurā, now F 2 in the Mathurā Museum. Red sandstone, 2′ 5″. Second century A. D. (?)

PLATE XXII.

83. Bodhisattva (so designated in the inscription), presumably Śākya Muni, the Buddha, in monastic robes; shaven head, the *uṣṇīṣa* apparently broken away, no *ūrṇā*; fragments show that the right hand was raised in *abhaya mudrā* the left as usual clenched on the hip, supporting but not holding the robe; a sitting lion between the feet. The head is of the same type as the illustrated in figures 9, 86, 96, and many other Mathurā sculptures, including railing pillars and Jinas. Dedicated by Friar Bala. Mathurā manufacture, set up at Sārnāth 123 A. D., now B (a) 1 in the Sārnāth Museum. Red sandstone, 8′ 1 ½″. See pages 56, 58.

PLATE XXIII.

84. Bodhisattva (so designated in the inscription) presumably Śākya Muni, the Buddha, with shaven head, spiral *uṣṇīṣa*, scalloped halo. Bodhi tree, *puṣpāṇi divyāni* raining flowers, seated on a lion throne; two attendants with *cauris*; inscription in Brāhmī characters not dated, but similar to that of figure 83. The right hand in *abhaya mudrā*, the left on the knee, not clenched. From the Kaṭrā mound, Mathurā, now A 1 in the Mathurā Museum. Early second century A. D. Red sandstone, 2′ 3 ¼″. See pages 46, 56, 57.

85. Buddha or "Bodhisattva" similar to figure 83, but less perfectly preserved. The attendant on the proper right holds a *vajra* and must represent Indra. The right hand in *abhaya mudrā*, the left on the knee, clenched. From Mathurā, now 25. 437 in the Museum of Fine Arts, Boston. Mottled red sandstone, 2′ 4 ½″. Early second century A. D. See pages 50, 56, 57.

86. The Jaina Tīrthaṁkara Pārśvanātha protected by the Nāga Dharaṇendra. Type the same as that of figures 84, 85. From the Kaṅkālī Ṭīlā, Mathurā, now J 39 in the Lucknow Museum. Mottled red sandstone, 3′ 4″ × 1′ 10½″ × 8′ 5″. Date first or early second century A. D. See pages 37, 50, 57, 58.

87. Bodhisattva or crowned Buddha, seated, the right hand in *abhaya mudrā*, the left on the knee. One of two *puṣpāṇi divyāni* preserved above, part of a group of standing figures in monastic robes on the proper right, each with right hand raised and some object held in the left. Relief, probably from the square basement of a *stūpa*. Evidently from Mathurā, at present in the possession of Messrs Yamanaka, New York. Mottled red sandstone, height about 1′ 4″. Early second century A. D. Cf. pages 50, 56 note 5, 58 note 3, and fig. 78.

PLATE XXIV.

88. The Bīmarān reliquary. Figure of Buddha on the left, two worshippers centre and right. Gold, set with gems. From Bīmarān, Afghānistān, now in the British Museum. Early first century A. D.? See pages 50, 51.

89. The Kaniṣka reliquary. Seated nimbate Buddha above with two worshippers; band of *haṁsas* round the flange of the lid; Erotes bearing a garland below, with a seated Buddha in the centre; incised inscription. Metal, 7¾″. From Kaniṣka's relic tower at Shāh-jī-kī-Ḍherī, now in the Indian Museum, Calcutta. Second quarter of second century A. D. See pages 50, 52, 54.

90. Standing Buddha, one of the best Gandhāran examples. Plain nimbus with donor's inscription in Kharoṣṭhī characters, not dated. Blue slate. Unknown source, now No. 255 in the Lahore Museum. First century A. D.? See pages 50, 52, and Vogel, 3.

PLATE XXV.

91. Relief slab from the base of a *stūpa*, with scenes from the Buddha's life. Above, niche representing the section of a *caitya*-hall, with the Buddha preaching the first sermon represented in the pediment; below, various other scenes; at the base, left, the Gift of Bowls, and the Parinirvāṇa. Blue slate, Gandhāra, now in the Art Institute, Detroit. Late first century A. D.? See page 50.

PLATE XXVI.

92. *Dīpaṅkara Jātaka.* On the left a youth with a purse in his right, a water vessel in his left hand, purchasing lotus flowers from a girl, who has a jar under her left arm; in the centre the same youth prepared to cast the flowers at Dīpaṅkara Buddha; right, the same youth prostrate offering his hair as a carpet for the Buddha's feet; Dīpaṅkara Buddha on the right. The use of continuous narration is unusual in Gandhāran art. Gandhāra, present situation unknown. Blue slate, 1' 4". Gandhāra, somewhat Indianised, second century A. D. See pages 50 ff., cf. fig. 49.

93. *Vessantara Jātaka*, the gift of the sacred elephant of Jettatura. The elephant with an attendant holding an *aṅkuśa* in his left hand and raising his right in a gesture of respect, is emerging from the city gate. The Bodhisattva, nimbate, with thick curly hair holds its trunk in his left hand (as in figure 47 from Bhārhut); the right hand, which should hold the water vessel from which water is poured in ratification of gift, is missing, and only the foot of the Brāhmaṇ recipient appears on the extreme left. On the right a Corinthian pilaster with a seated Buddha. From Gandhāra, unknown site, now 25. 467 in the Museum of Fine Arts, Boston. Blue slate, 11". Gandhāran, Indianised, second century A. D. See pages 50, 51 note 1, 149. Cf. fig. 49.

PLATE XXVII.

94—97 Four Buddha types.

94. Head of Buddha, wavy flowing locks, *uṣṇīṣa* prominent, pure Hellenistic style. Source unknown, now in the Museum of Fine Arts, Boston. Blue slate, 9¾". First century A. D. Cf. fig. 49. See pages 50, 52, 60

95. Head of Bodhisattva, apparently Avalokiteśvara, with Dhyāni Buddha in headdress. Source unknown, now in the Field Museum, Chicago. Blue slate. First century A. D. See pages 50, 63.

96. Head of Buddha, type of Friar Bala's Sārnāth Boddhisattva (fig. 83). From Mathurā, now in the Museum of Fine Arts, Boston, no. 17. 3120. Mottled red sandstone, 11". Early second century A. D. See pages 58 note 5, 60.

97. Head of Buddha, the hair in curls. From Amarāvatī, now in the Museum of Fine Arts, Boston, no. 21. 1520. White marble, 8½". End of second or beginning of third century A. D. See page 71.

PLATE XXVIII.

98—101 Four Buddha types.

98. Head of Buddha, the hair in curls. From Mathurā, now in the Museum of Fine Arts, Boston, no. 21. 2230. Mottled red sandstone, 12¾". Gupta, fifth century. See page 60.

99. Head of Boddhisattva, with elaborate crown. From Mathurā, now in the possession of Mr. C. T. Loo, New York. Mottled red sandstone. Gupta, fifth century.

100. Head of Buddha, the hair in curls. From Romlok, Ta Keo, Funan (Southern Cambodia). "Indianesque" or "pre-Khmer", sixth century A. D. See pages 153, 183.

101. Head of Buddha, the hair in curls. From Boroboḍur, now in the Metropolitan Museum of Art, New York. Basalt, 1' 4". See page 203.

PLATE XXIX.

102. Kṛṣṇa Govardhanadhara. From Mathurā, now D 47 in the Mathurā Museum. Mottled red sandstone, 1' 8½". Late Kuṣāna, third century A. D. See page 66.

103. Sūrya, seated in a chariot drawn by four horses; indistinct objects held in the hands, perhaps a lotus and a sword. The deity is provided with small shoulder wings, and a large, semicircular halo, radiate at the edge. From the Śaptasamudri well, Mathurā, now D 46 in the Mathurā Museum. Mottled red sandstone, 2' 9". About 100 A. D.? See pages 12, 67.

104. Five scenes from the life of Buddha, relief, probably from a *stūpa* base. From left to right in the reproduction: 1. Parinirvāṇa, 2. First Sermon, 3. Descent from the Tuṣita Heavens, 4. Māra Dharsana, 5. Nativity. In the lower rank, below no. 4, Māra shooting an arrow at the Bodhisattva, the latter with right hand in *bhūmisparśa mudrā*, calling the Earth to witness, the earliest instance of this *mudrā*; one of the daughters of Māra at the Bodhisattva's side. In the lower right hand corner, the infant Bodhisattva standing between the two Nāga kings Nanda and Upananda, issuing from masonry wells. From the Rāj Ghāṭ, Mathurā, now H 1 in the Mathurā Museum. Red sandstone, 2' 2". Second century A. D. See page 62.

PLATE XXX.

105. Plaque, representing a nude goddess, probably the Earth. From the Vedic burial mound at Lauṛiyā-Nandangaṛh, seventh or eighth century B. C. Gold. See page 10.

106. Punch-marked coin (*purāṇa, dharaṇa, kārṣāpana*) unknown source, now Asiatic Society, Bengal. Silver, 48 gr, 85". Symbols, humped bull, fishes, taurine, sun, &c. (Reverse blank.) Smith, 6, p. 136 and pl. XIX, I. See pages 43, 45.

107. Punch-marked coin, unknown source, now Asiatic Society, Bengal. Silver, 51.3 gr., 1.1" by 0.7". Symbols: two solar, square tank with fishes, one-horned rhinoceros. One of the solar symbols like the sun on fig. 112, the other of the "Taxila" type, with crescents and broad arrows alternating round a central ring. Smith, 6, p. 139, and pl. XIX, 5. See pages 43, 45.

108. Punch-marked coin, unknown source, now Indian Museum, Calcutta. Silver, 52.3 gr., 0.65" by 5". Symbols: three human figures (man and two women, mountain of five peaks with a peacock upon it, and square. (The reverse has a mountain only.) Smith, 6, p. 138, and pl. XIX, 3. See pages 43, 45.

109. Coin of Apollodotos, ca. 156—140 B. C., now in the Museum of Fine Arts, Boston, no. 22. 56. Silver, 30.8 gr. Reverse, with humped bull, probably of Śaiva significance, and Kharoṣṭhī legend. (The obverse has an elephant and Greek legend.) See page 45.

110. Coin of Pavata (Pārvata) of Kosām, second century B. C., now in the Indian Museum, Calcutta. Copper, die-struck on cast blank, 26.3 gr., .65" by .57". Obverse with *caitya-vṛkṣa*, mountain of three peaks, and snake, and Brāhmī legend *Pavatasa*. (Reverse has a humped bull.) Smith, 6, p. 155, and pl. XX, 4. See pages 44, 45.

111. Anonymous coin, Kosām, second century B. C., now in the Indian Museum, Calcutta. Copper, 102.3 gr., 1.01". Obverse with *caitya-vṛkṣa*, mountain of six peaks, eight-rayed wheel, *svastika*, cross and balls (near to "Ujjain" symbols). (Reverse has a lanky humped bull.) Smith, 6, p. 155, and pl. XX, 5. See pages 44, 45.

112. Coin of Avanti, probably Ujjain. Asiatic Society, Bengal. Copper, 128.2 gr., .72". Obverse, king standing, *svastika*, taurine, "Taxila", solar symbol, as in fig. 107, sun on pillar. (Reverse has "Ujjain" symbol with inner circle and dot in each orb.) Smith, 6, p. 153, and pl. XX, 2. See pages 44, 45.

113. Coin of Taxila, fourth or third century. B. C. 145 gr., .8". Indian Museum, Calcutta. Obverse with mountain of three peaks, surmounted by a crescent, pyramid of balls, *svastika*, and snake, all in incuse. (Reverse is blank.) Smith, 6, p. 156, and pl. XX, 6. See pages 44, 45.

114. Southern India, Pāṇdyan coin, before 300 A. D. From Kantarōdai, Ceylon, now in the Museum of Fine Arts, Boston, no. 21. 1000. Copper, 138.1 gr. Obverse, with elephant, two *caitya-vṛkṣas*, mountain of three arches, raised frame. (Reverse has indistinct symbol within similar raised lines.) See pages 44, 45.

115. Coin of Amoghabhūti, Kuṇiṇḍa, of Kāṅgrā, &c. second century B. C. Indian Museum, Calcutta. Silver, 33.8 gr., .67". Obverse, woman with a lotus in r. hand, stag with symbol between horns, railed umbrella *caitya* (not a *stūpa*, see page 45), and circle surrounded by dots; Brāhmī legend. (Reverse with other symbols and Kharoṣṭhī legend.) Smith, 6, p. 167 and pl. XX, 11. See pages 44, 45 note 2.

116. Audumbara coin, Paṭhānkoṭ or Kāṅgrā, Early first century A. D. Copper, 27 gr., .65". Obverse with a railed (circular?) pavilion with four pillars and domed (thatched?) roof with projecting eaves; indistinct Brāhmī letters. Smith, V. A., in J. A. S. B., LXVI, pt. 1, 1897. See pages 45 note 2, 48.

117. Audumbara coin, Paṭhānkoṭ or Kāṅgrā, Early first century A. D. Copper, 34 gr., .65". Obverse with a railed (circular?) pavilion with five pillars and domed (thatched?) roof with projecting caves, and small finial; three Brāhmī letters. Smith, V. A., *ibid.* See pages 45 note 2, 48.

 Another building appears on a coin of Dhara Ghoṣa, Audumbara. Cunningham, 5, p. 68, and pl. IV, 2, calls it "a pointed-roofed temple of two or three storeys, with pillars". Fine square coins from Kantarōdai, Ceylon, probably early Pāṇḍyan (Korkai), bear very clear representations of railed circular pavilions with pillars and domed roof, closely resembling figs. 116, 117 (Pieris, p. 50 and pl. XIII, 7, 8, 11, 12).

118. Kṣatrapa coin, first century A. D.? Silver, 98.5 gr., .65". Obverse, woman or goddess, r. hand raised, l. hand on hip, standing under a *toraṇa*, of which the base of the right hand post is railed. The figure is presumably the goddess of Abundance, Ardochṣo-Lakṣmī. (Obverse has horse and Brāhmī legend.) Smith, *ibid.*

119. Coin of Kadaphes (Kadapha, Kadphises I, ca. 40—78 A. D.). Copper or bronze, 24 gr., .62". Reverse with seated king or Buddha cross-legged, with broad shoulders, r. hand raised holding some object, l. hand on hip, the elbow extended; triangle under elbow of r. arm. Smith, V. A., in J. A. S. B., LXVII, pt. 1, 1898, coin no. VI. Another example of this rare and interesting type is reproduced by Whitehead, R. B., pl. XVII, no. 29. Another example is in the Museum of Fine Arts, Boston. See page 59.

120. Coin of Huviṣka, ca. 160 A. D. Gold, 110 gr., .8". Bust of king, nimbate, with jewelled pointed crown. (Reverse has goddess, Ardochṣo-Lakṣmī, enthroned, a form much more usual in the Gupta period.) Smith, V. A., in J. A. S. B., LXVI, pt. 1, 1897, coin no. IV. See page 66.

121. Coin or token from Ceylon, first or second century A. D. Now in the Museum of Fine Arts, Boston, no. 21. 1040. Lead-alloy, 94. 3gr. Obverse with standing figure of Māyādevī-Lakṣmī, nude except for girdle, holding the stems of lotuses in each hand, each lotus flower, at the level of the head, supporting an elephant with inverted water-jar. (The reverse has an elevated railed *svastika*.) The composition occurs in the oldest Indian Buddhist sculptures, and on the coins of Agilises. See Codrington, H. W.

122. Coin of Kaniṣka, 120—160 A. D. In the Museum of Fine Arts, Boston, no. 22,57. Gold, 23 gr. Obverse, king standing nimbate, with pointed helmet and diadem, r. hand dropping grains on fire altar, l. hand with trident, flame on shoulder; reverse, Śiva standing before the bull Nandi, r. hand with *pāśa*, left with *triśūla*, flaming nimbus, Greek legend *Oesho*. See pages 45, 66, 67.

123. Coin of Kaniṣka, British Museum. Gold, 109.2 gr., .8". Obverse, king standing as before but with elephant goad in r. hand over fire altar, and Greek legend better preserved, *Shaonano Kanerki Koshano*; reverse, Buddha standing facing, nimbate, r. hand raised, l. hand holding robe (not a wallet, as Gardner says), Greek legend *Boddo*. Gardner, p. 130 and pl. XXVI, 8. See pages 59, 66, 67.

124. Coin of Kadphises II, 78—120 A. D. British Museum. Gold, 244.2 gr., .95″. Obverse, king seated on throne, flames rising from shoulders, in r. hand a branch, footstool under feet, Greek inscription. (Reverse has two-armed Śiva with bull, flames rising from head, Kharoṣṭhī inscription.) Gardner, p. 124 and pl. XXV, 6. See page 66.

125. Coin of Kaniṣka. Museum of Fine Arts, Boston, no. 22. 58. Gold, 120 gr. Reverse, Śiva standing, four-armed, l. r. hand with inverted vase u. r. hand with drum (?), u. l. hand with triśūla, l. l. hand on hip, a goat prancing in r. field, Greek legend Oesho. (Obverse has king standing at altar.) See pages 45, 67.

126. Coin of Vāsudeva, ca. 185—220 A. D. Museum of Fine Arts, Boston, no. 25. 469. Gold, .75″. Reverse, Śiva, standing, three-faced, four-armed, wearing dhotī and yajño-pavīta, l. r. hand in abhaya hasta, u. r. hand with pāśa, u. l. hand with triśūla, l. l. hand with kamaṇḍalu (water-vessel). (Obverse has king standing at altar.) See pages 45, 55, 67, 100 note 1.

126 A. Coin of Huviṣka. British Museum. Gold, 31 gr., .5″. Skanda, Mahāsena, and Viśākha in low domed pavilion with ornamented plinth. Gardner, p. 150 and pl. XXVIII, 24. See pages 43 note 1, 48.

127. Coin of Kaniṣka. British Museum. Gold, 27.7 gr., .5″. Reverse, with goddess of abundance (Ardochṣo-Lakṣmī) with a cornucopiae; Greek legend Ardochṣo. Obverse has king standing at altar as usual. Gardner, p. 130 and pl. XXVI, 6.

The Prākrit form Ardochṣo has been interpreted (1) as Ardha-Ugra = half of Śiva = Pār-vatī, and (2) as referring to the Persian Ashis, a goddess of fortune, daughter of Ahuro.

128. Coin of Kaniṣka. Reverse, representing the Wind-god running. Greek legend Oado (Vado). British Museum. Copper, .6″. Gardner, pl. XXVII, 6. See page 67.

129. Coin of Candragupta II, 380—415 A. D. From a plaster cast in the British Museum. Obverse, king slaying lion; reverse, goddess (Lakṣmī-Ambikā) seated on lion, holding lotus. Lettering in Gupta characters. Allan, p. 40 and pl. VIII, 17.

130. Coin of Samudragupta, 330—380 A. D. British Museum. Gold, 119.5 gr., .85″. Obverse, king seated nimbate, playing a harp or lyre which rests on his knees. (Reverse has goddess seated.) Allan, p. 19 and pl. V, 3.

131. Coin of Kumāragupta I, 415—455 A. D. In Museum of Fine Arts, Boston, no. 21. 2587. Gold, 126.3 gr. Obverse, king riding a caparisoned horse. (Reverse has goddess, Lakṣmī, seated on a wicker stool, feeding a peacock.)

132. Coin of Candragupta II. Lucknow Museum. Gold, 120.6 gr., .85″. Obverse, king standing nimbate, r. hand drawing an arrow from the quiver at his feet, l. hand holding bow, Garuḍa standard in l. field. Reverse, goddess nimbate, seated on lotus, holding noose (pāśa) in r. hand, lotus in l. hand. Allan, p. 26 and pl. VI, 10.

133. Carnelian seal, king on wicker throne, from the Yaṭṭhālā Dāgaba, Ceylon. Now in the Manchester Museum. Wax impression, .78″. Second century B. C.? Parker, 1, pp. 81 ff., and 2. See page 159.

134. Soapstone disc from Saṅkīsa, Maurya or older, 2″ diameter. Decoration in three zones, the innermost with fan palms, taurines, nude goddess. Cunningham, 4, vol. XI, pl. IX, 3. See page 20.

PLATE XXXI.

135. Part of the façade of the caitya-hall at Kaṇheri, with figures of donors. Evidently based on the Kārlī model. Second century A. D. See page 69.

PLATE XXXII.

136. Casing slab from the Amarāvatī *stūpa*, now in the Madras Museum. Marble, 6'2''; late second century A. D. See page 70.

This relief affords a good idea of what must have been the appearance of the Amarāvatī *stūpa* at the height of its glory (nothing now remains *in situ*). The edges of the frame, r. and l., represent very elaborate *stambhas* carrying *dhamma-cakkas*. The centre of the frieze above represents the Assault of Māra and the Temptation by the Daughters of Māra; here the Buddha is visibly represented, but in the panels to r. and l. he is represented only by an empty throne.

PLATE XXXIII.

137. Standing figure of Buddha of a very massive type, Amarāvatī, now in the Madras Museum. Marble. End of second or very early third century A. D. See pages 70, 71.

138. Two standing Buddhas, Amarāvatī, now in the Madras Museum. Marble, 6' 4''. End of second or very early third century A. D. See pages 70, 71.

139. Standing Buddha. Amarāvatī, now in the Madras Museum, End of second or very early third century A. D. Marble, 5'5''. See pages 70, 71.

140. Stele representing Four Great Events of the Buddha's life, from Amarāvatī, now in the Madras Museum, 4'. Marble. Late second century A. D. See page 70.

Below, the Great Renunciation; second, the Great Enlightenment, represented by the Temptation by the Daughters of Māra; third, the First Sermon; fourth, the Parinirwāna.

141. Slab with a scene from the Buddha's life, from Amarāvatī, now in the Madras Museum. Late second century A. D. Marble, ca. 1'. See page 70.

PLATE XXXIV.

142. Slab of *āyāgapata* type with a representation of a two-storeyed shrine, like the so-called *punya-śālas* at Bhārhut. Women with offerings within, a figure probably representing the donor standing without. A wild date palm to left. From Jaggayyapeta, now in the Madras Museum. Marble. First or second century B. C. See page 38.

143. Pilaster, with lotus capital and addorsed monsters, in Bhārhut style, and figure or a Yakṣī or river goddess standing on a *makara*. From Jaggayyapeta, now in the Madras Museum. Marble. First or second century B. C. See page 38.

144, 145. Two sides of a votive column (*cetiya-khabha*, according to the inscription). The first showing a *dhamma-cakka* with an empty *āsana* in front of it, probably representing the First Sermon; the second a domed shrine, containing a reliquary on an altar. The two other sides have representations respectively of a tree and *āsana* (Great Enlightenment), and of a *stūpa* (Parinirvāna). From this it would appear as though the Four Great Events were represented; but the reliquary is not a usual symbol of the Nativity. In fig. 145 it is clearly indicated that the dome, which tends to the globular form, is of corbelled construction. Fergusson, 2, vol. I, p. 312, has a good discussion of Indian domes, but overlooks this important example. As he points out, only the horizontal, corbelled construction permits the support of a heavy dome by pillars alone.

Marble, 4' 3''; probably first or second century B. C.; the column is grouped by Burgess (7, p. 86 and Pl. XLV, 1—4) amongst the older sculptures from Amarāvatī. Now in the Madras Museum. See pages 38, 70.

146. Lower part of a pillar, with representation of a Nāga *stūpa*, with elaborate range of umbrellas. Marble, ca. 5'; now in the Madras Museum. Perhaps first century B. C. See pages 38, 70, 73 note 4, 76 note 1, 122 and Burgess, 7, page 85 and Pl. XLIV, 2).

PLATE XXXV.
147. The Kapoteśvara temple, Chezārla, Kistna District. Ca. fourth century A. D. Total height 23′ 8″. See page 77.
148. The Lāḍ Khān temple, Aihoḷe, Bijāpur District. Ca. 450 A. D. See pages 79, 178, 181.

PLATE XXXVI.
149. *Caitya*-hall (temple 18) at Sāñcī; the foundation Aśokan, the stone pillars replacing earlier wooden structures about the seventh century. See page 94.
150. The iron pillar at Delhi, originally set up about A. D. 415 by Kumāragupta I in honour of his father Candragupta II, probably at Mathurā. A statue originally crowned the capital. Height 23′ 8″.
151. Temple 17 at Sāñcī. Early fifth century. See page 78.

PLATE XXXVII.
152. The Durgā temple, Aihoḷe, Bijāpur District. Sixth century. See page 78.
153. The Hucchīmalligudi temple, Aihoḷe. Sixth century. See page 79.

PLATE XXXVIII.
154. Façade of the *caitya*-hall, Cave XIX at Ajaṇṭā. Sixth century. See pages 60, 74, 76.

PLATE XXXIX.
155. Upper part of the façade of the Viśvakarmā *caitya*-hall, Elūrā. Ca. 600 A. D. See page 77.
156. Pillars and architrave, verandah of *vihāra*, Cave II at Ajaṇṭā. Ca. 600—650 A. D. See page 98.
157. Capital of pillar, verandah of *vihāra*, Cave XXIV at Ajaṇṭā. Ca. 600—650 A. D. See page 98.

PLATE XL.
158. Buddha, from the Jamālpur (jail) mound, Mathurā, now A 5 in the Mathurā Museum. Fifth century. Red sandstone, 7′ 2″. See pages 60, 74, 84.
159. Buddha, said to have been found in Burma, but probably made in India, now in the Museum of Fine Arts, Boston, no. 21. 1504. Bronze, 1′ 8″. See pages 60, 85, 171.

PLATE XLI.
160. Buddha, from Sulṭāngañj, Bengal, now in the Birmingham Museum and Art Gallery. Early fifth century. Copper over earthy core, 7′ 6″. See pages 60, 74, 85.
 The figure is cast in two layers, the inner of which was moulded on an earthy, cinder-like core, composed of a mixture of sand, clay, charcoal, and rice husks. The segments of this inner layer were held together by much corroded iron bands, originally three quarters of an inch thick. The outer layer of copper seems to have been cast over the inner one, presumably by the *cire perdue* process; it was made in several sections, one of which consisted of the face and connected parts down to the breast. The whole weighs nearly a ton. Cf. Smith, 2, p. 172 and references there quoted.

PLATE XLII.
161. Buddha, from Sārnāth, now B (b) 181 in the Sārnāth Museum. The position of the hands (*dharma-cakra mudrā*) and the wheel on the pedestal indicate the preaching of the First Sermon; the five figures with shaven heads on the pedestal are probably the Five Companions who deserted the Bodhisattva at Gayā but afterwards became his first followers; the woman and child probably represent donors. Fifth century. Chunār sandstone, 5′ 3″. See pages 60, 74, 85.

PLATE XLIII.

162. Buddha from Māṅkuwār, Allahābād District, dated 448/9 A. D. The only Gupta example of the old Kuṣāna type with shaven head; the body is nude to the waist. The fingers are webbed, as in several other early Gupta examples. Sandstone. See pages 74, 85.

163. Buddha from Faṭhpur, Kāṅgṛā District, now in the Lahore Museum. Sixth century inscription. Brass, the eyes and ūrṇā and some other details in silver, other details in copper, 11.8″. Cf. Vogel, 4. See pages 85, 142, 175.

164. Litany of Avalokiteśvara, and Buddhas, &c., in situ, Kaṇheri, Cave LXVI. The "Litany" on the right, shows Avalokiteśvara standing bētween two Tārās, a monastic figure at his feet, with four panels on either side representing persons in distress praying for aid. It should be noticed that the roughness of the porous rock surface was originally covered with a fine plaster finish, and coloured. The type and various details suggest a comparison with Cambodian "pre-Khmer" work. See pages 60, 74, 85, 183.

PLATE XLIV.

165. Ceiling slab from the old temple known as Haccappya's at Aihole (= A. S. I., A. R., 1907—08, p. 203, fig. 6), representing Viṣṇu seated upon Ananta Nāga. The deity holds the discus and conch in the upper right and left hands. Sixth century. Stone.

166. Detail of toraṇa pillar representing Kṛṣṇa Govardhanadhara; Mt. Govardhana is shown with many peaks, amongst which are seen two cobras, a lion, and a horse-headed fairy; Kṛṣṇa, gopas and gopīs, and cattle below. Maṇḍor, Jodhpur State. Sandstone. Fifth century. See pages 26 note 3, 86.

167. Rāmāyaṇa panel; Rāma, Lakṣmaṇa and Sītā at the hermitage of Savari, from the Gupta temple at Deogaṛh. Sandstone, 2′ 10″. Ca. 600 A. D. See pages 79, 86, 204 note 2.

PLATE XLV.

168. Standing figure of Brahmā, found near Mīrpur Khās, now in the Museum at Karāchi. Bronze. Probably sixth century. See page 86.

169. Architect's plummet, with a Bacchanalian dancing scene on the neck. From the river Surma, East Bengal, now in the British Museum. Iron, coated with bronze, 6¾″. Sixth century. See page 86.

170. Narasiṁha, from Besnagar, now in the Gwāliar Museum. Sandstone. Sixth century. See page 86.

171. Head of Lokeśvara or Śiva, from an attendant figure at the vase of an image of Trailokyavijaya, Sārnāth, now in the Sārnāth Museum. Sandstone. Sixth or seventh century. See pages 153, 183 note 1.

In a remarkable way this head anticipates the characteristic appearance of many Far Eastern, especially Japanese, works.

PLATE XLVI.

172. Nāgarāja and Rānī, in a rock-cut niche outside Cave XIX at Ajaṇṭā. Sixth century.

173. Detail from a group representing a Gandharva and Apsaras, from Sondani, now in the Gwāliar Museum. Fifth or sixth century. See page 86.

174. The Varāha Avatār of Viṣṇu raising the Earth from the Waters at the commencement of a cycle of creation. At Udayagiri, Bhopāl State. Ca. 400 A. D. See pages 85, 100.

175. Kārttikeya, seated in his peacock vāhanam. Collection of the Bharata Kala Pariṣad, Benares. Seventh century. Sandstone. See page 86.

PLATE XLVII.

176. Nāginī, Maṇiyār Maṭha, Rājagṛha. Fifth century. Stucco. See pages 82, 86.

177. River goddess, Gaṅgā, standing on a *makara*. From Besnagar, now in the Museum of Fine Arts, Boston no. 26.26 Sandstone. Ca. 500 A. D. See page 86.
 This panel was originally the base of a door jamb. The type appears already at Bhārhut (Cunningham, 2, pl. XXIII, 2) where the nymph is named in the inscription as Sudarsanā Yakṣī; the name of Gaṅgā Devī seems to be of later usage. Cf. Vogel, 18.
178. Nativity of Mahāvīra or of Kṛṣṇa. From Paṭhāri, now in the Gwāliar Museum. Sandstone, about life size. Seventh century or later. See page 86.

PLATE XLVIII.
 179. A prince and a princess walking, with attendants, and a love scene, not identified. Ajaṇṭā, Cave XVII, over left side door and window. Ca. 500 A. D. See page 89.
 180. Gandharva and Apsarases, in clouds. Ajaṇṭā, Cave XVII, verandah wall, left of door. Ca. 500 A. D. See page 89.
 181. Bodhisattva Avalokiteśvara. Ajaṇṭā, Cave I, back wall, left of antechamber. Ca. 600 at 650 A. D. See pages 91 note 1, 99.

PLATE XLIX.
 182. Head of a beggar, detail from the *Vessantara Jātaka*. Ajaṇṭā, Cave XVII, left side of hall, right corner. Ca. 500 A. D. See page 89.

PLATE L.
 183. Wall painting. Bāgh. Sixth century. See page 89.
 184. Apsaras and attendant. In the rock pocket at Sīgiriya, Ceylon. Ca. 479—497 A. D. See page 163.
 185. Detail of ceiling painting. Ajaṇṭā, Cave I. Ca. 600—650 A. D. See page 99.

PLATE LI.
 186. Lakṣmaṇa temple, Sīrpur. Brick. Seventh century or later. See page 93.

PLATE LII.
 187. Mālegitti or Suvatī temple, Bādāmī. The oldest structural shrine in Drāviḍa style. Ca. 625 A. D. See page 95.
 188. Virūpākṣa temple, Paṭṭakadal. Ca. 740 A. D. See page 95.

PLATE LIII.
 189. *Caitya*-hall, Cave XXVI, Ajaṇṭā, interior, showing the *stūpa*, roof and pillars dividing the nave from the side-aisle. Early seventh century.
 190. Verandah of the Rāmeśvara cave, Elūrā. Seventh century. See pages 86, 97, 98.

PLATE LIV.
 191. The old temple at Gop, Kāṭhiāwād. Sixth or seventh century. See page 82.
 192. The Kailāsa, Elūrā. The tower of the main shrine is at the far end. In the middle, on the left, one of the two *dhvaja-stambhas*, the other in the corresponding position on the right. The roof of the porch in which is preserved the ceiling painting of fig. 196 appears immediately to the right of the capital of the first *dhvaja-stambha*. Eight century. See page 99.

PLATE LV.
 193. Upper part of the Mt. Kailāsa relief, Kailāsa, Elūrā. Pārvatī turning to Śiva, who presses down the mountain with his foot. Eighth century. See pages 100, 166, 193.
 194. Maheśvara-mūrti at Elephanta. Eighth century. See pages 96, 100.

PLATE LVI.
 195. Maheśvara-mūrti, Elephanta, detail of the proper left face. Eighth century. See page 100.

PLATE LVII.

196. Detail of ceiling painting, porch in the upper storey, Kailāsa, Elūrā, representing Lakṣmī riding on a Garuḍa. Eighth century. See pages 100, 121.

PLATE LVIII.

197. The Kailāsanātha temple, Kāñcīpuram: outer façade of the peristyle, entrance *gopuram* (centre) and *vimāna* (right). See pages 102, 104.

198. Plain double-roofed shrine, the fundamental unit of Drāviḍa architecture, corresponding to the Bhārhut Sudhamma Deva-Sabhā (fig. 43) but square, and with small *caitya*-window (*kuḍu*) ornaments on the cornice and dome. Bhagiratha is represented as worshipping Śiva, seen in relief in the open door of the shrine. Part of the Gaṅgāvataraṇa, Māmallapuram. Early seventh century. See pages 103, 104.

199. Pillars at the Agastyeśvara temple at Melapaḷuvūr. Trichinopoly District. Seventh or early eighth century. See page 102.

PLATE LIX.

200. The "Draupadī Ratha", Māmallapuram. This is a shrine of Durgā, but with the attributes of Lakṣmī. The curved four-angled roof does not differ fundamentally from that of other four-, six-, or eight-angled domes, but being single and almost without decoration more clearly reveals its bent bamboo origins. Height about 18'. First half of seventh century. See page 104.

201. The "Shore" temple, Māmallapuram. Ca. 700—720. See page 105.

202. The Gaṇeśa Ratha, Māmallapuram. First half of seventh century. See page 102.

203. West view of central shrine, Paṇamalai. Ca. 700—720 A. D. See pages 105, 182.

PLATE LX.

204. Effigies of Mahendravarman and his two queens, in the Ādi-Varāha cave, Māmallapuram. First half of seventh century. See pages 103, 104.

205. Gaja-Lakṣmī, in the Ādi-Varāha cave, Māmallapuram. First half of seventh century. See page 103.

206, 207. Details from the Gaṅgāvataraṇa, Māmallapuram. Pallava, early seventh century. See page 103.

206. Bhagiratha at the shrine of Śiva (see fig. 198).

207. Nāgas and Nāginīs; cat and mice.

PLATE LXI.

208. Durgā-Mahiṣamardinī, relief in the Yamapuri or Mahiṣa-maṇḍapam at Māmallapuram. First half of seventh century. See page 103.

209. Viṣṇu-Anantaśayin, relief in the Yamapuri or Mahiṣa-maṇḍapam at Māmallapuram. First half of seventh century. See page 103.

PLATE LXII.

210. The great temple at Bodhgayā, commonly called Mahābodhi, as now restored. A temple of this type existed in the time of Hsüan Tsang, and probably already in the Kuṣāna period. See pages 81, 170. Cf. figs. 62, 69, 309.

PLATE LXIII.

211. Hoysaleśvara temple, Halebīd. Left unfinished in 1311 A. D. See page 118.

212. The Telī-kā-Mandir, Gwāliar Fort. The uppermost storey is a simplified restoration; the roof was probably like that of the Vaitāl Deul at Purī. Eleventh century. See page 109.

213. Brick temple of Siddheśvara, Bāṅkurā (Bahulara), Bengal. See page 108.

PLATE LXIV.

214. Kandārya Mahādeva temple, Khajurāho, Bundelkhaṇḍ. Total height 116 feet. Between 950 and 1050 A. D. See page 109.

PLATE LXV.
215. Lingarāja temple, Bhuvaneśvara, Oṛissā. Ca. 1000 A. D. See page 115.

PLATE LXVI.
216. Paraśurāmesvara temple, Bhuvaneśvara, Oṛissā. Ca. 750 A. D. See pages 79, 115.
217. *Maṇḍapam* ("Jagamohan") of the Sun temple (Sūrya Deul) at Konāraka. Thirteenth century. See page 116.

PLATE LXVII.
218. Vaitāl Deul, Bhuvaneśvara, Durgā-Mahiṣamardinī and other sculptures. Ca. 1000 A. D. See page 116.
219. Mukteśvara temple, Bhuvaneśvara, detail from the base of the *śikhara*, a Nāginī. Ca. 950 A. D. See page 116.
220. Sūrya Deul, Koṇāraka, detail from a spoke of one of the decorated wheels of the basement of the temple; representing a horseman slaying a panther. Thirteenth century. See page 116.

PLATE LXVIII.
221. Ceiling of Tejahpāla's temple, Dilwāṛa, Mt. Ābū. 1232 A. D. Marble. See page 112.

PLATE LXIX.
222. Viṣṇu, from Sulṭānpur, now in the Lucknow Museum. Buff sandstone, 3' 5". Tenth or eleventh century. See page 110.
223. Padmapāṇi (Avalokiteśvara). From Mahobā, now in the Lucknow Museum. Buff sandstone, 2' 2". Eleventh or twelfth century. See page 110.
224. Viṣṇu, from the Dekkhan or Maisūr, now in the Pennsylvania University Museum, Philadelphia. Polished granulite, 6'. Ninth or tenth century. See page 118.
225. Brahmā, from Kuruvatti in the Bellary District, Madras, now in the Pennsylvania University Museum, Philadelphia. The fourth face, at the back, is bearded. Stone, 5' 5 ¾". Probably eleventh century. See pages 118, 120.
 Inscription recording the maker's name, Cāvuṇḍoja of the Trailokya-malleśvara temple (the present Mallikārjuna) at Kuruvatti. See Rūpam, no. 18, p. 66.

PLATE LXX.
226. Stone sculpture, worshipped as Rukmiṇī, at Nokhas, Etah District. Sandstone, 5' 4 ½". Probably tenth century.

PLATE LXXI.
227. Sūrya, from Chapra, Rājshāhi District, now F (a) 1 in the Rājshāhi Museum. Black slate, Pāla school of Bengal-Bihār-Oṛissā, eleventh century. See page 114.
228. The Eight Great Events of the Buddha's life, the main figure representing the Bodhisattva seated under the Bodhi tree, with right hand in *bhūmi-sparśa mudrā* "calling the earth to witness" on the occasion of Māra's challenge, previous to the Great Enlightenment. As a Bodhisattva, Gautama is represented with crown and jewels, though otherwise in the monastic robes of a Buddha. From Bengal or Bihār, now in the Museum of Fine Arts, Boston, no. 21.1835. Black slate, 17 ¾". Pāla school of Bengal-Bihār-Oṛissā, eleventh century. See page 114. See Coomaraswamy 9 (2), p. 75.
229. Arapacana Mañjuśrī, from Bengal or Bihār, now in the collection of Mrs. Burnet (Miss Cora Timken), New York, and exhibited at the Metropolitan Museum of Art, New York. Black slate, 3' 9 ¾". Pāla school of Bengal-Bihār-Oṛissā, tenth or eleventh century. See page 114.
230. Umā-Maheśvara group, from Bengal or Bihār, now in the Museum of Fine Arts, Boston, no. 21.1651. Copper, 6 ¼". Pāla school of Bengal-Bihār-Orissa, eleventh or twelfth century. See page 114.

PLATE LXXII.

231. Viṣṇu (Trivikrama), from Sagardighi, Murshīdābād District, now $\dfrac{O\,(a)\,1}{21}$ in the collection of the Baṅgīya Sāhitya Pariṣad, Calcutta. Brass, 2′ 1½″. Pāla school of Bengal-Bihār-Oṛissā, eleventh or twelfth century. See page 114.

 For this and two other figures in the same style see Ganguly, M., 2, pp. 137—141, where detailed iconographic descriptions are given. For other figures in similar style see Spooner, 6, and Coomaraswamy 9 (2), pp. 67, 78 (21. 1652 and 1653).

232. Bodhisattva, now in the Śrī Partāp Singh Museum, Śrīnagar, Kaśmīr. Pāla school of Bihār (Nālandā?), ninth or tenth century. See pages 113, 142.

233. Buddha, seated under the Bodhi tree on the occasion of the Great Enlightenment, the right hand in *bhūmi-sparśa mudrā*, "Calling the Earth to witness". With inscription. From Nālandā, in the Museum at Nālandā. Bronze or copper, 9″. See pages 114, 142.

234. The Tīrthaṁkara Pārśvanātha, a Jaina image from Kannaḍa, now in the possession of Mr. K. Kay. With inscription in Kanarese chacters of the tenth or eleventh century naming the donor, "The illustrious Maldayya of Pṛthvī-Gollarijas, follower of Guṇasena, pupil of Mallisena Bhaṭṭāra of the Mata . . . gana". Copper, 13¾″. See page 119.

PLATE LXXIII.

235. Rājrājeśvara, Tanjore, central *vimāna* and *mukha-maṇḍapam* from the east. Ca. 1000 A. D. See page 122.

236. A *gopuram* of the great temple of Sundareśvara and Mīnākṣī at Madura. Masonry below, brick and stucco above. Seventeenth century. See page 124.

237. The great temple at Tiruvannāmalai. All of the conspicuous tall structures are *gopuras*; the principal shrines are small *vimānas* scarcely distinguishable in the centre of the right hand part of the enclosure. The *gopuras* are of the Cola and later periods. See page 122.

PLATE LXXIV.

238. Detail of the Subrahmaṇiya temple, Tanjore. Eighteenth century. See page 124.

239. Part of a *maṇḍapam* at Auvaḍaiyar Kovil. Observe the elaborated corner of the roll cornice, and imitation of wooden forms beneath it, also the columnettes of the corner pillar. Typical Vijayanagar style, fourteenth century. See pages 123, 124.

240. Monolithic pillars of the *maṇḍapam* at Śrīraṅgam, Trichinopoly, with horsemen spearing leopards, &c. Seventeenth century. See page 124.

241. A *sthapati*, in charge of the erection of a temple at Auvaḍaiyar Kovil, 1907 A. D., with the elevation of a pillar and superstructure drawn on a wall according to *śāstraic* rules. See page 124.

PLATE LXXV.

242. Naṭarāja, from Southern India, now in the Museum of Fine Arts, Boston, no. 21. 1829. The deity is three-eyed and four-armed, the l. r. hand in *abhaya mudrā*, the u. r. hand holding the drum (*ḍamaru*), the u. l. hand holding a flame, the l. l. hand and arm in the *ḍaṇḍa* or *gaja hasta* position. In his spreading locks can be seen the figures of Gaṅgā and the digit of the moon. He dances on a prostrate dwarf, a survival of the old Yakṣa *vāhanam*, here representing Mala, "ignorance" or illusion. The encircling fiery halo (*tiruvāsi*) is lacking. Copper, 2′ 5⅞″. Seventeenth century. See page 126.

PLATE LXXVI.

243. Sundara-mūrti Svāmi, Śaiva boy-saint. From Poḷonnāruva, now in the Colombo Museum. Copper, 1′ 2⅝″. Twelfth or thirteenth century. See pages 126, 167.

244. Devī (Umā, Pārvatī, Śivakāmī), seated at ease, the r. hand in *kaṭaka hasta* as if holding a flower. From Southern India, now in the Museum of Fine Arts, Boston, no. 21. 1827. Copper, 1′ 4⅝″. Fourteenth century? See page 126.

245. Figures of Kṛṣṇa Deva Rāya of Vijayanagar, and his two queens, in the Śrīnivāsa-Perumāl temple at Tirumala, Tirupati. Copper. Eearly sixteenth century. See pages 123, 126.

246. Viṣṇu, from Southern India, now in the Museum of Fine Arts, Boston, no. 21. 1833. Brass, 1′ 1″. Fourteenth century? See page 126.

247. River-goddess or Vṛkṣakā (the two motifs are combined, the tree proceeding from the mouth of the *makara vāhanam*, and being prolonged into a decorative scroll). Door jamb, north *gopuram*, Rāmasvāmi temple, Tāḍpatri, Anantapur District. See page 124.

248. Śiva, Gajasaṁhāra-mūrti, part of a monolithic pillar in the Śiva temple at Perūr, Coimbatore District. The deity is eight-armed and stands in a dance pose on the head of the elephant of which the skin forms the oval frame within which the figure is enclosed. Seventeenth century. See page 126.

PLATE LXXVII.

249. Horizontal *makara toraṇa*, a gateway lintel, Bījāpur. Ca. 1100.

250. City wall and gateway, Dabhoi, Gujarāt. Ca. 1100. See page 113.

251. Jaina *kīrttistambha* at Chitor (Citauṛgaṛh), Mewār. 1440—1448 A. D. See page 111.

PLATE LXXVIII.

252. Gwāliar fort and palace; palace of Mān Siṅgh, ca. 1500 and Hāthī Pol on the left. See page 121.

253. Palace and garden at Dīg, Rājputāna. Built by Sūraj Mal, second quarter of the eighteenth century. See page 121.

PLATE LXXIX.

254. The old palace at Datiā, Bundelkhaṇḍ. Built by Bīr Siṅgh Dev of Orchā, early seventeenth century. The building is over a hundred yards square. See page 121.

PLATE LXXX.

255, a and b. Two leaves of a Gujarātī Jaina manuscript of the *Kalpa Sūtra*. Above, left, the Rāṇī Triśalā (afterwards mother of Mahāvīra) reclining behind the *pardah* (hence the separation of the two parts of the composition) listening to, right, the Interpretation of Dreams, with Rāja Siddhārtha enthroned and a Brāhmaṇ consulting a book; above, left, text in Jaina Nāgarī characters, and right, the Dīkṣā of Mahāvīra, with Indra in attendance, in landscape. Indicatory marginal sketches in margins. Now in the Museum of Fine Arts, Boston, no. 17. 2276. Paper, size of leaves 11″ by 3¾″. Fifteenth century. See page 119, and Coomaraswamy, 9 (4).

256. Detail of a Digambara Jaina ceiling painting, Jaina temple, Kāñcīpuram. With text in Grantha characters. Apparently scenes from the life of a Tīrthaṁkara. Perhaps eighteenth century. See page 119 note 1.

PLATE LXXXI.

257. Two pictures from Mr. N C. Mehta's Gujarātī manuscript of the *Vasanta Vilāsa*. Manuscript in scroll form on cotton. Width of manuscript 7¾″. Dated equivalent to 1451 A. D. See page 120; also Mehta, I, and Gangoly in O. Z., N. F., II, 1925.

PLATE LXXXII.

258. Kṛṣṇa expecting Rādhā, southern Rājput or Gujarātī painting, with Gujarātī text; "One of her companions is leading Rādhā forward, the slender Rādhā, branch of love, and many of her friends are with her, creeper and vine side by side; before them is a garden full of trees, and there is Kṛṣṇa, expectant of her coming". Features unusual or unknown in Rājput painting and of Gujarātī character are the representation of the eye in profile as if seen from the front, and the representation of bees, here of special significance both as designating Rādhā's lotus-face, and suggesting her glances making a "bee-line" for Kṛṣṇa, as in *Karpura-mañjarī*, II, 6. Now in the Museum of Fine Arts, Boston, no. 25. 426. Paper, 7″ by 9 ¼″. Sixteenth century. See page 129, and colour reproduction, Coomaraswamy 9 (5).

PLATE LXXXIII.

259. Sadh-malāra Rāgiṇī, superscribed *Śrī Rāga 3*. A *yogī* with a *vīṇā* seated on the roof of a house, feeding a peacock; clouds, rain, and lightning. Belongs to Rāgmālā series 2; reverse with a *dohā*. Now in the Metropolitan Museum of Art, New York. Paper, 5 ¾″ by 7⅞″. Late sixteenth century, or ca. 1600; pure Rājput (Rājasthānī) style. See page 129.

PLATE LXXXIV.

260. Lalitā Rāgiṇī, detail enlarged, a woman sleeping on a bed in a room. Costume: skirt, *colī*, and *sārī*, jewellery and large pompoms. From the same Rāgmālā series as fig. 258 and by the same hand. Now in the Museum of Fine Arts, Boston, no. 17. 2384. Paper, 2⅝″ by 3 ¼″. Late sixteenth century, or *ca.* 1600; pure Rājput (Rājasthānī) style. See page 129.

PLATE LXXXV.

261. Madhu-mādhavī Rāgiṇī, with superscribed Hindī verses alluding to the storm clouds and the "sweet, sweet rumbling of thunder", and their effect on the peacocks and on the lady's heart and desires. Now in the Museum of Fine Arts, Boston, no. 15. 53. Paper, 7″ by 9⅞″. Early seventeenth century. See page 129, and Coomaraswamy, 9 (5) and 10 (coloured reproduction).

PLATE LXXXVI.

262. Wall painting, Udaipur, Mewāṛ. Rājput, Rājasthānī, late nineteenth century. See p.129.
263. Pig-sticking. Rājput, Rājasthānī, from Jaipur. Collection of the author. Paper, 6″ by 8″. Modern, about 1900. See page 129.
264. Portrait of Mahārāja Abhai Siṅgh of Jodhpur, r. 1781—1806, enlarged detail. Now in the Museum of Fine Arts, Boston. No. 25, 427. Paper, 1¾″ by 1⅝″. Late eighteenth century. See page 130.
265. Head of Kṛṣṇa, coloured cartoon for a *Rās Līlā* composition. The complete work in the Mahārāja's Library, Jaipur; the cartoon now in the Metropolitan Museum of Art, New York. Paper, 18″ by 26″. See page 129, and Coomaraswamy, 8, pl. IX (coloured reproduction).

PLATE LXXXVII.

266. Scene from the *Rāmāyaṇa*, Siege of Laṅkā; Rāma, Lakṣmana, and Vibhīṣaṇa seated with Hanuman and Jambavān surrounded by the army of monkeys and bears, two Rākṣasa spies being brought in. Now in the Museum of Fine Arts, Boston, no. 17. 2745. Rājput, Pahāṛī, Jammū. Paper, 23 ½″ by 33″. First half of nineteenth century. See page 130.
267. Kṛṣṇa welcoming Sudāma. Rājput, Pahāṛī, Jammū. Collection of the author. Paper, 6¾″ by 11 ½″. First quarter of the seventeenth century. See page 130.

Plate LXXXVIII.

268. *Kāliya Damana*, Kṛṣṇa overcoming Kāliya; Nanda, Yaśodā, *gopas* and *gopīs* on land, Kṛṣṇa, Kāliya and Kāliya's wives in the whirlpool. Rājput, Pahāṛī, Kāṅgṛa or Gaṛhwāl. Collection of the author. Paper, 10″ by 7″. Late eighteenth century. See page 131, and Coomaraswamy, 8, pl. LIII (coloured reproduction).

269. *Gītā Govinda*. The scene is laid amongst low hills in the Vṛndāvana the Jamunā flowing in the foreground. On the left is Kṛṣṇa dallying with a bevy of *gopīs*; on the right, Rādhā, with the messenger (*dūtikā*) addressing her, and pointing to Kṛṣṇa. Rājput, Pahāṛī, Kāṅgṛā. In the collection of the author. Paper, 14½″ by 10½″. Middle or early eighteenth century. See page 131.

PLATE LXXXIX.

270. "Cowdust" (*Godhūlī*); Kṛṣṇa returning with the herds to Gokula at sundown, accompanied by other *gopas*, and by *gopīs* returning from Jamunā Ghāṭ; other *gopīs* looking down from balcony windows (*jharokhā*). Nanda seated with friends in a *barādari* above. Now in the Museum of Fine Arts, Boston, no. 22. 683. Rājput, Pahāṛī, Kāṅgṛā. Paper, 8½″ by 10¾″. Late eighteenth century. See page 131, and Coomaraswamy, 8, pl. LI (colour reproduction).

PLATE XC.

271. *Rās Līlā*, enlarged detail, representing a chorus of *gopīs*. Now in the Museum of Fine Arts, Boston, no. 17. 2618. Rājput, Pahāṛī, Kāṅgṛā. Paper, 3¼″ by 4″. Late eighteenth century. See pages 131, 132.

PLATE XCI.

272. Viṣṇu, from Kaśmīr, probably Avantipur. Now in the Pennsylvania University Museum, Philadelphia. Greenish slate, height 8¾″. Ninth century. See page 143, and Coomaraswamy in Museum Journal, Philadelphia, March, 1926.

273. Mask of the goddess or queen Mujunīdevī of a Rāja Hemaprakāśa with inscription in old Nāgārī and Śāradā characters. From a temple treasury Nirmaṇḍ, Kuḷū. Gilt brass. Ninth or tenth century. See Shuttleworth; Vogel 19; and page 108.

274. Hindū temple at Malot, Pañjāb, showing trefoil arches and elaborate pediments. The small structure on the top is modern. Eighth century. See pages 74, 108, 143.

275. Meruvardhanasvāmin temple at Pāṇḍreṇṭhān, Kaśmīr. Limestone. Built by the minister of king Pārtha (906—921). The Kāśmīrī style is here typically illustrated. See page 143.

PLATE XCII.

276—278. Copper images from Nepāl: see page 145.

276. Avalokiteśvara (Padmapāṇi). Now in the Museum of Fine Arts, Boston, no. 17. 2315. Copper, gilt and jewelled, 12³⁄₈″. Ninth century.

277. Viṣṇu: l. r. h. with fruit, u. l. h. with *gadā*, l. l. h. with *Saṅkha*. Now in the Museum of Fine Arts, Boston, no. 17. 2319. Copper, gilt and jewelled, 8¾″. Ninth or tenth century. Cf. B. É. F. E. O., 1922, pl. XXV.

278. Buddha, seated, the hands in *dharma-cakra mudrā*. Now in the Museum of Fine Arts, Boston, no. 17. 2317. Copper, gilt, 3¼″.

PLATE XCIII.

279. Painted cover of a Nepalese manuscript, detail showing two episodes of the *Vessantara Jātaka*, viz. the Gift of the White Elephant, and Madrī Devī with the two children in the carriage. In the collection of Professor Abanindronath Tagore, Calcutta. Wood, with tempera painting, length about 5½″, Twelfth or thirteenth century. See pages 146, 149, and cf. *Vessantara Jātaka* illustrations from Bhārhut (fig. 47), Gandhāra (fig. 93), Amarāvatī, Mīrān (fig. 284), Ceylon (Coomaraswamy, 1, pl. I).

280. Green Tārā, enlarged from a Nepalese manuscript of the *Aṣṭasāhasrikā Prajñāpāramitā*. Now in the Museum of Fine Arts, Boston, no. 20. 589. 1136 A. D. Palm leaf, width shown 2¼". See pages 146, 172 and M. F. A. Bull, no. 114.

281. Painted cover of the manuscript of fig. 280, detail enlarged, showing the Bodhisattva Mañjuśrī, riding on a horned lion (*sārdula*), with attendants. Wood, with tempera painting, area shown 2½" by 2½". 1136 A. D. See pages 146, 172, and M. F. A. Bull, no. 114.

282. Painted cover of a Bengālī manuscript, representing Kṛṣṇa with the flute, under a *kadamba* tree, with *gopīs*, and wild deer attracted by the sound. Wood, with tempera painting. About 12" by 5½". Eighteenth century.

PLATE XCIV.

283—285. Khotān paintings of Indian character:

283. Water-nymph. Fresco at Dandān Uiliq. Before the eighth century. Stein, 4, pl. 11. See pages 65, 150.

284. *Vessantara Jātaka*, gift of the White Elephant. Fresco at Mīrān. About the fourth century. Stein, 7, fig. 137. See pages 55, 149; cf. figs. 47, 93, 279.

285. Maheśa or Sadāśiva, here perhaps Lokeśvara. Panel from Dandān Uiliq, now in the British Museum. Wood, with tempera painting. Stein, 4, pl. LX. See pages 100 note 1, 149.

PLATE XCV.

286. Stele with two elaborated forms of the *puṇṇa-ghaṭa* or "full-vessel" motif, and a Nāga and Nāginī. Abhayagiriya Dāgaba, so-called, Anurādhapura, Ceylon. Dolomite. Ca. 300 A. D. See page 162.

287. Sat Mahal Pāsāda. Polonnāruva, Ceylon. Brick. Twelfth century. See page 165.

288. "Moonstone", *Irihaṇḍa-gala* (doorstep of a temple or monastery). Lotus centre, floral borders alternating with *haṁsa* and elephant, horse, lion and bull bands. Anurādhapura, Ceylon. Granulite. Fifth century A. D. (?).

PLATE XCVI.

289. Head of a Bodhisattva. From Anurādhapura, now in the Colombo Museum. Dolomite. Ca. 200—300 A. D. See page 161.

290. Head of a Bodhisattva, perhaps Avalokiteśvara. Dāgaba in the headdress. From Anurādhapura, now in the Colombo Museum. Dolomite. Ca. 200—300 A. D. See page 161.

291. Detail of fresco, figures of deities. Northern temple ("Demaḷa Maha Seya"), Polonnāruva. Twelfth century. See pages 161, 164, 177.

292. Model *dāgaba*, showing the basement, protected by guardian elephants, and *dāgaba* proper, consisting of "three-tier ornaments" or "bracelets" (*tun-māl pēsāwa* or *pēsā-walallu*), dome (*geba = garbha*, "womb"), square enclosure (*hataṟes kotuwa*) and pavilion of the deities (*dēvatā kotuwa = harmikā*), spire (*koṭa*) consisting of a solid condensed range of umbrellas (*sat = chatra*) and finial (*koṭa keṟella*). The form is that known as *Bubbulu* (bubble), most usual in Ceylon. On the platform of the Ruanweli Dāgaba, Anurādhapura, Ceylon. Dolomite. Second century B. C. (?). See pages 12 note 3, 30, and Parker, 2, pp. 336ff.

This is perhaps the actual "little *silāthūpaka*" built by Lañjatissa, 59—50 B. C. (*Mahāvaṁsa*, XXXIII, 24).

PLATE XCVII.

293. Standing figure of Buddha, on the Ruanweli Dāgaba platform (taken before 1906). Dolomite, over life size. About 200 A. D. (?). See page 161.

294. Statue of King Duṭṭha-Gāmaṇi, or a Bodhisattva, on the Ruanweli platform (taken before 1906). Dolomite, over life size. Ca. 200 A. D. (?). See page 161.

PLATE XCVIII.
295. Buddha seated in *jhāna*, the hands in *dhyāna mudrā*. Anurādhapura, Ceylon. Dolomite, over life size. Fourth century A. D. (?). See page 161.

PLATE XCIX.
296. Buddha seated, teaching, r. hand in *vyākhyāna mudrā*, left holding robe. Bronze, height 3′ 7″. From Badullā, now in the Colombo Museum, no. 13. 118. 289. Fifth or sixth century A. D. See page 166.
297. Avalokiteśvara, seated, teaching, the right hand in *vyākhyāna mudrā*. Dhyāni Buddha Amitābha in the headdress. Bronze, height 3 ½″. Eighth century. See page 166, and Coomaraswamy, 6 and 9 (4).
298. Jambhala (Kubera), seated, r. hand with a citron (*jambhara*), l. hand holding a mongoose (*nakula*) vomiting coins which fall into a pot; under the r. foot an overturned pot with more coins. Bronze, height 3⅛″. Eighth century. See page 166, and Coomaraswamy, 6 and 9 (4).
299. Vajrapāṇi, r. hand holding a *vajra*, l. hand on thigh, elbow extended as in the early Kuṣāna images. Copper, height 4¾″. See page 166, and Coomaraswamy, 6 and 9 (4).

PLATE C.
300. Pattinī Devī, or perhaps a Tārā. Eastern Ceylon. Copper gilt, height 4′ 9 ½″. Tenth century (?). See page 167, and Coomaraswamy, 6.
301. Parākrama Bāhu I, or a sage, reading. Poḷonnāruva, Ceylon. Rock-cut *in situ*, 11′ 6″. Not later than the twelfth century. See page 164, and A. S. C., A. R., 1906, p. 11 (suggests it may be Kapila).

PLATE CI.
302. Northern temple ("Demaḷa Maha Seya"), Poḷonnāruva, Ceylon; north outer wall with architectural façade and figures in niches. Brick, with stucco. Twelfth century. See pages 164, 196.
303. Thūpārāma Vihāra, Poḷonnāruva, Ceylon. Brick, with stucco, partially restored. Twelfth century. See page 164 note 2.
304. Waṭa-dā-gē, Poḷonnāruva, Ceylon. Stone and brick. Twelfth century. See page 165.

PLATE CII.
305. Nat Hlaung Gyaung, Pagān, Burma. Brick. 931 A. D. See page 170.
306. Ngakye Nadaun, Pagān, Burma. Brick, with green glazed tiles. Tenth century. See page 170.
307. Thatbinnyu, Pagān, Burma. Brick. Twelfth century. See page 169.
308. Bidagat Taik (library), Pagān, Burma. Brick. Eleventh century. See page 170.
309. Mahābodhi, Pagān, Burma. Brick. 1215 A. D. See page 170.
310. Shwe Dagon, Rangoon, Burma. Nineteenth century in present form. See page 171.

PLATE CIII.
311. Padmapāṇi. Fresco in the Nanda Mannya, Minnanthu, near Pagān, Burma. Thirteenth century. See page 172.
312. Devatā. Fresco in the Paya Thonzu, east shrine, near Pagān, Burma. Twelfth or thirteenth century. See page 172.
313. Mingalazedi, Pagān, Burma. 1274 A. D. See pages 170, 172.

PLATE CIV.
314. Brahmā, relief, Nanpayā, Pagān, Burma. Stone. Eleventh century. See page 171.
315. Buddha, in the Museum at Pagān. Bronze. Twelfth century.

316. Siddhārtha in his five storeyed palace, before the Great Renunciation, in the Ānanda pagoda, Pagān, Burma. Stone. End of eleventh century. See pages 170, 171.

317. Buddha, in the Ānanda temple, Pagān, Burma. Stone. End of eleventh century. See pages 170, 171.

PLATE CV.

318. *Dhamma-cakka*, from Prapathom, Siam. Stone. Fifth or sixth century. See pages 175, 176 note 1.

319. Bodhisattva, from Prapathom, Siam, now in the Samson Collection, Hamburg. Stone. Seventh or eighth century (?). See page 176 note 1, and Salmony, p. 9.

320. *Devadhamma Jātaka*, Wāt Si Jum, Sukhodaya, Siam. Engraving on stone. Ca. 1361 A. D. See page 177 and Fournereau, 2.

321. Head of Buddha, from Lopburi, Siam, now in the Samson Collection, Hamburg. Bronze, 4¾″. End of the twelfth century. See page 177; and Salmony, p. 22.

PLATE CVI.

322. Head of Buddha, from Siam, now in the Museum of Fine Arts, Boston, no. 25. 495. Stone, lacquered and gilt, 1′ 1¼″. Eleventh century. See page 177.

PLATE CVII.

323. Temple at Lopburi, Siam. Stone. Eleventh or twelfth century. A. D. See page 177.

PLATE CVIII.

324. Sandstone cella of slab construction, Préi Kuk, Kompoṅ Thoṁ, Cambodia. Indianesque or pre-Khmer, seventh century. See page 182, and Groslier, 6, 7.

325. Façade of brick temple, from the south, at Phnoṁ Bayang, Tréang, Ta Kèo Province, Cambodia. Indianesque or pre-Khmer, seventh century. See page 182, and Groslier, 6.

326. Brick tower, Bakong, Cambodia. Ninth century. See page 187.

327. A tower of the Bayon temple, Aṅkor Wāt, Cambodia. Stone. End of the ninth century. See pages 188, 189 and Dufour, and Carpeaux.

328. Left angle tower of the upper terrace, Aṅkor Wāt, Cambodia. Stone. First half of twelfth century. See pages 192, 193.

PLATE CIX.

329. Aṅkor Wāt, general view from the west from the causeway, within the outer wall, showing the galleries, and three of the five towers of the upper terrace. Stone. First half of twelfth century. See page 192.

330. The Bayon, Aṅkor Thoṁ, general view from the south, showing the central and surrounding towers. Stone. End of the ninth century. See page 188, and Dufour and Carpeaux.

331. Phiméanakas, Aṅkor Thoṁ, Cambodia. Stone. End of ninth century. See page 188.

PLATE CX.

332. Lokeśvara, Cambodian, now in the Stoclet Collection, Brussels. Black stone, 3′ 11″. Indianesque or pre-Khmer, sixth or early seventh century. See page 183.

333. Harihara, from Prasāt Andet, Cambodia, now in the Museum at Phnoṁ Peñ. Stone, 6′ 3″. Indianesque or pre-Khmer, early seventh century. See page 183.

PLATE CXI.

334. One of the four masks, probably of Śiva, from a tower of the Bayon, Aṅkor Thoṁ, Cambodia. Masonry *in situ*. Late ninth century. See page 189.

PLATE CXII.

335—338. Four Cambodian heads; see page 185:

335. Head of Buddha, Cambodian, now in the Sachs Collection, Cambridge, U. S. A. Sandstone, 9½″. Ninth century.

336. Head of a Bodhisattva (?), Cambodian, now in the Museum of Fine Arts, Boston, no. 20. 447. Stone, 9³/₈". Siamese period, fourteenth century.

337. Head of Śiva or a deified king, Cambodian, now in the Museum of Fine Arts, Boston, no. 21. 1072. Stone, 10½". Ninth or tenth century.

338. Head of a king, Cambodian, from the Moura collection, now in the Cleveland Museum of Art. Stone, 14¾". Eleventh century.

PLATE CXIII.

339. Apsarases, relief, inner wall of inner court, Aṅkor Wāt, Cambodia. First half of twelfth century. See pages 192, 193. Cf. Groslier, 9.

340. Part of the procession of an army, southern gallery, left side, Aṅkor Wāt, Cambodia. Middle twelfth century. See page 192.

PLATE CXIV.

341. Great temple at Mi-son, Campā. Brick. Early seventh century. See page 196.

342. Buddha from Dong-duong, Campā, now in the Museum of É. F. E. O. at Hanoï. Bronze. Third century A. D., perhaps of Indian or Ceylon origin. See page 197.

343. Crowned Buddha sheltered by the Nāga Mucalinda, from the Tours d'Argent, Binh Dinh, Campā. Bronze. See page 197.

344. Śiva, from Tra-Kiệu, Quang-Nam, Campā, now in the Museum at Tourane. Seventh century. Stone, 3' 11¼". See page 196.

PLATE CXV.

345. Caṇḍi Puntadewa, Dieng, Java. Stone. Seventh or early eighth century. See page 202.

346. Caṇḍi Bīma, Dieng, Java. Seventh or early eighth century. Stone. See pages 80, 202.

347. Borobodur, from the air. Stone. Probably late eight century. See page 203.

348. Caṇḍi Loro Jongrang, Prambanam, Java; the Śiva temple. Stone. Late ninth century. See page 206.

PLATE CXVI.

349. Borobodur. Probably late eighth century. See page 203.

350. Caṇḍi Mendut. Probably late eighth century. See page 203.

351. Temple gateway, Batur, Bali. Limestone. Eighteenth or nineteenth century. See p. 210.

352. Panataran, Java; the main shrine (triple basement only) is in the rear. Fourteenth to fifteenth century. See page 209.

PLATE CXVII.

353. Buddha tempted by the daughters of Māra, Borobodur, Java. Probably late eighth century. See pages 203, 204.

354. Hāritī ("the Buddhist Madonna"), Caṇḍi Mendut. Late eighth century. See page 203.

355. Head from Caṇḍi Bīma, Dieng, Java. Stone. Seventh or early eighth century. See page 202.

356. *Rāmāyaṇa* frieze, Śiva temple, Caṇḍi Loro Jongrang, Prambanam, Java. Late ninth century. See page 206.

PLATE CXVIII.

357. Buddha, in Caṇḍi Mendut. Probably late eighth century. See page 204.

358. Arapacana Mañjuśrī, Java, now in the Museum für Völkerkunde, Berlin. Basalt, 3' 6". Dated equivalent to 1343 A. D. See page 208.

359. Agastya, from Caṇḍi Banon, *afd.* Magelan, Kadu, Java, now in the Museum at Batavia, no. 63c. Stone. First half of ninth century. See pages 68, 206; and cf. Durvasa Maharṣi in the Dhenupureśvara temple, Palleśvaram (A. S. I. photo D. 75). See also Gangoly, 4.

360. King Erlaṅga, in the form of Viṣṇu, riding on Garuḍa, from Belahan, now in the Museum at Mojokerto, Java. Stone. Ca. 1043 A. D. See pages 185, 207, and Krom, 2, p. 410.

PLATE CXIX.

361, 362. Two Bodhisattvas, from Pesindon, *afd.* Wonosobo, Kedu, Java, now in the Museum at Batavia, nos. 498a and 499. Gold. Eighth or ninth century. See page 206.

363. Padmapāṇi, seated in *mahārājalīlāsana* on a lion throne, from Java, now in the British Museum. Copper. See page 206, and Coomaraswamy, 15.

364. Hevajra, dancing, from Bantéai Kedei, now in the Museum at Phnoṁ Peñ, no. E 329. Bronze, 1″1½″. Ca. tenth century. See A. A. K., 1, pl. XXXV.

365. Apsaras, dancing, probably from the Bayon, Aṅkor Thoṁ, Cambodia, now in the Museum of Fine Arts, Boston, no. 22.686. Bronze, 15½″. Late ninth or early tenth century. See page 189.

PLATE CXX.

366. Caṇḍi Jābung, north-west side; *dist.* and *afd.* Kraksan, Pasuruwan, Java. Tenth century(?). See page 208.

PLATE CXXI.

367. Mask, used in dramatic performances, Central Java, in the possession of the author. Wood, painted, 7″. Eighteenth or nineteenth century. See page 211 note 4.

PLATE CXXII.

368. Earring (*jhumkā*), northern India, now in the Museum of Fine Arts, Boston, no. 17.831. Gold filigree, 2″. Eighteenth century. See page 135.

369. Earring, south Indian, now in the Museum of Fine Arts, Boston, no. 01.6541. Gold, 2¼″. Eighteenth century. See page 135.

370. Reverse of an Rām-nomī pendant, Jaipur, now in the Museum of Fine Arts, Boston, no. 21.1660. The obverse has a representation of Rādhā, Kṛṣṇa and cows in the Vṛndāvana. Enamel on gold, 1¼″. Eighteenth or early nineteenth century. See page 135.

371. Armlet, with figures of Rāma, Sītā and Lakṣmaṇa. Formerly in the Goloubew collection. Enamel on gold. See page 135.

372. Bracelet, Jaipur, now in the Museum of Fine Arts, Boston, no. 21.1662. Red, green sky blue and white enamel on gold, dia. 3⅜″. See page 135.

373. Gold filigree beads, Kandy, Ceylon. Eighteenth century. Author's collection. See page 168.

374. Gold bead with figures of deities, attached to a *Rudrākṣa-mālā*, worn by a Brāhmaṇ priest in Southern India. See page 136.

~75. Clasp of a necklace, from Ceylon (Tamil or Siṁhalese), now in the possession of Stella ʼloch. Gold. Eighteenth century. See pages 12 note 9, 135, 168.

, CXXIII.

Pendant, known as *kurulu-padakkama*, belonging to the Dambevinne family, Kandy, Ceylon. Gold, set with cabochon rubies, &c., width 2¾″. See page 135, 168.

. Comb (*irkoḷḷi*), with handle composed of four deer with two heads, south Indian, now in the Victoria and Albert Museum, London. Brass, 8⅝″. Seventeenth or eighteenth century.

8. Part of a knife (*keṭṭa*), Kandyan Simhalese, owned by A. R. Casse Lebbe, Kandy. Silver pierced and repoussé, *liya pata*, *liya veḷa*, *sīnamala* and *ṣerapēṇdiya* motifs. Eighteenth century.

379. *Huqqa* bowl, Lucknow, present ownership unknown. Enamel on silver. See page 135.

380. Bronze bell, from Gunung Rongsa, *afd.* Malang, *res.* Pasuruwan, Java. Now in the Museum at Batavia.

PLATE CXXIV.

381. *Dalamura taṭuva*, ceremonial betel tray, in the Daḷadā Māligāwa, Kandy, Ceylon. Gold, set with cabochon sapphires, dia. 13⅝". Said to have been dedicated by the mother of Kīrti Śrī Rāja Siṁha. Eighteenth century. See pages 134, 168.

382. *Huqqa*-bowl, North Indian, now in the Victoria and Albert Museum, London. *Bidrī*, inlaid with gold and silver (with Mughal influence or for Mughal use), 7¼". Seventeenth century. See page 134.

383. *Huqqa*-bowl, North Indian. Brass. Seventeenth century. Author's collection. Cf. p. 134.

384. Spittoon, north Indian. Brass, inlaid with niello and silver, 4". Seventeenth century. Author's collection. See page 134.

385. *Ran-vaṭaha-pata*, ceremonial votive fan, Daḷadā Māligāwa, Kandy, Ceylon. Gold, set with cabochon sapphires, 17½". Said to have been dedicated by Kīrti Śrī Rāja Siṁha. Eighteenth century. See pages 134, 168.

386. *Killotaya* ("betel-box") for lime, from Kandy, Ceylon, now in the Colombo Museum. Copper, inlaid with silver, dia. 2". See page 134.

PLATE CXXV.

387. Detail of a small two-wheeled carriage, Tanjore palace. Ivory veneer, engraved and inlaid with coloured lac. Seventeenth or eighteenth century. See page 136.

388. Plaque from the base of a door jamb, Ridī Vihāra, Ceylon. Seventeenth a eighteenth century. Ivory. See page 136.

389. Detail of another small two-wheeled carriage, Tanjore palace. In centre, ivory plaque representing a *sarja anna paḍçi* (= Siṁh. *sēra-pēndiya*). Seventeenth century. See p. 136.

390. *Hak-geḍiya*, a conch, engraved and inlaid with lac, brass mounting with gold and silver inlay, terminating in a *sērapēndiya*. Said to have been made for Narendra Siṁha and dedicated by him to a *devāle* in Uḍanuwara, Ceylon. Collection of Leslie de Saram, Colombo. Eighteenth century. See pages 134, 137.

391. Part of a book cover, with *picca mala* design, from a Kandyan library. Wood, painted.

392. Three bead bags, Kāṭhiāwāḍ, now in the Museum of Fine Arts, Boston: *svastika*, Lakṣmī, and elephant designs.

PLATE CXXVI.

393. Part of a *paṭola* silk *sārī*, Surāt, now in the Museum of Fine Arts, Boston. Eighteenth or early nineteenth century. See page 138.

394. *Kimkhwāb*, gold brocade, Benares, now in the Museum of Fine Arts, Boston. Eighteenth century. See page 138.

PLATE CXXVII.

395. Part of an embroidered turban, Rājputāna, now in the Museum of Fine Arts, Boston, no. 21.1734. Silk and gold on cotton. Seventeenth or eighteenth century. See p. 140.

396. Part of a *paṭiya*, a belt, with archaic designs; in the possession of Tiboṭuvava Maha Nayaka, Malvaṭṭe, Kandy, Ceylon. Cotton, width 8½" (total length 6' 3"). Eighteenth century. See page 168.

397. Part of an embroidered skirt, Kāṭhiāwāḍ, now in the Museum of Fine Arts, Boston. Silk. Early eighteenth century. See page 140.

PLATE CXXVIII.

398. *Batik*, Central Java, now in the Museum of Fine Arts, Boston. Twentieth century.

399. *Kain prāda*, batik with gold design impressed, from Bali, detail, now in the Museum of Fine Arts, Boston. Nineteenth or twentieth century. See page 139.

400. *Sienggi kombu*, garment from Sumba, now in the Museum of Fine Arts, Boston, no. 21.1659. *Ikat*-woven cotton, 6' 3" by 3' 9½". Twentieth century. See page 137.

I

Dabhoi
Narbada - R.
Surat
Nāgpur
Rāipur
Rajim
Pitalkhora
Ajantā
Ellora
Nasik
Kanherī
Karlī
Bombay
Elephanta
Bhājā
Bedsā
Ter
DEKHAN
Warangal
Gulbarga
Bijapur
Haidarābād
ĀNDHRAS
EST CĀLUKYAS
Jagayyapeta
Bezwada
Godavari - R.
Bādāmī
Paṭṭakadal
Aihole
Amarāvatī
Guntur
Goa
Dhārwār
Bellary
Tādpatri
Sitra - R.
Gudimallam
Tiruvalūr
Madras
Vellore
Māmallapuram
Mysore
Kāñcipuram
Srāvana
Belgola
Tiruvannāmalai
Cidambaram
Kāveri R.
Trichinopoly
Tanjore
Negapatam
Sittanavāsal
Madura
Jaffna
Trivandrum
Rāmeśvaram
Anurādhapura
Poloñnaruva
Sīgiriya
Kurunegala
Colombo
Kandy
CEYLON
Mahāgāma

Ganges - R.
KALINGAS (ORISSA)
Udayagiri
Bhuvaneśvara
Khandagiri
Puri Konārak
Mahanadi - R.
Kuṭṭada
Ghaṇṭaśāla
Sāḷipatam
Kistna - R.
W. CĀLUKYAS
CERAS
TRAVANCORE
PALLAVA
COLAS
PAṂDYAS

SOUTH-INDIA

255

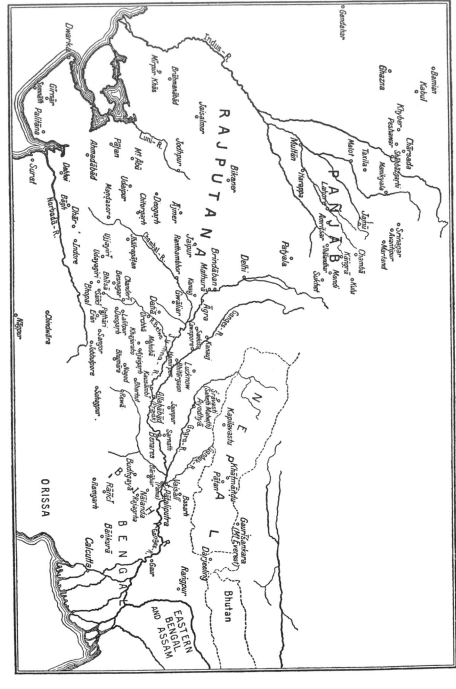

NORTH-INDIA

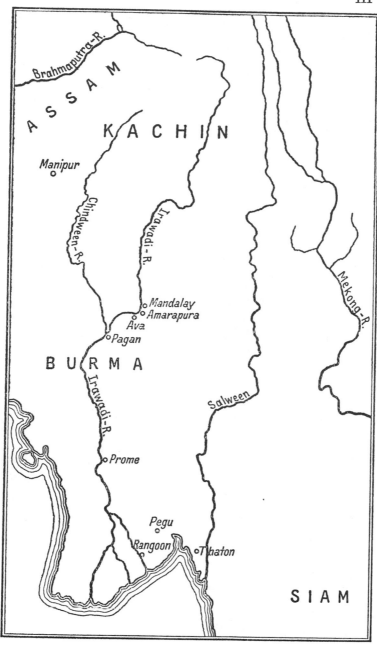

BURMA

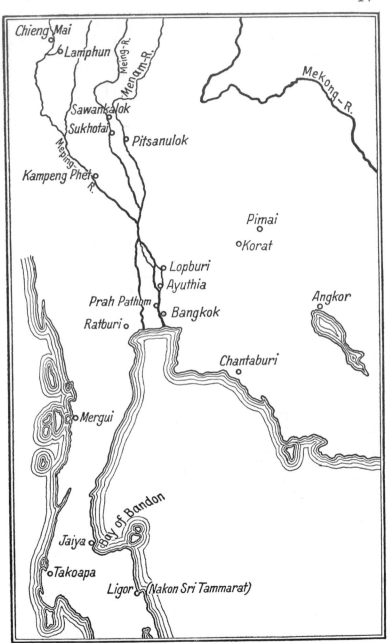

Chieng Mai

Lamphun

Meing-R.

Menam-R.

Mekong-R.

Sawankalok

Sukhotai

Pitsanulok

Meping-R.

Kampeng Phet

Pimai

Korat

Lopburi

Ayuthia

Prah Pathom

Bangkok

Ratburi

Angkor

Chantaburi

Mergui

Bay of Bandon

Jaiya

Takoapa

Ligor (Nakon Sri Tammarat)

SIAM

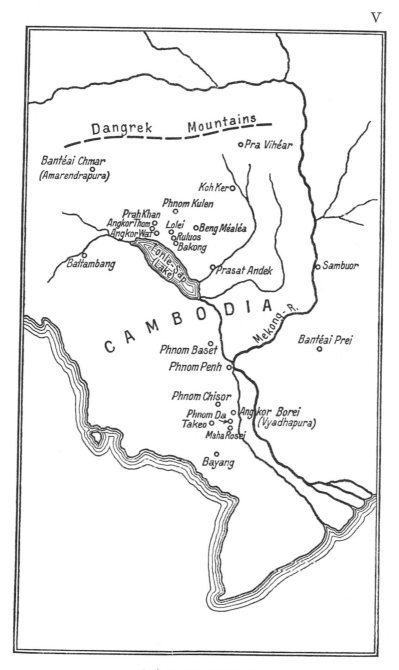

CAMBODIA

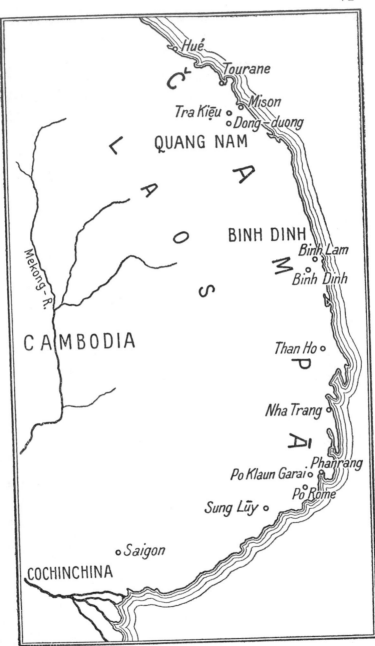

CAMPĀ

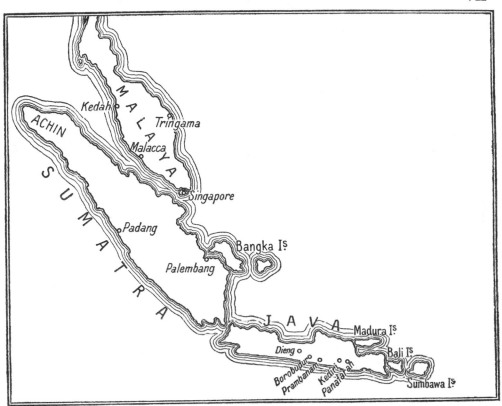

MALAYA · SUMATRA · JAVA

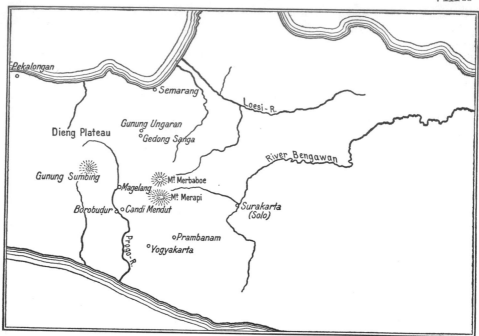

CENTRAL JAVA

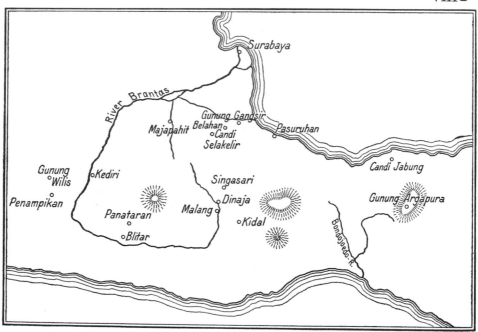

EAST JAVA

GENERAL INDEX

As a rule names of authors have been mentioned only when they occur in the text itself, mere references made to them in the foot-notes being omitted.

Amarapura, Burma 173, 174
Amarāvati 23, 33, 38, 46, 62, 65, 69—72, 84,
 101, 104, 122, 161; figs. 97, 136—141,
 144—146
Amarendrapura, Cambodia 186
Āmb, Shāhpur Dist. 108
Amber palace 121
Amida, Japanese Buddha 155
Amin, Karnal District, Śuṅga remains 32
Amoghabhūti, Kuṇinda, of Kāṅgṛa 44, 45;
 fig. 115; see also Coins
Āmohinī 37
Amrith (Marath), North Syria 12
Amritsar 117, 127
Ānanda, disciple of Buddha 34
Ānanda, statues of 163, 164
Ānanda (pagoda), Pagān 170—172; figs. 316,
 317
Ananta Gumphā 37
anāsaḥ = noseless, designating Dravidians? 5
Anawratā (Aniruddha), Burmese king 170
Ancestors, honoured by dedications 189
— deification 19, 23, 30, 185
— portrait statues 43, 185, 207
— portrait statues of royal ancestors 48, 67,
 185, 189
aṇḍa, see Architecture
Āndhra period 6, 11, 15, 23, 30, 35, 38, 49,
 67, 69, 70, 76, 101, 126; figs.: Early
 Āndhra 30, 31, 34, 35, 51—56, 63, 72, 75,
 142—146; Later Āndhra 94—97, 135
 to 141
Anhillavāḍa-Pātan (Gujarāt) 93, 111
A-ni-ko, Nepalese artist in Tibetan 147, 153

Animals, actual or mythical:
— Avatārs of Prajāpati 41
— birds 12, 42, 45, 55, 137, 139; see also
 Garuḍa
— bull 4, 17, 18, 25, 26, 29, 31, 41, 44, 45,
 49, 50, 67, 103, 118, 137, 161, 162, 187,
 188; figs. 2—4, 14, 26, 33, 105, 109, 122,
 288
— cat 103
— cātakas 150
— camel 45
— centaurs 11, 50
— chank 4, 6, 7, 136
— cobra 45; figs. 76, 166
— conch 4, 6, 134, 136; figs. 165, 390

Animals, deer 11, 31, 38; fig. 7
— dog 45
— duck 121
— eagle, see Symbols
— elephant (hātki, nāga, gaja) 4, 17, 18, 20,
 25, 26, 29, 31, 38, 45, 49, 50, 101, 103,
 116, 118, 121, 137, 161, 162, 182, 187,
 188, 189, 192; figs. 5, 11, 27, 28, 30,
 35, 46, 47, 54, 71, 75, 93, 114, 248, 279,
 284, 288, 292, 392; see also Airāvata,
 Gaja Lakṣmī
— fantastic, Sumerian and Mesopotamian
 relations 4, 11
— fish 36, 45, 101, 162; figs. 57, 106, 107
— Garuḍa, mythical bird and semi-human
 vehicle of Viṣṇu 45, 50, 100, 101, 144,
 186, 188, 207; figs. 196, 360
— griffons 11
— haṁsa, sacred goose or swan 18, 50, 54,
 160, 184; figs. 89, 288
— horse 4, 7, 11, 17, 18, 25, 33, 41, 44, 45,
 50, 67, 68, 116, 124, 161, 162, 188, 189;
 figs. 26, 61, 103, 131, 220, 240, 279, 288
— kīrttimukha, grotesque mask 77, 104, 105,
 202, 203
— lion (siṁha, rachi si) 11, 17, 18, 29, 36, 37,
 45, 50, 57, 58, 68, 102, 104, 123, 124,
 161—163, 179, 187, 188; figs. 12, 42, 83,
 84, 129, 166, 288, 363; see also śārdula,
 siṁkamugam
— makara, crocodile 34, 45, 50; figs. 177, 247
— mice 103
— monkey 31, 103
— nora-singh, manlion 179
— on toraṇa 55
— panther 116, 123; fig. 220
— peacock 45, 140; figs. 108, 175, 259, 261
— rhinoceros 3, 45; fig. 107
— śārdula, horned lion 101, 118, 161; fig. 281
— Scythian animal style 24
— siṁhamugam, lion-face 104
— snake 43, 68, 69, 150; figs. 110, 113; see
 also Nāga
— squirrel fig. 82
— tiger 4, 44, 121, 123
— tritons 11
— yāli, vyāla 102, 118, 124
— with interlocking necks, of Sumerian
 kinship 11

Buddha, Nālandā 113; fig. 233
— Nara 93
— Nāsik 28, 98
— Nepal 145; fig. 278
— Pagān 170, 171; figs. 315, 317
— Parinirvāṇa images 74, 98, 173
— Pāṭaliputra 58
— Rājagṛha 59
— Romlok, Cambodia 76, 182; fig. 100
— Saheth-Maheth 58
— Sāñcī 85
— Sarnāth 85; fig. 161
— shaven head 37, 61, 74, 150; fig. 162
— Siam 177; figs. 321, 322
— Sultāngañj 74, 85, 167; fig. 160
— supposed early anthropomorphic repre-
 sentations 33, 43, 59, 60, 161
— with shoulder flames 22, 60
— see also Bodhisattva, Bodhi-tree, Graeco-
 Buddhist art, Mathurā, *mudrā, urṇā, usnīsa*
Buddhaghoṣa 169
Buddha-tree, see Boddhi-tree
Buddhisme; "Buddhist India" a fallacy 72
— Mahāyāna 113
— in relation to Śaivism 113, 190
— Tāntrik 113, 114, 148
Bull, see Animals
Bundelkhaṇḍ 121, 127—133; see also Raj-
 putāna
Buniār, Kasmīr, temple 143
Burgess, J. 39
Burma 169—174; figs. 305—317

cābutra, see Architecture
cādar, see Costume, Textiles
Caitu, see Craftsman
Caitya, cetiya, a sanctuary, holystead or shrine
 such as a sacred tree, a tower, or *stūpa*
 47
caitya-halls, mentioned 6, 12, 18, 21, 28—30,
 36, 38, 39, 40, 48, 69, 75—77, 89, 96,
 104, 141, 185; figs. 29—35, 91, 135, 145,
 146, 149, 154, 155, 189; see Architecture
caitya-vṛkṣa, sacred tree 26, 30, 41, 45, 47,
 151; figs. 10, 27, 110, 111, 114, 115;
 see also Architecture, Symbols
— *Yakkha-cetiya* 47, 48, 125
cakra, see Symbols, *dharma-cakra*
Cakravārtin 41

Caḷukya dynasty 94—99
— early 77—79, 94—99, 157, 201; figs. 156
 to 157, 185—188; see also Costume
— style 116, 121
— later (Coḷa) 105 ff., 165, 166; figs. 233 to
 235, 237
Camel, see Animals
Cambodia 180—195; figs. 100, 324—340,
 364, 365
Campā 195—198; figs. 341—344
campākālī, jasmine-bud necklace 20
Cāmuṇḍa Rāja, Hoyśala 118
Candela 105, 109, 110
Caṇḍi, Javanese designation of temples
Candragupta, Gupta king 24, 71; figs. 129,
 132; see also Coins
Candravatī, queen 164
Candrehe, Rewā 109
cankrama, see Architecture
Caṅkuṇa, minister of Lalitāditya 205
Cañyalu, Java 201
Carnelian 4, 159
Caṣṭana, Āndhra king; portrait statue 66
Cat, see Animals
cātaka, see Animals
Catisgāoṅ, see Chittagong
Caucasus, Northern 3
Cauṅsat, Joginī temples 110
caurī-bearer 17, 25, 26, 46, 172; figs. 10, 17,
 24, 84
Centaurs, see Animals
cetanā see Aesthetic, Painting
Ceylon 156—169; figs. 286—304
Chakdana 19
Chalcolithic, culture 3
Chanda, R. 34
Chandimau 86
Chaṇḍor tombs 122
Changu Nārāyan, Vaiṣṇava temple at 144
Chank, see Animals
Chapels, see Architecture
Chapra, Rājshāhī Dist. 114; fig. 227
Chārsada (Haṣṭnagar) 12, 52, 55, 73
chatra, chatta, see Symbols
chatrī, see Architecture
Chatrāṛhi, Cambā 108
Chenla = Cambodia 184
Chezārla, Kistna dist., *caitya*-hall 77; fig. 147
Chieṅmai, N. Siam 176, 177

Kapila, Ceylon sage 162
Kapilavastu 89, 91; fig. 179
Kapiśa, Afghānistān 49
Kapīśa Avadāna, see Texts
Kapoteśvara temple, Chezārla 77; fig. 147
Kārlī; *caitya* hall 28, 29, 69, 74, 85; figs. 34, 35
kārṣāpana, see Coins, punch-marked
Kārttikeya, see Skanda
karuṇā-rasa 91
Kasiā (Kuśinagara) 74, 84, 87
kasida, see Textiles
Kaśmīr 15, 49, 52, 55, 61, 69, 73, 74, 82,
 141—143, 149, 153; figs. 272, 273, 275
— Pāla bronze 114; fig. 232
Kassapa I, Ceylon 162, 163
Kassites 7
kasūri, see Textiles
Kaṭāha (Kiḍāra, etc.) 199
Kathāsarit-Sāgara, see Texts
Kaṭhiāwāḍ, caves 77; figs. 392, 397
— textiles 139, 140; fig. 397
Kaṭoch dynasty of Kāṅgrā 131
Kaṭupilana 162
Kaundinya 180, 181
Kauśāmbī, see Kosām
Kauthāra, Campā 195
Kāverīpumpaṭṭanam 44, 101
kāyotsarga 118
Kedah, Malayu 175, 200
Kelaṇija Vihāra 168
Kerala (Malabar) 10
Kertanagara, "Sivabuddha", East Javanese
 king 200, 201, 208
Keśava Dās 131
— temple, Somnāthpur 110, 117
Kesiman, Bali, temple 210
Ketu 43
Khadāliq, Khotān 149
Khajurāho, Bundelkhaṇd 64, 109, 110; fig. 214
Khalybes 7
Khaṇḍagiri, Oṛissa 37, 38; fig. 36
khañjarī, see Textiles
Khāravela, Kalinga king 23, 30, 37, 43
Kharoṣṭhī script, see Inscriptions
Khmer and pre-Khmer type 7, 76, 175—177;
 fig. 100
Khmer, Origins 180, 184, 188
— see Cambodia
Khoh, Nagoḍh State 78, 86

khon, see Theatre
Khotān 66, 69, 148, 150, 154; figs. 283
 —285
Kidal, Caṇḍi, Java 208
kimkhwāb, see Textiles
Kīrti Śrī Rājasiṁha 168
kirttimukkha, see Animals
kīrttistambha, Chitor 111; fig. 251; see also
 Architecture
Kīrttivarman, Pala king 110
Kish, Sumerian faience seals 4
Kistna-Godāverī delta (later Veṅgī) 21, 23, 38,
 106; see also Veṅgī
Kiu-su, Campā 195
Kiyul, arch 77
Koh Ker, Cambodia 190
kolan, Cam wooden temple type 197
Kompoṅ Sway 191
Koṇāraka 64, 79, 115, 116; figs. 217, 220
Kon Wewa 165
Kondāñe 28
Kondawgyi, Pagān 170
Kondivte, Western India 18, 19, 38
Kont Guḍi, Aihole 79
Koraṅganātha temple 122
Korat, Siam 177, 194
Korea 154
Korkai 6
Kosām (Kauśāmbī) 21, 32, 37, 86; figs. 60,
 110, 111
Kramrisch, St. 127
Krom, N. J. 207

Kṛṣṇa, mentioned 66, 69, 86, 103, 106, 123,
 124, 127—129, 131, 206; figs. 102, 166,
 178, 245, 258, 265, 267—270, 282
— Dān Līlā 69
— Dēva Rāja 106, 123, 124; figs. 245, 258
— Dudhādhārī 103
— Govardhanadhara 66, 69, 103; figs. 102,
 166
— incarnation of Viṣṇu 127, 167
— Līlā 66, 69, 86, 128, 129, 131; figs. 265,
 267—270
— nativity 86; fig. 178
— with the flute 131; figs. 270, 282
— and Rādha, see Kṛṣṇa Līlā
— see also Viṣṇu
— II, Rāṣṭrakūṭa king 99
Kṛṣṇāyana, see Texts

Phnoṁ Bakeṅ, Cambodia 190, 191, 205
— Chisor, Cambodia 192
— Da, Cambodia 182, 184
— Peñ, Cambodia 84, 186, 194
Phoenizian tombs 12
phūlkārī, see Textiles
Piṇḍapātra Avadāna, see Texts
pippala, aśvattha, sacred fig, ficus religiosa
 4, 31, 47; fig. 6
— see also Bodhi-tree, *nyagrodha*
Piprāwā 12, 73
Pitalkhorā 28, 29
pīṭha, pedestal 41; see also Images
— *siṁhāsana,* lion throne 57
Pitsanu, see Viṣṇu
Pitsanulok, Siam 175, 176
Plaosan, Caṇḍi, Java 206
Plaques 10, 20, 21, 37, 42, 65, 80, 81, 136,
 172, 173, 196; figs. 2—6, 62, 71, 105, 388
Po Klaun Garai, Campā 197
Poḷonnāruva (Pulatthipura), Ceylon 73, 126,
 159, 163—167, 196; figs. 243, 287, 291,
 301—304
Polynesian elements in Indopersian art 200,
 208, 209
Po Nagar, Campā 197, 198
Ponambalavāneśvaran Kovil, Colombo 125
Porcelain 178—179, see also Pottery
Po Rome, Campā 198
Porus 42
"Pot and foliage", see Architecture, capitals
Potala, Mt. 147
Pottery 4, 6, 8, 12, 15, 168; see also Faïence,
 Porcelain
Pottier, E. 14
prabhā-maṇḍala, see Nimbus
pradakṣiṇā, see Architecture, circumambu-
 lation
Prāḥ Khān, Aṅkor Thoṁ 184, 186, 187
— Piṭhu, Aṅkor Thoṁ 188
— Vihéar, Cambodia 191, 192
Prajāpati 43
Prajñāpāramitā (Tārā) 208
prakāra, see Architecture
pralambapada, see *āsana*
Pramāṇam, see Aesthetic, appreciation
Prambanam, Java 79, 199, 203—207; fig. 348
prāṅg-type, see Architecture, terraces
Prapathom, Siam 175, 177; figs. 318, 319

Prasāt Andet, Cambodia 183; fig. 333
pratikṛti, see Images
pratimā, see Images
Pratimānāṭika, see Texts
Préi Kuk, Cambodia 182; fig. 324
Pré Rup, Cambodia 190
Primitives 71
Pringapus, Caṇḍi, Java 203
Prome (Pisanu Myo, Śrīkṣetra), Burma 169,
 172, 174
Przyluski, J. 60
Pṛthvī 42
Puḍu Maṇḍapam, Madura 124
pūjā, ritual of devotional service 5, 17, 39,
 127; fig. 66
pūjā-śilā-prakāra, railed enclosure 22; see also
 Architecture, *prakāra*
Pūjārī Pālī, Bilāspur Dist. 80
Pulakeśin I, Cāḷukya 94, 99
Pulakeśin II, Cāḷukya 92, 94, 95
puṇṇa-ghaṭa, full vessel, fertility emblem 65;
 fig. 286; see also Fertility and Symbols
Puntadeva, Caṇḍi, Java 202; fig. 345
puṇya-śala, see Architecture
Puppets 174, 211
pur, city 5
Pura ye Ganga, temple, Bali 210
purāṇa, see Coins, punch-marked
Purāṇādhiṣṭhāna, see Pāndrenthān
Purī, Oṛissā 109, 115; fig. 218
Puritanical aesthetic 36
Pūrṇavarman, West Javanese king 200
— of Magadha 93
Purnea, near Murshidābād, Bengāl 134
Puṣkalāvatī, Afghānistān 49, 55, 73
pustakāśrāma, see Libraries
Puṣyamitra, Śuṅga 23
Pyathonzu 172
Pyus, Burmese proper 169, 172

Qalm, pen, style; see Textiles
Qalmdar, see Textiles
Quintus Curtius 34, 42

Rach Gia, S. Cambodia 183
rachi si, see Animals, lion
Rāden Pāñji, see Kāmeśvara
Rādha and Kṛṣṇa, see Kṛṣṇa Līlā
Radha Krishna, Pandit 56

siṁha, see Animals, lion
siṁhamugam, see Animals
siṁhasāna = lion-pedestal, see Animals, lion and pīṭha
Siṁhavarmaliṅgeśvara, see Śiva, *liṅgam*
Siṁhavarman, Pallava king 101
Siṁhaviṣṇu, Pallava king 101, 103
Simuka, Āndhra king; portrait statue 23
Sinbhua, Cawnpore Dist. 108
Siṅd valley 9, 73, 93
Siṅgasāri, Java 208
Sino-Tibetan migrations 7
śiraś-cakra, see Nimbus
Sirén, O. 152
Sirkap, Taxila 52, 54
Sīrpur, mediaeval temples 93, 108; fig. 186
Sirsukh, Taxila 54
śīśadār, see Textiles
śiśna, see Śiva *liṅgam*
Śītā 135; fig. 371; see also Rāmāyana
Śītāwaka 166
Sithammarat, Siam 178
Sittanavāsal 89, 102

Śiva (Maheśa, Maheśvara, Mahadēva, Naṭa-rāja, Sadāśiva, Saṅkara, Vaidyanātha) mentioned 3, 5, 8, 21, 22, 32, 39, 41 to 43, 45, 46, 48, 49, 50, 55, 61, 66—69, 78, 82, 86, 92, 95—100, 103—105, 107, 110, 114, 126, 127, 142, 143, 144, 148 to 150, 166, 167, 177, 186, 189—192, 194, 196, 197, 201, 202, 206, 208, 209; figs. 66, 68, 122, 125, 126, 171, 193—195, 198, 230, 242, 248, 285, 334, 337, 344, 356
— Ardhanārīśvara 67, 143
— attributes 43, 45
— Bhadreśvara 194
— bull deity of Puṣkalāvatī 49, see also Animals, bull, Nandi, Puṣkalāvatī
— development of type on coins and seals 45, 67, 68
— Harihara, see Harihara
— Iconography, see Iconography, development
— images mentioned, Patañjali 43; see also Images
— Kadphises II 67
— Kapaleśvara 191

Śiva *liṅgam*, *śiśna*, *mukha-liṅgam*, phallic-symbol 5, 32, 41, 67, 78, 86, 104, 105, 142, 189, 197; figs. 66, 68
— — colossal 82
— — prehistoric 5
— — mentioned by name:
 Bhadrapatīsvara 197
 Bhadreśvara 196
 Haṭakeśvara 197
 Kapaleśvara 191
 Parasuramesvara 39; fig. 66
 Śambhu-Bhadreśvara 197
 Siṁhavarmaliṅgeśvara 197
 Yaśodheśvara 190
— — from particular sites:
 Bhīṭā 32
 Cupuvatu 105
 Elūrā 99
 Guḍimallam 39; fig. 66
 Kuñjarakuñja 201
 Mathurā 67; fig. 68
 Pallava 104, 105
— connected with Lokeśvara 55, 95, 107, 149, 186, 189; figs. 171, 285
— Mahāyogī 191
— Maheśa, Sadāśiva: three-headed form, miscalled Trimūrti
— — References 55, 100, 103, 143
— — at Elephanta 8, 96, 100; figs. 194, 195
— — in Gandhāra 55
— — in Kaśmīr 142, 143
— — in Khotān and Far East 55, 148, 149
— — on coins:
 at Elephanta 100
 in Gandhāra 55
 in Kaśmīr 143
 in Khotan 55, 98
 of Śātakarṇi, Āndhra 67
 of Vāsudeva 55; fig. 126
— Naṭarāja, four-armed dancing image 3, 39, 97, 126, 167; figs. 126, 242
— — type described 126, 127
— his *pañcakṛtya* 127
— seals 67;
— Sikhareśvara, the "Lord of the Peak" 192
— temples, early 48, 66
— Umā-Maheśvara groups 21, 69, 86, 110, 114, 144; fig. 230

Śiva Vaidyanātha, "Lord of Physicians" 107
— with shoulder flames 61
Śiva adj. = Śaiva
Śivabuddha, see Kertanagara
Śivācārya, Brāhmaṇ 192, see also Craftsman
Śivamitra, see Craftsman
Six dynasties, China 152, 183
Skanda (Kārttikeya) 22, 43, 48, 67, 86, 167, 196; fig. 175
Skandagupta 71
slendang, see Textiles, kain
Smith, V. A. 49, 51, 74
Snake, see Animals
Śoḍāsa, satrap 24, 37
Sohāgpur 108, 109
Solanki (Cāḷukya) 111—113
Somā, Cambodian Nāginī 180, 181
Somanātha-Pāṭan, Kaṭhiāwāḍ 111
Somnāthpur, Mysore 110, 117
Sonāgaṛh, Jaina temples 116
Sona Tapan, near Bāṅkurā, Bengal 80, 108
Sonārī 18, 21
Sondani, Gwāliar 86; fig. 173
Song Luy, citadel, Campā 195
sopāna, see Architecture
Sornakkāḷai Āsāri, see Craftsman
Spooner, D. B. 51, 58
Śravaṇa Begoḷa 110, 118, 121
Śrāvastī 34, 58, 61, 87, 99, 190
śreni, see Craftsman, gilds
Śrī, Hindu goddess 31
Śrī Māra dynasty, Campā 195
Śrīkaṇḍi, Caṇḍi, Java 202
Śrīnaṅgams, gopurams 122; fig. 240
Śrīnivāsanalūr 122
Śrīvadra, seal 86
Śrīvijaya = Sumatra 198, 199
Śrutavarman of Cambodia 181
stambha, see Architecture, pillars
Stede, W. 17
Steel, see Iron and steel
Stein M. A. 149
sthapati, see Craftsman
sthayi-bhāva 91
sthira-sukha, see āsana
Stirrups, earliest known representation 25
Stobaeus 67
Stone age 3, 7, 13
Strzygowski, J. 5, 8, 66

stūpas (dāgabas) 10, 12, 15, 18, 19, 23, 25, 26, 28, 29, 30, 31, 32, 33, 34, 36, 37, 38, 39, 44, 45, 50, 51, 53, 54, 55, 56, 62, 63, 70, 72, 73, 75, 76, 77, 83, 113, 141, 142, 144, 145, 148, 149, 152, 159—163, 169, 170, 171, 172, 182, 199, 204, 205; figs. 29, 32, 34, 42, 50—56, 72, 136, 189, 292
— defined, see Architecture
Subrahmaṇiya temple, Tanjore 122, 124; fig. 238
sūci, see Architecture
Sūciloma Sutta, see Texts
Sudāma cave, Barābar hills 18, 20
Sudhamma Sabhā 19, 29, 40; fig. 43; see also Architecture
Suiko period, Japan 154
Śujānpur, near Nādaun 131
Sujātā 47
Sukhotai-Sawankalok (Sukhodaya-Saijanā-laya), Siam 175—178; fig. 320
Sukul, Java 209
Sultāngañj 85; fig. 160
Sultānpur 110; fig. 222
Śulva-Sūtras, see Texts
Sumatra 198—200, 212
Sumba, textiles 137, 212; fig. 400
Sumber Nanas, Caṇḍi, Java 207
Sumbing, Mt., Java 203
Sumeru, Mt., see Meru, Mt.
Sun, see Sūrya, Symbols
Sundara-mūrti-Svāmi 127, 167; fig. 243
Sung period, China 153
Sung Yün 153
Śuṅga art 11, 13, 19, 20, 31, 32, 35, 43, 44, 56, figs. 13, 17—21, 24—27, 29, 32—33, 36—52, 57—61, 67, 70
Śuṅga dynasty 15, 23, 24
Supalayat, Burmese queen 173
Surajkund, Ṭhākurjī temple 32
Suraj Mahall, Raja 121; fig. 253
Surakarta (Soerakarta), Java 84, 211
Surāṣṭra (Kaṭhiāwāḍ) 93
Surāt 138; fig. 393
Suratgaṛh 69
Sūrya, Sun 25, 41, 66—68, 92, 103, 144, 167, 169; figs. 24, 61, 106, 227
— with wings 67; figs. 61, 103
— Deul, Koṇāraka 115, 116; figs. 217, 220
— temple, Osiā 98, 111

Tra-kiĕu (= Simhapura, Indrapura), Campā 195, 197; fig. 344
Tribhuvanācārya, see Craftsman, Guṇḍa
Trichinopoly 102
Trident, see Symbols
Trimūrti, see Śiva, Maheśa, three-headed
Triṅgānnu, Malaya 137, 200
triratna, see Symbols
triśūla, see Symbols, trident
Tritons, see Animals
Trivikrama, see Viṣṇu
"Troy" mark, see Symbols
Tun Huang 146—148, 150, 152
Turkistān, Chinese 148—150; figs. 283—285
Tusāran-Bihār, near Partabgaṛh, Mathurā sculpture 66

Uchahara 78
Udaipur, Mewāṛ, see Udayapur
Udayaditya Paramāra 109
Udayagiri, Bhopāl 77, 78, 85, 100, 103; fig. 174
Udayagiri, Oṛissā 37
Udayana, Javanese king 207
Udayapur, Gwāliar 109, 121, 122, 129; fig. 262
Udyāna 53, 62; see also Svāt valley
Ujjain 15, 23, 67, 122; fig. 112
Umā, see Dēvī
Umā-Maheśvara groups, see Śiva
Uṇḍavalli 104
Ungaran, Mt., site, Java 203
Upaniṣads, see Vedic literature
Ur 12
ūrdhva-bāhu, arms raised 103
ūrṇā, mole, tuft of hair on the brow 57, 74; fig. 163
Uṣkur (Huviṣkapura), near Bārāmūla 141
uṣṇīṣa (1) turban 39, 194, 200
— (2) prominence on the Buddha's head 32, 39, 52, 57, 62; figs. 83, 84, 94
— (3) coping of a vedīka 30
Uttara-Rāma-Carita, see Texts
Uttareśvara temple, Ter 95

vāhanam, vehicle of a deity 45; fig. 175
vāhanam, see Yakṣa
Vaidyanātha, see Śiva
Vaikuṇṭha, see Inscriptions

Vaikuṇṭha Perumal, Kāñcī 105
Vaiśālī, see Basāṛh
Vaiṣṇava cave, Bādāmi 64
— temple, Nepal 144, 146
— — Besnagar, 48
Vaiśravaṇa, see Yakṣa
Vaitāl Deul, Purī 109, 116; fig. 218
vajra, see Symbols
Vajrapāṇi 50, 166, 199; fig. 299
vajrāsana, adamantine throne of the Great Enlightenment 31, 47, 81
Vajrāsana, see Bodhgaya, Bodhi-maṇḍa
Vākāṭaka dynasty 76
Valabhī 93
Vāmana-avatāra 103
Vāngath, Kaśmīr, temple 143
Varāha-avatāra cave 85, 102, 103; fig. 174
Vardhana, see Yakṣa, Nandi and Vardhana
varman, patronymic 156, 181
varṣa-sthala, a rain-vase 30
Vasanta Vilāsa, see Texts
Vāsiṣka, Kuṣāna king 55, 63, 69
Vastupāla 112
Vāsudeva, Kuṣāna king; coins 55
Vāsudeva, see Viṣṇu
Vasundharā (Wathundaya), Earth Goddess 65
Vedas, early culture 5, 7
— later culture 9
Vedic literature (*Brāhmaṇas, Upaniṣads, Sūtras*) 9, 15, 36, 41; see also Texts
vedīkā, see Architecture
Vellūr 123
Veṅgī (Kistna-Godaveri Dist.) 70, 95, 101, 126, 157
Vesara, Dekhani or Caḷukya style of archi- tecture 107
Vicitrasagara, legendary king of Campā 197
Vidiśa, see Besnagar
Vidyādurrapuram 38
Vieṅ Sraḥ, Old Siam, Malay Peninsula 175, 199
vihāras 27, 28, 37, 38, 48, 50, 63, 69, 70, 75—77, 84, 89, 96, 98, 99, 189, 199, 203; figs. 156, 157; see also Architecture, monasteries
Vijabror, town of Kaśmīr 141, 142
Vijaya, first Indian settler in Ceylon 158
Vijayanagar art 123, 124; figs. 239, 245; see also Architecture
Vijayanagar dynasty 106, 119

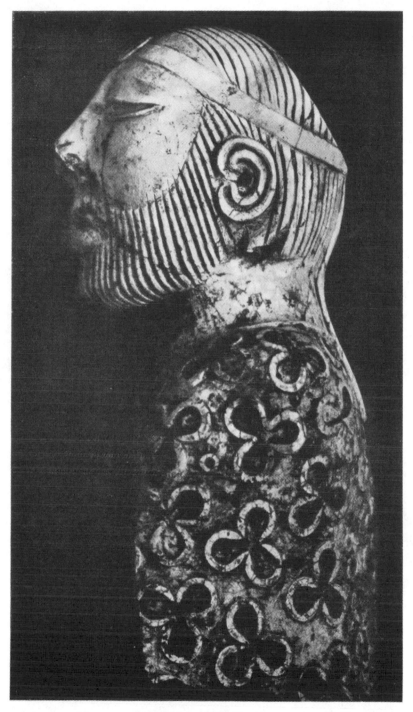

1. Limestone statue, Mohenjo-Daro; ca. 2000—3000 B. C.
Indo-Sumerian.

2

3

4

5

6

2—6. Seals. Indo-Sumerian. Mohenjo-Daro; ca. 2000—3000 B.C.

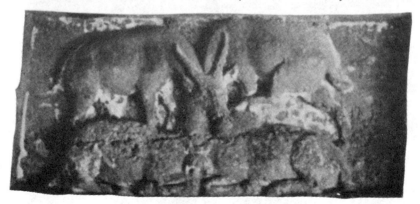

7. Four deer. Early Mediaeval. Ajaṇṭā, Cave I; ca. 600—650 A.D.

Indo-Sumerian and Early Mediaeval.

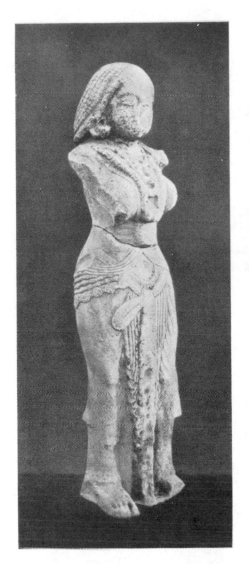 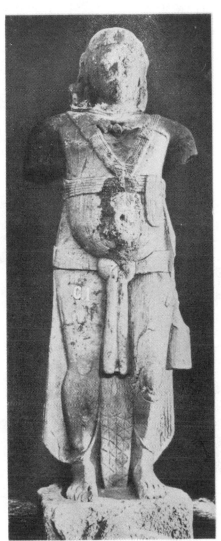

8. Yakṣī, Besnagar. Calcutta Museum. 9. Yakṣa, Pārkham. Mathurā Museum.

Maurya.

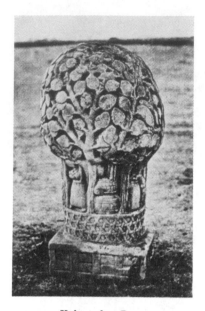

10. *Kalpa-vṛkṣa*, Besnagar.
Calcutta Museum.

11. Elephant, Dhauli; ca. 257 B.C.

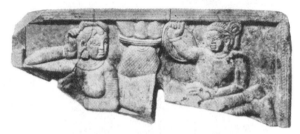

13. Stone relief, Bhīṭā.

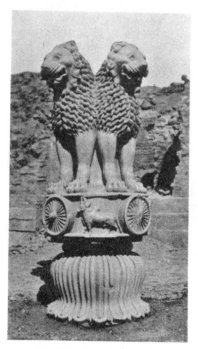

12. Lion-capital, Śārnāth.
Śārnāth Museum.

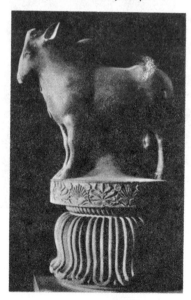

14. Bull capital, Rāmpurvā.
Calcutta Museum.

Maurya.

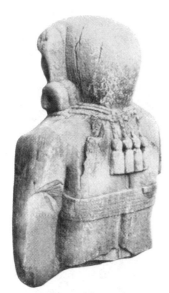

15. Yakṣa or king, Barodā.
Mathurā Museum.

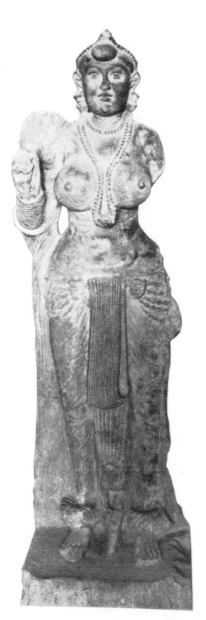

16. Winged godess, terra-cotta,
Basāṛh.

17. *Caurī*-bearer, Dīdargañj.
Patna Museum.

Maurya.

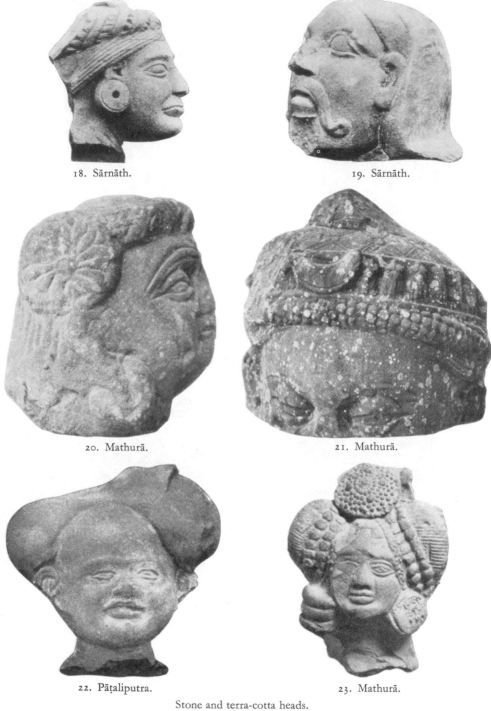

18. Sārnāth. 19. Sārnāth.

20. Mathurā. 21. Mathurā.

22. Pāṭaliputra. 23. Mathurā.

Stone and terra-cotta heads.

Maurya and Śuṅga.

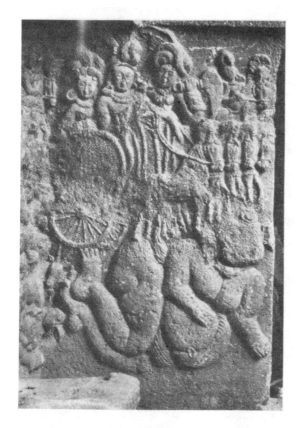

24. Sūrya.

25. Guardian or royal figure.

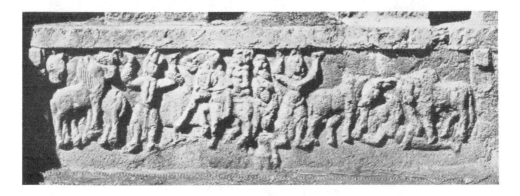

26. Frieze.

Reliefs in verandah, Bhājā *vihāra*.

Late Maurya or Early Śuṅga.

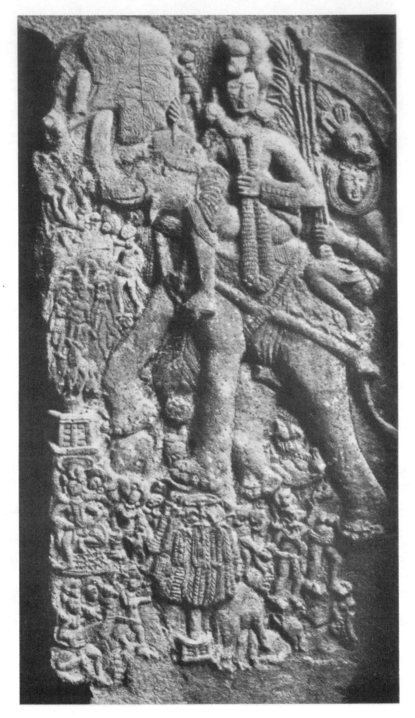

27. Indra, relief in the verandah, Bhājā *vihāra*.

Late Maurya or Early Śuṅga.

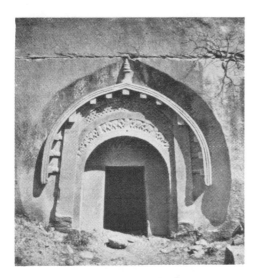

28. Lomas Ṛṣi cave, Barābar; third century B.C.

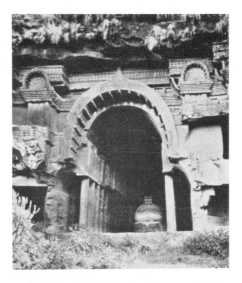

29. Bhājā *caitya*-hall; second century B. C.

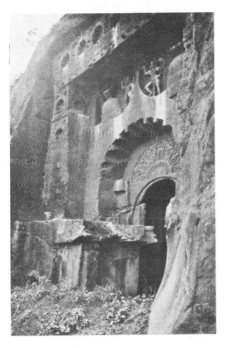

30. Mānmoda *caitya*-hall; first century B.C.

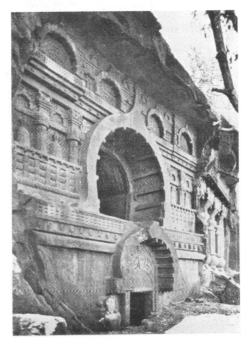

31. Nāsik *caitya*-hall; first century B. C.

Maurya, Śuṅga and Early Āndhra.

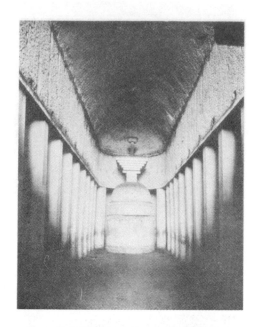

32. Beḍsā, *caitya*-halls; ca. 175 B. C.

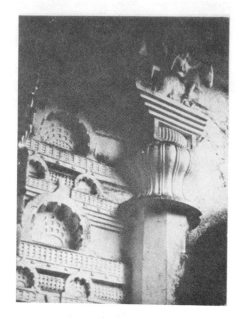

33. Beḍsā, verandah.

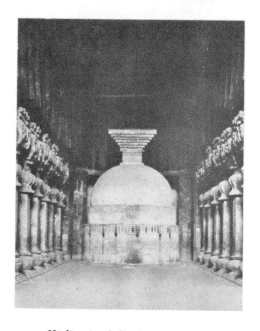

34. Kārlī, *caitya*-hall; first century B. C.

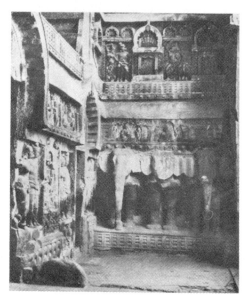

35. Kārlī, verandah.

Śuṅga and Early Āndhra.

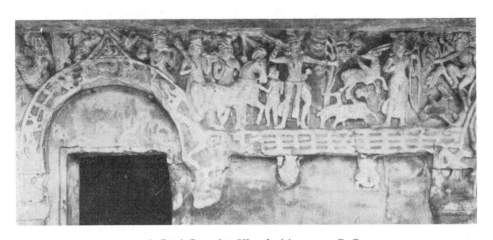

36. Rāni Gumphā, Khaṇḍagiri; ca. 100 B. C.

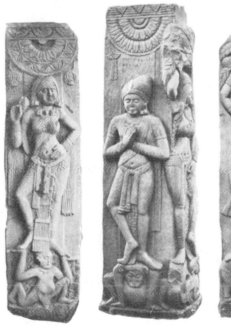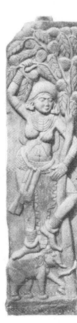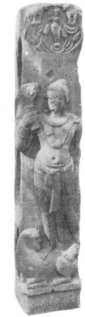

37. Yakṣī, 38. Kuvera, 39. Culakoka Devatā, 40. Indra as Śānti,
Batanmārā. Bhārhut. Bhārhut. Bodhgayā.

Śuṅga.

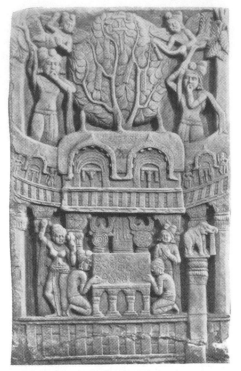

41. Bodhi-tree shrine.

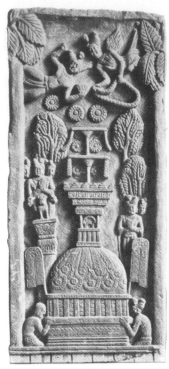

42. *Stūpa.*

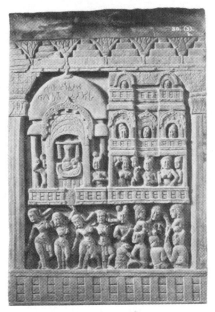

43. Devadhamma Sabhā.

44. Figures of donors.

Reliefs from Bhārhut. Calcutta Museum.

Śuṅga.

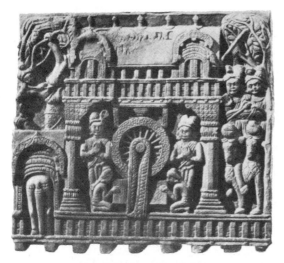

45. *Dhamma-cakka* shrine.

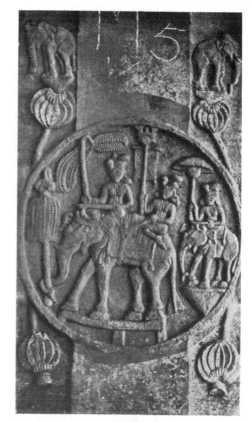

48. Railing pillar.

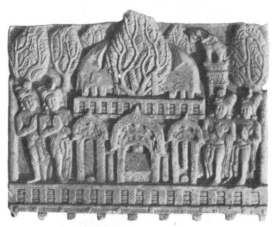

46. Bodhi tree shrine.

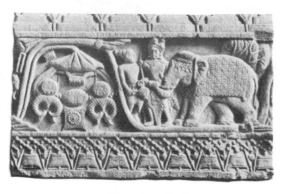

47. *Vessantara Jātaka.*

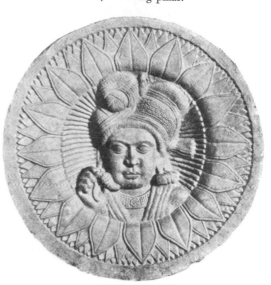

49. Railing medallion.

Reliefs from Bhārhut. Calcutta Museum.

Śuṅga.

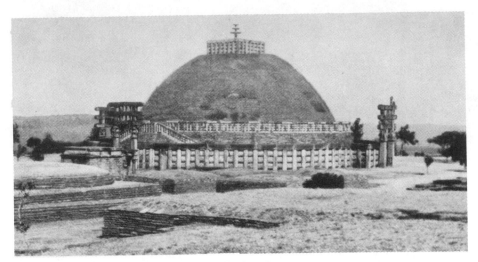

50. Sāñcī, Stupa I; third to first century B. C.

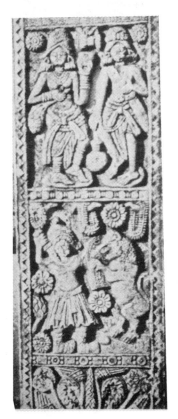

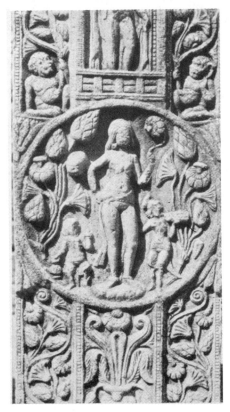

51—52. Sāñcī, Stūpa 2, railing details, primitive and advanced.

Śuṅga and Early Āndhra.

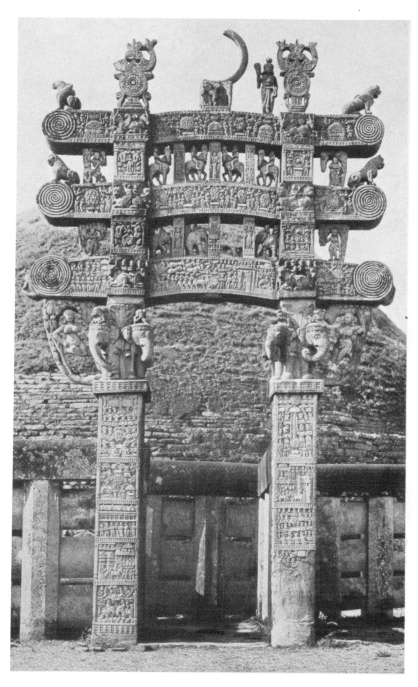

53. Sāñcī, Stupa I, North *toraṇa;* early first century B. C.

Early Āndhra

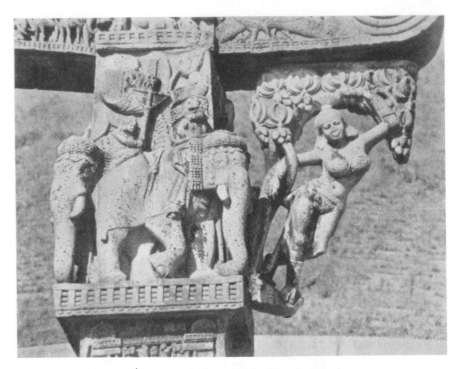

54. *Toraṇa* pillar and bracket with Yakṣī or Vṛkṣakā.

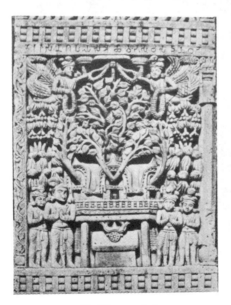

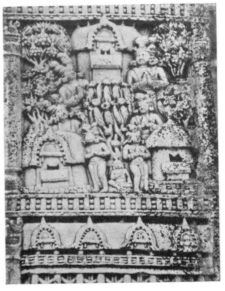

55. Bodhi-tree shrine.　　　　56. Worshippers at shrines.

Sāñcī, Stūpa I, *toraṇa* details.

Early Āndhra.

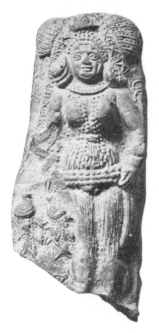
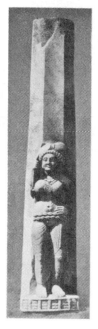
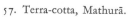
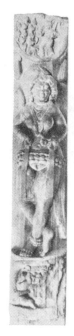

57. Terra-cotta, Mathurā. 58. Rājasan. 59. Mathurā. 60. Terra-cotta, Kosām.

61. Sūrya, Bodhgayā. 62. "Bodhgayā plaque", Patna.

Maurya, Śuṅga and Early Kuṣāna

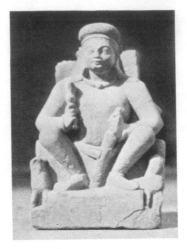

63. Maṇibhadra, Pawāyā;
first century B. C.

64. Kuṣāna king, Mathurā;
second century A. D.

65. Kaniṣka, Mathurā;
early second century A. D.

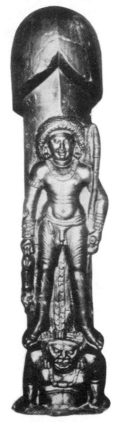

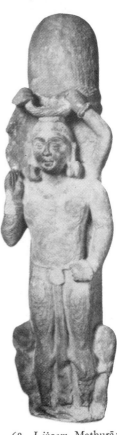

66. *Liṅgam*, Guḍimallam;
first century B. C.

67. Yakṣa, Patna;
second century B. C. Patna Museum.

68. *Liṅgam*, Mathurā;
second century A. D.

Śuṅga, Early Āndhra, and Early Kuṣāna.

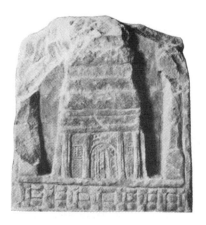

71. *Āyāgapaṭa* with Jina, Mathurā; first century A. D.
Lucknow Museum.

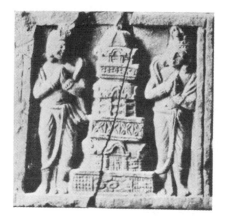

69—69 A. Two shrines, Mathurā;
ca. 100—150 A. D. Mathurā Museum.

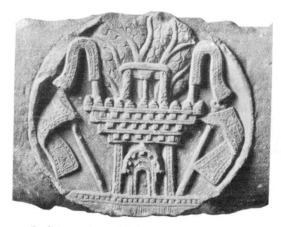

70. Bodhi-tree shrine, Mathurā; second century B. C.
Boston.

72. *Āyāgapaṭa* of Loṇāśobhikā, Mathurā;
late first century B.C. Mathurā Museum.

Śuṅga and Early Kuṣāna.

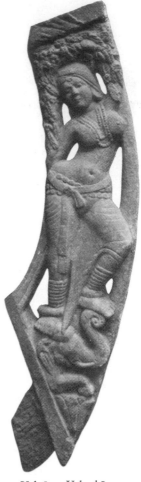

73. Woman and child.
Mathurā Museum.

74. "Abundance".
Lucknow Museum.

75. Yakṣī or Vṛkṣakā.
Lucknow Museum.

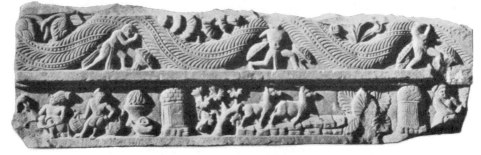

76. *Jātaka* scenes (?). Mathurā Museum.
Two pillars, bracket, and relief, from Mathurā.

Early Āṇdhra and Kuṣāna.

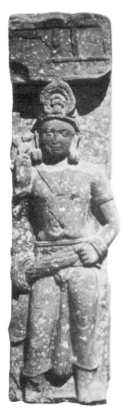 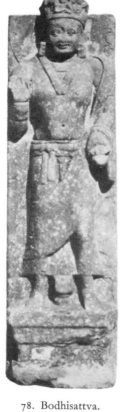 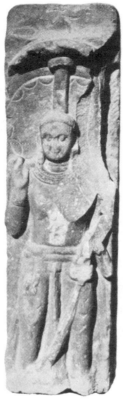 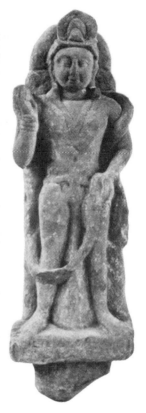

77. Donor (?). 78. Bodhisattva. 79. Buddha. 80. Bodhisattva. Philadelphia.

Three railing pillars, Lucknow Museum.

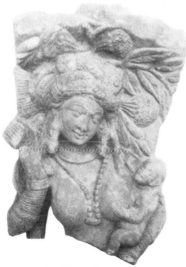

81. Pillar fragment. 82. Aśoka tree, reverse of Nāginī image.
Mathurā Museum. Mathurā Museum.

Sculptures from Mathurā.

Early Kuṣāna.

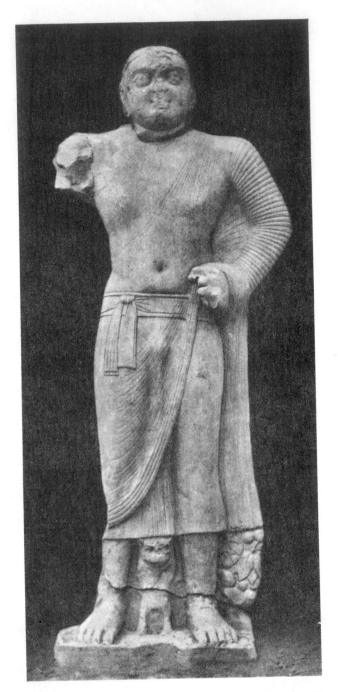

83. "Bodhisattva" (Buddha) of Friar Bala, Sārnāth; 123 A.D.
Sārnāth Museum.

Early Kuṣāna.

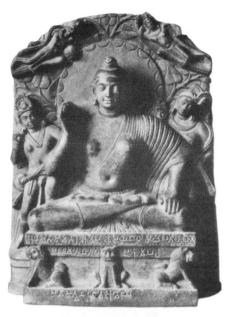

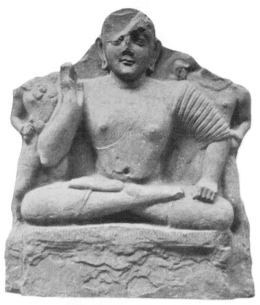

84. "Bodhisattva" (Buddha), Mathurā.
Mathurā Museum.

85. Buddha, Mathurā.
Boston.

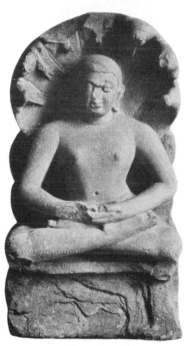

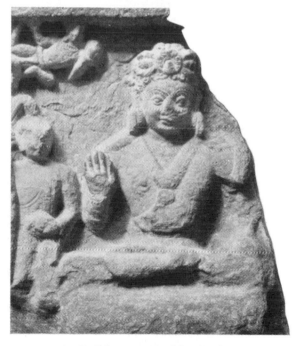

86. Pārśvanātha, Mathurā.
Lucknow Museum.

87. Bodhisattva or Buddha, Mathurā.
Yamanaka.

Early Kuṣāna.

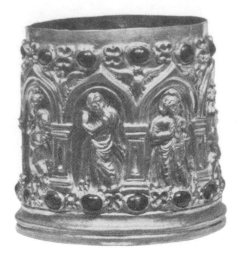

88. Bīmarān casket. British Museum.

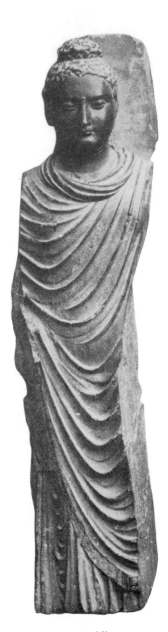

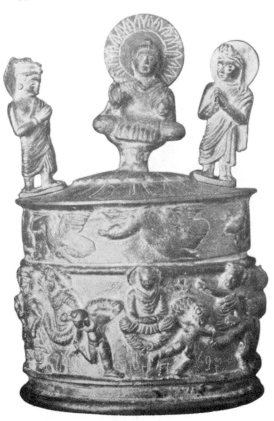

89. Kaniṣka casket, S̲h̲āh-jī-kī-Ḍherī.
Calcutta Museum.

90. Buddha.
Lahore Museum.

Gandhāra; mainly early Kuṣāna.

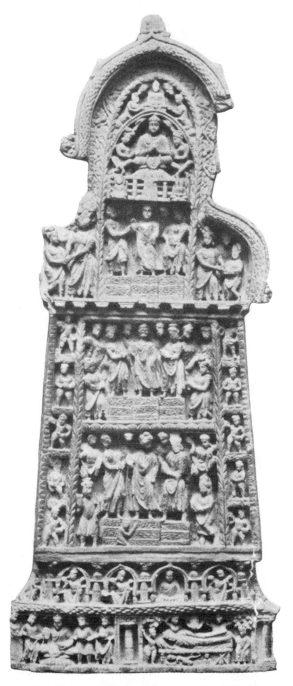

91. Gandhāra reliefs, Scenes from the life of Buddha.
Detroit Institute of Arts.

Early Kuṣāna.

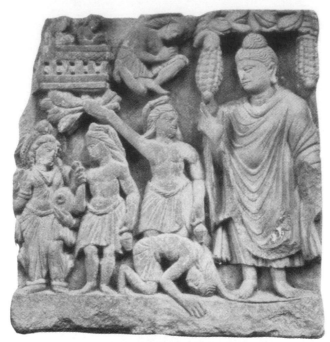

92. *Dīpaṅkara Jātaka.*

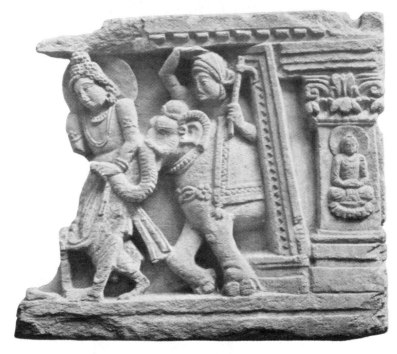

93. *Vessantara Jātaka.* Boston.
Gandhāra reliefs.

Kuṣāna.

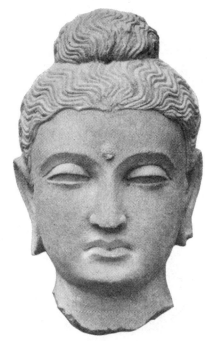

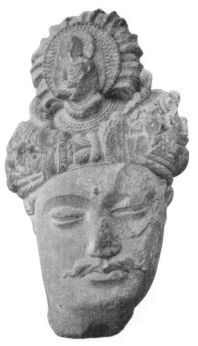

94. Buddha, Gandhāra.
Boston.

95. Bodhisattva, Gandhāra.
Field Museum, Chicago.

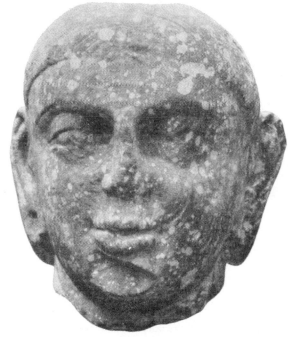

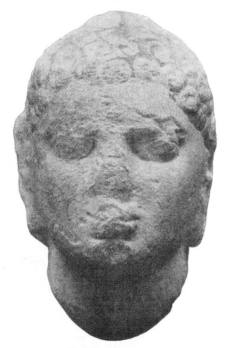

96. Buddha, Mathurā.
Boston.

97. Buddha, Amarāvatī.
Boston.

Buddha types.

Kuṣāna and Later Āndhra.

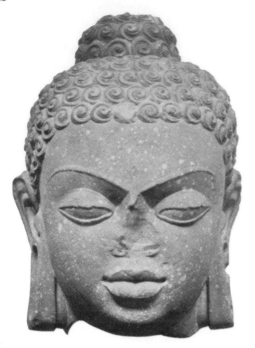

98. Buddha, Mathurā. Boston.

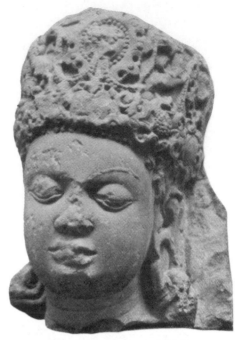

99. Bodhisattva, Mathurā. C. T. Loo.

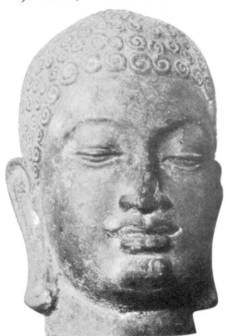

100. Buddha, Romlok. Phnoṁ Peñ.

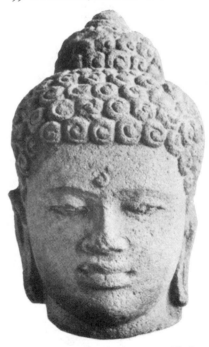

101. Buddha, Borobuḍur. New York.

Buddha types.

Gupta, Cambodian, Javanese.

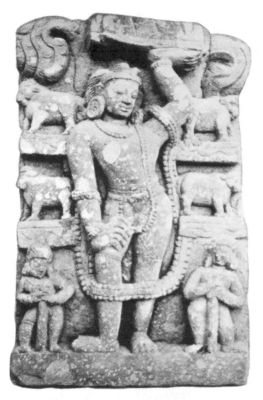

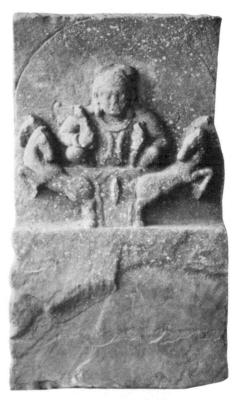

102. Kṛṣṇa Govardhana-dhara, Mathurā.
Mathurā Museum.

103. Sūrya, Mathurā.
Mathurā Museum.

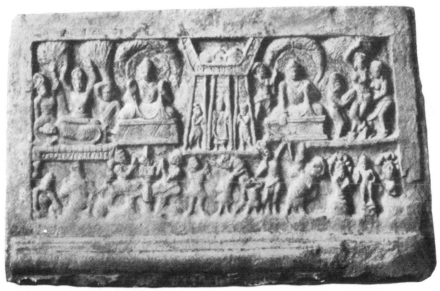

104. Scenes from the life of Buddha, Mathurā. Mathurā Museum.

Kuṣāna.

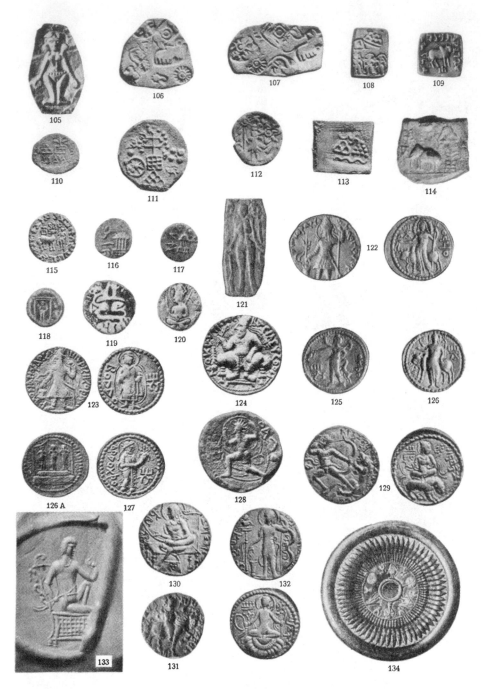

105—134. Plaques, coins, and seals.

Fourth century B. C. to fifth century A. D.

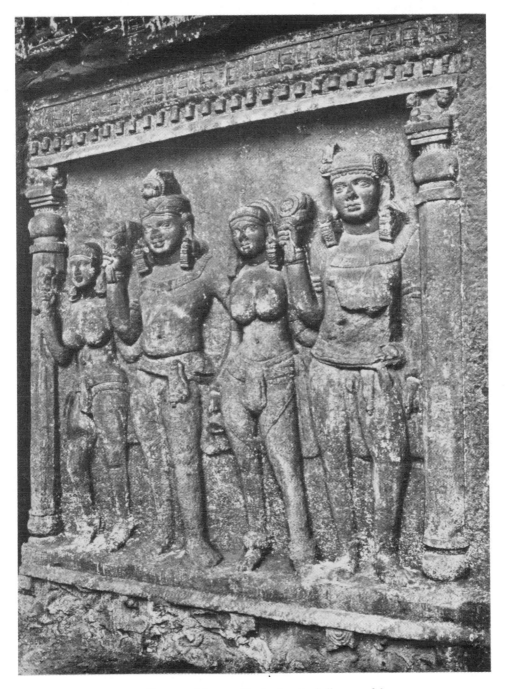

135. Figures of donors, Kaṇheri, *caitya*-hall, verandah.
Second century A. D.

Later Āndhra.

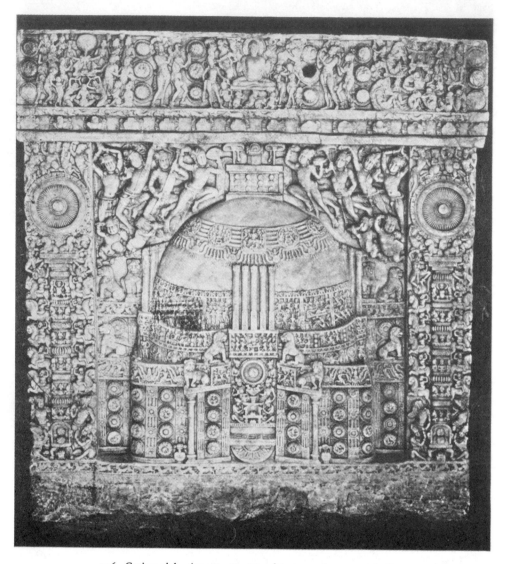

136. Casing slab, Amarāvatī *stūpa*; late second century A. D.
Madras Museum.

Later Āndhra.

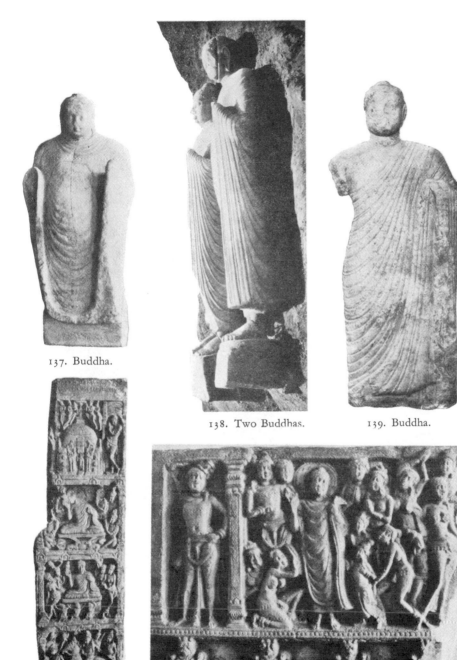

137. Buddha.

138. Two Buddhas.

139. Buddha.

140. Life of Buddha.

141. Scene from Buddha's life.

Sculptures from Amarāvatī; late second century A. D.; Madras Museum.

Later Āndhra.

142. Two-storeyed shrine 143. Pilaster

(reliefs, Jaggayyapeṭa; first or second century B. C.).

144. *Dhamma-cakka* 145. Domed shrine 146. *Stūpa* with Nāga

(two sides of one square pillar). (base of a pillar).

Amarāvatī, probably first century B. C. Madras Museum.

Early Āndhra.

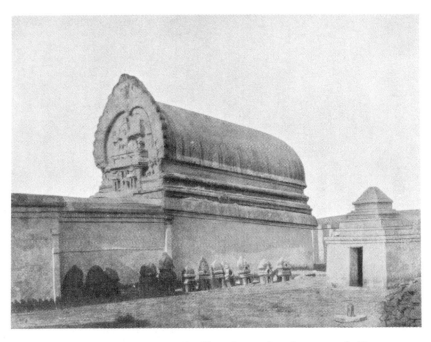

147. Kapoteśvara temple, Chezārla; ca. fourth century A. D.

148. Lād Khān temple, Aihoḷe; ca. 450 A. D.

Gupta.

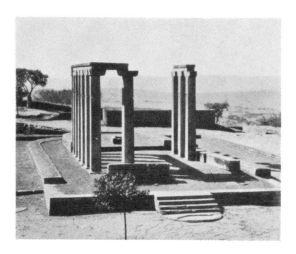

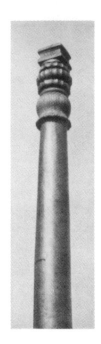

149. *Caitya*-hall, Sāñcī; seventh century, on older foundations.

150. Iron pillar, Delhi. 415 A. D.

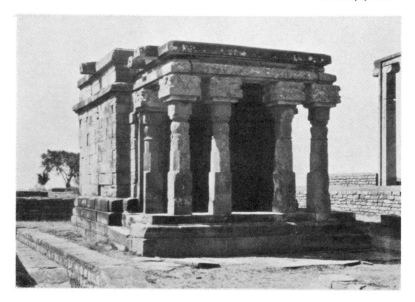

151. Temple 17, Sāñcī; early fifth century.

Gupta.

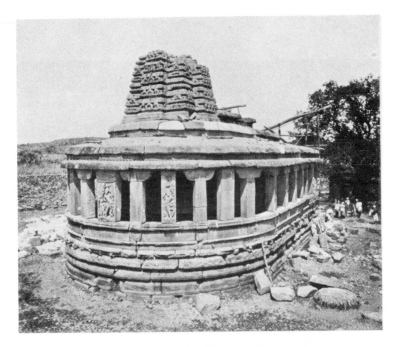

152. Durgā temple, Aiholẹ; sixth century.

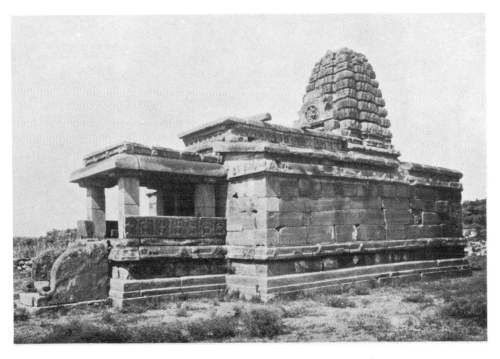

153. Hucchīmallīguḍi temple, Aiholẹ; sixth century.

Gupta.

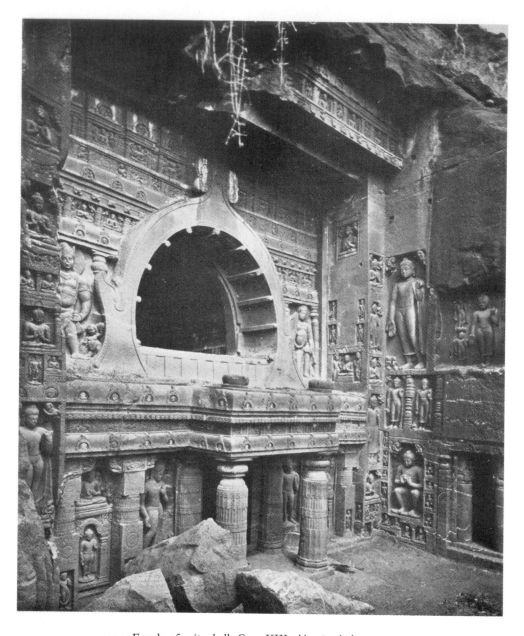

154. Façade of *caitya*-hall, Cave XIX, Ajaṇṭā; sixth century.

Gupta.

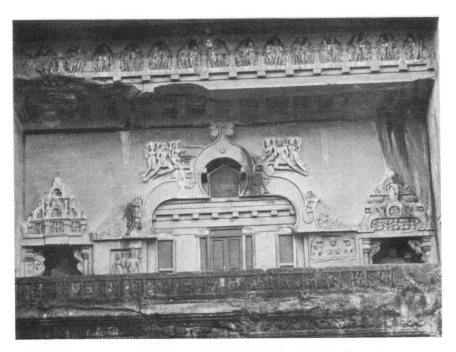

155. Viśvakarmā *caitya*-hall, Elūrā; ca. 600 A. D.

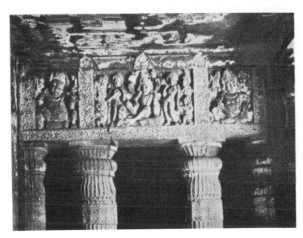

156. Pillars and architrave, Ajaṇṭā, Cave II; ca. 600—650 A.D. 157. Capital, Ajaṇṭā, Cave XXIV.

Gupta and Early Cāḷukya.

 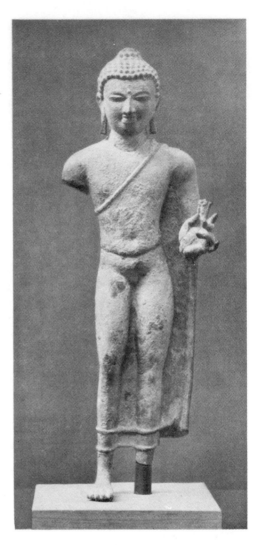

158. Buddha, stone, Mathurā;
fifth century. Mathurā Museum.

159. Buddha, bronze;
fifth century. Boston.

Gupta.

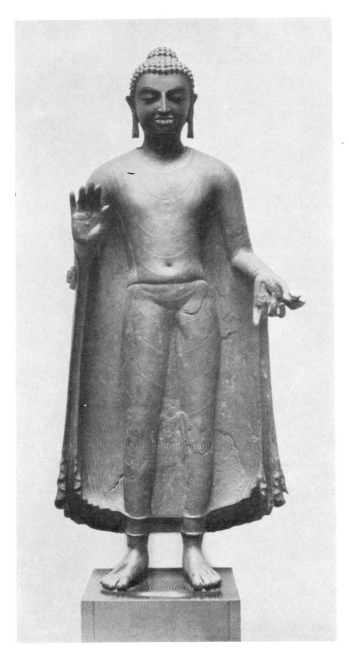

160. Buddha, copper, colossal, Sulṭāngañj; early fifth century.
Birmingham Museum and Art Gallery.

Gupta.

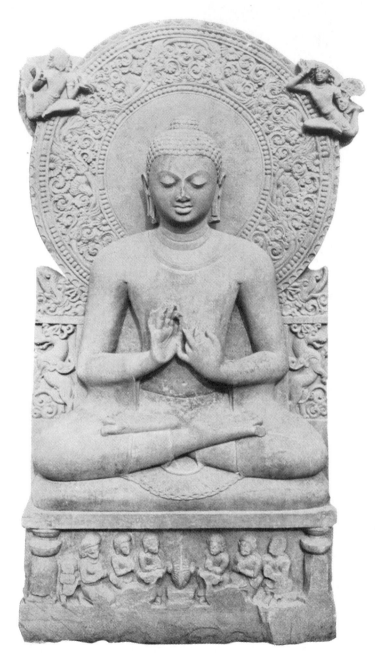

161. Buddha, stone, Sārnāth; fifth century.
Sārnāth Museum.

Gupta.

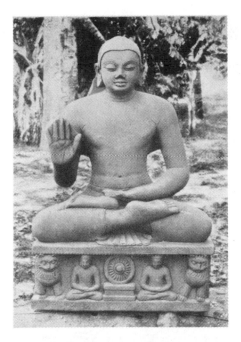

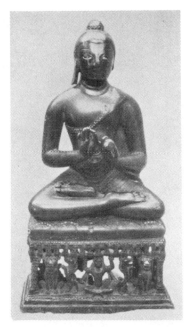

162. Buddha, stone, Maṅkuwār;
448—49 A. D.

163. Buddha, brass, Kāṅgṛā;
sixth century.

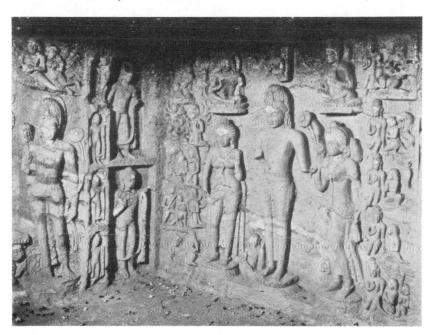

164. Avalokiteśvara, litany, Kaṇheri, Cave LXVI; sixth century.

Gupta.

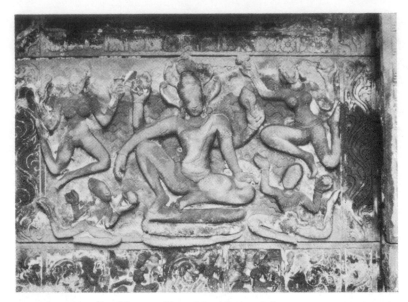

165. Viṣṇu, ceiling slab, Aiholẹ; sixth century.

166. Kṛṣṇa Govardhanadhara,
Maṇḍor. 4th—5th century.

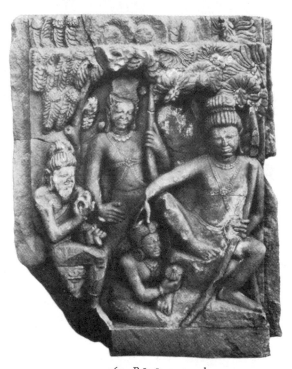

167. *Rāmāyaṇa* panel,
Deogaṛh; ca. 600 A. D.

Gupta.

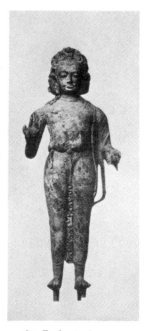

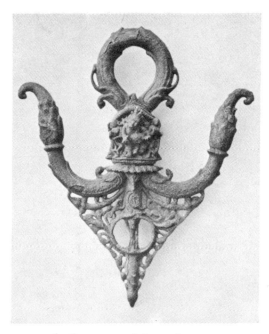

168. Brahmā, bronze.
Karāchi.

169. Bronze-coated iron plummet.
River Surma, Bengal.

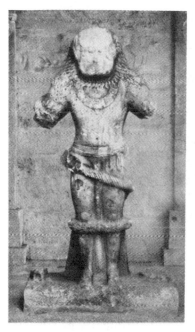

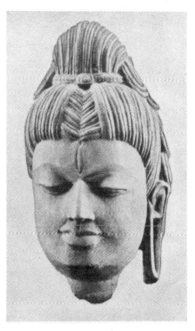

170. Narasiṁha, Besnagar.
Gwāliar Museum.

171. Lokeśvara or Śiva, Sārnāth.
Sārnāth Museum.

Gupta.

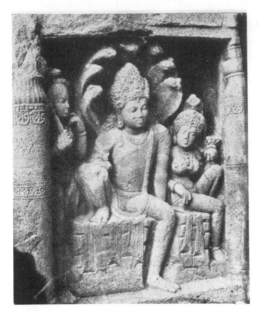

172. Nāgarāja and queen, Ajaṇṭā, Cave XIX;
sixth century.

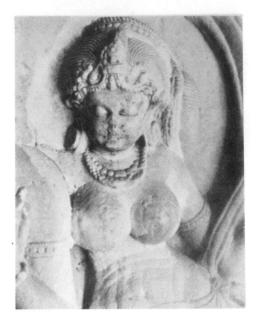

173. Apsaras (detail).
Gwāliar Museum.

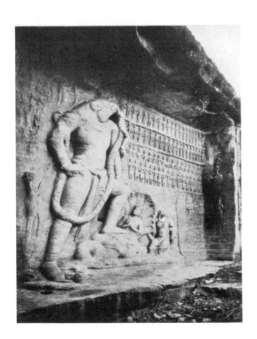

174. Varāha Avatār, Udayagiri (Bhopāl);
ca. 400 A. D.

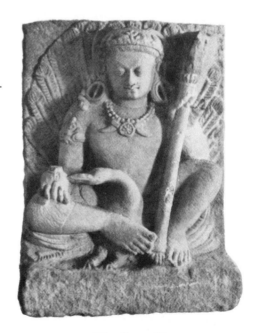

175. Kārttikeya; Bharata
Kalā Pariṣad, Benares.

Gupta.

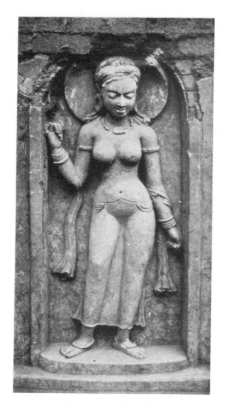

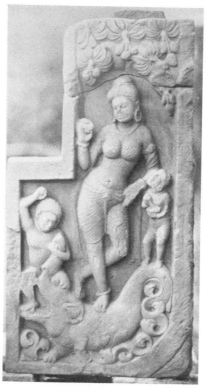

176. Nāginī, stucco, Maṇiyār Maṭha; fifth century.

177. Gaṅgā Devī, Besnagar; ca. 500 A.D. Boston.

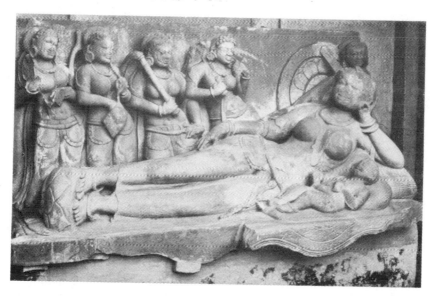

178. Nativity of Mahāvīra or Kṛṣṇa, Paṭhāri; seventh century? Gwāliar Museum.

Gupta.

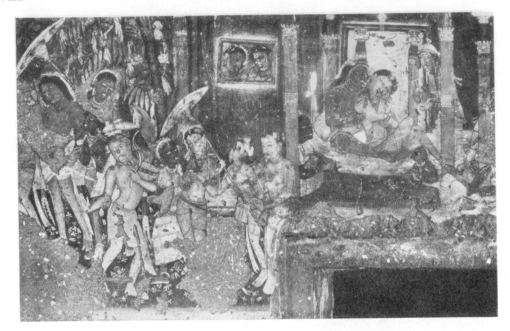

179. Prince and princess with attendants, and love scene, Cave XVII; ca. 500 A. D.

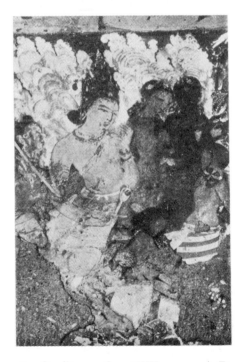

180. Gandharvas, Cave XVII; ca. 500 A. D. 181. Avalokiteśvara, Cave I; ca. 600—650 A. D.

Painting, Ajaṇṭā.

Gupta and Early Mediaeval.

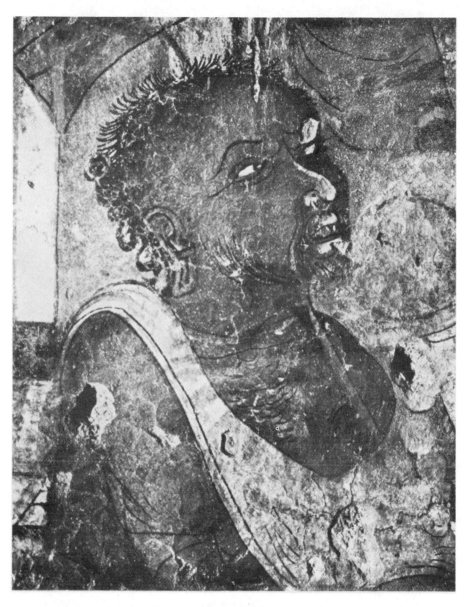

182. Head of a beggar, *Vessantara Jātaka*, detail, Ajaṇṭā, Cave XVII; ca. 500 A. D.

Gupta.

183. Dance, wall painting, Bāgh; sixth century.

184. Apsaras and attendant, Sīgiriya, Ceylon; fifth century.

185. Ceiling painting, Cave I, Ajaṇṭā, detail; ca. 600—650 A. D.

Gupta and Early Cāḷukya.

186. Lakṣmaṇa temple, brick, Sīrpur; seventh century.

Early Mediaeval

187. Mālegitti temple, Bādāmī; ca. 625 A. D.

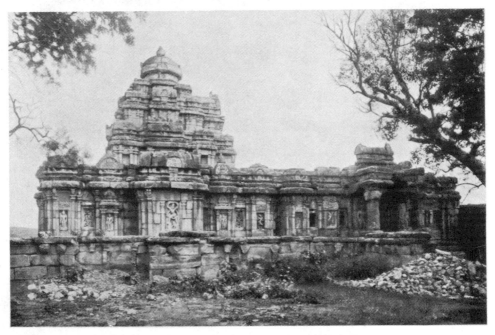

188. Virūpākṣa temple, Paṭṭakadal; ca. 740 A.D.

Early Mediaeval (Cāḷukya).

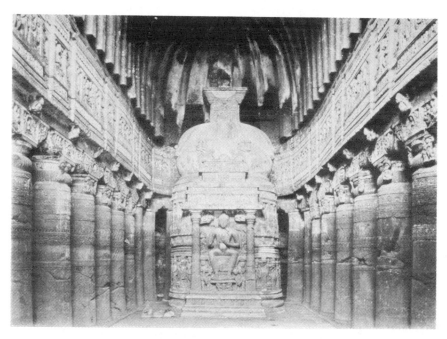

189. *Caitya*-hall, interior, Cave XXVI, Ajaṇṭā; early seventh century.

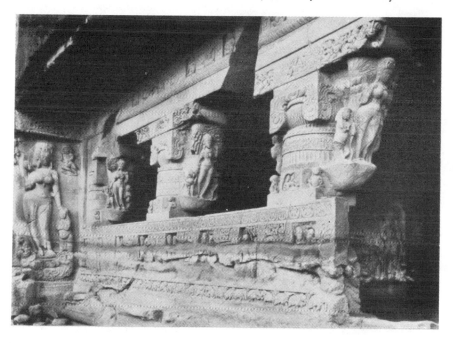

190. Verandah, Rāmeśvara cave, Elūrā; seventh century.

Early Mediaeval.

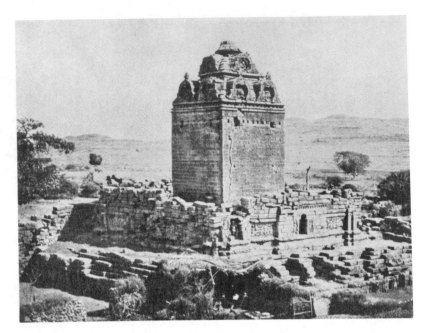

191. Temple at Gop; sixth or seventh century.

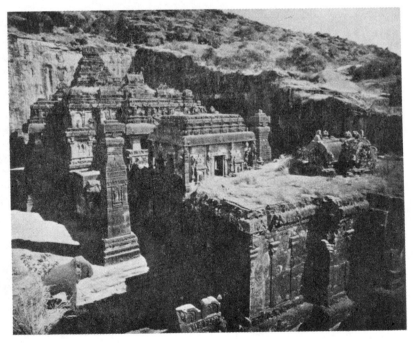

192. Kailāsanātha temple, Elūrā; eighth century.

Early Mediaeval.

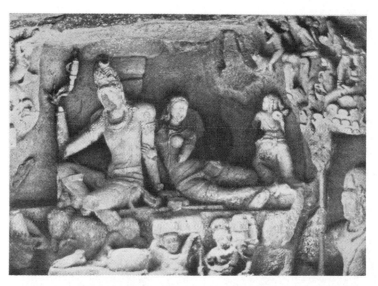

193. Śiva and Pārvatī, Kailāsa, Elūrā; eighth century.

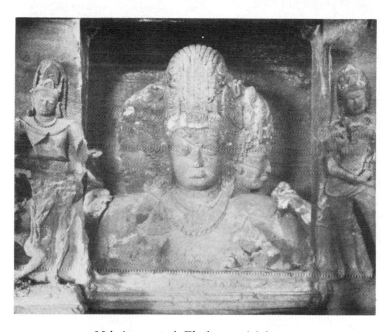

194. Maheśvara-mūrti, Elephanta; eighth century.

Early Mediaeval (Rāṣṭrakūṭa).

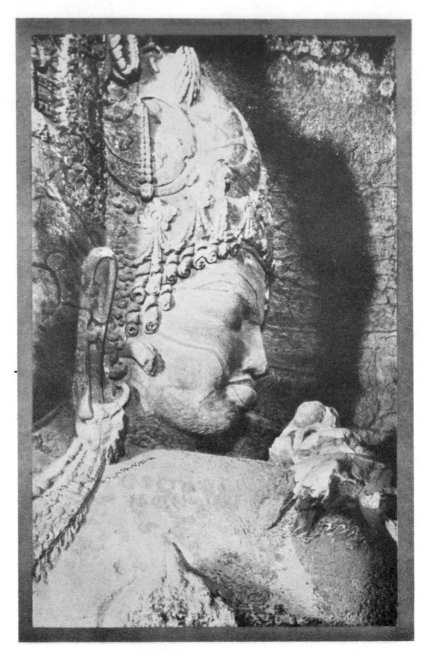

195. Maheśvara-mūrti, Elephanta, detail; eighth century.

Early Mediaeval (Rāṣṭrakūṭa).

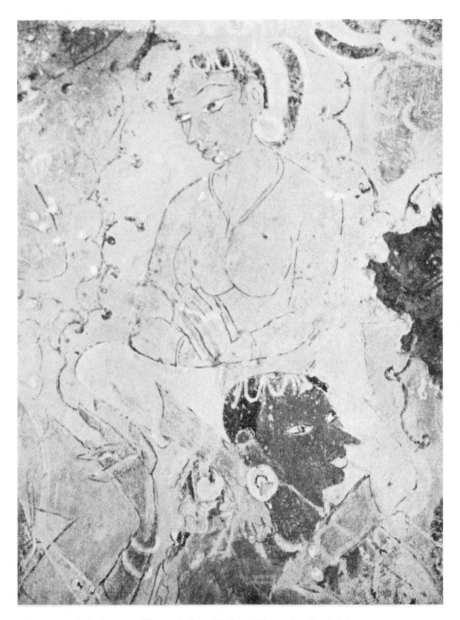

196. Lakṣmī, ceiling painting, Kailāsa, Elūrā, detail; eighth century.

Early Mediaeval (Rāṣṭrakūṭa).

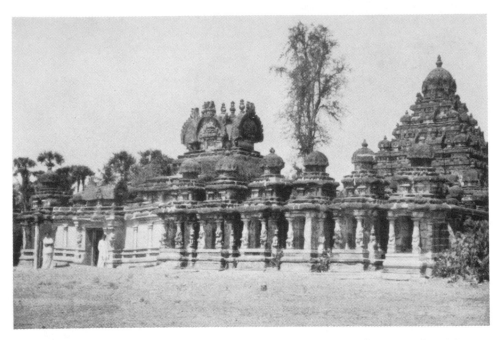

197. Kailāsanātha temple, Kāñcīpuram, exterior; eighth century. Early Mediaeval (Pallava).

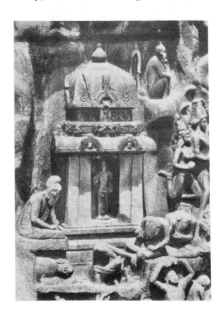

198. Temple, Gaṅgāvataraṇa,
Māmallapuram, detail; seventh century.

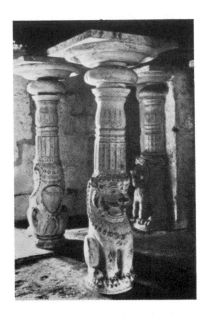

199. Agastyeśvara temple. Melapaḷuvur;
eighth century.

Early Mediaeval (Pallava).

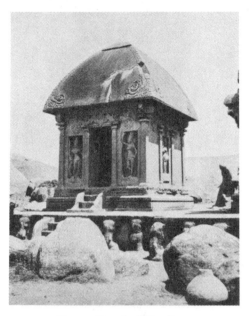

200. Draupadī *ratha*, Māmallapuram.

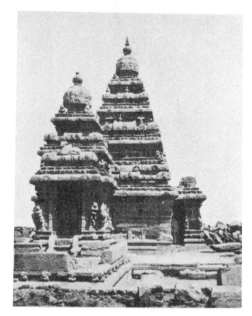

201. "Shore" temple, Māmallapuram.

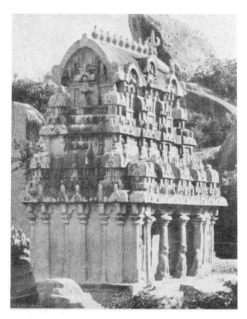

202. Gaṇeśa *ratha*, Māmallapuram.

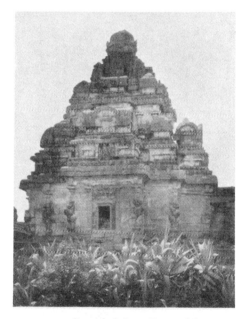

203. Central shrine, Paṇamalai.

Early Mediaeval (Pallava).

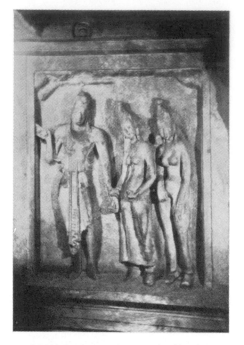

204. Mahendravarman and queens, Ādi Varāha.

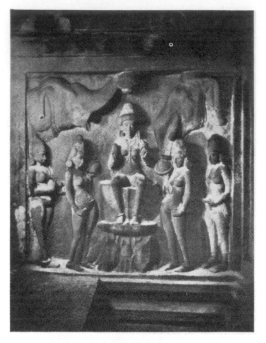

205. Gaja-Lakṣmī, Ādi Varāha.

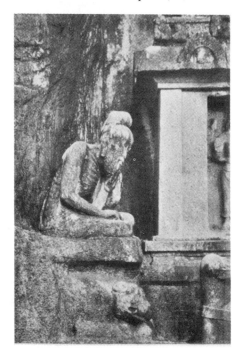

206. Bhagiratha,
Gaṅgāvataraṇa, detail.

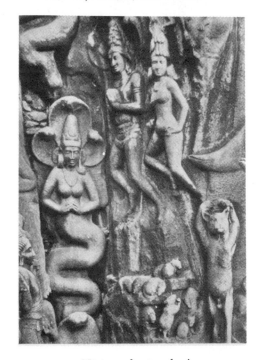

207. Nāgas and cat and mice,
Gaṅgāvataraṇa, detail.

Māmallapuram, early seventh century.

Early Mediaeval (Pallava).

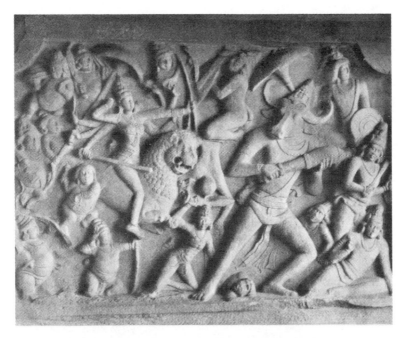

208. Durgā-Mahiṣamardinī.

209. Viṣṇu-Anantaśayin.
Reliefs in Mahiṣa-*maṇḍapam*, Māmallapuram; seventh century.

Early Mediaeval (Pallava).

210. Bodhgayā temple ("Mahābodhi"); as restored.

Early Gupta.

211. Hoyśaleśvara temple, Halebīd; early twelfth century.

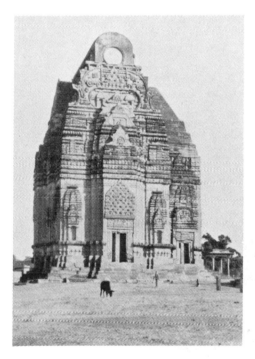

212. Telī-kā-Mandir, Gwāliar;
eleventh century.

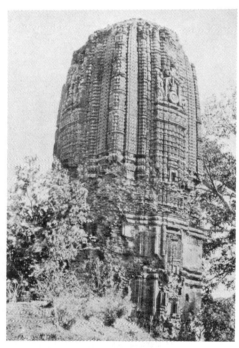

213. Siddheśvara, Bāṅkurā;
tenth century.

Mediaeval.

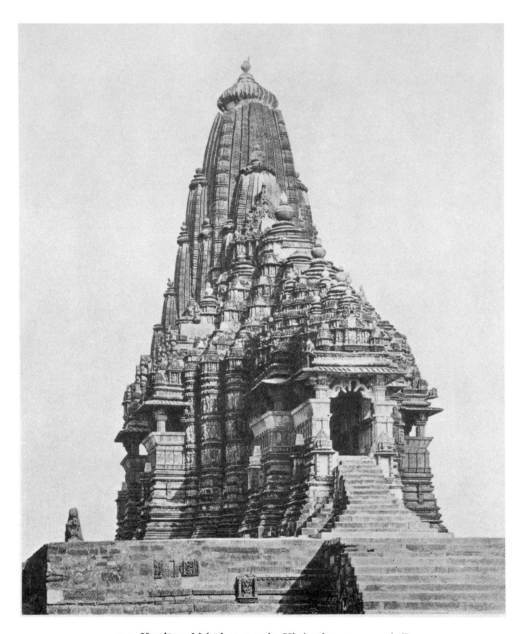

214. Kandārya Mahādeva temple, Khajurāho; ca. 1000 A. D.

Mediaeval.

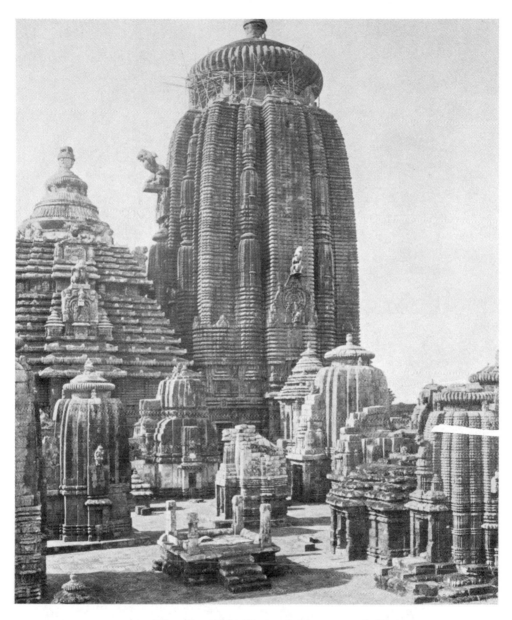

215. Liṅgarāja temple, Bhuvaneśvara; ca. 1000 A. D.

Mediaeval.

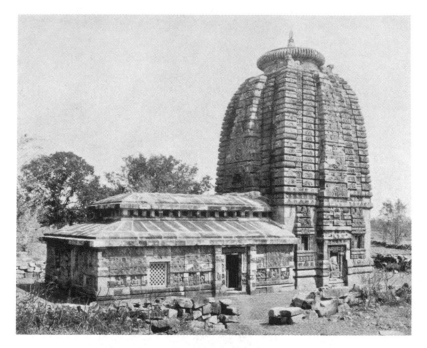

216. Paraśurāmeśvara temple, Bhuvaneśvara; ca. 750 A. D.

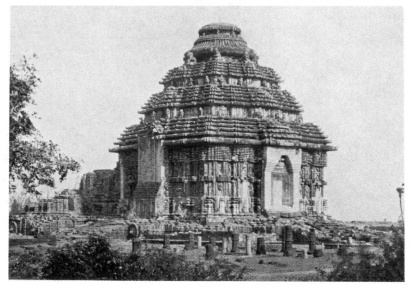

217. *Maṇḍapa* (*jagamohana*) of the Sūrya Deul, Koṇaraka.

Mediaeval.

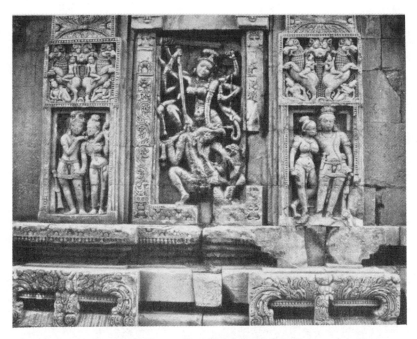

218. Durgā-Mahiṣamardinī, Vaitāl Deul, Purī; ca. 1000 A. D.

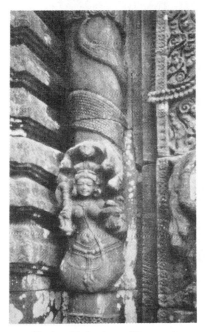

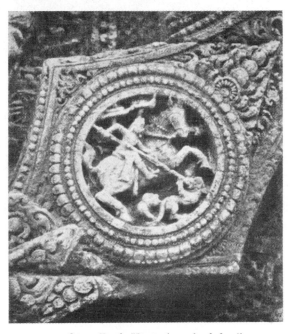

219. Nāginī, Mukteśvara, Bhuvaneśvara;
ca. 950 A. D.

220. Sūrya Deul, Koṇāraka, wheel detail;
thirteenth century.

Mediaeval.

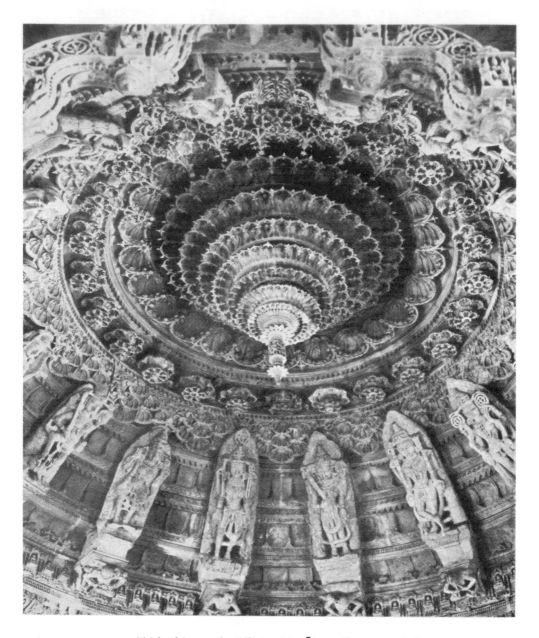

221. Tejahpāla's temple, Dilwāṛa, Mt. Ābū, ceiling; 1232 A. D.

Mediaeval.

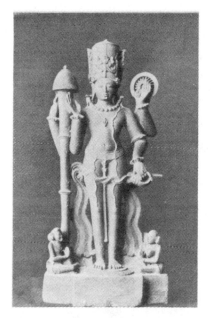

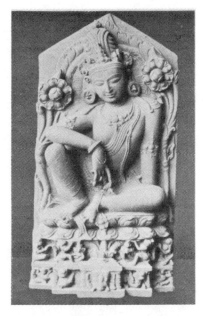

222. Viṣṇu, Sulṭānpur;
ca. tenth century. Lucknow Museum.

223. Padmapāni, Mahobā;
ca. eleventh century. Lucknow Museum.

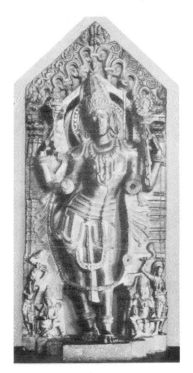

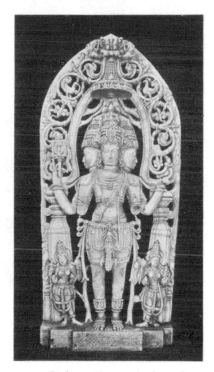

224. Viṣṇu, Dekkhan or Maisūr, ca. ninth
century. Philadelphia.

225. Brahmā, Kuruvatti; eleventh
century. Philadelphia.

Mediaeval.

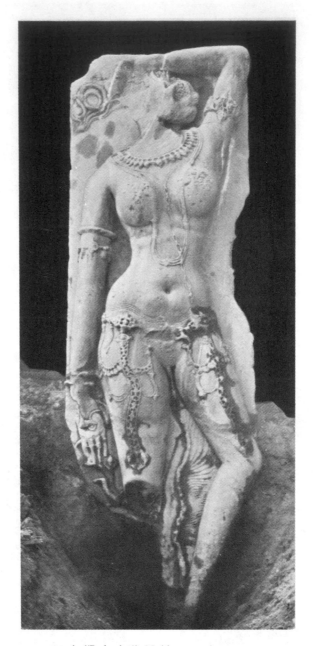

226. "Rukmiṇī", Nokhas; tenth century.

Mediaeval.

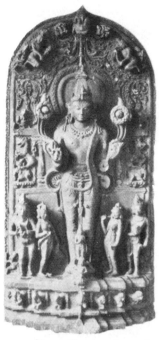

227. Sūrya, Chapra; eleventh
century. Rājshāhi Museum.

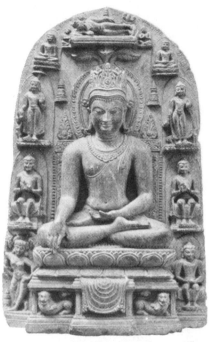

228. Buddha, Bengal;
tenth century. Boston.

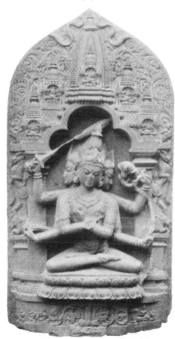

229. Arapacana - Mañjuśrī, Bengal;
eleventh century. Timken Collection.

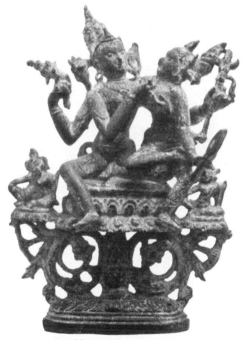

230. Umā-Maheśvara group.
bronze, Bengal, Boston.

Mediaeval (Pāla).

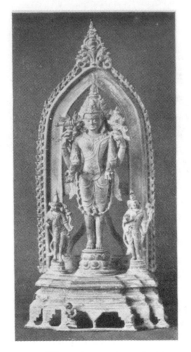

231. Viṣṇu, brass, Sagardighi; eleventh century. Calcutta.

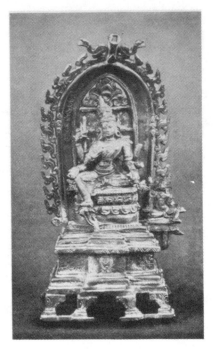

232. Bodhisattva, bronze, Kaśmīr? tenth century. Srinagar.

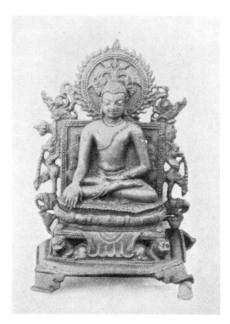

233. Buddha, bronze, Nālandā; tenth century. Nālandā.

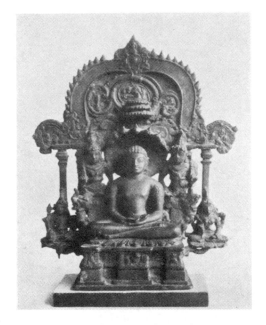

234. Pārśvanātha, Kannaḍa; tenth century. Kay Collection, Madras.

Mediaeval (Pāla and Cāḷukya).

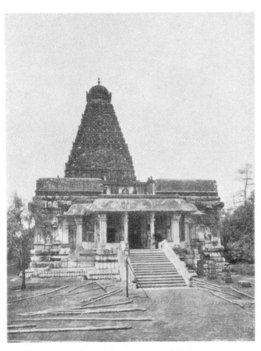

235. Rājrājeśvara temple, Tanjore;
ca. 1000 A. D.

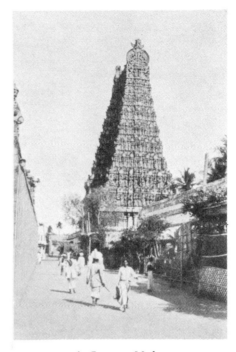

236. *Gopuram*, Madura;
seventeenth century.

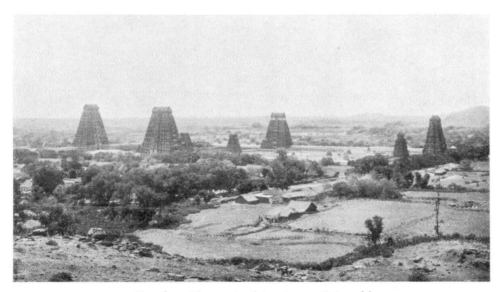

237. Temple at Tiruvannāmalai; *gopurams*, Coḷa and later.

Mediaeval (Coḷa and Madura).

238. Subrahmaṇiya temple, Tanjore, detail;
eighteenth century.

239. *Maṇḍapam*, Auvaḍaiyar Kovil.
Fourteenth century.

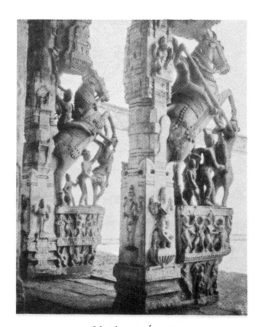

240. *Maṇḍapam*, Śrīraṅgam;
seventeenth century.

241. Architect (*sthapati*), Auvaḍaiyar
Kovil, 1907 A. D.

Late Mediaeval (Vijayanagar and Madura).

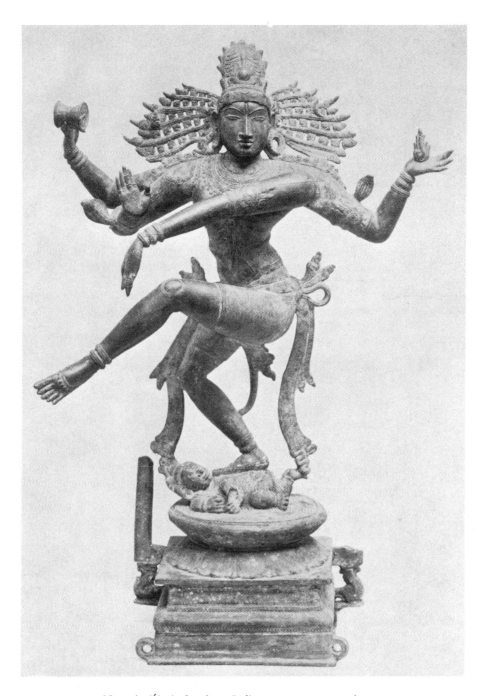

242. Naṭarāja (Śiva), Southern India, copper; seventeenth century.
Boston.

Late Mediaeval (Madura).

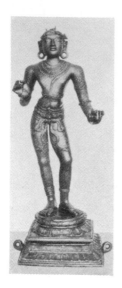

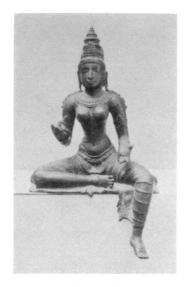

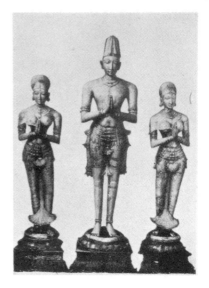

243. Sundara-mūrti Svāmi,
Poḷonnāruva, Colombo.

244. Umā, S. India.
Boston.

245. Kṛṣṇa Deva Rāya and queens.
Tirupati; 1509—1529 A. D.

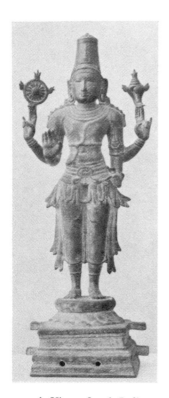

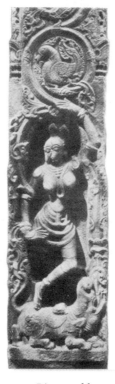

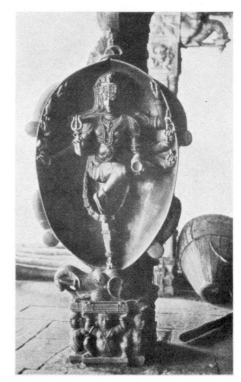

246. Viṣṇu, South India.
Boston.

247. River-goddess.
Taḍpatri.

248. Śiva, Perūr;
seventeenth century.

Late Mediaeval (Vijayanagar and Madura).

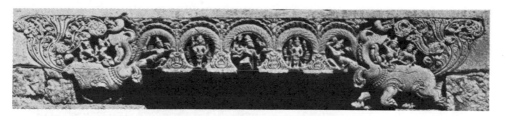

249. *Makara toraṇa* lintel, Bījāpur; ca. 1100 A. D.

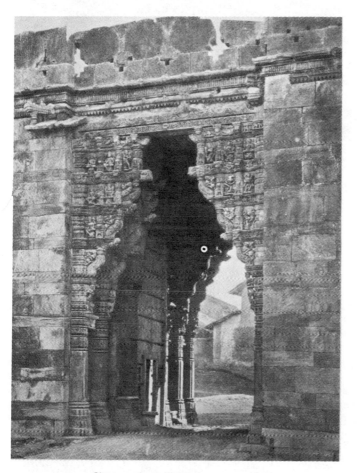

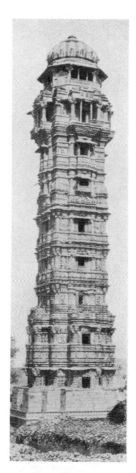

250. City gateway, Dabhoi; ca 1100 A. D.

251. *Kīrttistambha*, Chitor; 1440—1448 A. D.

Mediaeval.

252. Palace of Mān Siṅgh, Gwāliar; ca. 1500 A. D.

253. Suraj Mahall's palace, Dīg; latter eighteenth century.

Late Mediaeval (Rājput).

254. Bīr Siṅgh Dev's palace, Datiā; early seventeenth century

Late Mediaeval (Rājput).

255 a and b. Two leaves of a manuscript of the *Kalpa Sūtra*,
Gujarātī; fifteenth century. Boston.

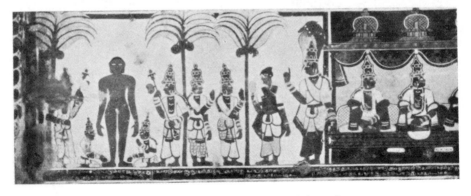

256. Jaina ceiling painting, Kāñcīpuram; eighteenth century.

Late Mediaeval.

257. Part of a manuscript of the *Vasanta Vilāsa*, Gujarātī; 1451 A. D.
N. C. Mehta Collection.

Late Mediaeval.

258. Kṛṣṇa expecting Rādhā, Rājasthān or Gujarāt; sixteenth
century. Boston.

Late Mediaeval (Rājput).

259. Sadh Malāra Rāginī, Rājasthānī; late sixteenth century.
Metropolitan Museum of Art, New York.

Late Mediaeval (Rājput).

260. Lalitā Rāgiṇī, enlarged detail, Rājasthānī; late sixteenth century.
Museum of Fine Arts, Boston.

Late Mediaeval (Rājput).

261. Madhu-mādhavī Rāgiṇī, Rājasthānī; early seventeenth century.
Museum of Fine Arts, Boston.

Late Mediaeval (Early Rājput).

262. Modern wall-painting,
Udaipur.

263. Pig-sticking, Jaipur; modern.
Author's Collection.

264. Mahārāja Abhai Siṅgh of Jodhpur; 1781—1806.
Enlarged detail. Boston.

265. Kṛṣṇa, cartoon; Jaipur,
eighteenth century. New York.

Late and modern Rājput.

266. *Rāmāyaṇa*, Siege of Laṅkā, Jammū; ca. 1640 A. D. Boston.

267. Kṛṣṇa welcoming Sudāma, Jammū; ca. 1625 A. D. Author's Collection.

Late Mediaeval (Early Rājput).

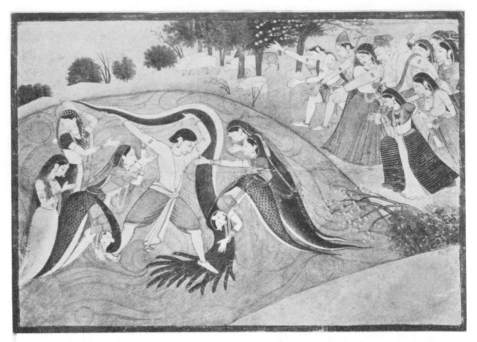

268. *Kāliya Damana*, Kāṇgṛā; late eighteenth century. Author's Collection.

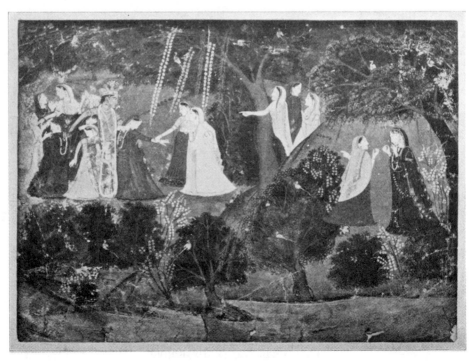

269. *Gīta Govinda*, Kāṇgṛā; early eigtheenth century. Author's Collection.

Late Rājput.

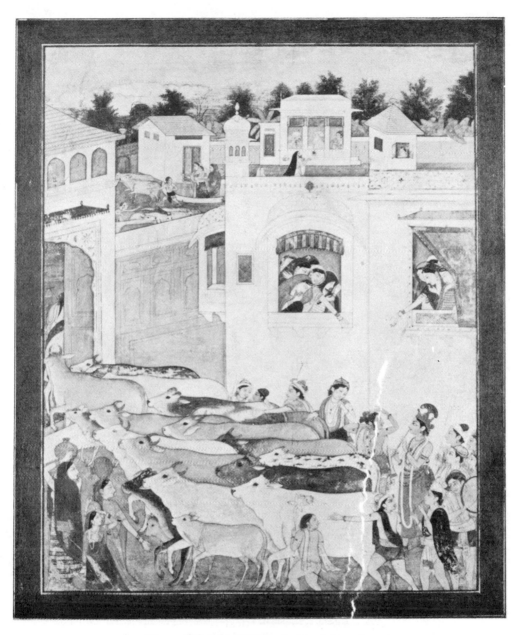

270. "Hour of Cowdust", Kāṅgṛā; late eighteenth century.
Museum of Fine Arts, Boston.

Late Rājput.

271. *Rās Līlā*, enlarged detail, Kāṇgṛā; late eighteenth century.
Museum of Fine Arts, Boston.

Late Rājput.

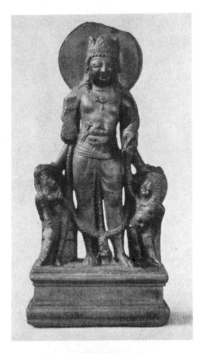

272. Viṣṇu, Kaśmīr; ninth century.
Philadelphia.

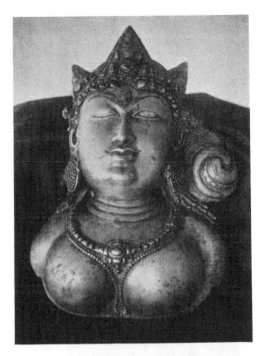

273. Mujunīdevī, mask, Kuḷū;
ninth or tenth century.

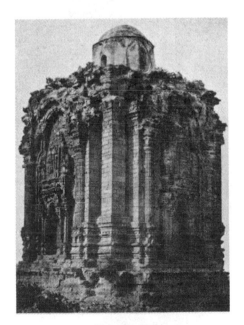

274. Temple, Malot;
eighth century.

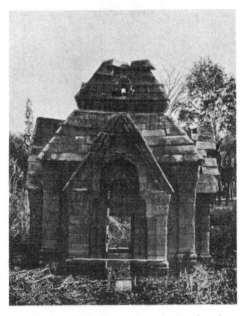

275. Meruvardhana-svāmin temple, Pāṇḍrenthān.
Early tenth century.

Mediaeval (Kaśmīr and Pañjāb).

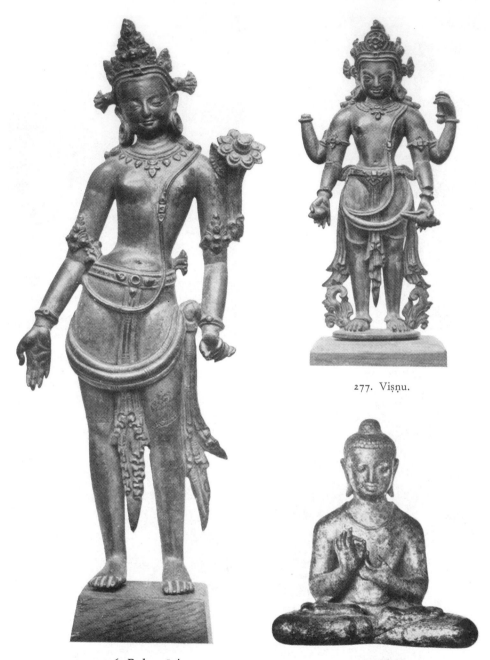

277. Viṣṇu.

276. Padmapāṇi.
Copper, ninth and tenth century.

278. Buddha.
Museum of Fine Arts, Boston.

Nepāl.

279. *Vessantara Jātaka*, Ms. cover, Nepāl; thirteenth century.
Tagore Collection, Calcutta.

280. Green Tārā, Ms. cover, Nepāl;
twelfth century. Boston.

281. Mañjuśrī, from the same.

282. Kṛṣṇa with the Flute, Ms. cover, Bengal; late eighteenth century.
Ghose Collection, Calcutta.

Mediaeval and Modern.

284. *Vessantara Jātaka*, Mirān; fourth century.

283. Water-nymph, Dandān Uiliq;
before the eighth century.

285. Maheśa or Lokeśvara, Dandān
Uiliq; before eighth century.

Turkistān.

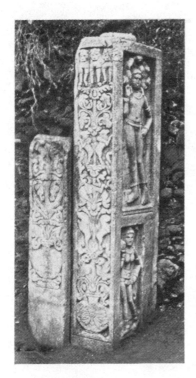

286. Stelae, Anurādhapura;
ca. 300 A. D.?

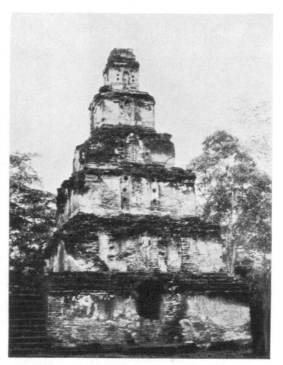

287. Sat Mahal Pāsāda, Polonnāruva;
twelfth century.

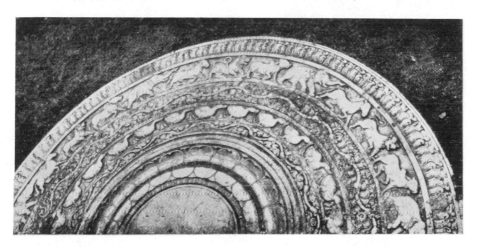

288. *Irihaṇḍa-gala*, "moonstone" door-step, Anurādhapura;
fifth century?

Ceylon.

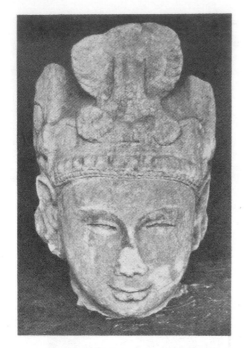

289. Bodhisattva, Anurādhapura;
fourth century A. D.? Colombo Museum.

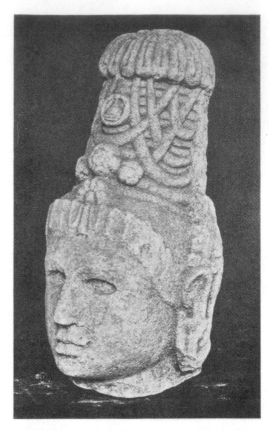

290. Maitreya, Anurādhapura; fourth century A. D.?
Colombo Museum.

291. Deities, fresco, Poḷonnāruva;
twelfth century.

292. Model *dāgaba*, Anurādhapura;
second century B. C.?

Ceylon.

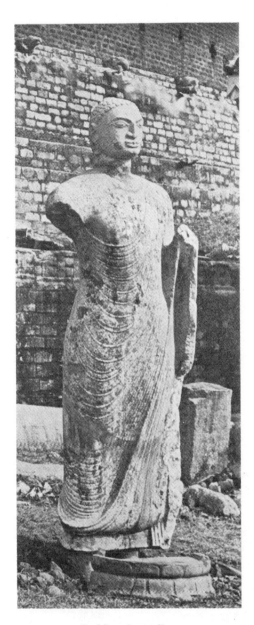

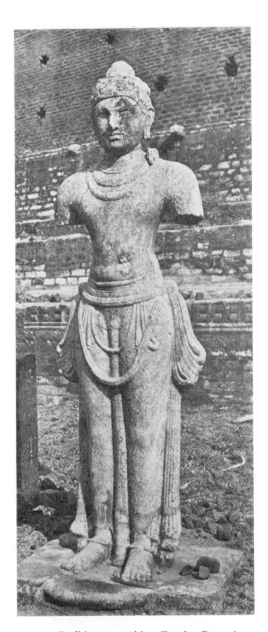

293. Buddha, Anurādhapura; ca. 200 A. D.

294. Bodhisattva or king Duṭṭha Gāmani, Anurādhapura; ca. 200 A. D.?

Ceylon.

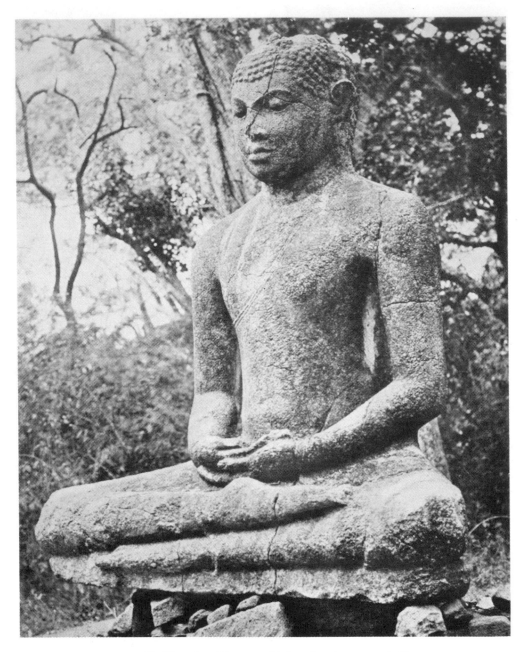

295. Buddha, Anurādhapura; third or fourth century A. D.

Ceylon.

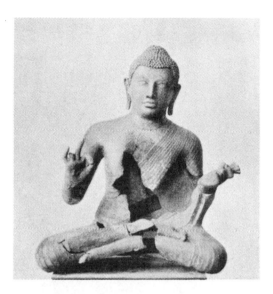

296. Buddha, Badullā; fifth
or sixth century. Colombo Museum.

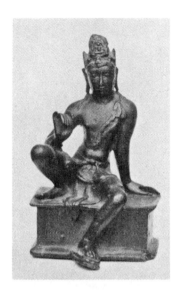

297. Avalokiteśvara; eighth
century. Boston.

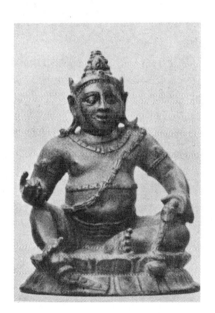

298. Jambhala; eighth century.
Boston.

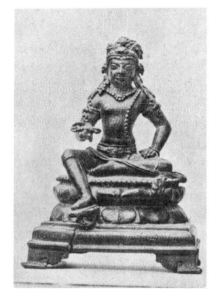

299. Vajrapāni; ninth century.
Boston.

Ceylon.

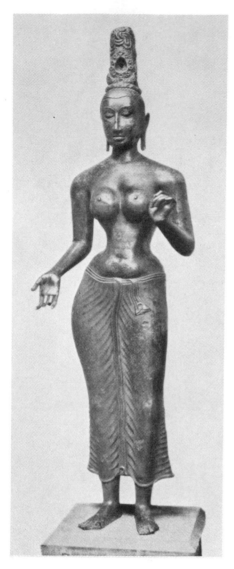

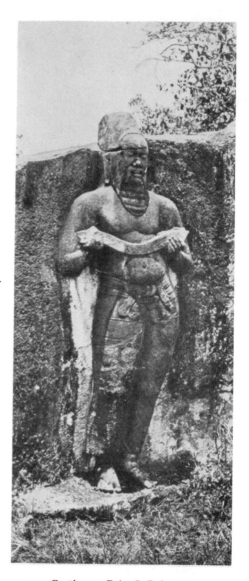

300. Pattinī Devī; tenth century?

301. Parākrama Bāhu I, Poḷonnāruva;
twelfth century.

Ceylon.

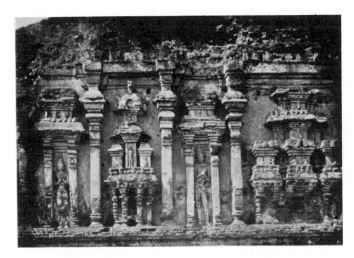

302. Northern temple, Poḷonnāruva; twelfth century.

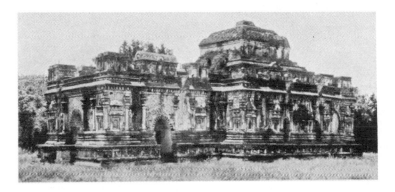

303. Thūpārāma Vihāra, Poḷonnāruva; twelfth century.

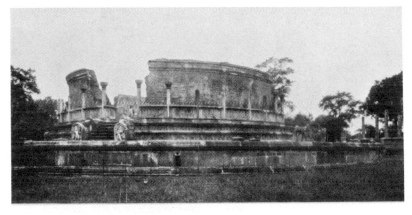

304. Waṭa-dā-gē, Poḷonnāruva; twelfth century.

Ceylon.

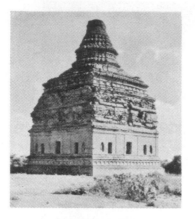

305. Nat Hlaung Gyaung,
Pagān; 931 A. D.

306. Ngakye Nadaun,
Pagān; tenth century.

307. Thatbinnyu, Pagān; twelfth century.

308. Bidagat Taik, Pagān; eleventh century.

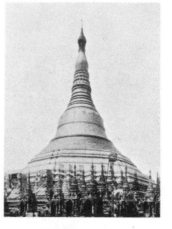

309. Mahābodhi,
Pagān; 1215 A. D.

310. Shwe Dagon, Rangoon;
modern.

Burma.

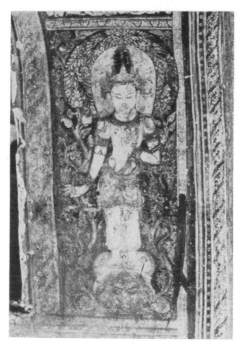

311. Padmapāṇi, fresco, Pagān;
thirteenth century.

312. Devatā, fresco, Pagān;
thirteenth century.

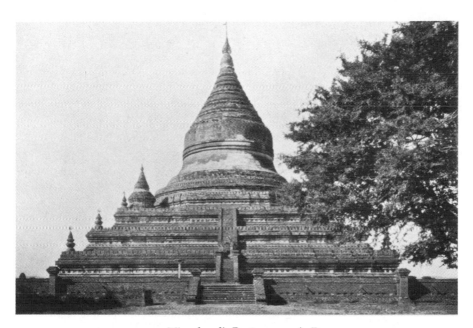

313. Mingalazedi, Pagān; 1274 A. D.

Burma.

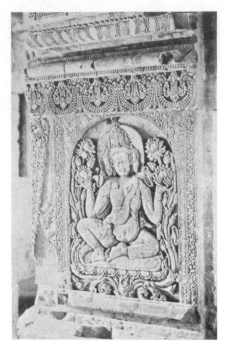

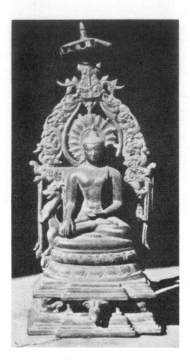

314. Brahmā, Nanpayā, Pagān;
eleventh century.

315. Buddha, Pagān Museum;
twelfth century.

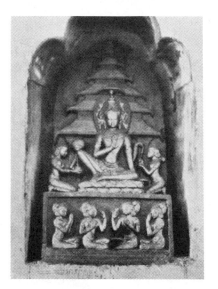

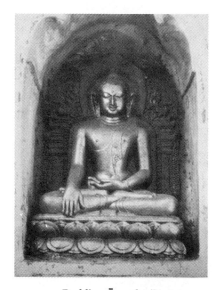

316. Siddhārtha, Ānanda, Pagān;
late eleventh century.

317. Buddha, Ānanda, Pagān;
late eleventh century.

Burma.

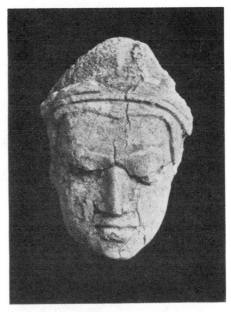

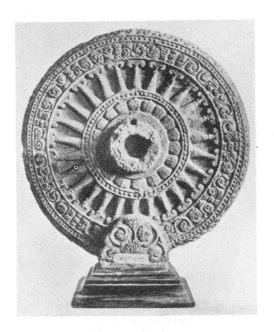

318. *Dhamma-cakka*, Prapatom;
fifth or sixth century.

319. Bodhisattva; Prapatom;
seventh century. Samson Collection.

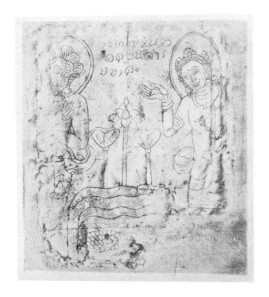

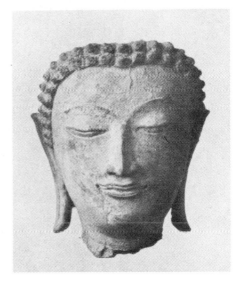

320. *Devadharma Jātaka*, Wāt Si Jum;
ca. 1361 A. D.

321. Buddha, Lopburi; twelfth
century. Samson Collection.

Siam.

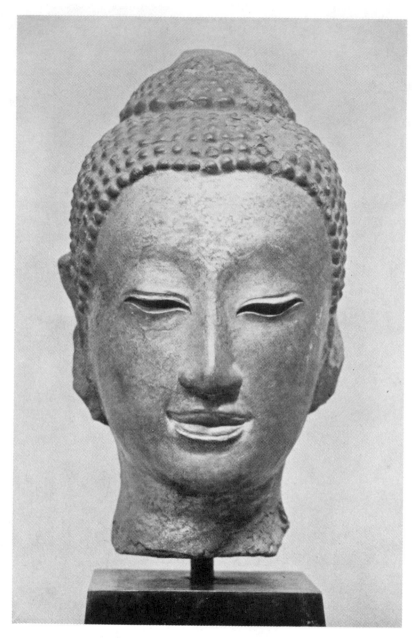

322. Buddha, lacquered stone; eleventh century. Boston.

Siam.

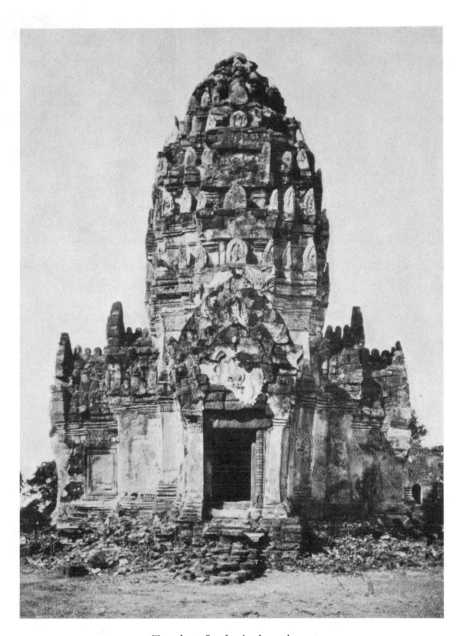

323. Temple at Lopburi; eleventh century.

Siam.

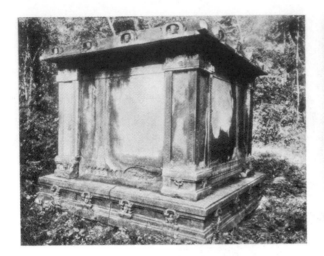

324. Cella, Préi Kuk; seventh century.

325. Brick temple, Bayang;
seventh century.

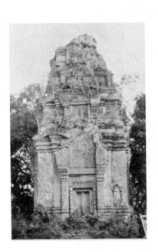

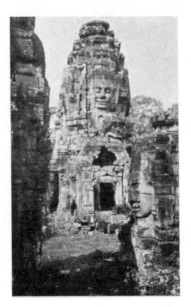

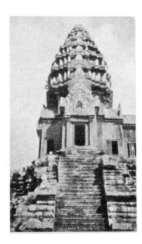

326. Brick tower, Bakong;
ninth century.

327. Tower, Bayon;
late ninth century.

328. Tower, Aṅkor Wāt;
early twelfth century.

Cambodia.

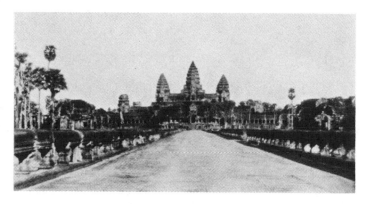

329. Aṅkor Wāt; early twelfth century.

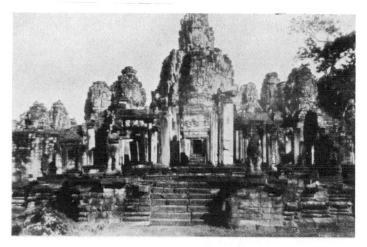

330. Bayon; late ninth century.

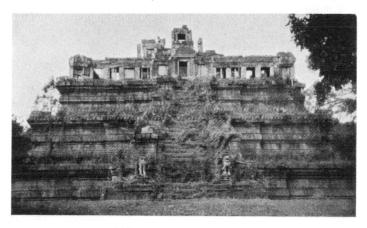

331. Phiméanakas; late ninth century.

Cambodia.

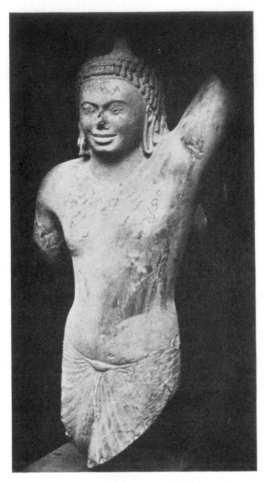

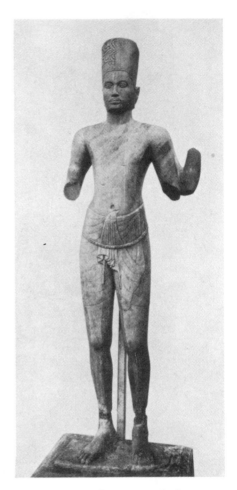

332. Lokeśvara; sixth or early seventh century.
Stoclet Collection.

333. Harihara, Prasāt Andet;
early seventh century.

Cambodia.

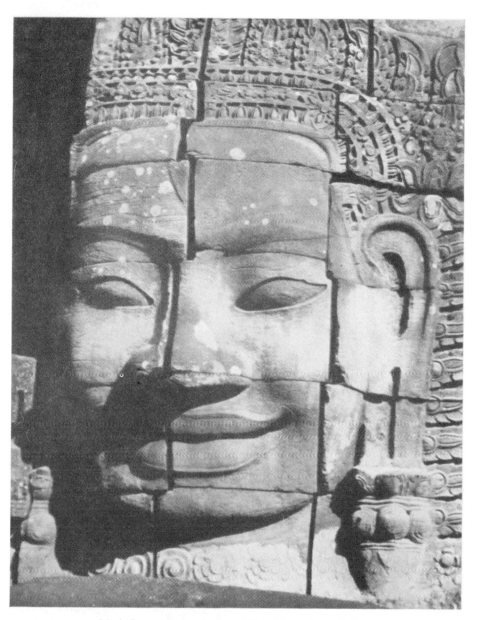

334. Mask from a tower, Bayon, Aṅkor Thoṁ; late ninth century.

Cambodia

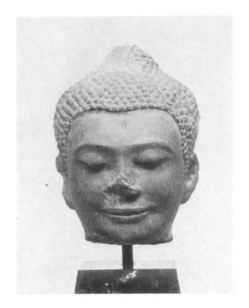

335. Buddha; ninth century.
Sachs Collection.

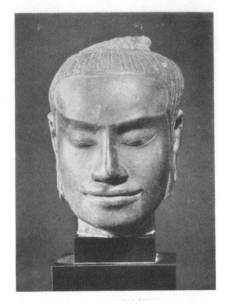

336. Bodhisattva?
fourteenth century. Boston.

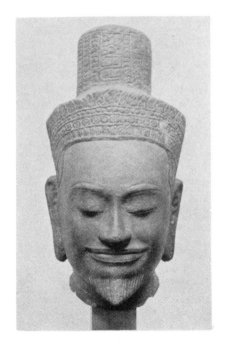

337. Śiva or king; ninth or
tenth century. Boston.

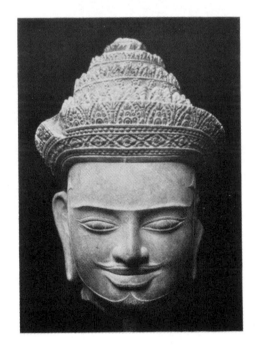

338. King; eleventh century.
Cleveland Museum.

Cambodia.

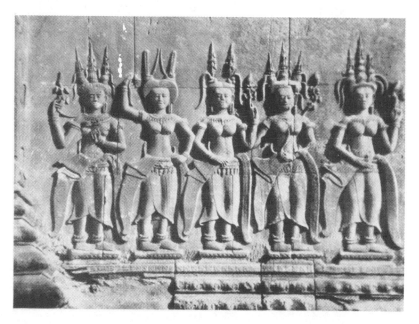

339. Apsarases, inner court, Aṅkor Wāt; early twelfth century.

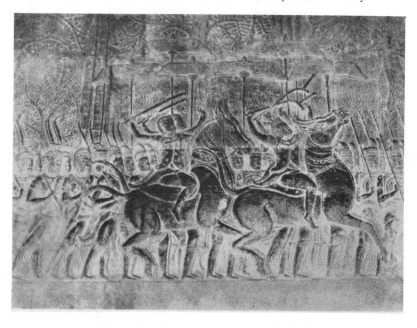

340. Army, gallery relief, Aṅkor Wāt; middle-twelfth century.

Cambodia.

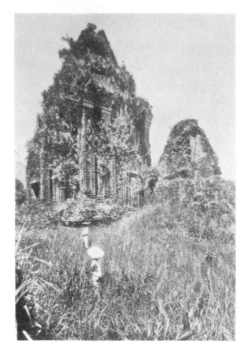

341. Brick temple, Mi-son;
early seventh century.

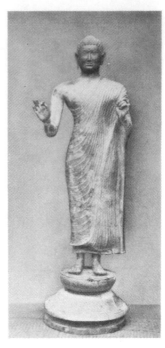

342. Buddha, Dong-duong;
third century.

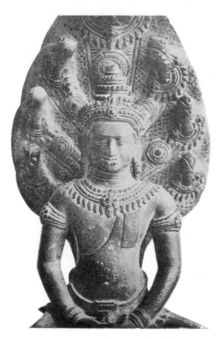

343. Buddha, Binh Dinh;
twelfth century.

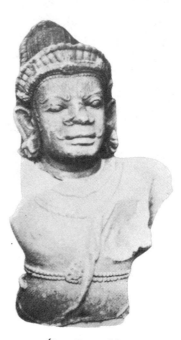

344. Śiva, Quang-Nam;
seventh century.

Campā.

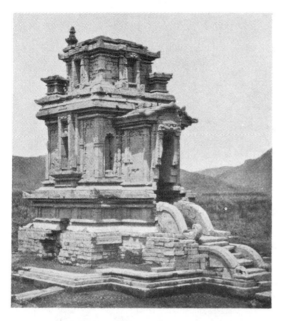

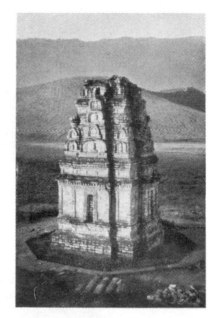

345. Candi Puntadeva, Dieng; 346. Caṇḍi Bīma, Dieng;

seventh or early eighth century.

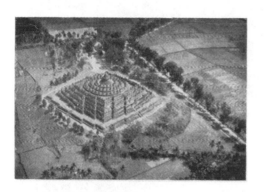

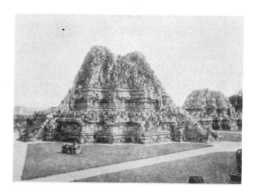

347. Borobuḍur, from the air; 348. Caṇḍi Loro Jongrang, Prambanam;
late eighth century. late ninth century.

Java.

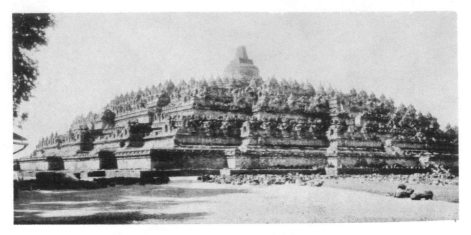

349. Caṇḍi Borobuḍur; late eighth century.

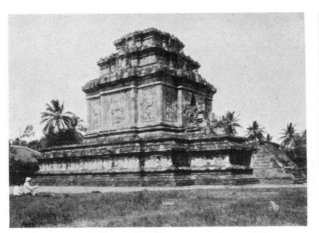

350. Caṇḍi Mendut; late eighth century.

351. Temple, Bali; modern.

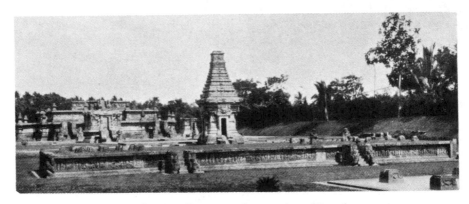

352. Temple ruins, Panataran; fourteenth to fifteenth century.

Java and Bali.

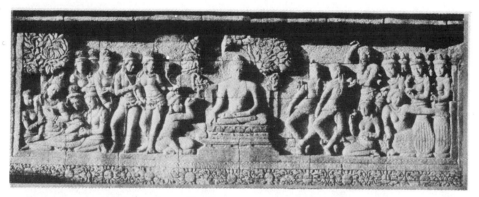

353. Temptation of Buddha, Borobuḍur; late eighth century.

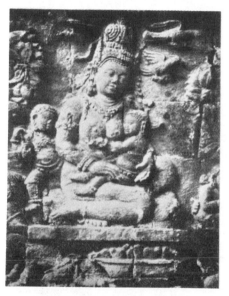

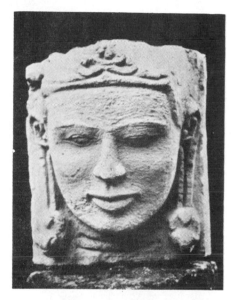

354. Hāritī, Caṇḍi Mendut; late eighth century.

355. Head from Caṇḍi Bīma, Dieng; seventh or early eighth century.

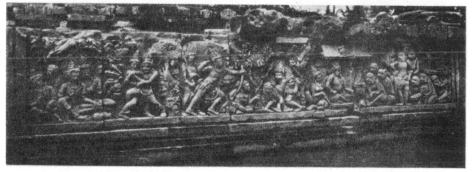

356. *Rāmāyaṇa* frieze, Caṇḍi Loro Jongrang, Prambanam; late ninth century.

Java.

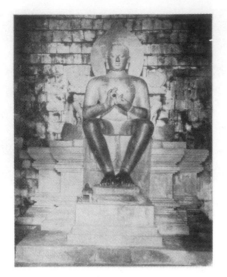

357. Buddha, Caṇḍi Mendut;
late eighth century.

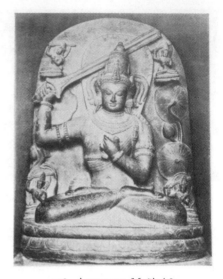

358. Arapacana Mañjuśrī;
1343 A. D. Berlin.

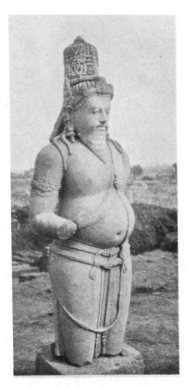

359. Agastya, Caṇḍi Banon;
early ninth century. Batavia.

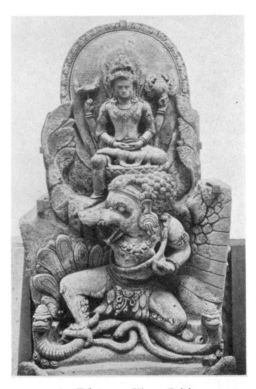

360. Erlaṅga as Viṣṇu, Belahan;
ca. 1043 A. D.

Java

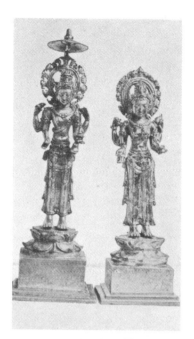

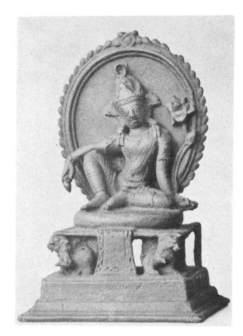

361. 362. Bodhisattva, gold, Java; eighth or ninth century. Batavia.

363. Padmapāṇi, copper, Java; tenth century. London.

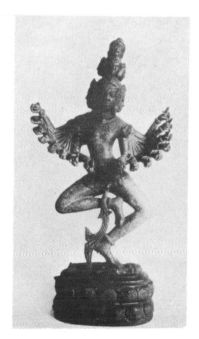

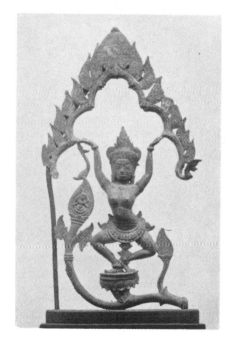

364. Hevajra, bronze, Bantéai Kedei; tenth century. Phnoṁ Peñ.

365. Apsaras, bronze, Bayon; late ninth century. Boston.

Java and Cambodia.

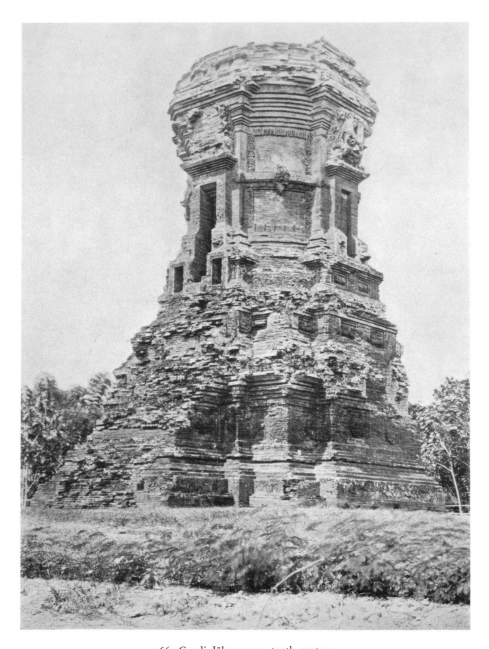

366. Caṇḍi Jābung; ca. tenth century.

Java.

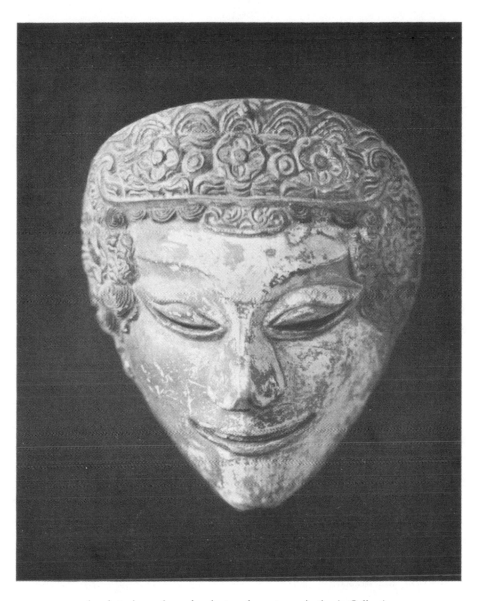

367. Actor's mask; early nineteenth century. Author's Collection.

Java.

368. Earring, gold.

369. Earring, gold.

370. Pendant, enamel
on gold, Jaipur.

371. Armlet, enamel on gold, Jaipur.

372. Bracelet, enamel on
gold, Jaipur.

373. Beads, gold, Kandy.

374. Pendant, gold, S. India.

375. Clasp, gold, Kandy.

Jewellery, seventeenth to eighteenth century.

376. Pendant, Kandy; eighteenth
century. Dambewinne.

377. Comb, S.
Indian. London.

378. Knife, Kandy
18th century.

379. *Huqqa* bowl, enamel on silver;
early eighteenth century.

380. Bell, Java; ninth
century. Batavia.

Metal work and Jewellery.

381. Betel dish, gold, Kandy; eighteenth century.

382. Bidrī *huqqa* bowl; seventeenth century.
London.

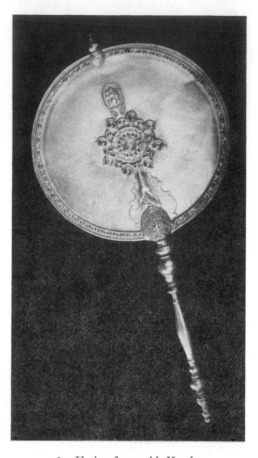

385. Votive fan, gold, Kandy;
eighteenth century.

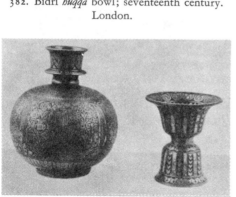

383. 384. Brass *huqqa* bowl and spittoon;
seventeenth century. Author's Collection.

386. Betel-box, silver on copper;
eighteenth century. Colombo.

Metal work, seventeenth and eighteenth century.

387. Ivory veneer, Tanjore;
eighteenth century.

389. Ivory, Tanjore; eighteenth century.

390. Decorated conch, Ceylon;
eighteenth century. L. de Saram.

391. Painted book cover, Kandy;
eighteenth century.

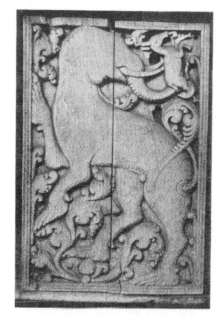

388. Ivory plaque, Ceylon;
seventeenth century.

392. Bead bags, Kāthiāwāḍ;
nineteenth century.

Ivory etc.

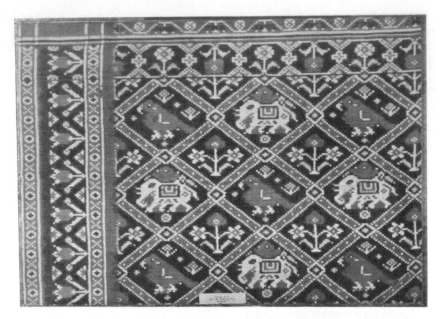

393. *Paṭola* silk *sāṛī*, Surāt; ca. 1800. Boston.

394. *Kimkhwāb*, brocade, Benares; eighteenth century. Boston.

Textiles.

395. Embroidered turban material, Rājputānaṣ;
eighteenth century. Boston.

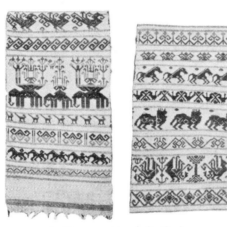

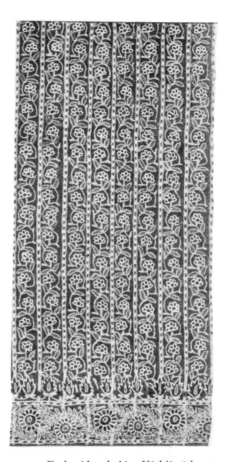

396. Woven cotton belt, Ceylon;
eighteenth century. Kandy.

397. Embroidered skirt, Kāṭhiāwāḍ;
ca. 1800. Boston.

Textiles.

398. *Batik*, Java; modern. Boston.

399. Gold stamped *batik*, Bali; nineteenth century. Boston.

400. *Ikat*-woven cotton, Sumba; modern. Boston.

Textiles.

A CATALOGUE OF SELECTED DOVER BOOKS
IN ALL FIELDS OF INTEREST

A CATALOG OF SELECTED DOVER
BOOKS IN ALL FIELDS OF INTEREST

CONCERNING THE SPIRITUAL IN ART, Wassily Kandinsky. Pioneering work by father of abstract art. Thoughts on color theory, nature of art. Analysis of earlier masters. 12 illustrations. 80pp. of text. 5⅜ × 8½. 23411-8 Pa. $2.25

LEONARDO ON THE HUMAN BODY, Leonardo da Vinci. More than 1200 of Leonardo's anatomical drawings on 215 plates. Leonardo's text, which accompanies the drawings, has been translated into English. 506pp. 8⅜ × 11¼.
24483-0 Pa. $10.95

GOBLIN MARKET, Christina Rossetti. Best-known work by poet comparable to Emily Dickinson, Alfred Tennyson. With 46 delightfully grotesque illustrations by Laurence Housman. 64pp. 4 × 6¾. ˙ 24516-0 Pa. $2.50

THE HEART OF THOREAU'S JOURNALS, edited by Odell Shepard. Selections from *Journal*, ranging over full gamut of interests. 228pp. 5⅜ × 8½.
20741-2 Pa. $4.00

MR. LINCOLN'S CAMERA MAN: MATHEW B. BRADY, Roy Meredith. Over 300 Brady photos reproduced directly from original negatives, photos. Lively commentary. 368pp. 8⅜ × 11¼. 23021-X Pa. $11.95

PHOTOGRAPHIC VIEWS OF SHERMAN'S CAMPAIGN, George N. Barnard. Reprint of landmark 1866 volume with 61 plates: battlefield of New Hope Church, the Etawah Bridge, the capture of Atlanta, etc. 80pp. 9 × 12. 23445-2 Pa. $6.00

A SHORT HISTORY OF ANATOMY AND PHYSIOLOGY FROM THE GREEKS TO HARVEY, Dr. Charles Singer. Thoroughly engrossing non-technical survey. 270 illustrations. 211pp. 5⅜ × 8½. 20389-1 Pa. $4.50

REDOUTE ROSES IRON-ON TRANSFER PATTERNS, Barbara Christopher. Redouté was botanical painter to the Empress Josephine; transfer his famous roses onto fabric with these 24 transfer patterns. 80pp. 8¼ × 10⅝. 24292-7 Pa. $3.50

THE FIVE BOOKS OF ARCHITECTURE, Sebastiano Serlio. Architectural milestone, first (1611) English translation of Renaissance classic. Unabridged reproduction of original edition includes over 300 woodcut illustrations. 416pp. 9⅜ × 12¼. 24349-4 Pa. $14.95

CARLSON'S GUIDE TO LANDSCAPE PAINTING, John F. Carlson. Authoritative, comprehensive guide covers, every aspect of landscape painting. 34 reproductions of paintings by author; 58 explanatory diagrams. 144pp. 8⅜ × 11.
22927-0 Pa. $4.95

101 PUZZLES IN THOUGHT AND LOGIC, C.R. Wylie, Jr. Solve murders, robberies, see which fishermen are liars—purely by reasoning! 107pp. 5⅜ × 8½.
20367-0 Pa. $2.00

TEST YOUR LOGIC, George J. Summers. 50 more truly new puzzles with new turns of thought, new subtleties of inference. 100pp. 5⅜ × 8½. 22877-0 Pa. $2.25

THE GUIDE FOR THE PERPLEXED, Moses Maimonides. Great classic of medieval Judaism attempts to reconcile revealed religion (Pentateuch, commentaries) with Aristotelian philosophy. 473pp. 5⅜ × 8½. 20351-4 Pa. $6.95

REASON IN ART, George Santayana. Renowned philosopher's provocative, seminal treatment of basis of art in instinct and experience. Volume Four of *The Life of Reason.* 230pp. 5⅜ × 8. 24358-3 Pa. $4.50

LANGUAGE, TRUTH AND LOGIC, Alfred J. Ayer. Famous, clear introduction to Vienna, Cambridge schools of Logical Positivism. Role of philosophy, elimination of metaphysics, nature of analysis, etc. 160pp. 5⅜ × 8½. (USCO)
20010-8 Pa. $2.75

BASIC ELECTRONICS, U.S. Bureau of Naval Personnel. Electron tubes, circuits, antennas, AM, FM, and CW transmission and receiving, etc. 560 illustrations. 567pp. 6½ × 9¼. 21076-6 Pa. $8.95

THE ART DECO STYLE, edited by Theodore Menten. Furniture, jewelry, metalwork, ceramics, fabrics, lighting fixtures, interior decors, exteriors, graphics from pure French sources. Over 400 photographs. 183pp. 8⅜ × 11¼.
22824-X Pa. $6.95

THE FOUR BOOKS OF ARCHITECTURE, Andrea Palladio. 16th-century classic covers classical architectural remains, Renaissance revivals, classical orders, etc. 1738 Ware English edition. 216 plates. 110pp. of text. 9½ × 12¾.
21308-0 Pa. $10.00

THE WIT AND HUMOR OF OSCAR WILDE, edited by Alvin Redman. More than 1000 ripostes, paradoxes, wisecracks: Work is the curse of the drinking classes, I can resist everything except temptations, etc. 258pp. 5⅜ × 8½. (USCO)
20602-5 Pa. $3.50

THE DEVIL'S DICTIONARY, Ambrose Bierce. Barbed, bitter, brilliant witticisms in the form of a dictionary. Best, most ferocious satire America has produced. 145pp. 5⅜ × 8½. 20487-1 Pa. $2.50

ERTÉ'S FASHION DESIGNS, Erté. 210 black-and-white inventions from *Harper's Bazar*, 1918-32, plus 8pp. full-color covers. Captions. 88pp. 9 × 12.
24203-X Pa. $6.50

ERTÉ GRAPHICS, Erté. Collection of striking color graphics: *Seasons, Alphabet, Numerals, Aces* and *Precious Stones.* 50 plates, including 4 on covers. 48pp. 9⅜ × 12¼. 23580-7 Pa. $6.95

PAPER FOLDING FOR BEGINNERS, William D. Murray and Francis J. Rigney. Clearest book for making origami sail boats, roosters, frogs that move legs, etc. 40 projects. More than 275 illustrations. 94pp. 5⅜ × 8½. 20713-7 Pa. $1.95

ORIGAMI FOR THE ENTHUSIAST, John Montroll. Fish, ostrich, peacock, squirrel, rhinoceros, Pegasus, 19 other intricate subjects. Instructions. Diagrams. 128pp. 9 × 12. 23799-0 Pa. $4.95

CROCHETING NOVELTY POT HOLDERS, edited by Linda Macho. 64 useful, whimsical pot holders feature kitchen themes, animals, flowers, other novelties. Surprisingly easy to crochet. Complete instructions. 48pp. 8¼ × 11.
24296-X Pa. $1.95

CROCHETING DOILIES, edited by Rita Weiss. Irish Crochet, Jewel, Star Wheel, Vanity Fair and more. Also luncheon and console sets, runners and centerpieces. 51 illustrations. 48pp. 8¼ × 11. 23424-X Pa. $2.00

DECORATIVE NAPKIN FOLDING FOR BEGINNERS, Lillian Oppenheimer and Natalie Epstein. 22 different napkin folds in the shape of a heart, clown's hat, love knot, etc. 63 drawings. 48pp. 8¼ × 11. 23797-4 Pa. $1.95

DECORATIVE LABELS FOR HOME CANNING, PRESERVING, AND OTHER HOUSEHOLD AND GIFT USES, Theodore Menten. 128 gummed, perforated labels, beautifully printed in 2 colors. 12 versions. Adhere to metal, glass, wood, ceramics. 24pp. 8¼ × 11. 23219-0 Pa. $2.95

EARLY AMERICAN STENCILS ON WALLS AND FURNITURE, Janet Waring. Thorough coverage of 19th-century folk art: techniques, artifacts, surviving specimens. 166 illustrations, 7 in color. 147pp. of text. 7⅞ × 10¾. 21906-2 Pa. $8.95

AMERICAN ANTIQUE WEATHERVANES, A.B. & W.T. Westervelt. Extensively illustrated 1883 catalog exhibiting over 550 copper weathervanes and finials. Excellent primary source by one of the principal manufacturers. 104pp. 6⅝ × 9¼.
24396-6 Pa. $3.95

ART STUDENTS' ANATOMY, Edmond J. Farris. Long favorite in art schools. Basic elements, common positions, actions. Full text, 158 illustrations. 159pp. 5⅝ × 8½. 20744-7 Pa. $3.50

BRIDGMAN'S LIFE DRAWING, George B. Bridgman. More than 500 drawings and text teach you to abstract the body into its major masses. Also specific areas of anatomy. 192pp. 6½ × 9¼. (EA) 22710-3 Pa. $4.50

COMPLETE PRELUDES AND ETUDES FOR SOLO PIANO, Frederic Chopin. All 26 Preludes, all 27 Etudes by greatest composer of piano music. Authoritative Paderewski edition. 224pp. 9 × 12. (Available in U.S. only) 24052-5 Pa. $6.95

PIANO MUSIC 1888-1905, Claude Debussy. Deux Arabesques, Suite Bergamesque, Masques, 1st series of Images, etc. 9 others, in corrected editions. 175pp. 9⅜ × 12¼.
(ECE) 22771-5 Pa. $5.95

TEDDY BEAR IRON-ON TRANSFER PATTERNS, Ted Menten. 80 iron-on transfer patterns of male and female Teddys in a wide variety of activities, poses, sizes. 48pp. 8¼ × 11. 24596-9 Pa. $2.00

A PICTURE HISTORY OF THE BROOKLYN BRIDGE, M.J. Shapiro. Profusely illustrated account of greatest engineering achievement of 19th century. 167 rare photos & engravings recall construction, human drama. Extensive, detailed text. 122pp. 8¼ × 11. 24403-2 Pa. $7.95

NEW YORK IN THE THIRTIES, Berenice Abbott. Noted photographer's fascinating study shows new buildings that have become famous and old sights that have disappeared forever. 97 photographs. 97pp. 11⅜ × 10. 22967-X Pa. $6.50

MATHEMATICAL TABLES AND FORMULAS, Robert D. Carmichael and Edwin R. Smith. Logarithms, sines, tangents, trig functions, powers, roots, reciprocals, exponential and hyperbolic functions, formulas and theorems. 269pp. 5⅜ × 8½. 60111-0 Pa. $3.75

HANDBOOK OF MATHEMATICAL FUNCTIONS WITH FORMULAS, GRAPHS, AND MATHEMATICAL TABLES, edited by Milton Abramowitz and Irene A. Stegun. Vast compendium: 29 sets of tables, some to as high as 20 places. 1,046pp. 8 × 10½. 61272-4 Pa. $19.95

HOW THE OTHER HALF LIVES, Jacob A. Riis. Journalistic record of filth, degradation, upward drive in New York immigrant slums, shops, around 1900. New edition includes 100 original Riis photos, monuments of early photography. 233pp. 10 × 7⅞. 22012-5 Pa. $7.95

CHINA AND ITS PEOPLE IN EARLY PHOTOGRAPHS, John Thomson. In 200 black-and-white photographs of exceptional quality photographic pioneer Thomson captures the mountains, dwellings, monuments and people of 19th-century China. 272pp. 9⅜ × 12¼. 24393-1 Pa. $12.95

GODEY COSTUME PLATES IN COLOR FOR DECOUPAGE AND FRAMING, edited by Eleanor Hasbrouk Rawlings. 24 full-color engravings depicting 19th-century Parisian haute couture. Printed on one side only. 56pp. 8¼ × 11. 23879-2 Pa. $3.95

ART NOUVEAU STAINED GLASS PATTERN BOOK, Ed Sibbett, Jr. 104 projects using well-known themes of Art Nouveau: swirling forms, florals, peacocks, and sensuous women. 60pp. 8¼ × 11. 23577-7 Pa. $3.00

QUICK AND EASY PATCHWORK ON THE SEWING MACHINE: Susan Aylsworth Murwin and Suzzy Payne. Instructions, diagrams show exactly how to machine sew 12 quilts. 48pp. of templates. 50 figures. 80pp. 8¼ × 11. 23770-2 Pa. $3.50

THE STANDARD BOOK OF QUILT MAKING AND COLLECTING, Marguerite Ickis. Full information, full-sized patterns for making 46 traditional quilts, also 150 other patterns. 483 illustrations. 273pp. 6⅞ × 9⅝. 20582-7 Pa. $5.95

LETTERING AND ALPHABETS, J. Albert Cavanagh. 85 complete alphabets lettered in various styles; instructions for spacing, roughs, brushwork. 121pp. 8¾ × 8. 20053-1 Pa. $3.75

LETTER FORMS: 110 COMPLETE ALPHABETS, Frederick Lambert. 110 sets of capital letters; 16 lower case alphabets; 70 sets of numbers and other symbols. 110pp. 8⅜ × 11. 22872-X Pa. $4.50

ORCHIDS AS HOUSE PLANTS, Rebecca Tyson Northen. Grow cattleyas and many other kinds of orchids—in a window, in a case, or under artificial light. 63 illustrations. 148pp. 5⅜ × 8½. 23261-1 Pa. $2.95

THE MUSHROOM HANDBOOK, Louis C.C. Krieger. Still the best popular handbook. Full descriptions of 259 species, extremely thorough text, poisons, folklore, etc. 32 color plates; 126 other illustrations. 560pp. 5⅜ × 8½. 21861-9 Pa. $8.50

THE DORÉ BIBLE ILLUSTRATIONS, Gustave Doré. All wonderful, detailed plates: Adam and Eve, Flood, Babylon, life of Jesus, etc. Brief King James text with each plate. 241 plates. 241pp. 9 × 12. 23004-X Pa. $6.95

THE BOOK OF KELLS: Selected Plates in Full Color, edited by Blanche Cirker. 32 full-page plates from greatest manuscript-icon of early Middle Ages. Fantastic, mysterious. Publisher's Note. Captions. 32pp. 9¾ × 12¼. 24345-1 Pa. $4.50

THE PERFECT WAGNERITE, George Bernard Shaw. Brilliant criticism of the Ring Cycle, with provocative interpretation of politics, economic theories behind the Ring. 136pp. 5⅜ × 8½. (Available in U.S. only) 21707-8 Pa. $3.00

TOLL HOUSE TRIED AND TRUE RECIPES, Ruth Graves Wakefield. Popovers, veal and ham loaf, baked beans, much more from the famous Mass. restaurant. Nearly 700 recipes. 376pp. 5⅜ × 8½. 23560-2 Pa. $4.95

FAVORITE CHRISTMAS CAROLS, selected and arranged by Charles J.F. Cofone. Title, music, first verse and refrain of 34 traditional carols in handsome calligraphy; also subsequent verses and other information in type. 79pp. 8⅜ × 11.
20445-6 Pa. $3.00

CAMERA WORK: A PICTORIAL GUIDE, Alfred Stieglitz. All 559 illustrations from most important periodical in history of art photography. Reduced in size but still clear, in strict chronological order, with complete captions. 176pp. 8⅜ × 11¼.
23591-2 Pa. $6.95

FAVORITE SONGS OF THE NINETIES, edited by Robert Fremont. 88 favorites: "Ta-Ra-Ra-Boom-De-Aye," "The Band Played On," "Bird in a Gilded Cage," etc. 401pp. 9 × 12. 21536-9 Pa. $10.95

STRING FIGURES AND HOW TO MAKE THEM, Caroline F. Jayne. Fullest, clearest instructions on string figures from around world: Eskimo, Navajo, Lapp, Europe, more. Cat's cradle, moving spear, lightning, stars. 950 illustrations. 407pp. 5⅜ × 8½. 20152-X Pa. $4.95

LIFE IN ANCIENT EGYPT, Adolf Erman. Detailed older account, with much not in more recent books: domestic life, religion, magic, medicine, commerce, and whatever else needed for complete picture. Many illustrations. 597pp. 5⅜ × 8½.
22632-8 Pa. $7.95

ANCIENT EGYPT: ITS CULTURE AND HISTORY, J.E. Manchip White. From pre-dynastics through Ptolemies: scoiety, history, political structure, religion, daily life, literature, cultural heritage. 48 plates. 217pp. 5⅜ × 8½. (EBE)
22548-8 Pa. $4.95

KEPT IN THE DARK, Anthony Trollope. Unusual short novel about Victorian morality and abnormal psychology by the great English author. Probably the first American publication. Frontispiece by Sir John Millais. 92pp. 6½ × 9¼.
23609-9 Pa. $2.95

MAN AND WIFE, Wilkie Collins. Nineteenth-century master launches an attack on out-moded Scottish marital laws and Victorian cult of athleticism. Artfully plotted. 35 illustrations. 239pp. 6⅛ × 9¼. 24451-2 Pa. $5.95

RELATIVITY AND COMMON SENSE, Herman Bondi. Radically reoriented presentation of Einstein's Special Theory and one of most valuable popular accounts available. 60 illustrations. 177pp. 5⅜ × 8. (EUK) 24021-5 Pa. $3.50

THE EGYPTIAN BOOK OF THE DEAD, E.A. Wallis Budge. Complete reproduction of Ani's papyrus, finest ever found. Full hieroglyphic text, interlinear transliteration, word-for-word translation, smooth translation. 533pp. 6½ × 9¼.
(USO) 21866-X Pa. $8.50

COUNTRY AND SUBURBAN HOMES OF THE PRAIRIE SCHOOL PERIOD, H.V. von Holst. Over 400 photographs floor plans, elevations, detailed drawings (exteriors and interiors) for over 100 structures. Text. Important primary source. 128pp. 8⅜ × 11¼. 24373-7 Pa. $5.95

THE RIME OF THE ANCIENT MARINER, Gustave Doré, S.T. Coleridge. Doré's finest work, 34 plates capture moods, subtleties of poem. Full text. 77pp. 9¼ × 12. 22305-1 Pa. $4.95

SONGS OF INNOCENCE, William Blake. The first and most popular of Blake's famous "Illuminated Books," in a facsimile edition reproducing all 31 brightly colored plates. Additional printed text of each poem. 64pp. 5¼ × 7. 22764-2 Pa. $3.00

AN INTRODUCTION TO INFORMATION THEORY, J.R. Pierce. Second (1980) edition of most impressive non-technical account available. Encoding, entropy, noisy channel, related areas, etc. 320pp. 5⅜ × 8½. 24061-4 Pa. $4.95

THE DIVINE PROPORTION: A STUDY IN MATHEMATICAL BEAUTY, H.E. Huntley. "Divine proportion" or "golden ratio" in poetry, Pascal's triangle, philosophy, psychology, music, mathematical figures, etc. Excellent bridge between science and art. 58 figures. 185pp. 5⅜ × 8½. 22254-3 Pa. $3.95

THE DOVER NEW YORK WALKING GUIDE: From the Battery to Wall Street, Mary J. Shapiro. Superb inexpensive guide to historic buildings and locales in lower Manhattan: Trinity Church, Bowling Green, more. Complete Text; maps. 36 illustrations. 48pp. 3⅞ × 9¼. 24225-0 Pa. $1.75

NEW YORK THEN AND NOW, Edward B. Watson, Edmund V. Gillon, Jr. 83 important Manhattan sites: on facing pages early photographs (1875-1925) and 1976 photos by Gillon. 172 illustrations. 171pp. 9¼ × 10. 23361-8 Pa. $7.95

HISTORIC COSTUME IN PICTURES, Braun & Schneider. Over 1450 costumed figures from dawn of civilization to end of 19th century. English captions. 125 plates. 256pp. 8⅜ × 11¼. 23150-X Pa. $7.50

VICTORIAN AND EDWARDIAN FASHION: A Photographic Survey, Alison Gernsheim. First fashion history completely illustrated by contemporary photographs. Full text plus 235 photos, 1840-1914, in which many celebrities appear. 240pp. 6½ × 9¼. 24205-6 Pa. $6.00

CHARTED CHRISTMAS DESIGNS FOR COUNTED CROSS-STITCH AND OTHER NEEDLECRAFTS, Lindberg Press. Charted designs for 45 beautiful needlecraft projects with many yuletide and wintertime motifs. 48pp. 8¼ × 11. 24356-7 Pa. $1.95

101 FOLK DESIGNS FOR COUNTED CROSS-STITCH AND OTHER NEEDLE-CRAFTS, Carter Houck. 101 authentic charted folk designs in a wide array of lovely representations with many suggestions for effective use. 48pp. 8¼ × 11. 24369-9 Pa. $1.95

FIVE ACRES AND INDEPENDENCE, Maurice G. Kains. Great back-to-the-land classic explains basics of self-sufficient farming. The one book to get. 95 illustrations. 397pp. 5⅜ × 8½. 20974-1 Pa. $4.95

A MODERN HERBAL, Margaret Grieve. Much the fullest, most exact, most useful compilation of herbal material. Gigantic alphabetical encyclopedia, from aconite to zedoary, gives botanical information, medical properties, folklore, economic uses, and much else. Indispensable to serious reader. 161 illustrations. 888pp. 6½ × 9¼. (Available in U.S. only) 22798-7, 22799-5 Pa., Two-vol. set $16.45

YUCATAN BEFORE AND AFTER THE CONQUEST, Diego de Landa. Only significant account of Yucatan written in the early post-Conquest era. Translated by William Gates. Over 120 illustrations. 162pp. 5⅜ × 8½. 23622-6 Pa. $3.50

ORNATE PICTORIAL CALLIGRAPHY, E.A. Lupfer. Complete instructions, over 150 examples help you create magnificent "flourishes" from which beautiful animals and objects gracefully emerge. 8⅛ × 11. 21957-7 Pa. $2.95

DOLLY DINGLE PAPER DOLLS, Grace Drayton. Cute chubby children by same artist who did Campbell Kids. Rare plates from 1910s. 30 paper dolls and over 100 outfits reproduced in full color. 32pp. 9¼ × 12¼. 23711-7 Pa. $2.95

CURIOUS GEORGE PAPER DOLLS IN FULL COLOR, H. A. Rey, Kathy Allert. Naughty little monkey-hero of children's books in two doll figures, plus 48 full-color costumes: pirate, Indian chief, fireman, more. 32pp. 9¼ × 12¼.
24386-9 Pa. $3.50

GERMAN: HOW TO SPEAK AND WRITE IT, Joseph Rosenberg. Like *French, How to Speak and Write It.* Very rich modern course, with a wealth of pictorial material. 330 illustrations. 384pp. 5⅜ × 8½. (USUKO) 20271-2 Pa. $4.75

CATS AND KITTENS: 24 Ready-to-Mail Color Photo Postcards, D. Holby. Handsome collection; feline in a variety of adorable poses. Identifications. 12pp. on postcard stock. 8¼ × 11. 24469-5 Pa. $2.95

MARILYN MONROE PAPER DOLLS, Tom Tierney. 31 full-color designs on heavy stock, from *The Asphalt Jungle, Gentlemen Prefer Blondes*, 22 others. 1 doll. 16 plates. 32pp. 9⅜ × 12¼. 23769-9 Pa. $3.50

FUNDAMENTALS OF LAYOUT, F.H. Wills. All phases of layout design discussed and illustrated in 121 illustrations. Indispensable as student's text or handbook for professional. 124pp. 8⅜ × 11. 21279-3 Pa. $4.50

FANTASTIC SUPER STICKERS, Ed Sibbett, Jr. 75 colorful pressure-sensitive stickers. Peel off and place for a touch of pizzazz: clowns, penguins, teddy bears, etc. Full color. 16pp. 8¼ × 11. 24471-7 Pa. $2.95

LABELS FOR ALL OCCASIONS, Ed Sibbett, Jr. 6 labels each of 16 different designs—baroque, art nouveau, art deco, Pennsylvania Dutch, etc.—in full color. 24pp. 8¼ × 11. 23688-9 Pa. $2.95

HOW TO CALCULATE QUICKLY: RAPID METHODS IN BASIC MATHE-MATICS, Henry Sticker. Addition, subtraction, multiplication, division, checks, etc. More than 8000 problems, solutions. 185pp. 5 × 7¼. 20295-X Pa. $2.95

THE CAT COLORING BOOK, Karen Baldauski. Handsome, realistic renderings of 40 splendid felines, from American shorthair to exotic types. 44 plates. Captions. 48pp. 8¼ × 11. 24011-8 Pa. $2.25

THE TALE OF PETER RABBIT, Beatrix Potter. The inimitable Peter's terrifying adventure in Mr. McGregor's garden, with all 27 wonderful, full-color Potter illustrations. 55pp. 4¼ × 5½. (Available in U.S. only) 22827-4 Pa. $1.50

BASIC ELECTRICITY, U.S. Bureau of Naval Personnel. Batteries, circuits, conductors, AC and DC, inductance and capacitance, generators, motors, trans-formers, amplifiers, etc. 349 illustrations. 448pp. 6½ × 9¼. 20973-3 Pa. $7.95

SOURCE BOOK OF MEDICAL HISTORY, edited by Logan Clendening, M.D. Original accounts ranging from Ancient Egypt and Greece to discovery of X-rays: Galen, Pasteur, Lavoisier, Harvey, Parkinson, others. 685pp. 5⅜ × 8½.
20621-1 Pa. $10.95

THE ROSE AND THE KEY, J.S. Lefanu. Superb mystery novel from Irish master. Dark doings among an ancient and aristocratic English family. Well-drawn characters; capital suspense. Introduction by N. Donaldson. 448pp. 5⅜ × 8½.
24377-X Pa. $6.95

SOUTH WIND, Norman Douglas. Witty, elegant novel of ideas set on languorous Mediterranean island of Nepenthe. Elegant prose, glittering epigrams, mordant satire. 1917 masterpiece. 416pp. 5⅜ × 8½. (Available in U.S. only)
24361-3 Pa. $5.95

RUSSELL'S CIVIL WAR PHOTOGRAPHS, Capt. A.J. Russell. 116 rare Civil War Photos: Bull Run, Virginia campaigns, bridges, railroads, Richmond, Lincoln's funeral car. Many never seen before. Captions. 128pp. 9⅜ × 12¼.
24283-8 Pa. $6.95

PHOTOGRAPHS BY MAN RAY: 105 Works, 1920-1934. Nudes, still lifes, landscapes, women's faces, celebrity portraits (Dali, Matisse, Picasso, others), rayographs. Reprinted from rare gravure edition. 128pp. 9⅜ × 12¼. (Available in U.S. only)
23842-3 Pa. $6.95

STAR NAMES: THEIR LORE AND MEANING, Richard H. Allen. Star names, the zodiac, constellations: folklore and literature associated with heavens. The basic book of its field, fascinating reading. 563pp. 5⅜ × 8½.
21079-0 Pa. $7.95

BURNHAM'S CELESTIAL HANDBOOK, Robert Burnham, Jr. Thorough guide to the stars beyond our solar system. Exhaustive treatment. Alphabetical by constellation: Andromeda to Cetus in Vol. 1; Chamaeleon to Orion in Vol. 2; and Pavo to Vulpecula in Vol. 3. Hundreds of illustrations. Index in Vol. 3. 2000pp. 6⅛ × 9¼.
23567-X, 23568-8, 23673-0 Pa. Three-vol. set $32.85

THE ART NOUVEAU STYLE BOOK OF ALPHONSE MUCHA, Alphonse Mucha. All 72 plates from *Documents Decoratifs* in original color. Stunning, essential work of Art Nouveau. 80pp. 9⅜ × 12¼.
24044-4 Pa. $7.95

DESIGNS BY ERTE; FASHION DRAWINGS AND ILLUSTRATIONS FROM "HARPER'S BAZAR," Erte. 310 fabulous line drawings and 14 *Harper's Bazar* covers, 8 in full color. Erte's exotic temptresses with tassels, fur muffs, long trains, coifs, more. 129pp. 9⅜ × 12¼.
23397-9 Pa. $6.95

HISTORY OF STRENGTH OF MATERIALS, Stephen P. Timoshenko. Excellent historical survey of the strength of materials with many references to the theories of elasticity and structure. 245 figures. 452pp. 5⅜ × 8½. 61187-6 Pa. $8.95

Prices subject to change without notice.
Available at your book dealer or write for free catalog to Dept. GI, Dover Publications, Inc., 31 East 2nd St. Mineola, N.Y. 11501. Dover publishes more than 175 books each year on science, elementary and advanced mathematics, biology, music, art, literary history, social sciences and other areas.